W9-AEJ-919

50,-

JOHN SLOAN'S PRINTS

A Catalogue Raisonné of the Etchings, Lithographs, and Posters

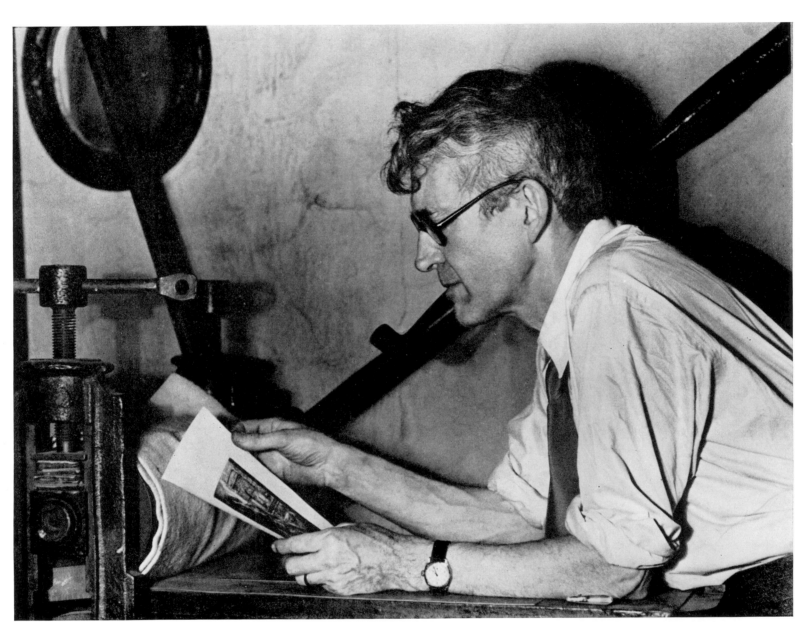

John Sloan and his etching press, 1933.

JOHN SLOAN'S PRINTS

A Catalogue Raisonné of the Etchings, Lithographs, and Posters

by Peter Morse

With a Foreword by Jacob Kainen

New Haven and London, Yale University Press

1969

Library of Congress catalogue card number: 79–84676
Standard book number: 300–01134–2

Designed by John O. C. McCrillis,
set in Baskerville type,
and printed in the United States of America by
Connecticut Printers, Inc., Hartford, Connecticut.
Distributed in Great Britain, Europe, Asia, and
Africa by Yale University Press Ltd., London; in
Canada by McGill University Press, Montreal; and
in Latin America by Centro Interamericano de Libros
Académicos, Mexico City.

Quotations from John Sloan's *New York Scene* are with permission of Harper & Row, copyright
© 1965 by Helen Farr Sloan; from *Gist of Art* with the permission of Helen Farr Sloan, copyright
© 1939 by John Sloan; from "John Sloan's Paintings and Prints," exhibition catalogue, with the
permission of Dartmouth College, copyright © 1946 by the Trustees of Dartmouth College; from
The Poster Period of John Sloan, © 1967, ed. by Helen Farr Sloan, published privately by the
Hammermill Paper Company, by Helen Farr Sloan.
The letter of Somerset Maugham is quoted with the kind permission of Mr. Spencer Curtis Brown.
Sloan's etched illustrations for *Of Human Bondage* are reproduced by permission of the George
Macy Companies, Inc.; and the excerpts from Holger Cahill's notes are cited with the permission
of Mrs. Dorothy C. Miller. All retain their respective copyright protection.

for Helen Farr Sloan

Foreword

The reputation John Sloan enjoys as a lively chronicler of city life has tended to make us forget that he was far more than an inspired reporter. Certainly his subjects represent a radical break with the genteel, academic tradition that dominated American art in the early years of the twentieth century, but the appropriateness of his formal expression must not be overlooked. His new subject matter was only part of the story—he was also deeply concerned with problems of form, both in his early and late work. Even in his raciest and most amusing subjects he was never a superficial realist. Sloan was always conscious of structure. His main problem in the early work, in fact, lay in giving animation to groups of figures while making them three-dimensional at the same time, so that many of his etchings have the appearance of sculptural tableaux.

Up to the late 1920s, when Sloan began to stress form and to minimize subject, he was particularly interested in the give and take of everyday existence in a big-city environment. More than any other printmaker of the period, he was the champion of the common man and woman, seen sympathetically but without illusion in their least guarded moments. The makeshift character of life among the nonaffluent, with their small pleasures, was his basic theme.

He was the witty observer who found an essential humanity in the commonplace. His subjects perform accustomed and natural actions—a man and wife embrace, the man's suspenders dangling, while a child looks on approvingly; girls with umbrellas walk in the rain in Washington Square; a wife turns out the light on going to bed. Other subjects, more clearly documentary, still have the sharp flavor of personal involvement, as in his old teacher Anshutz explaining anatomy; Henri and his wife with the Sloans; the look of Sixth Avenue at Thirtieth Street; and others. Sloan was, in fact, a natural diarist—a man who so enjoyed the normal flow of life around him that he was reluctant to let it die. He felt moved to record it in all its little, unpredictable ways.

When Sloan began his *New York City Life* set in 1905, he was already an accomplished etcher. Few other artists have had such an extended preliminary period before embarking on their own personal and uncommissioned work. While there is no reason for including biographical and technical data here that are amply covered in the catalogue and appendix, it is relevant to point out that Sloan had produced 126 known etchings before beginning work on the prints by which he made his reputation. It is true that he was mainly self-taught as an etcher, but, through trial and error, he became a master of his craft. His self-deprecation as a technician is not to be taken seriously. The process of etching is notoriously unreliable, even in the most skilled hands—Meryon himself called the etcher's acid "that traitrous liquor."

In the fifty or so etchings Sloan made between 1891 and 1893 to illustrate the novelty publications by A. Edward Newton, he developed his technical skills. When in 1902 he began his illustrations for the novels of Charles Paul de Kock, Sloan attacked the plates with great assurance. The 53 etchings are extraordinary illustrations, among the finest done in America,

and Arthur B. Davies' comment to Henri—"nothing better has ever been done"—is unprecedented praise from a man not given to superlatives. The illustrations are spirited, full of character, and rich in black-and-white. The De Kock etchings sharpened Sloan's abilities to capture the essence of a human situation, already developed through his newspaper illustrations. As a reporter-artist, Sloan learned to memorize incidents and gestures, which he re-created in his studio. In the De Kock illustrations he trained himself to invent situations with figures in action, and also perfected a line system for rendering forms and textures with needle and acid.

Sloan was a student of line techniques throughout his life. In his *Gist of Art* (1939), he counsels students: "Study the classical line techniques of the masters: Dürer, Hogarth, Titian, Leonardo, Rembrandt, and Leech." The surprising name here is that of Leech, who seems out of place in such exalted company. But Sloan was interested in John Leech, and in Charles Keene as well, primarily because these artists had developed fresh line techniques to give form to their illustrations of everyday events. Their unromanticized approach to London life in the latter nineteenth century, their brisk attack with the pen, and their kindly but penetrating interpretations, seemed closely allied to his own art. While he studied their work, particularly that of Leech, he did not copy their methods but adapted them to his needs. It is remarkable that so careful a student of the line techniques of other artists should be so free from their specific influence in his own work.

In 1893 Sloan became acquainted with Japanese art through Beisen Kubota, a Japanese newspaper artist attending the Chicago World's Fair, and produced posters and newspaper illustrations in simplified patterns of black-and-white. The work had a kinship with the prevailing style of Art Nouveau, although at the time Sloan had not yet seen the art of European masters of the genre. His approach was intuitive, but the concept of decorative patterning was obviously a natural one for the burgeoning art of the poster. Sloan's contribution was recognized at an early date—some pieces were included in Percival Pollard's *Posters in Miniature* (1896), along with examples of such masters as Beardsley, Bradley, Chéret, Mucha, Bonnard, Steinlen, and Toulouse-Lautrec.

It is not surprising, then, that the ten prints of the original *New York City Life* set, produced in 1905 and 1906 (three prints were added later), signaled the appearance of an American etcher of outstanding stature. Nothing like these etchings had been done before. They were lively, acutely observed, and convincingly executed. They were entirely original and contemporary in outlook, were telling in black-and-white pattern, and had an unbuttoned honesty that sometimes verged on rowdiness. Certainly the prints were disturbing to many of Sloan's contemporaries, who were still attuned to more genteel subjects. Girls looking into the slots of penny arcade movies having such lurid titles as "Girls in Night Gowns—Spicy," and "Those Naughty Girls"; a young girl staring at a well-endowed manikin figure in a case and tentatively exploring her own bosom; and the well-known "Turning Out the Light," were

unprecedented subjects for an American artist. When the American Water Color Society in 1906 rejected four of the ten *New York City Life* prints as "vulgar" and "indecent," it was merely reflecting the standards of the time.

Obviously the artist was more than a kindly, witty observer of humble life. His unsparing honesty and insight into human relationships gave his work an added dimension, one that was liberating artistically as well as socially. In "Love on the Roof" (no. 167), for example, he shows a woman of about thirty and a teen-age boy making love. Sloan comments, "Note the protest of the fluttering garments and the neglected child . . . The nightshirts and underwear belong to her husband." Morse adds, "See 'Sloan Defends Love Etching,' *New York Sun,* December 13, 1934, p. 29, concerning an occasion when this etching was cited in a trial as an example of 'immorality.' "

Sloan has not yet received credit for bringing a sharply different viewpoint into the tired and derivative traditions of American printmaking. While other etchers were looking to Meryon and Whistler, and more distantly to Rembrandt, or were working more naively without consideration of formal matters, Sloan was building on the hearty Anglo-Saxon tradition of Hogarth, Leech, and Keene, which reflected his own heritage. The latter two artists probably appealed to him most directly, as his repeated acknowledgment of debt makes clear, but Sloan learned at least as much from the savage Hogarth. From him Sloan learned to pack his compositions with incident, to treat them fully in light and dark, and to make formal organizations. Hogarth was the outstanding example of the engraver who scorned clever technique and who built his tones through simple cross-hatching; and Sloan, while not as harsh and dry, no doubt found this uningratiating approach congenial to his own nature. In one sense Hogarth repelled Sloan, who noted in *Gist of Art* that the former based his work on hatred—"Many of his pictures were a sort of tirade, a diatribe on the manners and ways he disliked." But Hogarth was the father of the English tradition of commenting sharply on the life around him, and Sloan, even though he showed a more charitable nature, was essentially of the same lineage. Certainly he was more attracted to the genial Daumier but technically and from the aesthetic standpoint Sloan's roots were in the English outlook founded by Hogarth.

If we except older artists such as Joseph Pennell and Thomas Moran, there were no significant American etchers following Whistler's death in 1903. John Marin, working in the Whistler vein, was just beginning in 1906. Arthur B. Davies, who had made prints since the early 1880s, had not yet found himself. Childe Hassam did not etch seriously until 1915. Thus Sloan, with his *New York City Life* set, was the first important American etcher to reach maturity in the twentieth century. The fact that his prints had no popular sale should not blind us to the influence he exerted, both directly and obliquely, in the

following decades. Writing in 1930, Guy Pène du Bois says of him,

> His place in the annals of American etching is enviable. He was for many years the only one of our etchers to do figures in their natural environments as people rather than as lay dummies to show the scale of a much more handsomely treated building. It is to him more than to any other individual that we owe the move away from the purely architectural subject that has taken place in recent American etching.

This statement is not entirely true—C. F. W. Mielatz and Charles H. White were even better known than Sloan as etchers of city life in the first decade of the century. But they lacked Sloan's zest, his forcefulness, and they were soon forgotten.

Sloan's etchings of the 1920s continued in his typical vein but his handling gradually became more methodical. The lines of cross-hatching were laid down more deliberately and tones were built up more systematically. What Sloan was losing in charm and verve he was gaining in austerity. By the late twenties the character of Sloan's work had changed—it had become more clearly form-conscious. The shapes were not classical or gracious, however. They were often knobby and hard, with the lines doggedly applied as if to show a disdain for "brilliant" handling. There was a greater concern with the female nude, often posed against such settings as an etching press, a staircase, or a bookcase. The setting, in any case, was simple.

Such subjects brought no story-telling associations. "Nude Reading" of 1928 (no. 234) is the first of a long series of nudes, continued through 1933, in which the figure is heavily and thoroughly modeled. The action, the animation that had given his early work its warmth and charm, were now dispensed with. Nor was there any fleshly appeal in the nudes. Sloan by his own admission was determined to make them as hard and impersonal as metal. He was concerned with a large statement, with a compelling solidity that would go beyond the easy attraction of subject or technique. Certainly some of the nudes have a tough, uncompromising character that seems close to such masters as Signorelli and Mantegna.

By the end of 1937 Sloan had created over three hundred prints. Thereafter he devoted his time more fully to his paintings. His production of etchings slackened and he made only eleven more before he stopped printmaking in 1949. He had made a great contribution, one that looms larger as time passes. It is likely that he produced a greater number of memorable prints than any of his American contemporaries. Sloan had the gift for making an image vivid, for fixing it enduringly in the mind.

JACOB KAINEN

Curator, Prints and Drawings
National Collection of Fine Arts

Preface

This catalogue raisonné has grown out of a long personal love of John Sloan's prints from all periods of his creative life. The artist's work and his words are allowed to speak for themselves. The factual data assembled and ordered here will, it is hoped, be useful source materials for scholars, curators, and collectors.

The listing is inclusive, covering every known work done by Sloan in an original multiple medium. Every discovered etching, drypoint, lithograph, and linoleum block print, without exception, is catalogued here. Likewise, all currently known poster designs by Sloan are listed. If this book encourages further inquiry into Sloan's remarkable art, it will have more than served its purpose.

Far beyond all others, my thanks and appreciation go to Helen Farr Sloan, the artist's widow. Since I first came to ask her help, she has given me immeasurable amounts of direct assistance, personal recollections, and total access to Sloan's files of prints, notes, letters, diaries, business records, and all material belonging to the John Sloan Trust, on deposit at the Delaware Art Center. This would have been a completely different and perhaps impossible work without her help. It has been a personal pleasure for me to work with her. At the same time, it must be noted that this is not a commissioned or "authorized" work. The responsibility for every fact and opinion in it is entirely my own. Such a situation only leaves me in greater debt for all of Helen Sloan's generosity. To her this book is most gratefully dedicated.

Jacob Kainen, my associate at the Smithsonian Institution, has given me the continual benefit of his advice and experience. It has been a great privilege to work with him. My appreciation also goes to the Smithsonian Institution and its policy of encouraging research. Much direct assistance has been given, including a special grant from the Fluid Research Fund.

There are many others who have helped. Foremost is Carl Zigrosser, who generously relinquished his prior interest in this project and gave me much personal advice and help from his notes and files. If he had undertaken it, this would surely have been a better work. Kneeland McNulty and the staff of the print department of the Philadelphia Museum of Art have been of constant and patient help. Bruce St. John and the staff of the Delaware Art Center, Wilmington, have given freely of their time. Kirke Bryan and George Tweney, noted collectors of the works of A. Edward Newton, were both exceptionally generous in making available unique early Sloan prints. George Lohman of the Smithsonian Institution and Alfred J. Wyatt of the Philadelphia Museum of Art are individually responsible for most of the fine photographs in this book. Anne Wilde, Yale University Press, has been a wonderfully skillful and empathic editor.

Others who have been of very special help are Elizabeth M. Harris; Antoinette Kraushaar; A. Hyatt Mayor, John McKendry, and the staff of the Metropolitan Museum of Art; Lloyd Goodrich and the staff of the Whitney Museum; the staff of the Museum of Modern Art; Karl Kup, Elizabeth E. Roth, and the staff of the New York Public Library; and Jack Goodwin, Charles Berger, and the Smithsonian Library staff. I am also particularly grateful to Angna Enters, Don Freeman, Robert Chapellier, Jewel Sullivan, Linda I. Young and Mrs. Richard C. Young, Ellen Shaffer and the staff at the Free Library of Philadelphia, and many members of the staff at the Library of Congress.

My appreciation and thanks also go to Peggy Bacon; Violette de Mazia, Barnes Foundation; Cecil C. Bell; Mrs. Sherrill L. Berger; John Alden and Ellen M. Oldham, Boston Public Library; Marvin S. Sadik and the staff at Bowdoin College; Christine D. Hathaway, Brown University Library; Truman H. Brackett, Jr., Dartmouth College; Ulrich Middeldorf; Jon Nelson, University of Nebraska; James W. Norwood; Alan Shestack; Henry Alexander and Richard Hofmeister, Smithsonian Institution; James E. Spears; and Mabel Zahn. Many others who have helped are acknowledged with gratitude in the text of this catalogue.

In addition to these, I am most grateful to the curators and librarians of the more than two hundred museums, libraries, and universities who gave personal help and answered inquiries about material in their collections. There are many others to whom I owe special appreciation and to whom I apologize for not mentioning them here.

Finally, a very special expression of thanks to my estimable secretary, Patricia Turner, who not only corrected my grammar, spelling, and self-contradictions but did so much splendid work on this manuscript that she must know it by heart.

A catalogue raisonné is never truly complete, for its appearance in print invariably stimulates a search in dusty corners for forgotten material. I should be grateful if those who make new discoveries—prints, state proofs, historical data, and, not the least, errors in these pages—would write to me.

P. M.

Division of Graphic Arts
Smithsonian Institution
Washington, D.C.
1967

Abbreviations

Bowdoin	Walker Art Museum, Bowdoin College, Brunswick, Me.
Brooks	Van Wyck Brooks, *John Sloan: An Artist's Life,* New York, 1955.
Bryan	Collection of Mr. Kirke Bryan, Norristown, Pa.
Dart	Comments by John Sloan in the Dartmouth College exhibition catalogue, "John Sloan Paintings and Prints," Hanover, N.H., June 1 to September 1, 1946.
FLP	Free Library of Philadelphia, Pa.
Fogg	Fogg Art Museum, Harvard University, Cambridge, Mass.
Gist	John Sloan, *Gist of Art,* New York, 1939.
HFS	Helen Farr Sloan, the artist's widow, used in reference to her manuscript notes of the year given (in JST), unless the context indicates otherwise.
JS	John Sloan, referring to manuscripts of the year given (in JST), unless otherwise indicated.
JST	John Sloan Trust, material cited here which remains in Mrs. Sloan's possession, at present on deposit in the Delaware Art Center, Wilmington, Del. (Other material may be elsewhere.)
LC	Library of Congress, Washington, D.C.
Lock Haven	Annie Halenbake Ross Library, Lock Haven, Pa. (John Sloan Memorial Collection).
Met	Metropolitan Museum of Art, New York, N.Y.
Mod	Museum of Modern Art, New York, N.Y.
NYPL	New York Public Library, Main Branch, New York, N.Y.
NYS	*John Sloan's New York Scene,* edited by Bruce St. John (New York, 1965), with both the page number and the date of Sloan's diary entry given when pertinent.
Ph	Philadelphia Museum of Art, Philadelphia, Pa.
Rosenwald	Lessing J. Rosenwald Collection, Jenkintown, Pa.
SI	Smithsonian Institution, Division of Graphic Arts, Washington, D.C.
Tweney	Collection of Mr. George H. Tweney, Seattle, Wash.
Whitney	Whitney Museum of American Art, New York, N.Y.
WP	Working proof, an abbreviation used by Sloan.
WSFA	Wilmington Society of the Fine Arts, Delaware Art Center, Wilmington, Del.

Numbers in parentheses, otherwise unexplained, refer to catalogue numbers of Sloan's prints in this book. Unannotated page numbers also refer to the present volume. The name of a city refers to the principal art museum of that city, if not differently indicated.

Contents

Text Illustrations

Introduction

Each catalogue entry includes the following data, in the order given:

Catalogue number (letters for posters)
Title
Illustration(s)
Date, including sources for the dating
Titles, Alternatives, series titles, and captions
Medium
Size, height before width
States, including location of proofs
Edition
Printing, quantity, papers, and inks
Plate, existence, location, and description
Tissue, including location
Sloan's comments on the print
Other data, when pertinent

TITLE

In every case where Sloan assigned a specific title to a print, that title is used here. The titles of all the "published" prints (see p. 12) and of the De Kock prints are his own. On occasion he used more than one title for a print, all of which are noted here. Many of the early etchings, being book titles or illustrations, contain titles in the plate. The remaining trial or unpublished plates have been given simple descriptive titles by Carl Zigrosser and where necessary by the present compiler. The De Kock and *Of Human Bondage* etchings were published with captions, which are given here in full. Ellipses in caption quotations are also present in the original. The Title Index lists every reasonable key word and variation, to enable particular subjects to be located easily.

Sloan's notable fondness for puns is apparent in his titles. In most cases these are quite self-evident, such as *Arch Conspirators,* and no special explanation is felt to be necessary.

DATE

The chronology of Sloan's prints can be established with considerable accuracy. This entire catalogue, with only slight exceptions, is arranged in the order in which the prints were actually made. Where a print was finished long after it was begun, the starting date is used.

Dating is least reliable for the prints done before 1900 (nos. 1–62). Only fifteen of these contain the year date in the plate. Some can be dated from extrinsic evidence, as noted in each case. In the absence of other information, the arrangement is made stylistically. In every case the evidence for the dating is given.

After 1900, in the considerable majority of cases (217 out of 251), Sloan did include the date in the plate itself. The De Kock prints are considered to be dated only if the year is within the picture area. The copyright date, because of various inconsistencies, is not considered a dating of the print.

The following prints (81 of a total 313) *lack* an identifiable date in the plate; all others have it. *Before 1900:* 1–3, 5, 9, 12, 14–29, 32–41, 43–44, 47–51, 53, 55–60, 62. *After 1900:* 63, 64, 66, 68, 69, 70, 72, 78, 79, 80, 83, 84, 91, 103, 147, 157, 158, 160, 161, 163, 165, 168, 180, 189, 191, 194, 199, 201, 203, 243, 277, 302, 309, 311. In two cases a date appears in early states of the plate and was subsequently removed (148, 195).

The date Sloan began a print can frequently be determined to the day. The greatest weight is given to his diary entries, actively maintained during the years 1906–12 and 1943–51, and to contemporary personal letters. Next in importance are dates entered by Sloan in pencil on trial proofs. These inscriptions are presumed to be contemporary with the prints involved. He did not write such dates on his proofs with any consistency. There exists, nevertheless, a considerable number, from all periods of his work. Each date, the state of the print on which it appears, and the present location of the inscribed proof is given in the catalogue. Such dates are particularly common from the period 1920–31.

Other dates inscribed by Sloan are included in his various business records, such as printing and sales invoices, described further on. They usually give only the month, not the day. These records are in the John Sloan Trust on deposit at the Delaware Art Center, unless otherwise noted. In some cases, external evidence of dating is used.

When no direct evidence is known, as in the case of the 1933 nude subjects, the catalogue entries are given in their sequence in Sloan's printing records, on the assumption that he entered them in the book as he completed them. Sometimes a limitation can be established. If a print was sent to a printer, for instance, or appeared in an exhibition early in the year given in the plate, it can be dated within a few months. Also, if a print is known to have been used as a New Year or Christmas greeting to Sloan's friends, we can with reasonable certainty date it late in a given year.

The year given in the plate is the date of the print in all but three instances. When other sources for a date are noted here, the date in the plate, if present, can be assumed to correspond

with the given data. In three cases (170, 179, 217), a year different from that in the plate is presumed. These three New Year greetings are very likely to have been done late in the preceding years: 1914, 1915, and 1925 respectively. In numerous cases, more than one kind of date evidence is available. Usually only the most precise is given.

In one area, that of the De Kock etchings, the strict time sequence has been altered. It was felt more important in this case to present these prints in the order in which they appear in those publications, an arrangement which does very little violence to chronology (see p. 65). In the *Of Human Bondage* set (280–96), it was impossible to fix a definite order of creation. These are listed in the order of the chapters they illustrate.

MEDIUM

The vast majority of Sloan's prints are pure etchings. Of the others, four are drypoints (1, 62, 78, 79); ten are lithographs (133, 142, 143, 144, 145, 147, 192, 203, 209, 210); and three are original linoleum-block posters (194, 201, 277). Burin engraving is combined with etching in a number of later subjects, but no plate is totally engraved. Aquatint is used with line etching in eight plates (173, 185, 186, 220, 222, 224, 225, 261), in seven of which it predominates (all but 261). Mezzotint techniques appear in two plates (304, 305). The term "etching" is used here in its specific sense of a plate etched by acid through a grounded surface, not in the generic sense including all intaglio plates. Monotypes, of which Sloan made a number, are not included in this catalogue.

SIZE

Sizes are given both in millimeters and inches, height preceding width. The inch dimensions, with rare exceptions, are made no finer than a quarter of an inch and are rounded off accordingly, easing the comparison of plates in standard sizes. The metric measurements are rounded to the nearest millimeter.

Where the original plate is known to exist, its dimensions are given. In all other cases the size is the outside dimensions of the print's platemark. What is being measured is stated in each instance. Prints are usually 2 to 3 percent smaller than their corresponding plates, owing to paper shrinkage in drying. Considerable variations have been found in the dimensions of different proofs of the same print. In a number of Sloan's earlier plates, particularly the De Kock series, the subject matter, often within a frame line, is smaller than the platemark. In such cases a picture measurement is given in addition to that of the plate or platemark. These have been taken from prints, even where a plate exists. Measurements of lithographs and posters are of the extreme limits of the design, as is customary.

Finally, it should be noted that, without exception, the measurements given here have been made personally by the compiler from the original plates or prints. Any errors are mine alone.

STATES

Printmaking is the only artistic medium that allows us to see separately the various steps of an artist's creative process. In other media, early work is covered or eliminated by subsequent steps and can only be discovered inferentially.

Sloan's prints have many early states. He consistently pulled trial proofs at various stages in his work, and he kept these proofs instead of discarding them, as many artists do. Only very occasionally did he sell or give away working proofs.

"State," in the sense used here, means any impression of a print showing a deliberate change in a plate, distinguishing it from another impression of the same plate. Accidental scratches are not considered to constitute state differences, although they are sometimes noted here when they appear to be significant. In only one case (178) is there some slight question whether a change in a plate is deliberate or accidental. All others are self-evident.

In many instances Sloan personally noted the state of a print on a trial proof. This occurred in two significantly different manners. First, he sometimes wrote the state descriptions on the prints on the immediate occasion of printing them. He started this procedure as early as 1902, with some of the De Kock etchings, but did not maintain it with any consistency whatever. Thus, some prints from all periods have whole series of state proofs inscribed by Sloan. Many others have none. His personal contemporary inscriptions are very accurate. They have been contradicted in a few cases here only after the most careful study. What differences do occur in this category are generally where Sloan marked too many states. In some instances he may have been indicating series of printing experiments, not state changes.

The second type of state inscription is more frequently found. In about 1945 Sloan looked through large numbers (but not all) of his trial proofs with his wife, Helen Farr Sloan. He considered each and told its place in the sequence. Mrs. Sloan then entered this information directly on the print as Sloan gave it to her. These inscriptions, in HFS's hand, are in the form of Arabic digits enclosed in square brackets, usually placed in the lower left corner of the sheet of paper. HFS has never marked the state on a print without its having been dictated by Sloan on the spot. These notes, while largely accurate, do not have quite the same degree of reliability as Sloan's contemporary inscriptions. This is understandable, as most of them were made many years after the prints and without access to a number of proofs. In every case where I have revised the state listings the differences are noted. It should be made clear that the differences between the Sloan notes and mine are mentioned here, not the agreements. The latter are in the great majority.

A considerable quantity of state proofs has also been found which were not annotated in any way by Sloan. In most cases these were simply filed and forgotten by the artist and remained unnoticed during the 1945 examination. In a few instances Sloan changed a plate after part of its edition had been published, without annotation.

It should be added that all the descriptions of state differences are those of the compiler, not of Sloan. In every case these were made from an actual inspection of the prints. Photographs were also used to verify observations made from the prints.

A few notes are in order on terminology in these state descriptions, especially the confusion of "left" and "right." Here, when left or right is applied to a person, or to an object which has a

left and right of its own, such as an armchair, the term always means the person's or the object's *own* right or left. In all other cases the term refers to the viewer's right or left. To take a specific example, that of *Dolly Sloan 1936* (279), there is much additional work in later states on her *right* arm (the viewer's left), to the *right* side of her nose (the viewer's left), and on the chair to the *right* of her head (the viewer's right).

Since this catalogue includes certain state sequences which differ from Sloan's inscriptions, it is recommended that the state numbers (e.g. "4th state") be entered lightly in pencil on the backs of prints in museum collections. Sloan's and Mrs. Sloan's inscriptions should certainly not be removed, even though different from those given here. With the permission of the appropriate curators or owners, the compiler has already added such data in the lower left corner on the backs of a small number of proofs.

EDITION

As given here, an edition is an implied contract between the artist and the purchaser of a print that no more than a given number of impressions will be pulled from a plate. Sloan apparently started to set limited editions of his prints between 1916 and 1920, perhaps on the advice of his cataloguer, A. E. Gallatin, or his dealer, John F. Kraushaar. He decided on a figure of 100 as a useful size for an edition and seldom varied it. This is indicated by Sloan's inscription, "100 proofs," on the "published" prints. He also applied this limitation retrospectively to the prints before 1920 of which he still had the plates. In a few cases, he wrote "100 proofs" on impressions printed and signed earlier but still unsold. Generally, however, Sloan prints actually printed before 1920 do not have the edition inscription; those after 1920 do have it, as do late impressions of early plates. A little caution is advisable here, however. Other factors, particularly the quality of the printing and the type of paper, should always be taken into account in judging the date of a particular proof.

In only five cases has the declared edition been exceeded. *Fifth Avenue Critics* (128) of 1905 was printed in a large unsigned edition in 1909, published in the *Gazette des Beaux-Arts* of Paris. This is clearly distinguishable, by the state change in the plate, from the regular published and signed edition of 100.

Copyist at the Metropolitan (148) was printed in a special edition of 115 proofs by E. Weyhe of New York in 1919. There is no state difference between the two editions, and both are signed. I have found no reliable way of telling them apart. The edition of this print must therefore be considered to be exceeded, with a total of 190 impressions. The two frontispieces for Thomas A. Daly's books of poems (140 and 159) were printed in large quantities, unsigned, in addition to Sloan's own signed large-paper editions of 100 each. There is no state difference. *Bandit's Cave* (195) was printed in 500 to 600 copies, with a clear state change distinguishing these from Sloan's personal edition of 35. Finally, nos. 304 and 313 are sometimes found with inscriptions of edition size different from those actually set.

By general convention, followed by Sloan, all unfinished trial proofs and 10 "artist's proofs" (25 in the single case of the *Of Human Bondage* set) in the finished state are excluded from the edition. For this reason some prints show a total printing record of 110, which is considered to include the ten artist's proofs. This figure will also be considered the limitation of any future printing of incomplete editions of 100. It should be made clear that the artist's proofs do not differ in state from the published prints, nor did Sloan, in most cases, inscribe them differently.

PRINTING

Quantity

All of Sloan's prints at present in existence (in 1967), except for a few unpublished subjects, were printed during his lifetime. All the "published" prints were personally approved by him. (But note the special printing of no. 165, in 1969, for this book.) The printing records given in this catalogue, therefore, represent Sloan's personal production of prints from his plates. He did not print most of them to the edition limits, because of the cost of printing and his relatively slow sales.

The plates for all but four (148, 193, 195, 307) of the "published" etchings are still in Mrs. Sloan's possession. She contemplates eventual further printing from these plates up to the limits of the editions which are not yet complete. This procedure was specifically authorized by Sloan before his death. No such printing had been done as of 1967.

The determination of the printing to date has been made by the compiler of this catalogue from existing records in John Sloan's estate. Mrs. Sloan has cross-checked the data in record books, checkbooks, and inventories. She is in agreement with the compiler that the quantities of printing given here should be honored in determining future printing. This means, for example, in the case of the etching, *Little Bride* (138), of which 85 have been printed so far including artist's proofs, that no more than 25 additional prints, or a total of 110, will be made from this plate. When and if this printing is done, Mrs. Sloan

will approve and sign them in the manner indicated on page 17.

If any edition of a print is not printed in full before Mrs. Sloan's death, the completion of the work will be supervised by the John Sloan Trust. Sloan requested that the plates not be canceled after the full edition printing, and proofs may occasionally be pulled to replace destroyed proofs. To date, only the editions of the following "published" etchings have been printed in full: 128, 134, 136, 137, 148, 152, 186, 195, 228, 235, 306, 307, 313. Unless the plate of 193 is found again, its printing must be considered complete.

The principal source for Sloan's printing records is a large manuscript record book in Sloan's hand, now in JST, on deposit at the Delaware Art Center, apparently begun in April 1931, when specific dates and printers' names are first listed. Earlier, Sloan had kept his printing records on the envelopes in which he stored his plates. In 1930 and 1931, without Sloan's approval, the printers Gaston and White discarded a number of these envelopes. When Sloan started the big book, he filled in the missing figures from memory and entered the others from the remaining envelopes.

In the first column of the book a figure is written next to the print title, indicating the total number of impressions printed as of the date of the book, followed by specific notes of printings

between 1931 and 1951, when the great majority of his printing was done. A typical entry in the book looks like this:

McSorley's Back Room 45 20 (May 1/31) 25 (5/50 R.)

The figure 45 shows the number of impressions made, according to Sloan's memory and early records, before 1931. These may have been done by Sloan himself, by the Peters brothers, or by Platt. The next note, 20 (May 1/31), shows twenty impressions received on May 1, 1931. It is known, from an invoice of that date, that this printing was done by White. The final entry shows 25 prints made by Roth in May 1950. The total number of prints pulled to date is therefore 90. Sloan's figures included the allowable ten artist's proofs, but no early-state proofs, except in the few cases where he made changes in the plate after the start of edition printing. In the case of *McSorley's Back Room,*

Printers

All the printers who are known to have made prints from Sloan's etched plates are listed here. There are quite certainly no others. "Early" in the listings refers to prints pulled by Sloan, Peters, or Platt, made before Sloan started to keep detailed printing records. Along with the information given in the section on papers, there should be enough data here to identify the printer of almost any individual proof of a Sloan etching.

Sloan. Almost without exception, Sloan did the printing of his trial proof etchings, prints which give us the characteristics of his own printing style. He did not, however, wish to take the time to print entire editions, nor could he, he said, sustain the consistent quality which he admired in the Peters printing. There are only a few cases in which he printed more than a few proofs himself; examples are some of the Christmas/New Year plates. Generally he made a single proof from a completed plate, incorporating his special qualities of inking and wiping, and then turned it over to a professional, who printed the edition. Professional printers were considerably more common in earlier days than they are now, and their prices were reasonable. Sloan nevertheless had only a few prints made at a time, as he needed them for sale, until his very last years.

The most striking attribute of his own printing is the extremely heavy press pressure he used. In some cases the paper has been broken at the platemark, despite his careful beveling of the edges. This is recognizable even in his proofs of prints from the 1890s, very likely made by him on the Peters brothers' presses. He apparently had no press of his own until about 1902. Sloan was in general an excellent printer, though his proofs do not have the finished quality of professional work. In early years he liked more ink tone left on the plate and more retroussage than he did later. By 1944 he came to write, "I like a pretty cleanly wiped plate . . . the design bitten in the surface, not inked on by the printer" (JS 1944). A comparison of early and late proofs of the "New York City Life" series will show his changing taste in the matter. His own proofs are often identifiable by some special inscription.

Peters. The brothers, Richard W. and Gustav A. Peters (Figs. 1, 2), did most of Sloan's edition printing for him for more than thirty-five years. He told of their help and advice when he was first learning to etch, and he always had the highest praise for the quality of their printing, both at the time and in retrospect.

Little biographical information about the brothers is known. In the 1885 Philadelphia business directory, "Charles Peters,

therefore, twenty more may be printed before exhausting the edition.

Another important source of data is the invoices of the various printers, billing Sloan for the work done for him. Sloan's surviving manuscript notes on the plate envelopes, diaries, sales and financial records, and personal inventories all provide further corroboration. In the case of the lithographs, printing was evidently done at the time the stone was made, in each case. The edition size noted on the proofs is therefore also the size of the total printing. This catalogue, then, relying principally on Sloan's written records, modified in a few cases by information from other sources, may be considered the record of the printing of Sloan's prints during his lifetime, and the basis for determining future printing.

printer" first appears. In 1889 he is joined at the same address by Richard and Gustav Peters. In 1891 the two brothers have become "C. Peters' Sons, printers," and in 1904 "Peters Brothers." Of the two, Gustav did most of the actual printing and Richard (the elder) managed the business and met the clients. Neither brother was married. In later years they lived with the family of their nephew, Richard C. Young, son of their sister. (Mrs. Young has kindly given me much of the information here.) Both brothers died early in 1925, Richard probably in January and Gustav on February 12 (Philadelphia *Evening Bulletin,* Feb. 14, 1925). The business was liquidated at the time of their death. Mrs. Young and James Fincken arranged to get back to Sloan twenty of his plates which he had left for printing. The probable disposal of other plates is discussed below.

The brothers printed etchings for quite a number of well-known artists of the period, notably (besides Sloan) for Joseph Pennell, Peter Moran, and Stephen Parrish. A description of their shop in 1919 indicates that it had two presses and was in a state of considerable clutter. The brothers, however, seemed to know the exact location of whatever they needed. The printing procedure is described, the most notable feature being the final wiping of each plate with the hand. See Margaret C. Getchell's "A Little Print Shop . . ." (Philadelphia *Public Ledger,* magazine section, July 27, 1919).

The brothers apparently printed all of Sloan's etchings for the Newton and De Kock series, as well as his "published" prints up to 1925. There are no known printing or payment records of their work for Sloan, probably because Sloan almost always took in his work and paid his bill in person. The last plate from which they are definitely known to have printed is *Copyist at the Metropolitan* (148), in 1919. It is quite possible that Sloan had little professional printing done between 1915 and 1925. Many of his printing records for that period are missing, but it is known that he had little money and was engaged in a large number of other activities. He was just preparing a considerable printing order at the time of the Peters brothers' deaths.

The Peters' flawless impressions from Sloan's plates show the high quality of their craftsmanship. In general, the plates have noticeable ink tone left. The printer's careful hand-wiping has darkened and lightened the surface where appropriate, often giving strong contrasts. Some of Sloan's notes on the prints (e.g. on 95) show that he depended to some extent on this kind of expert handling by the printer to achieve some of his effects. The

plate bevels are always carefully wiped, up to the frame line of the picture, when there is one. (It should be noted, however, that the unattractive card-wiped proofs in the inexpensive editions of the De Kock books are also Peters work, probably fast and low-priced.) The color prints from the De Kock series show the result of the printers' craft. The different colors are all applied to the plate together and printed in a single run through the press. The white highlights on the same prints are a result of hand-wiping. The paper edges of the Peters proofs from the published plates are usually cleanly cut, though sometimes torn neatly.

Sloan never lost his respect for the brothers' work. Their prints are often preferable to later proofs, as much as anything because Sloan tended, to some degree, to depend on their special printing and wiping effects in his earlier prints, qualities which he later worked to get into the plate itself.

Platt. Peter J. Platt (1859–1934) (Fig. 3) was one of the most

Platt's printing, in the case of Sloan's plates, did indeed live up to its high reputation. His proofs are as free of accidental errors as are those of the Peters brothers. In general, he hand-wiped the plates more cleanly than they did, undoubtedly on the artist's instructions. A few of his proofs from Sloan's 1933 plates seem to me somewhat too cleanly wiped and free of plate tone to be entirely pleasing. These, however, are definitely in the minority and evidently represent Sloan's own views at the time. Platt's proofs for Sloan seem to have been always stretched by being tacked at the edges, a procedure also pointed out by Miss Bacon. The paper was seldom trimmed after drying, and most of the prints show the tack holes around the torn or natural edges of the sheet. In my opinion, these holes are an almost infallible sign of Platt's printing. The following plates, as far as can be determined, were printed exclusively by Platt (aside from Sloan's own proofs): 60, 79, 81, 82, 178, 232, 233, 236, 240.

Gaston. In June 1930, Sloan took fifteen plates to E. S. Gaston,

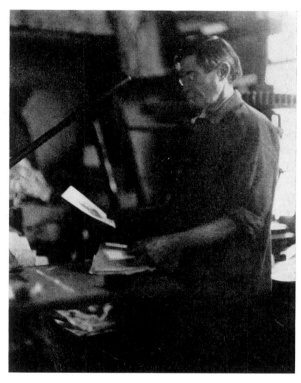

Fig. 1. Richard W. Peters.

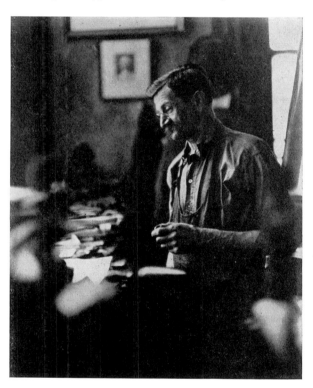

Fig. 2. Gustav A. Peters.

renowned of American plate printers. The son of a mezzotint printer, he printed artists' etchings for nearly fifty years. Though he worked alone, his New York shop became a gathering place for artists of all kinds. (See Leigh Harrison Hunt, *In Memoriam: Peter J. Platt,* New York, 1935; Peggy Bacon, "Etcher's Heaven," *Yale Review, 38,* Winter 1949, 271–82; and "Peter J. Platt," *New York Times,* Aug. 3, 1934, p. 17.)

Sloan first came to Platt late in the latter's career. The records in JST show that Platt's earliest printing for Sloan (except for the *New Republic* proofs of no. 195) was in May 1927, the last in December 1933, just a few months before his death. Sloan used two other printers (see below) during that period, but I suspect that it was because Platt was too busy (as Miss Bacon notes) to handle all his orders, not because of any dissatisfaction on Sloan's part. As it was, Platt did a large amount of work for Sloan, printing from 104 different plates and making 2,960 proofs of which we have records, and perhaps as many as a thousand more.

"plate printer for artists / 506 West Broadway, New York" (letterhead, JS records). He first appears in the New York telephone directory at this address in May 1922 and is last listed in the Winter 1933–34 volume, still at the same address. Sloan referred to him as "the Frenchman." His printing was quite unsatisfactory to Sloan, who destroyed the great majority of the proofs made for him by this printer. Those few which still exist do indeed show signs of faulty craftsmanship, such as uninked lines, excessive retroussage, white spots from dust on the plate, and poorly wiped bevels. There is virtually no plate tone left on the prints. He seems to have used only one kind of paper and a black ink of slightly bluish cast. In most of the plates known to have been printed by Gaston I have discovered no extant prints, except marked samples in the JST files, but unsigned proofs might turn up.

White. Charles S. White first printed from Sloan's plates in February 1931. He also did printing in November 1937, December 1938, October 1941, and in April, October, and November

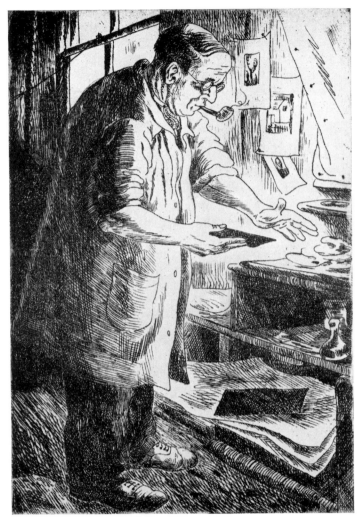

Fig. 3. Peter J. Platt Printing, etching by **Peggy Bacon**, 1929; **SI.**

of 1945. Altogether, he printed 2,050 recorded proofs from 61 plates. He was located at 412 Eighth Avenue in New York, first listed in the phone directory of May 1925, and much later moved to 939 Eighth Avenue; he continued printing until 1954–55.

Sloan felt that White's earlier printing was better than his late work. The printing appears generally clear and sensitive, relatively clean-wiped, as Sloan wished, and free of errors. His prints can often be recognized because they have been dried under pressure, flattening the platemark in the paper. Sloan disliked this practice. The edges of White's proofs are usually torn or natural deckle edges, though some "old paper" proofs have straight edges. The following plates, to the best of my knowledge, were printed only by White (excepting Sloan's proofs): 260, 278, 300, 306, 307, 308. As noted in the catalogue, White was responsible for losing one of Sloan's plates (193), but Sloan had changed over to Roth before that occurrence.

Furth. Charles Furth of New York is noted here for only one printing job for Sloan, that of the published impressions for Maugham's *Of Human Bondage* (280–86 and 288–96). It seems possible that Sloan never even met the printer, who was commissioned by the publisher. Despite this, however, his 24,000 impressions are of remarkably high quality and consistency. They are cleanly wiped, but with some retroussage to soften the texture, and quite free from errors. In my opinion they are superior to Charles White's printing of the twenty-five sets of artist's proofs from the same plates, which are handicapped also by a troublesome paper.

Roth. Ernest David Roth (1879–1964) made proofs from a large number of Sloan's "published" plates—a total of 3,580 recorded prints of 107 subjects. Born in Germany, he came to the United States at the age of five and achieved a considerable reputation as an etcher. (See Elizabeth Whitmore, *Ernest D. Roth,* New York, 1929, vol. 7 of the American Etchers series; and "Ernest David Roth," *New York Times,* Aug. 22, 1964, p. 21.) It is a curious coincidence that in 1915, at the Panama-Pacific International Exposition in San Francisco where Sloan received the third prize for etching, the second prize went to Roth. His sensitive landscape and architectural etchings show him to have been a very accomplished traditional artist. In 1945, when Sloan first met him at a dinner for the Institute of Arts and Letters, his reputation had faded considerably. Sloan knew and respected his work and was very touched when Roth offered to do some printing for him (HFS 1966). Sloan first sent him some plates in May 1945 and was pleased with the results. "Ninety etching prints came today from N.Y.C. printed by Ernest Roth and they are very good proofs of my plates. Better than we have been getting from Ch. White" (JS diary, June 27, 1945). Roth did more printing in 1948 and a large amount in late 1949, 1950, and 1951. In the last two years, Sloan for the first time ordered printing substantially beyond his current needs, commissioning proofs "for my estate" (JS 1950).

In general, Sloan was quite satisfied with Roth's work. "He has made very good proofs of my plates and it is luck to have him work on my editions. I want to sign as many of them as possible before the curtain comes down" (JS diary, March 6, 1950). When Sloan was not happy with the prints, Roth was quite willing to re-do them. He also won Sloan's special gratitude by printing many of his proofs on old paper which he (Roth) had saved for many years.

Roth's proofs, it seems to me, are of fine quality, if not quite up to the standards of the Peters brothers and Platt. The plates are cleanly wiped, with little retroussage, and quite free of errors. Roth evidently dried many proofs by sticking them down with strips of brown paper tape (of which fragments are occasionally seen). The edges of the paper were subsequently cut cleanly. He did not, however, either tape or cut his proofs on old paper. The appearance of the prints is somewhat darker than those of earlier printers. Roth seems to have used a particularly dense black ink and filled the lines quite completely. Though distinctive, they are certainly up to Sloan's high standards. It should be reemphasized that all of Sloan's "published" prints at present in circulation are of excellent quality, for each was approved by the artist, who would accept only the best of printing.

Shuster. Sloan's former pupil and artist friend, Will Shuster (1893–), printed published proofs from Sloan's last two plates (312 and 313) in Santa Fe in the summer of 1949. Their quality is not so good as that of other printers. A few proofs show various common errors, particularly under-inking and uneven press pressure. Sloan's diary and correspondence with his friend (JST) show his unhappiness with the results. More than half of Shuster's 250 proofs were returned to him (and presumably destroyed) as unsatisfactory. Shuster also used a blind-stamp of his stylized initials on his proofs, without Sloan's approval. Ernest Roth subsequently printed from both plates. Sloan was especially unhappy because he had wanted to give some of his printing business to an old friend—a factor, however, which certainly did not stand in the way of his artistic standards.

Harris. In the summer of 1966, Elizabeth M. Harris, special consultant to the Division of Graphic Arts of the Smithsonian

Institution, generously printed proofs from some of Sloan's rejected or unfinished plates. Very few proofs, and in some cases none at all, were previously known from any of these plates, preserved in Sloan's files. This printing was undertaken for the record of this catalogue. On June 28, 29, and 30, 1966, under the supervision of Mrs. Sloan, Jacob Kainen, and myself, Dr. Harris made proofs from the following plates: 25, 56, 61, 62, 77, 80, 115 (canceled), 154, 158, 165, 189, 237, 303, 309, 310, 311. HFS then signed them in her customary fashion.

Dr. Harris is an artist herself and an experienced printer. I am grateful to her for doing this work so ably. In a number of cases the plates were so lightly bitten that considerable ink had to be left on the surface in order to bring out the image.

Paper

A wide variety of paper has been used for Sloan's prints at one time or another. Most papers can be assigned with some confidence to particular printers, and they are so listed here.

In describing them, the preliminary distinction is between laid and wove paper, followed by the watermark (if any), the color (white, cream, tan), and the general weight or stiffness (light, medium, heavy). White paper, incidentally, can be easily distinguished from pale cream by comparing it with a sheet of white typewriter paper. It should be noted that watermarks are usually widely spaced on a sheet and often do not appear on the smaller individual pieces on which Sloan's etchings are printed. The final distinction is made, in the case of laid papers, by measuring the distance between the chain lines—the more widely spaced parallel watermark lines at right angles to the close lines of the wire grid of the laid paper mold. These measurements were made to the tenth of a millimeter by measuring across five or ten chain lines. These distances are usually consistent for any given brand of paper. "Old paper" is usually but not always laid paper and usually of light weight, but otherwise it appears in such profusion of types that it is impossible to catalogue. It can generally be distinguished by evident signs of age, such as browning at the edges—a characteristic more obvious now than it will be in a hundred years.

Sloan. For his own trial proofs, Sloan seemed to use almost any paper he found around the studio, including the backs of earlier proofs. Impressions by him are found on almost every variety of paper listed under the different printers. His personal file of blank paper, which remained at his death (now in JST), includes the following types.

Laid, cream, light (almost unsized), 29.5 mm. chain lines (somewhat irregular). A large quantity.

Laid, tan, light (almost unsized), 30.0 mm. chain lines (somewhat irregular). Used as early as 1915 for a proof of 137 with a dated exhibition label (JSC). Possibly used by Peters. Definitely used by White. Excellent paper.

Laid, white, very light weight, 28.6 mm. chain lines.

Laid, white, medium weight, 26.0 mm. chain lines. An old blank ledger book, with pages of 199 x 128 mm. (about 8 x 5 inch) sheet size. I know of no proofs on this good paper.

Wove, cream, heavy, with an irregular pattern sometimes known as *Japon nacré*. Used also by White and Roth.

Wove, cream, light, with a similar pattern.

Laid, "MBM" watermark (capitals), white, medium, 27.0 mm. chain lines. This paper was not in Sloan's file but is known on a number of his early proofs, as are various sorts of "old paper," too random to list.

Baskin. Dr. June E. Baskin of Williamsport, Pa., noted printmaker and bookbinder, has done the excellent 1969 edition printing of no. 165. (See catalogue entry.)

Lithographs. The proofs of 133 were well done by a professional printer at *Judge* magazine in New York. Those of 142, 143, 144, 145, and 147 were done by Sloan and his friend Moellmann, the vicissitudes of the printing being well described in Sloan's diary entries. The remaining four (192, 203, 209, 210) were all printed by Bolton Brown (1864–1936), one of the most able lithographic printers of his day, under Sloan's direct supervision. They are of excellent quality. The three linoleum-block prints (194, 201, 277) were clearly press-printed and show no particularly distinctive characteristics.

In his diary for February 7, 1907, Sloan noted, "Got old french paper at auction, also Japan paper" (*NYS*, p. 102). His appreciation for good paper came from childhood days when his father was in the stationery business. "As children, my sisters and I always had all the fine paper we wanted to draw on—samples and discarded stock" (JS 1945).

Peters. Laid, watermarked "Arches (FRANCE)" (in script and small capitals), medium weight, cream, 27.3 mm. chain lines. A similar paper, with 28.0 mm. chain lines, on which no watermark has been found, was also used by Peters and may be the same paper. The Arches paper was used for many of the proofs printed for Sloan by the Peters brothers, including, for instance, the 1906 set of the ten "New York City Life" prints now in the Metropolitan Museum of Art.

Laid, very light weight, tan, about 35.8 mm. chain lines. Occasionally used.

Wove, heavy, tan, a texture similar to vellum. This paper, generally known as Imperial Japan, was used for what Sloan called "japan proofs" (e.g. *NYS*, 175), for which he asked slightly higher prices in his early days. The name is confusing, for the very light laid papers listed above under Sloan's own papers are also known under the generic name of "japan" paper.

Wove, very heavy, cream. This paper, nearly as heavy as cardboard, was used for most of Sloan's commissioned etchings for A. Edward Newton.

Wove, heavy, white, almost unsized, often known as plate paper. It probably contains wood pulp, as it is sometimes brittle with aging. A smaller piece of wove, tissue-like, white paper (India paper) is often applied in the printed area, affixed by press pressure. The latter is also often known (confusingly) as laid china or *chine appliqué,* though it is not laid paper. Used for some proofs of the De Kock etchings, the "New York City Life" series, and other prints of the period, including 136 and 140. The "plate paper" without the "laid china" was also occasionally used. One piece, watermarked "BERVILLE," has been found in a proof printed by Sloan.

The De Kock etchings appeared in the books on a number of special papers, including real vellum (not paper), which are described along with the entire series of books (pp. 66–67).

Platt. Wove, watermarked "VAN GELDER ZONEN / HOLLAND" and the stylized squared initials "JP" in a double-line square border (27 mm. on a side), medium weight, pale cream (almost white). This paper has an extremely fine but clearly visible cross-hatch pattern of the woven wire mold, which is visible when the sheet is held to a light. It is the only paper listed here to show such a pattern. The initials in the square are the trade-

mark of the Japan Paper Company (further confusion), 109 East 31st Street, New York. This paper, of a very pleasing quality, was used by Platt for most of his printing for Sloan. It was possibly also used by White.

Wove, watermarked "PAPETERIES LAFUMA / 15*47 / L B N / Voiron" (the asterisk indicates a stylized dolphin, Voiron is in script), medium weight, cream color. This paper was used by Platt fairly frequently. Only these two papers can be definitely assigned to him.

Gaston. Wove, watermarked "B F K RIVES," heavy weight, cream, a very hard, heavily sized paper. This is the only paper known to have been used by Gaston. It was also definitely used by White (sometimes of a white color) and by Roth (for 313, at least).

White. Laid, watermarked "NAVARRE / 15*47" (the asterisk denotes a dolphin, as above), medium weight, cream, 29.0 to 29.2 mm. chain lines. Apparently also from the Papeteries Lafuma. Frequently used, including a few of Sloan's own proofs.

Laid, watermarked "J. WHATMAN / ENGLAND," medium, pale cream, 34.4 mm. chain lines. Frequently used by White and occasionally by Roth.

Laid, watermarked "G. W. Q. & S. / 1859" (large capitals), light weight, tan, 19.0 mm. chain lines. Apparently used only for 307.

"Old paper," many varieties. Sloan sometimes gave White a few sheets from his own supply to make prints on, particularly during the wartime paper shortage in 1944 and 1945. For this reason, too, one finds White's proofs on two and perhaps more of the papers listed under Sloan. Sloan would sometimes note in the lower left corner of the sheet that it was old paper.

White's paper for the artist's proofs from *Of Human Bondage* is listed in the body of the catalogue, as is Furth's paper for the published prints. Neither paper, to the best of my knowledge, was used elsewhere.

Roth. "Old paper" of various sorts was frequently used by Roth. Some of it has fragments of old writing and even printing on it, a factor which, as far as I have seen, always indicates a Roth proof. Sloan's and White's old paper printings are apparently always on unmarked pieces, as are most of Roth's. "Roth is using some wonderful old paper he brought from Europe some years ago. This is very kind of him, as he is a first rate etcher himself" (JS diary, April 6, 1950).

Inks

The great majority of impressions of Sloan's etchings and all of his lithographs are printed in black ink. Some of his early work, however, was done in a soft brown ink, used both by Sloan himself and by the Peters brothers. It was apparently used for most of his printing prior to 1905. Some proofs of subjects as late as 1920 (e.g. no. 197 at Bowdoin) are found in this ink. Generally speaking, it may be taken that an impression in brown is an early impression of the plate involved. In later years Sloan disliked the brown ink, feeling it was too romantic. Roth used some once, and Sloan asked him to stick to black (HFS 1967).

The eleven portrait etchings in the De Kock series are Sloan's

Laid, watermarked "LA BRIGLIA" and a figure of some sort with its foot on a ball, of which only a fragment has been seen, medium weight, cream, 28.0 to 28.8 mm. chain lines (irregular). The paper is noticeably thicker along the chain lines. Used fairly frequently.

Laid, watermarked "VAN GELDER ZONEN," medium, cream, 27.6 mm. chain lines. It may be this same paper which has been seen with a large watermarked coat-of-arms with a fleur-de-lis and crown. Occasionally used by Roth. Not to be confused with the wove paper of the same name, listed under Peters.

Laid, watermarked "F. J. Head" (small script), light, pale cream, 32.2 mm. chain lines. Not uncommon in Roth proofs.

Laid, watermarked "Arches (FRANCE)," medium weight, cream, 27.0 mm. chain lines. Very similar to that used by Peters, but somewhat stiffer. Relatively seldom used.

Laid, light, bluish, 27.0 mm. chain lines. Perhaps an old paper.

Laid, medium weight, white, irregular 30 to 33 mm. chain lines. Perhaps also an old paper.

Shuster. Wove, Watermarked "C.M. FABRIANO (ITALY)," medium weight, very white, little sizing. Apparently used for all of Shuster's printing for Sloan.

Harris. Laid, Watermarked "Arches (FRANCE)" (script and small capitals), medium weight, white, 27.2 mm. chain lines. This paper was used for all of Dr. Harris's proofs. Distinguished by its white color.

Lithographs. Sloan's lithograph paper was generally a wove, medium weight, pale cream paper, with a calendared surface, a type commonly used for lithographs. Any special notes are under the individual prints, as are comments on the linoleum-block posters.

The relative imprecision of these paper descriptions must be reemphasized. All factors of a particular paper should be noted. There may well be other papers which have been used but not seen by the compiler. A number of those listed here have, and others may have been, used by more than one printer. Sloan's own paper may have been used by any printer, but especially by White, and Sloan's proofs may appear on almost any paper. Prints cannot be confidently attributed to a particular printer on the basis of the paper alone. Other factors, as given earlier, must be considered.

only color prints. Four are in three colors each (72, 76, 106, 118), five in two colors (86, 89, 93, 101, 112), and two in a single uniform color (97, 121). Other than these, there are only individual exceptions to the use of black or brown. The trial states of *Isadora Duncan* (172) utilize several varieties. Early proofs of 195 and 215 are sometimes in a dark blue ink, and a few trial proofs of 226 have an assortment of colors. None of Sloan's "published" prints, however, has more than the one basic color. (The hand coloring of some of the De Kock prints for the "Versailles" edition was not done by Sloan.)

Plates

Of Sloan's original plates, 183 are still known to exist. All but two of them (115 and 189) are uncanceled. All but one (148) of the located plates are in JST. A few plates, notably those for 193, 195, and 307, may still be extant, though they are at present lost.

Sloan's early commissioned plates, particularly those done for A. E. Newton and for the De Kock series, were all printed by the Peters brothers of Philadelphia. It is believed that these remained in the printers' possession, as was customary at the time

— a practice followed by Sloan in known instances. Direct testimony about the disposal of the Peters' stock of plates was given to me by Mrs. Richard C. Young of Swarthmore, Pennsylvania, widow of their heir. Their files and equipment came into Mr. Young's possession at the death of the brothers. About 1930, finding himself with a large quantity of copper plates on his hands, he sold them to a scrap-metal dealer. It seems reasonable to assume, first, that Sloan's Newton and De Kock plates were in this batch, and second, that the scrap dealer did indeed melt them down for their copper. The chance that any of these plates still exists seems very slight, and no unaccounted proofs from any of them have ever turned up, to my knowledge. Sloan requested and received back his "published" plates which were in the Peters' files at the time of their deaths. He did not request the earlier plates, presumably because they were no longer his property. Probably the owners, Newton and the Quinby heirs, had long since relinquished all interest in them.

The existing plates, in JST, are all in good condition. Except for the two canceled plates, they are completely suitable for printing. Most are of copper; ten are of zinc (of which seven were used for aquatints). The metal is noted in each case. Many are (as of 1967) steel-faced (iron-faced, more accurately), meaning that a very thin coating of iron has been electrolytically deposited on the plate to harden the surface and prevent wear from printing. Generally, an edition printing of only 100 will cause little noticeable wear in any but the more delicately etched or drypointed plates. The steel facing, however, provides additional security, especially against accidental scratching. Wear from printing is not, in my opinion, an artistically significant factor in any of Sloan's etchings. Scratches that appeared on a few early plates before steel facing are noted in the catalog entries.

Most of the plates at present are wrapped in wax paper and enclosed in brown paper envelopes, some of which contain Sloan's early printing records. Some, those last handled by Ernest Roth, are protected with a light coat of etching ground. Some are covered with wax; others are untreated. Corrosion is not significant in any case. The backs of most of the plates show the marks of a great deal of hammering—evidence of the great amount of burnishing and corrective work Sloan put into their creation (Figs. 4, 5).

TISSUES

Sloan's working method often made use of preliminary drawings for his prints. These were generally done in pencil on light tissue papers, which were then waxed, backed with red ocher or other color, and transferred to the grounded plate by tracing. The term "tissue" is used only for the drawing actually transferred to the plate. "Drawing" or "sketch" refers to other preliminary studies. Occasionally, other transfer methods than tracing were used. The tissues give only the basic outlines of the design. The finished work was done directly on the plate. The transparent waxed tissue allowed the design to be transferred in either recto or verso, and there is no pattern in Sloan's choice of direction other than his own sense of composition.

A clear semantic difference is intended between two terms used in this catalogue. "Tissue unknown" means that a tissue is presumed to have been used for a particular etching, but that if it still exists, it has not been located. "No tissue" means that it is either stated by Sloan or strongly inferred that the design was made directly on the plate, without the use of a transfer tissue. Sloan was as diligent in preserving his tissues as his trial proofs, and many are located.

SLOAN'S COMMENTS

A unique feature of this catalogue is the inclusion of the artist's own specific comments on many of his prints. Such comments, particularly from a man as articulate as Sloan, can add a great deal to our total understanding of a work. Their existence and completeness are of special importance. Every significant known quotation from Sloan on each print is included here (only rephrasings and duplications of material are omitted).

In 1938 Sloan was given an important retrospective exhibition of his paintings at the Addison Gallery of American Art, Phillips Academy, Andover, Massachusetts. The curator, Charles H. Sawyer, invited him to make individual comments on the paintings in the show. Sloan took up this suggestion with enthusiasm and provided detailed commentary, which was printed in the exhibition catalogue and displayed next to the paintings. The following year he wrote similar comments for the much greater number of paintings illustrated in his *Gist of Art*.

In 1944 and early 1945 he prepared a parallel set of comments covering all of his "published" etchings. They were originally intended for an exhibition of his "complete" etchings held at the Renaissance Society of the University of Chicago, beginning in February 1945. The comments were displayed with the prints in this show but were not published. He also hoped to use some of them for a projected book on his etchings (see p. 381 n). The following year, 1946, Dartmouth College gave Sloan a large one-man exhibition, including eighty-one etchings. The previously prepared notes on these prints were published in the exhibition catalogue. These are referred to here by the abbreviation, "Dart," plus the catalogue numbers 28–108. The remaining comments have not been published until now, although some have had a small circulation in manuscript.

Sloan made the original comments verbally, while HFS took notes in a loose-leaf notebook (he also gave state numbers to some trial proofs at the same time). She would then type them and give them to Sloan for his correction and approval. In a number of cases Sloan revised his remarks, apparently more out of respect for his audience than for any inaccuracy. They were, of course intended for the general public, not for "experts." The comments given here under the reference "JS 1945" include both the edited and unpublished notes, as they appeared at the Chicago exhibition, and his original and sometimes more strongly expressed remarks, wherever they offer additional data. Other unpublished notes are cited in similar fashion.

The next important sources quoted here are Sloan's diaries, all written in his own hand. Large sections of his 1906–13 diaries have been published: *John Sloan's New York Scene*, Harper & Row, New York, 1965. The book contains (my estimate) about 60 percent of the text of the originals and is well selected by Bruce St. John. I have read the manuscript diaries and have added here any unpublished material that seems pertinent to particular prints. In addition, Sloan kept diaries from 1943 until his death, none of which has been published. Some of them apply to his last four prints and are quoted here.

Other sources for comments by Sloan are *Gist of Art*, personal letters and articles written by him, quotations from him in other

Fig. 4. The plate for *Copyist at the Metropolitan* (148); SI.

articles and books, recordings of radio and television broadcasts, and miscellaneous sources cited as they appear. A few quotations from sources other than Sloan are included where they seem significant. Misspellings and punctuation have been corrected without special note. Wherever Sloan has given the title of a print or other work of art, it has been italicized to conform with the practice in the rest of this catalogue. Notes in square brackets are my own.

It is important to note that many of the comments, particularly the 1945 series, were made at quite a distance in time from the actual print. Sloan tried to allow for this. He wrote, "In pro-

viding comments for the various pictures in this collection I shall endeavour to return to the mood under which they were produced" (Dart, Introduction). But his ideas and methods changed constantly throughout his life. Many of his expressed thoughts may be different from what they were at the time the print was done. A few facts are inaccurate, for he was too busy painting to do research on details. The date must always be kept in mind when evaluating these comments as source material—not that they are unreliable but that they sometimes represent a different Sloan than the prints do.

COLLECTIONS

The location of rare subjects and of state proofs given in this catalogue is meant to be as comprehensive as possible. Two collections of Sloan's prints include major representation of his state proofs, as well as published prints and unusual subjects.

The most important collection is that of the Philadelphia Museum of Art (abbreviated Ph), located in the print department. In 1956 the museum purchased a set of proof states, early work, tissues, and published prints from the Sloan estate. Mrs.

Fig. 5. Back of the plate for *Copyist at the Metropolitan* (148); SI.

Sloan has since made additional gifts and has generously promised much other material (more than a hundred prints) discovered during the present research, all listed here as "Ph." This collection of Sloan's prints and tissues now includes over 900 items, the most nearly complete in the world.

The John Sloan Trust (JST) includes the material listed here which remains in Mrs. Sloan's possession. She has set aside a number of state proofs (duplicates of those in Ph) as part of a study collection on deposit at the Delaware Art Center. The De Kock tissues and trial proofs are also on deposit in Wilmington. Also, the etched plates (except 148) and Sloan's personal papers, etc., are on deposit there under the supervision of Bruce St. John, curator of the Sloan Collection. All of Sloan's original work and manuscripts (which he gave to Helen Farr Sloan during their marriage and in his estate) are under the control of the John Sloan Trust.

Other significant collections, containing large numbers of the published prints and some state proofs, are in the print departments of the following institutions:

Metropolitan Museum of Art, New York (gift of Mrs. Harry Payne Whitney)

Museum of Modern Art, New York (gift of Mrs. Abby Aldrich Rockefeller

Whitney Museum of American Art, New York (gift of Mrs. Harry Payne Whitney)

Wilmington Society of Fine Arts, Delaware Art Center, Wilmington, Del. (gift of Mrs. Helen Farr Sloan)

Walker Art Museum, Bowdoin College, Brunswick, Maine (gift of George O. Hamlin)

Detroit Institute of Arts, Detroit, Mich. (gift of Bernard Walker)

Library of Congress, Washington, D.C.

All have been studied extensively in person by the compiler.

Other collections with notable representation of Sloan's prints are:

Smithsonian Institution, Division of Graphic Arts, Washington, D.C. (posters and unpublished work)

New York Public Library, Main Branch, New York, N.Y. (especially De Kock proofs)

Achenbach Foundation, Palace of the Legion of Honor, San Francisco, Calif.

Art Students League, New York, N.Y.

Barnes Foundation, Merion, Pa.

Boston Public Library, Boston, Mass.

Brooklyn Museum, Brooklyn, N.Y.

Chicago Art Institute, Chicago, Ill.

Cleveland Museum of Art, Cleveland, Ohio

Los Angeles Museum of Art, Los Angeles, Calif.

Museum of New Mexico, Santa Fe, N.M.

Public Library of Newark, N.J.

Lessing J. Rosenwald collection, Jenkintown, Pa.

Santa Barbara Museum of Art, Santa Barbara, Calif.

Wadsworth Atheneum, Hartford, Conn.

Only two museums in other countries have, to my knowledge, any significant number of Sloan's prints at the present time: the British Museum, London, England; and the Art Gallery of New South Wales, Sydney, Australia.

Libraries with complete sets of the De Kock novels containing Sloan's etchings are listed separately (pp. 66–67).

One hundred and twenty-five museums, universities, and libraries have reported that they have at least one Sloan print. Another twenty have drawings or paintings but no prints. It is interesting to note that the etching, *Turning Out the Light* (134), is in thirty public collections, more than any other Sloan print. It is followed in museum "popularity" by *Connoisseurs of Prints* (127) and *Copyist at the Metropolitan* (148), with twenty-seven each. Others with more than twenty proofs each in public institutions are: *Fifth Avenue Critics* (128), *Fun, One Cent* (131), *Women's Page* (132), *Memory* (136), *Night Windows* (152), *Bandit's Cave* (195), and *Robert Henri, Painter* (246).

A few private collections are cited here, notably those of Kirke Bryan of Norristown, Pennsylvania, and George H. Tweney of Seattle, Washington. Both these gentlemen have Sloan etchings not found elsewhere. A few trial state proofs are known to me whose owners did not wish them mentioned here. None that I have seen differs from states listed here in identified proofs.

SELF-PORTRAITS

Sloan never did an original print in which his own portrait was the central subject matter. He nevertheless included himself in a number of prints. He also very likely portrays himself in *Snake Dance* (203). Of course, his first wife Dolly Sloan and various of his friends, particularly Robert Henri, are frequent subjects (see Title Index). The following are those in which

Sloan's own features are clearly distinguishable and acknowledged by him:

Memory (136)	*Copyist at the Metropolitan* (148)
Anshutz on Anatomy (155)	*Twenty-Fifth Anniversary* (226)
Arch Conspirators (183)	*Romany Marye in Christopher*
X-Rays (225)	*Street 1922* (278)

"PUBLISHED" PRINTS

This is a designation somewhat arbitrarily assigned to those prints which Sloan considered to be independent, self-sufficient works of art. The distinction is quite clear in Sloan's writings and records. It is these "published" prints on which he commented individually for the 1945 exhibition. Each was given a predetermined edition and most proofs were signed and titled by the artist. They include a few of his early prints, which he later decided to publish, and most of the independent subjects. *Not* included, for the sake of definition, are the De Kock and *Of Human Bondage* series, the unfinished and rejected plates, and most

of the early work, including all the etchings done for Newton. Two prints, 45 and 115, were included by Kraushaar in his lists of Sloan's published work, though he knew there were only two proofs of each. They are not included among the "published" prints here.

For convenience and to eliminate any question, there follows a list of the 155 prints considered to be Sloan's independent "published" etchings: 2, 4, 24, 60, 70, 79, 81, 82, 104, 125–32, 134–41, 148–53, 155, 156, 159–64, 166–76, 178–88, 190, 193, 195–200, 202, 204–08, 211–36, 238–76, 278, 279, 297–302, 304–08, 312, 313.

"UNPUBLISHED" PRINTS

No. 154, dated 2–1912 in plate; no. 165, *Woman with Hand to Chin*.

ATTRIBUTIONS

There is little problem in authenticating all the prints in this catalogue as Sloan's work. The vast majority are listed in Sloan's personal handwritten records, are signed in pencil by him, and have his signature or initials as an integral part of the plate or stone. Sloan clearly did the entire artistic work in the creation of all the original prints in this catalogue.

The name in the plate is taken as prime evidence of Sloan's authorship. This is particularly important for some of the early prints, such as the Newton etchings, where no evidence except their style is known. It should be kept in mind that there was absolutely no motivation for anyone to copy Sloan's signature in the early 1890s, when he was unknown artistically.

The following (33 of 313) are the prints *without* Sloan's sig-

nature in the plate: 2, 3, 12, 14, 16, 18, 20, 22, 24, 25, 36, 41, 47, 49, 51, 56, 61, 62, 70, 77, 79, 80, 157, 158, 160, 161, 163, 165, 189, 191, 277, 309, 311.

In these instances, ten are authenticated by Sloan's handwritten signature or by their presence in his records and diaries (2, 24, 62, 70, 79, 160, 161, 163, 277, 311). Eleven more are verified by their inclusion in Sloan's files of his own work, and by the specific recollections of HFS and Carl Zigrosser that Sloan discussed them as his own work (3, 25, 47, 56, 61, 77, 157, 165, 189, 191, 309).

In the other cases, eight are associated in sets with signed prints, (12, 14, 16, 18, 20, 22, 36, 41); no. 51 is authenticated by a signed drawing of the same subject; no. 80 is etched on the verso

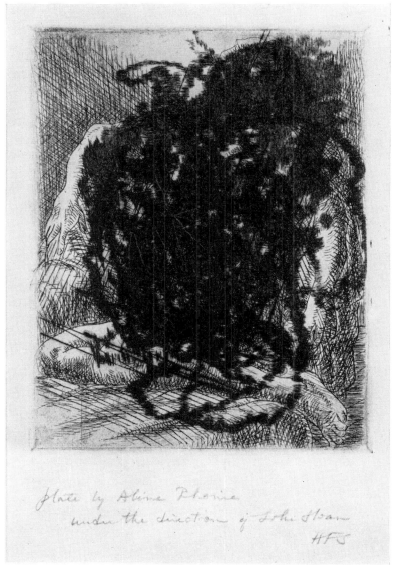

Fig. 6. Nude, proof from canceled plate by Aline Rhonie, 1933; JST.

of the signed plate of no. 237; and no. 158 has Sloan's clearly identifiable handwriting in the plate. *Artist's Portfolio* (49) is the only true attribution, for the reasons given in the catalogue entry. Needless to say, all these unsigned prints are considered to be stylistically compatible with the rest of Sloan's work of their appropriate period.

Questions of attribution might arise in the future. I trust it will not seem immodest to suggest that any print ascribed to Sloan, but not included in this catalogue, should be examined most critically. Both likely and unlikely sources have been consulted in the preparation of this book. A number of prints have been discovered that were not previously catalogued, several of them completely unknown even to their owners.

Sloan was such a careful keeper of records that assuredly no more "published" prints are known. If other subjects are found, they will surely be either additional work done for Newton or others in the period 1890–93, or they will be demonstration plates done while he was teaching a student. In the first instance, I have discovered many more early prints than Sloan ever bothered to recall; it is not impossible that others exist.

Student work may occasionally pose some problems and may superficially resemble Sloan's. An example is that of Aline Rhonie, who studied etching with Sloan in April 1933 and per-

haps at other times. Sloan kept three of the copper plates she made during her lessons, removing most of the image by scraping, in order to eliminate just the sort of confusion that may arise (Fig. 6). ("This plate by Sloan's pupil, Aline Rhonie. JS had done some work on it. He told me this in 1944" HFS records, 1966.) An impression from one of these scraped plates is illustrated here, showing fragments of a nude. The drawing is similar to Sloan's, but clearly much weaker. It is possible that impressions from this or other uncanceled student work may return to haunt the future scholar. Proofs from the three canceled Rhonie plates which were in Sloan's possession have been deposited at Ph, WSFA, and SI. They show enough of a ghost image to enable a comparison to be made with a complete proof, if any exists. Sloan sometimes added a few lines to a student's plate while teaching etching. Miss Angna Enters has kindly told me of such an instance (plate now lost) when Sloan was giving her lessons. Such plates are not, of course, included here with Sloan's original work. Stylistic differences should preclude confusion of students' work with Sloan's.

There are other scraped plates in JST. *Their Appointed Rounds* (304) derives from one such, evidently Sloan's own. It is at least possible that others may also represent Sloan's eradication of his own work, and early proofs might still exist. If any

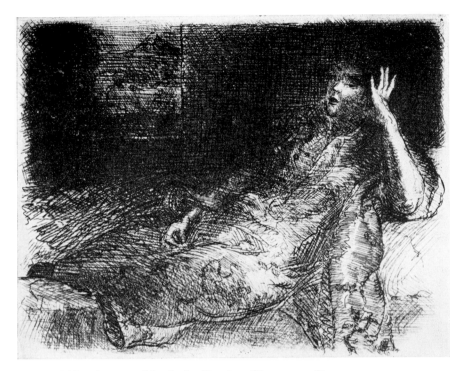

Fig. 7. Girl in Kimono, etching by Isa Urquhart Glenn, 1913; SI.

should appear, they may be compared with the faint images on those scraped plates.

Much more frequently, student work, under Sloan's encouragement, is so distinctive that no questions can reasonably arise. A particularly interesting example is the illustrated etching, *Girl in Kimono* (Fig. 7), by Isa Urquhart Glenn (in SI). This was done in 1913, at the same time and from the same model as Sloan's print (164). Miss Glenn was a capable artist and had some of her work published in *The Masses* (e.g. vol. 5, July 1914, p. 20), but it clearly has no stylistic relation to Sloan's work.

There is also an American printmaker named James Blanding Sloan (1886–1950?) who may be confused in name only. He has done able landscapes and fantasies in both etching and woodcut, in a style somewhat reminiscent of Eric Gill. There is also said to be a Canadian sculptor named John Sloan, of Hamilton, Ontario, whose work is unknown to me. These men may be noted, but their work can hardly cause any serious identification problems.

One case is known of a reproduction signed by Sloan in a format which may give it the appearance of an original print. Entitled *Pickets,* it is a photomechanical line engraving from a drawing on a textured surface. It is listed here as Poster Q, though not strictly a poster, and is illustrated and described in detail. The screenless photogravures which were made from Sloan's drawings to illustrate the De Kock novels (in addition to the original etchings) have sometimes been confused with original aquatints. They show a platemark, as do etchings, and no halftone screen pattern. They have, however, the character of wash drawings, without the clear etched lines of Sloan's original work. A typical example is illustrated here for comparison (Fig. 8). Separate proofs of these photogravures were occasionally signed by Sloan (e.g. Met). None of his illustrations for *The Masses* or other magazines is an original lithograph, although some have been described as such. Known reproductions that may cause confusion are noted in the respective catalogue entries.

In summary, additional discoveries of early print subjects,

such as Newton commissions, are possible. Later subjects, said to be incomplete, unpublished, or rejected work, are not impossible but are much more likely to be students' work. Photomechanical reproductions of drawings and prints are known and may appear in the future.

Fig. 8. M. Dubotte and Mme Callé (126 x 83 mm., 5 x 3¼ inches), screenless photogravure from a drawing by John Sloan for De Kock's *Adhémar,* 1904. The original drawing, formerly in the John Quinn collection, is now in the Addison Gallery, Andover, Mass. (see also *NYS,* p. 612).

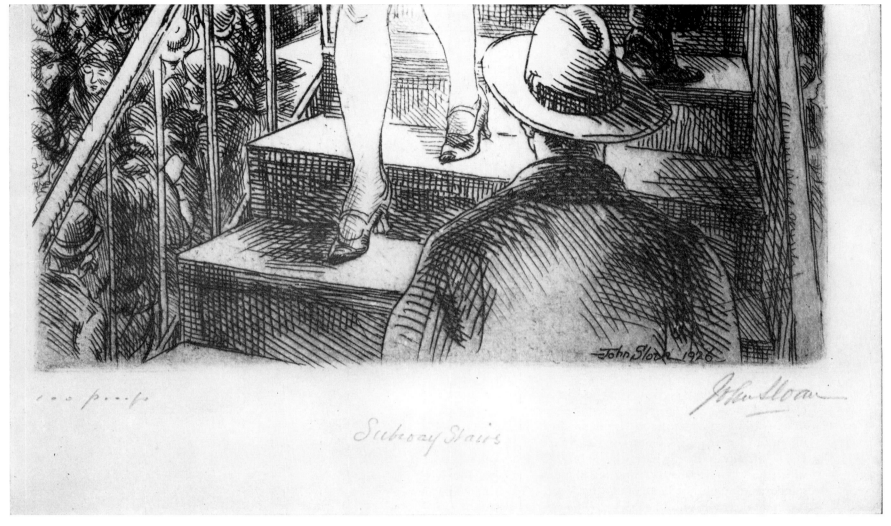

Fig. 9. Inscriptions by John Sloan on a "published" proof of *Subway Stairs* (221), enlarged 1½ times.

SIGNATURES

Sloan used a number of different styles of handwriting, each quite distinctive. This is the most important point about his signatures. The three different inscriptions which typically appear on Sloan's published prints—his signature, the title, and the edition—are often considered to be written by separate persons. They are, in fact, all by Sloan. The style in Figure 9 did not change significantly through the years.

Sloan's signature appeared only very rarely on proofs printed before 1902. The example given here (Fig. 10), dated 1891, is typical of the few that are known. He used "John F. Sloan" until about 1902. (It first becomes John Sloan in the 1902 Philadelphia business directory.) He then dropped his middle name, French, as a "romantic encumbrance" (*NYS*, p. xiii). Very occasionally he signed later proofs of his earliest prints with the "John F. Sloan." (This can be seen on the impressions of 2 and 4 in Mod.)

Fig. 10. Signature 1891, actual size.

Remarque proofs of the De Kock etchings are frequently signed, when they appear separately or in the most elaborate of the editions, the "Bibliomaniac" and "Romainville" sets. Examples can be seen in a number of the illustrations here of etchings

from the De Kock series. His signature in the plate, by contrast, was always in some form of printed lettering, never cursive.

The early proofs of the "New York City Life" set and the other "published" prints between 1905 and 1911 appear both signed and unsigned. As can be seen in a number of his diary entries in *NYS,* the signed prints sold for a higher price (when they sold at all) and were usually printed on japan paper. The set which he sold to the Metropolitan Museum of Art in June 1906, e.g., is unsigned (*NYS*, p. 44). Early proofs that he did sign had the signature (in pencil) only, with no other inscription (Fig. 11).

Fig. 11. Signature c. 1905, actual size.

In 1911 or 1912, apparently, he started signing all his proofs. His advertisement of March 8, 1912, offers only "signed proofs," though it makes a special point of their being signed (see p. 17). His sales folder sent out in 1915 uses the same phrasing.

Sloan's signature on his prints generally resembled his signa-

ture on letters but differed rather markedly from other occasions when he wrote his name, such as the illustrated example from an exhibition form of 1915 (Fig. 12).

Fig. 12. Handwritten name, not a signature, 1915, actual size.

Other notations on published prints are sometimes made by HFS, usually to designate her judgment about the particular printer of the proof (Fig. 13). Prints sold through Kraushaar Galleries sometimes carry the Kraushaar catalogue number (see Concordance) and the price. The lithographs printed by Bolton Brown are signed by the printer as well as by Sloan.

Fig. 13. Inscription by Helen Farr Sloan, actual size.

There is a variety of signatures and inscriptions on Sloan's own trial proofs and self-printed impressions of the published state. All known examples are by the artist himself. The most important fact to note is that when Sloan signed only his *initials* to a print, he was usually indicating an *unsatisfactory* proof, one which he was rejecting as being less than perfect by his high standards, though not bad enough to destroy. These now and then find their way onto the market. (In a very few cases, such as certain *Of Human Bondage* proofs, the "JS" or "S" may indicate an approved proof to be sent to the printer.) The first of the three illustrated examples (Fig. 14) is his usual form of initials. The second (Fig. 15) is a later style, and the third (Fig. 16) was used about 1905, perhaps also on an approved proof for a printer (Peters). An X scored with the thumbnail is occasionally found and indicates a reject, as does a penciled X.

Fig. 14. Sloan's initials 1930, actual size.

Fig. 15. Sloan's initials 1949, actual size.

Fig. 16. Sloan's initials c. 1905, actual size.

Other notes by Sloan are found on prints in published state, generally only on proofs intended for his printers. Six examples are given here (Figs. 17–22) mainly to show the wide variety in

Sloan's handwriting. All of these inscriptions are by Sloan. The right thumbprint has been found only on 167.

Fig. 17. Sloan's thumbprint 1914, actual size.

Fig. 18. Inscription by John Sloan, actual size.

Fig. 19. Inscription by John Sloan, actual size.

Fig. 20. Inscription by John Sloan, actual size.

Fig. 21. Inscription by John Sloan, actual size.

Fig. 22. Inscription by John Sloan, actual size.

Very few other markings appear on Sloan's prints. Most lithographs were signed and titled in a manner similar to that of the etchings. All Sloan's inscriptions are in pencil—with one exception. A small number of proofs from 1905 and 1906 have Sloan's writing in a purple indelible pencil. No pen inscriptions are known. A purple rubber stamp with Sloan's name and address "35 Sixth Ave. cor. 4th St." is found on the backs of a few proofs. His studio was at that address between May 1912 and October 1915 (*NYS*, p. 620, letters in JST). No inscriptions whatever by Dolly Sloan are known on prints. Only one example of a printer's handwriting is known on an etching—inking notes by Peter Platt on a proof impression of 60, in JST. Should any question

arise, examples of handwriting by both Peters brothers, Platt, Gaston, White, and Roth are in the files of JST and SI.

Fig. 23. Signature of Helen Farr Sloan on an approved proof of a print by John Sloan, actual size.

Only a very few "published" proofs remained unsigned at Sloan's death. As a general practice, he examined, approved, signed, and titled prints as soon as he received them from the printer. Helen Farr Sloan has sometimes signed proofs in pencil which were approved but not signed by Sloan, using the form, "John Sloan / per HFS" (Fig. 23). This form will be of future importance, for impressions made from Sloan's plates subsequent to this catalogue will be approved and signed by Mrs. Sloan in just this fashion, with the addition of the date.

CATALOGUES

Three prior numbered lists of Sloan's prints have been used in cataloguing various museum collections. Apologies are due for introducing a fourth set of numbers. Its inconvenience seems far outweighed by the importance of having a chronological arrangement of all the prints.

Albert E. Gallatin's checklist of 1916 (see Bibliography for all catalogues) mentioned a few early works and numbered 98 etchings from 1902 to 1916, plus 6 lithographs. Gallatin obtained his data directly from Sloan, but they contain a fair number of inaccuracies.

Kraushaar Galleries, Sloan's dealer, issued a more accurate list in 1937. This included only the "published" etchings up to 1936, omitting the Newton and De Kock etchings and the litho-

graphs. It has had wide circulation and has proven most useful.

Carl Zigrosser's checklist of 1956 has been the most comprehensive to date. It lists 291 subjects, mostly prints purchased in that year for the Philadelphia Museum of Art from the Sloan estate. For each there is given a title, year date, and dimensions in inches. Seven of his subjects (9, 25, 45, 56, 115, 303, and 309 here) were not included in the Philadelphia collection at that time. Mr. Zigrosser had worked on this listing for a number of years and had discussed it with Sloan. Its value to the present compiler cannot be too strongly acknowledged.

A concordance of the four sets of catalogue numbers is given on p. 399.

SALES OF PRINTS

Sloan made relatively little money from the sale of his prints. I have studied his financial records for the years 1924–52, helped by a summary compiled by HFS. His few sales for 1906–12 are noted in his diaries, published and unpublished, and there are assorted records for the intervening years.

His first large print sale, one of the few, was to John Quinn in 1910 for $340.00 (*NYS*, pp. 433, 437, 438). Sloan bought back these prints in 1926, after Quinn's death; they are at present in JST. Another significant early sale was of a group of prints to Dr. Albert C. Barnes in 1913, for $175.00, works now in the Barnes Foundation, Merion, Pennsylvania.

Between 1912 and 1915 Sloan made several strong efforts to sell his etchings. Though his prices were low, even for that time, his success was negligible. His advertisement in a concert program of March 8, 1912 (Rand School of Social Science, *Third Annual Concert and Ball*, p. 24), shows that he was then selling the "New York City Life" etchings for $5.00 each, three for $10.00, or ten for $25.00 in signed proofs. A year and a half later an ad appeared in *The Masses* (Oct. 1913, inside back cover), illustrating thirteen of his etchings. "The regular price of these proofs is $5.00 each. You can have any or all of them at $2.00 each, provided you add to your order $1.00 for a year's subscription to *The Masses*." Sloan's handwritten comment on his copy of the issue (JST) tells the result: "Not *one* order was received

for this offer / John Sloan." In February 1915 he sent out an illustrated folder offering his etchings to some 1,600 individuals and institutions, mostly chosen from *Who's Who*. This immense effort produced exactly two sales (see p. 384).

In only four years (1926, 1928, 1929, and 1931) did Sloan have a net income of more than one thousand dollars from the sale of prints, before taxes and exclusive of commissions. These years included the sales of three "complete" sets of etchings, now in the Metropolitan, Modern, and Whitney museums in New York. His commissioned etchings for book illustrations included the Newton, De Kock, Daly, and *Of Human Bondage* works. Aside from these, only a very few of his prints were special paid commissions. The rest are independently conceived and executed works of art—as are, of course, many of the commissioned works.

Sloan's records show a total of 1,149 "published" prints sold between 1927 and 1951, the years for which full records are still extant. He probably sold no more than 1,600 such prints during his entire lifetime and gave away as gifts another 700, at an estimate. On the other hand, some 10,000 of his prints were printed professionally during his lifetime (not including his own printing) and had to be paid for. This cost of printing, plus the customary dealer's commission, both had to be charged against his receipts. Printmaking for Sloan was clearly much more a matter of love than of profit.

UNREALIZED PROJECTS

From time to time there are notes in Sloan's diaries and comments about etchings suggested by him or to him, projects which were never realized. A memorandum in his notebook of 1890 (JST), for instance, says, "Don't forget scheme of etched Valentines—P & C." He might have made the suggestion to Porter & Coates, for whom he was then working, but there is not the slightest evidence that it was ever carried out.

There are also plentiful examples of drawings on tissue paper which appear to be preliminary sketches for etchings, many of which are in Ph and JST. Sometimes they are quite detailed, as is the one illustrated in Figure 24. Other ideas appear in his diaries: "On the way out 26th Street, I saw eyes between the slats of shutters and soft voices called me. A good subject for a plate" (Oct. 14, 1906, *NYS*, p. 69).

Fig. 24. Woman and Beggar, drawing on tissue by John Sloan, not waxed or traced (149 x 167 mm., 6 x 6½ inches); JST.

It is important to note, however, that I have not found a single example of a waxed and traced tissue without an etching to match it. Evidently when he had reached the stage of preparing the sketch for transfer to a plate, Sloan carried through to the finish.

Probably the unlikeliest of possible commissions was one suggested to him for etchings to illustrate a Christian Science

viewpoint of the 91st Psalm (Jan. 12, 1907, *NYS,* p. 98). Perhaps fortunately for all concerned, the potential patroness decided against the idea. "I'm just as well satisfied," commented Sloan. Examples of other unrealized projects are mentioned in *NYS,* pp. 62, 77, 85–86, 140, 313. Sloan's work does not suffer by the fact that they were never done.

CHRISTMAS AND NEW YEAR GREETINGS

Beginning in 1909, Sloan made yearly etchings as Christmas presents or New Year greetings for his close friends. The quantity of each as a greeting averaged about 25. These were usually printed by Sloan himself (included in the printing totals given here) and were personally inscribed by him in a straightforward style, such as, "New Year's Greetings from Dolly and John Sloan." Starting in 1925, he did three such etchings of Angna Enters, fascinated both by her dancing and by the pun with which he could use her name to greet the New Year: "1926 Enters." The list of recipients appears to have changed constantly. I know of no complete extant collection. All these plates, even those with an etched text, were subsequently printed separately, for sale. Thus they are all included in the group of "published" plates.

The following list gives all the etchings known, by inscriptions, to have been used as gifts and greetings. Since the adjacent Christmas and New Year are, of course, in separate years, a dou-

ble date is given for each. This also explains some of the confusion that has previously arisen in the dating of some of these plates. There is only one greeting plate for each Christmas–New Year season.

1909–10	*Christmas Dinners* (149)	1919–20	*Little Woman* (193)
1910–11	*Turkey from Uncle* (151)	1920–21	*Fire Can* (199)
		1921–22	*Stealing Wash* (204)
1911–12	none	1922–23	*Dragon of the Rio Grande* (205)
1912–13	*Hanging Clothes* (160)		
1913–14	*Rag Pickers* (166)	1923–24	*Herself* (213)
1914–15	*Greetings 1915* (170)	1924–25	*Bob Cat Wins* (214)
1915–16	*Greetings 1916* (179)	1925–26	*"Contre Danse"* (217)
1916–17	*Calf Love* (182)	1926–27	*"Rendezvous"* (small) (227)
1917–18	*Seeing New York* (188)	1927–28	*"Odalisque"* (232)
1918–19	*New Year's Eve and Adam* (190)	1928–38	none
		1938–39	*Their Appointed Rounds* (304)

The Catalogue

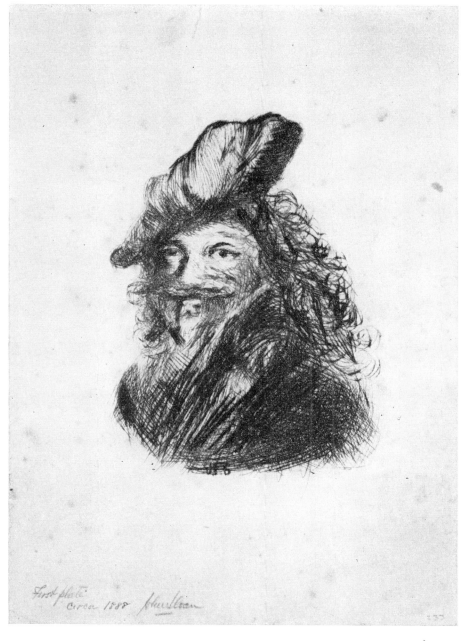

1. HEAD, AFTER REMBRANDT

1888. The print in Ph is inscribed by JS, "First plate, circa 1888, John Sloan." Since this print came before the next, which he definitely dated 1888, and after he went to work for Porter & Coates, Philadelphia, at the age of 16 (Brooks, p. 7), late 1887 at the earliest, the date of 1888 is very probable.

Drypoint, entirely. 121 x 81 mm. (4¾ x 3¼ inches) platemark; 101 x 71 mm. (4 x 2¾ inches) picture.

Only state. Ph.

No edition. Printing unknown.

Plate unknown.

No tissue. (Ph has one of his commercial pen-and-ink drawings of the same Rembrandt subject, signed and dated 1888.)

'There are one or two early etchings, copied from Rembrandt self-portraits. I used to make pen drawings from Rembrandt etchings. I could get five dollars apiece for as many as I could make. It was excellent training in pen draftsmanship, and therefore for etching" (JS 1945). Mentioned in "Autobiographical Notes," p. 382. "An overworked drypoint . . . looked like it was done inadvertently by someone turning on their heel" ("Hypocrisies Dissected by Sloan," undated article from the *Santa Fe New Mexican* of August or September 1936, Sloan file, Mod).

This print was evidently copied from Rembrandt's etching of 1639, *Rembrandt Leaning on a Stone Sill* (Hind 168, Bartsch 21).

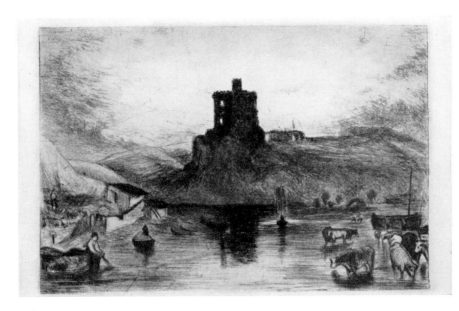

only state

2. DEDHAM CASTLE, AFTER TURNER

1888. JS records.

Alternative title: *Norham Castle.*

Etching. 82 x 127 mm. (3¼ x 5 inches) plate.

Only state. Early proofs of this print lack many of the accidental scratches which later appeared on the plate, notably the two strong vertical lines that are directly above the right end of the low part of the castle, as seen in the illustration.

Edition: 100. Printing: 75. Platt 25, Roth 50.

Plate exists: JST. Thin copper plate, steel-faced.

No tissue.

"This pale little plate, the earliest of my efforts at etching, is so timidly bitten that it looks like a drypoint. The exciting action of the acid evidently frightened me so that it is hard for me to believe that the lines ever saw acid. Done at the age of seven-teen" (Dart 28). "Made from a print, or copy, or watercolor, that hung over the mantelpiece" (JS 1945). Sloan's recollection varied as to whether it was a lithograph (see "Autobiographical Notes") or watercolor. This print is occasionally found with the signature "John F. Sloan," on later impressions (e.g. Mod).

It is a copy of Turner's subject, *Norham Castle on the Tweed,* of which two sepia drawings, two watercolors, and the etching, no. 57 of the *Liber Studiorum* (different in some details from Sloan's print) are known. Sloan's specific source may have been a chromolithograph mentioned by Rawlinson (*The Engraved Work of J. M. W. Turner, 2,* London 1913, 215, 419). As the titles were placed on the backs of the lithographs, Sloan may never have known the actual name of Turner's subject. An example of such a chromolithograph has not been seen by Rawlinson or the present compiler.

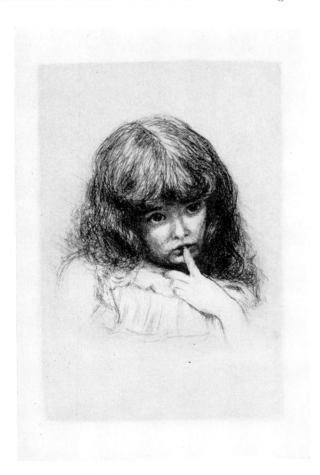

only state, reduced

3. MARIANNA SLOAN

1888. The print in Ph is inscribed "c. 1888" by JS.

Etching. 127 x 81 mm. (5 x 3¼ inches) platemark· 72 x 69 mm. (2¾ x 2¾ inches) picture.

Only state. Ph, JST.

No edition. Printing unknown.

Plate unknown.

No tissue.

"There are a few other early attempts [including] a head of my sister, Nan" (JS, May 1950 interview, p. 5). Sloan's sister, Marianna, was born September 21, 1875, and was therefore about thirteen years old when this etching was made.

"The big blizzard of 1888 saw Jack and Will [Carver] build a great snow house in front of our house, and it was a beauty. We had a grand long sled-coasting slide in the garden from the back fence to the gate. A little later on the sitting room was used for his experiments with etching. The open old fashioned gas flame made a good place to heat the plate, and the whole process of etching was worked out. I can remember the various steps and stages which he made—and a head of me was one of his very earliest plates. I was probably ten or eleven years old. That plate seems to be lost. Then he did one of George Eliot, and one of Ruskin, and one of the little Turner print that had always been on the wall in the parlor" (Marianna Sloan recollections, 1950, p. 4; JST).

only state

4. GEORGE ELIOT

1890. In plate.

Etching. 140 x 101 mm. (5½ x 4 inches) plate. 116 x 87 mm. (4½ x 3½ inches) picture.

Only state. Some scratches appear in later impressions, notably a strong vertical mark near the bottom, to the left of the signature, 26 mm. from the right edge of the picture.

Edition: 100. Printing: 75. Platt 25, Roth 50.

Plate exists: JST. Copper. Steel-faced.

No tissue.

"Made from a woodcut. While stronger than my first attempts, it has a sort of delicacy of approach that I haven't pushed much further" (JS 1945).

The original source appears to be the small circular (44-mm., 1¾-inch diameter) woodcut portrait that appears on the title page of *Scenes from Adam Bede* by George Eliot (New York, Clark & Maynard, 1888), a small paperbound booklet, no. 67 of the English Classic Series, evidently for school use. No other titles by George Eliot appear to have been published in that series. It is a source that would have been readily available to Sloan, working in a bookstore. The portrait faces in the same di-

rection as Sloan's etching and is virtually identical in detail and shading. Because of the size difference, however, Sloan's must have been a freehand copy. (A somewhat similar etching by S. A. Schoff appears in the *George Eliot Portfolio,* Boston, Estes & Lauriat, 1888, pl. I.)

There is a likely, though speculative, explanation for Sloan's having made this etching. Porter & Coates, the bookstore in Philadelphia for which Sloan worked at this time, was also a publisher of books. In April 1890 they announced the forthcoming publication of a fancy edition of Eliot's novel *Romola* (see advertisement in the *American Bookseller, 27,* April 15, 1890, 209). This was subsequently published in December 1890 (see advertisement in *Lippincott's Magazine, 46,* Dec. 1890, 40). It is a three-volume set, containing 60 photogravure illustrations, in an edition of 250 sets. It is quite possible that Sloan was either asked or volunteered to do a portrait of the author for inclusion in this publication. It then may have been rejected, either because the publishers did not like it or because of printing costs. This etching did not appear in the published set, and the plate remained in Sloan's possession.

23

Alfred Edward Newton (1864–1940) first met Sloan when they were both working in the Philadelphia bookstore, Porter & Coates, about 1887. In that year Newton left the bookshop to found his own "fancy goods" business. (See "A.E.N.," a pamphlet by his son, E. Swift Newton, Philadelphia, 1954. Also, a book in Mr. George H. Tweney's collection is inscribed: "A. Edward Newton from John M. Steffan on leaving Porter & Coates, January 8, 1887.")

The Philadelphia business directories tell some of the story of Newton's business. In 1887 there is a listing for "Edward A. Newton, clerk." In 1888 A. Edward Newton & Company, fancy goods, appears at 1012 Walnut Street. In 1890 the address changes to 1216 Locust Street, and in 1892, to 259 North Broad Street. In 1894 the only listing is for "A. Edward Newton & Company, painters," at 253 North Broad Street (evidently painters of candy boxes and the like). In 1895 and 1896 the listing reverts to "fancy goods" at 259 North Broad Street. In 1897 the company name, business, and address are the same but have been taken over by John M. Stephen (perhaps the John M. Steffan mentioned above) and Frank W. Magee, Jr., in which terms it lasts a few more years before disappearing.

Newton's products included all sorts of ephemeral novelties, such as greeting cards, match scratchers, and button and candy boxes. His 1890 letterhead proclaimed: "A. Edw. Newton & Co. / Artistic Fancy Goods / Manufacturers and Importers of the Finest / Bonbonieres / German Favors / Handkerchief Cases / Sachets / Hand Painted / Decorated / and Embroidered / Souvenirs / Christmas and Easter Goods" (LC).

Sloan went to work for Newton in 1890 (at $8 or $9 a week) and continued until late 1891. For the next two years he continued to do work for Newton on commission. A catalogue, "A Collection of Newton's Specialties," dated August 15, 1891, is now in Ph, having come from Sloan's files. It shows a sample of the novelty items designed by Sloan, with drawings (photomechanically reproduced) and verse. It says nothing about any etched work and it possibly precedes any of Sloan's etchings for Newton.

Of importance here is the fact that among Newton's "fancy goods" were quite a number of pamphlets and even small books of a type fairly common at the time, published under the imprint of A. Edward Newton & Co., Publishers. The first was a portfolio entitled *The Homes of the Poets*, dated 1887, with text by Edward Swift (a pseudonym for Newton), with six original photographs by William H. Rau.

When Sloan came to work for Newton, he was given the opportunity to execute several projects in etching. Probably the first was to copy the photographs in *The Homes of the Poets* for a new edition (5–10), "Illustrated with Etchings from Original Steel Plates" (perhaps copper steel-faced) by John Sloan, published in 1891. The *Westminster Abbey* series (11–23) is dated the same year.

A diligent search has turned up at least 49 individual etchings done by Sloan for Newton, illustrating 20 different publications. Several other plates represent discarded work and other work of the period not definitely known to be for Newton. The inclusion of one or more etchings in such pamphlets, usually consisting of poetical or philosophical quotations, undoubtedly gave them an appeal that attracted purchasers. They were evidently an appropriate type of publication for the properly cultivated home to have around. Sloan was certainly familiar with the genre, for similar pamphlets were published by Marcus Ward, for whom his father was a salesman. (Sloan's mother's sister was married

to Ward's son.) One cannot conceive that Newton would have continued to commission etchings from Sloan if they had not been a commercial success. All the printing of Sloan's plates for the publications, Sloan said, was done by the Peters brothers. The printing of all Newton's texts was said to have been done by Edward Stern & Co. (Newton letter of 1933; Free Library of Philadelphia).

In later years Newton became widely known as a rare book collector and as an author on the subject. In many respects he was the first man to popularize book collecting beyond a small, highly select group. For this reason his works have themselves become the object of book collectors, and thus a number of his early published pamphlets, with Sloan's etchings, have been fortuitously preserved. The quantity printed of each of these publications is unknown. The only testimony we have of any kind is that of Kirke Bryan: "Although Mr. Newton once informed me that some of the imprints were issued in numbers as high as a thousand, I can't believe that many appeared in such numbers" (Bryan, *Some Recent Amenities*, Philadelphia, 1954, p. 11).

Only one specific attempt so far has been made to catalogue these early Newton publications: John T. Winterich's article "The Imprints of A. Edw. Newton & Co., 1887–1893" (*The Colophon*, *1*, no. 4, n.s., Spring 1936, 510–22). This lists thirteen different publications, four of which had etchings by Sloan. Mr. Winterich advises me that he has done no subsequent research on the subject. Carl Zigrosser's catalogue of 1956 lists nine items done by Sloan for Newton, etchings which had previously been in Sloan's files.

The following etchings (eight of which do not appear in either the Winterich or Zigrosser lists) can be said with some certainty to have been made by Sloan on commission for Newton, and probably published in some fashion by the latter. Asterisks indicate those about which some slight doubt of a Newton publication still exists. Other items in this catalogue (24, 25, 46, 56) are less certainly connected with Newton.

Homes of the Poets (5–10)	Artist's Portfolio (49)*
Westminster Abbey (11–23)*	Poet's Portfolio (50)
Rays of Easter Dawn (26)	Musician's Portfolio (51)*
Easter Thoughts (27)*	Dickens' Immortals (52)
Lines to a Lady (28)	Favorites of Thackeray (53)
Calendar for 1893 (29–41)	Moments with George Eliot (54)
Selections from Browning (42)*	Beauties of Emerson (55)
Cathedral's Echoes (43)*	Golden Thoughts from Ruskin
Golden Thoughts from Frances	(57)
Ridley Havergal (47)	Wisdom of Franklin (58)
Book Lover's Portfolio (48)	Wisdom of Shakespeare (59)

It is possible that other Newton-Sloan etchings will turn up in the future from some unexpected source. It is important to note here that no etchings whatever have been discovered which were done for Newton by anyone but Sloan. There is therefore a strong initial presumption that an etching in an early Newton publication, even if unsigned, is by Sloan. The fragile and unprepossessing aspect of the material guarantees that it will be rare. As Mr. Winterich commented, "The second-hand bookseller . . . probably does not trouble to toss the items into the ten-cent bin. He simply throws them out. It does not require much throwing out to make books of this type rare" (*Colophon*, *1*, no. 4, n.s., Spring 1936, 511).

The publishing firm of Nims & Knight, Troy, N.Y., evidently had some connection with A. Edward Newton & Co. Henry B. Nims and Joseph Knight did business under that name from 1886

to 1891 (Troy business directories). Both the *Homes of the Poets* and *Westminster Abbey* are in a list of "books published in the United States in 1891," in volume 31 of the *American Bookseller* (Feb. 1, 1892, pp. 64, 66). Both are given as Nims & Knight publications. Copies of the *Homes* are known with the Nims & Knight imprint. It might be worthwhile, therefore, to keep one's eyes open for two other Nims & Knight publications in the same list, both of the same oblong octavo format and both illustrated: *By Stream and Roadside* (paper, ribbon-tied, $2) and *Gray's Elegy and Its Author* ($5; with flexible seal, $8). It is barely possible that the illustrations in these and any other such publications are etchings by Sloan. Needless to say, both these are un-

known to the compiler. One other possible unknown etching is suggested by Sloan's record of a $6 payment from Newton, dated April 1892, for a "Columbus Calendar" about which nothing else is known (Sloan file, Mod). The field, therefore, may not be completely exhausted.

In later years Newton made no public comment about his business association with Sloan, evidently feeling that he had risen above "fancy goods," which of course he had. He also kept no business records from that period, as his son, E. Swift Newton, has kindly told me. Sloan recalled meeting Newton only once again, in the 1930s. They had little to say to each other.

only state

5. THE HOME OF HENRY WADSWORTH
 LONGFELLOW
1891. Date of others in this series.
No. 1 of *Homes of the Poets*. A. Edward Newton commission.
Alternative title: *Craigie House*.
Etching. 125 x 173 mm. (5 x 7 inches) platemark; 116 x 162 mm.
(4½ x 6½ inches) picture.
Only state. Ph, FLP, Bryan, Tweney–2.
No edition. Printing unknown.
Plate probably destroyed.
Copied from a photograph in the 1st edition of this publication. The slight changes that Sloan made are interesting. In this print he added lines of shading in the sky, where the photograph had none.

Winterich no. 1A (*Colophon, 1,* no. 4, n.s., Spring 1936, 512–13). See also p. 31.

25

only state

6. THE HOME OF JAMES RUSSELL LOWELL
1891. In plate.
No. 2 of *Homes of the Poets*. A. Edward Newton commission.
Alternative title: *Elmwood*.
Etching. 124 x 176 mm. (5 x 7 inches) platemark; 113 x 162 mm.
(4½ x 6½ inches) picture.
Only state. Ph, FLP, Bryan, Tweney–2.
No edition. Printing unknown.
Plate probably destroyed.
Copied from photograph in 1st edition of this publication.
Sloan added the birds over the house and trimmed the picture at
the right.

only state

7. THE HOME OF NATHANIEL HAWTHORNE
1891. In plate.
No. 3 of *Homes of the Poets*. A. Edward Newton commission.
Alternative title: *The Wayside*.
Etching. 124 x 174 mm. (5 x 7 inches) platemark; 115 x 162 mm.
(4½ x 6½ inches) picture.
Only state. Ph, FLP, Bryan, Tweney–2.
No edition. Printing unknown.
Plate probably destroyed.
Copied from photograph in 1st edition of this publication.
Sloan added the area of open sky in the upper left corner.

only state

8. THE HOME OF EDGAR ALLAN POE
1891. In plate.
No. 4 of *Homes of the Poets*. A. Edward Newton commission.
Etching. 123 x 176 mm. (5 x 7 inches) platemark; 115 x 163 mm.
(4½ x 6½ inches) picture.
Only state. Ph, FLP, Bryan, Tweney–2.
No edition. Printing unknown.
Plate probably destroyed.
Copied from photograph in 1st edition of this publication.
Sloan made several changes in detail, removing the people
around the tree and at the top and bottom of the steps. He added
shading in the sky, thickened the trees at the lower left, trimmed
the picture at the bottom, and added at the top.

only state

9. THE HOME OF RALPH WALDO EMERSON
1891. Date of others in this series.
No. 5 of *Homes of the Poets*. A. Edward Newton commission.
Etching. 128 x 172 mm. (5 x 7 inches) platemark; 115 x 163 mm.
(4½ x 6½ inches) picture.
Only state. FLP, Bryan, Tweney–2.
No edition. Printing unknown.
Plate probably destroyed.
Copied from photograph in 1st edition of this publication.
Sloan added shading in the sky and trimmed at the right.

only state

10. THE HOME OF JOHN GREENLEAF
 WHITTIER

1891. In plate.

No. 6 of *Homes of the Poets*. A. Edward Newton commission.

Etching. 124 x 176 mm. (5 x 7 inches) platemark; 114 x 165 mm.
(4½ x 6½ inches) picture.

Only state. Ph, FLP, Bryan, Tweney–2.

No edition. Printing unknown.

Plate probably destroyed.

Copied from photograph in 1st edition of this publication.
Sloan changed the opened or closed positions of the shutters on
six of the house windows.

photograph from which Sloan copied his etching

The 1st edition of *Homes of the Poets* was published by Newton in 1887 (copyright Sept. 17, 1887), with text by Edward Swift (i.e. Newton himself) and original photographs of the six houses by William H. Rau.

The 2nd edition of 1891, with Sloan's etchings, is known with both the imprint of A. Edward Newton & Co. on the title page (FLP, Tweney) and with the imprint of Nims & Knight, Troy, N.Y. (Bryan, Tweney). The 2nd edition publications are otherwise identical. It was listed in the *American Bookseller* (*31*, Feb. 1, 1892, 66) as a Nims & Knight product, described as an oblong octavo, illustrated, in paper for $1.75 and limp leather for $2.50. Mr. Winterich has described both editions fully. (See also Sloan's "Autobiographical Notes," p. 382.)

Sloan's six etchings are extremely close to the six photographs of the 1st edition, both in subject and size. It seems possible that he took a tissue tracing from each photograph and used it to trace onto his plate. The subjects are in the same direction.

only state

11. WESTMINSTER ABBEY: TITLE PAGE
1891. In plate.
Westminster Abbey series.
Etching. 82 x 122 mm. (3¼ x 4¾ inches) platemark.
Only state. Ph–2.
No edition. Printing unknown.
Plate probably destroyed.
No tissue.

The *Westminster Abbey* series includes thirteen etchings by Sloan: a title, six pictorial subjects, and a title for each subject. The Ph copy of the set, the only complete one known to me, is in embossed and painted cardboard covers, tied with ribbon. The order of the etchings is the same as given here, with the etched title preceding the related picture in each case.

Sloan specifically remembered doing this series for Newton (see p. 382). In date and format, and particularly in the style of the cover, with its hand-painted flowers, it has every appearance of being an A. Edward Newton publication. The fact remains, nevertheless, that Newton's name is found nowhere in the booklet and is associated with it only by Sloan's recollection. The *American Bookseller* (*31*, Feb. 1, 1892, 68) gives the publisher as Nims & Knight, of Troy, N.Y. The relation between this firm and Newton's is unknown, though the former's imprint also is known on copies of Newton's *Homes of the Poets*. The publication is described as having six etchings, with text selections, of oblong format, with paper covers, ribbon-tied, and a price of $3. It is dated 1891. It should be noted, however, that it is not included in a full-page Nims & Knight advertisement in *Dial* (*12*, Dec. 1891, 303).

Sloan's pictorial source for these etchings appears to be a series of screenless photogravures, after paintings by Alfred Dawson. This is in close agreement with Sloan's recollection of their being "photogravures of drawings by some English artist" (p. 382). Two such photogravures were found in the graphic arts collection of SI. Undated, they were acquired in July 1888. The *Nave* measures 148 x 175 mm. (5¾ x 7 inches) platemark and 107 x 141 mm. (4¼ x 5½ inches) picture; the *West Front* is 135 x 98 mm. 5¼ x 3¾ inches) platemark and 111 x 79 mm. (4¼ x 3 inches) picture. They were published by the Typographical Etching Co. of London. Since these two subjects correspond so precisely in detail with Sloan's etchings, his other subjects are presumed to be derived from the same source, though actual examples have not been discovered. Their size indicates that Sloan did not trace them, but copied freehand.

Sloan's source, it should be noted, was not the illustrations in W. J. Loftie's *Westminster Abbey* (London, 1891), five of which are very close but perceptibly different from Sloan's subjects. He, of course, never saw Westminster Abbey in person, for he never left the United States.

only state

12. THE WEST FRONT: TITLE
1891. Date of other etchings in the series.
Westminster Abbey series.
Alternative title: *Ancient Coronation Chair.*
Etching. 81 x 121 mm (3¼ x 4¾ inches) platemark.
Only state. Ph.
No edition. Printing unknown.
Plate probably destroyed.
No tissue.

only state

13. THE WEST FRONT
1891. Signed and dated print in JST.
Westminster Abbey series.
Etching. 122 x 80 mm. (4¾ x 3¼ inches) platemark.
Only state. Ph–2, JST (signed and dated).
No edition. Printing unknown.
Plate probably destroyed.
No tissue.

only state

14. THE NAVE: TITLE
1891. Date of other etchings in the series.
Westminster Abbey series.
Etching. 81 x 123 mm. (3¼ x 4¾ inches) platemark.
Only state. Ph.
No edition. Printing unknown.
Plate probably destroyed.
No tissue.

second state

15. THE NAVE
1891. Date of other etchings in the series.
Westminster Abbey series.
Etching. 79 x 121 mm. (3¼ x 4¾ inches) platemark.
States:
 1. Lightly drawn. Sides and foreground blank. Ph.
 2. Considerably darkened and reworked throughout. Ph–2,
 JST (signed).
No edition.
Printing unknown.
Plate probably destroyed.
No tissue.

only state

16. SAINT ERASMUS' DOORWAY: TITLE
1891. Date of other etchings in the series.
Westminster Abbey series.
Etching. 81 x 122 mm. (3¼ x 4¾ inches) platemark.
Only state. Ph.
No edition. Printing unknown.
Plate probably destroyed.
No tissue.

only state

17. SAINT ERASMUS' DOORWAY
1891. Signed and dated print in JST.
Westminster Abbey series.
Etching. 122 x 80 mm. (4¾ x 3¼ inches) platemark; 109 x 76
mm. (4¼ x 3 inches) picture.
Only state. Ph–2, JST (signed and dated).
No edition. Printing unknown.
Plate probably destroyed.
No tissue.

only state

18. THE ABBEY FROM THE DEANS YARD:
 TITLE
1891. Date of other etchings in the series.
Westminster Abbey series.
Etching. 83 x 124 mm. (3¼ x 4¾ inches) platemark.
Only state. Ph–2.
No edition. Printing unknown.
Plate probably destroyed.
No tissue.

only state

19. THE ABBEY FROM THE DEANS YARD

1891. In plate.

Westminster Abbey series.

Etching. 80 x 125 mm. (3¼ x 4¾ inches) platemark.

Only state. Ph–2 (one signed and dated), JST.

No edition. Printing unknown.

Plate probably destroyed.

No tissue.

only state

20. THE POETS CORNER: TITLE

1891. Date of other etchings in the series.

Westminster Abbey series.

Etching. 80 x 120 mm. (3¼ x 4¾ inches) platemark.

Only state. Ph–2.

No edition. Printing unknown.

Plate probably destroyed.

No tissue.

21. THE POETS CORNER

1891. In plate.

Westminster Abbey series.

Etching. 127 x 85 mm. (5 x 3¼ inches) platemark; 121 x 80 mm.

(4¾ x 3 inches) picture.

Only state. Ph–2, JST (signed and dated).

No edition. Printing unknown.

Plate probably destroyed.

No tissue.

only state

only state

22. HENRY VII CHAPEL: TITLE
1891. Date of other etchings in the series.
Westminster Abbey series.
Etching. 81 x 121 mm. (3¼ x 4¾ inches) platemark.
Only state. Ph–2.
No edition. Printing unknown.
Plate probably destroyed.
No tissue.

only state

23. HENRY VII CHAPEL
1891. Date of other etchings in the series.
Westminster Abbey series.
Etching. 79 x 126 mm. (3¼ x 5 inches) platemark.
Only state. Ph–2.
No edition. Printing unknown.
Plate probably destroyed.
No tissue.

24. GIRL WITH HARP

1891. JS records give 1891. Prints are also known inscribed "c. 1890" (Met) and "'94" (JST). The 1891 date seems most reliable.

Alternative title: *Girl in Oval*. A variant of the following print.

Etching. 127 x 184 mm. (5 x 7¼ inches) plate; 89 x 100 mm. (3½ x 4 inches) oval.

Only state. Later impressions show light scratches in the blank areas, notably two parallel diagonal lines between the oval and the upper right corner. The false biting at the left is present from the beginning, though in the Met impression the area has been cleared of ink before printing. Edition: 100. Printing: 75. Platt 25, Roth 50.

Plate exists: JST. Copper.

Probably no tissue.

"A rather interesting example of a plate which was discarded because the ground had broken down and the acid had gotten out of control. Kept perhaps on account of a poetic quality" (JS 1945).

only state

25. GOLDEN THOUGHTS FROM TENNYSON

1891. Estimate based on the preceding print.

A. Edward Newton commission. Unfinished.

Etching. 125 x 126 mm. (5 x 5 inches) plate; 90 x 98 mm. (3½ x 4 inches) oval.

Only state. Ph, WSFA, SI.

No edition. Printing: 3. Harris 3.

Plate exists: JST. Copper.

Probably no tissue. A drawing of a different subject with the same title, dated 1892, is in JST (no. S–723).

"A. Edward Newton and Company frontispiece. Discarded. I was working for Newton making headings for calendars and poets. I taught myself to etch, making these things" (JS 1945). The chin is unfinished.

only state

second state, reduced

26. RAYS OF EASTER DAWN

1891. Estimate.

A. Edward Newton commission.

Etching. 177 x 92 mm. (7 x 3½ inches) platemark.

States:

 1. Nearly complete. Angel's ears visible. Ph (with pencil, printed by JS).

 2. Additional hair on forehead and sides of face, covering the ears and touching the tips of the eyebrows. Brown University Library (Peters printing).

No edition. Printing unknown.

Plate probably destroyed.

Probably no tissue.

 A copy of the complete publication is at Brown University. It is an eight-page booklet with printed and hand-painted celluloid covers, tied with pink ribbon, measuring 9⅝ x 7⅛ inches. Sloan's etched title is on the second page. The text consists of various poetic Easter sentiments.

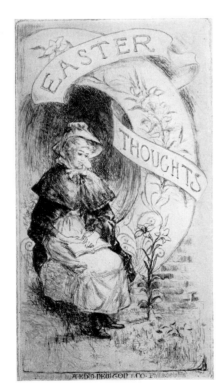

only state, reduced

27. EASTER THOUGHTS

1891. Estimate.

A. Edward Newton commission.

Etching. 177 x 92 mm. (7 x 3½ inches) platemark.

Only state. Ph (printed by JS).

No edition. Printing unknown.

Plate probably destroyed.

Probably no tissue.

 There is no evidence that Sloan started doing etchings for Newton before 1891. This and the preceding print are placed at this point in the numerical order only because of their stylistic quality. They may well have come later in the series. A letter of introduction from Sloan's uncle, William H. Ward, to C. W. Beck, manager of the Philadelphia Photo-Engraving Co., later head of the Beck Engraving Co., dated November 23, 1891 (JST), comments: "As you will see, he has made some attempts with the etching needle."

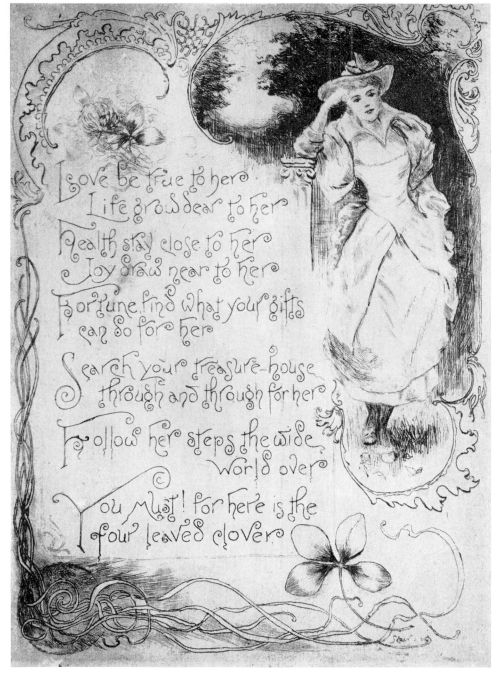

only state

28. LINES TO A LADY

1891. Estimate.

A. Edward Newton commission.

Etching. 189 x 133 mm. (7½ x 5¼ inches) platemark.

Only state. Bryan (Peters printing).

No edition. Printing unknown.

Plate probably destroyed.

Probably no tissue.

 "Phone call from T. Harvey, Jr., from Philadelphia, asks us to look up a brochure in Parke-Bernet Auction. *Lines to a Lady,* published by A. Edw. Newton. Etching on cover by Sloan" (March 1, 1948, JS diary). "She (Helen) went up to look at the Newton item at Auction gallery. Of no importance. One of the feeble etchings with a poem I made" (March 2, 1948, JS diary). See Parke-Bernet Galleries catalogue, March 1–2, 1948, lot 352. This copy, the only one known, is now in the Kirke Bryan collection. It is a sixteen-page, ribbon-tied pamphlet, measuring 9¼ x 7¼ inches, containing miscellaneous poetic quotations. The etching is trimmed to the platemark and pasted on the front paper cover. The poem in the etching is quite possibly by Sloan. His comment above could indicate this, and the poem does not appear in the standard reference works.

 Winterich no. 10 (*Colophon, 1,* no. 4, n.s., Spring 1936, 519–20), probably the same copy.

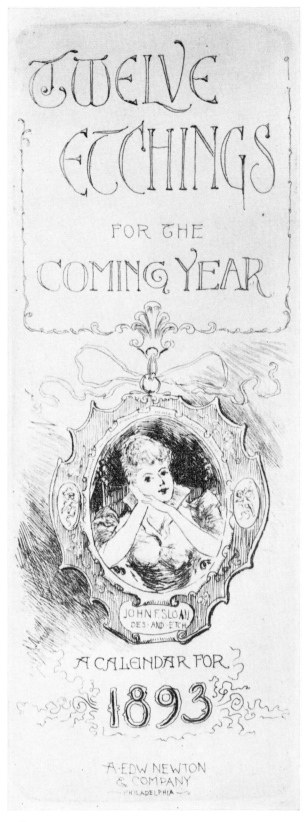

only state

29. CALENDAR FOR 1893: TITLE PAGE
1891. Date in *January* plate.
Calendar for 1893 series. A. Edward Newton commission.
Etching. 188 x 68 mm. (7½ x 2¾ inches) platemark.
Only state. Ph (printed by JS).
No edition. Printing unknown.
Plate probably destroyed.
No tissue.

Sloan's ledger book (Sloan file, Mod) records a June 23, 1892, payment from A. Edward Newton & Co., which includes $50.00 for "13 Cal. plates" and $6.24 for "13 copper plates @ 48," the latter being the cost of materials. A payment the following year (April 2, 1893) of only $10.00 for "Cal. 13 plates" seems to indicate that the latter commission was for drawings to be reproduced photomechanically, rather than for more expensive etchings.

40

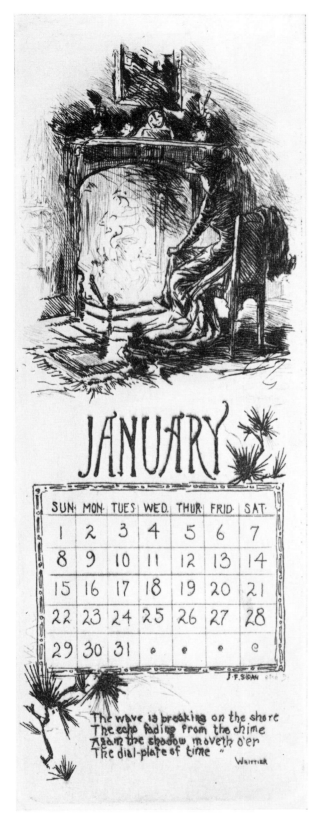

only state

only state

30. JANUARY

1891. In plate.

Calendar for 1893 series. A. Edward Newton commission.

Etching. 188 x 68 mm. (7½ x 2¾ inches) platemark.

Only state. Ph (printed by JS).

No edition. Printing unknown.

Plate probably destroyed.

No tissue.

31. FEBRUARY

1892. In plate.

Calendar for 1893 series. A. Edward Newton commission.

Etching. 189 x 66 mm. (7½ x 2¾ inches) platemark.

Only state. Ph (printed by JS).

No edition. Printing unknown.

Plate probably destroyed.

No tissue.

only state

only state

32. MARCH
1892. Date in *February* plate.
Calendar for 1893 series. A. Edward Newton commission.
Etching. 186 x 68 mm. (7½ x 2¾ inches) platemark.
Only state. Ph (printed by JS).
No edition. Printing unknown.
Plate probably destroyed.
No tissue.

33. APRIL
1892. Date in *February* plate.
Calendar for 1893 series. A. Edward Newton commission.
Etching. 186 x 68 mm. (7½ x 2¾ inches) platemark.
Only state. Ph (printed by JS).
No edition. Printing unknown.
Plate probably destroyed.
No tissue.

only state

only state

34. MAY
1892. Date in *February* plate.
Calendar for 1893 series. A. Edward Newton commission.
Etching. 189 x 66 mm. (7½ x 2¾ inches) platemark.
Only state. Ph (printed by JS).
No edition. Printing unknown.
Plate probably destroyed.
No tissue.

35. JUNE
1892. Date in *February* plate.
Calendar for 1893 series. A. Edward Newton commission.
Etching. 190 x 67 mm. (7½ x 2¾ inches) platemark.
Only state. Ph (printed by JS).
No edition. Printing unknown.
Plate probably destroyed.
No tissue.

My angel,—his name is Freedom,—
Choose him to be your king;
He shall cut pathways east and west
And fend you with his wing

only state

Dust on thy mantlel dust,
Bright Summer! on thy livery of green
A tarnish as of rust,
Dims thy late-brilliant sheen.

only state

36. JULY
1892. Date in *February* plate.
Calendar for 1893 series. A. Edward Newton commission.
Etching. 185 x 66 mm. (7½ x 2¾ inches) platemark.
Only state. Ph (printed by JS).
No edition. Printing unknown.
Plate probably destroyed.
No tissue.

37. AUGUST
1892. Date in *February* plate.
Calendar for 1893 series. A. Edward Newton commission.
Etching. 186 x 67 mm. (7½ x 2¾ inches) platemark.
Only state. Ph (printed by JS).
No edition. Printing unknown.
Plate probably destroyed.
No tissue.

only state

only state

38. SEPTEMBER

1892. Date in *February* plate.
Calendar for 1893 series. A. Edward Newton commission.
Etching. 186 x 67 mm. (7½ x 2¾ inches) platemark.
Only state. Ph (printed by JS).
No edition. Printing unknown.
Plate probably destroyed.
No tissue.

39. OCTOBER

1892. Date in *February* plate.
Calendar for 1893 series. A. Edward Newton commission.
Etching. 187 x 55 mm. (7½ x 2¾ inches) platemark.
Only state. Ph (printed by JS).
No edition. Printing unknown.
Plate probably destroyed.
No tissue.

There is no color in the world
No lovely tint on hill or plain
The summers golden sails are furled
And sadly falls the autumn rain

NOVEMBER

only state

'Neath the mistletoe bough
Welcome old Christmas now
Crown him with holly
Laugh sing be jolly
'Neath the mistletoe bough

only state

40. NOVEMBER
1892. Date in *February* plate.
Calendar for 1893 series. A. Edward Newton commission.
Etching. 184 x 67 mm. (7½ x 2¾ inches) platemark.
Only state. Ph (printed by JS).
No edition. Printing unknown.
Plate probably destroyed.
No tissue.

41. DECEMBER
1892. Date in *February* plate.
Calendar for 1893 series. A. Edward Newton commission.
Etching. 185 x 66 mm. (7½ by 2¾ inches) platemark.
Only state. Ph (printed by JS).
No edition. Printing unknown.
Plate probably destroyed.
No tissue.

only state

only state

42. SELECTIONS FROM BROWNING

1892. In plate (above and below signature).
A. Edward Newton commission.
Etching. 190 x 65 mm. (7½ x 2¾ inches) platemark.
Only state. Ph (printed by JS).
No edition. Printing unknown.
Plate probably destroyed.
No tissue.

43. CATHEDRAL'S ECHOES

1892. Estimate, from style and format similarity to the *Calendar for 1893*.
A. Edward Newton commission.
Etching. 187 x 70 mm. (7½ x 2¾ inches) platemark.
Only state. Ph (Peters printing).
No edition. Printing unknown.
Plate probably destroyed.
Probably no tissue.

only state

44. BUSINESS CARD
1892. Dated August 16, 1892, in JS ledger book (Sloan file, Mod).
Etching. 47 x 100 mm. (2 x 4 inches) platemark.
Only state. Ph, JST–2 (one with "705" changed to "806" by pen).
(All Peters printing.)
No edition. Printing unknown.
Plate unknown.
Copied from a sketch: JST.

 Sloan and Joe Laub moved into 705 Walnut Street about
April 1892 and shifted to 806 Walnut Street on September 5,
1893 (Sloan-Henri correspondence in JST; and JS 1950, pp. 323–
24). Sloan's ledger (Sloan file, Mod) shows an August 16, 1892,
payment of $5 to C. Peters Sons for "Card plate."

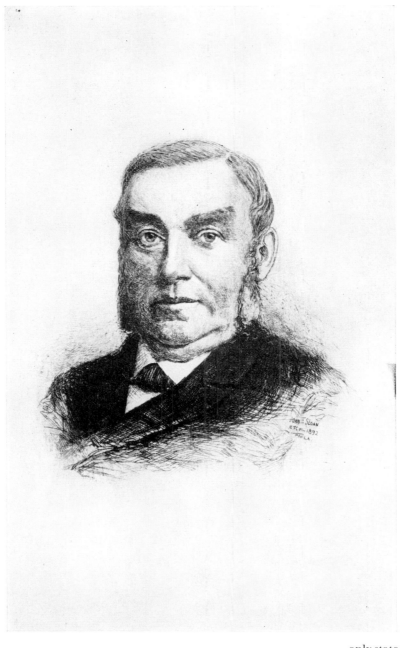

only state

45. GEORGE W. CHILDS

1892. Dated August 26, 1892, in JS ledger (Sloan file, Mod).
Etching. 214 x 138 mm. (8½ x 5½ inches) platemark; 101 x 94 mm. (4 x 3¾ inches) picture.
Only state. Met, Mod (both printed by JS).
No edition. Printing: only two prints presently known.
Plate lost.
Copied from a photograph which is now in JST.

"Plate lost by 'Col.' Jacob Eby Barr, Philadelphia, Pa." (JS records). "My portrait of George W. Childs, a plate I made from a photo, ordered by 'Colonel' J. Eby Barr (formerly with Porter & Coates) print dealer. I made Eby a plate and handed it with a proof over to his brother and that was the last I ever saw of it. *I was not paid a cent*. I had two or three proofs only" (JS diary, April 12, 1947). See also Sloan's "Autobiographical Notes" (p. 383). This diary entry was made the same day as the interview from which those "Notes" eventually derived. Col. Barr was head of the book department at Porter & Coates, stationers and publishers in Philadelphia. Sloan worked under him as a clerk from 1887 to 1890. Unlike the vast majority of his early work, this print was always included by Sloan in his "complete" listings of his prints. It has not been found in published form. Sloan's ledger book (Sloan file, Mod), under the date August 26, 1892, shows receipt of "1 Proof Childs red br [i.e. reddish brown ink]" from C. Peters Sons and subsequent receipt of six more proofs. The same ledger shows an undated delivery of "5 or 4 proofs Ch." to W. C. Barr, without record of payment.

George William Childs (1829–94) was a successful Philadelphia publisher, particularly known as the editor and proprietor of the Philadelphia *Ledger,* which newspaper he purchased in 1864. In later years he undertook numerous philanthropic works. (See George W. Childs, *Recollections,* Philadelphia, 1890; and *DAB.*)

only state

46. JOHN RUSKIN

1862. In plate. Probably April 1892 (see below).
Possibly an A. Edward Newton commission.
Etching. 156 x 115 mm. (6 x 4½ inches) platemark; 112 x 90mm.
(4½ x 3½ inches) picture.
Only state. Ph (printed by JS).
No edition. Printing unknown.
Plate probably destroyed.
Probably no tissue. Source unknown.

Sloan's ledger for April 1892 (Sloan file, Mod) shows that he
billed A. Edward Newton & Co. $10 for "Ruskin port." and was
paid for it on May 24. The records, however, do not indicate if
this was an etching or a drawing.

second state

47. GOLDEN THOUGHTS FROM FRANCES
 RIDLEY HAVERGAL

1892. Estimate.

A. Edward Newton commission.

Etching. 126 x 126 mm. (5 x 5 inches) platemark.

States:

1. Author's name misspelled "FRANCIS." Ph (with pencil
 and erasures; printed by JS).
2. Name corrected to "FRANCES." Ph, JST, Bryan (all Peters
 printing).

No edition. Printing unknown.

Plate probably destroyed.

Probably no tissue.

This print was issued as the title of a four-page folded pam-
phlet containing quotations from Havergal. The only known
complete pamphlet, in the Kirke Bryan collection, has the title
"Unforgotten Echoes / Havergal" on the paper cover. It meas-
ures 6½ x 6¼ inches, with the etching pasted on the verso of the
front cover. One copy, in Ph, is the four-page pamphlet without
covers.

51

only state

48. THE BOOK LOVER'S PORTFOLIO
1892. Estimate.
A. Edward Newton commission.
Etching. 132 x 147 mm. (5¼ x 6 inches) platemark.
Only state. Ph (Peters printing).
No edition. Printing unknown.
Plate probably destroyed.
Probably no tissue.

Known copies of the publication lack the Sloan etching. I have seen three such copies (FLP, Bryan–2). It is an eight-page pamphlet, measuring 6½ x 8 inches, a format which would be suitable for this etching.

The auction catalogue of the American Art Association-Anderson Galleries, New York, November 26, 1935, lot 330, lists this booklet with "engraved title-page." This is the copy described by Mr. Winterich (no. 8, *Colophon, 1,* no. 4, n.s., Spring 1936, 518–19). Its present location is unknown, and the gallery no longer has a record of the purchaser.

only state

49. THE ARTIST'S PORTFOLIO

1892. Estimate.

A. Edward Newton commission. Presumed.

Etching. 131 x 147 mm. (5¼ x 6 inches) platemark.

Only state. Ph (Peters printing).

No edition. Printing unknown.

Plate probably destroyed.

Probably no tissue.

This is the only unsigned print in this catalogue which is attributed to Sloan on other than firsthand evidence. Its relation to the *Book Lover's Portfolio* (48), both in style and format, is unmistakable. A Morellian analysis, for instance, shows an identical treatment of the hands. Furthermore, there are two drawings by Sloan in JST (nos. S–724, S–729) which, though quite different in subject matter, are both early trial sketches entitled *The Artist's Portfolio*.

A copy of the Newton publication of this title, without an etching, is in the Bryan collection. It is a six-page pamphlet, measuring 6½ x 8 inches, a format which would be suitable for this etching.

drawing of a similar subject, c. 1891

drawing of a similar subject, c. 1893

only state

50. THE POET'S PORTFOLIO
1892. Estimate.
A. Edward Newton commission.
Etching. 130 x 150 mm. (5¼ x 6 inches) platemark.
Only state. LC, Tweney (both Peters printing).
No edition. Printing unknown.
Plate probably destroyed.
Probably no tissue.

 The Tweney copy is the only one known of the complete pub-
lication with the etching. It is a ten-page pamphlet, measuring
6½ x 8 inches, like others of this Newton series. Other known
copies lack the etching.

only state

51. THE MUSICIAN'S PORTFOLIO

1892. Estimate.
A. Edward Newton commission.
Etching. 131 x 150 mm. (5¼ x 6 inches) platemark.
Only state. LC (Peters printing).
No edition. Printing unknown.
Plate probably destroyed.

 Copied, not traced, from a drawing, now in JST. Though the print is not signed, the drawing is. On the back of the drawing, in Sloan's hand, are the lines of poetry seen in the print and the notation, "For A. Edw. Newton, Booklet cover $2.00."

drawing of the same subject

only state

52. DICKENS' IMMORTALS
1893. In plate.
A. Edward Newton commission.
Etching. 112 x 175 mm. (4½ x 7 inches) platemark.
Only state. Bryan–2, Tweney–3 (all Peters printing).
No edition. Printing unknown.
Plate probably destroyed.
Probably no tissue.

The etching is used as title page of an eighteen-page pamphlet containing miscellaneous quotations from Charles Dickens. It measures 6 x 9⅛ inches, with paper covers, and is tied with ribbon. This etching and publication are also mentioned in a letter in the *Antiquarian Bookman,* November 27, 1948.

In Sloan's ledger book (Sloan file, Mod) there is recorded a payment of $53.40 by A. Edward Newton & Co., dated April 2, 1893, for "4 Title pages," which may refer to nos. 52, 53, 54, and 55 of this catalogue.

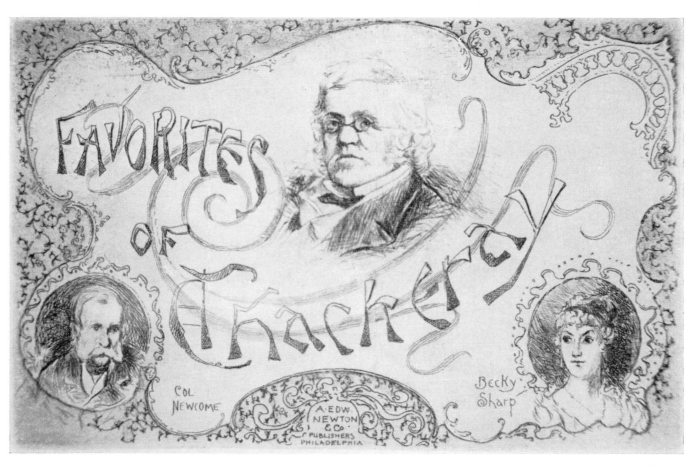

only state

53. FAVORITES OF THACKERAY
1893.
A. Edward Newton commission.
Etching. 111 x 175 mm. (4¼ x 7 inches) platemark.
Only state. Tweney–4 (Peters printing).
No edition. Printing unknown.
Plate probably destroyed.
Probably no tissue.

 The complete publication is a 6½ x 9½ inch pamphlet, with
paper covers, tied with metallic cord. Sloan's signature, barely
visible on the print, is in the left margin, near the lower end of
the letter "F."

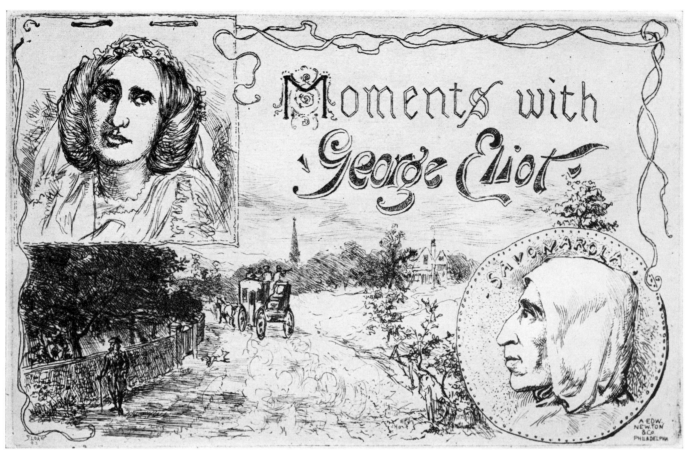

only state

54. MOMENTS WITH GEORGE ELIOT
1893. In plate.
Alternative title: *Eliot and Savonarola*
A. Edward Newton commission.
Etching. 108 x 172 mm. (4¼ x 6¾ inches) platemark.
Only state. **LC, FLP, Bryan, Tweney** (all Peters printing).
No edition. Printing unknown.
Plate probably destroyed.
Probably no tissue.

The Free Library, Bryan, and Tweney collections have the complete publication, a twelve-page, ribbon-tied pamphlet, measuring 6 x 9 inches.

The portraits of Eliot and Savonarola appear to have been copied from photogravures in the Porter & Coates edition of *Romola* mentioned under print no. 4. The original of the Eliot portrait was an etching by William Unger, the Savonarola portrait a painting by Fra Bartolommeo.

Winterich no. 11 (*Colophon, 1*, no. 4, n.s., Spring 1936, 520).

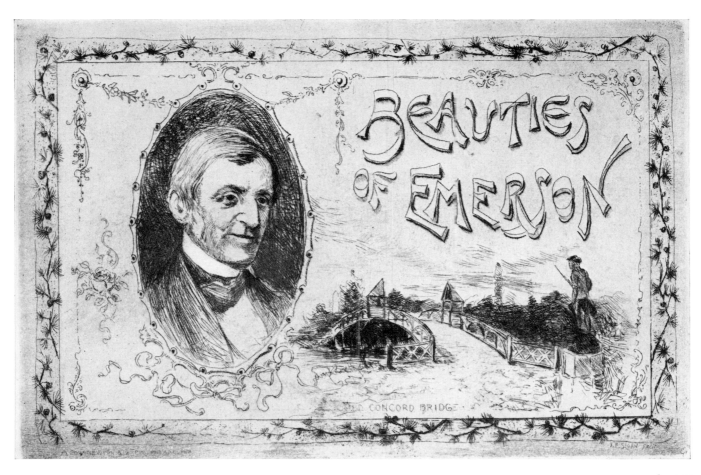

only state

55. BEAUTIES OF EMERSON
1893. Estimate, based on similarity to 54.
A. Edward Newton commission.
Etching. 110 x 175 mm. (4¼ x 6¾ inches) platemark.
Only state. Ph, LC, Bryan, Tweney (all Peters printing).
No edition. Printing unknown.
Plate probably destroyed.
Probably no tissue.

 The complete publication is a thirteen-page, ribbon-tied pamphlet, measuring 6 x 9 inches.

56. EVENING SMOKE
1893. In plate.
A. Edward Newton commission.
Etching. 69 x 98 mm. (2¾ x 4 inches) plate.
Only state. Ph, WSFA, SI, Bryan.
No edition. Printing: 4. Harris 4.
Plate exists: JST. Copper.
Probably no tissue.

This print was very possibly never used as intended. It is very lightly bitten and makes a most unsatisfactory impression. Furthermore, no early proofs of it are known. Carl Edelheim, a famous book collector in his own right, was Newton's father-in-law. The text in the plate reads: "An / Evening Smoke / Tuesday May 23, 1893 / 2115 Sansom St. / Mr. Newton requests / the honor of your company / To meet / Mr. Carl Edelheim / an early reply is requested."

only state

only state

57. GOLDEN THOUGHTS FROM RUSKIN
1893. Estimate, based on the style of drawing and signature in the plate (double-decker).
A. Edward Newton commission.
Etching. 124 x 123 mm. (5 x 5 inches) platemark.
Only state: Ph (Peters printing).
No edition. Printing unknown.
Plate probably destroyed.
Probably no tissue.

The style of the design and signature seems to put this plate well up into 1893. This is contradicted, however, by a May 24, 1892, payment of $10 from Newton for a "Ruskin Title" (Sloan file, Mod). The probability is that the item mentioned in the records represents a different piece of work, either an undiscovered etching or a drawing for photomechanical reproduction.

The only known example of this print is the title to a four-page folded pamphlet, measuring 6½ x 6¼ inches.

only state

58. THE WISDOM OF FRANKLIN
1893. Estimate.
A. Edward Newton commission.
Etching. 77 x 200 mm. (3 x 8 inches) platemark.
Only state. Ph, Bryan, Tweney (all Peters printing).
No edition. Printing unknown.
Plate probably destroyed.
Probably no tissue. A newspaper illustration of the printing press is in the files at JST, from which Sloan presumably made his copy. The original Franklin press is now in SI.

This print was first illustrated and discussed by Kirke Bryan in his booklet *Three Philadelphians* (Norristown, Pa., Christmas 1956).

The complete publication is a thirteen-page, ribbon-tied pamphlet, measuring 4 x 9 inches, with the etching trimmed close to the platemark and pasted on the front cover.

only state

59. THE WISDOM OF SHAKESPEARE
1893. Estimate.
A. Edward Newton commission.
Etching. 80 x 199 mm. (3 x 8 inches) platemark.
Only state. Ph, NYPL (both Peters printing).
No edition. Printing unknown.
Plate probably destroyed.
Probably no tissue.

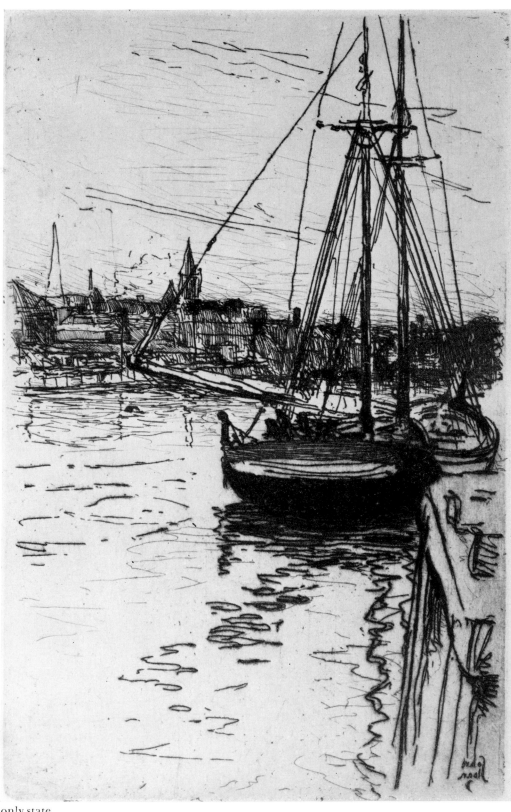

only state

60. SCHUYLKILL RIVER

1894. JS records.

Etching. 210 x 133 mm. (8¼ x 5¼ inches) plate.

Only state. There does not appear to be any distinctive difference between early and late proofs. (A maculature proof is in Ph.)

Edition: 100. Printing: 25. Platt 25.

Plate exists: JST. Copper.

No tissue.

"One of my few plates that looks like an etching from the connoisseur's point of view. It might be that had I pursued the direction here suggested my etchings might have become quite popular. This plate was made with William Glackens beside me, absorbing his first and only lesson in etching" (Dart 29). "I went out and drew directly from nature on the waxed plate, then came back to the studio to do the biting" (JS 1945). Glackens' etching, done at the same time, is now in SI, in a peculiar relief-printed proof. See Sloan's "Autobiographical Notes," p. 383.

61. SPEISEKARTE

1895. In plate.

Alternative title: *Invitation to a Party at 806 Walnut Street.*

Etching. 95 x 69 mm. (3¾ by 2¾ inches) plate.

States:

1. No shading on cat. Ph, JST–8.
2. Body and legs of cat covered with vertical shading. Ph, WSFA, SI.

All known early proofs of this print are in the 1st state. Yet the shading on the cat that is now found on the plate does not appear in any way accidental.

No edition. Printing. Early: unknown. Late: Harris 3.

Plate exists: JST. Copper.

Probably no tissue.

second state, reduced

only state, reduced

62. GIRL READING IN BED

1895. JS records.

Drypoint. 126 x 176 mm. (5 x 7 inches) plate.

Only state. Ph–2, JST, WSFA, SI. One each in Fh and JST are early proofs.

No edition. Printing. Early: unknown. Late: Harris 3.

Plate exists: JST. Copper.

Probably no tissue.

Sloan made 53 etchings to illustrate a series of *The Novels, Tales, Vaudevilles, Reminiscences and Life* of Charles Paul de Kock (1794–1871), published by the Frederick J. Quinby Co. of Boston. Quinby first appears as a publisher in the 1899 Boston city directory and continues to be listed until 1904. From 1905 to 1909 the company bearing his name is found in the city directory, but not the man himself. In 1910 the company, too, has disappeared. The De Kock volumes are the only books ever known to have appeared under the Quinby imprint. They were intended as a more or less elaborate limited-edition production—a type of publication not uncommon at the time—sold by subscription only.

William Glackens was approached in 1902 to do illustrations for this De Kock series. Through his friend's recommendation, Sloan received his first commission for the work. "I am working on etchings which through Glackens' kind word I have had a chance to do for an edition de more than luxe of the works of Paul de Kock, French comedy novelist," Sloan wrote to Robert Henri in early August 1902 (JST). "I hope that if these suit the publisher (who has never seen my work) more will follow." Henri's response was full of enthusiasm: "Glack is making wonderful drawings for that lux de lux lux lux and he tells me that your stuff has met with great favor" (Aug. 14, 1902, JST). Two months later, Sloan had completed the first four etchings, very probably nos. 63, 64, 66, and 68. "I have made four of them and may get more" (JS to Henri, Oct. 11, 1902, JST). Henri replied with praise: "Saw Glack on Saturday. He said the limit about your etchings. Said he would talk to the people and thought he could succeed in making them have the work done by your man [i.e. the printing done by the Peters brothers]. I also showed the etchings to Davies [Arthur B.] . . . He said 'nothing better has ever been done'" (Henri to JS, Oct. 22, 1902, JST).

Sloan did indeed receive further commissions, doing nine more etchings in the next seven months, in addition to five drawings for the De Kock books. His fee was $85 for each pictorial etching and $25 for each of the etched portraits in color. His records, kept in a small packet of Bristol board samples (JST), do not show any payments by the Quinby Co. during the first half of 1903. By July 2 Sloan was owed $585 for his work. "No etchings are now being made by me for Quinby and Company as they now owe me nearly $600 and won't settle. . . . It is too bad for I enjoyed doing the work, and had hoped there would be plenty of it for the next year" (JS to Henri, late Aug. 1903, JST). Henri continued his encouragement: "You cut out a place way up top in that work" (Henri to JS, Sept. 5, 1903, JST). A detailed review of the first eight volumes in the New York *Evening Sun*, April 25, 1903, included special praise for Sloan's etchings.

In October Sloan noted: "My lawyers have secured a full claim on Quinby and Company" (JS to Henri, JST). He immediately began work again, completing the two copies from photographs (83, 84) by October 7 (at a special price of $75 for the pair; JS records). Henri was pleased and observed: "Hear that Quinby's have settled up pretty much all around and that the thing is on the move again" (Henri to JS, Oct. 12 and 24, 1903, JST). This time Sloan had a written contract, dated November 3, 1903 (JST), which committed the Quinby Co. to pay him at least $200 a month for his illustrating work. The total amount owed him was not to exceed $600 at any time. The contract did not specify his fees, which must have been agreed upon orally. By November 20 he had completed the three etchings for *Jean* (85–87) at the old rate. He was then, for the first time, given entire novels to illustrate (at a flat rate of $350 per volume). The first volume of

André the Savoyard was done by the end of 1903. (The second volume was delayed and the order of etchings changed somewhat in the published books.)

The first part of 1904 was busy and productive for Sloan and evidently also for the Quinby Co. The latter was quite faithful in monthly payments of $200 through June 1904. Sloan completed thirteen etchings (88–96, 99–101, 103) during these six months. During the same period he also made his permanent move to New York City. On April 16, 1904, already in New York, he wrote to Dolly in Philadelphia, detailing arrangements for moving their belongings (JST). A note in the Philadelphia *Inquirer*, April 24, 1904, confirms the moving date. In the same letter he noted: "I have put in my time working on the plates for *Adhémar*." By June 14 he was well established in New York and still hard at work. In a letter to Dolly that day, he mentions receiving both the commission for the large portrait of De Kock (104) and the manuscript of *The Flower Girl* (JST).

About this time, however, the entire project was doomed by the courts. Sloan recalled: "When about thirty volumes were off the press, a court ruling was issued which released buyers of the whole set from their contracts. . . . This broke the limited edition business. Quinby went bankrupt and we artists had a lot of trouble collecting" (JS 1950, p. 131; see also "Autobiographical Notes," p. 383). A payment of $150 in August 1904 was apparently enough to encourage Sloan to complete the etchings for *The Flower Girl* (105–114), but by September 1 he was owed over $1,000. Additional small payments in September and November brought forth the *Cherami* illustrations (116–124), completed on January 18, 1905. But that was the end. Only a week later, William Glackens outlined his own similar problems: "I got a letter from the Quinbys this morning. . . . I am to see them tomorrow and arrange for getting my money on the installment plan I guess" (letter quoted by Ira Glackens, in *William Glackens*, New York, 1957, p. 62).

The Quinby Co. was clearly making a strong effort to pay its obligations. Sloan received $200 payments in January and March 1905. On May 13, 1905, he noted in a letter to Dolly, "It makes me feel quite jealous to hear of Peters' getting his money from Chapman, but I'm glad for his sake" (JST). (H. L. Chatman, formerly a dry goods commission merchant, was president of the Quinby Co. at this time.) Glackens was paid in full in early July (Glackens, p. 63), and Sloan laconically noted "Settled" at the end of his records on the De Kock series.

The publication of the volumes with his etchings continued through 1905, though he was not kept advised of progress on them. "Suppose you drop around and see Peters," he wrote Dolly in Philadelphia on July 27, 1905, "and find out how things stand, whether he is printing the *Cherami* plates or has heard of them at all." But the next day, there was better news: "This morning I was wakened by the express man, who had a package of proofs from Peters—the *Flower Girl* plates in the India and parchment editions. I am to sign them and send them to Boston" (JST). (These proofs were clearly destined for the "Romainville" and "Bibliomaniac" editions respectively. *The Flower Girl*, however, does not appear in any of the known listings of the published volumes in those two editions.)

Once he had been paid, Sloan was interested in doing more work on the De Kock series. On January 25 and again on July 9, 1906, he wrote, offering to do more at a reduced rate of $250 a volume, but he received no constructive answer (*NYS*, pp. 9, 46). On May 30, 1907, he commented in his diary that the C. J. Brainard Co. of New York had succeeded the Quinby Co. (*NYS*,

p. 132). As a last parenthetical note he mentioned Frederick J. Quinby in December 1908 as a real estate promotor (*NYS*, p. 268). There is no indication that Quinby ever "went out of his mind," as has been stated (Glackens, p. 39).

Of the planned 50 volumes in the De Kock series (100 volumes, same text, for the "Bibliomaniac" edition), 42 were ultimately published. There is no evidence to indicate that there were any more than this. The following table gives the titles of the entire series. The Library of Congress received as copyright deposits all 42 volumes of the "Saint Gervais" edition and the first 25 of the "Universal." The volume numbers are those used in the LC card catalog and those of most other libraries. They are not in the books themselves. The dates are those on which the "Saint Gervais" volumes arrived in LC. These are usually several weeks after the original copyright entries and generally a month or more prior to the receipt of the corresponding "Universal" volumes. They are also in close agreement with the dates on which Sloan recorded receiving his own "Saint Gervais" copies. The artists who did original etchings for each volume are noted, as well as the number of etchings. Other illustrations were included in each volume, by various artists, done by photomechanical processes, primarily screenless photogravure (see p. 14) and line engraving. (Incidentally, in *Barber of Paris I*, "Saint Gervais" edition, there is a most deceptive illustration—a hand-drawn pen-and-ink copy of a drawing by Sloan, not an original Sloan drawing.) Any question about identification of original drawings should be referred to the Delaware Art Center, where archives of the John Sloan Trust are kept on deposit.

Vol.	Title	Date Received	Etchers
1.	*Sister Anne I*	Nov. 17, 1902	Jacques Reich (1), Sidney L. Smith (1)
2.	*Sister Anne II*	Dec. 1, 1902	none
3.	*Monsieur Dupont I*	Jan. 3, 1903	John Sloan (1)
4.	*Monsieur Dupont II*	Jan. 12, 1903	John Sloan (2)
5.	*Frère Jacques I*	March 4, 1903	John Sloan (1)
6.	*Frère Jacques II*	March 4, 1903	John Sloan (3)
7.	*Barber of Paris I*	April 6, 1903	M. H. Sterne (1), Charles H. White (1)—not Sloan's printer
8.	*Barber of Paris II*	April 13, 1903	M. H. Sterne (1), Charles H. White (1)
9.	*Child of My Wife*	May 27, 1903	Charles H. White (2)
10.	*Gogo Family I*	Aug. 19, 1903	John Sloan (4)
11.	*Gogo Family II*	Oct. 21, 1903	Louis Meynell (1), John Sloan (2)
12.	*Memoirs*	Oct. 31, 1903	G. W. H. Ritchie (1), John Sloan (2)
13.	*My Neighbor Raymond I*	Nov. 20, 1903	Louis Meynell (2)
14.	*My Neighbor Raymond II*	Dec. 17, 1903	Louis Meynell (1)
15.	*Damsel of the Three Skirts*	Jan. 2, 1904	Louis Meynell (1)
16.	*Jean I*	Jan. 18, 1904	William Glackens (2)
17.	*Jean II*	Feb. 1, 1904	John Sloan (3)
18.	*Friquette*	Feb. 29, 1904	Louis Meynell (3)
19.	*Scenes of Parisian Life*	Feb. 29, 1904	William Glackens (6)
20.	*Edmond and His Cousin*	May 24, 1904	William Glackens (3)
21.	*Madame Pantalon*	April 9, 1904	John Sloan (4)
22.	*Gustave I*	April 30, 1904	George B. Luks (2)
23.	*Gustave II, etc.*	May 24, 1904	George B. Luks (1)
24.	*Adhémar*	June 30, 1904	John Sloan (5)
25.	*Little Lise*	Aug. 25, 1904	William Glackens (3)
26.	*André the Savoyard I*	Jan. 31, 1905	John Sloan (3)
27.	*André the Savoyard II*	Feb. 8, 1905	John Sloan (4)
28.	*The Flower Girl I*	Aug. 7, 1905	John Sloan (5)
29.	*The Flower Girl II*	Aug. 7, 1905	John Sloan (5)
30.	*Milkmaid of Montfermeil I*	Nov. 11, 1908	none
31.	*Milkmaid of Montfermeil II*	Nov. 11, 1908	none
32.	*Cherami I*	Dec. 13, 1905	John Sloan (4)
33.	*Cherami II*	Dec. 13, 1905	John Sloan (5)
34.	*Mustache I*	June 2, 1906	W. S. Potts (2)
35.	*Mustache II*	June 2, 1906	W. S. Potts (2)
36.	*A Queer Legacy*	May 27, 1907	none
37.	*Frédérique I*	May 27, 1907	none
38.	*Frédérique II*	Sept. 28, 1907	none
39.	*Sans-Cravate I*	Dec. 30, 1908	none
40.	never published		
41.	*Paul and His Dog I*	Feb. 19, 1909	none
42.	*Paul and His Dog II*	June 26, 1909	none
43.	*Cerisette I*	Sept. 1, 1909	none
44-50.	never published		

Of the total of 91 etchings in the series, Sloan did 53, more than half. Glackens did 14, and the other 25 are scattered. "Artist's proofs" appear to have been made of some prints with remarques, for the artist's own use. These are generally the proofs illustrated in this catalogue. A number of them are on *chine appliqué* or "India paper," as it was commonly known. Occasionally, Sloan has penciled extra remarques on such proofs (JST), perhaps for friends. He appears to have gotten his basic information on the contemporary usage and terminology regarding remarques, proofs on different papers, and various "editions" of a print from a booklet by C. Klackner, *Proofs and Prints* (New York, 1886, pp. 8-12). A copy of this publication was in Sloan's early files. Other pages of it were unopened. The etched plates for this series were undoubtedly steel-faced, for the impressions show little wear in the course of printing.

For convenience's sake, the De Kock prints are listed in this catalogue in the order in which they appear in each volume and in the order of the volumes, given above. The following is the best estimate of the actual chronological order, taken from dated proofs and Sloan's records: 63, 64, 66, 68, 65, 67, 69, 71, 73, 72, 74, 76, 75, 83, 84, 85, 86, 87, 98, 102, 97, 99, 90, 88, 89, 91, 93, 92, 96, 95, 94, 100, 101, 103, (104), 111, 107, 108, 113, 105, 106, 110, 112, 114, 109, 119, 116, 118, 120, 123, 124, 117, 121, 122. The date given in the copyright line of each print does not always agree with the actual year date of the print—differences are noted here—nor does either necessarily coincide with the actual copyright date of the volume.

It is possible that there are more states of some of these subjects (67 and 73, for instance) than are given here. Sloan may have used a few as gifts, and others may have appeared only in the "Bibliomaniac" and "Romainville" edition volumes which have not been seen.

Twelve different limited "editions" of the De Kock series are known to have been published by the Quinby Co. "Edition" is not meant here to indicate priority of publication, about which there is little information. Rather, they are different formats of publication, comprising the same text set in the same type, with differences in the number and quality of prints, the bindings, papers, and stated limitations, as listed below. Each edition has a special name, which usually appears only on the spine of the bound book, not on the title page. Each is in octavo volumes, uniformly bound. Paper sheet sizes are either

large (ca. 225 x 152 mm., 9 x 6 inches) or small (ca. 210 x 140 mm., 8¼ x 5½ inches). All editions appear to have top edges gilt and untrimmed edges at side and bottom. Locations are given here only for complete editions or long runs, with the etchings included. Individual etchings have frequently been detached from the books. Examples of all editions but the "Romainville" have been studied, and auction records have been found for all twelve. Only the principal differences useful for identification and those specifically affecting the etchings are given here. These are not complete bibliographical descriptions.

Only 2 of the 12 editions are known in sets containing all 53 of Sloan's etchings: the "Saint Martin" and the "Memorial." The "Saint Gervais" edition has 52, all but no. 76.

The 6 editions with a limit of 1,000 resemble each other very closely. They each have only a short list of Sloan's etchings, 28 out of the 53, as follows: 63, 65, 66, 68, 69, 71, 75, 83, 84, 87, 89, 91, 92, 96, 97, 100, 101, 103, 105, 107, 108, 110, 111, 113, 114, 116, 120, 122. In these 6 editions the first 25 volumes appear to be much more common than the later ones. The proofs in them are wiped very cleanly and coldly, "cardwiped," and are less attractive than those in the "Saint Martin," "Memorial," and "Saint Gervais" sets. The Peters brothers of Philadelphia, Sloan's printers, are believed to have printed all the etchings for all editions, of whatever quality.

There is no direct evidence concerning the quantity of printing done. The edition limitations stated in each set are of some inferential help. They appear in every known volume, in this or a similar form: "Limited to [five hundred] numbered and registered sets of which this is number _____." There are indications that these limits were honestly observed by the Quinby Co. Examples of 57 individually numbered sets have been noted, as well as 11 unnumbered sets. (In another 38 known instances, the numbering is unknown.) It is perhaps significant that of the 14 cases of known numbers in 500-or-less editions—presuming numbering to have been consecutive, starting with 1—only one is a number larger than half the edition limit. This suggests that only half or less of the more elaborate limited editions was ever printed. It seems safe to postulate a total edition of 500 (250 for no. 76) for those prints which appear only in these editions.

Of the editions with a stated limit of 1,000, 43 numbered sets have been discovered, plus 10 unnumbered. Among these 43 (numbers evenly spread between no. 25 and no. 986) no duplicate numbers appear. It is presumed that the limitation of 1,000 applied to the *total* of all 6 editions, not to each edition separately. Two duplications in number do occur between sets in the first class (500 or less) and sets in the second (1,000's). The edition total of the etchings which appear in both classes, therefore, might be as high as 1,500. It should be stressed that these figures are only estimates, made because of the lack of hard evidence, particularly any records of the Frederick J. Quinby Co.

"Bibliomaniac" Edition

49 volumes known, listed below, of a planned 100.

29 Sloan etchings in the known volumes, with remarques where applicable, signed by the artist in pencil. The printing quality is rather poor. Etchings, in general, do not print well on vellum.

Binding of full red crushed morocco, elaborately decorated with onlaid variegated flowers, contained in a similarly covered Solander box with brass clasps. (Also known in "full green morocco.")

Printed entirely on vellum, large size.

Stated limitation: 10.

Locations: Brown University has 6 volumes of set no. 4 (*Monsieur Dupont I–IV, Jean II,* and *Scenes of Parisian Life II*). Dartmouth College has one volume of the same set no. 4 (*Jean IV*). WSFA has one of set no. 6 (*Gogo Family V*).

A different set has appeared twice at auction: at Stan V. Henkels, Philadelphia, March 27, 1918, lot 39, and again at Parke-Bernet Galleries, New York, December 12, 1949, lot 90. It consisted of 49 volumes, was set no. 3, bound in green, and was believed in both instances to be unique, which it clearly is not. It has not been possible to examine this set, which is in a private collection at present.

Another set appeared at the Anderson Auction Co., New York, March 14, 1922, lot 113. Its number in the edition of 10 was not given. It was bound in red and consisted of 44 volumes, all those listed below except *Sister Anne* in 4 volumes and *Gustave II*. Its present location is unknown.

The original subscription price for this edition was $500 per volume, or a planned $50,000 for the entire set, a price never approached at auction.

The 49 listed volumes are: *Sister Anne* (4), *Monsieur Dupont* (4), *Frère Jacques* (4), *Barber of Paris* (4), *Child of My Wife* (2), *Gogo Family* (5), *Memoirs* (2), *My Neighbor Raymond* (3), *Damsel of the Three Skirts* (2), *Jean* (4), *Friquette* (2), *Scenes of Parisian Life* (2), *Edmond and His Cousin* (2), *Madame Pantalon* (2), *Gustave II* (1), *André the Savoyard* (4), and *A Queer Legacy* (2).

"Romainville" Edition

No example of this edition has been seen to date. The following information is taken from the records of three auction sales: Anderson Galleries, New York, January 24, 1923, lot 672, a single volume; American Art Association, New York, January 22, 1924, lot 235, a set of 25 volumes, letter E; and Anderson Galleries, New York, December 16, 1926, lot 133, a set of 26 volumes, letter P.

26 volumes known. The 1924 catalogue lists the following 25 volumes in the series: 1–14, 16–21, 26–27, 36–38, which contain a total of 29 Sloan etchings. The 1926 description does not list its 26 volumes by title, but does mention "a series of 30 etchings by John Sloan." The 1924 entry describes the etchings as being in "two states: one on plain paper and the other on India paper signed in pencils by the artist." The two states are probably with and without remarque.

Binding of crushed blue (or "red" or "green") levant morocco, with onlaid colored flowers, made by the Harcourt Bindery.

Paper specifications unknown, except as noted.

Stated limitation: 26, lettered A–Z.

No volumes located.

"Saint Martin" Edition

42 volumes.

53 Sloan etchings (complete), good quality printing.

Binding of full green morocco (also "crimson" or "blue"), with onlaid flowers in colors, three raised bands on spine, by Harcourt Bindery.

Paper: large size, cream wove, watermarked "St. Martin" in script and "LIMITED 100 SETS" in small capitals (also described with watermark "Ch. Paul de Kock.")

Stated limitation: 100.

No complete set located.

"Memorial" Edition

42 volumes.

53 Sloan etchings (complete), good quality printing.

Binding of half green morocco (also "full" or "three-quarter," and "brown" or "red" or "orange") and marbled paper, three raised bands on spine, made by Monastery Hill Bindery.

Paper: large size, cream wove, watermarked "LIMITED 250 SETS / Ch. Paul de Kock / Memorial," the latter two in script.

Stated limitation: 250.

Western Reserve University (42), Brown University (25), University of Washington (25).

"Saint Gervais" Edition

42 volumes.

52 Sloan etchings (lacking no. 76), good quality printing.

Binding of rough red ("buckram") cloth (also "half calf," or "half red crushed French levant morocco" or "full green morocco"), paper label on spine.

Paper: large size, cream wove, watermarked "Van Gelder" in script and "ST. GERVAIS LIMITED 500 SETS" in small capitals.

Stated limitation: 500.

LC (42), Boston Public Library (42), WSFA (33), University of Pittsburgh (25).

"Versailles" Edition

25 volumes (stated limit).

14 Sloan etchings, short list, some hand-colored (not by the artists), card-wiped printing, not attractive.

Binding of full red pigskin (also "full green"), raised bands on spine.

Paper: small size, cream wove, watermarked "Old Stratford" in script.

Stated limitation: 100.

No complete set located.

"Gregory" Edition

42 volumes.

Sloan etchings: short list, card-wiped printing.

Binding of green ribbed cloth.

Paper: small size, cream wove, watermarked "Old Stratford" in script.

Stated limitation: 1,000.

University of Oklahoma (42), Brooklyn Public Library (25), Columbia University (25), University of Virginia (25).

"Medal" Edition

41 volumes known.

Sloan etchings: short list, card-wiped printing.

Binding of ribbed green cloth.

Paper: small size, cream wove.

Stated limitation: 1,000.

Los Angeles Public Library (40), Cornell University (25), Tulane University (25), University of Colorado (25). American Art Association (Feb. 11, 1929, lot 214) records 41 volumes.

Saint Louis Exposition" Edition

42 volumes.

Sloan etchings: short list, card-wiped printing.

Binding of half brown morocco (also "green" or "red") and marbled paper.

Paper: small size, cream wove, watermarked "Old Stratford" in script.

Stated limitation: 1,000.

University of Nebraska (42), University of Pennsylvania (21).

"Universal" Edition

41 volumes known.

Sloan etchings: short list, card-wiped printing.

Binding of ribbed green cloth.

Paper: small size, cream wove, watermarked "Old Stratford" in script.

Stated limitation: 1,000.

University of Oregon (33, including later volumes), LC (25), NYPL (25), Brooklyn Public Library (25), University of Iowa (25), University of Michigan (25), University of Washington (25), Stanford University (24).

"Artists'" Edition

25 volumes known.

Sloan etchings, short list, card-wiped printing.

Binding of smooth red cloth, paper label on spine.

Paper: small size, cream wove, watermarked "1886 / S C° / EXETER."

Stated limitation: 1,000.

FLP (25), Duke University (25), University of Oregon (25), Yale University (17).

"Authors'" Edition

40 volumes known.

Sloan etchings: short list, card-wiped printing.

Binding of smooth red cloth, paper label on spine.

Paper: small size, cream wove, watermarked "Old Stratford" in script.

Stated limitation: 1,000.

Denver Public Library (40 in one set, 25 in another), University of Kansas (25), University of Virginia (two sets of 25 each), Buffalo Public Library (set of 25, mixed "Artists'" and "Authors'").

A source of some slight confusion is a set of 20 volumes, *The Masterpieces of Charles Paul de Kock*, issued by George Barrie & Son of Philadelphia, evidently in 1904, in a limited edition of 1,000. All the illustrations (none of which are by Sloan) appear to be photogravures. Sloan did recall using volumes from this series to read in preparation for his own illustrations. *The Flower Girl* and *Cherami* are the only two of his titles to be included in the Barrie set.

A promotional leaflet (JST, SI) put out by the Quinby Co. for the World's Fair in St. Louis, 1904, mentions two other possible "editions," of which no hard evidence has been discovered. One planned as a unique and ultraelaborate set, to be called the "King Rene copy," was to be sold for $200,000. It was to be made in a workshop at the Fair itself, but very likely was never done. (An uninformative article in the St. Louis *Star*, August 14, 1904, may refer to this set.) Also mentioned, along with the inexpensive "Gregory" and "Universal" editions, was a "Library" edition, said to be identical to the latter, except for a half-leather binding. This is probably the "Saint Louis Exposition" edition listed here. The price given for the "Gregory" and "Universal" sets was $2 per volume, and $4 each for the half-leather volumes. The subscription price of Sloan's own set of the "Saint Gervais" was $7.50 each (JS records), which, as Sloan commented, was undoubtedly the best bargain of all these De Kock editions.

fourth state

63. THE ROW AT THE PICNIC

1902. Done before October 11, 1902 (see letter from JS to Henri, p. 64).

De Kock series, *Monsieur Dupont*, vol. 1.

Caption: "Poor Bidois, who had been drawn into the midst of the tumult, . . . received upon his nose the blow intended for the toymaker."

Etching. 150 x 110 mm. (6 x 4 inches) platemark; 124 x 90 mm. (5 x 3½ inches) picture.

States:

1. Face of woman at right center is blank. JST–2 (one with pen).

2. Woman's face completed and strongly shaded, with a line under her left eye. Additional shading throughout. Remarque added at lower left. JST–2.

3. Woman's face burnished lighter; line removed from beneath left eye. JST.

4. Copyright line added at top. JST–2, WSFA, LC, Brown University ("Bibliomaniac").

5. Remarque removed. Regular published state.

Edition: 1,000. Printing by Peters. Quantity unknown.

Plate probably destroyed.

Tissue unknown.

Copyright 1902 by The Frederick J. Quimby Company

third state

64. THE SERENADE

1902. Done before October 11, 1902 (see letter from JS to Henri, p. 64).

De Kock series, *Monsieur Dupont,* vol. 2.

Caption: "The violin mounted the counter, the hunting-horn seated himself upon the loaves of sugar, the clarinet upon a keg of glue, and the fife upon a barrel of molasses."

Etching. 151 x 110 mm. (6 x 4 inches) platemark; 123 x 89 mm. (5 x 3½ inches) picture.

States:

1. Lightly drawn. JST.
2. Design filled out with much additional shading, including back wall, ceiling, and drum. Remarque added at lower left, showing a girl in bed, lightly drawn, in full profile, with her left hand in her lap. JST–2 (one with pen).
3. Additional light shading on nightcap of man standing at left. Copyright line added at top. JST–8, LC, Brown University ("Bibliomaniac").
4. Remarque removed and completely redrawn, showing a girl in bed in a similar pose, now with her left hand at her neck and face slightly turned toward the front. JST–10, WSFA, NYPL, Met.
5. Remarque removed. Regular published state.

Edition: 500. Printing by Peters. Quantity unknown.

Plate probably destroyed.

Tissue: JST.

69

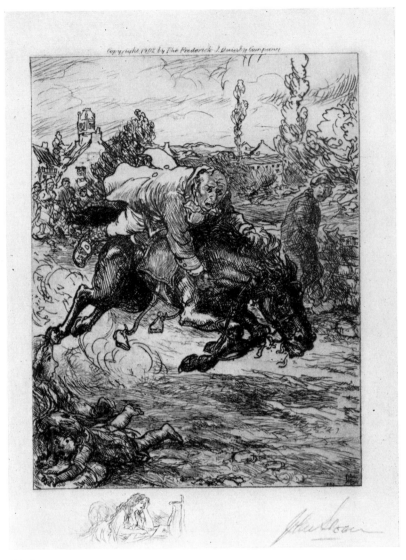

third state

65. DUPONT'S RIDE

1902. Proof of 3rd state dated December 12, 1902. Collection of E. I. duPont.

De Kock series, *Monsieur Dupont,* vol. 2.

Caption: "In vain did Dupont shout, 'Stop! Stop!' "

Etching. 146 x 106 mm. (6 x 4 inches) platemark; 122 x 89 mm. (5 x 3½ inches) picture.

States:

1. Lightly drawn. Woman in profile at lower left has a long thin nose and wide open mouth. JST–2 (one with pencil).
2. Woman's nose shortened; mouth less wide. Additional shading on rider's face, in foreground, and elsewhere. JST–2 (one with pencil).
3. Heavy shading added on side of woman's face. Remarque added at lower left. Copyright line added at top. Ph, JST–6, WSFA, LC, NYPL, Met, Brown University ("Bibliomaniac"), E. I. duPont.
4. Remarque removed. Regular published state.

Edition: 1,000. Printing by Peters. Quantity unknown.

Plate probably destroyed.

Tissue: JST.

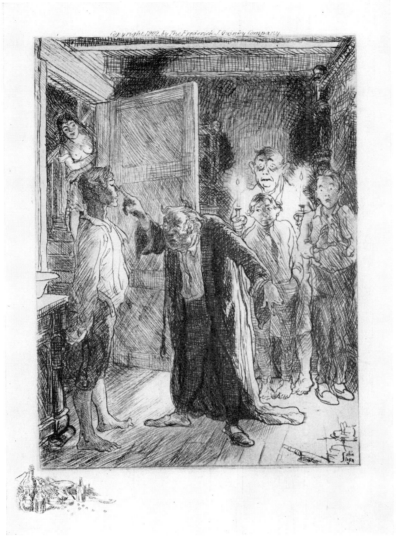

third state

66. SLEEP WALKER AND HYPNOTIST

1902. Proof of 3rd state dated September 19, 1902. JST.
De Kock series, *Frère Jacques,* vol. 1.
Caption: "He passed his hand several times before my face and put his index finger to the end of my nose."
Etching. 146 x 105 mm. (6 x 4 inches) platemark; 122 x 89 mm. (5 x 3½ inches) picture.
States:

1. Lightly drawn. Trousers of sleepwalking boy and hypnotist are both lightly shaded. Boy's face is unshaded. JST–2 (one with pencil).
2. Heavy shading on boy's trousers. Hypnotist's face burnished lighter. Additional shading on floor between boy and door, on the door, and on right shoulder of girl on stairs.

JST–4 (one with pencil).

3. Heavy shading added on trousers and face of hypnotist. Additional shading on back wall above spectators, on door, and elsewhere. The boy's face is shaded. His trouser straps remain light. Remarque added at lower left. Copyright line added at top. JST–2 (one inscribed "2nd state").
4. Boy's trouser straps darkened. Hypnotist's "horns" darkened. Added shading just above signature at lower right. JST–2, WSFA.
5. Remarque removed. Regular published state.

Edition: 1,000. Printing by Peters. Quantity unknown.
Plate probably destroyed.
Tissue: JST.

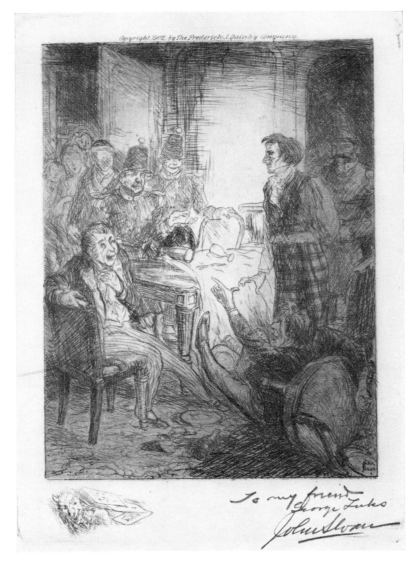

first state

67. THE ARREST
1903. In plate. Proof of 1st state dated January 1903. JST. (Copyright line reads 1902.)
De Kock series, *Frère Jacques,* vol. 2.
Caption: "Some gendarmes and a police officer came into the room."
Etching. 148 x 104 mm. (6 x 4 inches) platemark; 123 x 89 mm. (5 x 3½ inches) picture.
States:
 1. Design nearly complete. Remarque at lower left. Copyright line at top. JST–2, WSFA, LC.
 2. Additional diagonal shading on front of gendarme at center rear. Eyebrows, eyes, and mouth of woman directly above seated man at left are strengthened. Slight additional horizontal shading on wall above chair at center. Remarque removed. Regular published state.
Edition: 500. Printing by Peters. Quantity unknown.
Plate probably destroyed.
Tissue: JST.

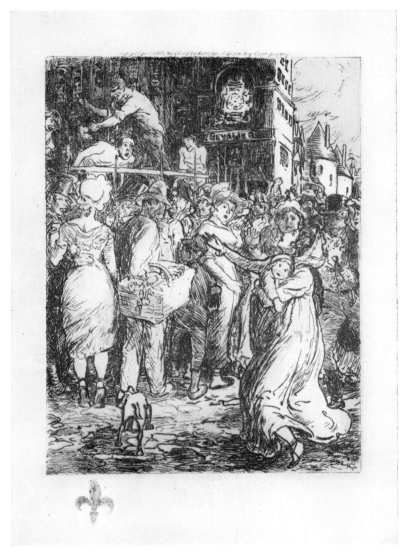

third state

68. THE BRANDING OF EDOUARD

1902. Proof of 2nd state dated September 1902. Met.
De Kock series, *Frère Jacques,* vol. 2.
Caption: "The eyes of the unfortunate man met hers. It was
Edouard; it was her husband."
Etching. 147 x 108 mm. (6 x 4 inches) platemark; 121 x 88 mm.
(5 x 3½ inches) picture.
States:
1. Nearly complete. Heavy shading on shirt of man with lash
 at upper left. Remarque at lower left. Ph, JST–2.
2. Man's shirt lightened. Shading added on face of man with
 basket. Eyes strengthened and shading added on woman's
 face directly above woman at right front. JST, Met.
3. Copyright line added at top. JST, WSFA, LC.
4. Remarque removed. Regular published state.
Edition: 1,000. Printing by Peters. Quantity unknown.
Plate probably destroyed.
Tissue exists: JST. Also a sketch on tissue, slightly different.
JST.

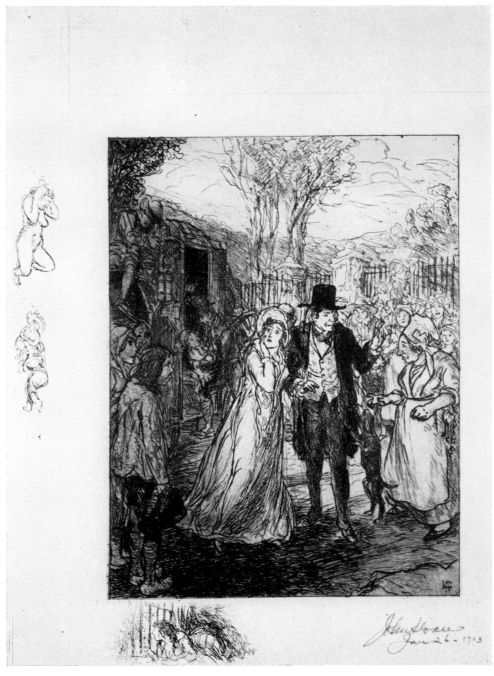

first state

69. MONSIEUR GERVAL RETURNS
1903. Proof of 1st state dated January 26, 1903. JST.
De Kock series, *Frère Jacques,* vol. 2.
Caption: "M. Gerval was obliged to make a sign to the villagers to withdraw themselves."
Alternative title: *Homecoming of Gerval.*
Etching. 148 x 106 mm. (6 x 4 inches) platemark; 121 x 89 mm. (5 x 3½ inches) picture.
States:

1. Nearly complete. Remarque at lower left. Two nudes sketched in margin at left. Weak sketch in margin at top. Platemark measures 174 x 125 mm. (7 x 5 inches). JST–3, LC (trimmed).

2. Plate cut down at top and left, removing sketches. Platemark now measures 148 x 106 mm. (6 x 4 inches). Slight additional shading on faces of man and woman at center. Copyright line added at top. Ph, JST–8, WSFA, Met, LC, Fogg (inscribed "OK John Sloan Feb. 3–1903").

3. Remarque removed. Regular published state.

Edition: 1,000. Printing by Peters. Quantity unknown.

Plate probably destroyed.

Tissue: JST.

70. ROBERT HENRI

1902. Proof dated November 23, 1902 (Robert Chapellier personal collection, New York, from the Henri estate). The annotation is clearly in JS's hand. This proof, evidently given to Henri on the occasion for which the etching was made (JS comment below), is strong evidence for dating this print. In his records, started in the late 1920s, Sloan variously dated it 1904 or 1905, dates that have persisted in subsequent catalogs. He first gave the plate to a printer (Platt) in April 1928. After the lapse of many years he probably supplied the later date erroneously from memory.

Etching. 171 x 114 mm. (6¾ x 4½ inches) plate; 136 x 95 mm. (5½ x 3¾) design.

Only state. Published state. Later impressions show some scratches, notably a short vertical line in the blank area above the head. The so-called "first state" in Ph, marked by HFS after JS's direction, is an early proof, but not a state. The Chapellier proof with date, noted above, is also an early proof by this test.

Edition: 100. Printing: 75. Platt 25, Roth 50.

Plate exists: JST. Copper.

No tissue.

"A sketch plate of my great friend and teacher, the distinguished painter, Robert Henri" (Dart 32). "Drawn directly. He posed for me one evening when he came over from New York for a day or two—on the occasion of his visit to Philadelphia just prior to my removal to New York" (JS 1945).

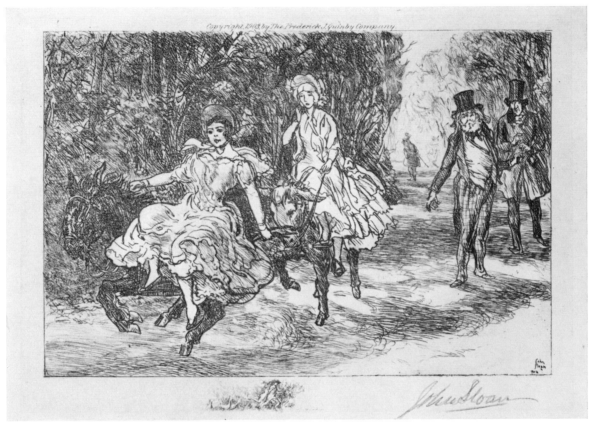

second state

71. THE DONKEY RIDE

1903. Proof of 1st state dated March 23, 1903. JST.

De Kock series, *The Gogo Family,* vol. 1.

Caption: "Her mount decided to take a gallop, and bore off his rider."

Etching. 102 x 148 mm. (4 x 6 inches) platemark; 88 x 132 mm. (3½ x 5 inches) picture.

States:

1. Before shading on ground at lower left. Remarque at bottom center. JST–3 (two with pencil).
2. Shading added at lower left. Horizontal shading added between and to the left of front donkey's ears. Copyright line added at top. WSFA.
3. Remarque removed. Regular published state.

Edition: 1,000. Printing by Peters. Quantity unknown.

Plate probably destroyed.

Tissue: JST.

second state

72. COUSIN BROUILLARD
1903. Delivered to Quinby Co. on April 7, 1903. JS records.
De Kock series, *The Gogo Family*, vol. 1.
Etching. Colors: brown, reddish brown (vest), black (hat, tie,
shoes). 165 x 86 mm. (6½ x 3½ inches) platemark; 153 x 79 mm.
(6 x 3 inches) picture.
States:
1. Design complete. No copyright line. JST–6 (color trials).
2. Copyright line added at top. Regular published state. JST
 has six color trials in this state.
Edition: 500. Printing by Peters. Quantity unknown.
Plate probably destroyed.
Tissue: JST.

The dimensions of the picture area of the De Kock color por-
trait plates give the area on which an ink tone has been left by
the printer. The effect is created by clean rag-wiping at the edge
of the plate. The white areas of the subject are also made by
hand-wiping.

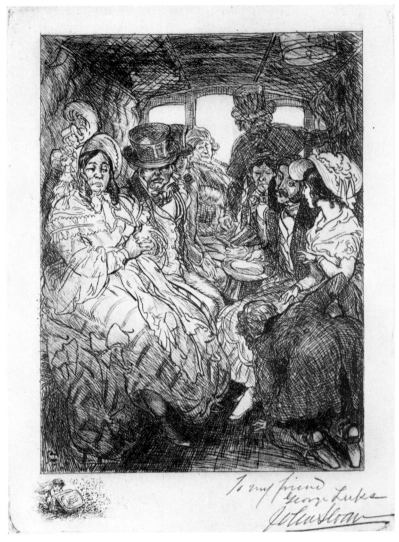

first state

73. THE LOST SNUFF BOX
1903. Proof of 1st state dated March 30, 1903. Fogg.
De Kock series, *The Gogo Family,* vol. 1.
Caption: "Irma, my dearest, move your foot a little."
Etching. 147 x 103 mm. (6 x 4 inches) platemark; 122 x 88 mm.
(5 x 3½ inches) picture.
States:
 1. Beard of man standing at right rear is relatively light. Remarque at lower left. JST, WSFA, Met, Fogg.
 2. Standing man's beard is much darker. Copyright line added at top. Remarque removed. Regular published state.
Edition: 500. Printing by Peters. Quantity unknown.
Plate probably destroyed.
Tissue: JST.

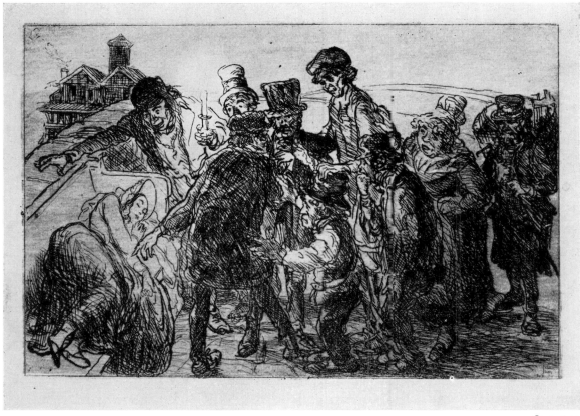

first state

74. THE FINDING OF ROSE MARIE

1903. Proof of 2nd state dated April 8, 1903. JST.
De Kock series, *The Gogo Family*, vol. 1.
Caption: "Ladouille held the candle to her face."
Alternative title: *The Wet Feet Patrons Finding Rose Marie.*
Etching. 104 x 150 mm. (4 x 6 inches) platemark; 89 x 139 mm.
(3½ x 5½ inches) picture.
States:

1. Lightly drawn. Background blank. JST–2.

2. Background dark. Much additional shading, completing the design. JST.

3. Remarque added at lower left. Copyright line added at top. Ph, WSFA, Met.

4. Remarque removed. Regular published state.
Edition: 500. Printing by Peters. Quantity unknown.
Plate probably destroyed.
Tissue: JST.

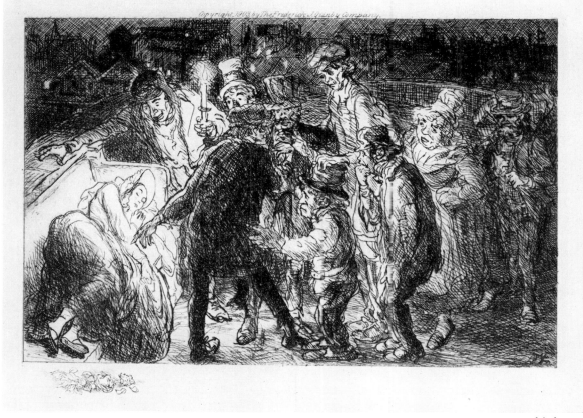

third state

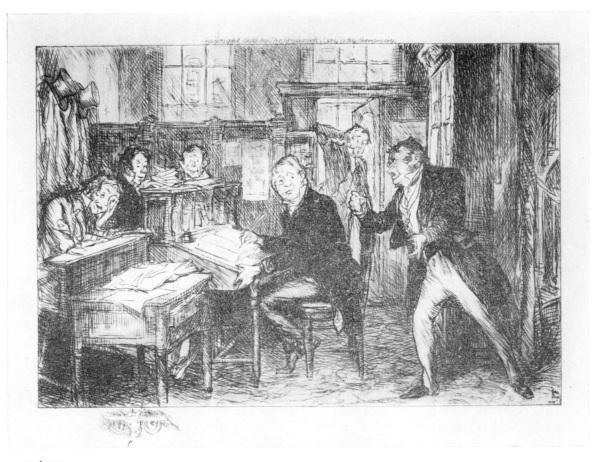

second state

75. THE BANKER OBJECTS TO SAVENAY'S
 WHISTLING

1903. Delivered to Quinby Co. on June 18, 1903. JS records.
De Kock series, *The Gogo Family,* vol. 2.
Caption: "Who is it who dares to sing thus?"
Alternative title: *Saint-Godebert Furious at Papa Savenay.*
Etching. 105 x 147 mm. (4 x 6 inches) platemark; 90 x 134 mm.
(3½ x 5½ inches) picture.
States:
 1. Nearly finished. Remarque at lower left. JST–3 (one with
 pen), WSFA.
 2. Coat and hair darkened on man second from left. Outline
 of head strengthened and coat darkened on man seated at
 center. Face of man at right lightened. Copyright line
 added at top. Ph, WSFA ("Bibliomaniac"), Met.
 3. Remarque removed. Regular published state.
Edition: 1,000. Printing by Peters. Quantity unknown.
Plate probably destroyed.
Tissue: JST.

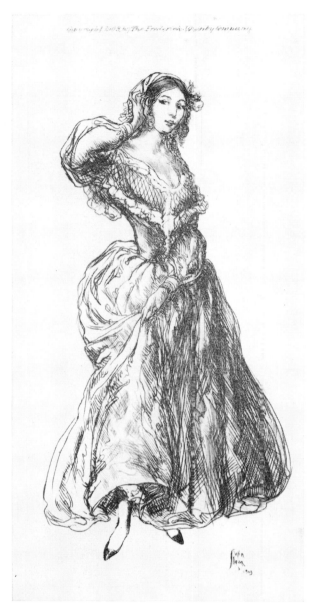

second state

76. MADAME MONDIGO
1903. Delivered to Quinby Co. on June 1, 1903. JS records.
De Kock series, *The Gogo Family*, vol. 2.
Etching. Colors: blue, reddish brown (hair), pink (skin). 159 x 83
mm. (6½ x 3½ inches) platemark; 147 x 70 mm. (6 x 3 inches)
picture.
States:
 1. Design complete. No copyright line. JST–2 (one proof in
 black, one in color).
 2. Copyright line added at top. Regular published state.
Edition: 250. Printing by Peters. Quantity unknown.
Plate probably destroyed.
Tissue: JST.

only state

77. MARIANNA SLOAN EXHIBITION

1903. September 1903 in plate.

Etching. 95 x 69 mm. (3¾ x 2¾ inches) plate.

Only state. JST (early), WSFA, Ph, SI.

No edition. Printing. Early by Peters: unknown. Late: Harris 3.

Plate exists: JST. Copper.

Probably no tissue.

 Sloan made numerous comments about his sister, Marianna, often saying that she had more talent than he himself had (Brooks, p. 36).

 A detailed review of this exhibition appeared in the Philadelphia *Press* (Sept. 27, 1903, sect. 6, pp. 1, 5). It was accompanied by three color reproductions of watercolors and a portrait of Miss Sloan. The reviewer especially praised her "remarkable atmospheric effects, which were so beautifully and subtly rendered."

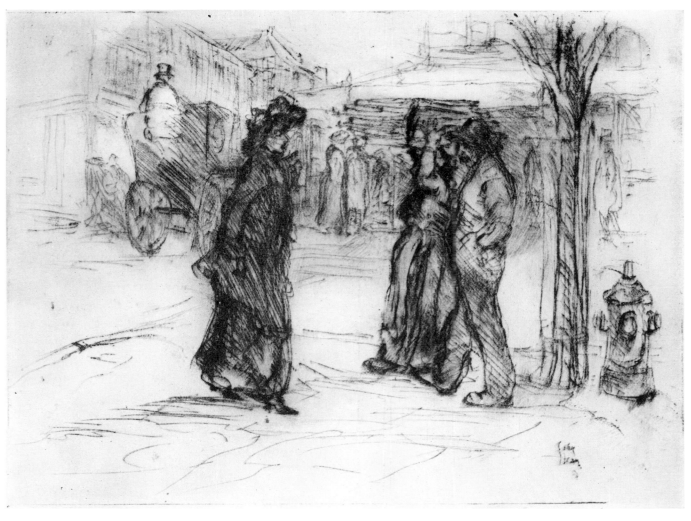

only state

78. STREET SCENE

1903. The only print known, in Ph, is inscribed "c. 1903" by HFS, after the direction of JS.
Drypoint (entirely). 127 x 176 mm. (5 x 7 inches) platemark.
Only state. Ph.
No edition. Printing unknown.
Plate unknown.
Probably no tissue.

There is a possibility that Sloan's memory may have been at fault and that this print actually dates from 1895, instead of 1903. The style, technique, and format are very similar to 62. It is, however, also similar to 79, which was dated 1903 by JS.

It has much the appearance of a monotype. There are, however, a few clear intaglio lines, notably the uninked lines at the upper center. The drypoint work is all very lightly scratched in the plate.

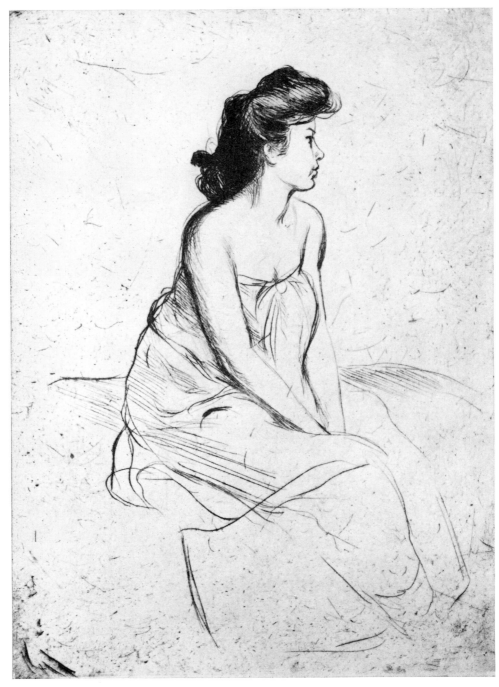

only state

79. GIRL SEATED

1903. JS records.

Drypoint. 177 x 127 mm. (7 x 5 inches) plate.

Only state. Early proofs (Ph, Met) are without the many scratches in the blank background, except for the lines in the lower left corner. Later printings show a great many scratches, as illustrated.

Edition: 100. Printing: 25. Platt 25.

Plate exists: JST. Copper. Steel-faced.

Probably no tissue.

"Is done in drypoint, a medium which has never appealed to me; consequently this is a rather lonely example in my output" (Dart 30). "Timid little thing. Deliberately done in a drypoint style. Some people like it because it has a kind of Japanese influence look. But I can't respect that kind of thing" (JS 1945).

only state

80. DOLLY SEATED BY PIANO (unfinished plate)
1903. Estimate based on the style of clothing.
Etching. 95 x 60 mm. (3¾ x 2¼ inches) plate.
Only state. Ph, WSFA, SI.
No edition. Printing: 3. Harris 3.
Plate exists: JST. Copper. The rejected variant of *Dolly 1929*
(237) is on the verso of this plate.
Probably no tissue. Similar in pose to the painting *Dolly in Wedding Dress* of 1901. Sloan estate.

Anna M. Wall Sloan (1877–1943), universally known as
"Dolly," was married to Sloan in Philadelphia on August 5,
1901. A photograph of 1902 or 1903, now in JST, shows her
seated next to the piano in the studio at 806 Walnut Street, Philadelphia. Her clothing is quite similar to that seen in this print.
There is also a metronome on top of the piano in both the photograph and the etching.

published state

81. C. K. KELLER
1903. In plate.
Etching. 82 x 127 mm. (3¼ x 5 inches) plate.
States.
 1. Eyes light. Hand almost unshaded. Ph–2 (one with pencil).
 2. Eye sockets dark. Hand shaded. Additional shading in hair
 and on left side of face. Published state. Late proofs show
 scratches in the blank background, especially diagonal lines
 above the left arm.
Edition: 100. Printing: 20. Platt 20.

Plate exists: JST. Copper. Steel-faced.
Probably no tissue.

'A friend in the art department of the Philadelphia Press.
This early plate is etched in a manner that shows a trifle too
much delicacy The hand is rather good, but it is very much under the influence of perspective. Etched in a manner that shows
a lingering admiration for some of Whistler's. So timid I can
hardly believe it is my own" (JS 1945).

See also Sloan's "Autobiographical Notes," p. 383.

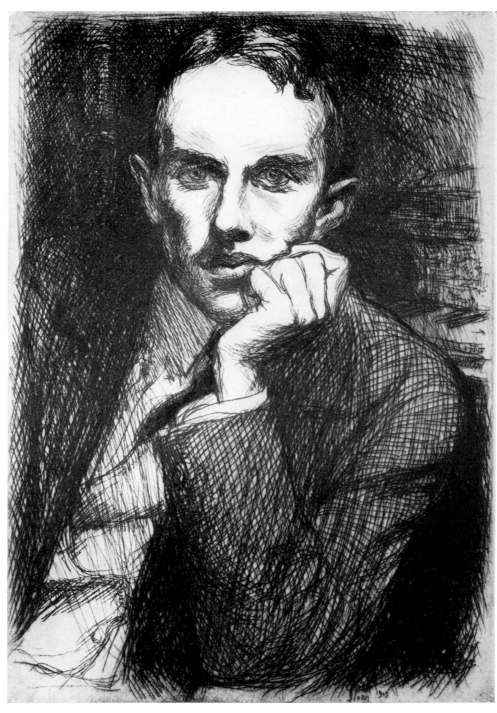

only state

82. WILL BRADNER

1903. In plate. The date in the plate, lower right, is vague and has previously been read 1905. A comment in 1914 by JS (see below) confirms 1903.

Alternative title: *Portrait of a Musician*.

Etching. 184 x 127 mm. (7¼ x 5 inches) plate.

Only state. Published state.

Edition: 100. Printing: 30. Platt 30.

Plate exists: JST. Copper.

Probably no tissue.

 "A violinist friend in Philadelphia. This plate shows growing skill with the medium owing to the fact that I was producing the de Kock etchings at this time. The experience I gained in making over fifty plates during a period of three years did a great deal for my growth and proficiency as an etcher." (Dart 33). "Dear Mr. Quinn:—Plate made in Philadelphia in 1903—I do not think you have this—it is the only proof I have—the plate is tucked away somewhere I suppose. J.S. June 1914" (inscription on proof for John Quinn; now JST). Sloan's inscription on the Bowdoin proof, "Bradner, Musician, Philadelphia 1905," is probably a later addition. Sloan commented that Bradner was a close friend of C. K. Keller (81); see "Autobiographical Notes," p. 383. Sloan's painting of Bradner playing the violin is in the Sloan estate.

second state

83. DE KOCK'S STUDY

1903. Delivered to Quinby Co. on October 7, 1903. JS records.
De Kock series, *Memoirs.*
Caption: "De Kock's study for forty years at 8 Rue Saint-Martin."
Etching. 103 x 149 mm. (4 x 6 inches) platemark; 90 x 139 mm. (3½ x 5½ inches) picture.
States:
1. Design complete. Remarque at lower left. Ph.
2. Copyright line added at top. WSFA, LC, and all "Saint Gervais" and the more elaborate edition impressions.
3. Remarque removed (sometimes incompletely). Regular published state.
Edition: 500 in 2nd state; 1,000 in 3rd state. Printing by Peters. Quantity unknown.
Plate probably destroyed.
Photograph of a wood engraving used as a tissue, showing indentations of tracing: JST.

second state

84. DE KOCK'S HOME
1903. Delivered to Quinby Co. on October 7, 1903. JS records.
De Kock series, *Memoirs*.
Caption: "The 'Lilacs,' his home at Romainville."
Etching. 99 x 147 mm. (4 x 6 inches) platemark; 87 x 138 mm.
(3½ x 5½ inches) picture.
States:
 1. Design complete. Remarque at lower left. JST.
 2. Copyright line added at top. Ph, WSFA, LC, and all "Saint
 Gervais" and the more elaborate edition impressions.
 3. Remarque removed. Regular published state.
Edition: 500 in 2nd state; 1,000 in 3rd state. Printing by Peters.
Quantity unknown.
Plate probably destroyed.
Photograph of a wood engraving used as a tissue, showing in-
dentations of tracing: JST.

second state

85. JEAN AND ROSE
1903. Delivered to Quinby Co. on November 7, 1903. JS records.
De Kock series, *Jean,* vol. 2.
Caption: "Come, Rose, sit still and listen to me."
Etching. 148 x 104 mm. (6 x 4 inches) platemark; 125 x 89 mm.
(5 x 3½ inches) picture.
States:
 1. Nearly finished. Man's mouth and eyes are weak. Remarque
 at lower left. JST–2.
 2. Man's mouth and eyes strengthened. Copyright line added
 at top. Ph, JST–2, WSFA.
 3. Remarque removed. Regular published state
Edition: 500. Printing by Peters. Quantity unknown.
Plate probably destroyed.
Tissue: JST.

second state

86. MONSIEUR BELLEQUEUE
1903. Delivered to Quinby Co. on November 7, 1903. JS records.
De Kock series, *Jean*, vol. 2.
Etching. Colors: brown, green (coat). 159 x 72 mm. (6½ x 3
inches) platemark; 147 x 60 mm. (6 x 2½ inches) picture.
States:
 1. No copyright line JST–2 (one in brown, one color trial).
 2. Copyright line added at top. Regular published state.
Edition: 500. Printing by Peters. Quantity unknown.
Plate probably destroyed.
Tissue: JST.

second state

87. THE BURGLARS

1903. Delivered to Quinby Co. on November 20, 1903. JS records.

De Kock series, *Jean,* vol. 2.

Caption: "Jean . . . presented to each burglar the muzzle of a pistol."

Etching. 104 x 147 mm. (4 x 6 inches) platemark; 90 x 135 mm. (3½ x 5½ inches) picture.

States:

1. Lightly drawn. Remarque at lower left. JST.
2. Additional shading on curtains at left, on hat, hair, and coat of man at center, and elsewhere. Copyright line added at top. JST–2, WSFA, Dartmouth College ("Bibliomaniac").
3. Remarque removed. Regular published state.

Edition: 1,000. Printing by Peters. Quantity unknown.

Plate probably destroyed.

Tissue: JST.

second state

88. THE FALL OF MADAME BOULARD
1904. Delivered to Quinby Co. on February 13, 1904. JS records.
De Kock series, *Madame Pantalon*.
Caption: "All the waltzers stopped, and hastened to pick up the
fallen couple."
Etching. 149 x 102 mm. (6 x 4 inches) platemark; 135 x 96 mm.
(5 x 3½ inches) picture.
States:
 1. Design complete. Remarque at lower left. JST–2.
 2. Copyright line added at top. Ph, JST–4, WSFA, Met.
 3. Remarque removed. Regular published state.
Edition: 500. Printing by Peters. Quantity unknown.
Plate probably destroyed.
Tissue: Ph.

second state

89. NANON BEATS THE DRUM

1904. Delivered to Quinby Co. on February 13, 1904. JS records.
De Kock series, *Madame Pantalon*.
Caption: "When she beat the roll on her drum the villagers
came running from all sides."
Etching. 148 x 103 mm. (6 x 4 inches) platemark; 134 x 97 mm.
(5 x 3½ inches) picture.
States:
 1. Design complete. Remarque at lower left. JST–2.
 2. Copyright line added at top. JST–4 (one with instructions
 to the printer), WSFA, NYPL, Met.
 3. Remarque removed. Regular published state.
Edition: 1,000. Printing by Peters. Quantity unknown.
Plate probably destroyed.
Tissue: Ph.

second state

90. MADEMOISELLE ELVINA
1904. Delivered to Quinby Co. February 5, 1904. JS records.
De Kock series, *Madame Pantalon*.
Etching. Color: purple only, with plate-wiped highlights. 159 x 77 mm. (6½ x 3 inches) platemark; 147 x 65 mm. (6 x 2½ inches) picture.
States:
 1. Design complete. No copyright line. JST–2 (both in blue ink).
 2. Copyright line added at top. Regular published state. (One JST proof in black ink.)
Edition: 500. Printing by Peters. Quantity unknown.
Plate probably destroyed.
Tissue: JST.

<div align="center">third state</div>

91. THE BOAR HUNT

1904. Delivered to Quinby Co. on February 13, 1904. JS records.
De Kock series, *Madame Pantalon*.

Caption: "The animal they were hunting passed quite near them."

Etching. 104 x 148 mm. (4 x 6 inches) platemark; 94 x 142 mm. (3½ x 5½ inches) picture.

States:

1. Nearly complete. Trees at right background touch the chin of woman at right. Remarque at lower left. P11, JST–2.
2. Light area burnished around face of woman at right. Eyes and mouth of woman in right background are strengthened. JST–3.
3. Copyright line added at top. JST–5, WSFA.
4. Remarque removed. Regular published state

Edition: 1,000. Printing by Peters. Quantity unknown.

Plate probably destroyed.

Tissue: JST.

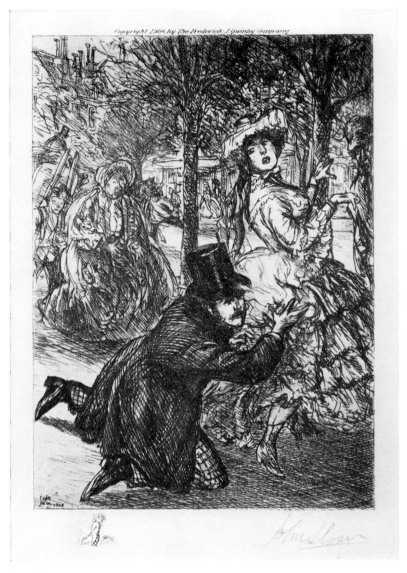

fourth state

92. THE BURNING GOWN
1904. Billed to Quinby Co. on May 15, 1904. JS records.
De Kock series, *Adhémar.*
Caption: "What is it?" "A lady on fire."
Etching. 156 x 111 mm. (6 x 4 inches) platemark; 138 x 96 mm.
(5½ x 3½ inches) picture.
States:
 1. Nearly complete. Remarque at lower left. Heavy shading
 on man's coat. Lower left corner is blank except for signa-
 ture. JST–3 (one with pen).
 2. Lighter lines of shading burnished off of man's coat. Right
 cheek of woman in background is burnished lighter. Addi-
 tional shading on ground in lower left corner, on front
 woman's skirt, above and below man's right arm. JST–3.
 3. Much additional shading on man's coat, resembling 1st
 state. Additional shading on cheeks of front woman. High-
 light burnished on front of man's hat brim. JST.
 4. Copyright line added at top. Ph, JST–8, WSFA, NYPL,
 Met.
 5. Remarque removed. Regular published state.
Edition: 1,000. Printing by Peters. Quantity unknown.
Plate probably destroyed.
Tissue: JST.

96

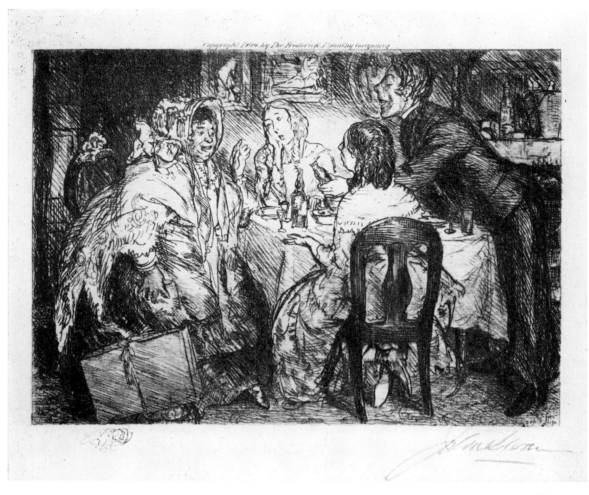

third state

93. MADAME PUTIPHAR AND CHARTREUSE

1904. Billed to Quinby Co. on May 15, 1904. JS records.

De Kock series, *Adhémar*.

Caption: "Take it, Putiphar, take it! a glass of champagne should never be refused."

Etching. 108 x 155 mm. (4 x 6 inches) platemark; 95 x 140 mm. (3½ x 5½ inches) picture.

States:

 1. Nearly complete. No shading on right hand of woman at left. Remarque at lower left. JST–2.

 2. Hand shaded. JST–3.

 3. Copyright line added at top. Ph, JST–5, WSFA, NYPL, Met.

 4. Remarque removed. Regular published state.

Edition: 500. Printing by Peters. Quantity unknown.

Plate probably destroyed.

Tissue: JST.

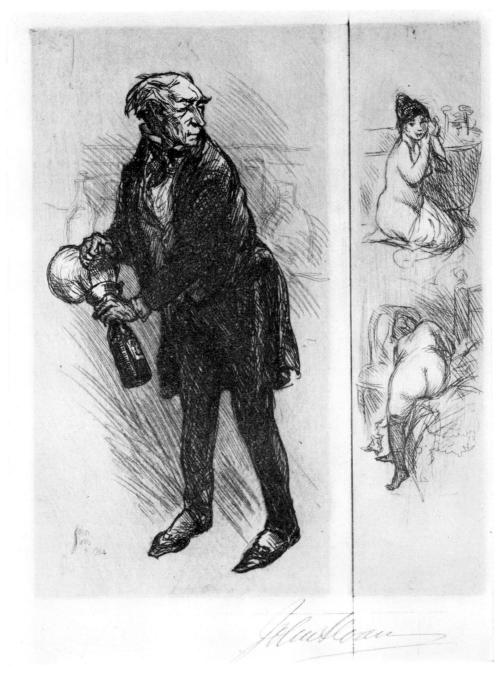

first state

94. MONSIEUR MIROTAINE WATERS THE WINE

1904. Billed to Quinby Co. on May 15, 1904. JS records.
De Kock series, *Adhémar*.
Etching. Colors: green, brown (face and hands). 161 x 86 mm.
(6½ x 3½ inches) platemark; 152 x 78 mm. (6 x 3 inches) picture.
States:

1. Man's figure complete. Two nude women in margin at
 right. Platemark measures 175 x 125 mm. (7 x 5 inches).
 JST–4 (inscribed "one of seven proofs before cutting plate"
 or "one of six proofs," all printed in black).
2. Plate cut down at right side and bottom, removing the
 nudes. Platemark now measures 161 x 86 mm., as above.
 Copyright line added at top. Regular published state.

Edition: 500. Printing by Peters. Quantity unknown.
Plate probably destroyed.
Tissue (the man only): JST.

98

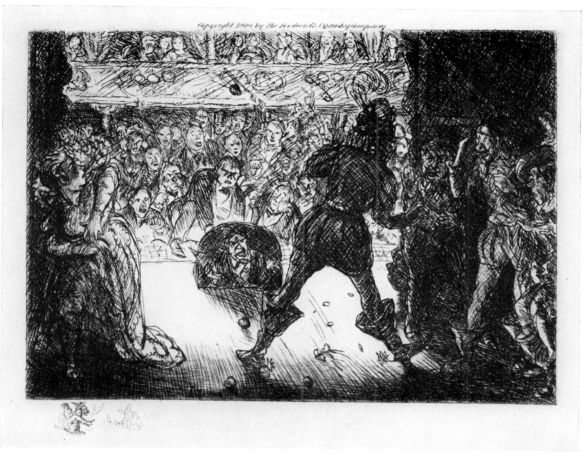

third state

95. DODICHET'S DEBUT A FAILURE
1904. Billed to Quinby Co. on May 15, 1904. JS records.
De Kock series, *Adhémar*.
Caption: "Some young men in the pit sent a shower of raw apples and coppers at the unlucky performer."
Etching. 109 x 156 mm. (4 x 6 inches) platemark; 95 x 139 mm. (3½ x 5½ inches) picture.
States:

1. Nearly complete. Woman at left is seen full-face. Remarque at lower left. JST–2.
2. Woman at left now in profile. Additional shading on scenery at upper right. JST–2.
3. Copyright line added at top. Ph, JST–9, WSFA, NYPL, Met.
4. Remarque removed. Regular published state.

Edition: 500. Printing by Peters. Quantity unknown.
Plate probably destroyed.
Tissue: JST.

A 2nd state proof in JST was evidently the print that Sloan sent to Peters, along with the plate, to show how the edition should be printed. It has these comments by Sloan in the margins: "This is *now pretty near* right. / *I have worked on this proof with rubber to show somewhat* the effect I'm after. Print the plate with the audience good and clear and bright. Don't let the stage darks get soft. / These actors [at the right side] are to show lighter, not pure white."

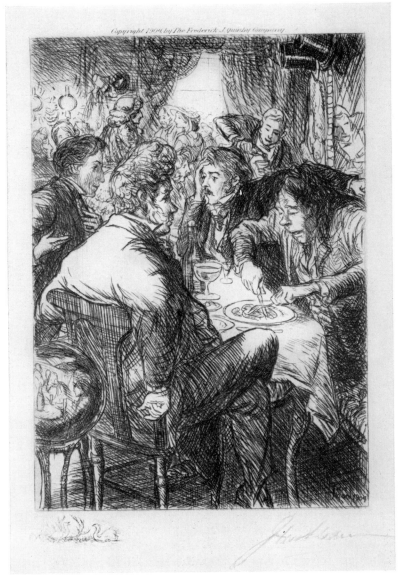

third state

96. FOUR FRIENDS AT THE CAFE
1904. Billed to Quinby Co. on May 15, 1904. JS records.
De Kock series, *Adhémar*.
Caption: "They served Dodichet, who, with his beefsteak, swallowed two rolls and emptied three small decanters."
Etching. 157 x 110 mm. (6 x 4 inches) platemark; 137 x 95 mm.
(5½ x 3½ inches) picture.
States:
 1. Lightly drawn. Man at left has light hair. Remarque at lower left. JST–3.
 2. Much additional shading, including hair and coat of man at left, globe at left, right arm of man at front center, coat of man at rear center, and elsewhere. JST.
 3. Copyright line added at top. Ph, JST–7, WSFA, NYPL, Met.
 4. Remarque removed. Regular published state.
Edition: 1,000. Printing by Peters. Quantity unknown.
Plate probably destroyed.
Tissue unknown.

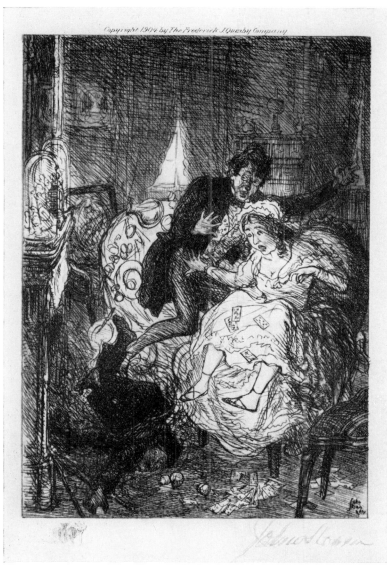

third state

97. PIERRE DROPS IN

1903. Proof of 1st state dated December 19, 1903. JST. (Copyright line reads 1904.)

De Kock series, *André the Savoyard,* vol. 1.

Caption: "Something black fell with a great crash, and rolled to the feet of the amorous couple."

Etching. 146 x 103 mm. (6 x 4 inches) platemark; 131 x 92 mm. (5 x 3½ inches) picture.

States:

 1. Lightly drawn. Remarque at lower left. JST–2.

 2. Added shading on man's hair, mantelpiece at left, boy's foot and arm. Horizontal shading across entire background. JST.

 3. Copyright line added at top. JST–4, WSFA.

 4. Remarque removed. Regular published state.

Edition: 1,000. Printing by Peters. Quantity unknown.

Plate probably destroyed.

Tissue: JST.

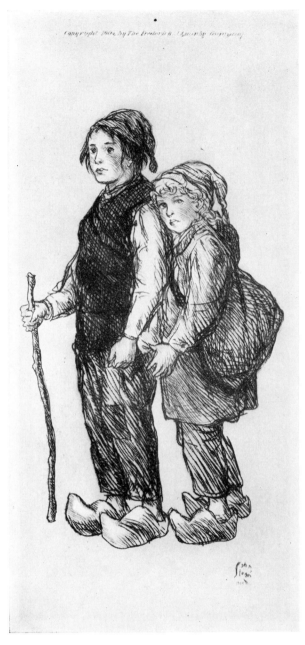

second state

98. LITTLE SAVOYARDS
1903. Delivered to Quinby Co. on December 15, 1903. JS records. (Copyright line reads 1904.)
De Kock series, *André the Savoyard,* vol. 1.
Alternative title: *André and Pierre.*
Etching. Colors: green, pink (faces and hands). 160 x 74 mm. (6½ x 3 inches) platemark; 145 x 67 mm. (6 x 2½ inches) picture.
States:
 1. Design complete. JST–2. (There are four color trials in JST, two in each state.)
 2. Copyright line added at top. Regular published state.
Edition: 500. Printing by Peters. Quantity unknown.
Plate probably destroyed.
Tissue: JST.

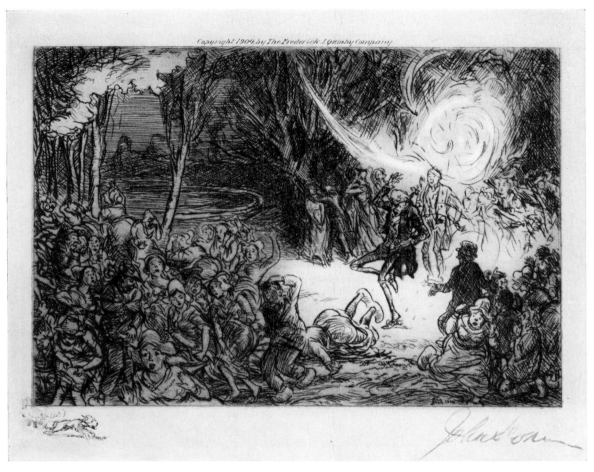

second state

99. MONSIEUR LE COMTE'S FIREWORKS
 EXPLODE

1904. Proof of 1st state dated January 19, 1904. JST.
De Kock series, *André the Savoyard,* vol. 1.
Caption: "He ran about the garden, jumping and twisting his body, like one possessed."
Etching. 103 x 145 mm. (4 x 6 inches) platemark; 90 x 134 mm. (3½ x 5½ inches) picture.
States:
 1. Nearly complete. No remarque. JST.
 2. Additional shading on hair and right front side of man at front center. Remarque added at lower left. Copyright line added at top. JST–3, WSFA.
 3. Remarque removed. Regular published state
Edition: 500. Printing by Peters. Quantity unknown.
Plate probably destroyed.
Tissue: Ph.

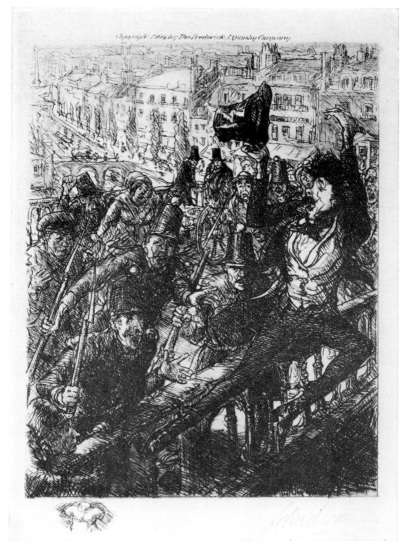

third state

100. ROSSIGNOL'S MERRY SUICIDE
1904. Proof of 1st state dated June 1904. JST.
De Kock series, *André the Savoyard,* vol. 2.
Caption: "Rossignol . . . threw himself into the river."
Etching. 148 x 107 mm. (6 x 4 inches) platemark; 132 x 99 mm.
(5½ x 3½ inches) picture.
States:
1. Nearly finished. Dark shading on face of jumping man. Remarque at lower left. JST–2.
2. Shading on jumper's face burnished out. Additional shading on three gendarmes. JST.
3. Copyright line added at top. Ph, JST–6, WSFA, NYPL, Met.
4. Remarque removed. Regular published state.
Edition: 1,000. Printing by Peters. Quantity unknown.
Plate probably destroyed.
Tissue: Ph. Also a sketch on tissue, somewhat different: JST.

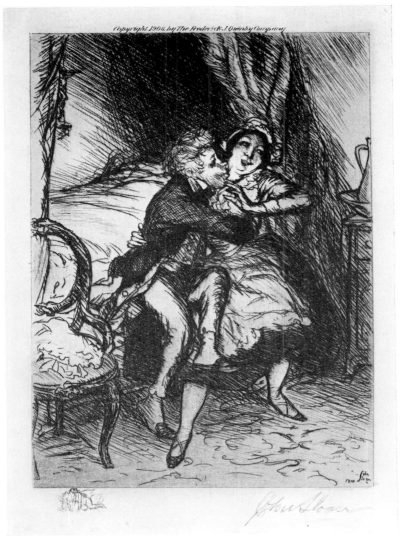

second state

101. LUCILLE'S ENGLISH LESSON

1904. Billed to Quinby Co. on June 15, 1904. JS records.

De Kock series, *André the Savoyard,* vol. 2.

Caption: "Ah, how pretty—kiss me—stay, I can say that quite readily."

Etching. 148 x 107 mm. (6 x 4 inches) platemark 135 x 98 mm. (5½ x 3½ inches) picture.

States:

1. Nearly complete. Remarque at lower left. Dark vertical line on girl's right cheek. JST–3.
2. Dark line removed from cheek. Slight shading added on girl's legs. Copyright line added at top. Ph, JST–7, WSFA, NYPL, Met.
3. Remarque removed. Regular published state.

Edition: 1,000. Printing by Peters. Quantity unknown.

Plate probably destroyed.

Tissue: Ph.

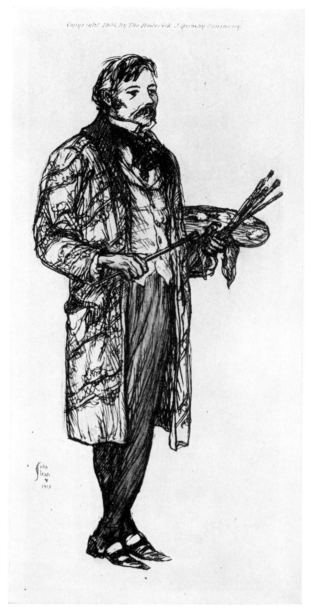

only state

102. MONSIEUR DERMILLY, BENEVOLENT ARTIST

1903. Delivered to Quinby Co. on December 15, 1903. JS records.
(Copyright line reads 1904.)
De Kock series, *André the Savoyard,* vol. 2.
Etching. Colors: dark brown, reddish brown (trousers).
160 x 75 mm. (6½ x 3 inches) platemark; 146 x 65 mm. (6 x 2½ inches) picture.
Only state. With copyright line at top. Regular published state.
Edition: 500. Printing by Peters. Quantity unknown.
Plate probably destroyed.
Tissue: JST.

"Memory portrait of Robert Henri" (JS inscription on proof in Ph).

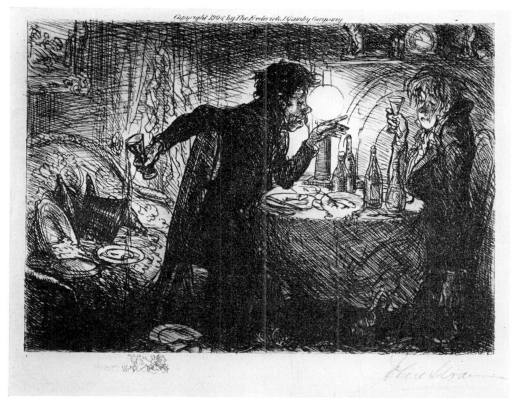

third state

103. ROSSIGNOL'S DRUNKEN ADVICE TO PIERRE

1904. Proof of 1st state dated June 1904. JST.

De Kock series, *André the Savoyard*, vol. 2.

Caption: "Rossignol did full justice to the repast . . . The corks flew and the bottles were emptied."

Etching. 107 x 148 mm. (4 x 6 inches) platemark; 96 x 139 mm. (3½ x 5½ inches) picture.

States:

1. Lightly drawn. Remarque at lower left. JST.
2. Much additional shading on hair and coat of center man, on hat at left, and in background and foreground. JST–3 (one with JS's instructions to the printer).
3. Copyright line added at top. Ph, JST–4, WSFA, NYPL, Met.
4. Remarque removed. Regular published state

Edition: 1,000. Printing by Peters. Quantity unknown.

Plate probably destroyed.

Tissue: JST.

104. CHARLES PAUL DE KOCK

1904. Commissioned June 14, 1904. JS letter (see below). Delivered to Quinby Co. on July 13, 1904. JS records.

Frederick J. Quinby Co. commission.

Etching. 406 x 331 mm. (16 x 13 inches) plate; 355 x 308 mm. (14 x 12 inches) picture, not including remarque.

States:

1. Head and hair lightly drawn. No remarque. Ph (on verso of 1st state proof of no. 126), Met (on verso of proof of no. 115). Illustrated, p. 110.

2. Additional shading on left side of forehead and beneath left eye. This state is known only in two fragments, on the backs of the two 1st state proofs of *Cherami's Duel* (124). JST. Together, the two pieces comprise about half of a single impression of this state, the right half, inscribed "2nd state" by Sloan. The noted changes are the only ones visible in this portion of the proof. The copyright line is not present; the remarque is unknown.

3. This state is known only in two fragments, on the backs of two 1st state proofs of *Capuchine Boys* (121). JST. Together, the two pieces comprise about one third of a single impression, the upper center and lower right portions. The latter is inscribed "3rd state" by Sloan. The visible areas are identical with those of the 2nd and subsequent states. The copyright line is not present; remarque unknown.

4. Design complete. Copyright line added at top. Remarque at lower left. All known proofs are inscribed in pencil by JS, "Ch. Paul de Kock / Portrait by John Sloan / from various contemporary sources." Published in this state.

5. Title etched at bottom center, as illustrated. Published in this state.

6. Title and copyright line removed. Remarque remains. Present state of the plate. Published state. A few proofs were evidently made before the addition of the copyright line, perhaps of the 3rd state. One is inscribed, "Four (4) proofs in this state, before letters," by JS (Kraushaar Galleries, New York). Another is inscribed, "Proof before letters," by JS (Met). These early proofs are now indistinguishable from this 6th state.

Edition: 4th state: unknown. 5th state: 100. 6th state: 100. Printing: 4th state: by Peters, quantity unknown. 5th state 100. Peters 100. 6th state 25. Platt 25.

Plate exists: JST. Copper, steel-faced. "Ch. Paul de Kock / John Sloan / 1904," scratched on verso of the plate, which also shows the hammering marks of the removal of title and copyright line.

Tissue: Met (American Paintings Department). Preliminary sketch in India ink (9¼ x 7 inches): Baltimore Museum of Art. Sloan's principal source is apparently a photograph by Bertall, reproduced in the Quinby volume of the *Memoirs,* said to show the author either at the age of 63 or 70.

"This large plate of Paul de Kock is a compilation from various contemporary portraits of the French novelist. From 1902 to 1905 I was engaged in making fifty-three etched illustrations for a limited edition of his works, which was published by Frederick J. Quinby, Boston" (Dart 31).

"Lichtenstein says they want a portrait of de Kock etched, about 12 x 15 inches plate, and 'would I like to try it?' he asks—I think that I will." (JS letter to Dolly, June 14, 1904; JST).

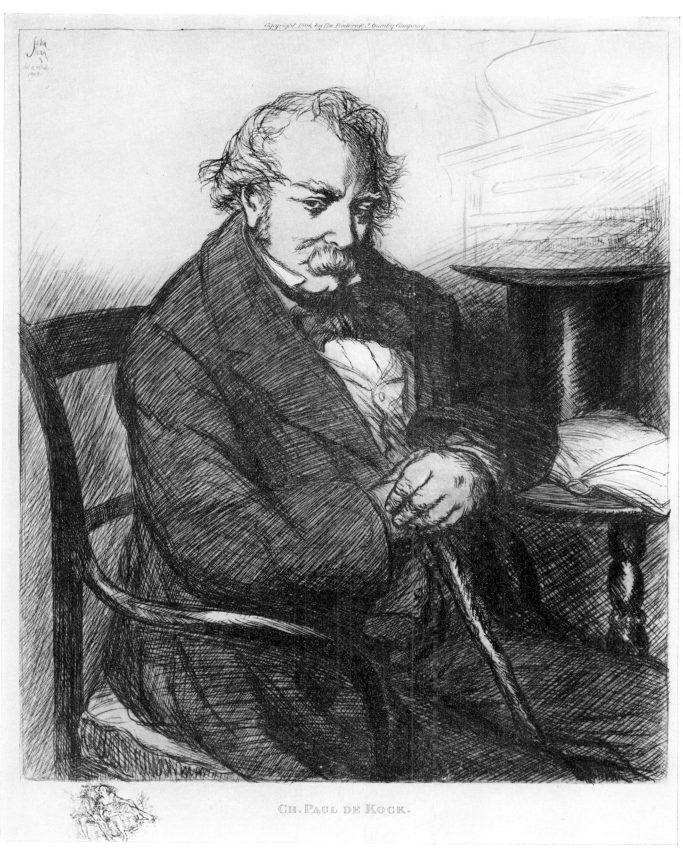

CH. PAUL DE KOCK.

fifth state, reduced

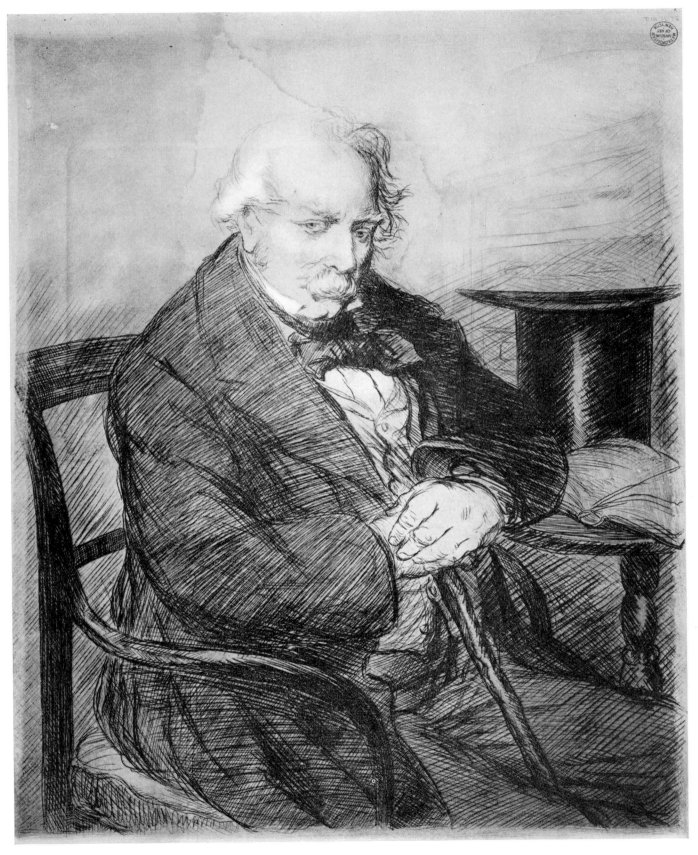

104, first state, reduced

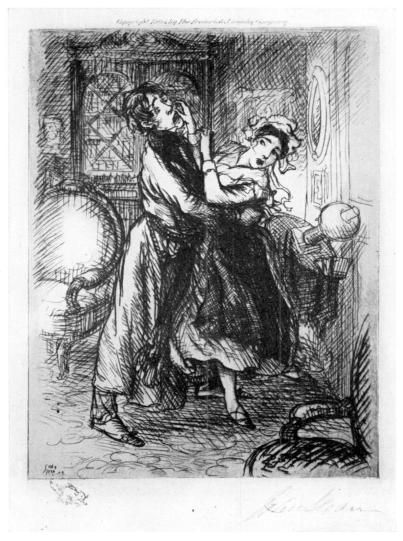

third state

105. JERICOURT AND VIOLETTE

1904. Billed to Quinby Co. on September 1, 1904. JS records.
De Kock series, *The Flower Girl,* vol. 2.
Caption: "Let me go, monsieur, you shall never kiss me."
Etching. 148 x 106 mm. (6 x 4 inches) platemark; 133 x 100 mm.
(5½ x 3½ inches) picture.
States:

1. Design complete. Remarque at lower left. JST–3.
2. Diagonal lines added next to cat in remarque. Frame line added. JST–4.
3. Copyright line added at top. Ph, JST–6, WSFA, NYPL, Met.
4. Remarque removed. Regular published state.

Edition: 1,000. Printing by Peters. Quantity unknown.
Plate probably destroyed.
Tissue: JST.

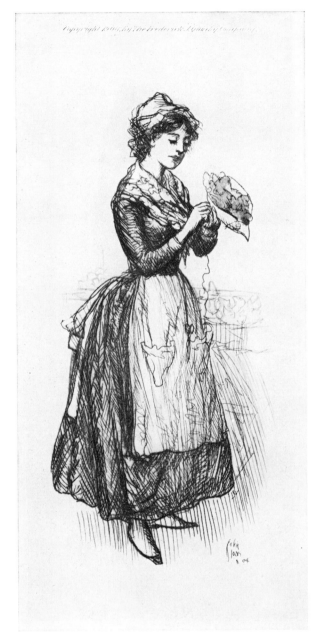

second state

106. MADEMOISELLE VIOLETTE

1904. Billed to Quinby Co. on September 1, 1904. JS records.
De Kock series, *The Flower Girl,* vol. 1.
Etching. Colors: black, brown (dress), red (flowers). 161 x 78 mm.
(6½ x 3 inches) platemark; 151 x 68 mm. (6 x 2½ inches) picture.
States:
 1. Design complete. JST–2 (one in black, one color trial).
 2. Copyright line added at top. Regular published state. (One
 JST proof in brown ink.)
Edition: 500. Printing by Peters. Quantity unknown.
Plate probably destroyed.
Tissue: JST.

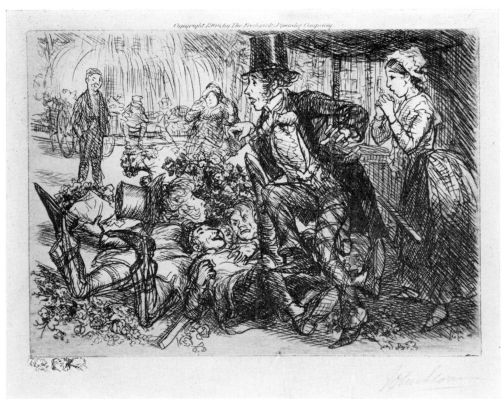

third state

107. UPSET AT THE FLOWER STALL
1904. Proof of 1st state dated August 1904. JST.
De Kock series, *The Flower Girl,* vol. 1.
Caption: "Violette uttered a cry, on seeing her wares dispersed on the pavement."
Etching. 109 x 147 mm. (4 x 6 inches) platemark; 99 x 142 mm. (3½ x 5½ inches) picture.
States:
1. Nearly finished. No awning at upper right. JST–15 (all JS impressions).
2. Awning added at upper right. Eye and lower line of nose strengthened on girl at right. Additional shading on woman in background and elsewhere. Remarque added at lower left. JST–2.
3. Copyright line added at top. Ph, JST–10, WSFA, NYPL, Met. (One JST proof is dated October 5, 1904.)
4. Remarque removed. Regular published state.
Edition: 1,000. Printing by Peters. Quantity unknown.
Plate probably destroyed.
Tissue: JST.

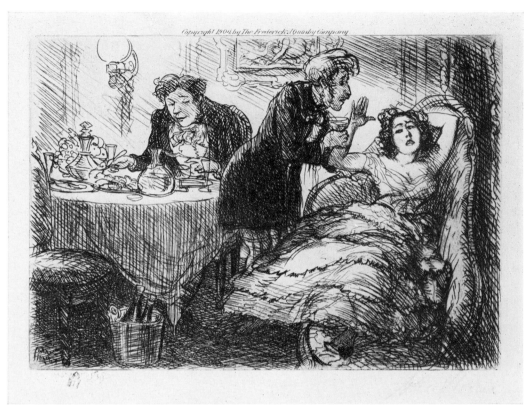

third state

108. MADEMOISELLE ZIZI FEINTS AT
 FAINTING

1904. Proof of 3rd state dated October 5, 1904. JST. This etching was, however, probably done earlier, as it was billed to the Quinby Co. on September 1, 1904. See also the dates noted under no. 107.

De Kock series, *The Flower Girl,* vol. 1.

Caption: "Alfred . . . approached his lady-love with a glass of cold water."

Etching. 106 x 148 mm. (4 x 6 inches) platemark; 96 x 141 mm. (3½ x 5½ inches) picture.

States:

 1. Nearly finished. Woman's feet clearly visible. Remarque at lower left. JST–3.

 2. Woman's feet covered with shading. JST–2.

 3. Copyright line added at top. Ph, JST–7, WSFA, NYPL, Met.

 4. Remarque removed. Regular published state.

Edition: 1,000. Printing by Peters. Quantity unknown.

Plate probably destroyed.

Tissue: Ph.

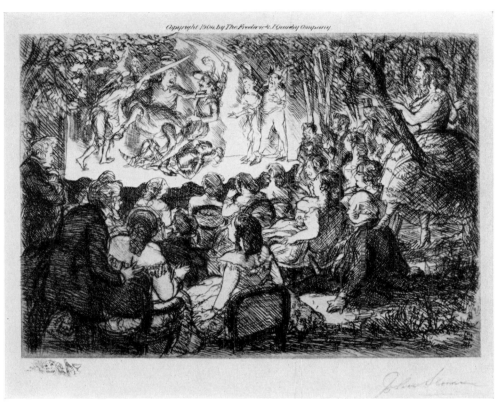

third state

109. PRIVATE THEATRICALS

1904. Proof of 1st state dated September 8, 1904. JST.

De Kock series, *The Flower Girl,* vol. 1.

Caption: "He fell upon the chemist and the two young men who were dressed as robbers."

Etching. 107 x 148 mm. (4 x 6 inches) platemark; 95 x 137 mm. (3½ x 5½ inches) picture.

States:

1. Lightly drawn. No signature; no remarque. JST–3 (one with pencil).

2. Signature added at lower right, remarque at lower left. Much additional shading in background, on figures on stage, at right side, on backs of chairs, and elsewhere. JST–9 (one proof dated September 9, 1904).

3. Copyright line added at top. Ph, JST–8, WSFA, NYPL, Met.

4. Remarque removed. Regular published state.

Edition: 500. Printing by Peters. Quantity unknown.

Plate probably destroyed.

Tissue: JST.

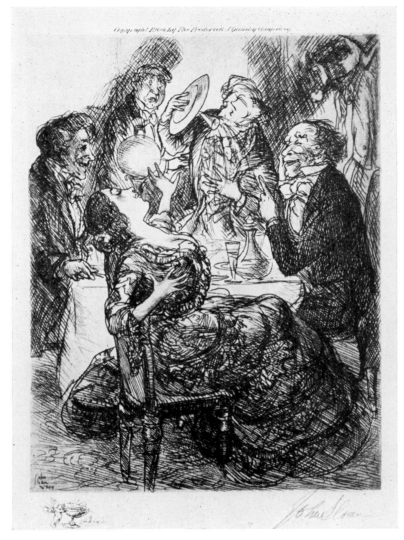

fourth state

110. WAYS OF DRINKING CHAMPAGNE
1904. Billed to Quinby Co. on September 1, 1904. JS records.
De Kock series, *The Flower Girl,* vol. 2.
Caption: "Monsieur knows thirty-three ways of drinking a glass of Champagne."
Etching. 148 x 106 mm. (6 x 4 inches) platemark; 131 x 97 mm. (5 x 3½ inches) picture.
States:
1. Nearly finished. Lamp globe at left center is completely blank. Hands and face of woman covered with shading. Remarque at lower left. JST (with pencil).
2. Horizontal shading added on lamp globe. Woman's face and hands burnished light. Left man's eye erased. JST (inscribed "First State" by JS).
3. Additional curved vertical shading on lamp globe. Shading added under woman's eye. Left man's eye added. JST–3.
4. Copyright line added at top. Ph, JST–7, WSFA, NYPL, Met.
5. Remarque removed. Regular published state.
Edition: 1,000. Printing by Peters. Quantity unknown.
Plate probably destroyed.
Tissue: JST.

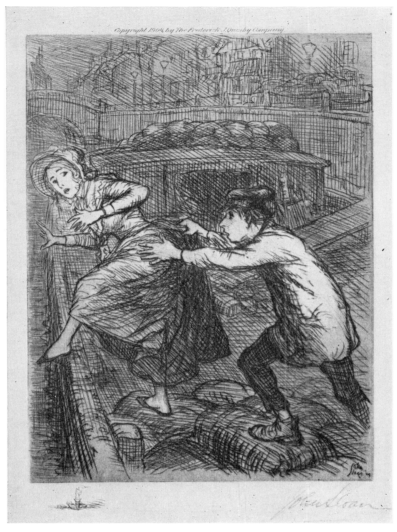

second state

111. VIOLETTE'S SUICIDE PREVENTED BY CHICOTIN

1904. Proofs of 1st state dated July 23, 1904. JST.

De Kock series, *The Flower Girl,* vol. 2.

Caption: "Poor Mam'selle Violette! you, too, want to die?"

Etching. 148 x 107 mm. (6 x 4 inches) platemark; 134 x 100 mm. (5½ x 3½ inches) picture.

States:

1. Design complete. Remarque at lower left. JST–10 (one with pencil).
2. Copyright line added at top. Ph, JST–7, WSFA, NYPL, Met.
3. Remarque removed. Regular published state.

Edition: 1,000. Printing by Peters. Quantity unknown.

Plate probably destroyed.

Tissue: JST.

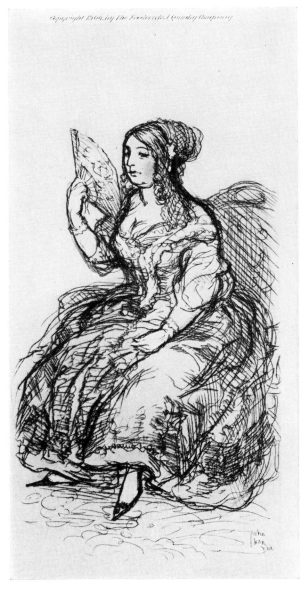

second state

112. MADAME DE GRANGEVILLE
1904. Billed to Quinby Co. on September 1, 1904. JS records.
De Kock series, *The Flower Girl*, vol. 2.
Etching. Colors: brown, red (cheek). 161 x 78 mm. (6½ x 3 inches) platemark; 151 x 72 mm. (6 x 2½ inches) picture.
States:
 1. Design complete. JST–5 (two in brown, three color trials).
 2. Copyright line added at top. Regular published state.
Edition: 500. Printing by Peters. Quantity unknown.
Plate probably destroyed.
Tissue: JST.

118 at bottom left.

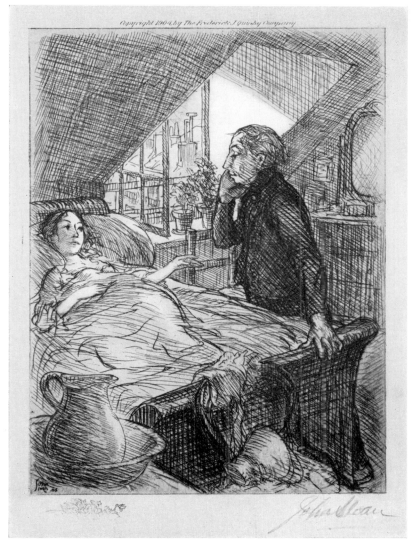

fifth state

113. CHICOTIN VISITS VIOLETTE

1904. Billed to Quinby Co. on September 1, 1904. JS records.
De Kock series, *The Flower Girl,* vol. 2.
Caption: "She smiled at Chicotin and held out her hand."
Etching. 148 x 106 mm. (6 x 4 inches) platemark; 1¾ x 99 mm.
(5½ x 3½ inches) picture.
States:

1. Highlight on girl's right cheek. Shading on her arms. Water pitcher has a pronounced pouring spout. Foot of bed is clear. Remarque at lower left. JST (with pencil).
2. Shading added across highlight on girl's cheek. JST.
3. Shading burnished off girl's arms. JST.
4. Water pitcher enlarged, reducing relative size of spout. Chair and clothing added at foot of bed. JST–c (all JS impressions).
5. Copyright line added at top. Ph, JST–9, WSFA, NYPL, Met.
6. Remarque removed. Regular published state.

Edition: 1,000. Printing by Peters. Quantity unknown.
Plate probably destroyed.
Tissue: JST.

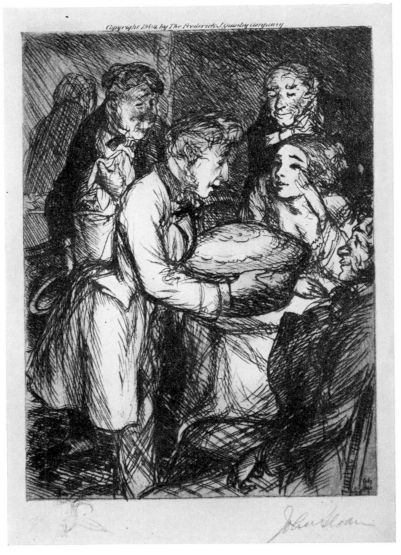

second state

114. THE SILENT PIE
1904. Billed to Quinby Co. on September 1, 1904. JS records.
De Kock series, *The Flower Girl,* vol. 2.
Caption: "Ah—the surprise is a pie?"
Etching. 147 x 106 mm. (6 x 4 inches) platemark; 131 x 96 mm.
(5 x 3½ inches) picture.
States:
 1. Design complete. Remarque at lower left. JST–2.
 2. Copyright line added at top. Ph, JST–7, WSFA, NYPL,
 Met.
 3. Remarque removed. Regular published state.
Edition: 1,000. Printing by Peters. Quantity unknown.
Plate probably destroyed.
Tissue: JST.

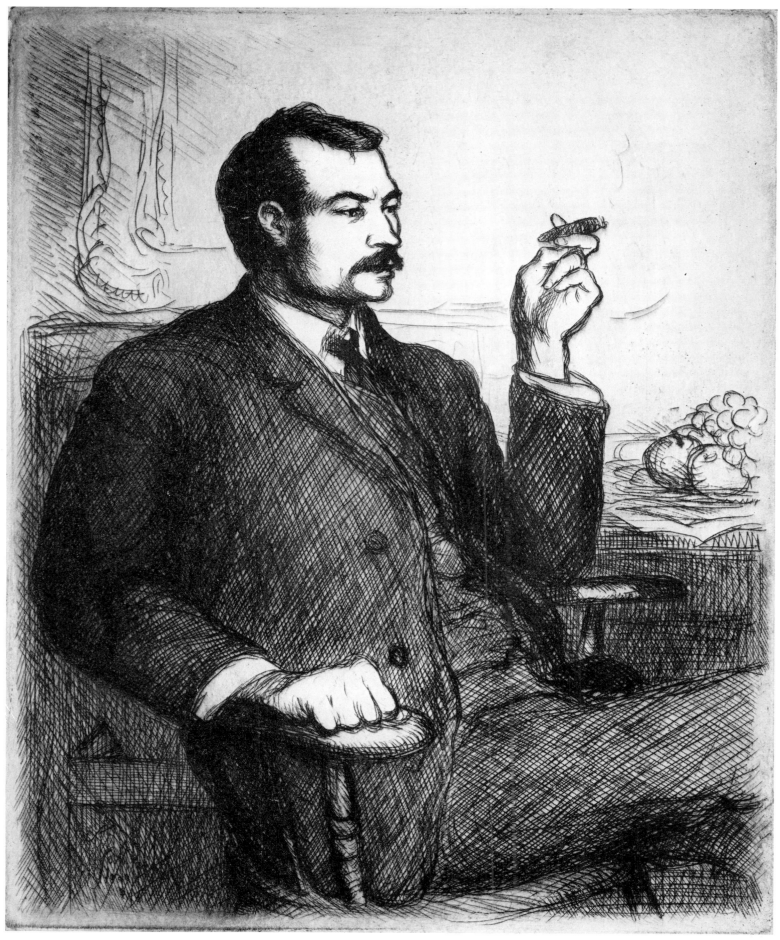

only state, reduced

115. ROBERT HENRI

1904. In plate (clearly). This print has often been dated 1905. It dates after July 1904, the date of 104, as the Met proof is on the verso of, and clearly subsequent to, that print.

Etching. 306 x 253 mm. (12 x 10 inches) plate.

Only state. Met, Mod. (The Met proof is on the verso of a first state of 104. In addition, it has an erasure on the proof of the lock of hair at the center of Henri's forehead and along the hairline.) Proofs from canceled plate: Ph, WSFA, SI.

No edition. Printing from uncanceled plate: 2, possibly 3 (see below). Canceled plate: Harris 3.

Plate canceled. Exists: JST. Copper. The portrait of James B. Moore (126) is on the verso.

Tissue unknown and probably nonexistent. See discussion of a similar drawing under no. 246.

"R. H. One of 2 proofs. Plate destroyed" (JS inscription on Met proof).

"Two or three proofs, plate defaced, used back for J.B.M. port." (JS inscription on Mod proof).

"Destroyed plate." (JS records).

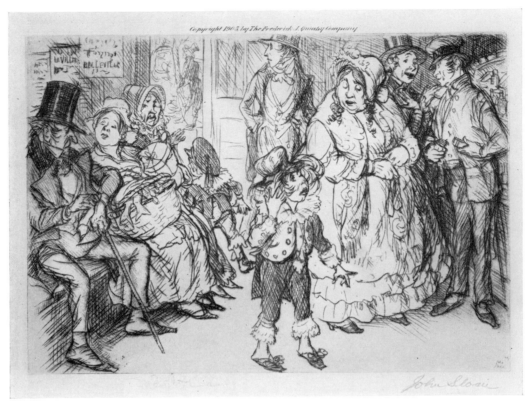

second state

116. THE BUS OFFICE

1904. Billed to Quinby Co. on December 1, 1904. JS records. (Copyright line reads 1905.)

De Kock series, *Cherami,* vol. 1.

Caption: "There was . . . a crowd in the office of the Porte Saint Martin."

Etching. 107 x 148 mm. (4 x 6 inches) platemark; 98 x 142 mm. (3½ x 5½ inches) picture.

States:

1. Design complete. Remarque at lower left center. JST–2.
2. Copyright line added at top. Ph, JST–7, WSFA, NYPL, Met.
3. Remarque removed. Regular published state.

Edition: 1,000. Printing by Peters. Quantity unknown.

Plate probably destroyed.

Tissue: JST.

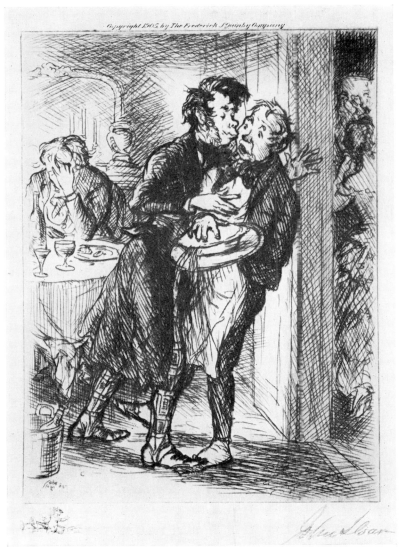

second state

117. THE MISPLACED KISS

1905. Billed to Quinby Co. on January 18, 1905. JS records.

De Kock series, *Cherami,* vol. 1.

Caption: "Cherami . . . applied a resounding kiss on the waiter's cheek."

Etching. 148 x 106 mm. (6 x 4 inches) platemark; 132 x 97 mm. (5½ x 3½ inches) picture.

States:
1. Design complete. No signature; no remarque. JST–2.
2. Signature, year date, and remarque added at lower left. Copyright line added at top. Ph, JST–11, WSFA, NYPL, Met.
3. Remarque removed. Regular published state.

Edition: 500. Printing by Peters. Quantity unknown.

Plate probably destroyed.

Tissue: JST.

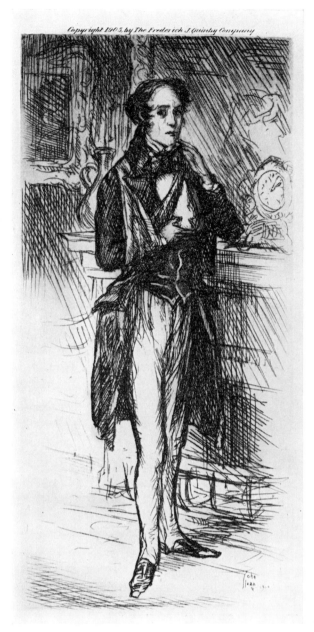

second state

118. MONSIEUR MONLEARD

1904. Billed to Quinby Co. on December 1, 1904. JS records.
(Copyright line reads 1905.)
De Kock series, *Cherami,* vol. 1.
Etching. Colors: brown, green (vest), light brown (face and
hands). 160 x 76 mm. (6½ x 3 inches) platemark; 148 x 69 mm. (6
x 2½ inches) picture.
States:
 1. Design complete. JST–3 (color trials, one with pencil).
 2. Copyright line added at top. Regular published state.
Edition: 500. Printing by Peters. Quantity unknown.
Plate probably destroyed.
Tissue: JST.

119. AN OFFER OF MARRIAGE

1904. Proof of 2nd state dated November 14, 1904. JST. (Copyright line reads 1905.)

De Kock series, *Cherami*, vol. 1.

Caption: "Why no, my dear father, I am not ill, and I have nothing to trouble me."

Etching. 147 x 106 mm. (6 x 4 inches) platemark; 134 x 97 mm. (5½ x 3½ inches) picture.

States:

1. Man and woman lightly drawn. No background. JST–3.
2. Background filled in. Much additional shading throughout. Woman's face slightly changed. Remarque added at lower left. JST–4.
3. Signature and year date added at lower left. Copyright line added at top. Ph, JST–11, WSFA, NYPL, Met.
4. Remarque removed. Regular published state.

Edition: 500. Printing by Peters. Quantity unknown.

Plate probably destroyed.

Tissue: JST.

first state

third state

second state

120. CHERAMI EATS, AUGUSTE WRITES
1904. Proof of 1st state dated December 7, 1904. JST. (Copyright line reads 1905.)
De Kock series, *Cherami,* vol. 2.
Caption: "Won't you drink a glass of this wine? It's very good."
Etching. 148 x 107 mm. (6 x 4 inches) platemark; 127 x 97 mm. (5 x 3½ inches) picture.
States:
 1. Design complete. Remarque at lower left. JST–4.
 2. Copyright line added at top. Ph, JST–10, WSFA, NYPL, Met.
 3. Remarque removed. Regular published state.
Edition: 1,000. Printing by Peters. Quantity unknown.
Plate probably destroyed.
Tissue: JST.

second state

121. CAPUCHINE BOYS
1905. Billed to Quinby Co. on January 18, 1905. JS records.
De Kock series, *Cherami*, vol. 2.
Alternative title: *Aristoloche and Narcisse*.
Etching. Color: green only.
159 x 77 mm. (6½ x 3 inches) platemark; 147 x 70 mm. (6 x 2½ inches) picture.
States:
 1. Design complete. JST–3 (one in black, two in orange-brown; two on verso of cut fragments of no. 104, 3rd state).
 2. Copyright line added at top. Regular published state.
Edition: 500. Printing by Peters. Quantity unknown.
Plate probably destroyed.
Tissue: JST.

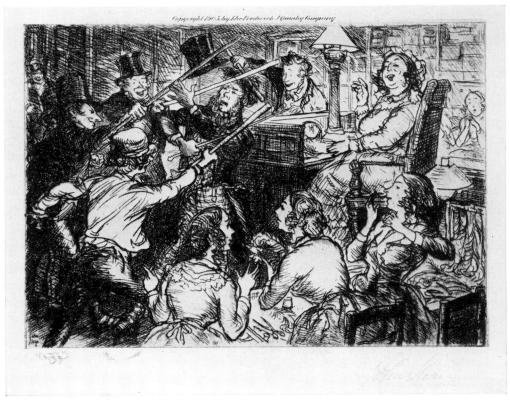

third state

122. CHERAMI ASKS FOR BROOMSTICKS
1905. Billed to Quinby Co. on January 18, 1905. JS records.
De Kock series, *Cherami,* vol. 2.
Caption: "So you want some broomstick! Well, you shall have
it."
Etching. 106 x 148 mm. (4 x 6 inches) platemark; 94 x 139 mm.
(3½ x 5½ inches) picture.
States:
 1. Design nearly finished. Remarque at lower left. Mouth of
 bearded man is thinly drawn. JST–2 (one with pen).
 2. Mouth strengthened. Additional shading on back wall, at
 left, and on chair backs and desk. JST.
 3. Copyright line added at top. Ph, JST–11, WSFA, NYPL,
 Met.
 4. Remarque removed. Regular published state.
Edition: 1,000. Printing by Peters. Quantity unknown.
Plate probably destroyed.
Tissue: JST.

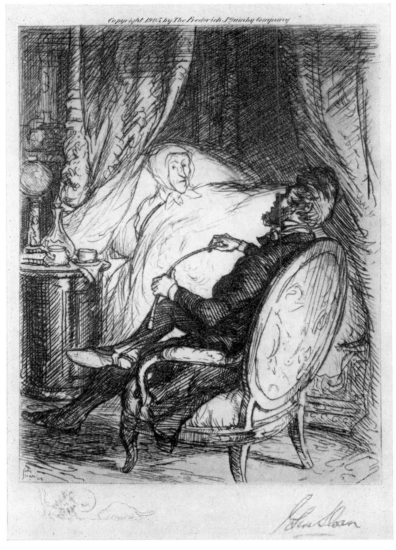

second state

123. CHERAMI CHALLENGES THE OLD
COUNT

1904. In plate. (Copyright line reads 1905.)

De Kock series, *Cherami,* vol. 2.

Caption: "And why do you want me to fight with you?"

Etching. 148 x 106 mm. (6 x 4 inches) platemark; 126 x 97 mm.
(5 x 3½ inches) picture.

States:

1. Design complete. Remarque at lower left. JST–3.
2. Copyright line added at top. Ph. JST–8, WSFA, NYPL,
 Met.
3. Remarque removed. Regular published state.

Edition: 500. Printing by Peters. Quantity unknown.

Plate probably destroyed.

Tissue: JST.

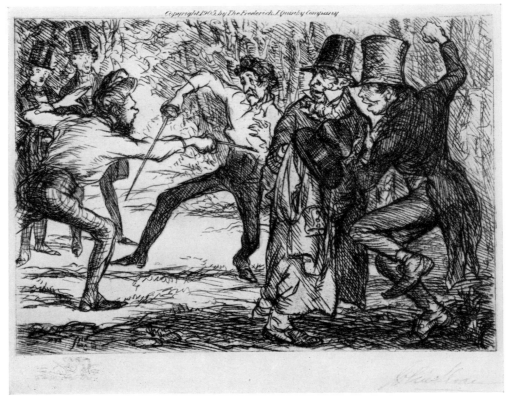

third state

124. CHERAMI'S DUEL WITH THE OLD COUNT

1904. In plate. (Copyright line reads 1905.)

De Kock series, *Cherami,* vol. 2.

Caption: "Fine play, M. le Comte, very pretty play. You must formerly have been a very good swordsman."

Etching. 107 x 147 mm. (4 x 6 inches) platemark; 95 x 137 mm. (3½ x 5½ inches) picture.

States:
1. Design nearly complete. Remarque at lower left. Background blank behind duelers. JST–2 (one with pen, both on verso of cut fragments of no. 104, 2nd state).
2. Foliage added behind duelers; grass added between them. Additional shading on left dueler's shirt and on the three top hats at far left and right. JST–2.
3. Copyright line added at top. Ph, JST–11, WSFA, NYPL, Met.
4. Remarque removed. Regular published state.

Edition: 500. Printing by Peters. Quantity unknown.

Plate probably destroyed.

Tissue unknown.

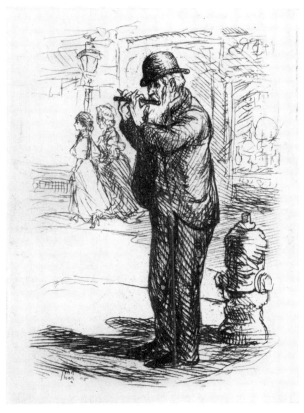

published state

125. FLUTE PLAYER

1905. In plate.

Etching. 95 x 70 mm. (3¾ x 2¾ inches) plate.

States:

1. Before shading on man's left side. Ph–2 (one with pencil), JST–3, Bowdoin.
2. Diagonal shading added. Published state.

Edition: 100. Printing: 75. Early 25, Platt 25, Roth 25.

Plate exists: JST. Copper.

Tissue unknown.

"This was made shortly after my arrival in New York. I am sure he was less awed by the great city than I was at the time" (JS 1945).

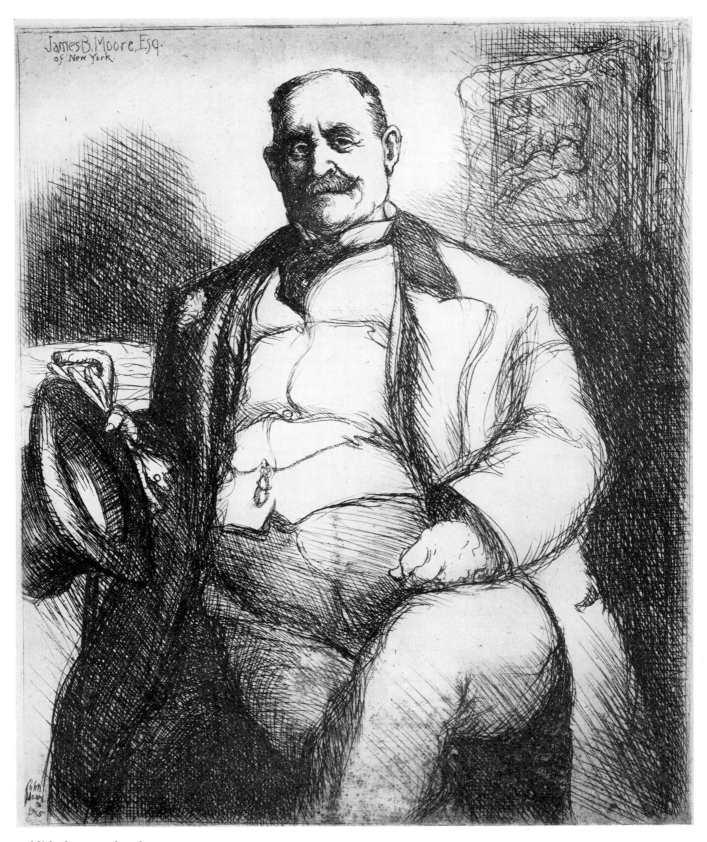

published state, reduced

126. JAMES B. MOORE, ESQ.

1905. In plate.

Etching. 306 x 253 mm. (12 x 10 inches) plate; 285 x 235 mm. (11¼ x 9¼ inches) picture.

States:

1. Hair completely across the top of the head. Moustache dark and drooping below corners of the mouth. Ph (on verso of 1st state of 104).

2. Entire face removed and new face drawn, with head bald at part line, hair at sides. Moustache light and turned up at corners. Large highlight under right eye. Highlight on left upper lapel. JST (Quinn proof).

3. Highlight under right eye mostly shaded, leaving only a crescent. Published state. An entire counterproof in Ph is the same as this published state. The Bowdoin print, inscribed "working proof," also appears to be of this state.

Edition: 100. Printing: 25. Early 25.

Plate exists: JST. Copper. No. 115, canceled, etched on verso.

No tissue.

"My dear Mr. Quinn—I have just unearthed this in going through some old proofs. It was drawn on copper from the life. It represents James B. Moore who, as proprietor of The Cafe Francis, Bohemian Rendezvous, figures quite importantly in the artistic life of New York. His house, 'The Secret Lair Beyond the Moat,' 450 West 23rd Street, was the scene of such gay 'parties' as few of us who participated can hope or wish to see again. He dozed in the chair while I drew the copper. I got a good portrait of his burly body—but the head shows the difficulty I had making a representation of the man awake from the sitter asleep" (JS inscription on 2nd state proof for John Quinn, April 27, 1911; see *NYS*, p. 530). "A typical New York bon vivant Tammany man, a friend and patron of the artists. He was keen on enterprising artists and bought some pictures. But he couldn't keep up his restaurant" (JS 1945). There is a photograph of Moore in the Sloan file at Mod.

"New York City Life" Set

Sloan's original set of "New York City Life" etchings included the following ten prints of 1905–06:

Connoisseurs of Prints (127) *Women's Page* (132)
Fifth Avenue Critics (128) *Turning Out the Light* (134)
Show Case (129) *Man, Wife, and Child* (135)
Man Monkey (130) *Roofs, Summer Night* (137)
Fun, One Cent (131) *The Little Bride* (138)

For some time, as mentioned frequently in his diaries (*NYS*), he insisted on their being sold as an integral set. Finally, faced with a lack of sales, he broke down and allowed them to be sold separately (Dec. 9, 1908, *NYS*, p. 269). Later he did three more prints in the same format, horizontal 5 x 7 inch plate (one is 4 x 6 inches), and generally considered them as part of the set:

Girl and Beggar (150)
Night Windows (152)
Picture Buyer (153)

In March 1906, at the invitation of the etcher Charles Mielatz, he sent the set of ten to the American Water Color Society exhibition in New York. Four of them were promptly rejected for being "vulgar" and "indecent." Mielatz was embarrassed and Sloan was furious. He wrote asking for all the rest to be withdrawn, "for it will be found that the same vulgar taint is in them all" (*NYS*, p. 33, and letters in JST). A reviewer in *The Scrip* (*1*, July 1906, 328) mentions four of the six prints that remained on display: *Fifth Avenue Critics, Man Monkey, Show Case,* and *Fun, One Cent.* Sloan also mentions the incident in his "Autobiographical Notes," p. 385. A similar situation again occurred in early 1911, when the prints were sent to an exhibition in Columbus, Ohio (*NYS*, pp. 500, 502).

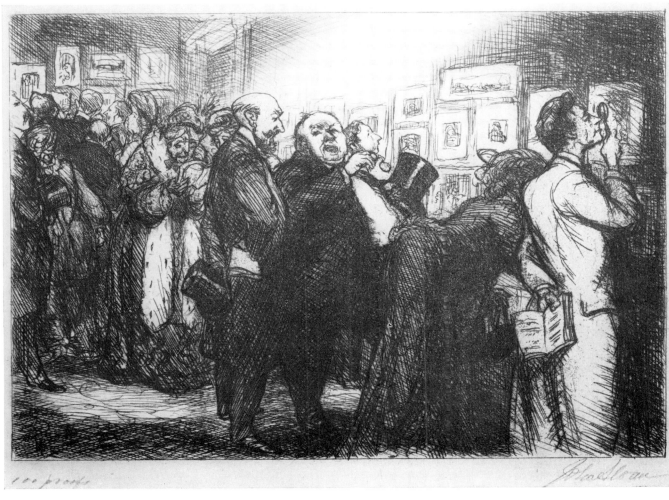

100 proofs John Sloan

only state

127. CONNOISSEURS OF PRINTS

1905. Proof dated February 1905. JST.

"New York City Life" series.

Etching. 127 x 178 mm. (5 x 7 inches) plate; 114 x 170 (4½ x 6¾ inches) picture.

Only state. Published state. Despite the presence of much visible reworking on the plate, no early state proofs have been discovered.

Edition: 100. Printing: 105. Early 65, Roth 40. Also Gaston 25, evidently all destroyed. The Peters brothers are known to have printed from this plate.

Plate exists: JST. Copper. Steel-faced.

Tissue: Ph.

"The first of my New York life plates. It shows an exhibition of prints that were to be auctioned at the old American Art Galleries on 23rd Street. The first of a series of 'Connoisseurs' planned but never made" (Dart 34). "Henri and I talked of making a series of connoisseurs, he was so pleased with this one" (JS 1945). "I had a call from Guy Pène du Bois of the *American*. He is looking for pictures to illustrate a story on the Columbus [Ohio] exhibition which is now on. . . . I loaned [him] a proof of *Connoisseurs* as one of the set which was suppressed" (Jan. 27, 1911, *NYS*, p. 502).

M. C. Rueppel ("Graphic Art of Davies and Sloan," University of Wisconsin, doctoral dissertation, 1956, p. 215) has pointed out the possible adaptation of this subject from Daumier's lithograph, "*Eh! bien en regardant ce tableau . . .*," of June 1865 (Delteil 3445).

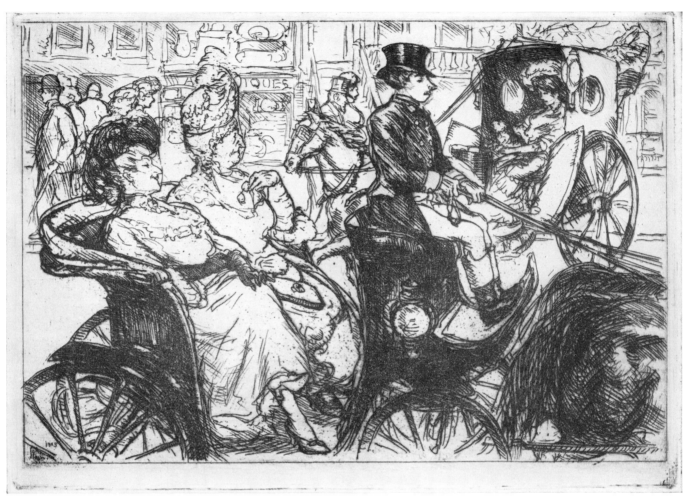

first state

128. FIFTH AVENUE CRITICS

1905. Proof of 9th state dated June 1905. Collection of Cecil C. Bell. The print was probably begun several months earlier. "New York City Life" series.

Alternative titles: *Connoisseurs of Virtue; Une Rue à New-York*.

Etching. 127 x 177 mm. (5 x 7 inches) plate; 115 x 170 mm. (4½ x 6¾ inches) picture.

States:

1. Lightly drawn. Ph, JST. Illustrated.
2. Much additional shading on entire left side, upper right side, and coachman's face. Eye closed. Ph (with pen).
3. Additional work on coachman's face; eyes appear open; heavy, almost vertical line beside mouth and nose; horizontal line back from corner of mouth. Darker shading, with highlight, behind carriage at left. Ph (with pen).
4. Coachman's eye and vertical line removed. Spot added for an eye. Added shading beside mouth. Ph, JST–2.
5. Shading added at midriff of woman with tall hat. Ph, JST.
6. Light shading on cheeks of both women at left front. Ph (labeled 4th state), JST.
7. Coachman's eye open. Light horizontal line under eye. Ph (labeled 5th state).
8. Small highlight on right side of coachman's seat is covered by shading. Ph (labeled 6th state), JST. Proofs of this state have the penciled title *Connoisseurs of Virtue*.
9. Coachman's face entirely changed from that of a young man to an older man with sideburns. Face quite darkly shaded. Collection of Cecil C. Bell, Staten Island, N.Y. Inscribed "Connoisseurs of Virtue / one of (3) proofs in this state of plate. J.S. / June 1905."
10. Shading on coachman's nose and chin burnished lighter. Very light shading has disappeared from hair of center woman and from triangular white area at center, between woman's skirt, coachman's seat, and horse's leg. (These latter two changes may be due only to wear in the plate.) Regular published state.
11. Inscriptions added beneath lower picture frame: "John Sloan inv. et sc." at lower left, "UNE RUE À NEW-YORK" at lower center, "Imp. A. Porcabeuf, Paris" at lower right. Published in the *Gazette des Beaux-Arts* (51,

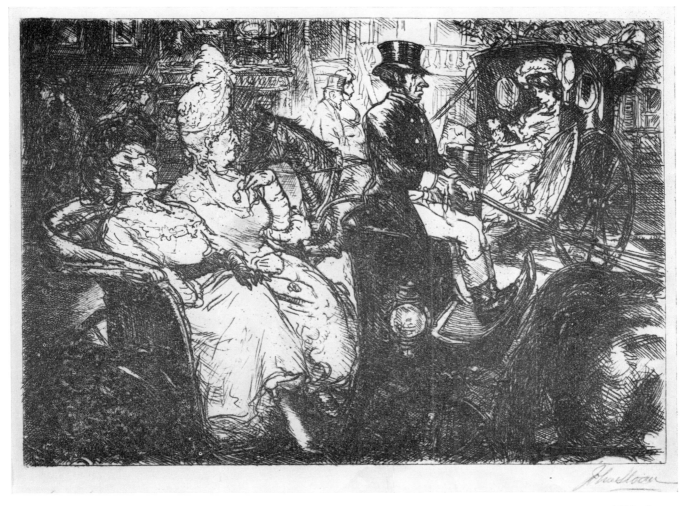

Paris, 4th period, Tome 11, Oct. 1909, facing p. 330). The inscriptions were subsequently removed from the plate.

Later printings are indistinguishable from the 10th state. Edition: 100 (in the 10th state). The size of the 11th state edition is unknown, as the records of the *Gazette des Beaux-Arts* prior to 1928 are missing. Jean Adhémar of the Bibliothèque Nationale advises me that the printing of each issue was about 3,000 at that time. This edition was printed on an inexpensive laid paper which has become quite brittle with age. The *Gazette* is also known to have pulled a presumably small number of special proofs in the 10th state, before the inscriptions. These are on a medium weight imperial japan paper and unsigned. Printing (10th state): 110. Early 80, White 30. The plate is known to have been printed by Peters and Platt.

Plate exists: JST. Copper. Steel-faced.

Tissue. Ph.

"These were typical of the fashionable ladies who used to drive up and down the Avenue about four o'clock of an afternoon, showing themselves and criticizing others" (Dart 35). "These two fashionable ladies used to drive up and down Fifth Avenue every day. I think the portraits are good and people have recognized them years later. In 1940 [April] I painted a picture

from the etching. [Now in the collection of Miss Ruth Martin.] Used a projector to throw the print up on a screen. Following the connoisseur idea, the proposed title of this plate had been *Connoisseurs of Fifth Avenue* [or *Connoisseurs of Virtue*]. But since the series seemed to lapse after this time, it assumed its present title. It became the most salable, popular, if that is not too strong a word, of all my prints" (JS 1945).

"Walter Pach called. Says that the *Gazette des Beaux Arts* (Paris) wants to borrow my copper plate (*Fifth Avenue Critics*) to print as supplement to his article. I wrote Peters in Philadelphia to send the plate to me" (March 11, 1909, *NYS*, p. 298).

"W. Pach called and I delivered the copper plate *Fifth Avenue Critics* to be forwarded to the *Gazette des Beaux Arts* in Paris" (March 15, 1909, *NYS*, p. 299).

"Walter Pach brought in my copper plate which has been in Paris. *Gazette des Beaux Arts* reprinted from it for the October number. The plate was held for duty in the Customs House here. Pach had all kinds of trouble getting it through. Quite funny exposure of the ignorance of the officials—plate made in this city! A copy of the *Gazette* which Pach gave me shows the plate, right well printed and with a French title lettered on it, *Une Rue à New York* or something of the sort" (Nov. 20, 1909, *NYS*, p. 353).

137

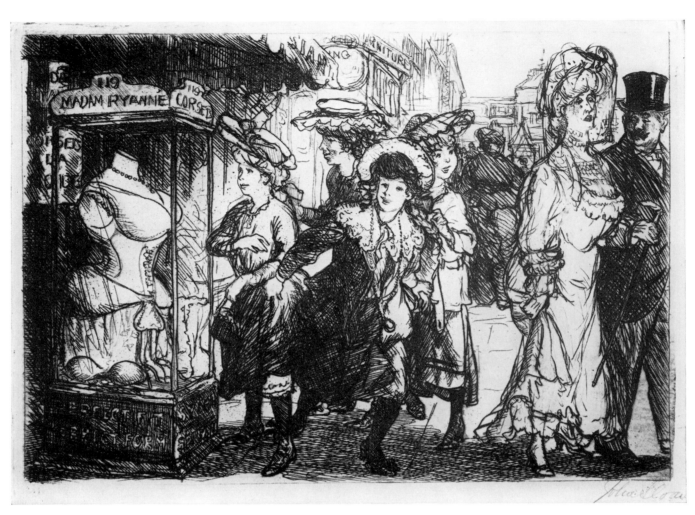

published state

129. THE SHOW CASE
1905. In plate.
"New York City Life" series.
Alternative titles: *Connoisseurage; Critics on Form.*
Etching. 127 x 178 mm. (5 x 7 inches) plate; 117 x 171 mm. (4½ x 6¾ inches) picture.
States:
1. Very lightly drawn. Ph ("only proof").
2. Much additional shading throughout. Almost complete. No shading on face of man at right. Spots of veil across face of woman at right. Ph, JST–4.
3. Man's face shaded. Spots of veil removed from woman's face. Light shading on face of girl at rear center. Published state.

Edition: 100. Printing: 75. Early 50, Roth 25. Peters printed from this plate. Gaston 25 proofs, presumably destroyed.
Plate exists: JST. Copper. Steel-faced. *"Connoisseurage"* scratched on verso.
Tissue and one sketch: Ph.

"Material from West 23rd Street and Sixth Avenue appealed to me at this time. The devices of the toilette, which were then secrets, created more excitement among the adolescents than they would today. Already it is apparent that the Connoisseurs motive was fading" (JS 1945).

138

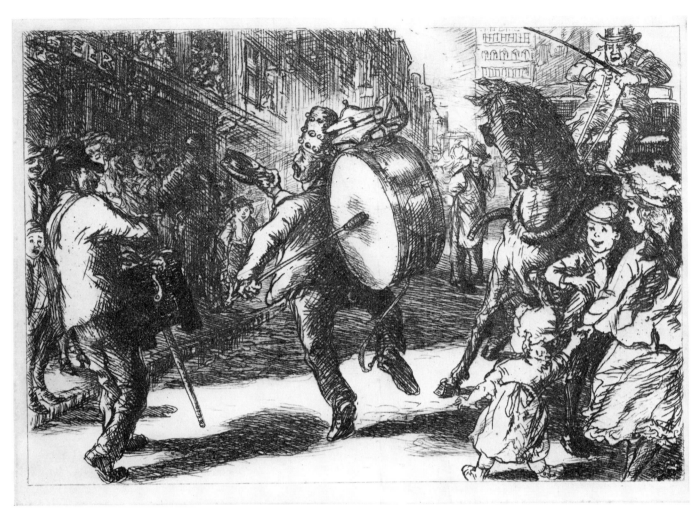

130. MAN MONKEY

1905. Proof of 2nd state dated June 13, 1905. JST.
"New York City Life" series.

Etching. 127 x 177 mm. (5 x 7 inches) plate; 115 x 169 mm. (4½ x 6¾ inches) picture.

States:

1. Nearly complete. Building behind drum rises to frame line. Drummer's hat covered with shading. No shading on drumhead. End of whip visible in sky at the end of the street. Sign on shop front at upper left reads "EER" in reverse. Ph–2 (one with pen), JST–2.

2. Shading added on drumhead and side of drum, and on curb between drummer and organ-grinder. Cross-hatching on coat of man between drummer and horse. Ph–2 (one with pen and erasures), JST.

3. Lines added in sky at end of street. Ph–2 (with pen and erasures).

4. Entire area at upper right and center and between drummer and organ-grinder scraped clean, except for one small boy. Ph–2 (one with pencil).

5. Figures between drummer and organ-grinder redrawn. Sky now shows above building behind drum. Shop front and windows at left covered with shading. "BEER" reads correctly. Front of drummer's hat redrawn lighter. Additional shading by turnbuckle on side of drum. Whip end removed. Published state.

Edition: 100. Printing: 100. Early 20, Platt 20, Roth 60. Peters printed from this plate. Gaston 25 proofs, presumably destroyed. Plate exists: JST. Copper. Steel-faced.

Tissue: Ph.

'In the side streets of the Chelsea and Greenwich Village districts, the one man band with hand organ accompanist furnished free entertainment to those who dropped no pennies. He worried the horse-drawn traffic of the time, but before many years the automobile and motor truck cleared him from the streets" (Dart 56). "The depth lines behind the men are close together and less deeply bitten" (JS 1945).

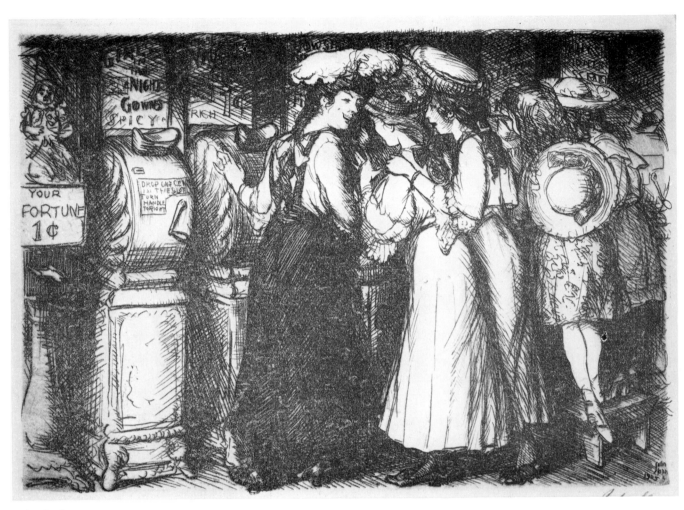

published state

131. FUN, ONE CENT

1905. In plate.

"New York City Life" series.

Etching. 127 x 178 mm. (5 x 7 inches) plate; 121 x 172 mm. (4¾ x 6¾) picture.

States:

1. Lightly drawn. Signs clearly visible on all movie machines, with diagonal shading only across them. Ph, JST–3.
2. Much additional cross-hatching at top and right side, covering signs at upper right, and elsewhere. Design added on dress of girl second from the right. Published state. Ph has two proofs in this state with pen trials by JS, mistakenly designated as additional states.)

Edition: 100. Printing: 60. Early 35, Platt 25. Peters printed from this plate.

Plate exists: JST. Copper.

Tissue: Ph (also one similar tissue not used).

"The Nickelodeon, with its hand-cranked moving photographs, was one of the attractions preceding the moving picture theatres. The one in which I garnered this bouquet of laughing girls was for many years on 14th Street near Third Avenue" (JS 1945). "23rd Street near 7th Avenue" (inscription on proof for John Quinn, ca. 1911; JST). "23rd Street near 9th Avenue" (inscription on Bowdoin proof).

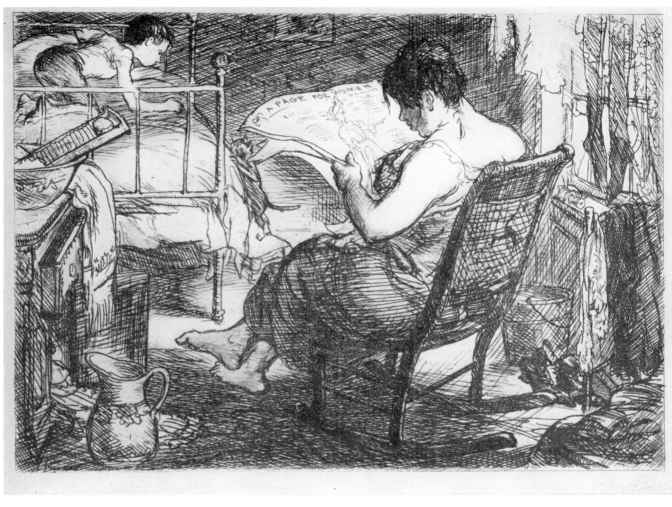

132. THE WOMEN'S PAGE

1905. In plate.

"New York City Life" series.

Etching. 127 x 177 mm. (5 x 7 inches) plate; 115 x 167 mm. (4½ x 6½ inches) picture.

States:

1. Nearly complete. Right side of boy's pants is blank. Ph, JST–2.
2. Additional shading on boy's pants and hair, and bed beneath boy. Boy's right shoulder and back burnished lighter. Published state.

Edition: 100. Printing: 100. Early 35, Roth 65. Peters and Platt printed from this plate. Gaston is also known to have had it. Sloan's 1931 personal inventory lists fourteen proofs of "Frenchman's printing," which have probably been subsequently destroyed.

Plate exists: JST Copper. Steel-faced.

Tissue and one sketch; Ph.

"Observation of life in furnished rooms back of my 23rd Street studio inspired many of my etchings and paintings of this period. Done with sympathy but no 'social consciousness'" (JS 1945). It was chosen by Sloan as one of his favorite prints, "perhaps the best all-around example, both in subject matter and treatment" (Carl Zigrosser quoting Sloan, unpublished notes, 1950).

Sloan: "The psychologists say we all have a little peeper instinct, and that's a result of peeping—the life across from me when I had a studio on 23rd Street. This woman in this sordid room, sordidly dressed—undressed—with a poor little kid crawling around on a bed—reading the Women's Page, getting hints on fashion and housekeeping. That's all. It's the irony of that I was putting over. No intent to make a design, in this case, but to put over this ironical attitude that my mind assumed in regard to what my eye saw." Hayter: "It's a literary concept. That is to say, it is of the literature of life and not of life directly." Sloan: "The subject can be translated into words, in some way as I just did" (JS and W. S. Hayter, on NBC television program, May 13, 1949; recording and transcript, JST).

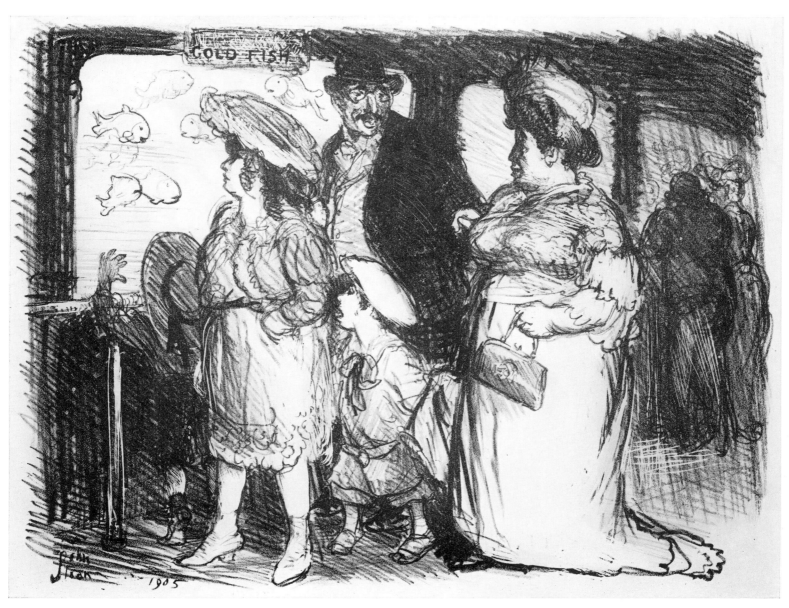

only state, reduced

133. GOLDFISH

1905. In stone. Dated middle of July 1905 in JS letters (below). Alternative title: *For Sure Gold Fishes* (Hudson Guild exhibition, 1916).

Lithograph. 265 x 356 mm. (10 x 14 inches) picture.

Only state. Published state. Ph, JST, WSFA, Detroit, Bowdoin.

Edition: 10 or less. Printing: 10 or less.

Stone presumably effaced.

Tissue unknown.

"First Litho, Printed for J.S. by E. W. Davis with *Judge* Publishing Co." (inscription on JST proof). "10 proofs (or less)" (inscription on Ph and Detroit proofs). "10 proofs—unpublished lithograph" (inscription on WSFA proof). E. W. Davis, father of Stuart Davis and a friend of Sloan's from Philadelphia days, was an editor, not a printer. He evidently took Sloan to the office of *Judge,* a satirical magazine he worked for in New York, where Sloan drew on the stone, which was then etched and printed by a professional pressman.

"Davis says he will have proofs of my lithograph tomorrow so I'll drop in on him at *Judge* and go to lunch with him" (JS letter to Dolly, n.d., except for "Sunday," but evidently written July 23, 1905). "Yesterday I went to *Judge* and got proofs of my first lithograph. They are pretty good" (JS letter to Dolly, July 25, 1905).

"I gave J. Moore a proof of my lithograph. I have decided that it is called *Rebecca at the Aquarium* (instead of *at the Well*)" (JS letter to Dolly, July 29, 1905). "I'm glad that I have made the first lithograph of the crowd. In case they all start, it gives me prestige, makes me the father of them. In fact I want to go it alone if possible" (JS letter to Dolly, Aug. 9, 1905). See also "Lithography," p. 155.

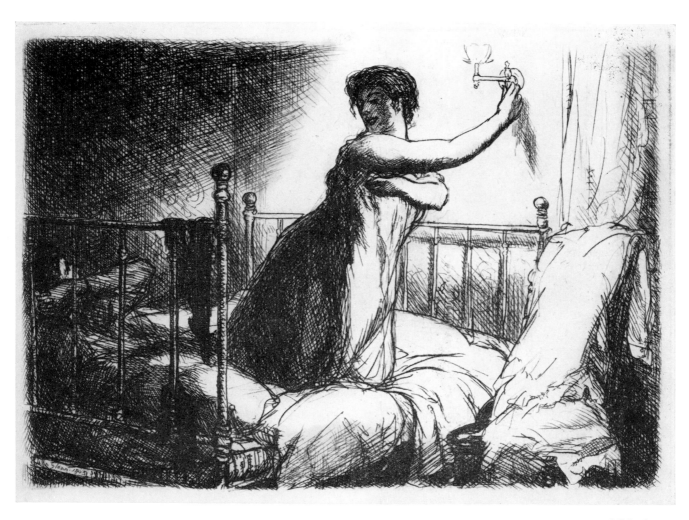

published state

134. TURNING OUT THE LIGHT

1905. Dated July 30, 1905, in JS letter (below).
"New York City Life" series.
Etching. 127 x 178 mm. (5 x 7 inches) plate.
States:

1. Relatively lightly drawn. Woman's mouth thin and closed. Ph, JST—3. Illustrated, p. 144.

2. Shading added on back wall, on man and bed beneath him, on woman's nightgown, and on wall beneath woman's hand. Stockings added, hanging on front bedstead. Additional shading on woman's hands and elsewhere. Ph, JST—4.

3. Woman's mouth now full-lipped. Slight additional shading on her chin. Published state. Illustrated.
Edition: 100. Printing: 110. Early 45, White 20, Roth 45. Peters and Platt both printed from this plate. Gaston is known to have had it. Sloan's 1931 personal inventory lists fifteen proofs of "Frenchman's printing," which have probably been subsequently destroyed.
Plate exists: JST. Copper. Steel-faced.
Tissue: Ph. Illustrated, p. 144.

"I made a plate—the woman turning out the light (I don't know whether you saw the sketch or not). It seems as tho' it might be all right but it's a little too soon to judge. This has taken all my working time since yesterday afternoon when I wrote you last" (JS letter to Dolly, July 31, 1905).

"This plate has 'charm.' A verdict handed down by a very well known art critic of those days, Russell Sturgis, to whom I showed this group of my New York etchings. Perhaps it has, I'm not interested" (Dart 37). "Called on Russell Sturgis and showed him my . . . etchings which he had asked to see. He looked them through but did not seem impressed. He says that my work lacks charm and seemed to suggest that many of the set of ten plates on New York life could be best expressed in words. I differ with him. He has the art critic's way of pointing out line combinations and light and shade arrangements as the 'charm' of the picture" (April 24, 1906, NYS, p. 31). "Went over to Mr. Sturgis's and left a set [of etchings] for him as a gift. If he does not value them now he may in the future if he lives long enough" (May 1, 1906, NYS, p. 32). "This morning, Russell Sturgis, Art Critic—returned to me as 'too costly a gift' the set of etchings which I had left for him—retaining only the *Turning Out the Light*, which was the one he liked. And thereby breaking a set" (May 3, 1906, NYS, p. 33).

"Rear 24th Street" (on proof for John Quinn, ca. 1911; JST). See also Sloan's "Autobiographical Notes," p. 385.

143

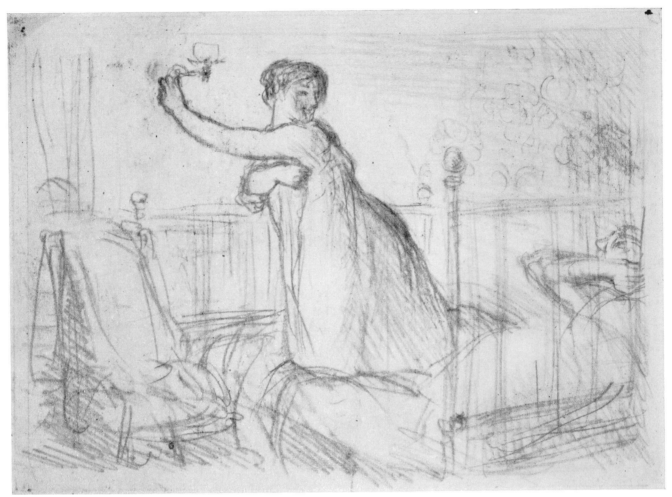

134, tissue

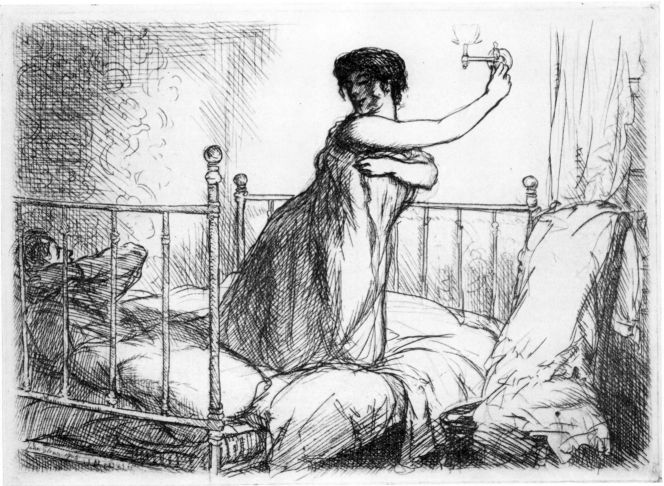

134, first state

144

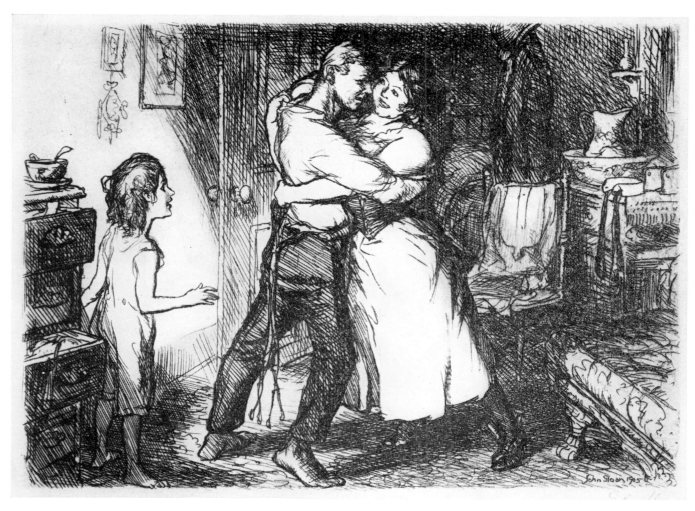

135. MAN, WIFE, AND CHILD

1905. In plate. Probably done August 6, 1905. See JS letter (below).

"New York City Life" series.

Alternative title: *Wrestling Bout.*

Etching. 127 x 177 mm. (5 x 7 inches) plate; 116 x 167 mm. (4½ x 6½ inches) picture.

States:

1. Nearly finished. Dark shading on man's cheek. Ph, JST–2.
2. Shading removed from man's cheek. Slight additional diagonal shading in middle of man's back. Man's nose burnished lighter. Ph, JST.
3. Additional shading on line of child's cheek, at corner of mouth, on forehead, and parallel to curved jawline. Ph, JST–2.
4. Child's jawline redrawn straight. Inner line of lip added in mouth. Fingers of child's right hand slightly shaded. Ph (labeled 3rd), JST–2.
5. Child's face redrawn, with shorter nose, removing vertical shading on cheek and inner line of lip. Slight shading on upper lip and chin. Published state.

Edition: 100. Printing: 85. Early 50, Roth 35. Peters is known to have had this plate.

Plate exists: JST. Copper. Steel-faced.

Tissue and two sketches: Ph.

"The conjugal status given by this title always has, I hope, prevented any improper interpretation being placed on this scene, which rewarded hours spent at my back windows. A small family in scant quarters" (JS 1945). "Rear 24th Street" (on proof for John Quinn, ca. 1911; JST).

"I worked on a new plate all night from 9 o'clock Sunday to 5:30 Monday morning [Aug. 6–7, 1905]. It is about finished, and Myers [Jerome] was in and liked it and so does Henri" (JS letter to Dolly, Aug. 8, 1905, a Tuesday). Although the etching is not identified in the letter, it is evidently this print. All of Sloan's prints of 1905, except *Turning Out the Light* (134) and *Man, Wife, and Child,* have the double-decker signature in the plate. These two have the horizontal signature, which was used on all subsequent signed plates. The change was clearly made between *Goldfish* (133) (double-decker), dated middle of July 1905, and *Turning Out the Light* (horizontal), dated July 30, 1905, both mentioned in Sloan's letters. This is the only other 1905 print with the latter signature. It does not seem likely that Sloan switched back and forth between the two signature styles. He must have decided on the horizontal style and stuck with it from then on.

' I did a little tinkering on *Man, Wife, and Child* plate (March 19, 1906, *NYS,* p. 23).

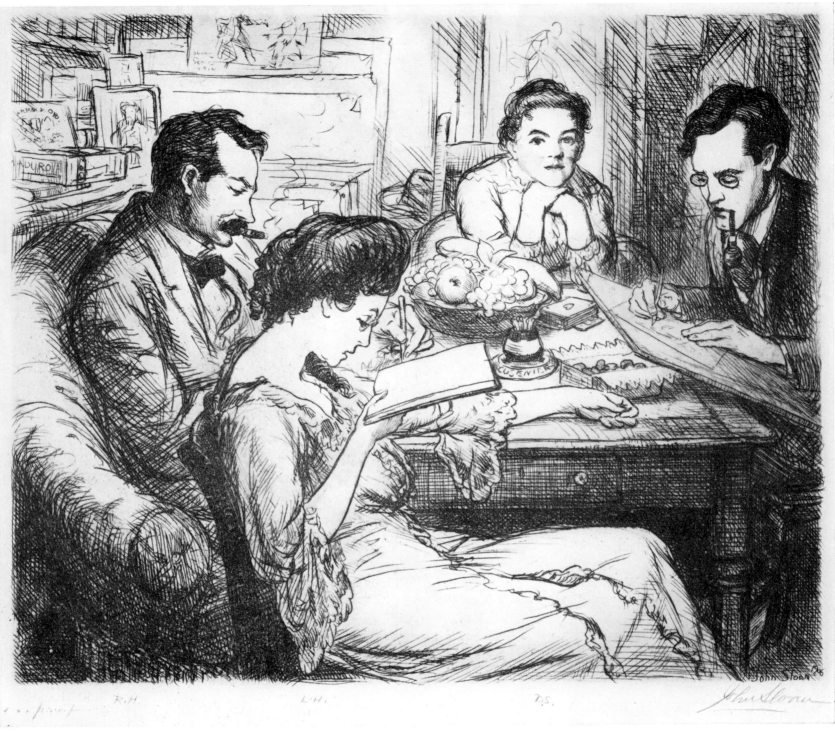

published state

136. MEMORY

1906. Dated January 14, 1906, in JS diary.
Alternative titles: *Memory of Last Year; Family Group.*
Etching. 191 x 227 mm. (7½ x 9 inches) plate.
States:

1. Design nearly complete. Dolly's hair flat against side of head. Sloan's head as shown. Illustrated. Ph, JST (with pencil), Philip Berman (Allentown, Pa.).
2. Dolly's hair extended slightly beyond ears. Sloan's head flattened at top. Light shading on Dolly's cheeks and under nose. Baldness at Sloan's hair part-line covered. Ph, JST with pencil).
3. Sloan's pipe shifted to front instead of below mouth. Ph (with pencil).

4. Sloan's head, hands, pipe, and drawing board entirely redrawn, as in published state. Ph, JST–6, Philip Berman (Allentown, Pa.).
5. Linda's right hand beneath book slightly shaded. Ph.
6. Curl of hair added in the upper part of Linda Henri's ear. (Ph proof annotated by JS, "Sixth State and Last.") Published state.

Edition: 100. Printing: 110. Early 45, Platt 25, White 20, Roth 20. Peters is known to have had this plate.
Plate exists: JST. Copper, once steel-faced, subsequently removed.
Tissue and one sketch: Ph.

"A memorial plate made after Linda Henri died, an intimate

146

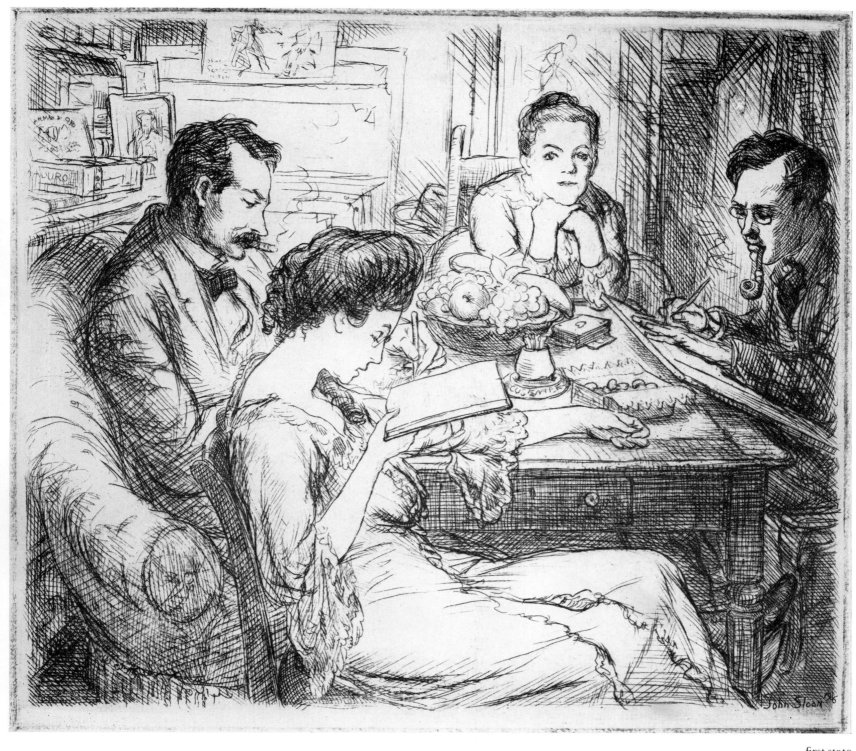

first state

print which has become one of the most popular of my etchings"
(Dart 40). The subjects are, from left to right, Robert Henri,
Linda Henri, Dolly Sloan, and John Sloan. Henri, incidentally,
really was left-handed. This is not an error.

"Henri was always amazed that I had remembered her ges-
ture: her hand rolling her fingers as she read aloud. It was made
purely from memory" (JS 1945). "Started sketch for etching—
memory of the evenings of last year at Henri's, when about the
old table from the Charcoal Club and 806 Walnut Street, would
gather Mrs. Henri (just died from us), Henri, Dolly (my wife)
and myself. Mrs. Henri reading aloud" (Jan. 14, 1906, *NYS,* p.
6). "Went on with sketch for *Family* group plate" (Jan. 15, 1906,
NYS, p. 6). "Henri is pleased with the *Family Group* plate so far
as 'tis finished" (Jan. 16, 1906, *NYS,* p. 7). "Today proved the

Family etched plate. Henri came in at 5:30 and liked the mem-
ory of Mrs. Henri and thinks the plate is a good one. I can im-
prove the portrait of Dolly in it. And hope that the plate will
go on and be one of the important ones" (Jan. 17, 1906, *NYS,* p.
7). "Henri made a sketch to help me out in my portrait which
I'm attempting with much disaster in the *Family* group etching"
(Jan. 29, 1906, *NYS,* p. 9). "Worked on the plate till 2 o'clock.
The head of myself is perhaps passable, at any rate looks some-
what like me, I think. Tho' it seems easier to suit myself than
any one else" (Jan. 30, 1906, *NYS,* pp. 9–10). "The proofs arrived
from Peters of the Mrs. Henri and group plate. They look very
well and Henri seems to be pleased with them" (Feb. 20, 1906,
NYS, p. 15).

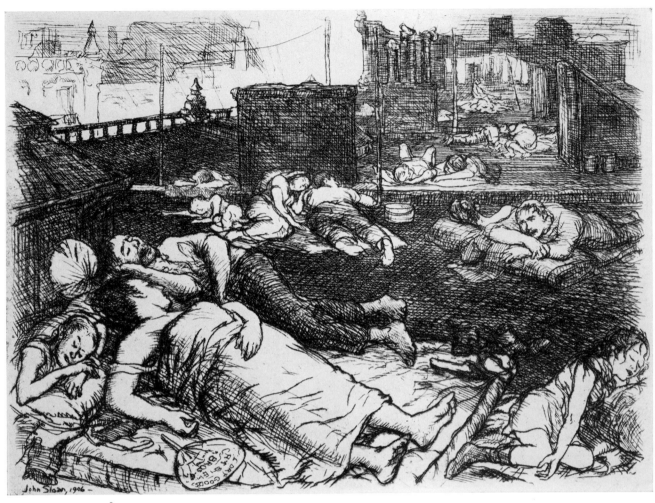

published state

137. ROOFS, SUMMER NIGHT

1906. Dated February 14, 1906, in JS diary.
"New York City Life" series.
Etching. 135 x 180 mm. (5¼ x 7 inches) plate.
States:

1. Nearly complete. No shading on face of woman at front center. Ph, JST–6.
2. Shading added around the edge of woman's face. Beard stubble added to man behind her. Additional shading on chimney at center, on man's two arms, woman's left hand, rain gutter at left, and elsewhere. Published state. (The Ph proofs labeled 1st, 2nd, and 3rd states are all of this 2nd state, with variations in inking only.)

Edition: 100. Printing: 110. Early 50, White 25, Roth 35. Peters and Platt printed from this plate.
Plate exists: JST. Copper. Steel-faced.
Tissue: Ph.

"I have always liked to watch the people in the summer, especially the way they live on the roofs. For many years I have not seen the summer life of the city, which has perhaps been better for my health than my production of city life etchings" (Dart 38). "The city seems more human in the summer" (JS 1945). "Start work on *Sleeping on Roofs* etching" (Feb. 14, 1906, *NYS*, p. 13). "I worked 'till four A.M. on the *Roofs, Summer Night* etching" (Feb. 16, 1906, *NYS*, p. 13). "I printed eight proofs of the *Roof* plate" (Feb. 17, 1906, *NYS*, p. 14).

148

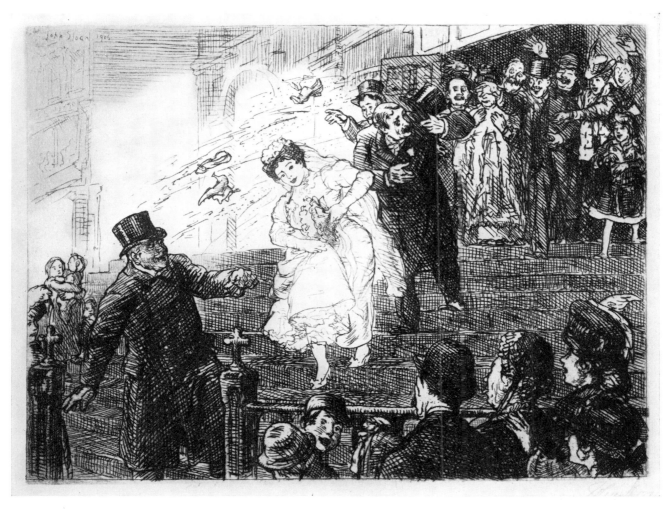

138. THE LITTLE BRIDE

1906. Dated February 18, 1906, in JS diary.

"New York City Life" series.

Etching. 134 x 179 mm. (5¼ x 7 inches) plate; 121 x 168 mm. (4¾ x 6¾ inches) picture.

Only state. Published state. Proofs in Ph and JST marked "working proof" show no state difference.

Edition: 100. Printing: 85. Early 55, Roth 30. Peters and Platt had this plate. Sloan's personal inventory in 1931 lists thirteen Peters proofs and ten Platt proofs.

Plate exists: JST. Copper. Steel-faced.

Tissue: Ph.

"Back in 1906 there was a considerable French population north of 23rd Street, and the church near Proctor's Theatre was known as the French Church. The stone steps down which these newlyweds are escaping have since been removed. I hope the couple lived happy ever after!" (JS 1945). "St. Vincent de Paul Church 23rd Street" (on proof for John Quinn, ca. 1911; JST). "Sat until 1:30 [A.M.] making sketch on the *Bride* plate which I think of doing" (Feb. 18, 1906, *NYS,* p. 15). "Went on with the *Little Bride* plate, finishing the sketch on the plate" (Feb. 19, 1906, JS diary, unpublished). "Home and worked on *Little Bride* plate" (Feb. 21, 1906, *NYS,* p. 15). "Proved the *Little Bride* plate and it seems all right to me" (Feb. 22, 1906, *NYS,* p. 15).

139. MOTHER

1906. Dated August 24, 1906, in JS diary.
Etching. 228 x 192 mm. (9 x 7½ inches) plate.
States:

1. Nearly finished. Forehead and cheeks almost blank. Blank highlight on pillow to right of head. Ph–4, JST–3. Illustrated, p. 152.

2. Forehead and cheeks covered with a network of light lines. Additional diagonals, lower left to upper right on pillow. Ph (fragment), JST (fragment).

3. Light shading, upper left to lower right, on pillow highlight. Shading added on lower left corner of fan, under dog's eye, and across Mrs. Sloan's midriff. Published state. Despite the large amount of work on this plate and the large number of trial proofs, these appear to be the only states. I have some question whether the 1st state described here represents the 1906 proofs. (See JS comments below.)

Edition: 100. Printing: 70. Early 35, White 15, Roth 20. Peters printed from this plate. Sloan's 1931 personal inventory lists proofs by both Peters and Platt. JST.

Plate exists: JST. Copper. Once steel-faced, subsequently removed.

Tissue: Two in Ph, one for head, one for body. Sloan may also have been aided by the photograph he took of his mother on December 23, 1906 (reproduced in *NYS*, p. 57).

"For many years my mother was an invalid, but a happy one, her interest in life and wit and humor were unfailing to the end" (Dart 39). "Started a new drawing of Mother on tissue paper for tracing on plate. Laid ground on plate under difficulties on the kitchen stove—they—Dolly and Bess—were ironing clothes and as there is no gas in the house, I was forced to use the uneven heat of the stove. Consequently when in the evening I was ready for the first biting my ground proved burned in places so I just let the acid bite away, hoping to fix at least a start on the plate" (Aug. 24, 1906, *NYS*, p. 60, written in Philadelphia). "Went into town and had Peters prove my plate of Mother. It may go on all right but the bad ground laying will cause me much labor in correcting wild bitings and over-bitten portions" (Aug. 25, 1906, *NYS*, p. 60). "Worked on etching of Mother this afternoon and evening" (Aug. 30, 1906, *NYS*, p. 61, in New York). "I have worked some on the etching of Mother, am not satisfied with it yet but have got to drop it and go on with this lot of cheap illustrating I have on hand" (JS letter to Dolly, Aug. 31, 1906; JST).

"I was working on the *My Mother* plate started last summer" (Feb. 18, 1907, *NYS*, p. 104). "Worked on *Mother* plate" (Feb. 19, 1907, *NYS*, p. 105). "Working on the *Mother* plate" (Feb. 23, 1907, *NYS*, p. 106). "Printed some new proofs of *Mother* plate in the afternoon. Am not very much satisfied with the state of the plate" (Feb. 28, 1907, *NYS*, p. 108).

"After dinner I rubbed down the plate of *Mother* taking out the head, which is unsatisfactory" (May 18, 1907, *NYS*, p. 129).

"I took up the plate of my mother which I started before she died [Mrs. Sloan died Aug. 28, 1907] and which I had laid aside, unsatisfied with the head. I had a small sketch of her which came in useful and I put in a head which is pretty nearly satisfactory to me" (June 22, 1910, *NYS*, p. 436). "I made several proofs of the *Mother* plate which I had put into nearly finished state last night" (June 23, 1910, *NYS*, p. 437). The dog's name was Dixie (*NYS*, p. 364). Exhibited in the Armory Show, New York, February 1913.

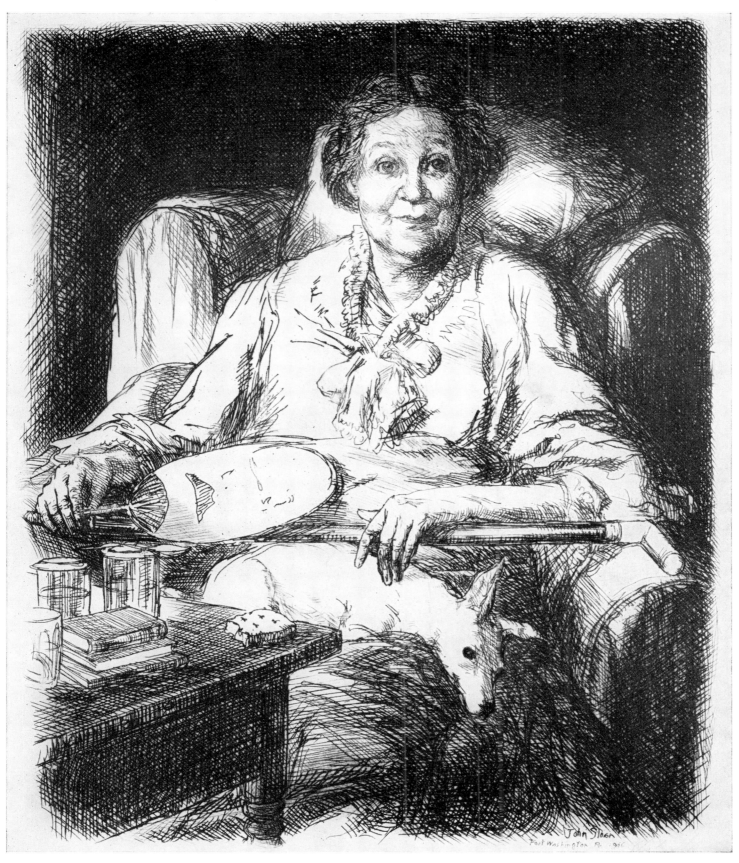

published state

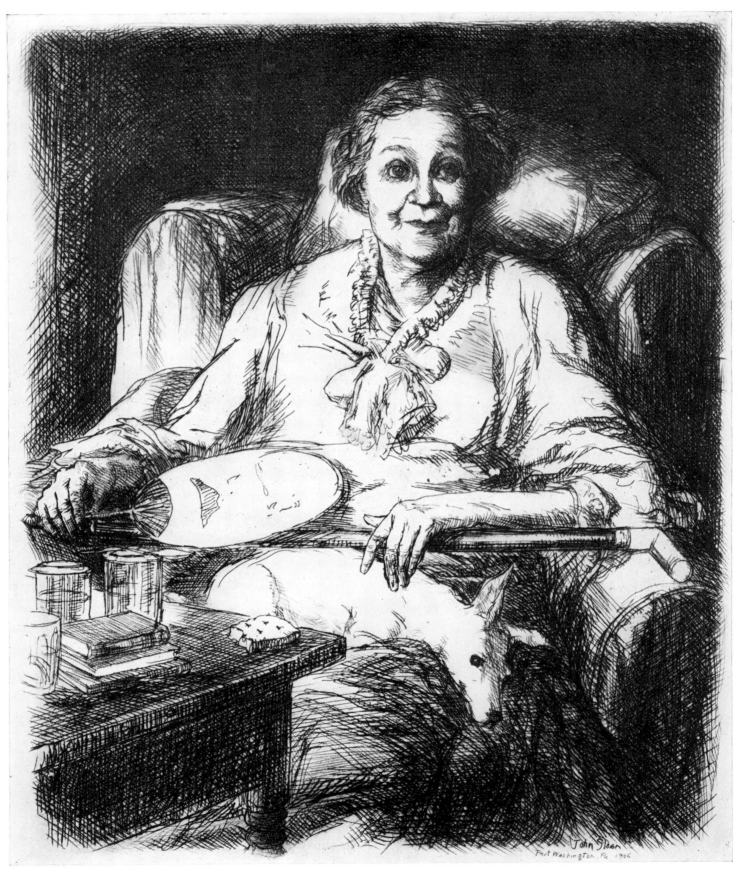

139, first state

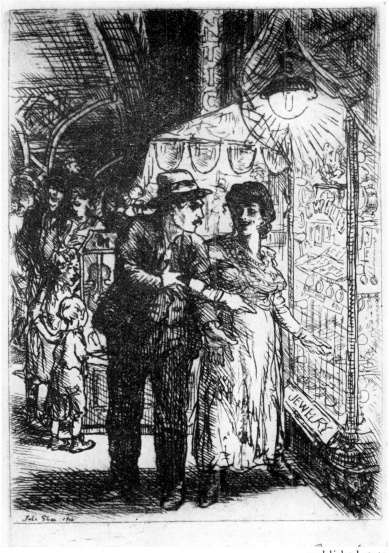

published state

140. JEWELRY STORE WINDOW

1906. Dated September 12, 1906, in JS diary.

Alternative title: *Carlotta's Indecision.*

Etching. 145 x 96 mm. (5¾ x 3¾ inches) plate; 125 x 88 mm. (5 x 3½ inches) picture.

States:

1. Nearly complete. Ph.
2. Additional shading on man's left hand, on flaps of awning, and in violin showcase behind man. Published state.

Edition: 100 in JS proofs. No edition for book. Printing: 100 JS proofs (signed, large paper). Early 80, Platt 20. An estimated 11,000 proofs were used as the frontispiece to Thomas A. Daly's *Canzoni* (Philadelphia, Catholic Standard & Times Publishing Co., 1906; LC copyright entry Oct 12, 1906). I have seen a copy of the book (JST), with the etching, imprinted "Eleventh Thousand, November 1914." A 14th edition of the same book (JST) has a halftone reproduction of the etching for a frontispiece, as do all copies of *Canzoni* and *Songs of Wedlock* (New York, 1916), which is completely reset, with additional poems and without Sloan's linecut illustrations. The publishers have kindly advised me that their records from the applicable years have not been retained. The impressions used in the book were all printed by Peters, and well printed, on wove, heavy white paper, of a page size 175 x 115 mm. (6¾ x 4½ inches).

Plate exists: JST. Copper, steel-faced.

Tissue: Ph.

"This plate was made for *Canzoni* by T. A. Daly, whose sentimentally humorous Dago dialect poems were nationally known" (JS 1945).

"Tom Daly writes from Philadelphia . . . would like me to illustrate a book of his poems which he is going to get out in the fall" (Aug. 2, 1906 *NYS*, p. 49). "Tom Daly came in. Suggested a frontispiece etching and he jumped at the idea" (Sept. 11, 1906, *NYS*, p. 62). "Peters, the plate printer, called . . . said that Daly had seen him and given him the order to print the plate for frontispiece. Dolly and I went down to the Lower East Side about 10 o'clock this evening and saw some of the interesting life at night. I wanted to see material for the Daly frontispiece, which I made a pencil sketch for on our return at 12 o'clock" (Sept. 12, 1906, *NYS*, p. 63). "Finished the plate for Daly's Poems and after making a few proofs took it downtown to 23 Barclay Street to have it steel faced for printing" (Sept. 14, 1906, *NYS*, p. 63). "*Canzoni* by T. A. Daly by mail today. Etching and illustrations mine" (Oct. 11, 1906, *NYS*, p. 69). "Here's 'our' book, John. This is one of the first copies off press. Yours ever / Tom Daly / Oct. 11 / '06" (inscription in JS copy; Ph). "Daly says *Canzoni* is in its fourth thousand and that there will be another payment to me when he gets accounts straightened" (March 1, 1907, *NYS*, p. 109).

Sloan's etching illustrates Daly's poem "Carlotta's Indecision" (*Canzoni*, pp. 17–18).

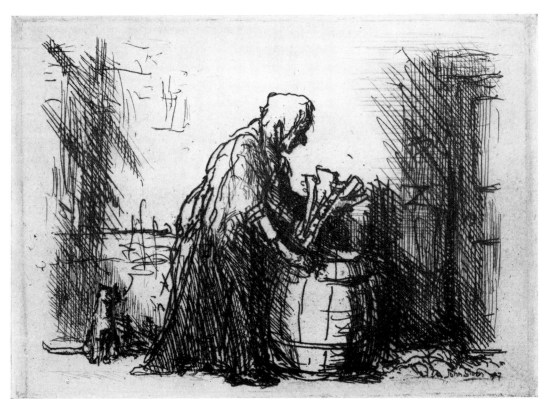

only state

141. TREASURE TROVE
1907. Dated January 15, 1907, in JS diary.
Alternative title: *Old Woman and Ash Barrel.*
Etching. 102 x 139 mm. (4 x 5½ inches) plate.
Only state. Published state.
Edition: 100. Printing: 81. Early 35, White 21, Roth 25.
Plate exists: JST. Copper, steel-faced. Trademark of platemaker,
"John Sellers & Sons / Sheffield England," embossed on verso of
plate.
No tissue.

 "This was a demonstration plate made to show the technical
routine of biting various kinds of linework. Sometimes admired
for its rather romantic treatment, but for the same reason not
much to my liking" (Dart 41). "Today Mr. King came in and I
grounded a plate and started and (in the evening) went on with
the etching of *Old Woman and the Ash Barrel,* finding corsets,
did it to show him the method of biting, laying ground, etc."
(Jan. 15, 1907, *NYS,* p. 99). "Finished plate of *Old Woman and
Ash Barrel* in the evening" (Jan. 16, 1907, *NYS,* p. 99). "I proved
the *Old Woman and Ash Barrel.* Gave Henri a proof, he likes
the plate" (Jan. 24, 1907, *NYS,* p. 101).

Sloan's first exposure to the process of lithography was in 1905, during the making of *Goldfish* (133). The experience evidently caught his imagination, for he went back to *Judge* magazine to get further information on materials (JS letter to Dolly, Aug. 1, 1905). He also bought a book on the subject: W D. Richmond, *The Grammar of Lithography* (2nd ed. London, 1880; now Ph). He has written the date, August 2, 1905, in the book and mentioned it in a letter to Dolly the next day. He started looking for a press but found it to be too expensive, and he refused to give up the etching press in exchange (JS letters to Dolly, Aug. 4 and 9, 1905). That was the end of the first experiment.

In May 1908 another opportunity arose. "Arthur G. Dove came in today and offered to let me have the use of his lithographic press and outfit while he is abroad. I accepted with joy" (*NYS*, p. 220; see also *NYS*, p. 97). By coincidence, Carl Moellmann, a casual friend and a professional lithographer (with the Ottman Lithography Co., Elizabethport, N.J.; May 21, 1908, unpublished diary), turned up the following day (*NYS*, p. 220; see also *NYS*, p. 102). The next few weeks were a scramble, in which Sloan and Moellmann struggled to produce five lithographs (142–145, 147) with inadequate materials. Arthur Dove did not return and presumably reclaim his press for more than a year (*NYS*, p. 328), but Sloan had done no further work in lithography.

His last four lithographs (192, 203, 209, 210) were done with the aid of the finest of professional lithographers, Bolton Brown, and show the competence of such professionalism. Brown mentioned briefly Sloan's use of a special hardened stearine crayon (Bolton Brown, *Lithography for Artists*, Chicago, 1930, p. 21). Sloan also discusses the process in *Gist* (pp. 186–87).

142. SIXTH AVENUE AND THIRTIETH
STREET
1908. Dated May 23, 1908, in JS diary.
Alternative titles: *6th Ave. & 27th St.; Street Woman; Girl of 27th Street; In the "Tenderloin"; Evening 27th St.*
Lithograph. 355 x 278 mm. (14 x 11 inches) design.
Only state. Published state. Ph, JST–11, WSFA, LC, Met, Bowdoin, Brooklyn, Detroit, British Museum, Rosenwald. (See notes below for special data on the Rosenwald proof.)
Edition: 20. Printing: ca. 20, by JS and Moellmann. There is a great deal of variation in the printing quality.
Stone effaced.
Tissue was made, now unknown.

"Started a tissue drawing to put on stone. A girl of the streets starting out of 27th Street, early night, little girls looking at her. Grained up a stone and got it ready to trace the sketch" (May 22, 1908, *NYS*, pp. 220–21). "I went on with my drawing on the *Girl of 27th Street* stone which seems to look as tho' it would turn out pretty well . . . I worked on the stone" (May 23, 1908, JS diary, unpublished). "Today I fussed with the press some, did some shopping for it, getting ready for another proving afternoon tomorrow when Moellmann is to come" (May 29, 1908, *NYS*, p. 222). "Moellmann spent the afternoon running off some impressions of the Street Woman or whatever I may call it" (May 30, 1908, *NYS*, p. 223).

On the proof now in the Rosenwald collection Sloan has made additions with litho crayon. The woman's two feet, pointed toward the lower left, have been erased and replaced with a single right foot, pointed toward the lower right. Shading has been added on the front of the dress to cover the outline of the left leg and change it to that of a right leg. The woman, instead of standing still with her head turned, is now striding forward with considerable force. Illustrated, p. 158.

The original version, that of all but this one proof, was reproduced in the *Craftsman* of December 1909 (*17*, 270). Two subsequent illustrations during Sloan's lifetime were of the redrawn proof (*The Arts, 11*, April 1927, 174; and *International Studio, 97*, Dec. 1930, 39). Sloan clearly submitted the redrawn version as representing his final thoughts on the subject. The first version has been submitted for publication twice since Sloan's death (Wilmington Society of the Fine Arts, "The Life and Times of John Sloan," exhibition catalogue, Wilmington, 1961, p. 42; and *NYS*, dust jacket).

Mr. Rosenwald purchased the redrawn proof in 1947 (Parke-Bernet Galleries, Jan. 7–8, 1947, lot 227) from the collection of Mrs. George A. Martin. It is the only Sloan print in that auction catalogue, and no special note is taken of it in the description.

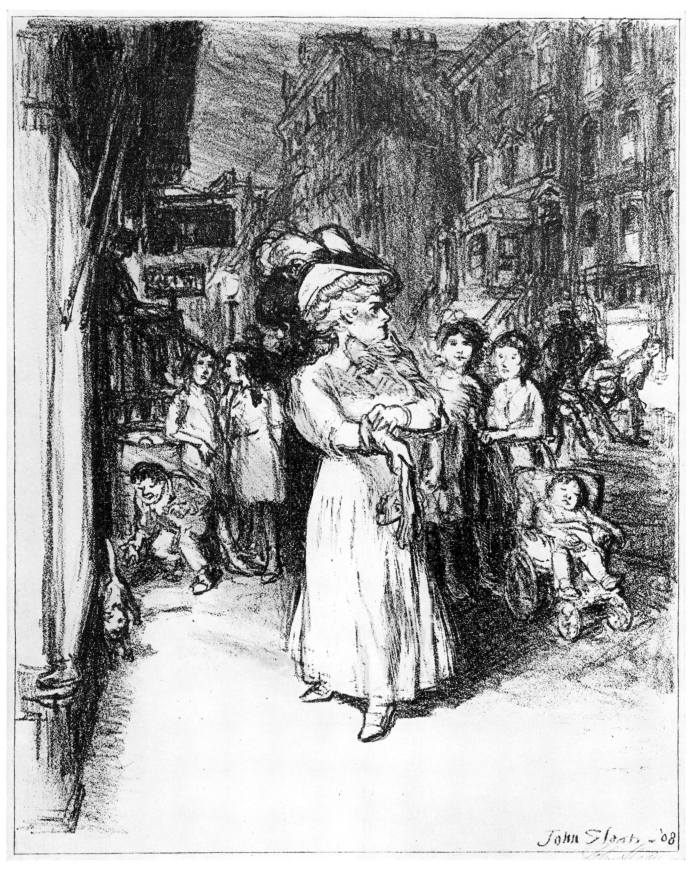

only state, reduced

157

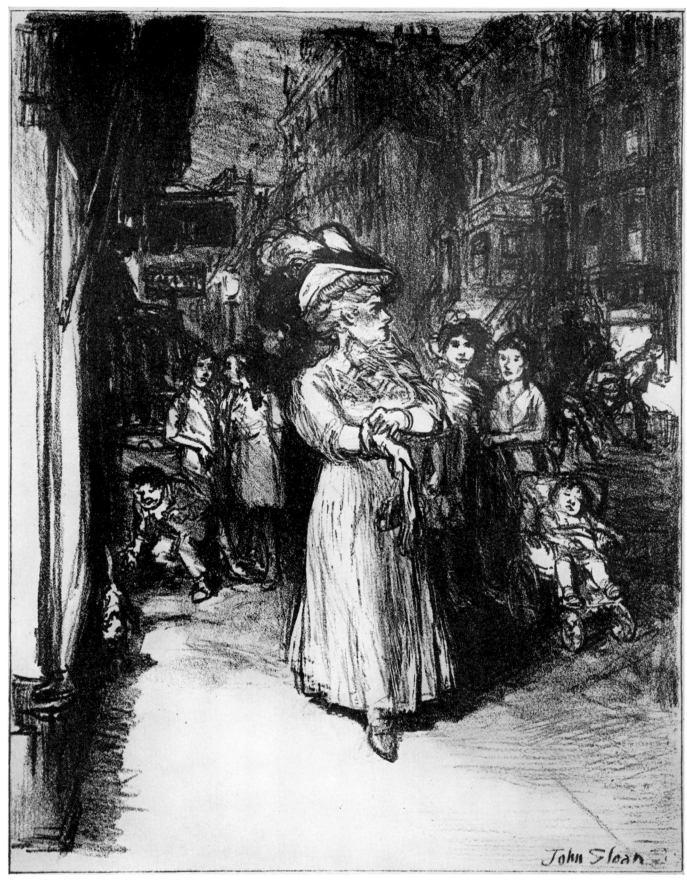

142, proof redrawn in crayon by Sloan, reduced

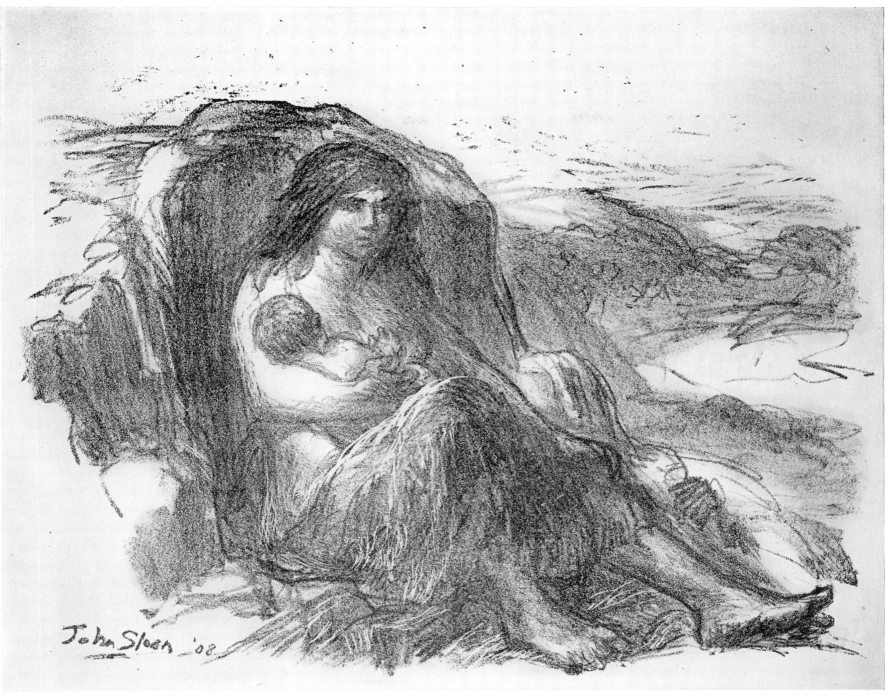

only state, reduced

143. MOTHER OF THE FIRST KING

1908. Dated May 24, 1908, in JS diary.
Alternative titles: *Prehistoric Mother; Primitive Mother*.
Lithograph. 361 x 478 mm. (14¼ x 18¾ inches) stone.
Only state. Ph, WSFA, Met, Detroit, Bowdoin.
Edition: 5. Printing: 5 presumably (see below), by JS and Moellmann.
Stone effaced.
No tissue.

"First Attempt at Litho Printing" (JS inscription on WSFA proof). "I ground a stone and made a drawing on it right on the slab where I'd ground it. Woman, primitive, sitting with child at breast. An old idea of mine, Mother of the Man who first made himself Chief or King of Men" (May 24, 1908, *NYS*, p. 221). "I went out in the morning and bought some things necessary for the proving of the litho stone this evening. . . . Moellmann came to dinner . . . then we got at the litho press. Moellmann found that the can of ink was too old to get any good results and we got no good proofs after struggling till after one o'clock in the morning. . . . We worked on the stone of the primitive woman and baby, *Mother of the First King*, as I don't want to risk the better drawing on the other stone [i.e. *Sixth Avenue and Thirtieth Street*]" (May 25, 1908, *NYS*, p. 221). "Walked down to Warren Street to Fuchs and Lang where I bought zinc and ink for the press. . . . Spent the afternoon trying to get a better proof of the stone but without much success. . . . Printed an impression or

two, not good. I'll save five proofs and grind off this stone tomorrow" (May 26 1908, *NYS*, p. 221, and unpublished).

The subject of this lithograph clearly derives from the following poem, which was found copied out in Sloan's hand in the files at JST.

THE MOTHER OF THE FIRST KING
(manuscript copy by John Sloan)

Long, long ago when Earth and Life were young
When Motherhood into the World brought Love
To stir ambition in the human heart
She sat upon her solitary rock
And dreamed again her dream of coming years.

No longer men were struggling for themselves
But led by one more wise, more strong than they
Were joined in bonds of common loyalty
And Selfish Love which left her sitting lone
Gave place to Love for Others, Ah how long!
How long was he upon his conquering way—
This man, the Nation builder of her dreams!

The man child foaled in her ambition stirred
Upon her lap—but she—she saw him not
Nor knew that she was mother to the King.

No author or source for the poem has been discovered, despite a diligent search. It is possible that it is by Sloan himself.

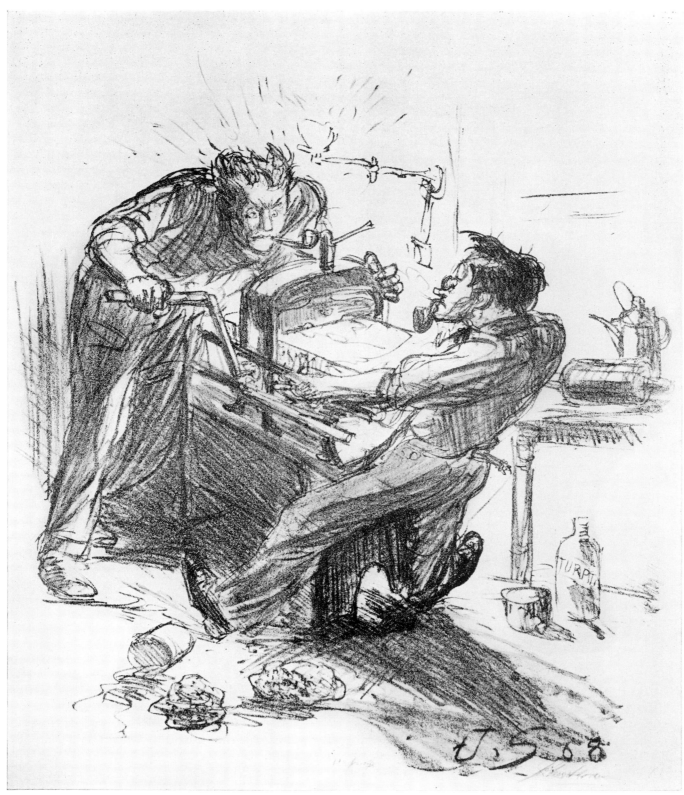

second state, reduced

144. AMATEUR LITHOGRAPHERS
1908. Dated May 27, 1908, in JS diary.
Alternative title: *Beginners.*
Lithograph. 469 x 395 mm. (18½ x 15½ inches) stone; 414 x 381 mm. (16½ x 15 inches) design.
States:
1. Nearly complete. Horizontal shading only on near end of press bench. Ph, JST, LC, Bowdoin.
2. Vertical shading added on end of bench. Lines added on floor under end of bench. Ph, JST–3, WSFA, Detroit.
Edition: 12 (includes both states, between which JS made no distinction). Printing: 12, by Moellmann and JS.

Stone presumably effaced.
No tissue.

The struggling printers are, of course, Moellmann at left and Sloan at right. "Amateur Lithographers / As is proved by this Proof!" (JS inscription on a weakly printed proof, 2nd state; JST). "Ground and grained a stone and cut down the table on which the litho press is fixed and got ready for Moellmann who came for dinner. I roughed in a drawing of himself and myself struggling with the proving. And after dinner we struggled to much better purpose as I had some decent ink to prove with. Moellmann and I worked with the litho press till about 1:30" (May 27, 1908, *NYS*, pp. 221–22).

preliminary sketch

145. THE LUISITANIA IN DOCK

1908. Dated June 1, 1908, in JS diary.
Lithograph. 364 x 471 mm. (14¼ x 18½ inches) design, 1st state
364 x 357 mm. (14¼ x 14 inches) design, 2nd state.
States:
1. Horizontal rectangular design, signature at lower left. Ph, JST, Met, Bowdoin, Detroit, Atlanta.
2. Design erased at left and right sides, now square. "J.S. 08," scraped in white at lower right. Ph, JST, WSFA, Detroit.

Edition: 1st state: "about 6 proofs" (Ph), "5 pfs" (Detroit); 2nd state: "20 proofs" (Ph), "10 proofs" (JST and Detroit). Printing by Moellmann and JS, not precisely known, as indicated by the JS inscriptions.
Stone presumably effaced.

Probably no tissue. Sketch in JST (no. S–309).

"I took a walk along the river as far as the upper Cunard pier where the big liner Lusitania is docked. Men and boys are selling postcards of the big boat to the people who come down to look at her. A right interesting sight to watch the small crowd on the street and the big boat back of them—with hot sunlight, for it is a very warm day" (May 24, 1908, *NYS*, p. 221). "I worked on the stone, Lusitania in Port" (June 1, 1908, *NYS*, p. 223). "After dinner, Moellmann and I proved a stone, the Lusitania in Dock, got a few decent proofs" (June 2, 1908, *NYS*, p. 223). "Proof after cutting off ends. This now seems to me to have been a mistake. John Sloan 3/20/1916" (JS inscription on 2nd state proof for John Quinn; JST).

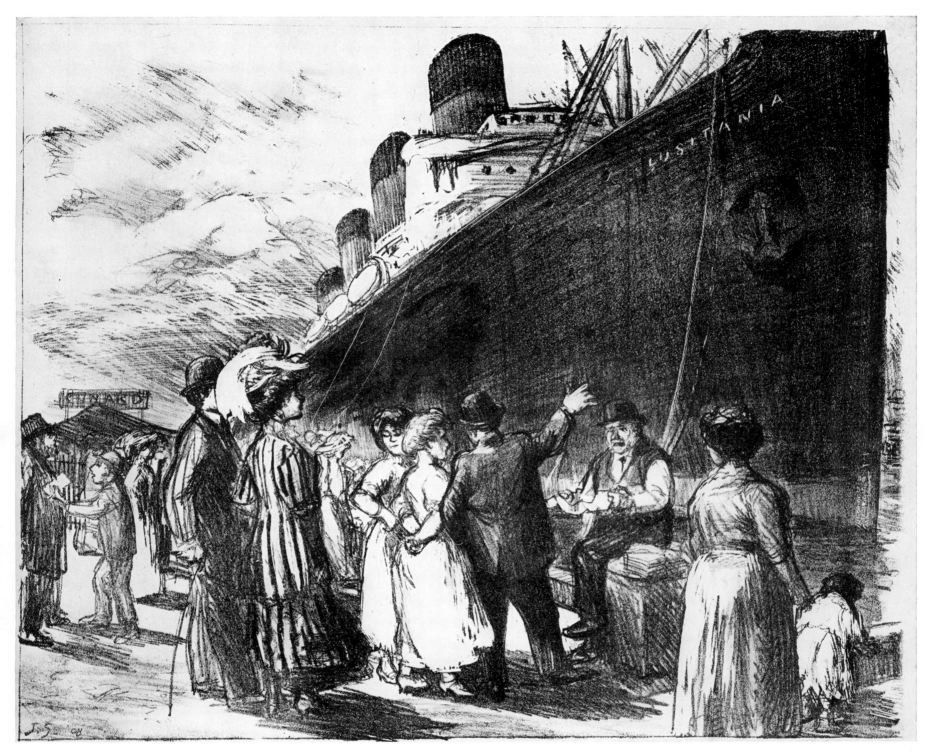

145, first state, reduced

162

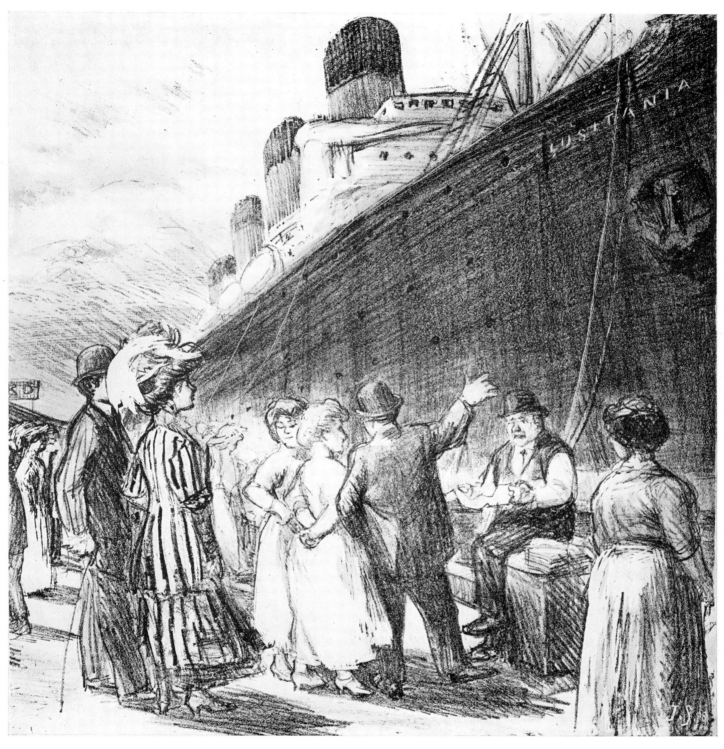

145, first state, reduced

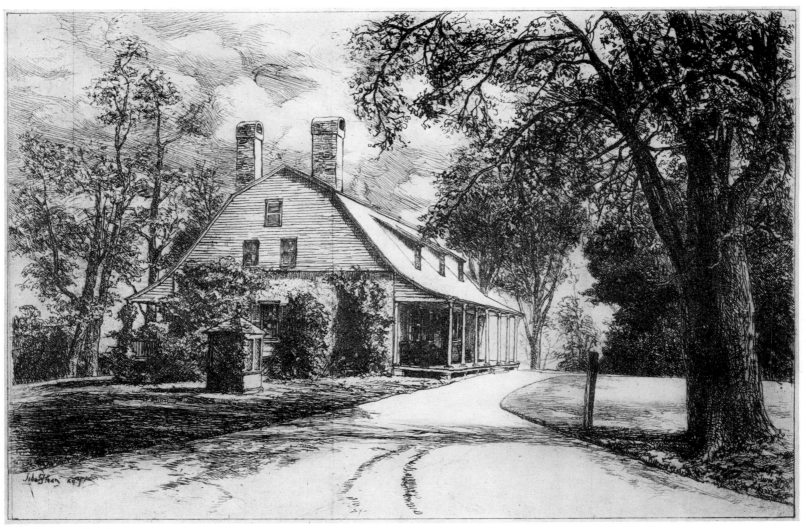

second state, reduced

146. THE VERPLANCK HOUSE

1908. Dated June 3, 1908, in JS diary.

Etching. 250 x 349 mm. (10 x 14 inches) platemark; 198 x 306 mm. (8 x 12 inches) picture.

States:

1. Before signature and clouds. Ph.
2. Signature and date added at lower left. Clouds added in sky. Additional shading elsewhere. Frame line added. Ph, JST, Bowdoin.

No edition. Printing (by Sloan) unknown but small. The Ph proof of the 2nd state is inscribed by JS, "one proof—plate destroyed (ground off)," which is clearly in error, as at least four proofs are known, as indicated above.

Plate destroyed.

Tissue and photograph unknown.

"Letter from Peters says that Mr. Buck would probably give me some plates to do for his work on historic houses, etc. Will go and see him" (Dec. 6, 1907, NYS, p. 170).

"Today I went to see Benjamin F. Buck, to whom Peters (Philadelphia etching printer) referred me some weeks since. Mr. Buck seems to be a fine man and honest, if one can judge by impressions. He wants me to undertake some etchings of historical places, to be paid for at the rate of 25 cents for each proof pulled from the plate and sold. I will make one and see if it pleases him" (March 16, 1908, NYS, p. 206). "Rode down to Dey Street, and got a 10 x 14 plate at John Sellers & Sons. Charged it to B. F. Buck. Walked up as far as the Astor Library and looked over some histories in the matter of Swedish settlement of Wilming-

ton, which is one of the subjects I'm to try for Buck" (March 17, 1908, NYS, p. 206). "Mr. Buck called after noon and stayed a couple of hours. He seems a very nice sort of man. Dolly was favorably impressed. I am to go ahead on one of his etchings as soon as I come back from Pittsburgh" (March 18, 1908, NYS, p. 207, and unpublished). "In Phila. I stopped in the Press after lunch with Fincken. F. is not at all busy, had a dull winter and is now working on a plate for Mr. Buck's series" (March 20, 1908, NYS, p. 207, and unpublished).

"Mr. Buck called in the afternoon and was enthusiastic and conceited as usual—it seems a creditable sort of conceit—He wants me to get to work on my etching of the old Verplanck house for him. I've put it off and off" (June 2, 1908, JS unpublished diary). "Photographed Verplanck home to use in tracing on the copper for Buck. Had a copy made for him at the photographer's across the street, Sweeney & Son, fifty cents. Took his original to him. Grounded the plate and prepared to go on with this job which I don't much like to tackle" (June 3, 1908, NYS, pp. 223–24, and unpublished). "Worked all day on Buck's plate. Kirby called . . . but I did not want to stop my work" (June 4, 1908, NYS, p. 224, and unpublished). "Worked on plate for Buck" (June 5, 1908, NYS, p. 224). "Worked all day on the plate for Mr. Buck" (June 6, 1908, NYS, p. 224). "I stopped to show Mr. Buck proof of plate which seems to suit him better than me" (July 16, 1908, NYS, p. 231).

There is no further mention of this print in the JS diary, no indication of why it was never used, and no record of a publication by Buck.

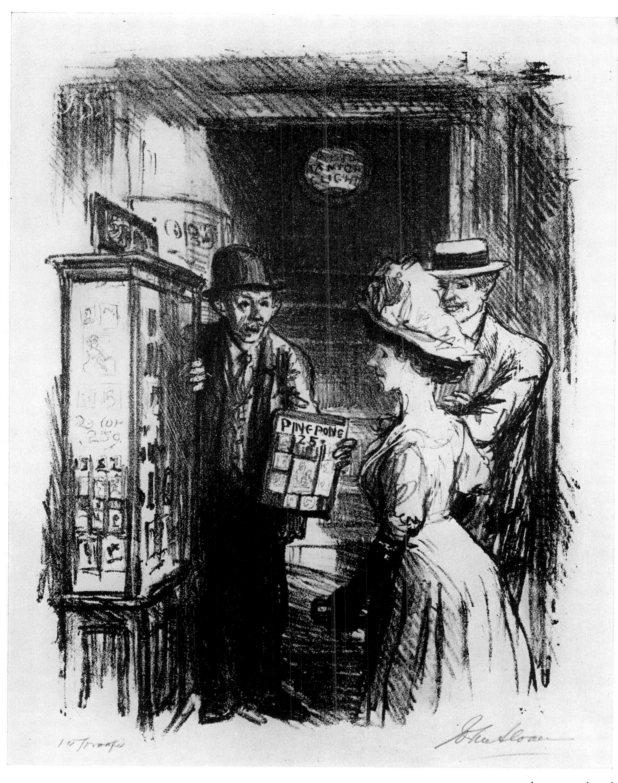

only state, reduced

147. PING PONG PHOTOGRAPHS

1908. Dated June 8, 1908, in JS diaries.

Lithograph. 218 x 172 mm. (8½ x 6¾ inches) stone; 204 x 156 mm. (8 x 6¼ inches) design.

Only state. Ph–2, JST–6, WSFA, Met, Bowdoin, Detroit, Philip Berman (Allentown, Pa.).

Edition: 15. Printing: 15, by JS.

Stone presumably effaced.

Probably no tissue.

"Moellmann and Potts came to dinner. . . . Afterward I worked on a small stone. *Ping Pong Photos*" (June 8, 1908, JS diary, unpublished). "I spent the whole day struggling with the mysteries of lithographic printing of the *Ping Pong Photo* stone with varying success" (June 9, 1908, *NYS*, p. 224).

An excellent photomechanical reproduction of this lithograph exists, a relief linecut, prepared for the *Century Magazine* (106, Aug. 1923, 572) and printed also in a separate edition on good paper. It is identifiable by its smaller size, the design measuring 162 x 127 mm. (6½ x 5 inches), and by its relief printing.

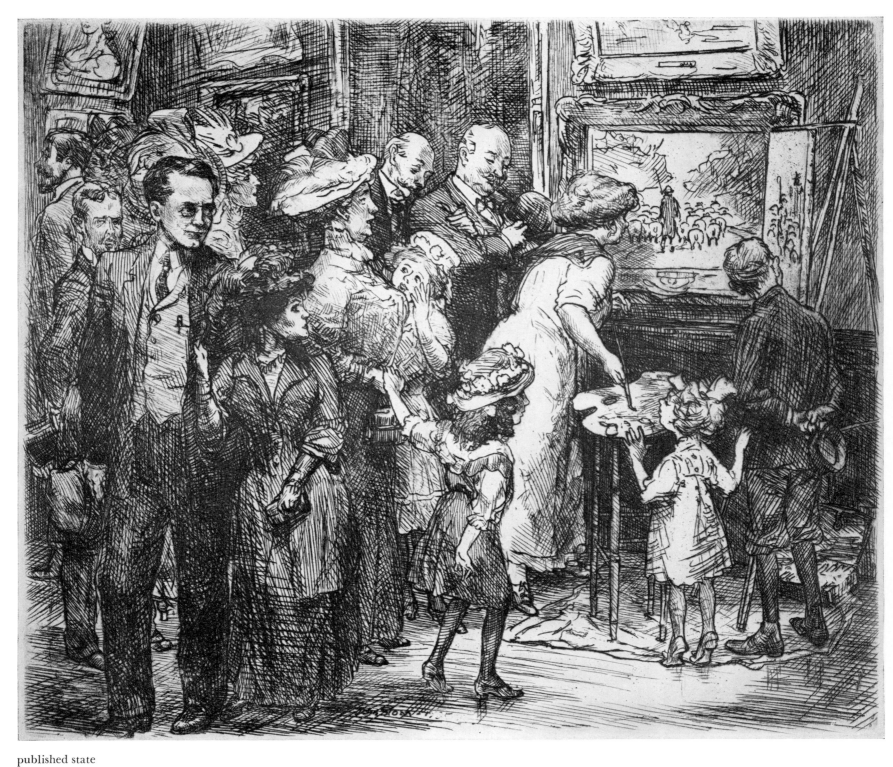

published state

166

148. COPYIST AT THE METROPOLITAN MUSEUM

1908. Dated September 6, 1908, in JS diary.
Etching. 191 x 227 mm. (7½ x 9 inches) plate.
States:

1. Lightly drawn. Sloan's face (man at left front) is long, looking downward. Signature and date, 1908, clearly visible at bottom center. Ph, JST, SI. Illustrated, p. 169.

2. Sloan's face, redrawn, appears to be sneering. Much additional shading throughout, including covering signature and date. Ph, JST, SI. Illustrated, p. 170.

3. Sloan's face, redrawn again, resembling final state but with almost no shading. His feet and lower legs redrawn longer. Dolly's face (woman next to Sloan) redrawn, with larger eye, vertical line at corner of mouth, and shading on cheeks and neck. Hair of the copyist is burnished lighter. Hat of large woman at center burnished lighter. Additional shading on wall at upper right and elsewhere. Date erased. This state clearly represents work on the plate when it was taken up again in 1910, indicated also by a change of ink and paper from proofs of the first two states. Ph, SI.

4. Sloan's face shaded. Ph, SI. Illustrated, p. 171.

5. Additional diagonal shading on top and right side of hair of copyist. Shading added on face of man behind Sloan's right shoulder. SI.

6. Top of copyist's hair burnished lighter. Ph, JST, SI.

7. Dolly's face again redrawn, now with mouth a single short line, sharper nose and chin, and darker eye. Sloan's face somewhat redrawn, with longer and tighter mouth and cleft in chin. Ph, SI, Rosenwald, Bowdoin.

8. Dolly's mouth enlarged, showing pursed lips clearly. Published state. Illustrated.

Edition: 100 in JS edition; 115 in Weyhe edition. Printing: 75 in JS edition. Early 15, Platt 20, Roth 40. It is possible that the proofs before the Weyhe edition were in the 7th state. The printing of 115 for the Weyhe edition was done by Peters. These proofs are not inscribed with any edition limitation.
Plate exists: SI (gift of HFS). Copper, steel-faced.
Tissue and one sketch on tissue paper: Ph. See p. 168.

"I remember having trouble with an attempt at likenesses of myself and Dolly, in the foreground of this plate. Why should the artist be so critical in such an unimportant matter?" (Dart 42). "I've always had trouble with portraits of members of the family. I had the head of Dolly in and out of the plate innumerable times" (JS 1945).

"Went in to the Metropolitan Gallery, where the 'Copyists' at work are very amusing" (May 22, 1907, *NYS*, p. 130). "Walked up to the Metropolitan Museum of Art" (Sept. 1, 1908, *NYS*, p. 243). "In the evening, I started to make a plate of a copyist at work in the Metropolitan Museum of Art, crowd around as it is a sheep picture which the lay copyist is 'takin' off.' Made preliminary drawing on tissue paper and grounded my plate and got the red chalk tracing sketches on the ground" (Sept. 6, 1908, *NYS*, p. 244). "In the evening, I started to 'needle in' the *Sheep Picture* or *Copyist at work in the Metropolitan* which I drew last Sunday night (Sept. 8, 1908, *NYS*, p. 245). "Worked on the plate today" (Sept. 12, 1908, *NYS*, p. 245). "Printing proof of

the *Copyist* plate today—which is overbitten and, I'm afraid, will not turn out much of a success. I worked with the etching press all afternoon. In the evening, I took up the plate again and worked all over it. I sat up working til 4 A.M. which is not the best thing for my health, I'm sure" (Sept. 14, 1908, *NYS*, p. 246). "Up at 11 o'clock and worked at the plate again and in the afternoon made proofs of the second state. Not a good plate—I've lost a good deal of my 'practice' hand in etching it has been so long since I made a plate. . . . A little bit in the 'blues' tonight, no work coming in—and the plate so unsatisfactory. Still I work to please myself, which perforce makes it hard sometimes to get the 'coin' from the world" (Sept. 15, 1908, *NYS*, p. 247, and unpublished).

"About 11 P.M. I started to work on the plate *Copyist in Metropolitan Museum of Art*, which I had laid aside nearly two years ago. Worked till nearly 3 A.M." (June 6, 1910, *NYS*, p. 431). "After dinner at home, I worked a while on the *Copyist* plate" (June 7, 1910, *NYS*, p. 432). "Worked on the *Copyist* plate all afternoon and till late at night" (June 8, 1910, *NYS*, p. 432). "Worked all day on the plate. Great struggle to get a representation of my own self among the figures in the crowd watching the copyist at work. It seems hardly worth while but I hate to be too badly defeated at it. . . . The company had all gone by 12 o'clock. I took up my plate and got started on it again. Worked till nearly 4 A.M" (June 9, 1910, *NYS*, p. 432). "After Mr. Yeats and [Abbott] had gone about four or half past, I went on with the plate. Though I had been working while they were here I was so much interested I did not accomplish much. Still struggling with the head of myself. I feel it will have to go with a poor portrait in it" (June 10, 1910, *NYS*, p. 432). "Worked right along on the *Copyist* plate" (June 11, 1910, *NYS*, p. 433). "Printed some proofs of plate. . . . I worked on my plate" (June 13, 1910, *NYS*, pp. 433–34). "I printed five more proofs of the *Copyist* etching this morning and have now laid it aside as about finished. I do not think that the plate equals others I have done but I hate to have a rankly unfinished copper plate on hand. It's not that at any rate" (June 14, 1910, *NYS*, p. 434).

The prints for the Weyhe edition were assembled by Carl Zigrosser, director of the Weyhe Gallery at the time, and published in a portfolio in 1919, *Twelve Prints by Contemporary American Artists* (introduction by Carl Zigrosser, New York, 1919). Mr. Zigrosser remembers visiting Sloan and looking through a large number of prints before selecting this one. In the portfolio this notation appears: "Of this portfolio one hundred and fifteen copies have been made, of which fifteen comprise a special artist's edition, and one hundred are offered for sale." The prints were signed in pencil. The complete portfolio is to be found in LC and NYPL. A letter from Zigrosser to Sloan, dated January 29, 1920, says, "One *Copyist* trial proof . . . was bought some time ago" (JST).

Sloan's drawing *The Past and the Futurist*, published in *The Masses* (8, Jan. 1916, 4), is a satirical variation on the theme of the *Copyist*. That drawing is now in the Wichita (Kansas) Art Museum.

An article by the present compiler examines the technique of this etching. See Bibliography.

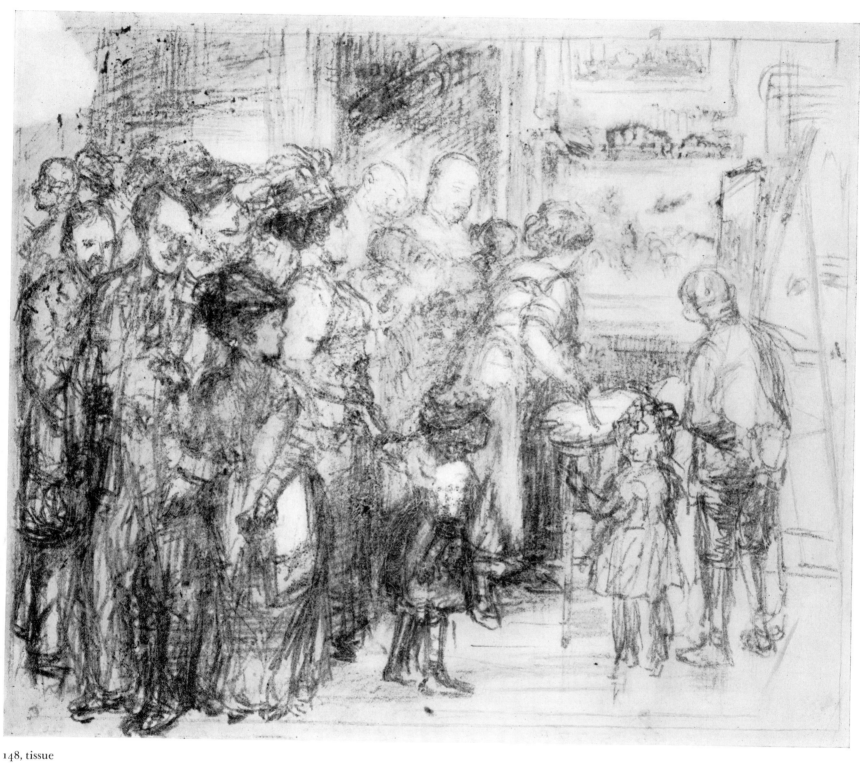

148, tissue

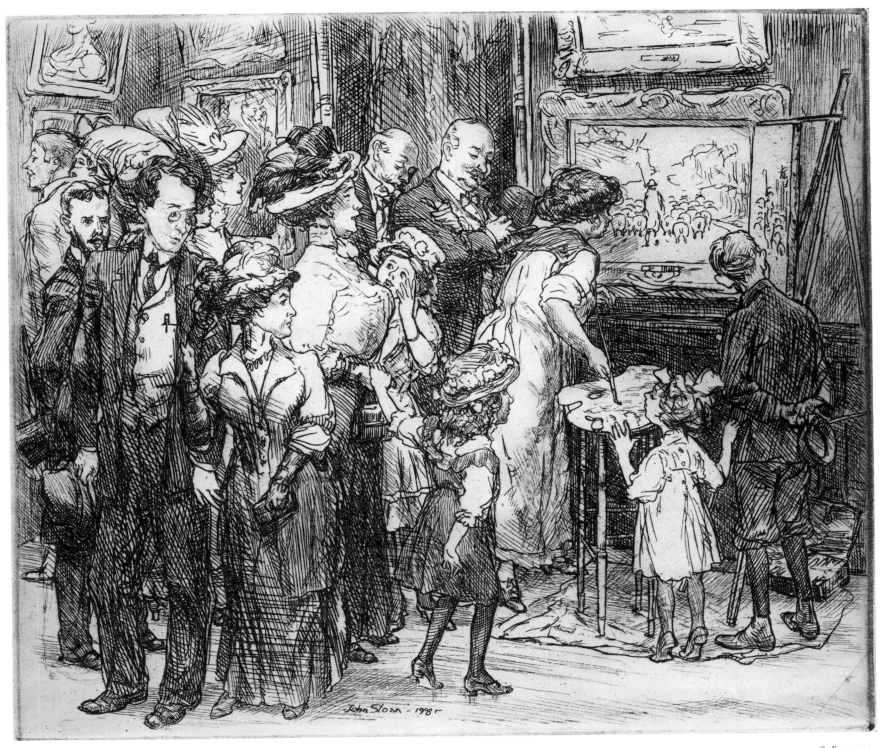

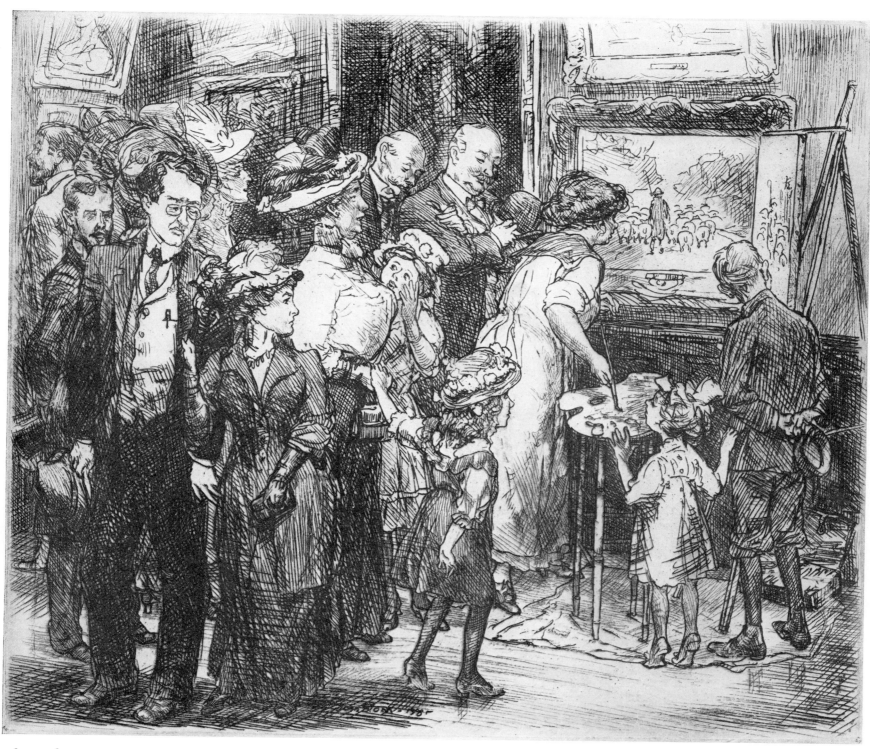

148, second state

170

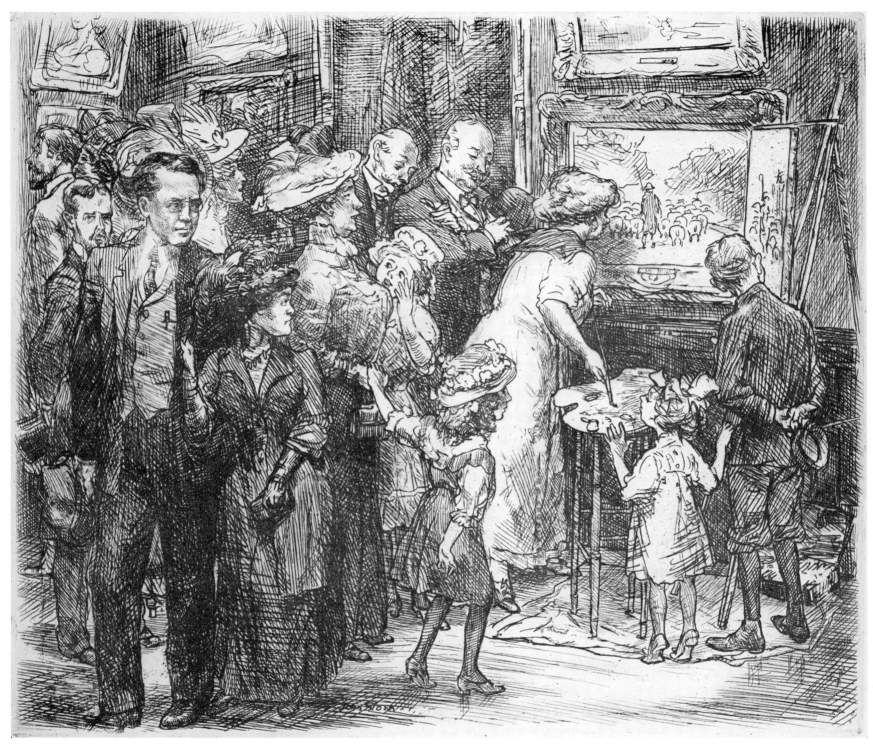

148, fourth state

*I will have about 20 proofs tonight
and in about another day they will
be pressed and dry.*

*Wednesday
Dec 15/09*

6.30 P.M.

*Dear Dolly :- first to show you that
I've not been idle this afternoon —
I'm going out to dinner now — Lots and lots of*

Love from your John Sloan

first state

published state

149. CHRISTMAS DINNERS

1909. Dated December 15, 1909, in JS diary.
Alternative title: *Salvation Army Girl.*
Etching. 70 x 121 mm. (2¾ x 4¾ inches) plate.
States:

1. Nearly complete. Sign reads "2500." JST. Illustrated.
2. Number on sign changed to "25000." Bowdoin.
3. Woman's face redrawn to appear younger. Heavy vertical line removed from man's face. Published state.

Edition: 100. Printing: 75. Early 50, Roth 25. Platt is known to have had this plate.
Plate exists: JST. Copper.
Tissue unknown, probably nonexistent.

"While contributions drop into the pot the city derelict wonders if he will live to dine. A sketch plate" (JS 1945). "I made a small etching *Salvation Girl* with pot on tripod ringing bell, announcement of 'Christmas Dinner for 25,000' and a lank hungry man loitering and wishing the Christmas dinner wasn't so far away from him. Made the plate, proved about 26 proofs and sent one to Dolly. We are going to send these around as Xmas Greetings to some of our friends" (Dec. 15, 1909, *NYS,* p. 360). "Dear Dolly: Just to show you that I've not been idle this afternoon. I will have about 20 proofs tonight, and in about another day they will be pressed and dry. I'm going out to dinner now. Lots and lots of love from your John Sloan. Wednesday Dec. 15/09, 6:30 pm" (on proof of 1st state; JST). The state changes were probably made before the printing that same evening. "Finished up the printing of the small *25,000 Xmas Dinners* plate in the morning and early afternoon" (Dec. 16, 1909, *NYS,* p. 360). "During the afternoon I wrote cards and addressed envelopes for our Christmas etching, getting them all ready. Dolly had sent a list of names from Phila. and I added others, about 26 in all" (Dec. 20, 1909, *NYS,* p. 362). This was the first in a long series of Christmas and New Year etchings done by Sloan for his friends and only later issued in published editions (see p. 18).

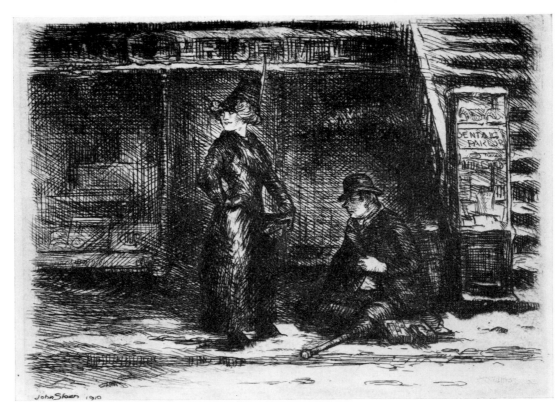

published state

150. GIRL AND BEGGAR

1910. Dated November 25, 1910, in JS diary.
Alternative title: *Putting the Best Foot Forward.*
Etching. 101 x 152 mm. (4 x 6 inches) plate.
States:
1. Nearly finished. Unshaded area on store window between girl and beggar. Ph, JST–3.
2. Additional shading between girl and beggar, on store window at left, store window above beggar, bottom of girl's dress, street and sidewalk at left, and elsewhere. Published state.
Edition: 100. Printing: 85. Early 35, Platt 25, Roth 25. Peters had this plate.
Plate exists: JST. Copper, steel-faced.
Tissue: Ph.

"Twenty-third Street, a winter night, and two haunters of the sidewalk. 'Putting the Best Foot Forward,' a drawing made for *Harper's Weekly* was a variant on this theme" (Dart 44).

"I worked on a plate *Girl and Beggar*, street walker and cripple turning to note an approaching wayfarer (who is not shown in the picture)" (Nov. 25, 1910, *NYS*, p. 480). "I went on working on the *Girl and Beggar* etching. First ground turned out too much heated, chipped away, so much trouble will be the result" (Nov. 26, 1910, *NYS*, p. 481). "I printed a few trial proofs of the *Girl and Beggar* plate. It will need further work I think" (Nov. 28, 1910, *NYS*, p. 481). "I printed a couple of dozen proofs of the *Girl and Beggar* plate and it looks right good to me" (Nov. 29, 1910, *NYS*, p. 481). "During the evening Henris called and we had a very pleasant talk with him. He liked my new plate *Girl and Beggar* very much" (Dec. 11, 1910, *NYS*, pp. 485–86).

The drawing, *Putting the Best Foot Forward,* a subject somewhat similar to this print, appeared in *The Masses* (6, June 1915, 4). Sloan was doing considerable work for both *Harper's* and *The Masses* at the time.

Exhibited in the Armory Show, New York, February 1913.

only state

151. TURKEY FROM UNCLE

1910. Dated November 30, 1910, in JS diary.
Alternative title: *Hock Shop*.
Etching. 96 x 70 mm. (3¾ x 2¾ inches) plate.
Only state. Published state.
Edition: 100. Printing: 45. Early 45. Platt is known to have had this plate.
Plate exists: JST. Copper.
Tissue: Ph.

"Two years have passed with few etchings. I remember an intensified interest in painting. During this period I first painted with Hardesty Maratta's colors, the use of which gave me my first real insight into color principles" (JS 1945). "I started a plate (very small one) which I will, if it turns out well enough, use for a Xmas card this year. The subject is one of the group sent to the *Coming Nation* in the Xmas drawing they bought. Poor woman at door of *Hock Shop*—title *Expecting a Turkey from Uncle*" (Nov. 30, 1910, JS diary, unpublished). "Working again on the small *Hock Shop* plate" (Dec. 1, 1910, *NYS*, p. 482). "I printed a number of proofs of my new little Xmas card plate" (Dec. 5, 1910, *NYS*, p. 484). "Finished printing enough Xmas plate to serve for our friends" (Dec. 6, 1910, *NYS*, p. 484).

Sloan's reference is to the drawing published in the *Coming Nation* (Girard, Kans., no. 15, Dec. 24, 1910, p. 5, a weekly Socialist paper). It is a large center-page drawing of seven different *Christmas Scenes,* including this subject in the lower left corner. The drawing shows an older woman, facing in the opposite direction, with the title: *Expecting a Turkey from Uncle.* The etching is far from an exact copy of the drawing. There is no pertinent text associated with the published drawing. He had earlier submitted it to *Collier's,* where it was rejected (see *NYS,* pp. 471, 472, 476, 478).

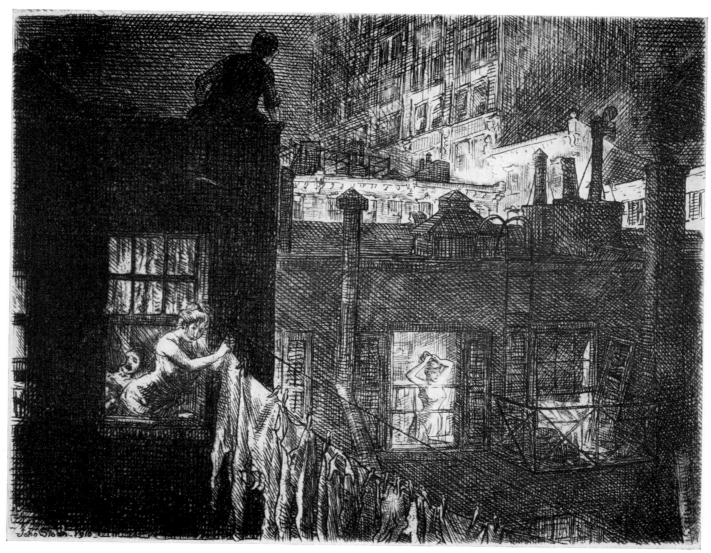

published state

152. NIGHT WINDOWS

1910. Dated December 6, 1910, in JS diary.
Alternative title: *Roof and Windows*.
Etching. 136 x 179 mm. (5¼ x 7 inches) plate.
States:

1. Design nearly complete. Man on roof holds a pipe. Woman hanging clothes has heavy features. Sky has only horizontal and diagonal shading. Ph, JST–5.
2. Vertical shading added in sky. Much additional shading on buildings, laundry, and man's back. Ph, JST.
3. Man's right hand and pipe erased, leaving a blank space. Ph, JST.
4. Man's right hand redrawn, resting on roof edge. Features of woman hanging clothes redrawn, softer, with sharp nose. Additional shading on right side of girl in window center. Her mouth strengthened. More shading on laundry. Burnishing on windows of tall building at center. Ph, JST–6.
5. Eyes of girl at window center are burnished lighter, removing eyebrows. Published state.

Edition: 100. Printing: 110. Early 30, Platt 50, Roth 30. Peters had this plate also.
Plate exists: JST. Copper, steel-faced.
Tissue unknown.

"While his faithful wife is doing the wash downstairs my neighbor casts a roving eye across the areaway. A commonplace or even vulgar incident may produce a work of art" (Dart 43). "Back of 23rd Street. Perhaps I should make paintings from some of these old plates, but without the color impulse from the place itself I don't feel that I could get the livingness of the place" (JS 1945).

"Then I started on another plate, at least made the pencil sketch for it. Night, man on roof—woman at window in act of undressing." (Dec. 6, 1910, *NYS*, p. 484). "I started a new etched plate after dinner. The subject of the plate is one which I have had in mind—night, the roofs back of us—a girl in deshabille at a window and a man on the roof smoking his pipe and taking in the charms while at a window below him his wife is busy hanging out his washed linen" (Dec. 12, 1910, *NYS*, p. 486). "Working on my plate (man on roof looking at girl dressing)" (Dec. 14, 1910, *NYS*, p. 486). "It seems presumptuous on my part to undertake to teach anyone the technique of etching. I am so uncertain myself and at night late I went to bed with much sadness for my *Roof and Windows* plate has turned into a mess of line which will give me much trouble" (Dec. 19, 1910, *NYS*, p. 487). "I worked all afternoon on the *Roof and Windows* plate which is in a pretty bad snarl just now and I have a few hopes left" (Dec. 20, 1910, *NYS*, p. 487). "I took up again the *Man on Roof* (looking at girl dressing) plate and worked on it till quite late" (Jan. 30, 1911, *NYS,* p. 502).

Exhibited in the Armory Show, New York, February 1913.

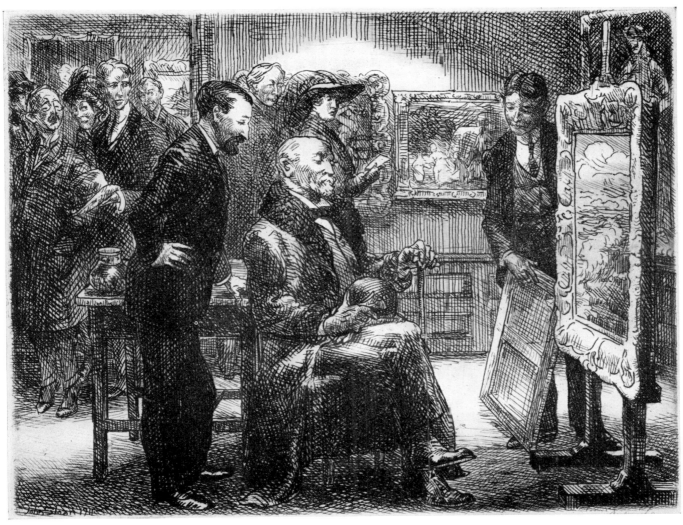

published state

153. THE PICTURE BUYER

1911. Dated February 1, 1911, in JS diary.

Etching. 135 x 179 mm. (5¼ x 7 inches) plate.

States:

1. Lightly drawn. Wall blank at top center. Ph, JST–2.
2. Much additional shading, on back wall at top center, on men's clothes, on floor, and elsewhere. Heavy shading on left cheek of man at right, showing picture. Ph, JST–5.
3. Shading on man's cheek and mouth burnished lighter. Ph, JST.
4. Man's face redrawn. Shading radiates down from nose. No eyebrow over left eye. Ph, JST.
5. Man's mouth strengthened. Left eyebrow added. Published state.

Edition: 100. Printing: 85. Early 60, Roth 25. Peters and Platt had this plate. Gaston 25, presumably destroyed. Sloan's personal inventory in 1931 lists 18 proofs by Platt.

Plate exists: JST. Copper. Steel-faced.

Tissue: Ph.

"William Macbeth hopes to make a sale. Casual visitors to his gallery tiptoe about, awed by the presence of purchasing power. A strong plate" (JS 1945). Macbeth was the dealer who exhibited the "Eight" in 1908.

"I walked back, stopping at Macbeth's where I saw a very pretty comedy, Mr. M. showing paintings to a prospective buyer. I told Henry and MacIntyre, the clerks, that I should perhaps make a picture of the scene" (Jan. 24, 1911, *NYS*, p. 501). "I started on a new plate, made a sketch during the evening. The *Picture Buyer* at Macbeth's, thing I saw last week" (Feb. 1, 1911, *NYS*, p. 503). "Made some liquid ground and used it for the first time to protect a ground which before biting showed some symptoms of weakness—the *Picture Buyer* plate" (Feb. 9, 1911, *NYS*, p. 506). "I worked all day on the *Picture Buyer* plate till about 8 o'clock" (Feb. 22, 1911, *NYS*, p. 511). "Worked on *Picture Buyer* plate and printed several proofs" (Feb. 25, 1911, *NYS*, p. 511). "An incident in the galleries of William Macbeth—he is shown purring in the ear of the victim" (JS inscription on proof for John Quinn, April 27, 1911; see *NYS*, p. 530; JST).

Exhibited in the Armory Show, New York, February 1913.

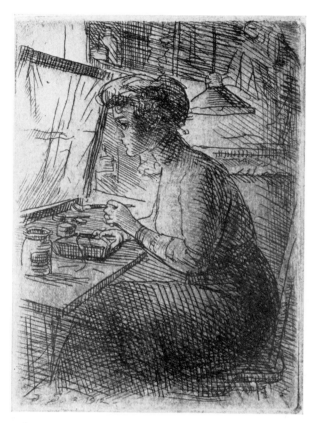

only state

154. WOMAN WITH ETCHING TRAY
1912. Dated "2–1912," i.e. February 1912, in plate.
Etching. 95 x 70 mm. (3¾ x 2¾ inches) plate.
Only state. Ph–2 (including the only known early proof), WSFA,
SI.
Edition: 150 plus 25 "artist's proofs," set by HFS. Printing: 4
proofs known. Early 1, Harris 3. Edition not yet printed (1969).
Plate exists: JST. Copper.
Probably no tissue.

Judging from the date in the plate, the subject is likely to
be the woman described in the following diary excerpt: "Mrs.
Bernstein had her second lesson in etching today. She's a nice
girl, mother of two children and two adopted ones. Studies art,
'makes her a better mother and a better artist' she says quite
truly" (Feb. 7, 1912, *NYS*, p. 599). As the subject of this etching
wears a wedding ring, it is presumed to be Mrs. Bernstein and
not the Miss Grandin whom Sloan also had as an etching pupil
in February 1912 (*NYS*, p. 599).

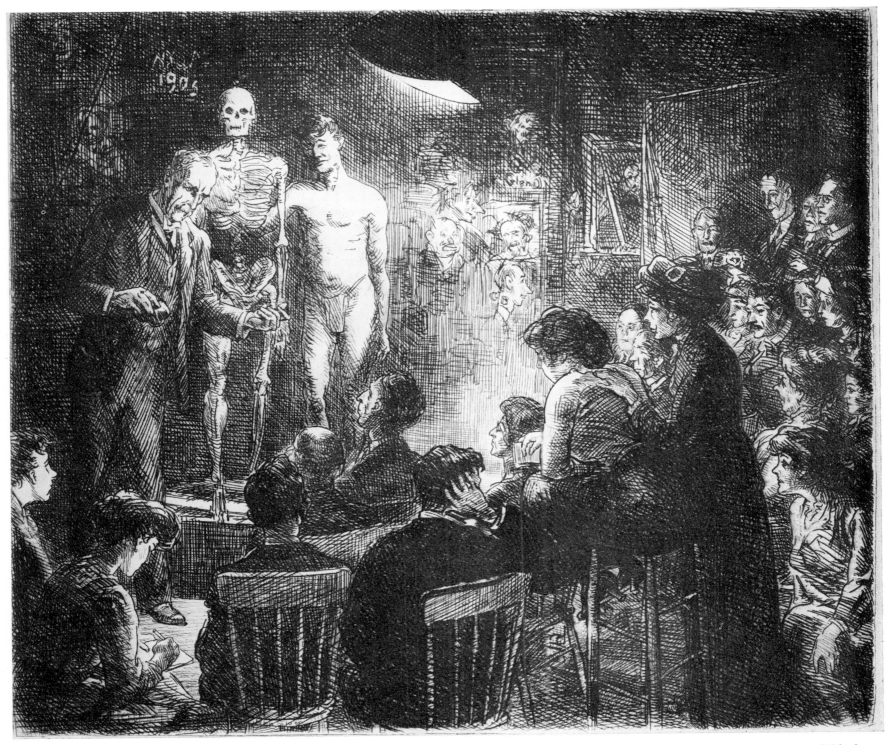

155. ANSHUTZ ON ANATOMY

1912. Dated February 26, 1912, in JS diary.
Etching. 191 x 229 mm. (7½ x 9 inches) plate.
States:

1. Lightly drawn. Ph, JST, Bowdoin, British Museum.
2. Much additional shading, particularly on the students in the foreground. Ph, JST.
3. Additional diagonal shading across entire background. Shading on cheek of woman at lower right (Linda Henri) burnished lighter. Ph, JST, British Museum.
4. Left side of woman on stool and left arm and side of woman to her right are scraped out. Large highlight burnished on left hip of woman on stool. Ph–2 (both with pen).
5. Heavy horizontal and diagonal cross-hatching on left side of woman on stool, following the curve of her body. New hatching on arm and side of standing woman follow the contours of the form, instead of going across both. Ph, JST–2, Bowdoin.

6. Face of man between these two women's heads burnished lighter. Ph, JST–2, British Museum.
7. Heavily etched lines added: horizontally on left side of woman on stool, following contour of her skirt, lengthwise on upper arm of standing woman and down the back of her dress. Ph, JST–3.
8. Mouth of man at extreme upper right (Sloan), formerly with a downward stroke at the corner, made straighter and firmer. Published state.

Edition: 100. Printing: 80. Early 30, White 25, Roth 25. Sloan's personal inventory in 1931 lists proofs by both Peters and Platt. JST.

Plate exists: JST. Copper, once had steel-facing, subsequently removed.

Tissue and three sketches: Ph. The tissue actually used has a separate insert for Anshutz' head.

"Tom Anshutz, our old teacher at the Pennsylvania Academy,

gave anatomical demonstrations of great value to art students. Modelling the muscles in clay, he would then fix them in place on the skeleton. Those present in this etched record of a talk in Henri's New York class include: Robert and Linda Henri, George Bellows, Walter Pach, Rockwell Kent, John and Dolly Sloan'' (Dart 45).

"Anshutz and Henri at dinner. After . . . Anshutz gives the first of a series of six talks on anatomy at the New York School of Art. He takes the thigh and hip and with clay builds each muscle to the skeleton of that section. Very interesting" (Jan. 20, 1906, *NYS*, p. 7).

"I worked on plate (sketch of it)—Tom Anshutz delivering his clay muscle talk on anatomy at the N.Y. School of Art, about seven years ago or so" (Feb. 26, 1912, *NYS*, p. 604). "Printing plate, first proofs not very cheerful. I forget so much between etching periods that I have great trouble with over and under biting" (March 2, 1912, *NYS*, p. 604). "Worked on the Anshutz plate in the morning. . . . Worked on my plate again in the evening" (March 3, 1912, *NYS*, pp. 605–06). "Worked on plate, great trouble I'm having with it—but I've got a right good portrait (memory) of Tommy Anshutz so I'll stick at the job. . . . After dinner worked again on the plate" (March 4, 1912, *NYS*, p. 606). "Scraping, polishing, hammering up, printing—struggling with the plate of Anshutz today" (March 6, 1912, *NYS*, p. 607).

"Anshutz Talking on Anatomy at the N.Y. School of Art, 1905, a memory of this visit. Thos. P. Anshutz was instructor in Penna. Academy of Fine Arts for thirty years. R. Henri, W. Glackens, myself and A. S. Calder are among his students" (inscription on proof for Quinn, ca. 1914; JST).

"I studied under Thomas P. Anshutz. I have a habit of spelling the name *sch*utz, which is an error. He was instructor in the Penna. Acad. of Fine Arts, for more than 25 years—died in 1912. I went there about 1889–1890 [actually 1892–93; JS records]. He

was a great friend of Thomas Eakins and his work was of a kindred sort. Eakins is now recognized as one of our great masters. Anshutz was a great teacher. Henri, Glackens, and other notable painters studied with him. His talks on anatomy were repeated several times each term at the P.A.F.A. and were about the best means I ever heard of for giving an artist an idea of essential bone and muscle structure. He laid the muscles, which he formed in clay, upon the skeleton, demonstrating their use by means of a living model. The occasion pictured in my plate was such a talk, one of a series, at the invitation of Robert Henri, to students and friends in the N.Y. School of Art, 6th Ave. and 57th St.—1905. Among those present (in my etching): Robert Henri, Linda Henri (his first wife), myself, Rockwell Kent, my wife (Dolly S.), Sherman Potts. The model didn't matter (personally)" (JS letter to Dr. Frederick T. Lewis, March 18, 1936, quoted with the permission of the Fogg Art Museum, Cambridge, Mass.).

Exhibited in the Armory Show, New York, February 1913.

Some of the people portrayed by Sloan can be identified on the numbered diagram as follows: 1) Thomas P. Anshutz; 6) Walter Pach; 10) William Glackens; 13) Maurice Prendergast; 15) George Bellows; 17) John Sloan; 19) Robert Henri; 23) Dolly Sloan; 24) Linda (Mrs. Robert) Henri.

Alexander Calder wrote me that he was unable to identify his father, A. S. Calder, in the print, "unless he is 4 or 7—but it's only a guess." Rockwell Kent studied the print, confirming some of the other identifications, but did not see his own portrait. "We used to paint all over the walls of the studio," he added, "and Sloan shows some of those paintings in his etching. The one bearing the initials 'GB' is probably someone's caricature of Bellows at that time. The one with 'Glen O' under it is definitely Glen O. Coleman." I am most grateful to both men for their help.

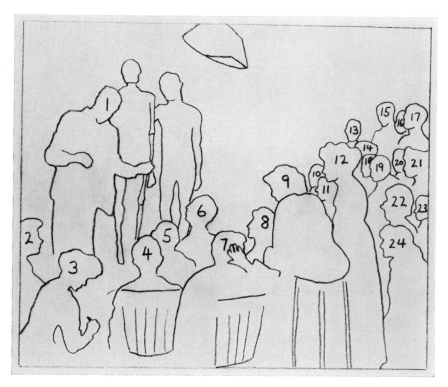

key to portraits

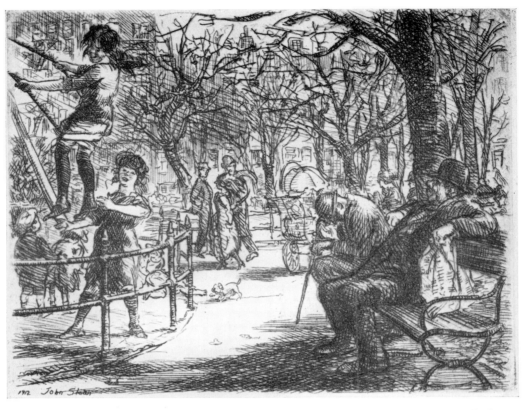

published state

156. SWINGING IN THE SQUARE

1912. In plate.

Alternative title: *In the Park*.

Etching. 102 x 133 mm. (4 x 5¼ inches) plate.

States:

1. Girl on swing has light hair. Diagonal shading on front of standing girl. Ph, JST–3.
2. Hair of swinging girl is darkened. Ph (with pen).
3. Additional shading on face and dress of standing girl, on tree at right, on front man's clothing, and on dress of swinging girl. Published state. (The inscribed "working proof" in the Barnes Foundation is of this state, but poorly inked.)

Edition: 100. Printing: 75. Early 25, Platt 25, Roth 25.

Plate exists: JST. Copper, steel-faced.

Tissue: Ph. The drawing for *The Masses* cover (see below) is at Yale University, New Haven, Conn.

"I have always had enthusiastic interest in unspoiled girlhood, more in evidence in 1912 than now. Growth toward real womanhood is often checked at about this age" (JS 1945). "Stuyvesant Square. The peak of the swing, like the cover for the *Masses,* with deeper meaning. I felt that most women reached the best age then" (JS 1945). A single girl on a swing, similar in treatment, was on the cover of *The Masses,* May 1913. "Walked down to the East Side this afternoon, enjoyed watching the girls swinging in the Square, Avenue A and 8th Street East. A fat man watching seated on a bench" (June 26, 1906, *NYS,* p. 44).

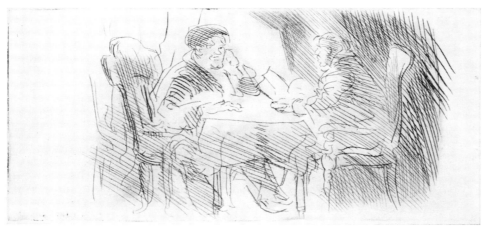

only state

157. TWO MEN AT TABLE
1912. Estimate.
Etching. 59 x 133 mm. (2¼ x 5¼ inches) platemark.
Only state. Ph.
No edition. Printing unknown. Only one proof known.
Plate unknown.
Probably no tissue.

 The single proof of this subject was in Sloan's possession and was identified by him as his own work, in discussion with HFS. The date estimate is very rough. This was probably a demonstration plate for an etching lesson.

only state

158. ETCHING TEST PLATE
1912. Estimate.
Etching. 120 x 68 mm. (4¾ x 2¾ inches) plate.
Only state. Ph, WSFA, SI.
No edition. Printing: 3. Harris 3.
Plate exists: JST. Copper.
No tissue.

 The handwriting in the plate is identifiably Sloan's. This was clearly intended as a demonstration of acid biting for a student. It was probably never intended for printing, as the writing is reversed when printed. The estimate of date is made solely for convenience in cataloguing, with no basis in evidence.

159. THE SERENADE

1912. In plate. The book was copyrighted November 8, 1912.
Alternative title: *The Laggard in Love*.

Etching. 148 x 82 mm. (5¾ x 3¼ inches) plate; 129 x 76 mm. (5 x 3 inches) picture.

States:
1. Without mandolin on ground at lower right. Ph, JST–7, Barnes Foundation.
2. Mandolin added. Published state.

Edition: 100 in JS proofs. No edition for book. Printing: 90 JS proofs (signed, large paper). Early 90.

An estimated 3,500 proofs were used as the frontispiece to Thomas A. Daly's *Madrigali* (Philadelphia, 1912). Harcourt, Brace & World, Inc., successors to the original publishers, David McKay, advise me that 3,449 copies of *Madrigali* were sold. The printer, Sloan said, was Peters. The prints are on medium-weight tan wove paper, of a page size 186 x 127 mm. (7¼ x 5 inches). The proofs used in *Madrigali* are not as well printed as those of *Jewelry Store Window* (140), being more cleanly wiped.

Plate exists: JST. Copper, steel-faced.

Tissue unknown.

"Another frontispiece for a second collection of Tom Daly's Dago dialect verse" (JS 1945). "Here's the book, John, and your work is *the* stuff as it always is. Blessings on you! / Tom Daly / Nov. 1912" (inscription in Sloan's copy of *Madrigali;* Ph). "I had forgotten to put the mandolin on the ground and at request of the author of *Madrigali* (T. A. Daly) I etched it in as above" (JS inscription on proof of 2nd state for John Quinn, June 1914; JST).

Sloan's etching illustrates the poem "The Laggard in Love" (*Madrigali,* pp. 20–21).

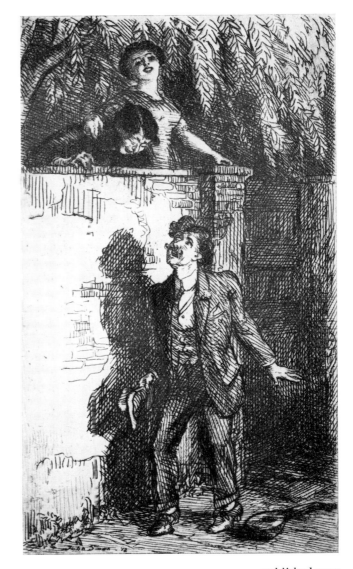

published state

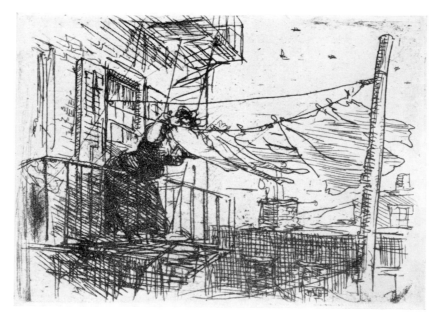

published state

drypoint sketch on back of plate

160. HANGING CLOTHES
1912. JS records.
Etching. 70 x 95 mm. (2¾ x 3¾ inches) plate.
States:

1. Nearly finished. Light lines on white cloth in front of wom-
 an's face. Ph.
2. Lines removed from cloth. Lines of woman's dress appar-
 ently rebitten more deeply, now very heavy. Published
 state.

Edition: 100. Printing: 45. Early 25, Roth 20. Platt had this
plate.
Plate exists: JST. Copper. The plate has a very slight drypoint
sketch on the verso, of a man's face and shoulder, which has not
been printed.
Tissue unknown.

"One of several small plates that were sent to friends at New
Year's" (JS 1945).

161. COMBING HER HAIR

1913. JS records.

Etching. 95 x 70 mm. (3¾ x 2¾ inches) plate.

States:

1. Nearly finished. Shading on left arm almost encircles arm from below. Heavy shading at bend in elbow. Ph, JST.
2. Shading burnished away from left elbow and lower part of left upper arm. Published state.

Edition: 100. Printing: 85. Early 35, Platt 25, Roth 25.

Plate exists: JST. Copper, steel-faced.

Tissue unknown.

"The secrets of the toilette as revealed to an incorrigible window watcher. Might also have been called *At the Switch*" (Dart 46). Drawing of a similar subject in JST.

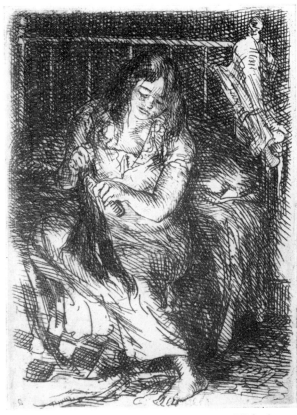

published state

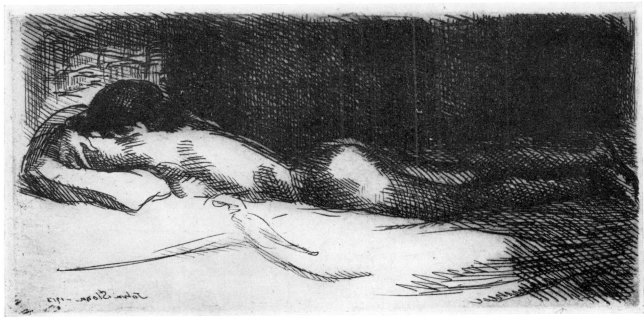

published state

162. PRONE NUDE

1913. In plate (reversed).

Etching. 82 x 165 mm. (3¼ x 6½ inches) plate.

States:

1. Nearly finished. Right hand has six fingers. Ph–2, JST.
2. Hand burnished and redrawn with five fingers. Upper outline of left buttock strengthened, with added shading. Published state.

Edition: 100. Printing: 60. Early 35, Roth 25.

Plate exists: JST. Copper, steel-faced.

Probably no tissue.

"My paintings of the figure made at this period lack the graphic expression in which lies the chief merit of this plate" (Dart 47).

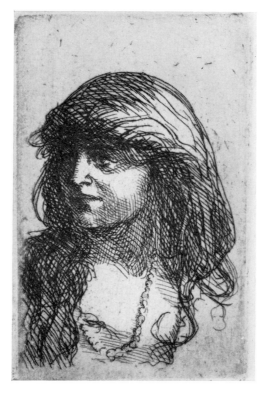

only state

163. HEAD WITH NECKLACE
1913. JS records.
Etching. 95 x 60 mm. (3¾ x 2⅜ inches) plate.
Only state. Published state. Later impressions have a number of
short heavy scratches in the blank background above the head.
Edition: 100. Printing: 75. Early 30, Roth 45.
Plate exists: JST. Copper, steel-faced.
Probably no tissue.

 "Not an important plate, but it has some technical relation-
ship to Rembrandt, greatest of all etchers" (Dart 48). "I can't say
that of all of them. The good ones have their own merits, not
mere technical association. But then I have always worshipped
Rembrandt" (JS 1945).

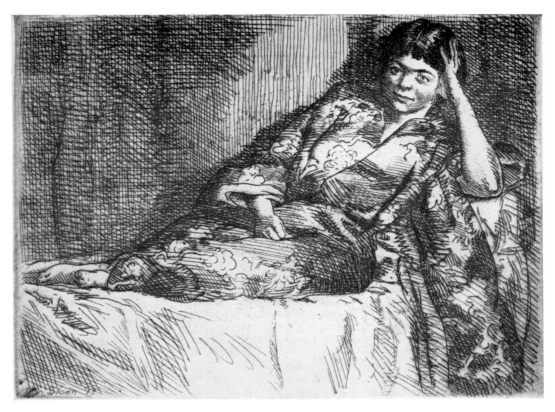

published state

164. GIRL IN KIMONO

1913. Dated about May 20, 1913, in JS diary.
Alternative titles: *Kimona* (Sloan's usual spelling of the word); *Indian*.
Etching. 102 x 139 mm. (4 x 5½ inches) plate.
States:
1. Nearly complete. Met.
2. Added strong line of left nostril. Slight vertical lines added at both corners of mouth. Published state. (The "working proof" in the Barnes Foundation appears to be of this state, but I cannot be certain, not having had another proof for comparison.)

Edition: 100. Printing: 45. Platt 25, Roth 20.
Plate exists: JST. Copper, steel-faced. Plate has wide commercial bevel. Trademark of platemaker, "John Sellers & Sons / Sheffield England," embossed on verso of plate.
No tissue.

"Less reality is found in this plate than in most others of this period, for the reason that it was made directly from life. I feel that it is too much a visual record. The earnest study from the living model in the plates I etched from 1931 to 1933 was directed toward more dynamic realization, beyond the visual" (JS 1945). "Girl in Kimono. (Indian blood.)" (inscription on proof for John Quinn, ca. 1914; JST).

"Mrs. Schindel, wife of Capt. S., U.S. Army, has been working with me at the studio for about a week. I'm showing her 'etching.' She is a cousin of J. McN. Whistler and in his famous class in Paris some years ago. A good companion she is" (May 20, 1913, *NYS,* p. 638). Mrs. Bayard Schindel, who worked under the name of Isa Urquhart Glenn, took lessons with JS in 1913. Her etching of the same subject, same pose, is in SI. Miss Aline Fruhauf, a lifelong friend of Mrs. Schindel, has verified that the two names refer to the same person. Miss Glenn later became known as a writer of fiction. (See p. 14 and fig. 7.)

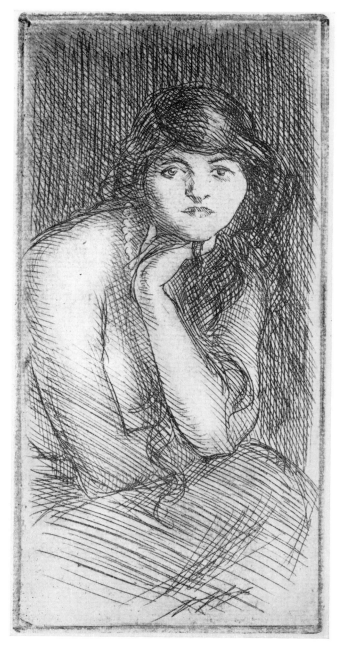

only state

165. WOMAN WITH HAND TO CHIN
1913. Estimate.
Etching. 165 x 82 mm. (6½ x 3¼ inches) plate.
Only state. Ph–2 (including the only known early proof), WSFA,
SI.
Edition: 150; 25 artist's proofs. Printing: Early unknown. Harris: 3. Baskin: 175.
Plate exists: SI. Copper.
Probably no tissue.

This plate, though unsigned, was clearly identified by JS as his work to HFS. Stylistically, it is unquestionable. The model appears to be the same Miss La Rue who posed for *Head with Necklace* (163), *Girl in Kimono* (164), and other paintings and drawings from the period 1912–15. Perhaps a demonstration plate for a student. The plate may have been set aside and not published for that reason. It is clearly a completed work.

The edition of this etching was printed in 1969. An impression is included in each of the 150 copies comprising the special limited edition of this book: *John Sloan's Prints*. The 25 artist's proofs are reserved for the Sloan Estate. Different papers have been used for edition prints and artist's proofs. All are signed by HFS, as noted on p. 17.

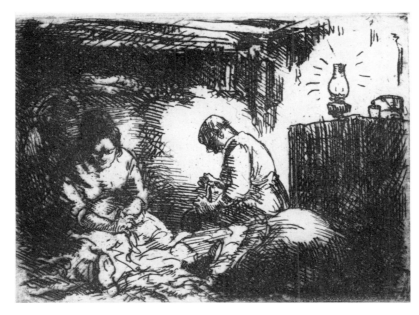

only state

166. RAG PICKERS

1913. In plate.

Etching. 70 x 96 mm. (2¾ x 3¾ inches) plate.

Only state. Published state.

Edition: 100. Printing: 55. Early 35, Roth 20.

Plate exists: JST. Copper, steel-faced.

Tissue: Ph.

"A glimpse into one of the cellars in West Third Street under the elevated tracks, which were occupied by rag sorters" (JS 1945). Used as a Christmas–New Year greeting.

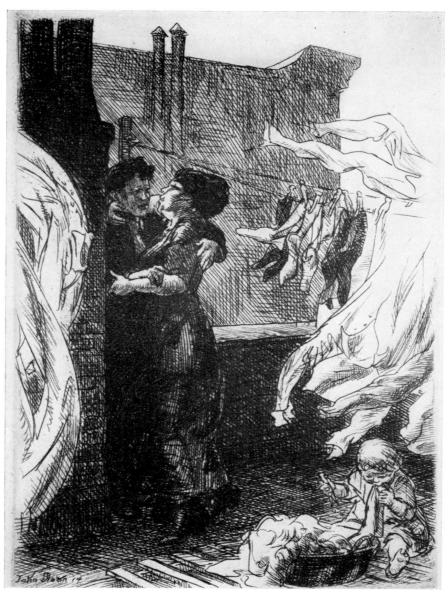

published state

167. LOVE ON THE ROOF

1914. Proof of first state dated April 21, 1914. Ph.
Etching. 151 x 111 mm. (6 x 4⅜ inches) plate.
States:

 1. Nearly complete. Woman's face unshaded. Ph–2, JST.
 2. Woman's face shaded. Additional shading on man's face, on laundry at right, on woman's dress, and elsewhere. Published state. A number of proofs exist inscribed "2nd State, JS" (Ph, JST–9). Though he may have thought at first of doing further work on this plate, Sloan did not do so, as indicated by the following inscription on a proof for John Quinn, in JST: "Dear Mr. Quinn—This is second state of the plate. I am not likely to carry it any further so send you this Japan proof. J.S. June 25, 1914."

Edition: 100. Printing: 50. Platt 30, Roth 20.
Plate exists: JST. Copper, steel-faced.
Tissue: Ph.

 "Poetic license probably permitted me to introduce many details in these city life plates. Note the protest of the fluttering garments and the neglected child. This woman was about thirty and the boy about eighteen. The nightshirts and underwear belonged to her husband. Seen from Fourth Street and Sixth Avenue, 11th floor studio. All these comments are deductions. I just saw it and etched it" (JS 1945). See "Sloan Defends Love Etching" (New York *Sun,* Dec. 13, 1934, p. 29), concerning an occasion when this etching was cited in a trial as an example of "immorality in art."

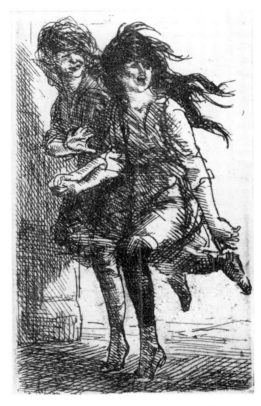

published state

168. GIRLS RUNNING

1914. JS records. (Plate bevel has effaced the signature and date at lower left.) Done before June 1914, when JS inscribed and dated a proof to John Quinn. JST.

Alternative title: *Girls Racing.*

Etching. 95 x 60 mm. (3¾ x 2⅜ inches) plate.

States:

1. Girl at right has closed mouth. Left leg of left girl is completely shaded. Ph, JST–6.
2. Girl at right has open mouth. Highlight burnished on back of left girl's left leg. Additional shading on right cheek of right girl. Heavy shading on side of her chin removed. Published state.

Edition: 100. Printing: 55. Early 35, Roth 20.

Plate exists: JST. Copper, steel-faced.

Tissue unknown.

"This plate is another arising from my love for untamed womanhood. Made from reality because made from memory, like all of my city life etchings" (Dart 49).

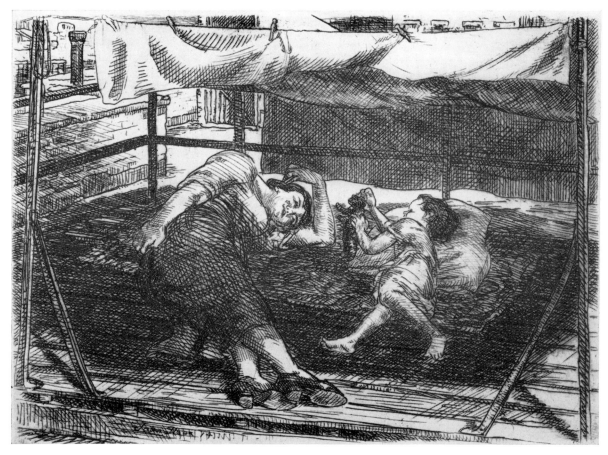

published state

169. WOMAN AND CHILD ON THE ROOF

1914. In plate. A proof of the 1st state, inscribed to John Quinn, is dated June 25, 1914. JST.

Etching. 111 x 151 mm. (4⅜ x 6 inches) plate.

States:

1. Lightly drawn. No background at left. Ph, JST–3.
2. Low wall and chimney added at left. Shading added on child's clothes, boards at bottom, and elsewhere. Ph–2, JST.
3. Shading on child's left forearm burnished lighter. Ph.
4. Toy bear's hind feet shaded black. Ph.
5. Woman's hair shaded completely dark. Ph, JST.
6. Light horizontal shading added on woman's left arm just above elbow. Ph.
7. Clothespins and distant view added above laundry at top.
Considerable shading on laundry. Shading on pillow to right of child. Ph, JST.
8. Diagonal shading added on wall at left. Published state.

Edition: 100. Printing: 60. Early 15, Platt 25, Roth 20.

Plate exists: JST. Copper, steel-faced.

Tissue unknown.

"The heat of summer in New York drives the folks at home to the roofs of the tenements, where extemporized shelters make spots that are comparatively cool. I suppose there are evidences of 'social consciousness' in this plate, but I hope no sentimentality" (Dart 50). "In lecturing on his etchings, Sloan would use this plate as evidence that he went on drawing and painting the world around him, instead of becoming involved with propaganda and subjects related to the war" (HFS 1966).

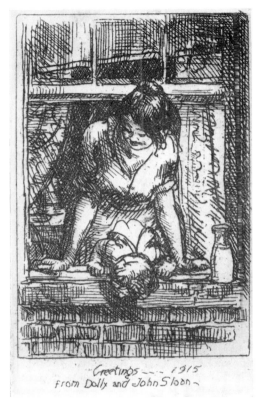

published state

170. GREETINGS 1915

1914. Although the year 1915 is given in the plate, this print was intended as a New Year's greeting and would almost certainly have been done late in 1914, to allow time for printing and mailing to arrive by the New Year.

Alternative title: *Mother and Child at the Window*.

Etching. 96 x 61 mm. (3¾ x 2⅜ inches) plate.

States:

1. Nearly complete. Line from left side of woman's nose to left corner of mouth. Mouth weakly drawn. Ph, JST, Met.
2. Line removed. Mouth strengthened. Highlight on top of woman's head reduced in size. Published state.

Edition: 100. Printing: 75. Early 45, Roth 30. Platt had this plate.

Plate exists: JST. Copper.

Tissue unknown.

"One of my New Year's plates. I watched this little mother as she watched the world go by" (JS 1945).

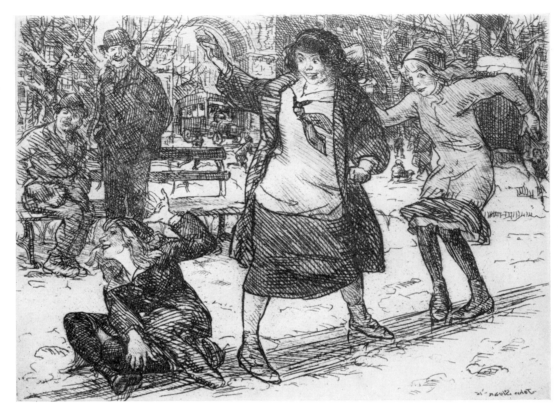

published state

171. GIRLS SLIDING
1915. In plate (reversed).
Etching. 109 x 151 mm. (4¼ x 6 inches) plate.
States:
1. Nearly complete. Center girl has wide open mouth. No shading on blouse and legs of center girl, nor on dress of girl at right. Hair of center girl is very close to top and side of left eye. Ph, JST–2.
2. Hair burnished away from left side of left eye of center girl. Ph (inscribed 1st state), JST–3.
3. Center girl's face redrawn, with mouth smiling but nearly closed. Shading added at waist of her blouse and on legs. Additional shading on buildings in background, covering highlight on front of standing man at left, and elsewhere. Ph (inscribed 2nd state), JST, Met, Bowdoin.
4. Light cross-hatching covering dress of girl at right. Light shading on right side and front of blouse of center girl. Additional shading to right of nose and left side of chin of center girl. Published state.

Edition: 100. Printing: 105. Early 40, Platt 30, Roth 35.
Plate exists: JST. Copper, steel-faced.
Tissue: Ph.

"Healthy happy girls putting on a floor show for appreciative bums in Washington Square. There are some battles in these things, but they are pretty well eliminated" (JS 1945).

194

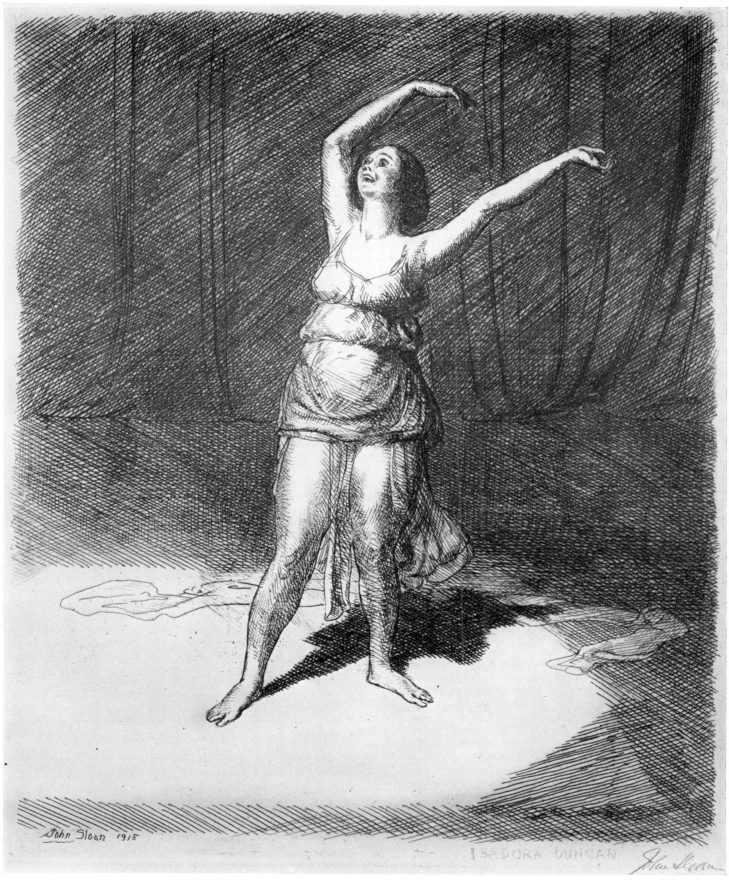

published state

172. ISADORA DUNCAN

1915. Proofs of 1st state dated March 17, 1915. Ph, JST.
Etching. 229 x 191 mm. (9 x 7½ inches) plate.
States:

1. Main figure drawn, with shadow on floor angling toward the upper right. Curtained background remains the same throughout the state changes. Ph–2 (one inscribed "First State," the other with erasures and pencil), JST (inscribed "First State"). Illustrated, p. 197.

2. Face redrawn, with heavy closed mouth and curved shaded area to the left of nose and mouth. Added diagonal and horizontal shading on the outside of right thigh. Ph (inscribed "II"), JST–3 (two with pencil on face).

3. Additional shading below the left corner of the mouth. Ph–2 (inscribed "III" and "IIII," the latter with pencil additions only).

4. Shading added on lower part of right side of neck. Ph–2 (one inscribed "V," with pencil and pen, the other inscribed "VII," with pencil).

5. Additional shading on chin and on right side of neck and

throat. Heavy shading removed from below the left corner of the mouth. Right eye burnished lighter. Horizontal lines added low on the stomach. Vertical lines added on upper left leg. Left eyebrow removed and replaced with a short stroke. Additional shading in and beside the shadow on the floor, between the legs, and to the left of the right calf. Ph (inscribed "VI").

6. Two vertical lines added below the left corner of the mouth. Mouth narrowed by joining the lines at the left corner. Ph (inscribed "VII").

7. Mouth now open wider, with a double line at bottom. Additional shading on left cheekbone and to the left of the mouth. Additional area of hatching on the right side of the neck. Additional line of diagonal shading on the left side of the neck. Another line added to left eyebrow. Curved lines added on the chin. Ph–2 (one with pencil, both inscribed "VII").

8. Hairline raised higher over the left eye. Right eye heavier and darker. Upper line of nose redrawn somewhat straighter. Ph (inscribed "VIII"), JST–4 (all inscribed "VII"). Illustrated, p. 198.

9. Face completely redrawn with left eye higher, upper nose line much straighter, lips thicker, and heavy shading to the left of the nose and mouth. Heavy shading added under chin and on left side of the neck. Shading removed from the right side of the neck. Some shading removed from upper left leg. Isadora's shadow removed and redrawn, angling toward the right rear. Additional shading in the lower right corner. Ph–2 (inscribed "IX" and "X," the latter with much erasure and pencil additions).

10. Left armpit burnished and new vertical shadow added. Fold added in costume over the stomach. Outlines of legs and feet strengthened. Light shading added across bodice and on the left side of waist. A heavy line added under the left eye. Ph (inscribed "XI").

11. A few new horizontal lines added in the left armpit, to complete the shape of the shadow. Ph (inscribed "XII").

12. New lines join the two shadows at the left side of the neck. Shading to the left of nose and mouth burnished lighter. Ph (inscribed "XIII").

13. Additional light shading on left cheek. Ph (inscribed "XIV"). An inscription by Sloan on this proof, "Warm *black* ink (not as above)," seems to be an instruction to Peters.

14. Lower outlines of both arms strengthened. Ph (inscribed "XIV"), JST (inscribed "XIV").

15. Left armpit burnished lighter. Ph (inscribed "XV").

16. Burnishing on the left side of the neck to bring out the line of the tendon. Ph (inscribed "XVI").

17. Lower outline of right forearm redrawn, now almost straight. Ph (inscribed "XVII").

18. Additional light horizontal shading at hairline to the left of the left eye. Ph–2 (one with erasures and pencil, both inscribed "XVIII"), JST, Andrew King Grugan.

19. Big toe of the right foot now spread from the other toes. Center drapery removed from left thigh, now thin, between the legs only. Ph (inscribed "XIX").

20. Right heel redrawn, now narrower than before. Ph–2 (one with pencil, both inscribed "XX"), JST (inscribed "XX"). Illustrated, p. 199.

21. New shading added on both sides of left thigh. Ph (inscribed "XXI").

22. Additional shading, almost vertical, at the front inner side of right thigh. Ph (inscribed "XXIII" and dated April 14, 1915).

23. Big toe of left foot now spread from the other toes. Additional shadow on the floor at right center, filling a blank space. Bowdoin (inscribed "Working proof XXIV, only one in this state").

24. Face completely redrawn. Left eye now round and wide open, placed level with right eye, lower than before. Mouth now wide open, with upper teeth showing. Heavy shading added on chin, on left cheek beneath the eye, and at the left side of the mouth. There is a single heavy vertical line at the right side of the mouth. Additional shading on the upper side of the right forearm. Ph (inscribed "XXIV" in brackets).

25. Shading on chin, on right cheek, and beneath the left side of the mouth is all burnished lighter. Met.

26. Title added lightly at lower right. Ph (inscribed "XXV" in brackets), JST.

27. Shading removed from right cheek next to mouth. JST (Quinn proof).

28. Light vertical shading added on left side of upper lip. Light diagonal shading added on chin, just beneath lower lip. Light horizontal shading added on upper part of right cheek. Curved line added around right corner of mouth and descending beneath it. Ph (inscribed "XXV").

29. Curved line burnished away from right corner of mouth, leaving a vertical line descending 2 mm. from the corner. Published state.

Edition: 100. Printing: 75. Early 25, Platt 25, Roth 25. There are at least 46 trial proofs, not included in this printing total. Sloan's 1931 personal inventory lists 25 "states of plate." JST.

Sloan used different colors of ink at various stages in the development of this print, as follows: states 1–9 black, 10–16 brown, 17–18 reddish brown, 19–23 black, 24–27 reddish, 28–29 black. These changes may indicate different working periods.

Plate exists: JST. Copper, steel-faced.

Tissue: Ph.

"When this great American and International high priestess of the dance [1878–1927] returned from France at the outbreak of World War I, for her first appearance in two years after the tragic death of her children, she lacked slenderness, but was still, in my opinion, the greatest dancer on earth" (Dart 51). "She was quite heavy, but still beautiful. A great dancer, she would bring tears to my eyes" (JS 1945). Sloan's enthusiasm for Isadora Duncan's dancing is set down in detail at several places in his diaries (e.g. *NYS*, pp. 352, 507–08, 512). He did numerous paintings, drawings, and monotypes of her. "This is one of many (about 40) working proofs—each one of which is slightly different. The plate is very nearly finished at this stage" (JS inscription on 27th state proof for John Quinn; JST). See also Sloan's "Autobiographical Notes," p. 388.

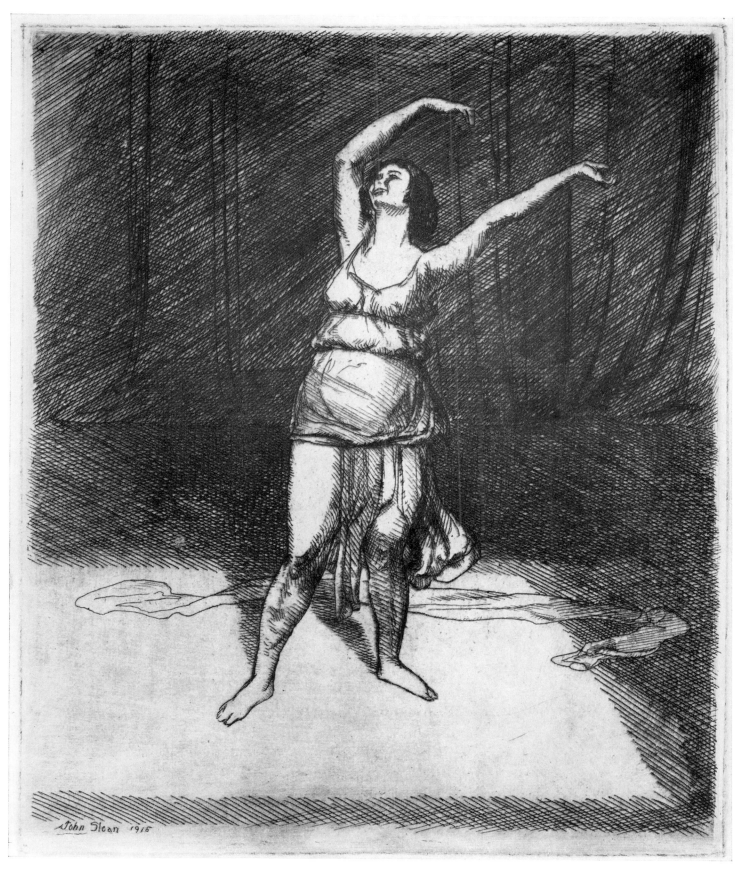

first state

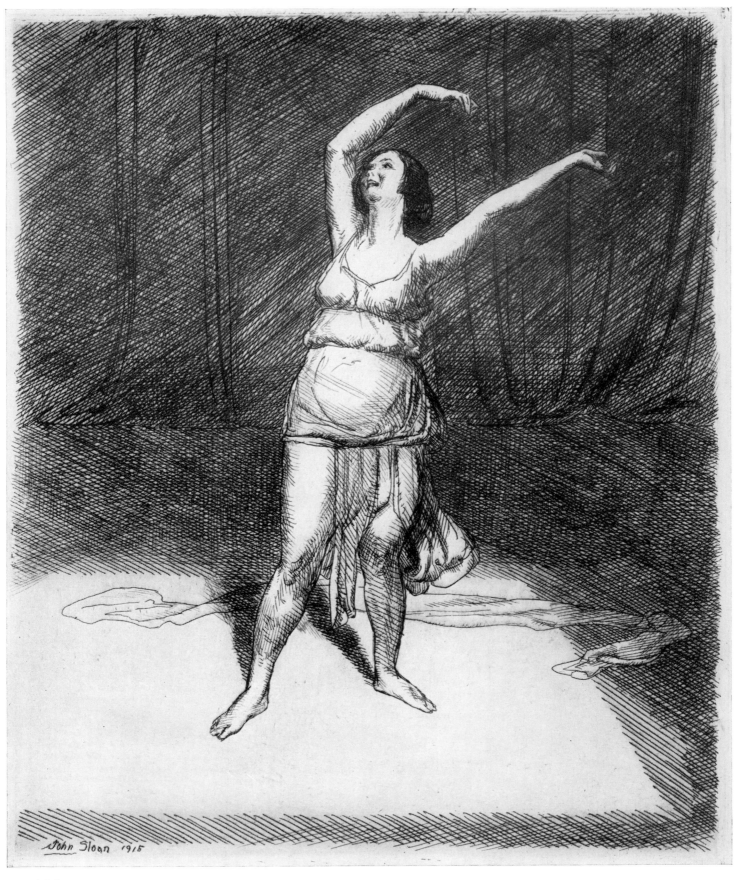

172, eighth state

198

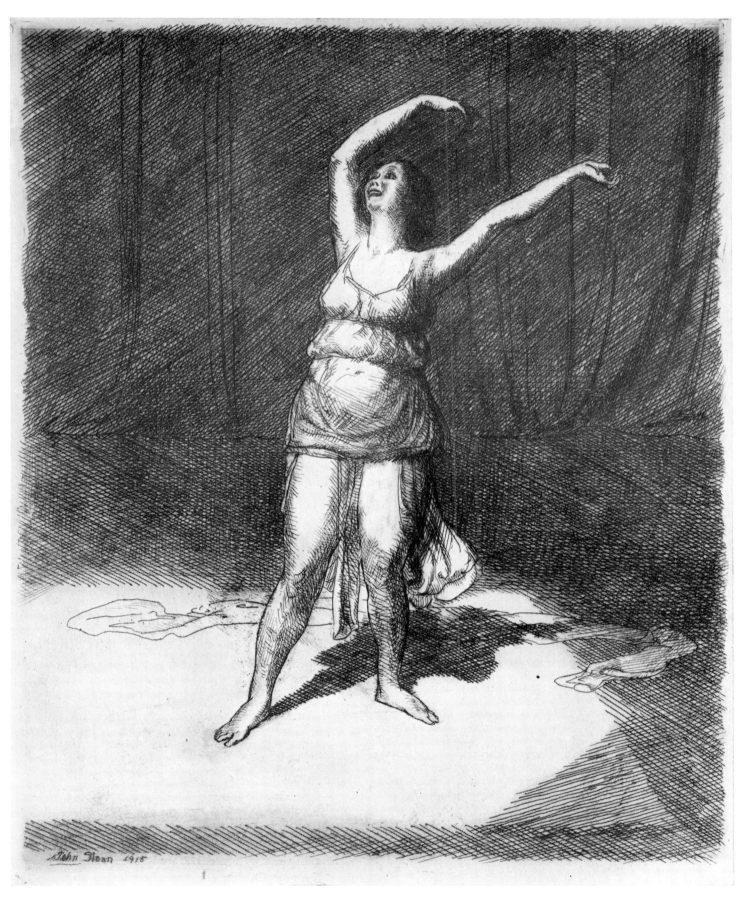

172, twentieth state

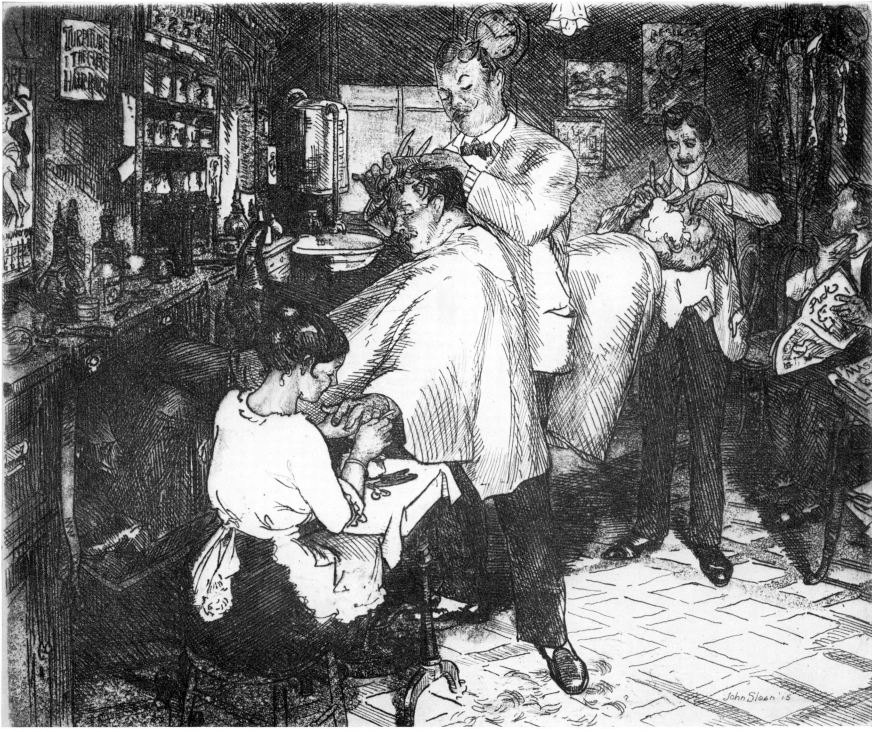

published state, reduced

173. BARBER SHOP

1915. In plate.
Etching and aquatint. 256 x 308 mm. (10 x 12 inches) plate.
States:

1. Both barbers' coats and sheets covering both customers are blank. Ph, JST–3.
2. Heavy lines of shading added on both sheets, on both coats, and in girl's lap. Slight additional shading on left side of face, nose, and neck of center barber. Ph–2 (one inscribed "unique in this state"), JST–2. The "unique" proof appears to be the same as the others of this state.
3. Additional light vertical hatching on arms and tail of sheet covering center customer. Light shading added on side of face of same man, between his eye and ear. Additional cross-

hatching on right sleeve of center barber. Published state.
Edition: 100. Printing: 35. Early 35. Sloan's 1931 personal inventory lists proofs by both Peters and Platt.
Plate exists: JST. Zinc.
Tissue unknown.

"Done on a zinc plate, which is not susceptible to delicate biting. The linework was etched first, then the plate coated with powdered resin and prepared for aquatint in the usual manner. The lightest areas were blocked out first with stopping-out varnish, then the medium darks, while the darkest darks were exposed the longest to the acid bath. I don't remember making any previous experiments with aquatint" (JS 1945). The sign at upper left reads, "Turpitude the Great Hair Raiser." Also note *The Masses* on the pile of magazines at right.

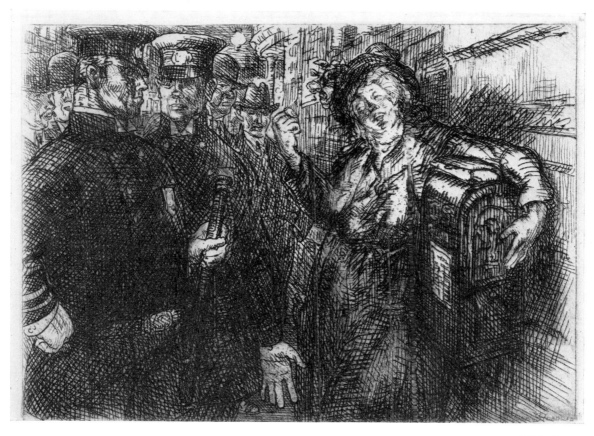

published state

174. MARS AND BACCHANTE

1915. Proof of 1st state dated October 1915. JST.
Etching. 110 x 151 mm. (4¼ x 6 inches) plate.
States:

1. Nearly complete. Diagonal lines of shading prominent on coat of policeman at left. Mailbox label blank. Ph, JST–3.
2. Additional hatching on left policeman, covering diagonals. Lines on mailbox label. Added shading on woman's left thigh. Shading on nose and cheek of man at extreme left. Ph ("only proof").
3. Front of woman's left thigh burnished lighter. Ph ("only proof").
4. Left thigh front burnished still lighter. Ph, JST–3 (including the proof inscribed "6"), Bowdoin.
5. Dark line of inner edge of woman's right coat lapel removed. Inner side of woman's right elbow burnished lighter. Front of dress below waist and upper part of right thigh lightened. Ph.
6. Added shading across highlight on front of woman's left thigh. New highlight burnished on outside of left thigh. Published state.

Edition: 100. Printing: 56. Early 25, White 31.
Plate exists: JST. Copper, steel-faced.
Tissue: Ph.

"A happy old harridan of pre-Prohibition days constituted herself a problem by seeking support from the U.S. Mail Box" (Dart 53).

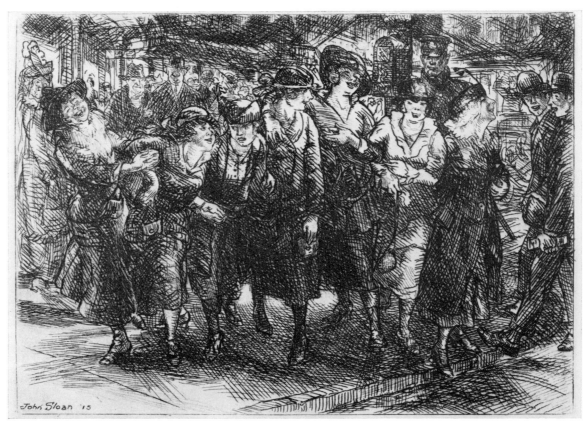

published state (eleventh)

175. RETURN FROM TOIL

1915. Proof of 5th state dated October 25, 1915. Ph.
Etching. 109 x 152 mm. (4¼ x 6 inches) plate.
States:

1. Lightly drawn. Ph, JST–4, Bowdoin.
2. Much additional shading across fronts of girls, on the El at top center, and elsewhere. Ph, JST.
3. Vertical shading added across open window at upper right. Ph, JST.
4. Long diagonal lines added on pavement in lower left corner. Ph ("only proof").
5. Heavy shading added on right foot of center girl. Ph ("only proof").
6. Shading strengthened on fronts of girls. Added horizontal shading on girl at right, diagonals beneath and between the two girls at left, and additional diagonals in lower right corner. Ph, JST–2.
7. Light shading added across highlight on right girl's right shoulder. Ph, JST–2.
8. Highlight burnished on right cheek of right girl. Ph ("only proof").
9. Heavy horizontal line removed from corner of her mouth. Ph–2, JST–3. A number of proofs in this state are marked "100 proofs." States 1 through 8 are inscribed as such by JS.
10. Large highlight burnished on front of girl at left. Hair of girl at right burnished much lighter, changing her to a blonde. Heavy shadow remains on right side of neck, below hair. Hat of girl near right in light dress, burnished lighter. Ph, JST, Bowdoin.
11. Shading at right side of right girl's neck burnished lighter. Published state.

Edition: 100. Printing: 85. Early 40, Roth 45. Gaston 25, mostly destroyed.
Plate exists: JST. Copper, steel-faced.
Tissue unknown.

"A bevy of boisterous girls with plenty of energy left after a hard day's work. A simplified version of this subject was made for a cover drawing of *The Masses*" (Dart 52). *The Masses* cover preceded the etching. It was on the issue of July 1913 (vol. 4).

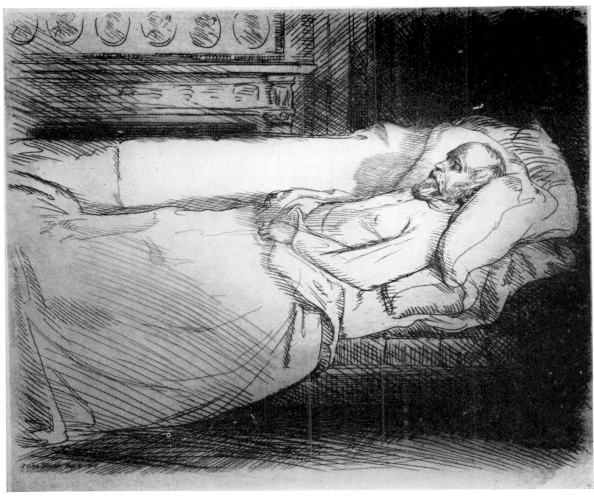

only state, reduced

176. SILENCE
1915. Dated November 4, 1915, in plate.
Alternative title: *Isaac L. Rice*.
Etching. 255 x 305 mm. (10 x 12 inches) plate.
Only state. Published state.
Edition: 100. Printing: 75. Peters 75.
Plate exists: JST. Copper.
No tissue. Two sketches in Ph.

"Isaac Rice's chief claim to fame lay in the fact that he backed
Holland in his early experiments with submarine vessels. This
post mortem etching was commissioned by his widow as a me-
morial. She sent for me, George Bellows, and someone else. We
drew him on his death bed. I did the etching right there. Bellows
made a drawing at the same time" (JS 1945). "Drawn on copper
from Isaac L. Rice, Esq., as he lay dead in his apartments in the
Hotel Ansonia, N.Y.C., Nov. 4, 1915" (JS inscription on proof
for John Quinn, ca. 1916; JST). Rice died late on November 2.
Isaac Leopold Rice (1850–1915) was a very successful corporation
lawyer, financier, and chess expert. No details are known of the
commissioning of this and the two following prints, as some of
Sloan's files from this period were discarded or lost during a sub-
sequent move. I have been unable to locate the Rice family.
Apparently, judging from the printing records, this is the only
etching of the three to be accepted under the terms of the com-
mission.

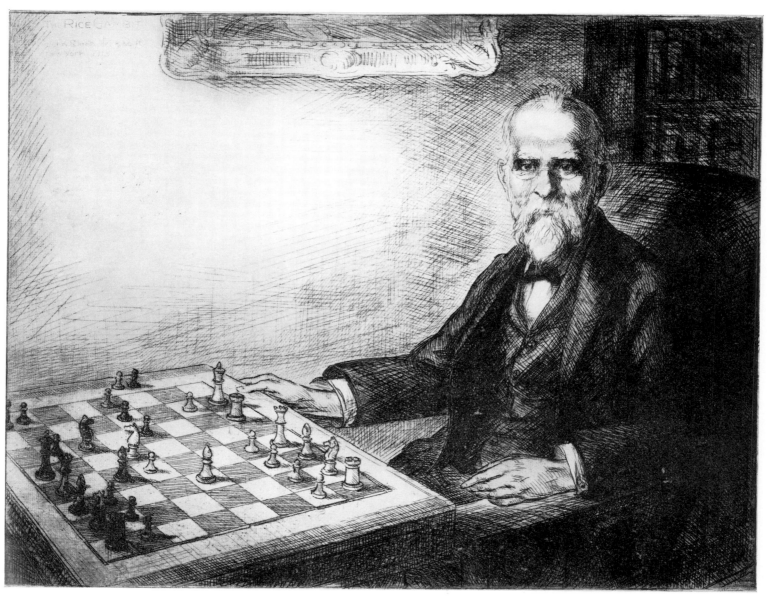

fourth state, reduced

177. THE RICE GAMBIT

1915. In plate.

Etching. 306 x 425 mm. (12 x 16¾ inches) platemark.

States:

1. Nearly complete. "The Rice Gambit" written twice, in upper left corner and on blank wall at left. Forehead shaded above left eye. Ph.

2. Much additional shading on coat, background at upper right, chair, edge of chess table, wall above chess table, and right arm. "The Rice Gambit" on wall at left is badly erased. Hair burnished lighter. Ph, JST–2; also fragment of head, JST.

3. Shading completely across forehead above both eyes. "The Rice Gambit" on wall completely erased. More shading on coat, especially inside right lapel. Additional shading on head and face. Ph, JST.

4. Additional shading along left margin from center to top. Ph, JST.

No edition. Printing: unknown, but evidently small.

Plate unknown, probably destroyed. See note under *Isaac Rice* (178).

Tissue: Ph, also one sketch and traced paper with red chalk. JST, one sketch of head. Not entered in any of Sloan's records.

The Rice Gambit was a highly regarded opening gambit in the early part of this century. It has since been superseded in favor of other variations. A booklet by Emanuel Lasker, one of the greatest of chess experts, was devoted entirely to this subject (*The Rice Gambit,* 5th ed. New York, June 1910). The diagram of the initial position of the gambit on page 7 of this publication is identical to the position on the chessboard in Sloan's etching. Sloan did not play chess himself but was familiar with the moves.

He felt that "it is bad taste to make an etching over 10 by 14 inches in size" (*Gist,* p. 178). Of his etchings, only nos. 104, 177, 178, 246 exceed that size, and only this print, an unpublished commission, exceeds it by any considerable amount.

published state, reduced

178. ISAAC L. RICE, ESQ.
1915. In plate.
Etching. 357 x 279 mm. (14 x 11 inches) plate.
States:

1. Before title and signature. Heavy shading on center and right of forehead. Ph, JST.
2. Forehead shading burnished lighter. Additional light diagonal shading on right eyebrow and along hair line. Ph, JST.
3. Shading on forehead much lighter. Additional shading on right side of forehead. Title added at lower left, signature and date at lower right. Published state. All but the earliest proofs have light vertical curved lines entirely across the blank wall. These have every appearance of being accidental scratches, not deliberate additions. This change is therefore not listed as a separate state.

Edition: 100. Printing: 25, Platt 25. A proof of the 3rd state in the Met is inscribed by JS, "one of five proofs—plate destroyed—JS." This is clearly an error and must refer to *The Rice Gambit* (177).
Plate exists: JST. Copper, steel-faced.
Tissue for the head: Ph. The cut fragment of the head from *The Rice Gambit* (JST) may have been used in preparation for this print. The two heads are very similar, in opposite directions. JST: complete tissue and five sketches.

"Isaac Rice was known among chess players as the inventor of the Rice Gambit. This portrait, commissioned by Mrs. Rice, was compiled from various photographic sources" (JS 1945). As only late (Platt) impressions are known apart from trial proofs, this commission was probably not completed.

only state

179. GREETINGS 1916

1915. This greeting for New Year's 1916, as written in the plate, was likely to have been made the preceding November or December.

Alternative title: *Standing Nude (small)*.

Etching. 95 x 60 mm. (3¾ x 2⅜ inches) plate.

Only state. Published state.

Edition: 100. Printing: 45. Early 45. Platt had this plate.

Plate exists: JST. Copper.

Tissue unknown, probably nonexistent.

"May be compared with the nudes etched in the Thirties, although the plate is relatively trivial in purpose" (JS 1945). Used as a New Year's greeting.

only state

180. GROWING UP IN GREENWICH VILLAGE

1916. Proofs dated February 1916 and initialed by JS. Met, Bowdoin. This print with no plate year is dated 1917 in the later JS records. It is found in a manuscript addition, by Sloan, to his copy of the Hudson Guild exhibition catalogue, February 10 to April 10, 1916, and in a list of prints consigned to Kraushaar on June 2, 1916. JST.

Etching. 165 x 83 mm. (6½ x 3¼ inches) plate.

Only state. Published state.

Edition: 100. Printing: 80. Platt 35, Roth 45.

Plate exists: JST. Copper.

Tissue unknown.

"A glimpse of the trials of a Village girl emerging into young ladyhood" (JS 1945). "Sloan did not print from this plate until some years after making it. He had felt it was coarsely bitten" (HFS 1966).

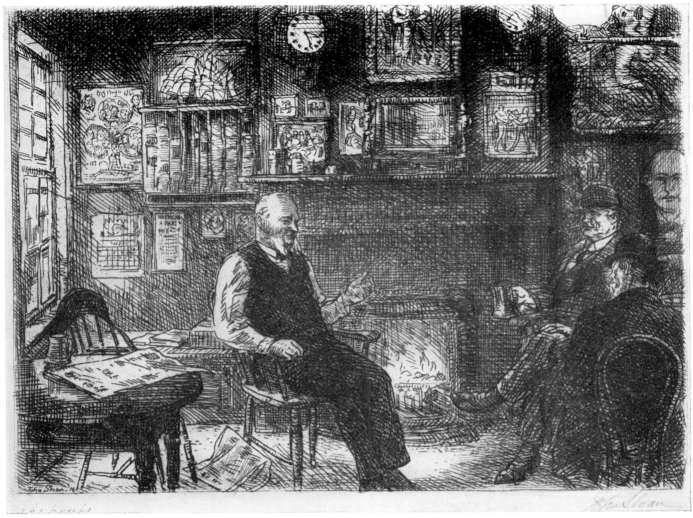

published state

181. McSORLEY'S BACK ROOM

1916. In plate. Done before June 2, 1916, when it is found on a dated consignment list from Sloan to Kraushaar. JST.

Etching. 135 x 180 mm. (5¼ x 7 inches) plate.

States:

1. Almost complete. Before title at bottom. Ph, JST–4.
2. Title added at bottom left center. Added vertical shading on lower calendar next to window at left. Diagonal shading added on face in picture at extreme right and on left lapel of man seated near back wall. Ph, JST–7, Met.
3. Vertical shading added on face in picture at right. Published state.

Edition: 100. Printing: 90. Early 45, White 20, Roth 25. Platt had this plate. Gaston 25, probably destroyed.

Plate exists: JST Copper, once steel-faced, subsequently removed.

Tissue and one sketch: Ph.

"Old John McSorley and two friends in the back room of the now famous McSorley's Old House at Home. Nothing but ale was ever served there" (JS 1945). "Old John McSorley died before I found the place. The son told me that the old man always sat there in the sun. A very remarkable saloon. Went right along all through Prohibition without any interference. They made their own beer in the basement. No woman ever touched foot in there and no hard liquor was ever served" (JS 1945). "I have never gone slumming to get subject matter. I was in McSorley's ale house about ten times in my life and painted five pictures of the place" (JS, quoted by HFS, in *NYS*, p. xx).

preliminary sketch

only state

182. CALF LOVE
1916. In plate.
Etching. 108 x 70 mm. (4¼ x 2¾ inches) plate.
Only state. Published state.
Edition: 100. Printing: 85. Early 35, Platt 25, Roth 25.
Plate exists: JST. Copper, steel-faced.
Tissue: Ph.

"Adolescent affection expresses itself in slaps and kicks and general rough handling" (Dart 54). Sloan had earlier noted this subject in his diaries. "Young girls of fifteen and sixteen and a little younger stand on the corners with the boys Sunday evening —a sort of rough and ready love making goes on, something like the play of animals; a smack in the face expresses the warmest regard" (Feb. 25, 1912, *NYS,* p. 604). The same general subject matter was used in a drawing, *Down at the Corner,* published in *Harper's Weekly* (*58,* Aug. 16, 1913, 24). The print was used as a Christmas-New Year's greeting.

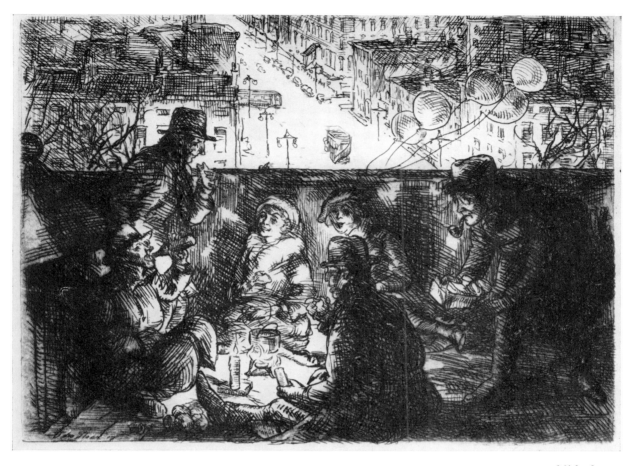

183. ARCH CONSPIRATORS

1917. In plate. The document drawn up and signed on the occasion is dated January 23, 1917. A photograph of it is in JST. The location of the original is unknown.

Etching. 110 x 153 mm. (4½ x 6 inches) plate.

States:

1. Nearly complete. Sloan's face, at right, in three-quarters front view. Ph, JST–8.
2. Sloan's face redrawn in profile. Published state.

Edition: 100. Printing: 100. Early 10, Platt 25, Roth 65.

Plate exists: JST. Copper.

Tissue: Ph.

"A mid-winter party on the roof of the Washington Square Arch. Among those present: Marcel Duchamp (Nude Descending the Stairs), Charles Ellis (actor), John Sloan, and Gertrude Drick ('Woe'), instigator of the affair. A document was drawn up to establish the secession of Greenwich Village from the United States and claiming protection of President Wilson as one of the small nations. The door of the Arch stairway has since been kept locked" (Dart 57). "Gertrude S. Drick, poet, was a wild little creature. I had found that the bronze door of the Arch was open. She said we must have a picnic. We had hot water bottles to sit on, sandwiches, and thermos bottles of coffee. There was a spiral iron stairway, then a big chamber eighteen feet high, the width

of the Arch, then a stairway to a trap door. When we left, we fastened colored balloons to the parapet. They stayed about a week. One of my bohemian incidents, one of the very few. A couple of the members were delayed because of two cops standing near the door' (JS 1945).

Sloan has identified only four of the six people in the picture. The photograph (JST) of the original "Declaration of Independence" document shows it to be a nonsense document, with most of the writing deliberately illegible. The date, January 23, 1917, can be read. There are seven signatures, in the order written: Gertrude S. Drick, Betty Turner, John Sloan, Marcel Duchamp, Chas. Frederick Ellis, Allen Russell Mann, Allen Norton. The author, Albert Parry, telling the story some years later (*Garrets and Pretenders*, New York 1933, pp. 275–77), lists the first six of these as participants (referring to A. R. Mann as "Forrest Mann"). It may well be that Norton was a latecomer to the party, stopped by the policemen, and not included by Sloan. In this case the six people in the etching, from left to right, are: Ellis, Duchamp (standing), Drick, Mann (foreground), Turner, and Sloan.

Another article about the incident, "Arch Conspirators" by Margaret Christie (New York *Tribune*, Dec. 30, 1923), tells essentially the same story. It quotes Sloan at length in the author's words and reproduces the 1st state of this etching.

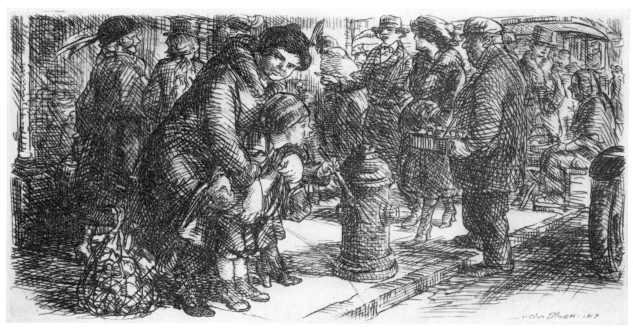

published state

184. SIDEWALK

1917. In plate.

Etching. 82 x 165 mm. (3¼ x 6½ inches) plate.

States:

1. Almost complete. Bright highlight on top of head of woman with boy. Ph, JST–2.
2. Woman's hair completely dark. Heavy vertical line removed from cheek of woman to right of hydrant. Hat of woman at left completely shaded. Published state.

Edition: 100. Printing: 45. Platt 25, Roth 20.

Plate exists: JST. Copper.

Tissue: Ph.

"An everyday incident on New York's East Side. A plate missing from most American collections" (Dart 55). "They put up signs in the sweller apartment house district, 'Curb Your Dog,' where they don't pay much attention to them anyhow. These horizontal plates I just had and used. They bring an awful pressure—no room for the 'place' " (JS 1945).

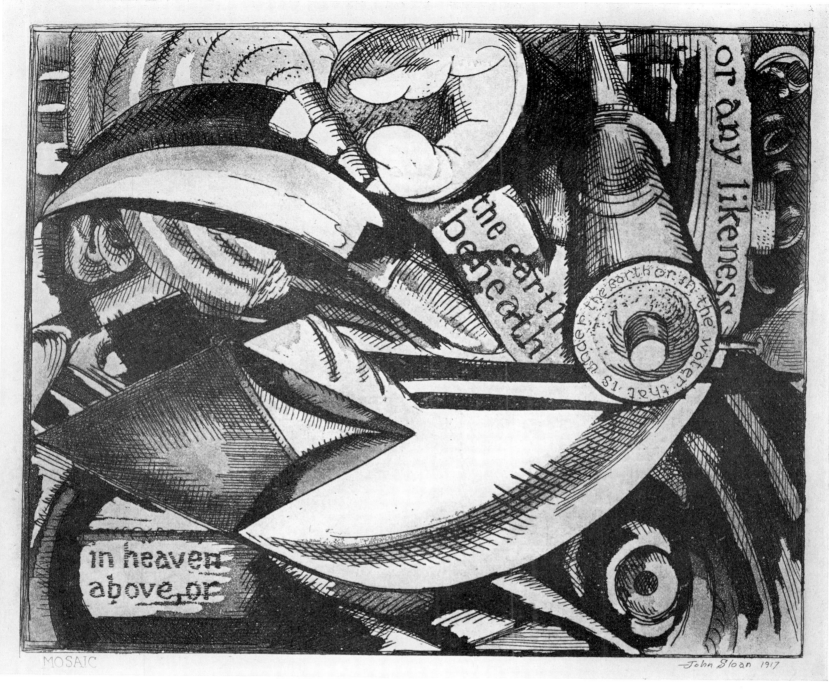

only state, reduced

185. MOSAIC

1917. In plate. Done before March 19, 1917, when it appeared in a Kraushaar Gallery exhibition catalogue in New York.

Alternative titles: *The Mosaic Law; Obedience to the Law of Moses; The New Movement.*

Etching and aquatint. 203 x 253 mm. (8 x 10 inches) plate.

Only state. Published state. "The Mosaic Law" at bottom left center, badly erased, remains in the plate and prints weakly in all known proofs.

Edition: 100. Printing: 35. Platt 25, Roth 10.

Plate exists: JST. Zinc.

Tissue: Ph.

"The plate is a satire on abstract art, and implies that followers of this trend are obeying the Mosaic Law" (JS 1945). "Thou shalt not make unto thee any graven image / or any likeness of anything in heaven above or / that is in the earth beneath or that is in the / water under the earth" (inscription in JS hand on proof printed by him; Met). See also Sloan's "Autobiographical Notes," p. 386.

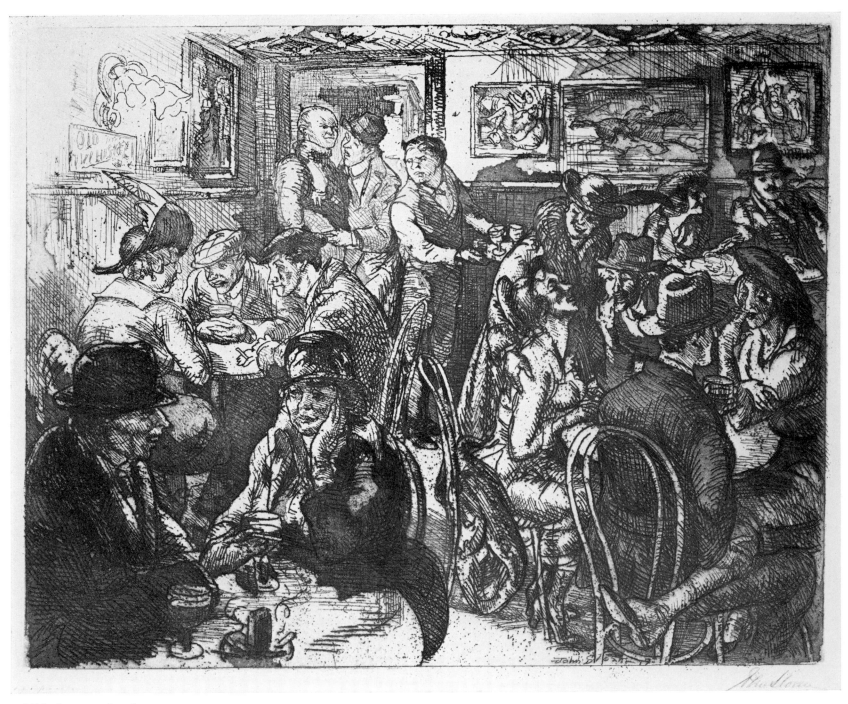

published state, reduced

186. HELL HOLE

1917. Proof of 1st state dated May 1, 1917, by JS. Ph, JST.
Etching and aquatint. 204 x 253 mm. (8 x 10 inches) plate.
States:

1. Before aquatint. Etched lines complete. Ph, JST–2.
2. Aquatint added. Published state.

Edition: 100. Printing: 110. Early 30, Platt 50, Roth 30.
Plate exists: JST. Zinc.
Tissue unknown.

"The back room of Wallace's at Sixth Avenue and West
Fourth Street was a gathering place for artists, writers, and bo-
hemians of Greenwich Village. The character in the upper right
hand corner of the plate is Eugene O'Neill. Strongly etched lines
are reinforced by aquatint tones" (Dart 56). "A little frame
house almost from Colonial days. After the Brevoort closed, they
would come for the night" (JS 1945).

"This bar was actually named 'The Golden Swan,' the hang-
out of the theatrical crowd, nicknamed 'the Hell Hole.' Its op-
posite number, the artist's hangout, was 'The Columbia Gar-
dens,' popularly known as 'The Working Girls' Home'" (from
Holger Cahill notes, Columbia University, New York, N.Y.,
April 1957, p. 56).

Mrs. Fred Gardner (whose husband was Vice-President of the
Society of Independent Artists for many years) has very kindly
given me notes which Sloan made on the back of her copy of this
print. Eugene O'Neill is identified as the man at the upper right.
Peggy O'Neill (no relation) is seated at the table with him. René
Lacoste is seated at right center. Charles Ellis (also in no. 183) is
in the left foreground.

This print was awarded a gold medal at the Sesqui-Centennial
International Exposition, Philadelphia, in 1926.

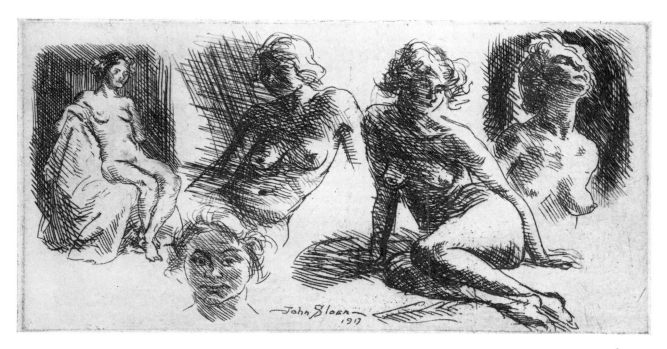

only state

187. NUDE SKETCHES

1917. In plate.

Etching. 82 x 165 mm. (3¼ x 6½ inches) plate.

Only state. Published state.

Edition: 100. Printing: 70. Early 20, Platt 25, Roth 25.

Plate exists: JST. Copper, steel-faced.

No tissue.

"Needled on the plate directly from life. This etching is interesting in its gradations of biting, which are well controlled" (Dart 59).

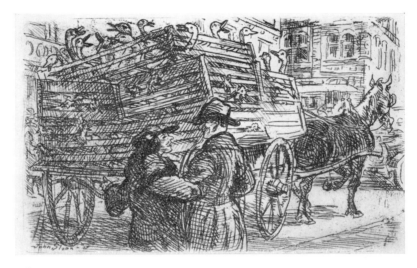

only state

188. SEEING NEW YORK

1917. In plate. Probably late in the year.
Etching. 60 x 95 mm. (2⅜ x 3¾ inches) plate.
Only state. Published state.
Edition: 100. Printing: 85. Early 40, Roth 45. Platt had this
plate.
Plate exists: JST. Copper.
Tissue unknown. HFS remembers an earlier drawing, location
now unknown.

"Poultry on the way to East Side execution. A sketch plate"
(Dart 58). "Out-of-towners going down to be koshered" (JS
1945). The subject was first noted in Sloan's diary nine years
earlier. "An amusing thing—wagons loaded with coops with live
poultry, on top a lot of geese with their necks poked through the
slats cackling and gazing at the city—'Seeing New York' wagon"
(Jan. 11, 1909, *NYS*, p. 280). The title refers to tour busses taking
sightseers around the city. Used as a New Year's card, inscribed:
"Greetings 1918, from Anna M. and John Sloan."

from canceled plate, reduced

189. TANK CORPS

1918. Estimate. The U.S. Tank Corps was first organized in the spring of 1918.

Etching. 178 x 253 mm. (7 x 10 inches) plate.

Only state. Unknown before cancellation. Ph, WSFA, 51.

No edition. Printing: None known before cancellation. Canceled plate: Harris 3.

Plate exists: JST. Copper.

Tissue unknown.

"Example of a failure. The propaganda motive was a mistake. A subject more suited to cartoon. I felt uncomfortable about it. The drawing, coarseness of biting, etc., shows. Discarded but kept" (JS, recalled by HFS, 1966).

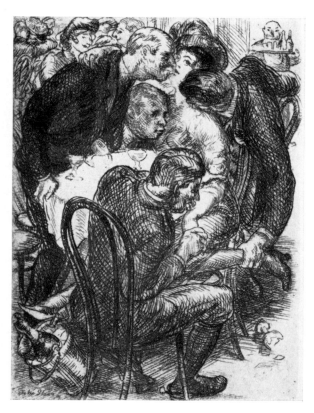

published state

190. NEW YEAR'S EVE AND ADAM
1918. In plate. Probably late in the year.
Etching. 96 x 70 mm. (3¾ x 2¾ inches) plate.
States:
1. Lightly drawn. Ph, JST–5.
2. Curved horizontal shading added, encircling right upper arm of man at bottom center. Added hatching on three men's coats and trousers. Ph, JST–12. The proofs of the 2nd state are all inscribed "first state" by JS.
3. Hair of man at right completely darkened. Man's face above edge of table at center burnished lighter. Shading removed from under woman's left eye. Published state.
Edition: 100. Printing: 85. Early 40, Roth 45.
Plate exists: JST. Copper, steel-faced.
Tissue: Ph.

"With some exaggeration this records an incident of the holiday season in a New York hotel, the Brevoort" (JS 1945). This print was used as a greeting for New Year's 1919.

only state

191. GEORGE O. HAMLIN
1918. Estimate. Three proofs are known, printed on the same piece of paper with *New Year's Eve and Adam* (190). JST, Bowdoin, Met.
Etching. 19 mm. diameter (¾ inch) platemark. Etched on a penny.
Only state. Ph, JST, SI, Bowdoin, Met.
No edition. Printing: Unknown.
Plate lost. Sloan gave the "plate" to his close friends the Hamlins. It was not, however, given to Bowdoin with the rest of the Hamlin collection. The executors of Mr. Hamlin's estate did not find the penny in his New York apartment when a thorough inventory was made on April 13, 1961. Herbert E. Hamlin, brother of George O. Hamlin, remembers seeing the penny during his brother's lifetime, but does not know what became of it. It must therefore be presumed lost.

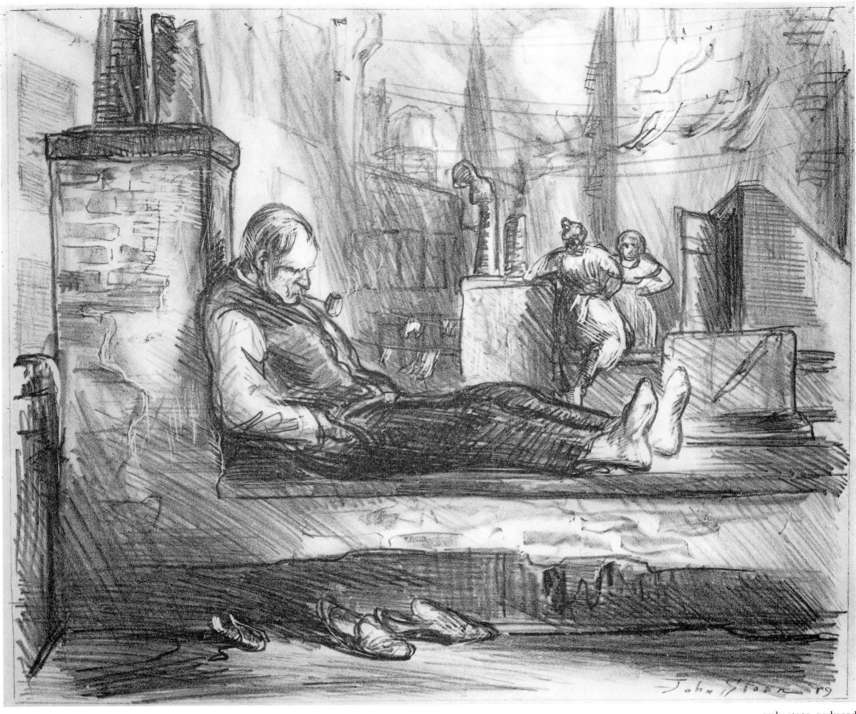

only state, reduced

192. SATURDAY AFTERNOON ON THE ROOF
1919. In stone. Pratt Institute, March 1919 (see below).
Alternative title: *Tenement Roofs.*
Lithograph. 268 x 326 mm. (10½ x 13 inches) design (frame line).
Only state. Ph, JST, WSFA, NYPL, Rosenwald, Detroit, Bowdoin, Addison (Andover, Mass.), Chicago.
Edition: 8. The Ph proof is annotated "8 proofs" in Sloan's hand, the only one known to be so marked. Printing: 8 or more, by Bolton Brown. Signed: "Bolton Brown imp."
Stone presumably effaced.
No tissue.

"Beginning March 3rd, and remaining for two weeks, Pratt Institute is holding an exhibition of the lithographs of Bolton Brown. During the exhibition and in the same gallery, a fully equipped lithographic press with stones, etc., will be operated. John Sloan, George Bellows, Albert Sterner, Abel Pann, and others will at different times make drawings on stone, and Mr. Brown on successive days will etch, roll up, and print them, all in the presence of as much of the public as chooses to be there. Thus a practical lesson will be given concerning the nature and resources of the art of lithography, an art that still is sadly neglected in spite of the efforts of a fine little band of craftsmen to give it its place" ("Art Notes," *New York Times,* March 7, 1919, p. 12, quoted in full).

Sloan's inscription on the Chicago proof says, "made in Brooklyn 1919." He also mentioned the occasion in his 1951 notes (p. 27; JST). Brown later mentioned and illustrated this print. "The drawing by John Sloan was done in public, on stone, at a lithographic demonstration given by me at Pratt Institute in 1919, printed by me at the time, in public, otherwise unpublished" (Bolton Brown, "Lithographic Drawing . . . ," *Print Connoisseur,* 2, Dec. 1921, 148–50).

The folder which accompanied Mr. Brown's demonstration (copy in JST) gives Sloan's name as one of the participating artists. The schedule shows that the actual drawing by the artists was done on March 5, 6, 8, 10, 11, 12, and 13. Sloan's work must have been done on one of those days.

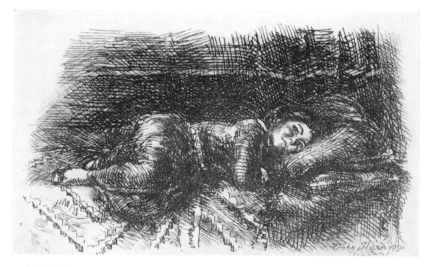

published state

193. LITTLE WOMAN
1920. Dated January 1, 1920, in plate.
Etching. 58 x 93 mm. (2⅜ x 3¾ inches) platemark.
States:

1. Nearly complete. Strong hard lines on face and under both eyes. Ph, JST–3.
2. Lines under right eye and on right cheek burnished softer. Ph, JST–6, Met, Bowdoin.
3. Slight horizontal shading added on right cheek directly above nose. Ph, JST–11.
4. Lines under left eye and line of mouth and chin burnished softer. Much additional shading: on legs and body, on upper corner of pillow, on bed to left of feet, in background at upper left, and elsewhere. Published state.

Edition: 100. Printing: 65. Early 55, White 10.
Plate lost by White, sometime between April 1945 and April 1947.
No tissue.

"This plate was made on New Year's Eve. While my wife was dozing in the New Year, I made this etching 'to start the New Year right'" (Dart 64). Sent as New Year's greeting in 2nd state (e.g. Bowdoin). "Chas. White had left at the Hotel desk a package of my etched plates which he has had for more than a year. He is one plate, *Little Woman, short* in the plates returned" (April 25, 1947, JS diary). It has not been found.

194. GIRL PAINTING BY THE SEA

1920. The Fourth Annual Show of the Society of Independent Artists was held from March 11 to April 1, 1920.
Linoleum cut, black ink on brown cardboard. 342 x 547 mm. (13½ x 21½ inches) entire design, including lettering; 294 x 334 mm. (11½ x 13 inches) picture area only, published state.
States:

1. Nearly finished. Space of 4 cm. between right edge of palette and right margin. Picture area only, with partially inked traces of lettering. Ph.
2. Right edge of block trimmed. Palette touches right margin. One line of shading removed from girl's jawline. Printed on light brown cardboard of poor quality. Ph, JST–6, WSFA, SI, Lock Haven.

No edition. Printing unknown.
Block unknown.
Probably no tissue.

The 1st state proof (Ph) is inscribed "John Sloan del & fecit." This press-printed poster is clearly from a linoleum block and not from a photomechanical linecut. A note in Sloan's hand, in an inventory he made on October 22, 1940, says: "Posters S. I. A., linoleum" (JST). Carl Zigrosser remembers that linoleum blocks were given out to various members of the S.I.A. in the early days, for the express purpose of making posters for the shows. Linoleum cutting tools were found in Sloan's kit of etching materials, now in JST. As a self-designed, self-carved image,

this poster certainly qualifies for inclusion among Sloan's original prints.

This print was illustrated in the magazine section of the New York *World* (Feb. 29, 1920, p. 8), in an article by Henry Tyrell, "Independent Artists' Posters." Mr. Tyrell commented: "Here, for instance, is John Sloan, President of the organization, with a picture-poster of Gloucester, the summer school of carefree modernists who thrive on open air and sunshine by the glad sea waves. The hand of the practiced illustrator appears in this print, even though Mr. Sloan hewed it out of a piece of linoleum, after the fashion of the antique wood cut."

"I don't think that any of these modern woodblock men can touch Bewick. Notice how he uses the white line. I don't see any point any more in using a black line when you can make a pen-and-ink drawing and hand it over to the photo-engraver. I made this linoleum block for a poster for the Independents. It's the first one I ever made and better than the ones I made following it" (JS 1930). Sloan had had considerable prior experience in white-line technique from making scratchboard illustrations for photomechanical reproduction. His technical comment on the subject was found in his 1950 notes: "Method of preparing woodblock or linoleum to cut with 'white line' like Bewick—first a wash of white over the surface, then plan the design in black and white and about three grays. Use watercolor to lay in a simple plan. Then cut to the *color*, more or less leaving blacks, and using a white line" (JS 1950, p. 212).

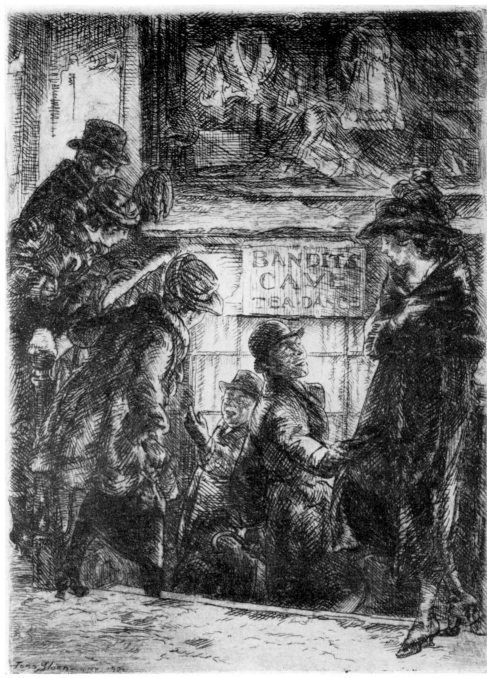

fifth state

195. BANDITS CAVE

1920. Done early in the year, as sent to an exhibition at Kraus-haar's on April 6, 1920 (JS records). Proof of 4th state dated October 1920, by JS. Ph.

Etching. 173 x 123 mm. (7 x 5 inches) platemark.

States:

1. Nearly complete. Light shading only on bottom of skirt of woman with foot on stairs. Light faces on both men on stairs center. Signature and date, 1920, at lower left. Ph.

2. Bottom of woman's skirt heavily darkened with cross-hatching. Ph, JST–7.

3. Faces of both center men darkened with shading. "ITS" of "BANDITS" darkened. Additional shading covering most of highlight above man at extreme left, at top center and right, and elsewhere. Ph, JST–5.

4. Large blank area burnished above man at extreme left. Ph ("only proof"). Judging from the date noted above, this state represents later work on the plate.

5. Two vertical lines in blank area, extending from top mar-gin to front point of man's hat. Two other vertical lines and some small horizontal shading in the same area. Left man's hat completely darkened. Published state, in edition of 35. Ph, JST—16, Met, Whitney, Bowdoin, Detroit, Yale.

6. Highlights burnished between right woman and sign, and between her shoulder and right margin. A few lines of shading added in these burnished areas and on her shoul-der. Highlights burnished on upper right and lower right corners of sign. Ankle of extreme left woman burnished light. Mod.

7. "1920" and "NY" removed from plate. Ph, JST, LC.

8. Light shading on left side of nose of woman at right is changed to a heavy diagonal line. The same woman's eye-lash is strengthened, now more nearly horizontal. Pub-lished state, *New Republic* edition.

Edition: 35 in states 5–7, up to 1,000 in 8th state. Printing: Early 35; between 500 and 600 by Platt in 8th state.

Plate lost.

Tissue: Ph.

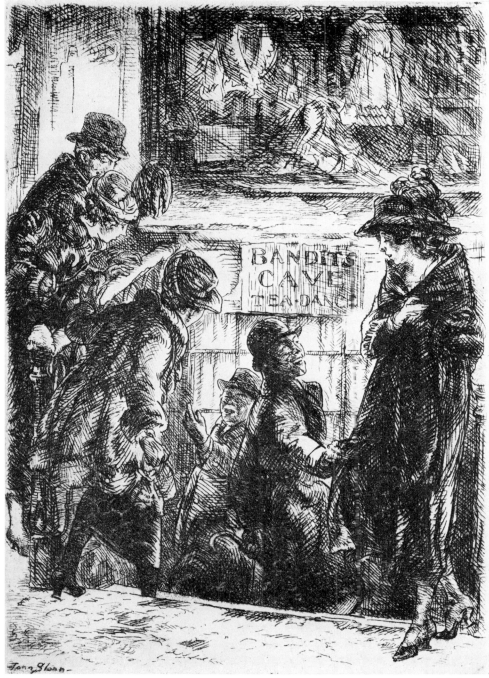

eighth state

"Uptown thrill seekers during the period of Prohibition are about to venture into a basement 'tea room' in Bohemia" (Dart 60). "One of the cafes in the Village. Two states; this plate was worked on later and sold for the *New Republic*" (JS 1945).

The *New Republic* edition was published as a promotional bonus to attract new subscribers. It was included in a portfolio, "Six American Etchings (Series I)," published in 1924, printed on medium-weight cream wove Van Gelder paper, about 14 x 11 inches, offered with a year's subscription for $8 (see advertisement in *Saturday Review of Literature,* Dec. 6, 1924, p. 350). The prints included, besides Sloan's, were *The Promenade Deck* by Peggy Bacon, *Sentinels of North Creek* by Ernest Haskell, *Night Shadows* by Edward Hopper (Zigrosser 22), *Brooklyn Bridge* or *Park Row* (Zigrosser 106 or 134) by John Marin (both used, one per portfolio), and *Play* by Kenneth Hayes Miller. Other than notes of a total payment of $250, the only correspondence relative to this print in Sloan's files (JST) is a letter from Robert Hallowell, secretary of the *New Republic,* dated January 14, 1925. In it he writes: "These went very well up until the end of last year. Since then, however, the orders have dropped

off so considerably that I think there is considerable doubt that we will ever dispose of as many as a thousand sets. Up to date the total is between five and six hundred." Sloan evidently printed a total of 35 impressions in states 5–7. It is possible that additional states may be found between the present 5th and 8th. These represent his 1924 work on the plate before turning it over to the *New Republic.* "Sloan was having a good time, making one change after another, to confuse the experts of some later day" (HFS). There are also 3rd states inscribed "100 proofs" (JST–2), and 5th and 6th states inscribed "25 proofs" (Met, Yale, Mod). The *New Republic* prints have only Sloan's signature, no title or edition.

The plate was evidently never returned to Sloan, as it is not with the rest in JST, nor was it listed in Sloan's various personal inventories since 1925. Miss Peggy Bacon advises me: "The plates were purchased outright from the artists." The *New Republic's* records for 1924–25 have since been destroyed, and Sloan's plate perhaps with them. It had undoubtedly been steel-faced for the printing of such a large edition.

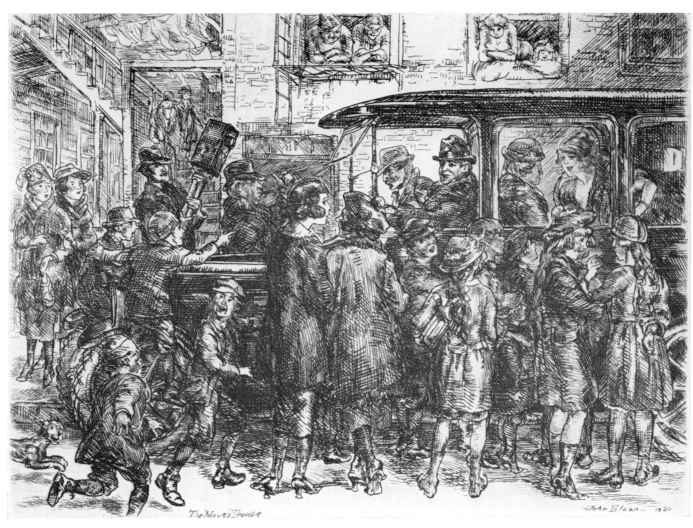

published state

196. THE "MOVEY" TROUPE

1920. In plate. Done before April 6, 1920, when sent to an exhibition at Kraushaar's. JS records.

Etching. 134 x 181 mm. (5¼ x 7 inches) plate.

States:

1. Nearly complete. Face of movie star in auto is very lightly drawn. Ph, JST–7.
2. Star's eyes and lips strengthened. Added shading on cheek of old woman in car. Face of running boy seen full-face at left center is shaded, leaving a curious white area on his right cheek and chin. Ph, JST–3.
3. Full-face boy now has wide open smiling mouth and strong horizontal lines on right cheek. Ph.
4. Face of man behind car, with raised hand and cigar, is shaded. Ph–2 (labeled respectively by Sloan, "Working Proof 4th state" and "Working Proof 5.")
5. Horizontal shading added in sky seen through and above door frame at upper left. Title added at bottom center. Ph ("working proof"), JST.
6. Added vertical shading on the back of the skirt over right leg of tall girl at left center. Bowdoin ("working proof, one in this state, JS"). The differences between this and the following (published) state are very slight and perhaps nonexistent.
7. Perhaps additional shading on chin of boy at center, below the driver. The lower line of the star's neck is perhaps strengthened and straightened. Published state.

Edition: 100. Printing: 50. Early 50. Platt had this plate.

Plate exists: JST. Copper, steel-faced.

Tissue and red chalk tracing paper: Ph.

"Director, leading man, leading lady, and camera man have made use of one of the picturesque backgrounds to be found in Greenwich Village at that time" (JS 1945).

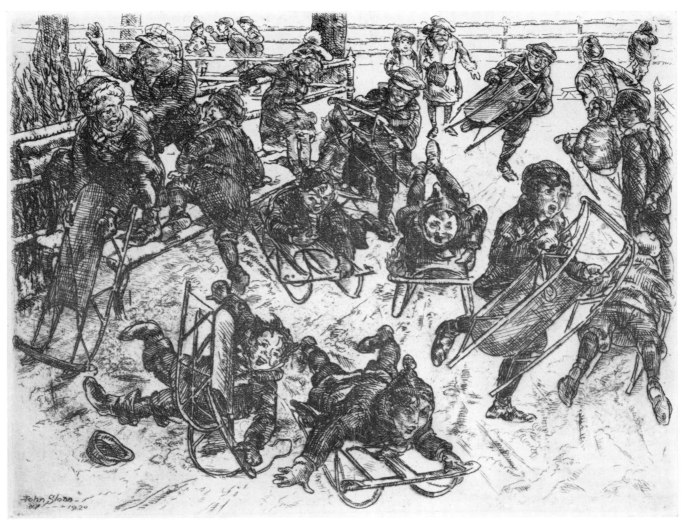

published state

197. BOYS SLEDDING

1920. In plate. Done before April 6, 1920, when sent to an exhibition at Kraushaar's. JS records.

Etching. 135 x 181 mm. (5¼ x 7 inches) plate.

States:

1. Nearly complete. Boy running and holding sled at right center foreground has heavily shaded face with mouth almost closed. Blond boy on bench at left has closed mouth. Dark line under left eye of boy at bottom center. Ph, JST–6.

2. Face of running boy at right center is completely redrawn, now with wide open mouth and eyes, highlight on forehead above nose. Dark line removed from cheek of boy at bottom center. Boy on bench has open-mouthed smile. Light shading on ground at rear and under bench. Ph, JST.

3. Light vertical lines added on right cheek of running boy. Highlight on his forehead covered with shading. Face of boy on bench burnished lighter. Published state.

Edition: 100. Printing: 50. Early 30, Roth 20.

Plate exists: JST Copper, steel-faced.

Tissue: Ph.

"A lively impression from Washington Square after a snowstorm. In going back over my etchings for the purpose of these comments, it seems notable that I have been more interested in life than in 'art.' Too many of us today are over-concerned with formulas. There is little doubt, however, that we will emerge eventually better artists for having been through a period of conscious study" (Dart 62). "Took a stroll on Ninth Avenue through the muck-covered streets with dirty heaps of melting show. Children swarming in the pools of dirt, sledding down three or five foot slushy heaps—having lots of fun" (March 9, 1907, NYS, p. 111).

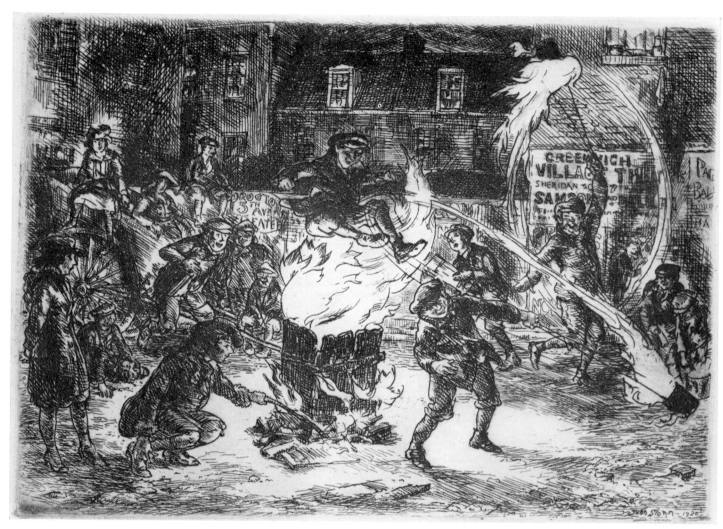

published state

198. BONFIRE

1920. In plate.

Etching. 132 x 188 mm. (5¼ x 7½ inches) plate.

States:

1. Relatively light. Ph, JST–2.
2. Additional shading on houses at left center and left, on ground at right and lower right, on face and legs of girl at left center, and elsewhere. Published state.

Edition: 100. Printing: 75. Early 25, White 25, Roth 25. Platt had this plate. Gaston 25, probably destroyed.

Plate exists: JST. Copper, steel-faced.

Tissue: Ph.

"This fire frolic in a vacant lot has resulted in a plate with fine qualities of light and movement" (Dart 61). "The boys had tin cans with wire handles, filled with embers" (JS 1945).

199. FIRE CAN

1920. In plate. Dated 1921 in JS records. The date in the plate is indistinct, even in the 1st state. It might be either 1920 or 1922, but not 1921. Its position in the list of Christmas–New Year greetings (p. 18), however, places it in late 1920.

Etching. 95 x 61 mm. (3¾ x 2⅜ inches) plate.

States:
1. Girl at left has frightened appearance, with circular mouth and horizontal lines covering both eyes. Ph, JST–14.
2. Girl's face redrawn, mouth laughing, eyes distinct. Published state.

Edition: 100. Printing: 45. Early 45. Platt had this plate.

Plate exists: JST. Copper.

Tissue unknown.

"A New Year plate dealing with the 'fun with fire' theme" (Dart 63). "A Fire Dance in Greenwich Village / New Year's Greetings 1921" (inscription on Bowdoin proof).

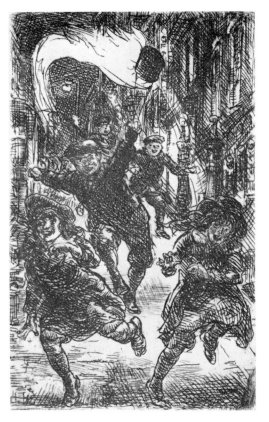

published state

200. INVITATION TO STUDIO PARTY

1921. Date of the party January 30, 1921, in plate. The print was presumably made shortly before.

Etching. 96 x 60 mm. (3¾ x 2⅜ inches) plate.

Only state. Published state.

Edition: 100. Printing: 75. Early 15, Platt 25, Roth 35.

Plate exists: JST. Copper.

Probably no tissue.

"This little plate, in which the technique is so well adapted to the scale, foretells a gay party at the studio" (JS 1945).

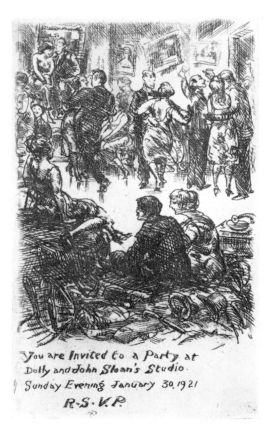

only state

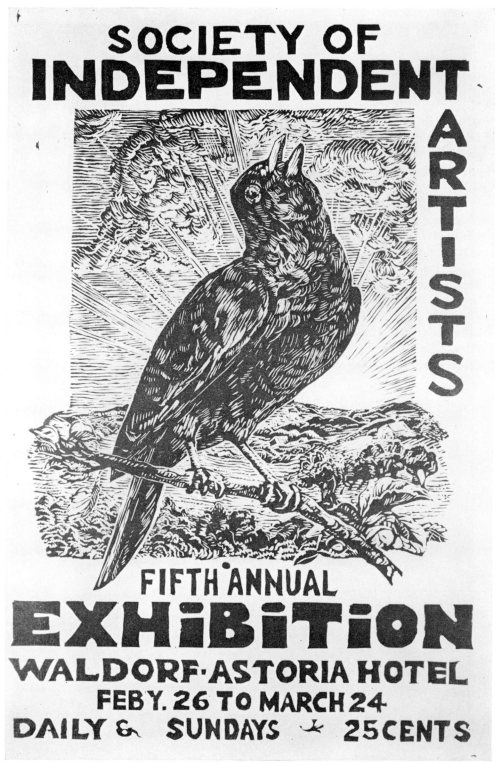

only state, reduced

201. BIRD SINGING

1921. The Fifth Annual Exhibition of the Society of Independent Artists was held from February 26 to March 24, 1921.
Linoleum cut, black ink on yellow or blue cardboard. 525 x 333 mm. (20¾ x 13 inches) entire design, including lettering; 355 x 313 mm. (14 x 12¼ inches) picture only.
Only state. Ph, JST, WSFA, SI, NYPL.
No edition. Printing unknown.
Block unknown.
Probably no tissue.

 This poster is clearly a press-printed linoleum cut. For further comments, see *Girl Painting* (194). "Drawn and cut on linoleum by John Sloan" (pencil note by Frank Weitenkampf on proof in NYPL).

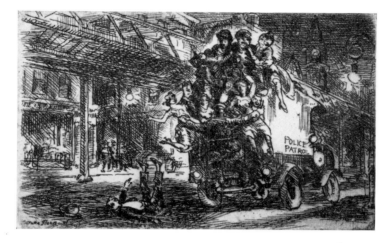

only state

202. PATROL PARTY

1921. A proof in JST is inscribed with the date of the party for which this was an invitation, April 15, 1921. The print was probably done shortly before.

Etching. 60 x 95 mm. (2⅜ x 3¾ inches) plate.

Only state. Published state.

Edition: 100. Printing: 75. Early 25, Platt 25, Roth 25.

Plate exists: JST. Copper, steel-faced.

Tissue unknown.

 "Another invitation plate for a studio party during Prohibition. Here again the technique is well adapted to the size of the plate" (JS 1945). "Souvenir of Hamlin & Sloan Party. April 16, 1921" (inscription on JST proof).

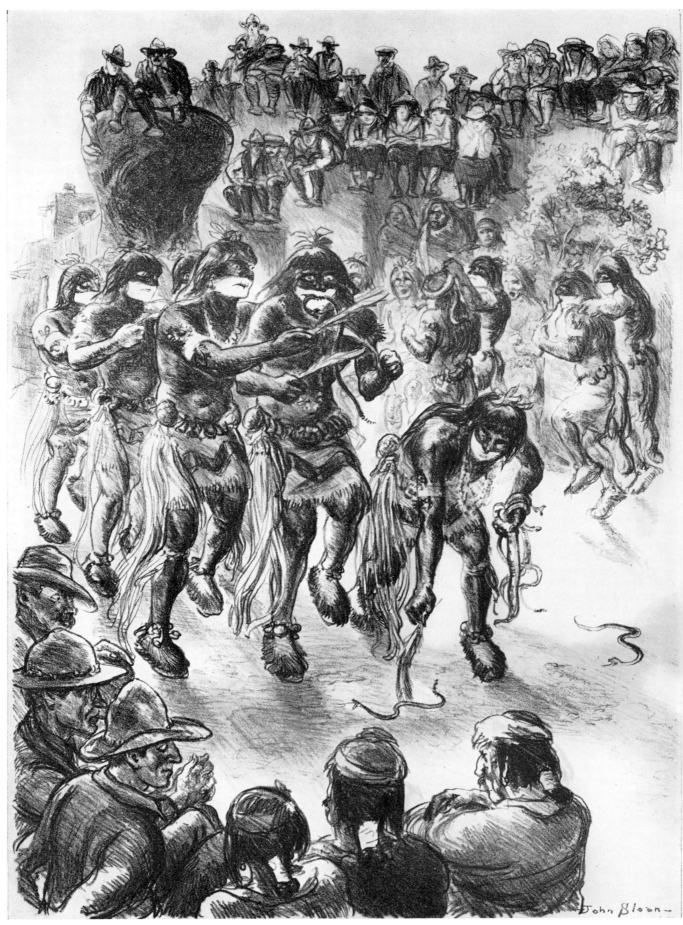

only state, reduced

203. SNAKE DANCE
1921. Proof dated 1921. JST.
Lithograph. 381 x 269 mm. (15 x 10½ inches) stonemark; 325 x 237 mm. 12¾ x 9¼ inches) picture.
Only state. Published state. Ph, JST, WSFA, Detroit (inscribed "First Pull, B.B."), Bowdoin.
Edition: 25. Printing: 25. Printed by Bolton Brown on Warren's Old Style, a heavy cream wove paper. Signed: "Bolton Brown imp."

Stone presumably destroyed. HFS remembers seeing the stone in Sloan's studio in 1929. It was evidently discarded during Sloan's move in 1935.
Tissue: JST.

"Hopi Snake Dance / Walpi Mesa / 1921" (JS inscription on JST proof). The man with glasses in the lower left corner is undoubtedly Sloan himself.

only state

204. STEALING THE WASH
1921. Dated December 1921 in the plate.
Alternative title: *Wash Thief*.
Etching. 95 x 60 mm. (3¾ x 2⅜ inches) plate.
Only state. Published state. The so-called 1st state in Ph has two
small white spots on the clock tower, probably caused by bits of
dust or paper on the plate during printing. Not a state difference.
Edition: 100. Printing: 50. Early 30, Roth 20.
Plate exists: JST. Copper, steel-faced.
Tissue: Ph.

"A connoisseur in woolen underwear makes his selection from
a wash hung out on the roofs below my studio window" (Dart
65). "An incident I saw from my Fourth Street studio on a Satur-
day or Sunday. I watched this fellow pick out all the work
things from the line. Then he hid behind a chimney and tried
on all the woolen socks he had stolen. He wrapped the rest in a
neat bundle, cleaned his feet, and went down the fire escape. I
felt in the position of God Almighty—saw this crime and didn't
do anything, as God wouldn't. I didn't have a phone, but that's
how I figured it out. A few minutes later I saw the discovery of
the theft. A stout Italian woman saw these gashes on her line
like missing teeth. Then she started to gesticulate went and got
four other women, and told her story" (JS 1945). Sloan told es-
sentially the same story in a newspaper interview in 1934 (New
York *Sun*, Dec. 13, 1934, p. 29). Used for a Christmas–New Year
greeting.

published state

205. DRAGON OF THE RIO GRANDE
1922. Proof of 1st state dated December 1922. JST.
Etching. 56 x 133 mm. (2¼ x 5¼ inches) plate.
States:
 1. Clouds closely drawn, with diagonal cross-hatching. White
 space remains between mountains and clouds. No shading
 in river on near side of bridge. (All 1st state proofs appear
 to be inscribed "Sky N.G.") Ph, JST–3.
 2. Clouds entirely redrawn, with mostly horizontal shading.
 No white space between mountain peak at center and
 clouds. Horizontal shading added in river foreground and
 on road at left. Published state.
Edition: 100. Printing: 60. Early 50, White 10. Platt also had
this plate.
Plate exists: JST. Copper, steel-faced.
Tissue unknown.
 "There are few landscape etchings among my works" (Dart
66). "A formation that looked like a prone dragon. On the route
to the cliff dwellings by way of Buckman, New Mexico. Putting
rocks under our Ford when climbing the hills" (JS 1945). This
print was used as a Christmas greeting.

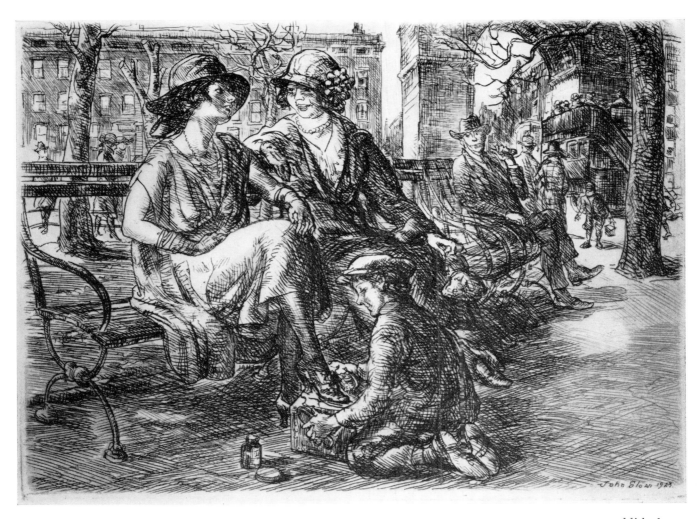

206. SHINE, WASHINGTON SQUARE

1923. Proof of 4th state dated March 31, 1923. JST.
Etching. 127 x 178 mm. (5 x 7 inches) plate.
States:

1. Lightly drawn. Boy's face dark with irregular shading. Ph, JST, Andrew King Grugan.
2. Face of woman at left covered with shading, including dark horizontal shading along the right jawline. Boy's face burnished and covered with a network of fine lines. Ph, JST.
3. White area burnished on side of boy's face, next to the ear. Ph.
4. Boy's face burnished much lighter. Heavy line added under boy's eye, following the curve of the cheekbone. Horizontal shading removed from left woman's jawline, leaving a white area. A large roll of hair remains next to her ear. Ph, JST–3.
5. Large roll of hair burnished out, leaving a single curl. Published state. (Includes various proofs inscribed "WP"; Ph, JST–6, Met.)

Edition: 100. Printing: 80. Early 55, Roth 25. Platt also had this plate. Gaston evidently also had it, as Sloan's 1931 personal inventory lists 10 proofs of "Frenchman's printing," perhaps subsequently destroyed.
Plate exists: JST. Heavy copper plate, steel-faced.
Tissue unknown.

"It has been said that my work has been influenced by Cruikshank, but no critic has traced it to its true source, which is the work of John Leech, particularly in his *Punch* drawings. Cruikshank's people always have a quality of caricature" (JS 1945). The lithograph of the same subject (210) is a later variation.

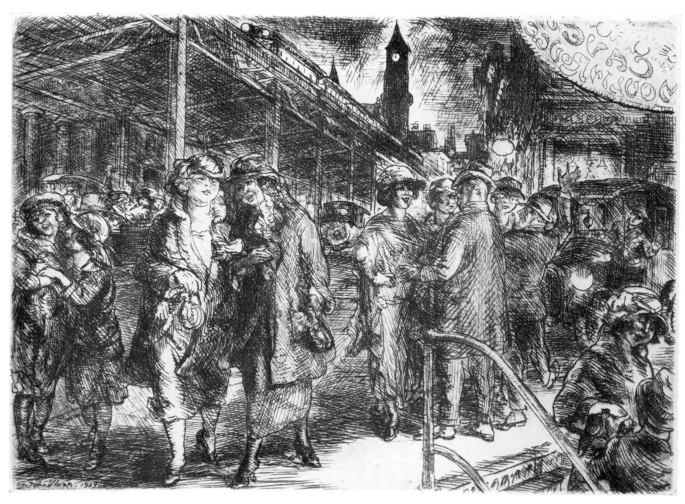

published state

207. SIXTH AVENUE, GREENWICH VILLAGE

1923. Proof of 3rd state dated April 8, 1923. Ph.
Etching. 127 x 178 mm. (5 x 7 inches) plate.
States:

1. Nearly complete. Somewhat lighter than final state. Woman at left center has closed mouth. Center woman, beneath tower, has closed mouth. Ph, JST.
2. Mouth of left center woman is wide open, with added chin line. Center woman's mouth slightly open, smiling. Vertical shading added on back of man at right with raised arm. Light vertical shading on woman at lower right. Additional shading below El at center, on car in left background, and on taxi at right. Ph, Met.
3. Much burnishing on back of man standing behind railing at right center, and on bottom of skirt of left center woman. Mouth of left center woman now only partly open. Additional shading in sky around tower at top center. Ph, JST.
4. Hatching, mostly vertical, added in both burnished areas. Additional shading in semicircle on headlight of taxi at right, on collar of woman at lower right, on raised arm and hand and bottom of coat of man at right, on faces and dresses of girls at left, on car and driver in left background, and beneath the El. Ph.
5. Shading covers "PILSENER" sign at upper right. Additional shading on side of taxi in center background and on pavement between two women at left center. Ph, JST.
6. Additional strong diagonals in a vertical row added on back of right center man. Ph, JST–2.
7. Additional heavy diagonals on left side of same man's coat. Face of center woman, under tower, redrawn, now much narrower, with the chin forming an acute angle. Ph.
8. Mouth line of woman at left center strengthened. Published state.

Edition: 100. Printing: 75. Early 20, Platt 25, Roth 30.
Plate exists: JST. Copper, steel-faced.
Tissue: Ph.

"Looking at this etching with the plates of Albrecht Dürer in mind, one notes a great difference in design and technique. Here, life is stressed, and formal composition is less evident, the handling more emotional. A comparison of extremes, perhaps" (JS 1945).

208. SISTERS AT THE WINDOW

1923. In plate. Done before April 13, 1923, when sent to the Brooklyn Society of Etchers exhibition. JS records.

Etching. 127 x 102 mm. (5 x 4 inches) plate.

States:

1. Right hand of girl at left grasps her left ankle. Her face has heavy shading and thin lips with left corner turned down. Front line of neck points at right side of chin. Ph. Illustrated.

2. Right hand of girl at left redrawn, now lying loosely in her lap. Mouth redrawn with full lips. Shading on both cheeks softened with burnishing. Light shading added on both cheeks, resembling cat's whiskers. Additional shading on right side of neck, right calf, and right hip. Much additional shading in background: on sill and wall beneath girls, at left and right sides, on window frame at upper left, on window panes, on curtain, and behind right hand of girl at right. Ph (inscribed "VII"). There may well be a number of additional states between the 1st and 2nd given here, but they have not been discovered to date.

3. Neck line of left girl redrawn, now pointing at center of chin. Left jawline now slightly curved. Heavy horizontal shading added on right cheek. Vertical lines added at right corner of mouth. Left cheekbone of right girl burnished lighter. Ph (inscribed "IX").

4. Heavy vertical shading removed from left knee area of left girl. Light horizontal shading added in the same area. Highlight burnished on front of right shoulder of left girl. Ph, JST–3. One proof of this state (JST) is inscribed "100 proofs."

5. Additional shading beneath lower lip of left girl, and on neck beneath her chin. "Cat's whiskers" removed from left cheek and replaced with horizontal shading. Added shading on right side of nose. Published state.

Edition: 100. Printing: 76. Early 25, White 26, Roth 25.

Plate exists: JST. Copper, steel-faced.

Tissue: Ph. Also one sketch, dated October 9, 1920. Ph.

"A girl on the brink of adolescence under the watchful eye of her younger sister, both under the watchful eye of the neighboring etcher. Subject matter which produced one of my best plates" (Dart 67).

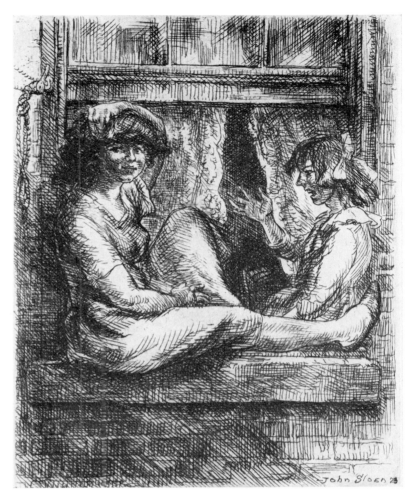

published state

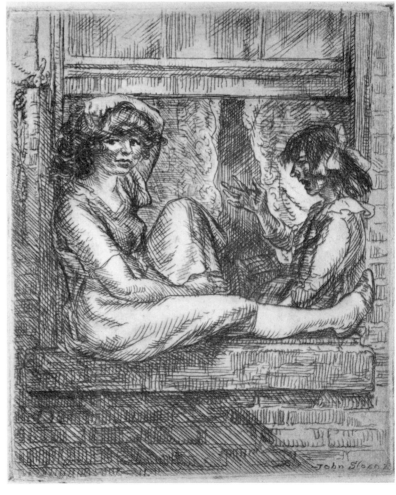

first state

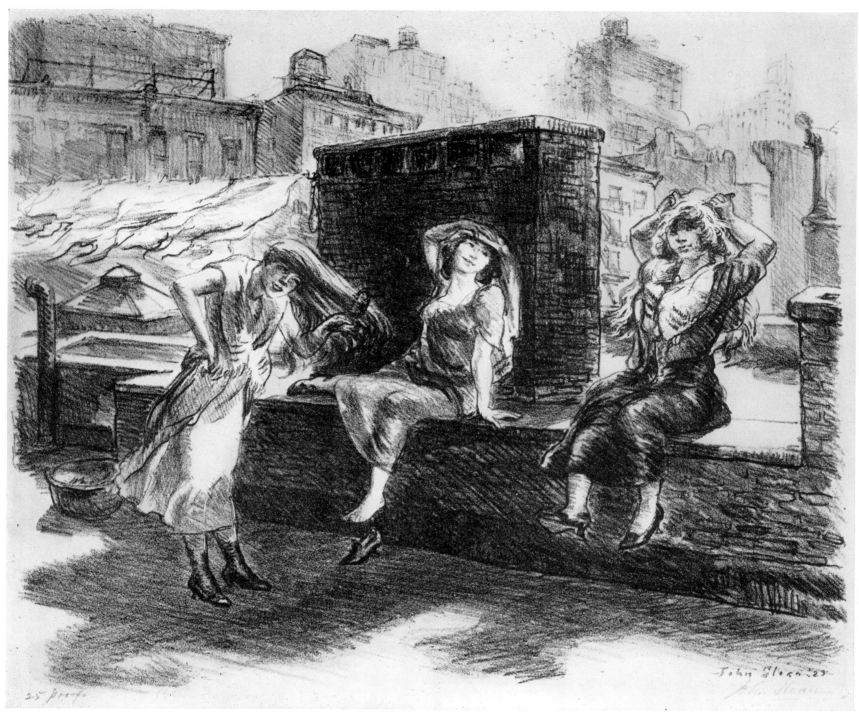

only state

209. SUNDAY, DRYING THEIR HAIR ON THE ROOF

1923. In stone. Before August 1923 (see below).
Lithograph. 215 x 258 mm. (8½ x 10¼ inches) stonemark; 186 x 230 mm. (7¼ x 9 inches) picture.
Only state. Published state. Ph, JST–3, WSFA, Detroit, Bowdoin, Wadsworth Atheneum (Hartford, Conn.), Milwaukee, Corcoran Gallery (Washington, D.C.).
Edition: 25. Printing: 25, by Bolton Brown. Signed: "Bolton Brown imp."

Stone presumably effaced.
Tissue: Ph.

Commissioned by *Century Magazine* and reproduced, much reduced in size (*106*, Aug. 1923, 569). This lithograph is a fairly close copy, in reverse, of Sloan's well-known painting *Sunday, Girls Drying Their Hair* of 1912, now in the Addison Gallery of American Art, Andover, Mass. "Another of the human comedies which were regularly staged for my enjoyment by the humble roof-top players of Cornelia Street," commented Sloan about the painting (*Gist*, p. 233).

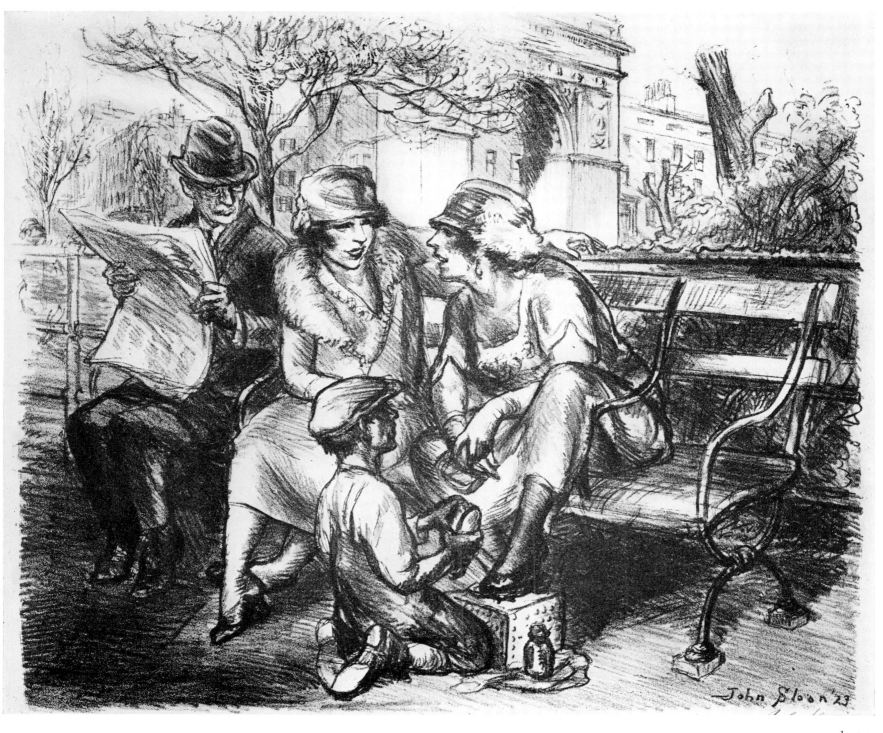

only state

210. SHINE, WASHINGTON SQUARE

1923. In stone. Before August 1923 (see below).

Lithograph. 212 x 245 mm. (8½ x 9¾ inches) stonemark; 186 x 229 mm. (7¼ x 9 inches) picture.

Only state. Published state. Ph, JST-2, WSFA, Boston, Detroit, Bowdoin, Wadsworth Atheneum (Hartford, Conn.).

Edition: 25. Printing: 25, by Bolton Brown. Signed: "Bolton Brown imp."

Stone presumably effaced.

Tissue: Ph. Also black chalked tissue used for transfer to stone.

This print was done on commission from *Century Magazine*, reproduced much reduced in size (*106*, Aug. 1923, 570). It is a different (reversed) version of the subject in the etching of the same name (206).

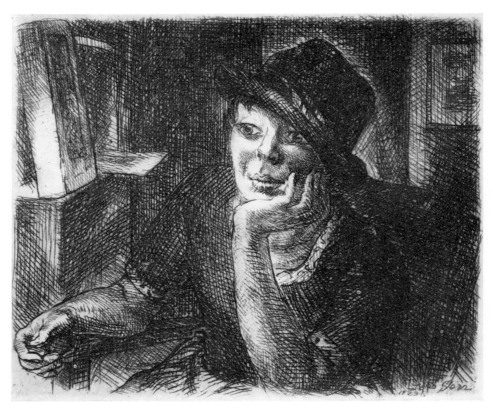

published state

211. RECTOR'S DAUGHTER

1923. Proof WP–16 dated November 25, 1923. Ph.
Etching. 102 x 127 mm. (4 x 5 inches) plate.
States:

1. Very close to the finished print. The face has a rather hard and impersonal appearance. Ph–2 (WP–1, WP–2). There are eighteen working proofs in Ph, inscribed "WP" with arabic numerals by JS. They do not all appear to represent different states or even the exact working sequence of states.
2. Burnishing lightens areas under nose and on chin. Ph (WP–3).
3. Additional diagonal hatching to the left of nose. Ph (WP–4).
4. Diagonal hatching added on left side of nose. Left forearm burnished lighter. Ph (WP–5).
5. Additional horizontal lines on right cheekbone. Ph (WP–6).
6. Diagonal hatching added on right cheekbone. Ph (WP–7).
7. Diagonal hatching added between left eye and nose. Ph (WP–8).
8. Added curved line in the upper part of right eye socket. Ph (WP–9).
9. Diagonal lines added across highlight on right cheekbone; vertical shading across highlight on left cheekbone. Ph (WP–10).
10. Small horizontal lines of shading added under right eye. Ph (WP–11).
11. Right eye, cheek, and nostril redrawn, very similar to the preceding. Without the triangular gap in the iris of the right eye. Strong vertical line added to the right of the mouth. Ph (WP–13).
12. Heavy horizontal shading between right eye and hat removed. Ph–3 (WP–12, WP–16, WP–17).
13. Light vertical shading added between right eye and nose. Ph–2 (WP–14, WP–15), JST (WP–15).
14. Right nostril burnished, softening the unnatural line of separation between the nostril and the nose. Slight added shading inside of nostril. Highlight shaded on upper part of left forearm. Published state. Includes WP–18 in Ph.

Edition: 100. Printing: 60. Early 15, Platt 25, Roth 20.
Plate exists: JST. Copper, steel-faced.
Probably no tissue.
"Ann Rector, a student at the League, who married [Edmund] Duffy, well-known cartoonist of the *Baltimore Sun*" (Dart 69).
"Both of them were students of JS" (HFS 1966).

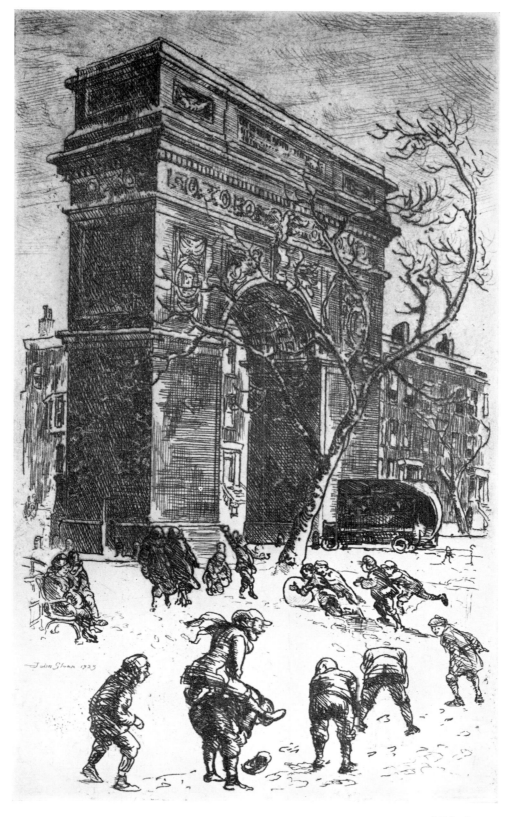

published state

212. WASHINGTON ARCH

1923. In plate. Probably November or December, as intended for Christmas.

Etching. 203 x 125 mm. (8 x 5 inches) plate.

States:

1. Central design only, of arch, tree, and some figures. Foreground blank. No clouds. No signature. Ph (inscribed "4th state").
2. Additional horizontal shading on upper front of arch. Ph ("1st state").
3. Greeting inscription and Sloan's signature added. Ph ("2nd state").
4. Clouds added in sky. Ph, JST, Met, Bowdoin. Used as Hamlin Christmas card. Illustrated, p. 238.
5. Inscription removed. Six boys playing leapfrog added in foreground. Published state.

Edition: No edition in 4th state; 100 in 5th state. Printing: Unknown in 4th state; 60 in 5th state. Early 40, Roth 20.

Plate exists: JST. Zinc.

Tissue: Ph.

"A simple and telling design which would have been weakened by more delicate technical approach. The state with lettering was made for our friends George and Elizabeth Hamlin, who had bought twenty paintings to help us with hospital bills" (JS 1945). The sale of twenty Sloan paintings to the Hamlins took place in late November 1923. The price at the time was publicized as being $20,000. It was actually $5,000.

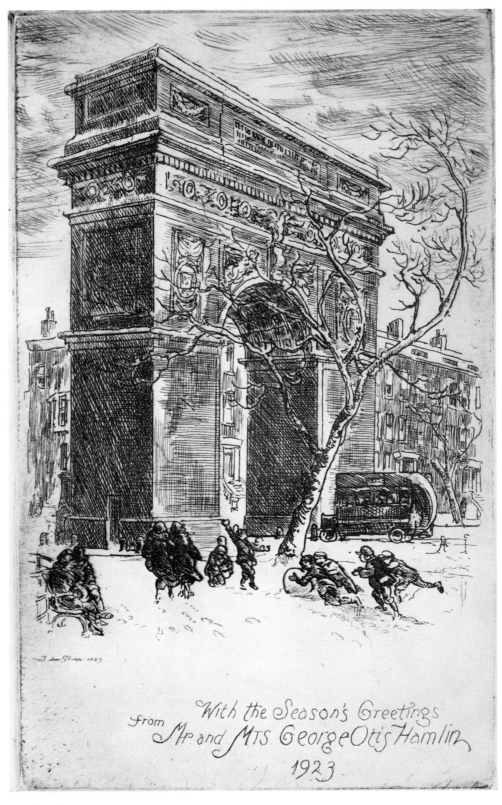

With the Season's Greetings
from Mr. and Mrs. George Otis Hamlin
1923

212, fourth state

238

213. HERSELF

1923. Proofs dated December 1923. Ph, JST.
Etching. 60 x 95 mm. (2⅜ x 3¾ inches) plate.
States:

1. Nearly complete. Face already burnished. Curved line to upper right of head, following line of head, evidently an earlier outline, poorly erased. Heavy line on right hand beneath the thumb, parallel to top edge of hand. Ph.
2. Line on hand removed. Added vertical shading in same area. Ph, JST–4.
3. Line next to head and scratches on lamp mostly removed. Face burnished lighter. Published state.

Edition: 100. Printing: 55. Early 45, White 10. Platt also printed this plate.
Plate exists: JST. Copper, steel-faced.
No tissue.

"Darning the stockings of 'himself' in a study of studio life, with light quality well rendered" (Dart 68). Used as a New Year's card, inscribed "New Year Greetings 1924."

published state

214. BOB CAT WINS

1924. In plate. Probably November or December, as used for Christmas greeting.
Etching. 60 x 95 mm. (2⅜ x 3¾ inches) plate.
Only state. Published state.
Edition: 100. Printing: 110. Early 50, Platt 25, Roth 35.
Plate exists: JST. Copper, steel-faced.
Tissue: Ph.

"A feminine row outside a 'tea room' during the days of Prohibition, demonstrating the advantages of the new bobbed hair in such an encounter" (Dart 70). Used as a Christmas–New Year's greeting.

only state

published state

215. "PATIENCE"

1925. Proof of 1st state dated January 22, 1925. JST.
Alternative title: *"He Was a Little Boy."*
Etching. 128 x 102 mm. (5 x 4 inches) plate.
States:

1. Nearly finished. No title. No signature. Ph, JST–2, Mint Museum (Charlotte, N.C.), Brigham Young University (Provo, Utah).
2. Eyes of right woman burnished out. Ph ("WP–A").
3. New eyes drawn, beside nose instead of above. Signature and title added at bottom. Much additional shading on left woman's hair, bosom, dress, and legs, right woman's chin, neck, collarbone, left cheek, and flowers in hair, on floor, and at top. Ph ("WP–B").
4. Left woman's mouth closed instead of open. Published state.

Edition: 100. Printing: 75. Platt 50, Roth 25.

Plate exists: JST. Copper, steel-faced.
Tissue unknown.

"An operatic episode. My memory fails to provide the names and place, but the plate makes its own record" (Dart 72). "Etched and printed in a talk at New Society Exhibition 1925" (JS inscription on fourth state proof; Bowdoin). The New Society of Artists exhibited at Anderson Galleries, New York, January 6–31, 1925. The first state probably represents Sloan's work at the exhibition.

The scene is the delightful comic duet from Act I of Gilbert and Sullivan's *Patience,* in which the two women repeat the line, "He was a little boy," with a different emphasis and different meaning each time. The actresses portrayed here are presumably Rosalind Fuller (Patience) at the left and Helen Freeman (Angela) at the right. The production was at the Provincetown Playhouse in New York (see *The New York Times,* Dec. 30, 1924, p. 15).

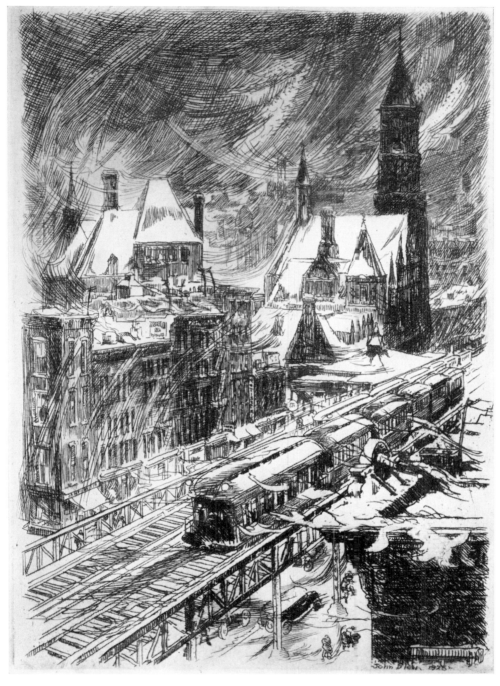

published state

216. SNOWSTORM IN THE VILLAGE

1925. Proof of 1st state dated February 1, 1925. Ph.
Etching. 177 x 128 mm. (7 x 5 inches) plate.
States:

1. Nearly complete. Separate snow flurries against wall at lower right, one low on wall. Ph, JST–3.
2. Snow flurries covered with hatching. New flurry added near roof line. Added shading on front platform of train, on white building at center, and on lower platform of tower at upper right. Ph ("2nd state / only proof").
3. Shading added on a diagonal white snow flurry, which was across the building at center above the front of the trolley car. Possibly additional burnishing on the buildings in the center distance. Published state.

Edition: 100. Printing: 100. Early 15, Platt 50, White 10, Roth 25. Gaston 25, probably destroyed.
Plate exists: JST. Copper, steel-faced.
Tissue: Ph.

"Viewed from my studio on Washington Place, the Jefferson Market Court tower and elevated tracks on Sixth Avenue under a swirl of snow" (Dart 71). "The printer sometimes leaves too much tone. I like the drawing to be on the plate" (JS 1945).

241

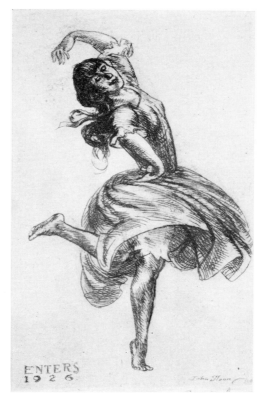

published state

217. "CONTRE DANSE"

1925. Sloan's inscription "Enters 1926," in the plate, is a pun welcoming the New Year 1926. This plate was therefore surely done in late 1925. Miss Enters, in her autobiography, *Silly Girl* (New York, 1944, pp. 230–31), tells of Sloan's coming to see her in a performance in November 1925. The etching must have been done shortly thereafter.

Alternative titles: *Angna Enters in Contre Danse; Enters 1926; Compositions in Dance Form.*

Etching. 95 x 60 mm. (3¾ x 2⅜ inches) plate.

States:
1. Nearly finished. Ph, JST–6.
2. Strong lines added on right (lower) side of nose and under both eyes. Published state.

Edition: 100. Printing: 80. Early 35, Roth 45.

Plate exists: JST. Copper, once steel-faced, subsequently removed.

Tissue: Ph. A drawing from life (no. 1896–A) shows a similar pose. JST.

"The first of a number of plates which were inspired by the charming and original dance episodes of Angna Enters. This is the only one for which she posed" (JS 1945). Used as a New Year's card. Miss Enters made extensive comments on her dance composition in *First Person Plural* (New York, 1937, pp. 42–43).

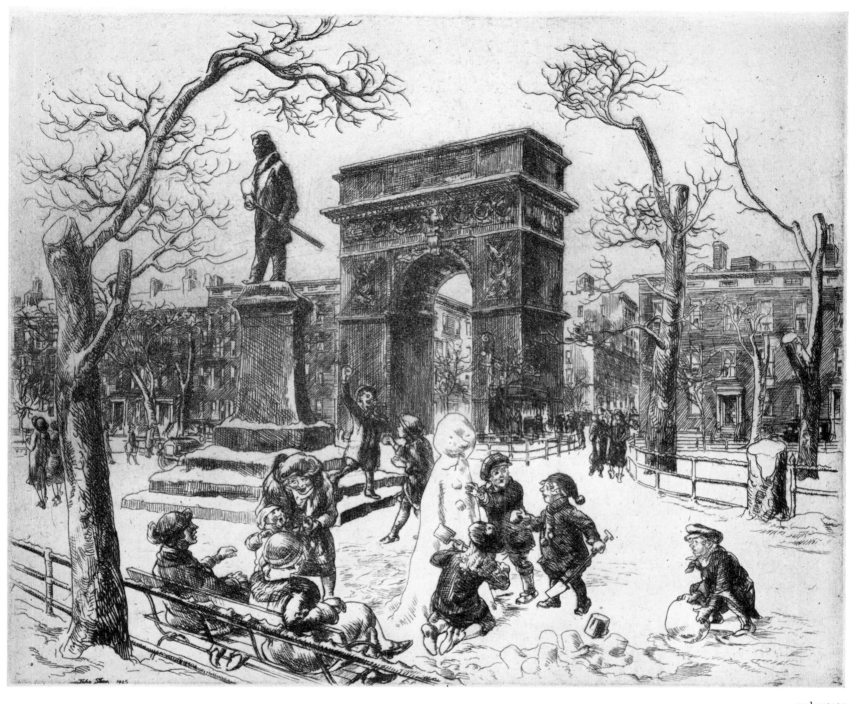

218. SCULPTURE IN WASHINGTON SQUARE

1925. In plate. Probably late in the year, as first sent to an exhibition with *Busses* (219), on January 2, 1926. JS records.

Etching. 203 x 254 mm. (8 x 10 inches) plate.

Only state. Published state.

Edition: 100. Printing: 75. Early 65 (probably mostly Platt), White 10. Gaston 25, probably destroyed.

Plate exists: JST. Copper, steel-faced.

Tissue and red chalked tracing paper: Ph.

"The title refers to the Garibaldi statue, the Washington Arch, the snow man, and the helter skelter Tammany tree surgery. A lot of funny cripples in the way of trees. The life of Washington Square furnished me with much material. I often regret leaving the neighborhood" (JS 1945).

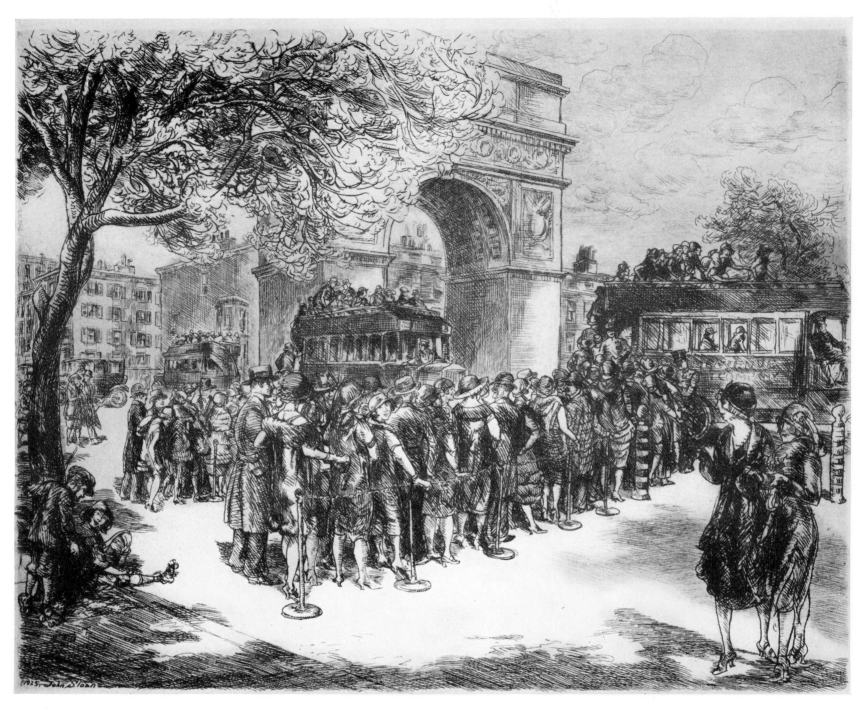

published state

219. BUSSES IN WASHINGTON SQUARE

1925. Proof of 3rd state dated December 25, 1925. Ph.
Etching. 202 x 254 mm. (8 x 10 inches) plate.
States:

1. Light and sketchy. Ph–2 (one with pencil).
2. Clouds added in sky. Additional shading on children at lower left, on arch, and at lower right edge. Ph–2 (WP–2, WP–3).
3. Horizontal shading added on cheek of man in line with cigar, just to the right of the arch. Diagonal shading added on profile of man in line below the right side of the arch. Ph (WP–4).
4. Shading covers hat of the second man mentioned above. Ph–2 (WP–5, WP–7). All other changes in these proofs are made by pencil and erasures on the prints. No WP–6 has been discovered.

5. White area burnished between tree and buildings at left, removing some tree branches and the tops of the buildings. Additional shading on the faces of both mentioned men and in blank areas on ground beside the women at right. Some horizontal lines in the sky burnished out. Published state.

Edition: 100. Printing: 55. Platt 45, White 10.
Plate exists: JST. Copper, steel-faced.
Tissue: Ph. Dated May 5, 1923. Also red chalked tracing paper and one sketch. Another sketch is in JST, with the same date.

"Holiday afternoons and Sunday were busy days for the Riverside Drive busses leaving the Square. My studio windows overlooked this patient crowd; this etching and several paintings of similar scenes resulted" (JS 1945).

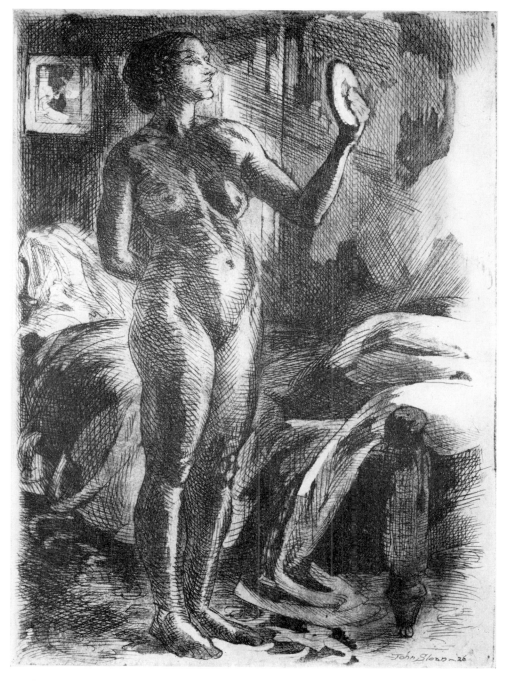

published state

220. NUDE WITH MIRROR

1926. In plate. Done before April 5, 1926, when it appeared in
an exhibition at Kraushaar Galleries, New York. JS records.
Etching and aquatint. 177 x 128 mm. (7 x 5 inches) plate.
States:
 1. Before aquatint. Ph, JST (both inscribed "2 proofs").
 2. Aquatint added. Published state.
Edition: 100. Printing: 45. Early 45 (probably mostly by Platt).
Gaston 20, of which some are known to still exist.
Plate exists: JST. Copper.
No tissue.
 "Line and aquatint. It may be here noted that with me aqua-
tint tones have no delicacy, nor do I desire such" (JS 1945).

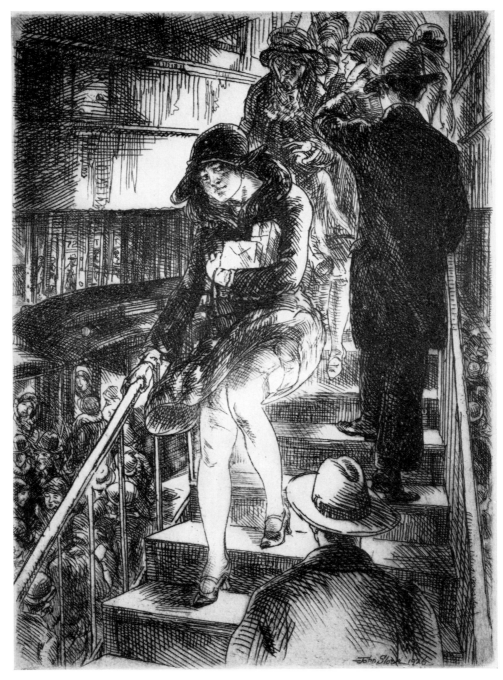

published state (seventh)

221. SUBWAY STAIRS
1926. Proof of 1st state dated April 1, 1926. Ph, JST.
Etching. 177 x 128 mm. (7 x 5 inches) plate.
States:
1. Nearly finished. Girl's face harshly drawn. No shading on her legs. Ph, JST ("two proofs").
2. Shading on girl's face removed. Mouth redrawn wide and full. Much additional shading on backs of both men. Shading added directly above subway train. Ph–2 (one with pencil, marked "3rd"), JST–2.
3. Diagonal shading added at upper left. Heavy shading on face of old woman. Cross-hatching on derby hat of girl on stairs to right of old woman. Ph, JST–3, Met, Whitney, Bowdoin. A small number of edition proofs may have been pulled in this state.
4. Heavy cross-hatching entirely covering both of girl's legs.

Lower lip erased. Light shading on both cheeks and chin. Both eye pupils strengthened. Hair slightly burnished next to left ear. Ph ("WP 1928 A").
5. Shading burnished lighter on lower part of left thigh and on chin. Ph ("WP 1928 B").
6. Back of left knee and calf burnished lighter. Ph ("WP 1928 C").
7. Shading almost entirely removed from girl's legs. Published state.
Edition: 100. Printing: 60. Early 15, Platt 25 (in 1928), White 20.
Plate exists: JST. Copper, lightly steel-faced.
Tissue: Ph. A drawing on heavy paper showing a plate mark. Clearly transferred to the plate by running through the press.

"In modern times incoming trains cause updrafts in the subway entrances. Getting on an omnibus in the hoop-skirt was exciting in grandmother's day" (Dart 74).

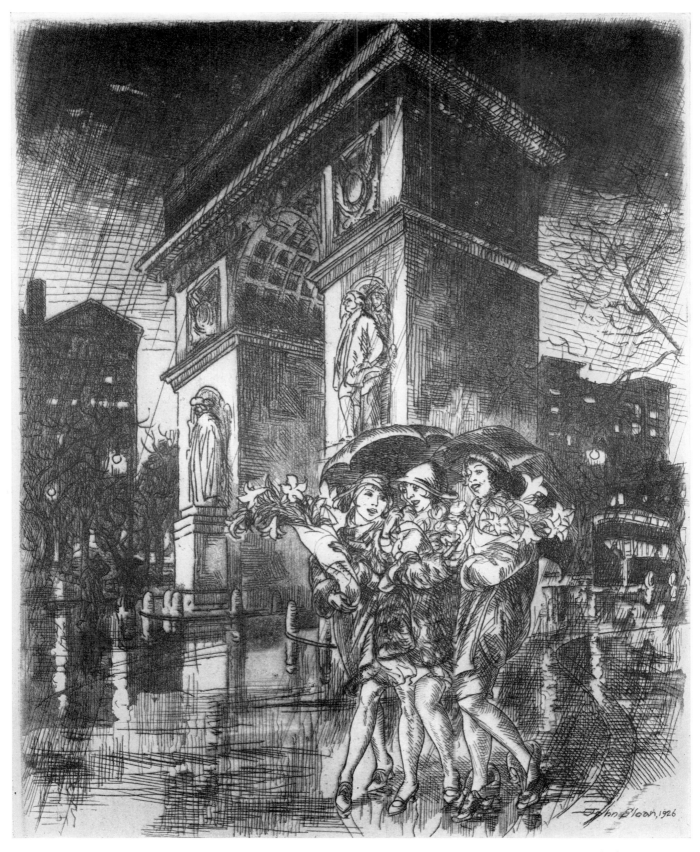

published state, reduced

222. EASTER EVE, WASHINGTON SQUARE
1926. Proofs of 1st state dated April 5, 1926. Ph, JST.
Etching and aquatint. 253 x 204 mm. (10 x 8 inches) plate.
States:
1. Before aquatint. Etching only. Ph, JST–2.
2. Diagonal lines of rain added. Additional shading else-
where. Ph, JST–3.
3. Aquatint added. Published state.
Edition: 100. Printing: 60. Platt 50, White 10.
Plate exists: JST. Zinc.

Tissue unknown.

"An aquatint record of an April shower, happy girls and
spring flowers" (Dart 76). "I saw that. It happened" (JS 1945).
Easter was April 4, 1926.

"I hardly ever use a zinc plate. They are so soft that you can't
work on them long before they get worn down in deep hollows.
The aquatints of *Easter Eve* and the *Fluoroscope* are on zinc
plates. The *Easter Eve* was started as a pure etching and the lines
were bitten too deeply and coarsely, so I went on and made an
aquatint of it" (JS 1931).

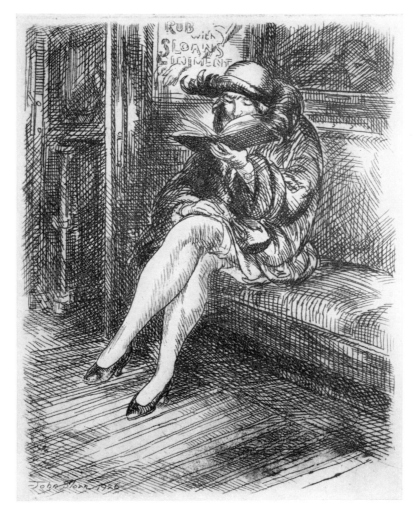

published state

223. READING IN THE SUBWAY
1926. Proofs of 1st state dated April 7, 1926. Ph, JST.
Etching. 128 x 101 mm. (5 x 4 inches) plate.
States:
1. Weakly and evenly etched. No shading on left calf. Ph, JST.
2. Lines of figure and some shadows regrounded and rebitten, creating strong shadow contrasts, particularly notable below the girl. Ph ("only proof").
3. Added light vertical shading on left calf. Published state.
Edition: 100. Printing: 85. Platt 50, Roth 35. Gaston 25, probably destroyed.
Plate exists: JST. Copper, steel-faced.
Tissue unknown.
"As Sir John Suckling wrote in 1620:

'Her feet beneath her petticoat
Like little mice peeped in and out,
As if they feared the light.' " (Dart 75).

"I had these lines in mind when I saw the scene. I've always written them on every proof. Crowninshield reproduced it in *Vanity Fair* [26, Aug. 1926, 51], enlarged, which isn't good for an etching. Then he kept after me for a follow-up in the same vein" (JS 1945). Note the advertisement on the rear wall.

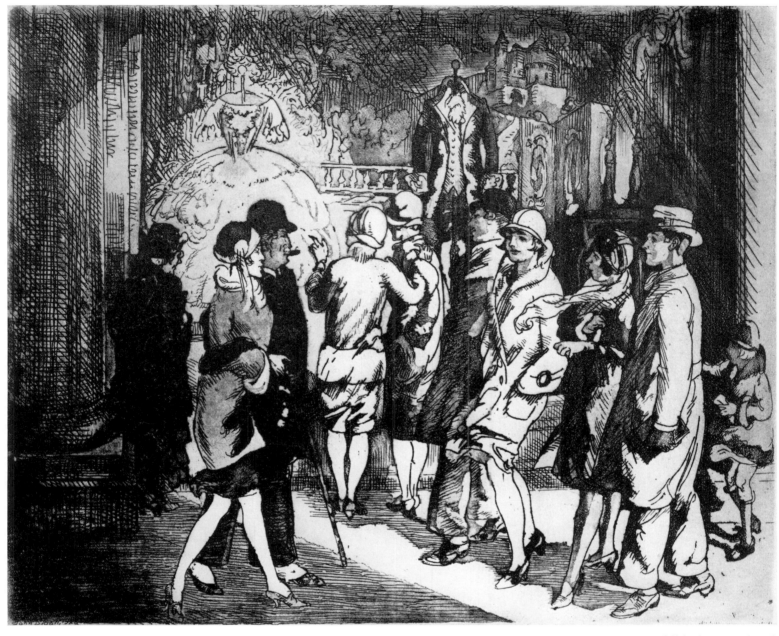

published state, reduced

224. FASHIONS OF THE PAST

1926. Proof of 4th state dated April 16, 1926. Ph.

Etching. 204 x 254 mm. (8 x 10 inches) plate.

States:

1. Etching only, before aquatint. Ph ("only proof"). Illustrated, p. 250.
2. Heavy aquatint added. Ph ("only proof").
3. Pillar at left burnished lighter. Burnished diagonal shading added at right. Ph ("only proof").
4. Signature and date added at lower left. Lines of hair added on neck of man at center. Diagonal etched lines of shading at upper right. Added etched shading on pillar at left, at top of store window, on dress of woman third from the right, and elsewhere. Ph ("only proof").
5. Horizontal lines of shading added in white area above dummy in window at center. Ph, Met.
6. Additional shading under eye of man at center. Published state.

Edition: 100. Printing: 75. Platt 50, Roth 25.

Plate exists: JST. Zinc.

Tissue: Ph.

"A well-arranged shop window and the contrasting costumes of the passers by, whose dress of the time will in turn become costumes of the past. Can't tell which store. They were too modish to put their names up in public" (JS 1945). "Lord & Taylor" (JS inscription on JST proof).

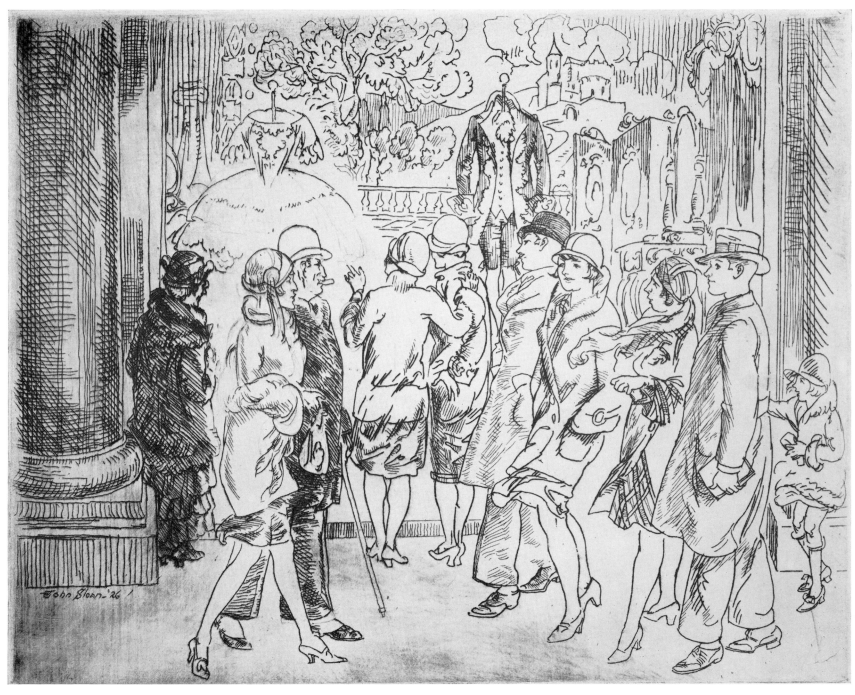

224, first state, reduced

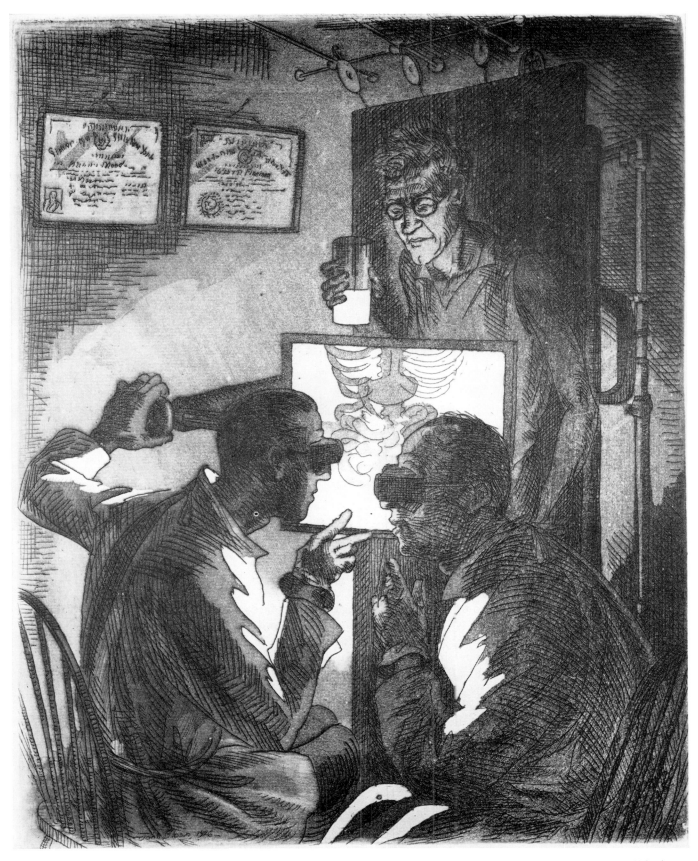

225. X-RAYS

1926. Proof of 1st state dated May 12, 1926. Ph.

Alternative titles: *Fluoroscope* (technically correct); *Department of the Interior.*

Etching and aquatint. 253 x 203 mm. (10 x 8 inches) plate.

States:

1. Nearly complete, including aquatint. Ph ("only proof").
2. Added diagonal hatching in highlight above Sloan's left ear. Added horizontal lines of hair on top of right doctor's head. Published state.

Edition: 100. Printing: 55. Early 20, Platt 25, White 10. Gaston 25, probably mostly destroyed.

Plate exists: JST. Zinc.

Tissue unknown.

"A consultation on the interior arrangements of John Sloan, this aquatint has always amused friends in the medical profession" (Dart 73).

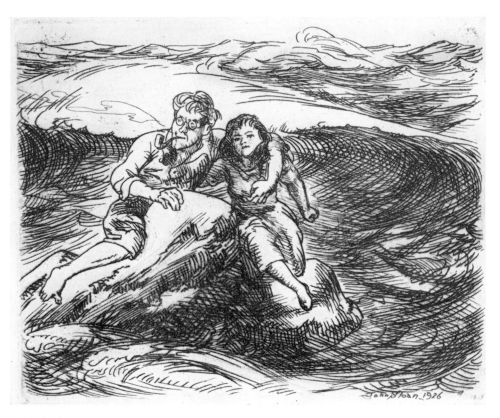

published state

226. TWENTY-FIFTH ANNIVERSARY
1926. The anniversary date was August 5, 1926.
Alternative titles: *Anniversary Plate; On the Rocks.*
Etching. 102 x 126 mm. (4 x 5 inches) plate.
States:
 1. Almost finished. No shading on Dolly's face and neck. Ph–
 2, JST (trial proofs with colored ink), Bowdoin.
 2. Shading added on Dolly's face and neck. Slight additional
 diagonal shading on Dolly's right calf. Published state.
Edition: 100. Printing: 100. Early 50, Platt 50 (April 1928). The
early printing of the 50 actual invitations is not included in
the JS records, but is included here (see below).
Plate exists: JST. Copper, steel-faced.
Probably no tissue.
 "An invitation to what turned out to be a very jolly affair in
the garden of our Santa Fe studio—about 80 people. (JS 1945.)
 "We have just passed our Twenty-fifth Wedding Anniversary
and pulled off a big party to celebrate the occasion. About
eighty guests, plenty of moonshine and orange juice, a really suc-
cessful stunt. . . . I'm sure you would have enjoyed it. We had the
garden brightly illuminated, and, as we have had plenty of rain
the past season, everything looked beautifully theatrical—dahlias
and hollyhocks, fruit trees and vines all lit by the electric lights.
The whole crowd had a good time. . . . I am sending you a print
of a plate which I made out here as a souvenir of the Wedding
Anniversary. I sent out about fifty proofs to invited friends—to
square us in the event of presents (of which by the way there
were many)" (JS to Henri, from Santa Fe, Aug. 1926; JST).

227. "RENDEZVOUS" (small)

1926. Probably December, as made for a New Year's Greeting.
Alternative titles: *Miss Angna Enters; Enters 1927; "Rendez-vous" (square); "Rendezvous" I.*
Etching. 81 x 82 mm. (3¼ x 3¼ inches) plate.
States:
1. Almost finished. No pupil in left eye. Ph, JST–8.
2. Pupil added in left eye. Published state.
Edition: 100. Printing: 60. Early 40, Roth 20.
Plate exists: JST. Copper.
Tissue: Ph.

"Rendezvous, small plate. A plate made for New Year's—the title: 1927 Enters" (JS 1945). Miss Enters' detailed comments on this dance are in her *First Person Plural* (New York, 1937, pp. 52–53).

published state

228. "RENDEZVOUS" (large)

1926. Proofs of 1st state dated December 9, 1926. Ph, JST.
Alternative title: *Angna Enters in "Rendezvous" (large).*
Etching. 128 x 101 mm. (5 x 4 inches) plate.
States:
1. Almost finished. Line of lower lip does not touch right corner of mouth. Ph, JST–4 (all inscribed "5 proofs").
2. Line of lower lip completed. Ph, JST–5 (all inscribed "6 proofs").
3. Additional shading on lower part of robe, including horizontal lines at left side of bottom white area. Published state.
Edition: 100. Printing: 110. Early 60, Roth 50.
Plate exists: JST. Copper.
Tissue: Ph. Sketch on tissue paper in JST (no. 1969).

"No one could be more able than Miss Enters to recreate the beauty of woman in the costume of past days. The spectator is carried back to live in the past, and he has a sensation of contemporary appreciation" (Dart 77).

published state

published state

229. KRAUSHAAR'S
1926. In plate. Dated 1927 in JS records. Probably done late in
1926.
Etching. 102 x 128 mm. (4 x 5 inches) plate.
States:
1. Nearly finished. Face of man at right (Kraushaar) nearly
 in profile, nose extending beyond face line. Face lightly
 drawn. Ph, JST–2.
2. Heavy lines added around mouth and eyes of Kraushaar's
 face. Added horizontal lines on upper right of both of
 woman's legs. Ph.
3. Kraushaar's face burnished lighter, especially around
 glasses. Heavy shading remains on chin. Neck of seated
 man and legs of woman burnished lighter. Ph, JST.
4. Kraushaar's mouth extended. Slight additional shading on
 upper lip. Ph.
5. Kraushaar's head redrawn in three-quarters view, with
 nose inside of face line. Ph.
6. Small vertical lines added above earpiece of glasses. Ph.
7. Diagonal shading added on backs of woman's legs. Ph, JST,
 Whitney (all inscribed "3 proofs").
8. Additional heavy horizontal lines on right side of painting
 frame. Vertical lines burnished lighter in same area. Pub-
 lished state.
Edition: 100. Printing: 75. Platt 20, Roth 55.
Plate exists: JST. Copper, steel-faced.
Tissue unknown.
 "My old friend, John F. Kraushaar, engaged in the difficult
job of selling a picture to a man whose wife feels she needs sables"
(Dart 78).

230. KNEES AND ABORIGINES

1927. Dated September 1927 in JS records.
Etching. 177 x 152 mm. (7 x 6 inches) plate.
States:

1. Nearly finished. Ph, JST–4. Inscribed "Santa Fe."
2. Added shading on face of woman with boots at left, on left leg of woman seated at right, on legs of people seated on wall at upper left, on chin, right arm, and both legs of woman seated at center, on arms of two Indians at right, and on face of man seated at lower right. Ph, JST–4.

3. Light diagonal shading added on right ribs of Indian at right. Published state.

Edition: 100. Printing: 75. Platt 50, Roth 25.
Plate exists: JST. Copper. Etched on the back of an old wedding invitation, with a New York address.
Tissue: Ph.

"A civilized audience when skirts were at their height, viewing the more modestly dressed savages at a Pueblo Indian dance in New Mexico. Perhaps the pun may be permitted" (JS 1945).

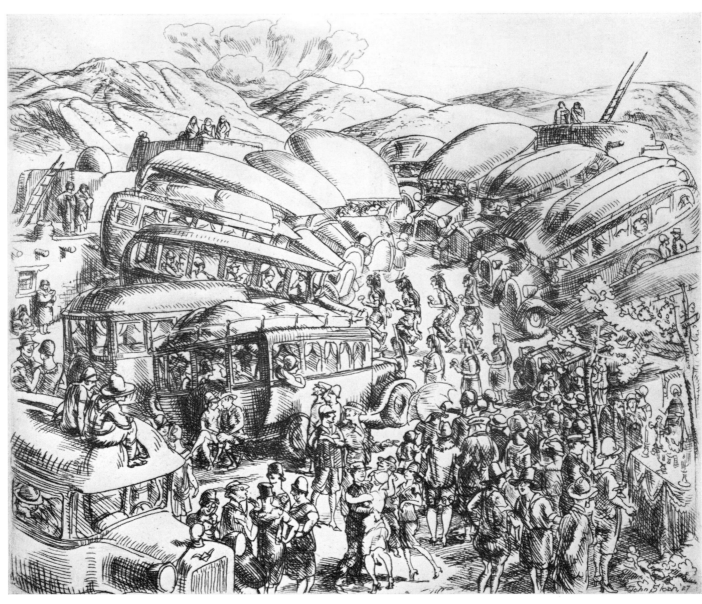

published state

231. INDIAN DETOUR
1927. Proofs of 1st state dated September 24, 1927. Ph, JST.
Etching. 152 x 184 mm. (6 x 7¼ inches) plate.
States:
 1. Nearly complete. Shading on both sides of roof of center
 bus. Ph, JST. Inscribed "Santa Fe / 3 proofs in this first
 state."
 2. Lines of shading removed from right side of center bus roof.
 Shading added on roof of lower right bus, on hood of bus
 at center left, and on parasol at bottom center. Ph, JST.
 3. Shading added on front end of roof of bus at lower right
 and an additional line across the front edge of the same
 roof. Published state.

Edition: 100. Printing: 70. Platt 25, White 20, Roth 25.
Plate exists: JST. Copper, steel-faced. Etched on the back of an
old wedding invitation plate, with a New York address.
Tissue unknown.

 "A satire on the Harvey Indian Tour. Busses take the tourists
out to view the Indian dances, which are religious ceremonials
and naturally not understood as such by the visiting crowds"
(Dart 79). This scene is identified as the corn dance at Santo
Domingo Pueblo, in an undated article from the *Santa Fe New
Mexican* of August or September 1936 (Sloan file, Mod).

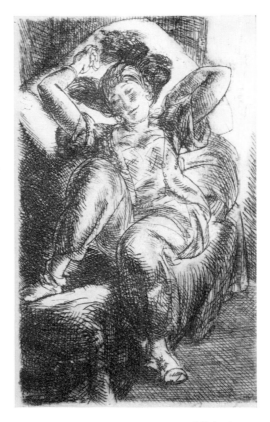

published state

232. "ODALISQUE"

1927. Proof of 1st state dated December 1927.

Alternative titles: *Angna Enters in "Odalisque"; Enters 1928.*

Etching. 95 x 61 mm. (3¾ x 2⅜ inches) plate.

States:

1. Lightly drawn. Ph ("only proof").
2. Additional shading on both legs and sleeves, side and end of couch, and elsewhere. Published state.

Edition: 100. Printing: 50, Platt 50.

Plate exists: JST. Copper, steel-faced.

Tissue: Ph. A drawing in red chalk, showing plate mark. Transferred to plate by running through the press. A sketch on tissue is in JST (no. 1961).

"Miss Enters' beautiful and sensuous interpretation of Renoir's painting of the same title" (JS 1945). Used as a New Year's card, inscribed "Greetings 1928" or "Enters 1928."

Miss Enters discusses her composition at length in *First Person Plural* (New York, 1937, p. 55), and in *On Mime* (Middletown, Conn., 1965, pp. 76–81).

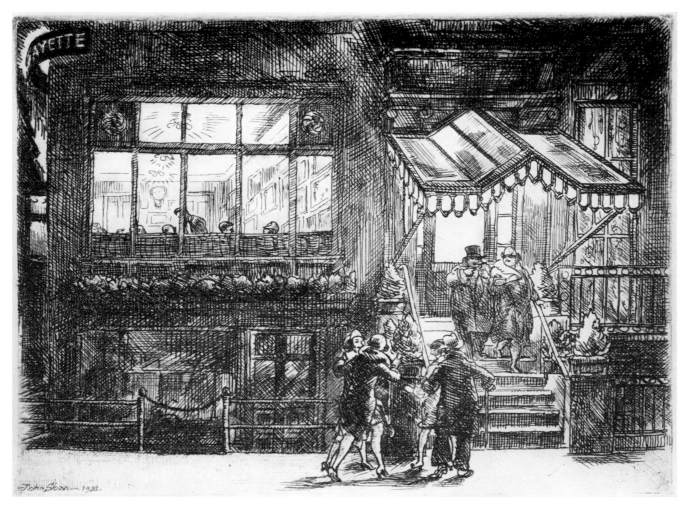

published state

233. THE LAFAYETTE

1928. Proofs of 1st state dated March 24, 1928. JST, Detroit.
Etching. 128 x 178 mm. (5 x 7 inches) plate.
States:
1. Relatively lightly drawn. Hair of woman on stairs is dark. No shading in white rectangles in alley at extreme left. Ph, JST–3, Detroit.
2. Woman's hair burnished lighter. Vertical shading in alley. Vertical shading, heavily burnished, added on sidewalk at left. Much added shading at top and elsewhere. Ph–3 (WP–1, WP–2, WP–3). The nine working proofs in Ph were possibly numbered by Sloan on a later occasion. They apparently do not all represent separate states.
3. Strong lines on right and left sides of woman on stairs softened with burnishing. Horizontal shading added on her. Right foot of man on stairs burnished lighter. Strong line on woman's hat burnished out. Added shading on hair of woman next to man on sidewalk. Ph–2 (WP–4, WP–5).
4. Two diagonal lines added on left side of woman on stairs. Three vertical lines added on the bottom center of her coat. Ph (WP–6).
5. Same woman's left fingers burnished lighter. Ph (WP–7).
6. Single diagonal line added on the left side of her chin. Published state (includes WP–8 and WP–9; Ph).

Edition: 100. Printing: 80. Platt 80. The figure "65" is in the JS printing records. HFS believes the printing was closer to 80. This is very likely, as Sloan gave 50 prints to the Lafayette Fund contributors, in addition to 22 recorded sales in his lifetime and 2 remaining proofs in a 1951 inventory. There have been no separate sales since 1951. His bank statements indicate payment in May 1928 for the printing of 100 proofs. In the absence of definitive data, a printing of 80 proofs is given here.
Plate exists: JST. Copper, steel-faced.
Tissue unknown.

"An old restaurant and hotel whose French cuisine has been for years and still is regarded as one of the best in New York. The atmosphere of the Nineteenth Century remains" (Dart 80). "I painted the place, a picture which is now in the Met. This plate was made for subscribers who contributed to the purchase fund. I felt I squared myself in a way by sending them this print" (JS 1945). The design of this print is completely different from that of the *Lafayette* painting.

HFS says (1966) of the Lafayette Fund: "Dr. Mary Halton and Dolly worked up the scheme of collecting $5,000 by donations to buy the *Lafayette* painting for presentation to the Metropolitan. Robert Henri was distressed by the idea when he heard of it. Sloan did not remember exactly whether they stopped appealing for the rest of the money, after Henri rebuked him. He made the etching to send to all the donors."

The gift of the painting was reported in *Art News* (March 31, 1928, v. 26, p. 10). Sloan sent the print out with the following mimeographed letter, dated April 20, 1928: "Desiring to express my thanks to each of the contributors toward the purchase and presentation of my painting *The Lafayette* to the Metropolitan Museum of Art, I have made and ask you to accept the enclosed print as a souvenir of the occasion. Sincerely yours, John Sloan." In JST is a typewritten list of fifty contributors, mostly Sloan's fellow artists. At the bottom of the list Sloan has written, "This does not seem complete."

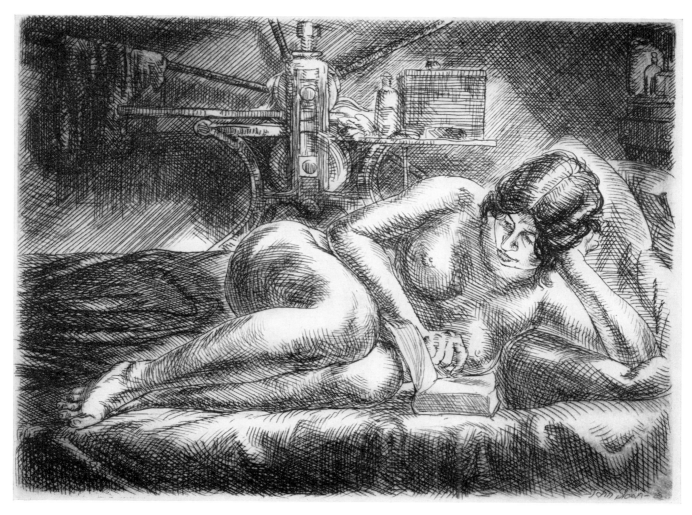

published state

234. NUDE READING

1928. Proofs of 1st state dated May 20, 1928. Ph, JST, Bowdoin.
Etching. 128 x 177 mm. (5 x 7 inches) plate.

States:

1. Sketchily drawn. Background blank. Ph–2 (one with pencil), JST–3, Bowdoin, British Museum.
2. Much additional shading on background at center and left, on woman's hair and body, and elsewhere. Upper right remains blank. Ph–2 (one with pencil), JST.
3. Additional shading at right center and right background. Bureau added at upper right. Woman's mouth is dark. Ph, JST–10. These proofs were first marked "100 proofs," which was then crossed out and replaced by "working proof third state."
4. Upper lip lightened by burnishing, separating into two

lines. This state difference is hard to perceive but appears to be consistent. Possibly also rebitten in upper left corner, to make the lines heavier, though this difference may be in the inking. Published state.

Edition: 100. Printing: 75. Platt 25, Roth 50.
Plate exists: JST. Copper. "Steel-face" scratched on the back, but never done.
No tissue.

"This nude posed in the etcher's studio gives the first strong evidence of sculptural approach. It is interesting to recall that the same quality is being sought in the paintings of and since that time" (JS 1945). The model has told me that she also posed for *Nude with Bowl of Fruit* (259) of 1931. "Drawn directly on wax ground free-hand, without preliminary tissue" (JS inscription on 1st state proof; Bowdoin).

235. FOURTEENTH STREET, THE WIGWAM
1928. Dated December 1928 in JS records.
Alternative title: *Tammany Hall.*
Etching. 249 x 178 mm. (9¾ x 7 inches) plate.
States:
 1. Lightly drawn. Shading across building at right center. Ph, JST.
 2. Building at right center burnished lighter, removing most of the diagonal shading. Ph.
 3. Cross-hatching added in sky above and behind campaign sign at left. Ph.
 4. Buildings at left center and center burnished lighter. Ph, JST.
 5. Sky heavily darkened with shading throughout. Campaign sign, coats in foreground, and all buildings shaded darker. Shadows added on ground at lower right and elsewhere. Ph.
 6. Diagonal shading added on right side of left center building and on other buildings. Ph, JST.
 7. Diagonal hatching added on three lower windows of right center building, covering the blank spaces. Published state.
Edition: 100. Printing: 110. Platt 100, Roth 10.
Plate exists: JST. Copper, steel-faced.
Tissue: Ph.

"Old Tammany Hall, the headquarters of the bosses of New York City, has ceased to exist. It lurked, menacing, in dingy red brick, facing the tawdry amusements of East Fourteenth Street" (Dart 101). The painting of this subject in the Met, done for the Federal Art Project, is copied directly from this etching. Another painting of the same subject, a different composition, in the Art Students League, New York, is a 1948 adaptation of a 1911 painting which had been destroyed by fire.

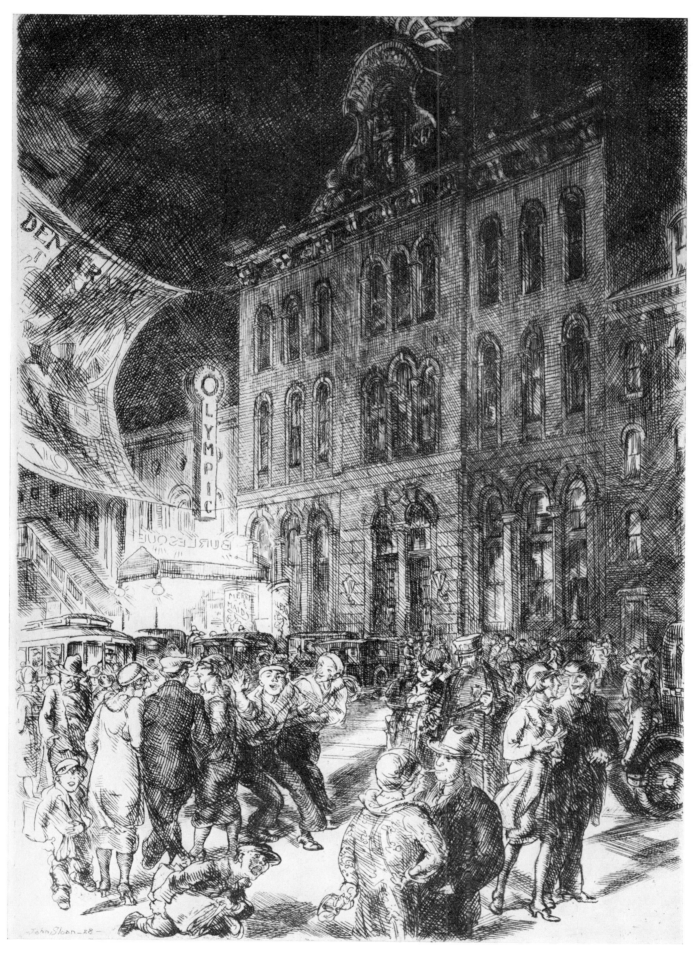

published state

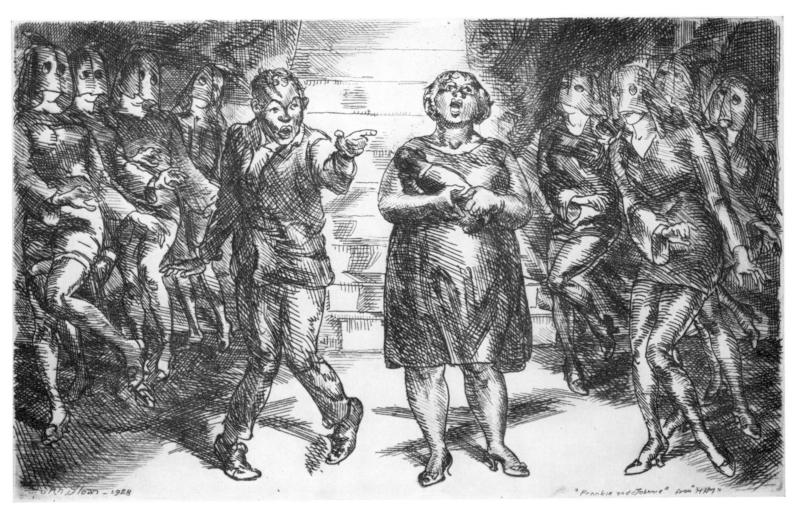

published state

236. "FRANKIE AND JOHNNIE"

1928. Proof of 2nd state dated December 1928. Ph.
Alternative title: *"HIM."*
Etching. 126 x 203 mm. (5 x 8 inches) plate.
States:
1. Curtain at top center on both sides of large woman. Ph, JST.
2. Curtain burnished much lighter. Ph.
3. Curtain removed to left of woman. Lines of stairs extended to fill the gap. Published state.
Edition: 100. Printing: 50. Platt 50.
Plate exists: JST. Zinc.
Tissue: Ph.

"A small chorus singing 'Frankie and Johnnie' crowds the tiny stage of the Provincetown Players Theatre in MacDougall Street. An episode from E. E. Cummings' intelligent and entertaining production, "HIM" (JS 1945).

"*Him* is about as thrilling an evening's entertainment as I have ever experienced. I liked it thoroughly—I don't claim to understand it—I do not believe that a work of art can be, nor need be understood even by its maker. It seemed to me to be a glimpse inside the cranium of an artist-poet" (JS letter to James Light of the Provincetown Players, April 25, 1928, JST; also quoted by Brooks, p. 199).

The scene shown is from Act II, Scene 5 of E. E. Cummings' *HIM* (New York, 1927, pp. 49–50). The setting is described: "The stage has become a semicircular piece of depth, at whose inmost point nine black stairs lead up to a white curtain." The two figures at center in the etching are referred to in the text only as two "coalblack figures," one male and one female. In the production Sloan saw, judging from his program, preserved in JST, the two parts were played by Hemsley Williams and Goldye Steiner. The female figure holds a doll, which is "Johnie." The well-known folk song "Frankie and Johnnie" is sung by backstage voices, while six (in the text) "coalblack figures" move silently around the two central characters.

262

237. DOLLY 1929 (rejected variant)
1929. In plate. Evidently done in early January 1929, as the published version of this subject (238) is dated January 1929 in the plate.
Etching. 95 x 60 mm. (3¾ x 2⅜ inches) plate.
Only state. Ph, WSFA, SI.
No edition. Printing: No early proofs known. Harris 3.
Plate exists: JST. Copper. On the verso of the unfinished *Dolly Seated by Piano* (80).
Tissue: Ph. Possibly the same tissue used for the published version.

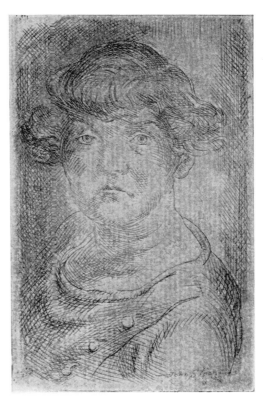

only state

238. DOLLY 1929
1929. Dated January 1929 in plate.
Etching. 111 x 76 mm. (4½ x 3 inches) plate.
Only state. Published state.
Edition: 100. Printing: 75. White 20 (in 1937), Roth 55.
Plate exists: JST. Copper.
Tissue: Ph. Red chalk sketch with plate mark from transfer. Also four sketches.

 "A worthy plate, but being family portraiture it never seemed entirely successful as a likeness, a common defect of good portraits" (Dart 82).

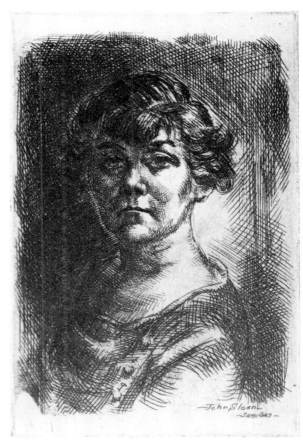

only state

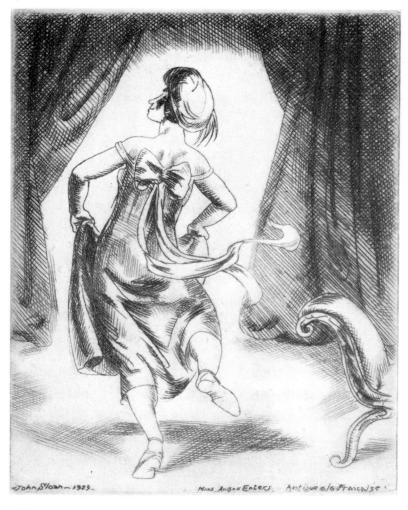

only state

239. "ANTIQUE À LA FRANÇAISE"
1929. Dated January 1929 in JS records.
Alternative title: *Miss Angna Enters in "Antique à la Française."*
Etching and engraving. 128 x 101 mm. (5 x 4 inches) plate.
Only state. Published state.
Edition: 100. Printing: 95. Platt 50, Roth 45.
Plate exists: JST. Copper, steel-faced.
Tissue unknown. A drawing (no. 1911) shows a similar pose.
JST.

"With all its precision this plate has a satisfactory sense of the life and artistry of Angna Enters' marvelous dance episodes. Some line engraving is used in addition to the etching" (Dart 83).

Miss Enters describes this dance composition in *First Person Plural* (New York, 1937, pp. 55–56).

264

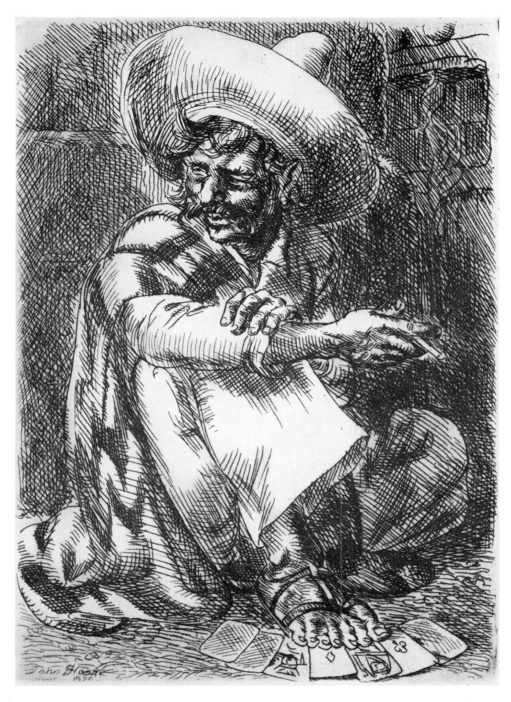

only state

240. SEVEN TOED PETE

1929. In plate. An acknowledgment from its patron, dated December 2, 1929 (JST), would appear to place this print late in the year.

Etching. 177 x 128 mm. (7 x 5 inches) plate.

Only state. Published state.

Edition: 100. Printing: 75. Platt 75.

Plate exists: JST. Copper.

Tissue: Ph.

"This plate was produced on order of a patron who was much interested in the card game so named. I don't regard it as of any importance—a commercial job" (JS 1945).

This print was commissioned by Edward J. Grassmann, a consulting engineer, of New York (25 Church Street) and Elizabeth, N.J. His correspondence with Sloan indicates that they had met in Santa Fe. The original agreement was that for $1,500 Grassmann would get 50 prints, with no more to be printed, and the canceled plate. He paid $1,000 in December 1929 and received the 50 prints. Sloan kept the plate. Over a year later Grassmann sent the additional $500, pleading the pressures of the business depression for the delay. Sloan had meanwhile reconsidered,

wanting proofs of the plate for other collectors, and suggested: "I now make this proposition—I am to have twenty-five proofs made from the plate for my own use (you already have your fifty). I then cancel the plate and give it to you. . . . If it is not to your liking I will return the check [$500] and retain the plate—printing fifty proofs for myself and resting perfectly satisfied with the transaction" (JS letter, Dec. 25, 1930, JST). Grassmann rejected both suggestions, wanting an exclusive on the print or nothing at all. Sloan replied: "Return me the proofs. If they are in good condition I will refund your One Thousand Dollars (the first payment)—The second payment $500.00 is enclosed and returned to you" (JS letter, Dec. 26, 1930, JST). Though there is no further correspondence in the JST files, Grassmann must have reconsidered and accepted Sloan's second proposition, for he kept the 50 proofs and the $500 refund. Sloan kept the uncanceled plate, the $1,000, and the right to print 50 more proofs from it, for a total edition of 100. Sloan's personal inventory of early 1931, shortly after the last letter above, shows he had 28 proofs of this print, indicating that Grassmann had kept the 50. None of his subsequent inventories show a greater total.

241. NUDE ON STAIRS

1930. Proofs of 8th state dated October 18, 1930. Ph, JST.
Etching. 254 x 203 mm. (10 x 8 inches) plate.
States:
1. Lightly drawn. Ph–2 (one with pen), JST.
2. Much additional shading on stairs, background, woman's face, and elsewhere. Pupil added in woman's eye. Ph, JST–2.
3. Additional dark shading on stairs. Stair riser behind woman's right shoulder now completely dark. Some burnishing on left arm and legs. Black and white contrasts much stronger. Ph, JST–3.
4. Heavy shading added under eye, on bridge of nose, and around mouth. Ph, JST–3.
5. New jawline, with more flesh under chin. Burnishing on chin and under eye. Ph, JST–3.
6. Additional strong shading on outside of left thigh near the knee, on kneecap, and on highlight to the left of head. Slight additional lightening on face at left of nose. Shading strengthens the line of right shoulder and upper arm. Ph, JST.
7. Lower line of chin strengthened. Ph, JST–3.
8. Shading removed from left side of chin. New line of eyelid, almost covering the pupil. Spot highlight on wall directly above right hand is covered with shading. Line of mouth strengthened. Ph, JST.
9. Additional line covers highlight along face line, indicating position of right eyebrow. Published state.
Edition: 100. Printing: 70. Platt 25, White 25, Roth 20.
Plate exists: JST. Copper.
No tissue.

"One of the larger plates and quite a successful translation of form and color-sculpture" (Dart 84). See also Sloan's "Autobiographical Notes," p. 387.

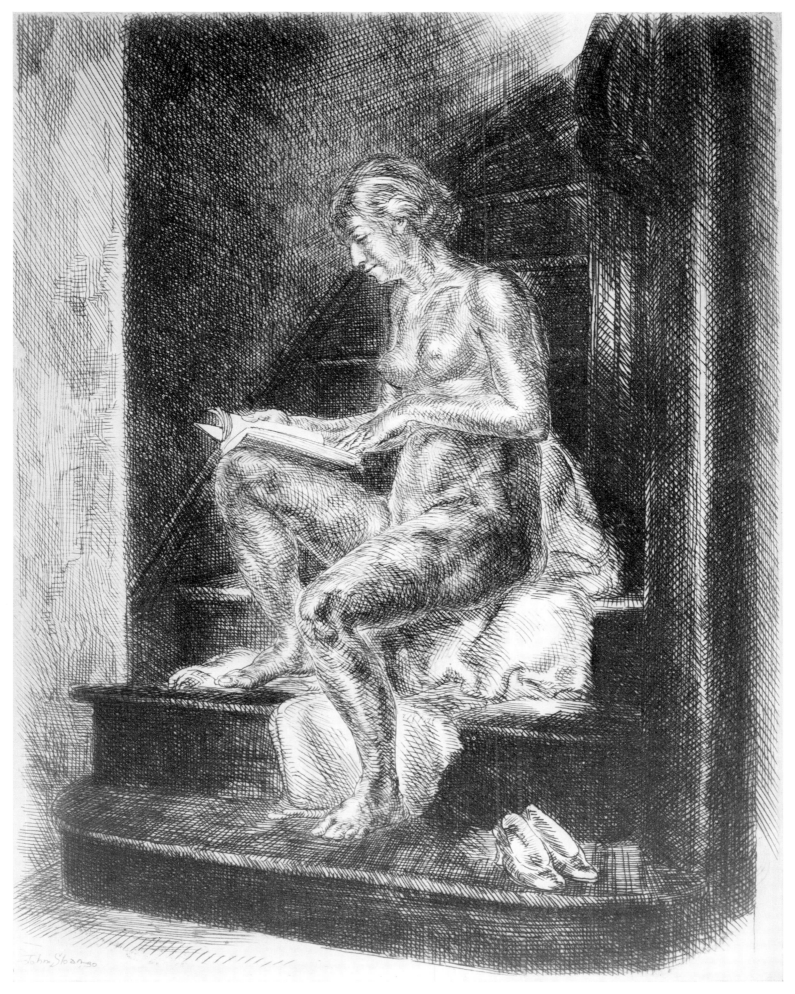

published state

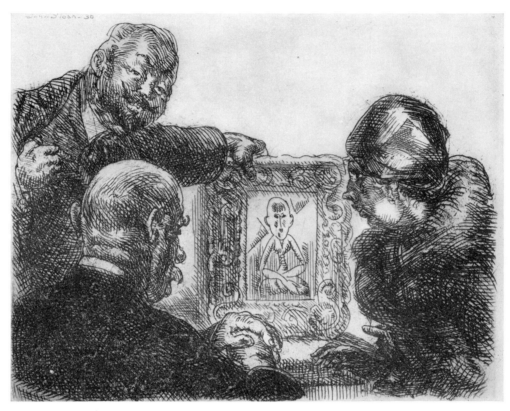

published state

242. SALESMANSHIP

1930. Proof of 4th state dated October 20, 1930. Ph.

Etching. 101 x 127 mm. (4 x 5 inches) plate.

States:

1. Dealer's hair line extends to the top of his head. Ph ("only proof").

2. Hair added to cover most of part line. Added heavy shading under woman's eye. Horizontal short shading added above and below center scroll on left side of picture frame. Ph ("only proof").

3. Horizontal shading burnished out above scroll, remaining below. Ph ("only proof").

4. Added horizontal shading on dealer's right hand below thumb. Ph.

5. Hair on top of front man's head burnished lighter. Ph–2.

6. Hair burnished further until he is completely bald on top. Small lines of shading added in shell of dealer's right ear. Published state.

Edition: 100. Printing: 85. Platt 15, White 70 (20 in 1931, 50 in 1944).

Plate exists: JST. Copper, steel-faced.

Tissue: Ph.

"The wily art of selling a thing that is neither liked nor wanted" (JS 1945). The dealer is a caricature of Charles W. Kraushaar, brother of John F. Kraushaar (229).

This print was advertised in the 1944 catalogue of the Society of Independent Artists (New York, 1944). It was offered for sale at $5, for the benefit of the Society. At most, only 14 prints appear to have been sold. They were donated by Sloan.

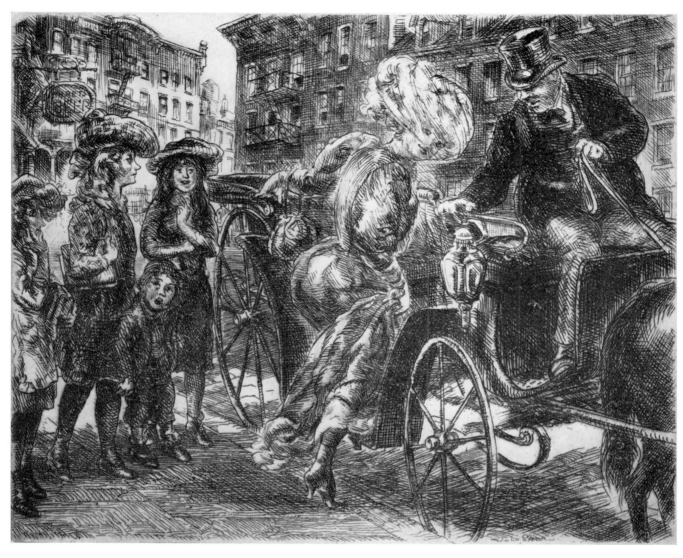

243. "UP THE LINE, MISS?"

1930. Dated October 1930 in JS records.

Etching. 140 x 178 mm. (5½ x 7 inches) plate.

States:

1. Nearly finished. Young lady at center is smiling. Girl left of center not smiling. Ph–2 (one with pen).
2. Young lady has lost her smile, and girl left of center has gained one. Much additional shading on all dresses, on buildings in background, and on carriage lamp. Ph, JST–3.
3. Coachman's legs burnished much lighter. Ph, JST.
4. Young lady has progressed to a half-smile. The front of her hat is burnished much lighter. Added shading on burnished area of coachman's legs. Eyes and mouth of small boy strengthened. Face of girl at extreme left is shaded. Ph, JST.

5. Following the bottom line of the young lady's veil upward from her nose, a small area in her hair just above this line is burnished white. Heavy line removed from the center of her back. Published state.

Edition: 100. Printing: 80. Platt 35, Roth 45.

Plate exists: JST. Copper.

Tissue and two sketches: Ph. ("From a 1907 drawing," noted on plate envelope; JST.)

"A young lady of Greenwich Village who is about to treat herself to an afternoon drive on Fifth Avenue. Etched from a sketch made years before [1907]" (JS 1945). "Not altogether satisfactory to me. I wasn't doing nearly as much etching" (JS 1945). "Kraushaar suggested that Sloan do some plates after his old New York drawings. This would account for the absence of a date in the plate. Sloan was uncomfortable with the project" (HFS 1966).

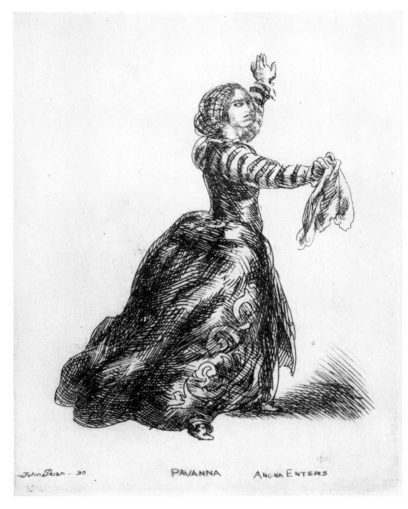

only state

244. "PAVANNA"
1930. Proof dated October 1930. Ph.
Alternative title: *Angna Enters in "Pavanna."*
Etching. 127 x 101 mm. (5 x 4 inches) plate.
Only state. Published state.
Edition: 100. Printing: 80. Platt 35, Roth 45.
Plate exists: JST. Copper.
Tissue: Ph. A drawing (no. 1905; JST) shows a similar pose.

 "This plate has merits, but it lacks the disdainful majesty of Miss Enters' portrayal of a proud, sensual and religious Spanish aristocrat" (JS 1945).

 Miss Enters discusses her composition at length in *First Person Plural* (New York, 1937, pp. 92, 123), and in *On Mime* (Middletown, Conn., 1965, pp. 9–13).

270

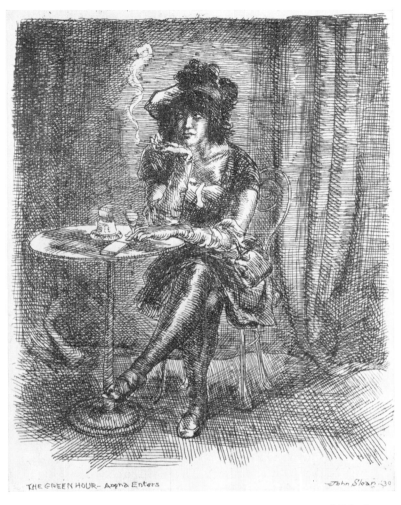

published state

245. "THE GREEN HOUR"
1930. In plate.
Alternative title: *Angna Enters in "The Green Hour."*
Etching. 127 x 102 mm. (5 x 4 inches) plate.
States:

1. Design complete. No title. No signature in plate. Ph–2,
 JST–16 (15 of which are unsigned).
2. Title added at lower left. Signature and date added at lower
 right. Published state.

Edition: 100. Printing: 90. Platt 25, White 30, Roth 35.
Plate exists: JST. Copper, steel-faced.
Tissue and one sketch: Ph. A similar drawing (no. 1917) is in
JST.

"I have made several etchings produced under the inspiration
of the creative genius of Angna Enters. This one has given me
great satisfaction" (Dart 85). "Sketch note made on the spot,
from which the tissue was planned and traced on the plate" (JS
1945).

See Miss Enters' *First Person Plural* (New York, 1937), pp. 71–
72.

246. ROBERT HENRI, PAINTER
1931. Dated January 1931 in JS records.
Etching. 355 x 279 mm. (14 x 11 inches) plate.
States:

1. Relatively lightly drawn. Lower lip visible below moustache, giving the face a decidedly sardonic expression. Ph ("only proof").

2. Lower lip no longer visible. The chin is more prominent, the forehead burnished lighter. Additional shading on hair at right side of head, upper eyelids, right cheekbone, right hand, bookshelf at left, and elsewhere. Ph ("only proof").

3. Title added at bottom center. Additional shading on top of nose. Right eye measures 2 mm. between upper and lower eyelids. Ph, JST (both inscribed "third state, two proofs").

4. Right eye now open to a width of 3 mm. Additional shading under right corner of right eye. Centers of right eyelid and right eyebrow burnished lighter. Additional shading in a line under the left eye, parallel to the lower eyelid. Additional light diagonal shading on the right coat lapel. New diagonal shading on the glass panes of the door at right now cover almost all white areas. Horizontal shading added in the same area at the center of the door, and also on the door area visible beneath the table at right. Ph, JST-2 ("3 proofs this state").

5. Slight additional shading in the burnished highlights beneath the right eye and in the center of right eyebrow. Ph, JST, Cleveland, Currier Gallery (Manchester, N.H.) (all inscribed "12 proofs this state"). Illustrated. Proofs of the 5th state were printed by Platt in February 1931 (JS records).

6. Additional vertical shading on the front edge of the table. Diagonals added on the right front of coat, next to upper button. Added horizontal shading across lower part of highlight of right cheekbone and across upper part of necktie. Right side of right lower eyelid burnished white. Heavy diagonal shading added along inside edge of left coat lapel. Vertical highlight burnished along the center molding of bookcase at left. Ph ("working proof"). (This and subsequent proofs are printed much more darkly, with retroussage.)

7. The hatched area between the second and third knuckles of right hand is burnished much lighter. The heavy line of shading below left eye is almost completely removed by burnishing. Ph-2, JST-11, NYPL, Mod, Met, Cleveland, Princeton. (All proofs of this state appear to be inscribed "100 proofs," except the Ph proof marked "4th State?" in brackets.) Illustrated, p. 274.

8. Heavy diagonal shading, slanted lower left to upper right, is added across entire left, top, and bottom sides of the picture. It is especially visible across the upper half of the framed print (104 in reverse) on the rear wall and also along the left and upper right edges, extending almost to the platemark. All shading is removed from the top of the nose. Published state. (All known proofs of this state are inscribed "100 proofs.") Illustrated, p. 275.

Edition: 100. Printing: 60. White 60, of which 30 were done in February 1931 (probably 7th state) and 30 in March 1931 (8th state).

Plate exists: JST. Copper.

Tissue: unknown. Red chalked tracing paper: Ph. Drawing (12 x 10 inches), initialed and dated 1905, in litho crayon on tissue paper, not waxed or traced: Sheldon Memorial Art Gallery, University of Nebraska, Lincoln, Nebr. Neither proof of print 115, of 1904, shows signs of tracing. The size, pose, and position of objects are virtually identical in prints 115 and 246 and in both the drawing and the tracing paper listed here. A tissue was surely used in making this print. Drawing illustrated, p. 276.

"Made after his death, from a planned portrait sketch of twenty-five years before. I am pleased with the plate and hope that it conveys some of the kindly strength and helpful wisdom which this great artist so freely gave to others" (Dart 87). "The hands are very much like him" (JS 1945).

"The big plate of Henri was bitten once all over in a bath, and the rest of the biting was done with the brush method. I bite my plates almost entirely that way. You have more control over what is happening and can see the acid bubbling more easily than you can in the bath. I don't generally time the biting, just clean the plate off now and then and judge the depth and character of the lines from experience. When I can't tell about the lines, I may clean off the ground and pull a proof" (JS 1931). "Some of the prints of the Henri plate are too cleanly wiped, and others look greasy. I have trouble in getting the printer to find a happy medium" (JS 1931).

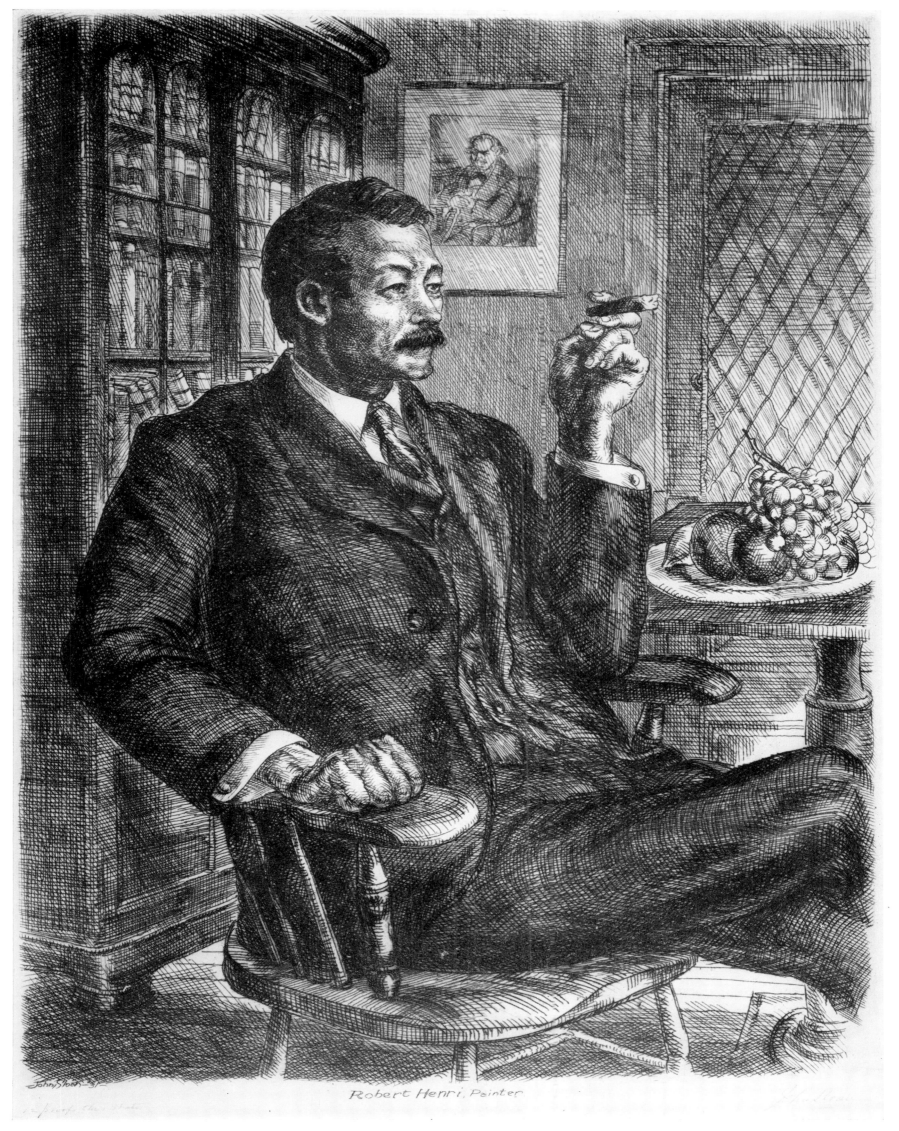

John Sloan 31

1st proof this state

Robert Henri, Painter

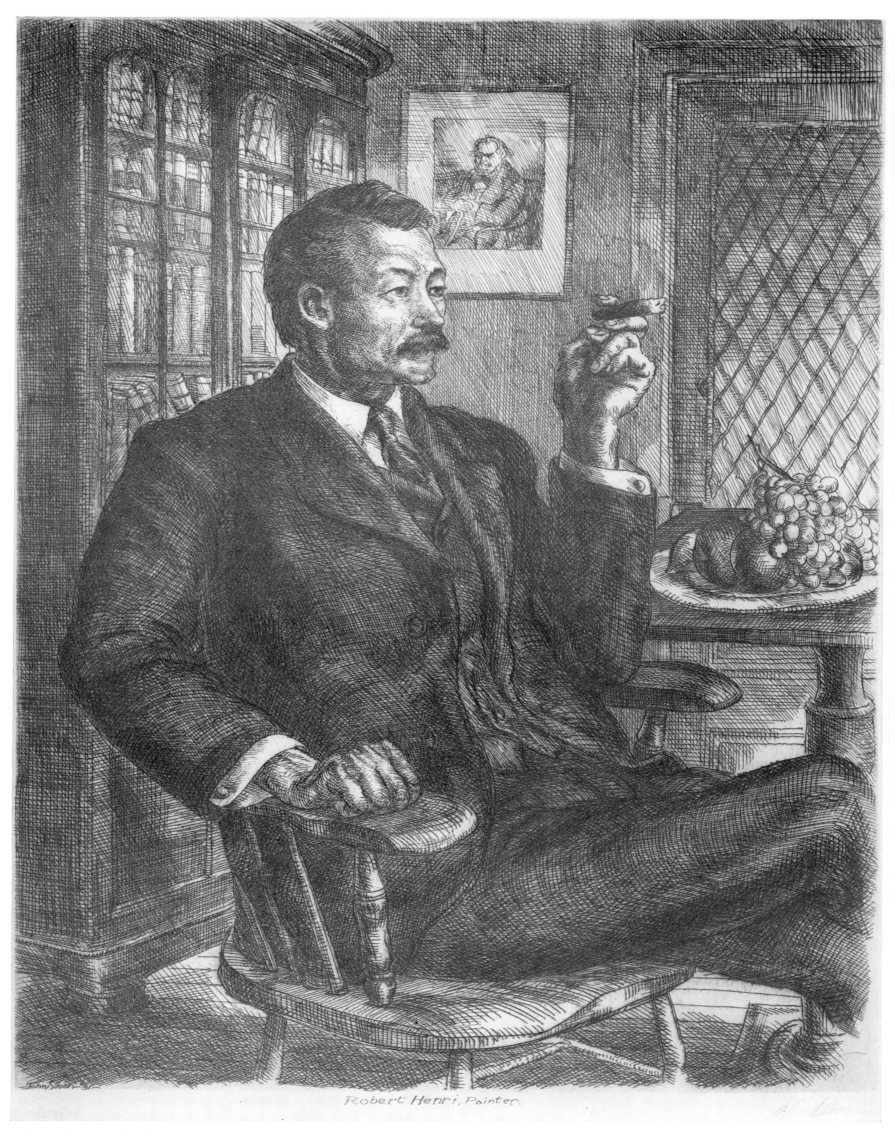

Robert Henri, Painter.

246, seventh state, reduced

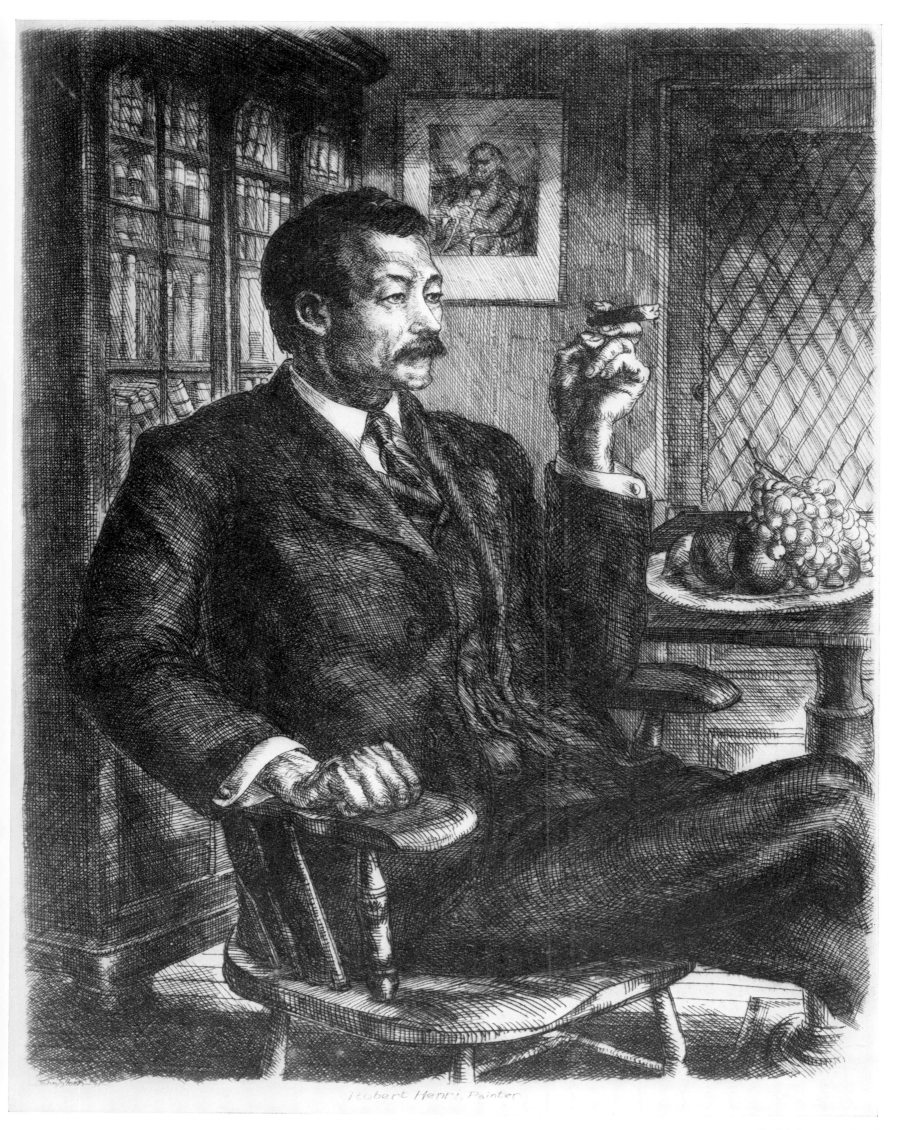

Robert Henri, Painter

246, eighth state, reduced

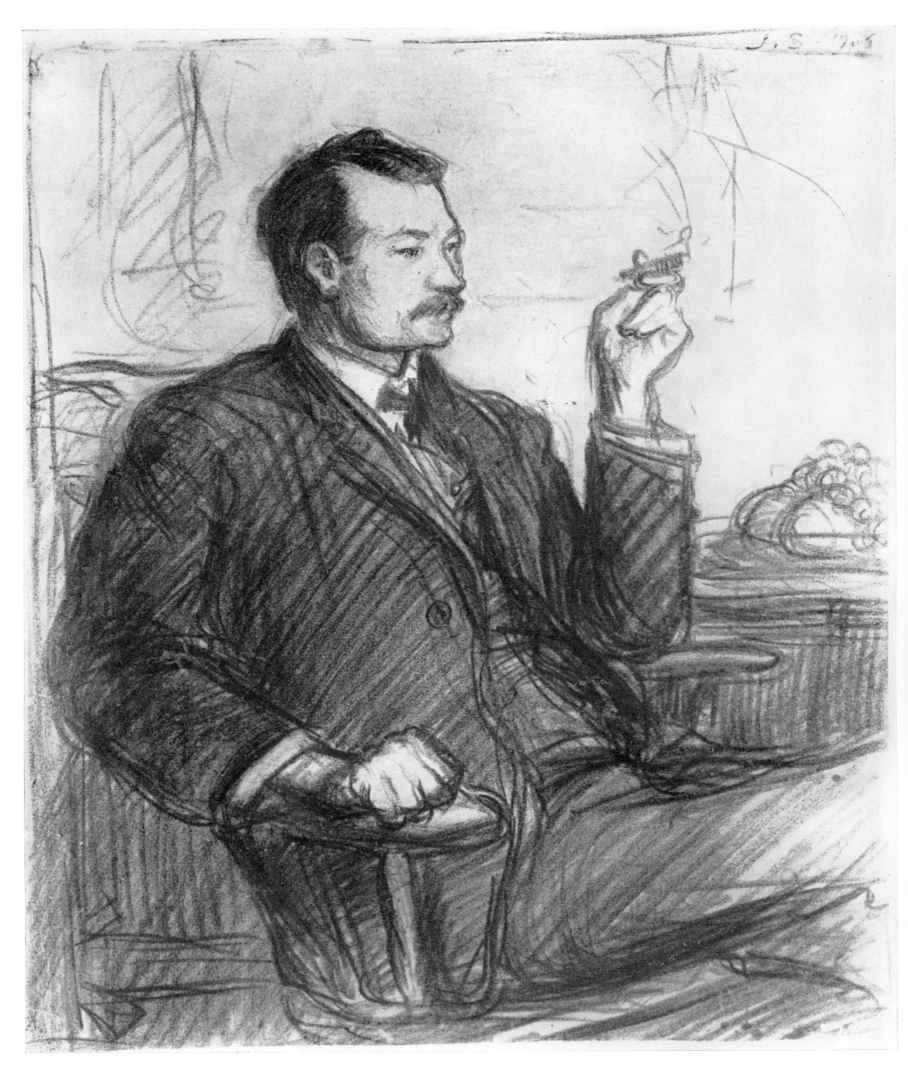

246, drawing, 1905, reduced

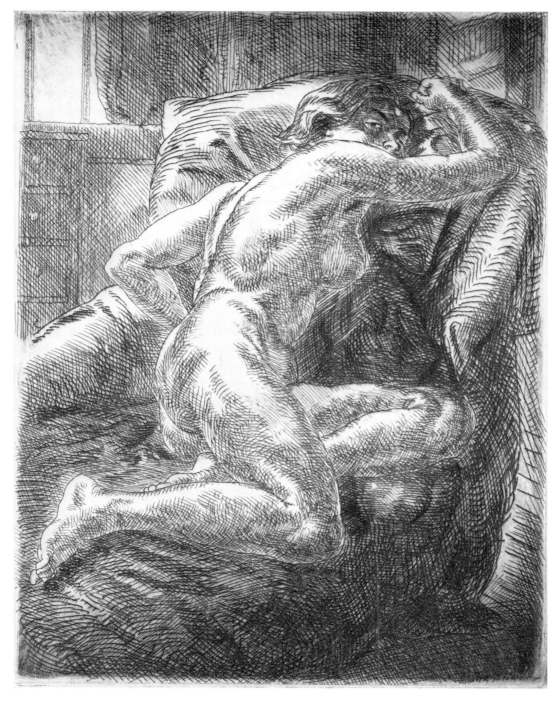

first state

247. NUDE ON DRAPED COUCH

1931. Proof of 1st state dated January 1931. JST.
Alternative title: *Nude on Draped Chair*.
Etching. 177 x 140 mm. (7 x 5½ inches) plate.
States:

1. Lightly drawn. Hair is light. Ph, JST–2.
2. Hair darkened. Additional shading on couch on all sides of the figure and in background at top and left. Ph–2 (one inscribed "WP Jan. 1931," with pencil, the other "June 1931"), JST.
3. Strong shading added on face around the right eye, covering highlight on forehead, and on legs, arms, and ribs. Published state. Illustrated, p. 278.

Edition: 100. Printing: 60. Platt 50, of which 25 were printed in January 1931 and may be of the 2nd state, and 25 in December 1931 in the 3rd state. White 10 (later).

Plate exists: JST. Copper, steel-faced. Thin plate, previously etched and then scraped clean.
No tissue.

"Now begins the period of sustained interest in the nude figure, both in my etchings and paintings, which holds me to the present day. This plate has good sculptural qualities" (Dart 86). "This has a nice flow to it" (JS 1945). Sloan made a painting from this etching in Santa Fe in 1943, which is now in the Montclair, New Jersey, Art Museum.

This print was selected as one of the *Fine Prints of the Year 1931* and was published in that volume (ed. Malcolm C. Salaman, 9th issue, New York, 1931, pl. 91 and p. 20). HFS believes that Sloan never learned of this tribute.

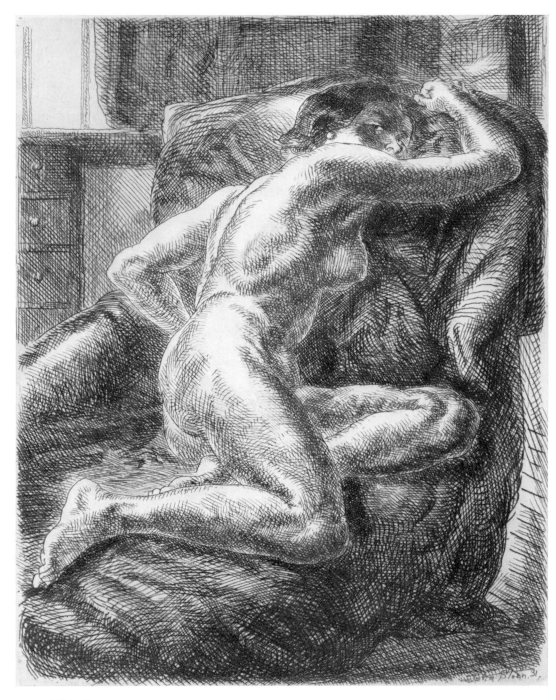

247, published state

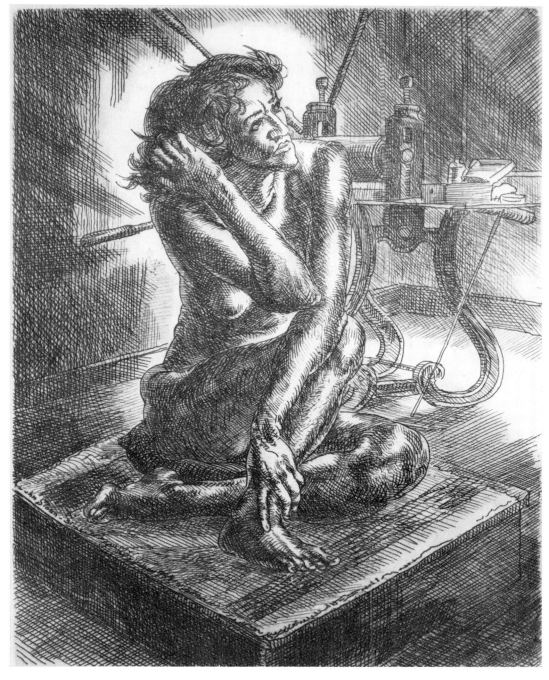

248. CROUCHING NUDE AND PRESS

1931. Proof dated January 1931. Ph.

Etching. 178 x 140 mm. (7 x 5½ inches) plate.

States:

1. Nearly complete. Entire lower part of right thigh is dark. Ph, JST.
2. Entire lower part of right thigh burnished somewhat lighter. Ph.
3. Strong highlight burnished on under side of right thigh, next to left hand. Lesser highlight burnished on bottom of right thigh directly above left ankle. Ph.
4. Additional heavy shading covers second highlight of 3rd state. Published state.

Edition: 100. Printing: 75. Platt 25, White 25, Roth 25.

Plate exists: JST. Copper, steel-faced.

No tissue.

"A very successful plate, a favorite of both the artist and some print collectors. A good one *without* flow" (JS 1945).

"That's a very fine one. I must make a painting of it. [He never did.] I could do the underpainting from the etching and then stain it up, changing it if I don't like it. I do, though, rather feel the need of the model to get color impulses" (JS 1931).

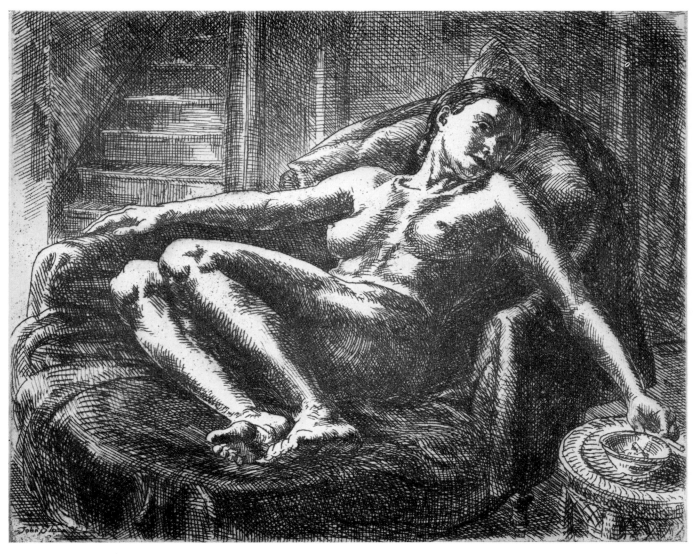

published state

249. NUDE WITH CIGARETTE
1931. Dated March 1931 in JS records.
Etching. 140 x 177 mm. (5½ x 7 inches) plate.
States:
1. Nearly complete. Light cross-hatching on left forearm. Ph, JST.
2. All light cross-hatching on left forearm removed. Ph, JST–2.
3. Horizontal shading added across highlight on riser of second stair above woman's right forearm. Published state.
Edition: 100. Printing: 70. White 45, Roth 25.
Plate exists: JST. Copper, steel-faced.
No tissue.

 "The nudes of this period were needled directly on the plate without preliminary studies, and when they achieve results like this I feel that they are of lasting importance. They kind of amaze me nowadays" (JS 1945).

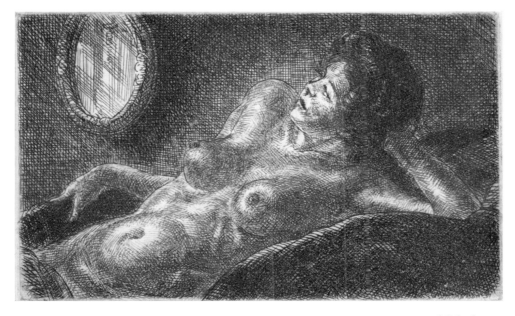

published state

250. HALF NUDE ON ELBOW

1931. Proof of 4th state dated March 1931. Ph.
Etching and engraving. 71 x 127 mm. (3 x 5 inches) plate.
States:

1. Nearly complete. Mouth very faint. Burnishing on entire body. Ph, JST–2.
2. Mouth, left eye, and right nipple strengthened. Nose now within face line. New left eyebrow added. Additional shading on forehead. Ph.
3. Added shading across top of nose. Left nipple darkened. Ph.
4. Added vertical shading on right and left parts of mirror. Forehead, nose, and area below left eye burnished lighter. Upper line of nose follows the face line. Ph (inscribed "100 proofs").
5. New upper line of nose curves down, separate from face line. Ph (inscribed "100 proofs").
6. Short heavy line added at lower corner of left nostril. Published state.

Edition: 100. Printing: 75. Platt 25, Roth 50.
Plate exists: JST. Copper.
No tissue.

"Here there is an attempt at linework of too much delicacy which interferes with the sense of realization" (JS 1945).

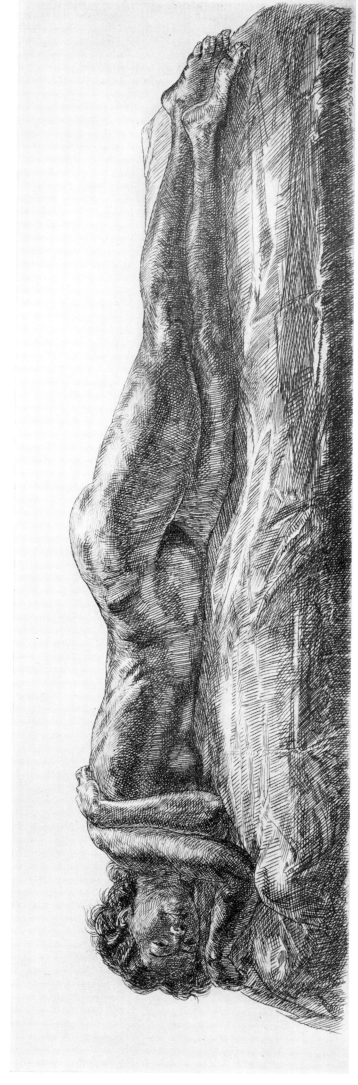

fifth state, reduced

251. LONG PRONE NUDE

1931. Proof of 2nd state dated March 14 1931. JST.
Etching and engraving. 109 x 352 mm. (4¼ x 13¾ inches)
plate.
States:

1. Nearly complete. Heavy etched cross-hatching on couch directly below hips. Ph, JST–3.
2. Dark cross-hatched area burnished out and replaced with parallel diagonal engraved lines. Additional slight diagonal shading on the back next to the right hand, on top of the left thigh and left calf. Ph, JST–3.
3. Shading added on highlights on left forearm, left upper arm, right forearm, and left heel. A further area of cross-hatching beneath the hips is burnished out and replaced with engraved diagonals. Ph, JST–3.
4. Shading across the lower of two highlights on cloth below the head. Ph, JST–9. All proofs of this state appear to be inscribed "100 proofs."

5. Added diagonal engraved shading on top and along the line of the sole of the left foot. Published state. These lines were engraved through the steel-facing applied to the plate. It seems quite likely that the 26 proofs printed by Platt are in the 4th state and the 20 White proofs in the 5th state. An inventory of the unsold impressions shows an equal number in each state at present.

Edition: 100. Printing: 46. Platt 26 (4th state), White 20 (5th state.

Plate exists: JST. Copper, steel-faced.
No tissue.

"The general effect is delicate, but it is robust in drawing, has monumental characteristics" (Dart 89). "It reminds me of some of those sarcophagus covers, though the figure is on its side, not on its back. The graver is used for auxiliary work in the drapery" (JS 1945).

252. NUDE WITH FURNITURE

1931. Proof of 2nd state inscribed March 24, 1931. JST.
Etching. 127 x 102 mm. (5 x 4 inches) plate.
States:

1. Nearly complete. Ph, JST.
2. Horizontal shading added on right side of forehead. Diagonal shading added at top right of mirror. Ph, JST–2.
3. Slight additional diagonal shading on inside of left wrist, covering dark wrist line previously visible. Published state.

Edition: 100. Printing: 45. Platt 25, Roth 20.
Plate exists: JST. Copper.
No tissue.

"This etching seems to catch the 'ethereal' quality of flesh amid furniture and draperies, although I must admit I had no such purpose in mind" (Dart 92). "The furniture in the background was 'invented.' The Windsor chair was made by one of his cabinetmaker Sloan ancestors" (HFS 1966).

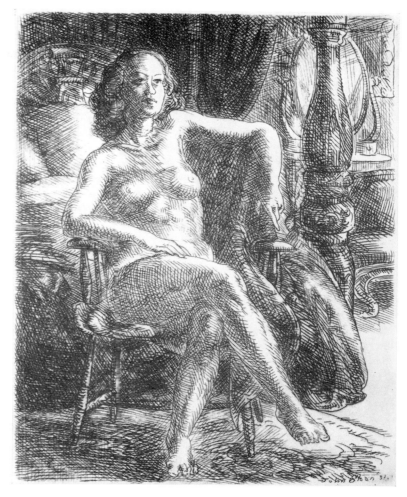

published state

253. NUDE IN SHADOW

1931. Dated April 1931 in JS records. Done before April 10, 1931, when first sent to Platt for printing. JS records.
Etching and engraving. 127 x 102 mm. (5 x 4 inches) plate.
States:

1. Nearly complete. The body is burnished. No shading on forehead above left eye. Ph.
2. Light shading added on forehead, beside left eye, on left hip, and elsewhere. Ph.
3. Highlight burnished in background between head and right shoulder. Published state.

Edition: 100. Printing: 52. Platt 25, White 27.
Plate exists: JST. Copper, steel-faced.
No tissue.

"Here I attempted the difficult problem of drawing a figure entirely in shadow without losing the sense of solidity" (Dart 90). "And yet it is solid, I hope" (JS 1945).

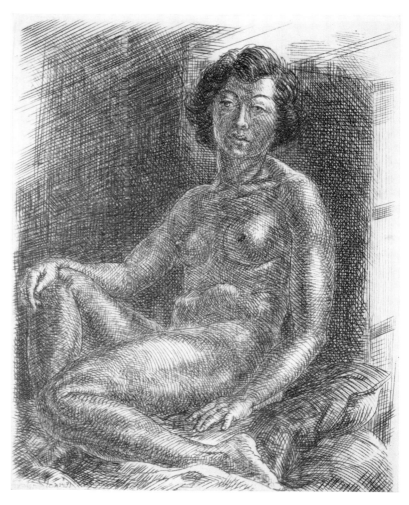

published state

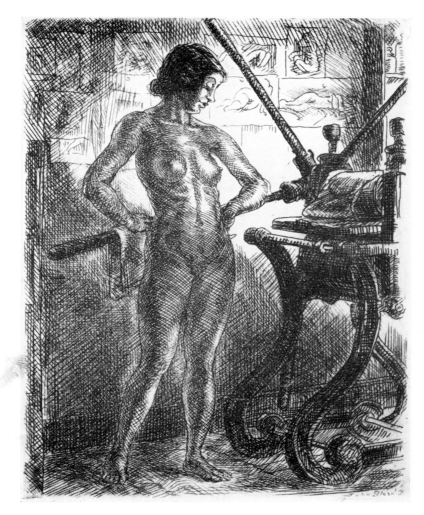

published state

254. NUDE AND ETCHING PRESS

1931. Done before April 10, 1931, on which date this print was first sent to Platt to be printed. JS records.

Etching. 127 x 101 mm. (5 x 4 inches) plate.

States:

1. Nearly complete. Ph.
2. Additional shading around and above the reversed picture of the *Long Prone Nude* (251) on the wall directly above the press. Burnishing on the body of the same nude in the picture. Published state.

Edition: 100. Printing: 51. Platt 25, White 26.

Plate exists: JST. Copper, steel-faced.

No tissue.

"If I am not mistaken this plate has charm, not, however, of a kind that I would object to" (JS 1945). None of the other pictures on the wall seem to be identifiable with specific etchings.

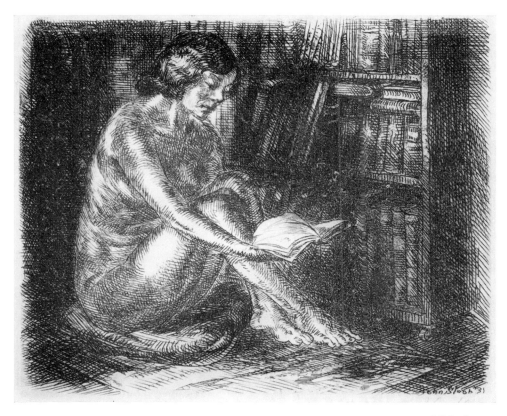

published state

255. NUDE BY BOOKCASE
1931. Proof of 1st state dated April 1931. Ph.
Etching. 102 x 127 mm. (4 x 5 inches) plate.
States:
1. Nearly complete. Woman has long pointed nose. Ph.
2. Diagonal shading added on upper row of books in bookcase. Much added dark shading at left side. Added shading on lower part of right thigh. Curved line added on right cheek. Ph, JST–2.
3. Face redrawn, with shortened nose, hair added to left of face, hair curled up in back of head, and shorter mouth. Published state.

Edition: 100. Printing: 44. White 24, Roth 20.
Plate exists: JST. Copper, steel-faced.
No tissue.

"Nothing could be less informative or romantic than the titles of these etchings. Perhaps I should have called this one *Poetry*" (Dart 88). "This is more successful" (JS 1945). The area of tone in the bookcase is more likely false-biting than aquatint.

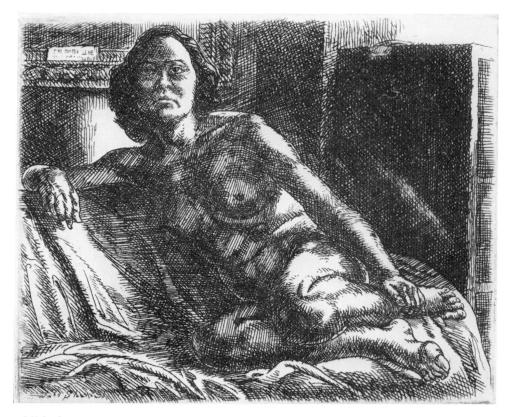

published state

256. NUDE RESTING ON ELBOW
1931. Dated April 1931 in JS records.
Alternative title: *Nude with Hand to Ankle*.
Etching. 102 x 127 mm. (4 x 5 inches) plate.
States:
 1. Nearly complete. Ph.
 2. Diagonal highlight burnished on screen at right, parallel
 to woman's left arm. Published state.
Edition: 100. Printing: 45. Platt 25, Roth 20.
Plate exists: JST. Copper.
No tissue.
 "Might this plate be too skillful and technically proficient?
Perhaps as well that it is, in this way, rather an exception" (Dart
91). The title *The Coffee Line,* visible at the upper left, is that of
one of Sloan's better known paintings, done in 1905, and winner
of an honorable mention at the Carnegie Institute, Pittsburgh,
1905. It is now in the Sloan estate (see *Gist,* p. 205).

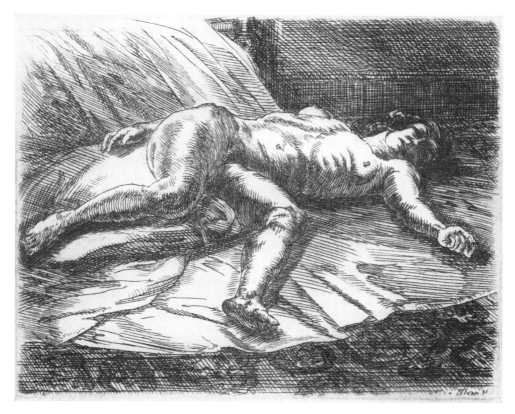

published state

257. NUDE ON THE FLOOR

1931. Proof of 1st state dated April 29, 1931. JST.
Etching and engraving. 101 x 127 mm. (4 x 5 inches) Plate.
States:
1. Nearly complete. Ph, JST.
2. Horizontal shading added on highlight on wall at upper center. Ph.
3. Small vertical highlight burnished at top center. Published state.

Edition: 100. Printing: 75. Platt 25, White 25, Roth 25.
Plate exists: JST. Copper, steel-faced.
No tissue.

"One of the best of this group of etchings. Shows my interest in achieving foreshortening without perspective. I have said a great deal about this in my *Gist of Art* [pp. 65–68]. Line engraving is introduced in this plate" (Dart 63). "One of the chefs d'oeuvre of the lot, when you consider that it was drawn directly in the smoked wax. I'd be bored if they were all like this in various degrees. If I had done fifty plates as good, there would be something the matter. This kind of merit might become very monotonous. I might become a skilled craftsman" (JS 1945).

"I have been playing around with the graver lately. It is very amusing and I like the clean severe line you can get with it. It is quite difficult to control a curved line, that is, to get something that isn't just an ordinary curve. This plate of the *Nude on the Floor* has a great deal of graved work in it. These sets of graved lines have something that etched lines don't have—a different tone" (JS 1931).

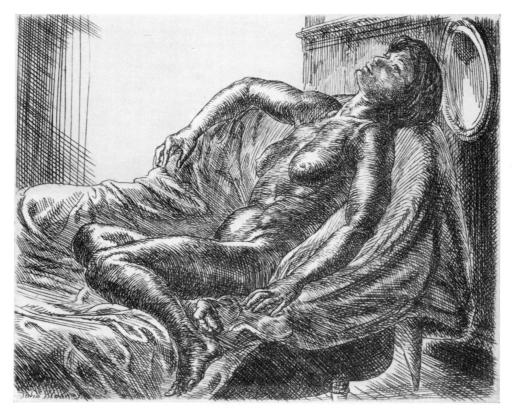

published state

258. NUDE WITH HALO

1931. Proof of 1st state dated April 29, 1931. Ph.
Etching and engraving. 102 x 127 mm. (4 x 5 inches) plate.
States:
1. Nearly complete. Outside edge of vertical hanging drapery to right of figure is unshaded. Face is dark. Ph, JST–2.
2. Face is burnished lighter. Drapery completely shaded to right edge. Highlight burnished on top of right upper arm. Ph, JST.
3. Highlight on arm covered with additional shading. Published state.

Edition: 100. Printing: 45. White 25, Roth 20.
Plate exists: JST. Copper.
No tissue.

"I think we can all agree that this lacks the voluptuous charm of a Boucher or Fragonard. 'Tis well" (Dart 95).

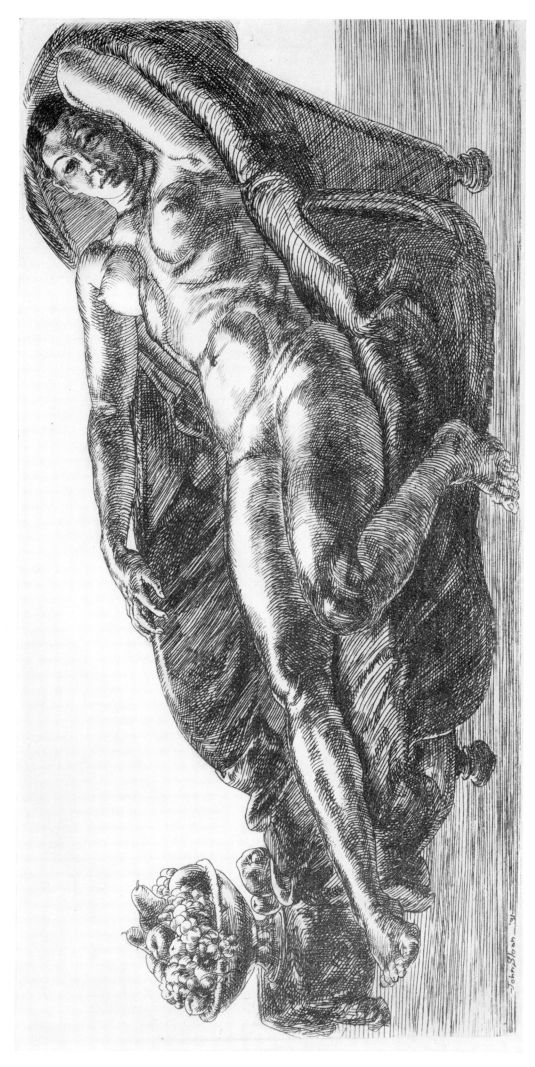

259. NUDE WITH BOWL OF FRUIT
1931. Dated May 1931 in JS records.
Etching and engraving. 131 x 273 mm. (5¼ x 10¾ inches) plate.
Only state. Published state.
Edition: 100. Printing: 50. Platt 25, White 25.
Plate exists: JST. Copper, steel-faced.
No tissue.

"Thirty-one nude subjects were etched between 1930 and 1933, and at the same time many canvases were painted. The most appreciative remark I have ever heard made about this print was: 'She looks like metal.' My liking for this expression indicates the fact that I am not interested in the delicate beauty of human flesh. Worthwhile sculpture has no such sensuous interest" (Dart 94).

"Someone said that the etching of the *Nude with Fruit* was like steel. I think that is a very good remark about it. Do you notice the work done all through it with the graver? I enjoy using it. You get a kick out of digging the copper out with the tool. And then it is a handsome dry line to use with etched lines" (JS 1931). The same model also appears in the *Nude Reading of 1928* (234).

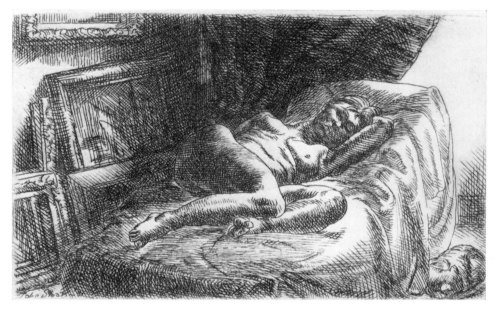

published state

260. NUDE ON STUDIO COUCH

1931. In plate.

Alternative title: *Nude with Cat*.

Etching and engraving. 76 x 127 mm. (3 x 5 inches) plate.

States:

1. Nearly complete. Ph–2 (inscribed "working 1st proof" and "working 2nd proof," with no visible difference).
2. Added row of vertical hatching on right calf. Additional shading on cat's head and neck. Published state.

Edition: 100. Printing: 51. White 51.

Plate exists: JST. Copper, steel-faced.

No tissue.

"Rather nice in technique. I am glad that they are not all nice in this way" (JS 1945).

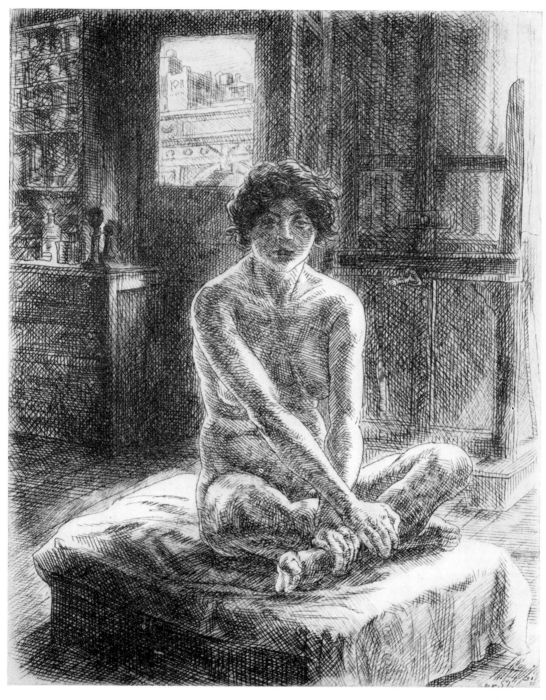

published state

261. NUDE ON POSING STAND

1931. In plate.
Etching and aquatint. 177 x 140 mm. (7 x 5½ inches) plate.
States:
1. Before aquatint. Eyes and mouth weak. Diagonals only one direction on forehead. Ph.
2. Aquatint added on telephone and in the general area to the left side of the picture. Ph, JST–5.
3. Mouth and eyes darker. Lower lip strengthened. Additional shading on forehead, upper lip, hair, right thigh, and elsewhere. Published state.
Edition: 100. Printing: 45. White 20, Roth 25.
Plate exists: JST. Copper.

No tissue.

"The technical delicacy of this plate is more likely to please others than the artist. It has good tonal qualities and perhaps 'charm.' I don't care for tonality in an etching. My interest is in the graphic force of the line" (JS 1945).

This and the preceding print are the only ones of 1931 not precisely datable by records or inscribed proofs. They were not printed until October 1933, unlike the other prints of 1931, which were printed at the time they were made. The most likely explanation is that they were the last ones done in that year, and that Sloan did not have an opportunity to have them printed before falling ill and going into the hospital.

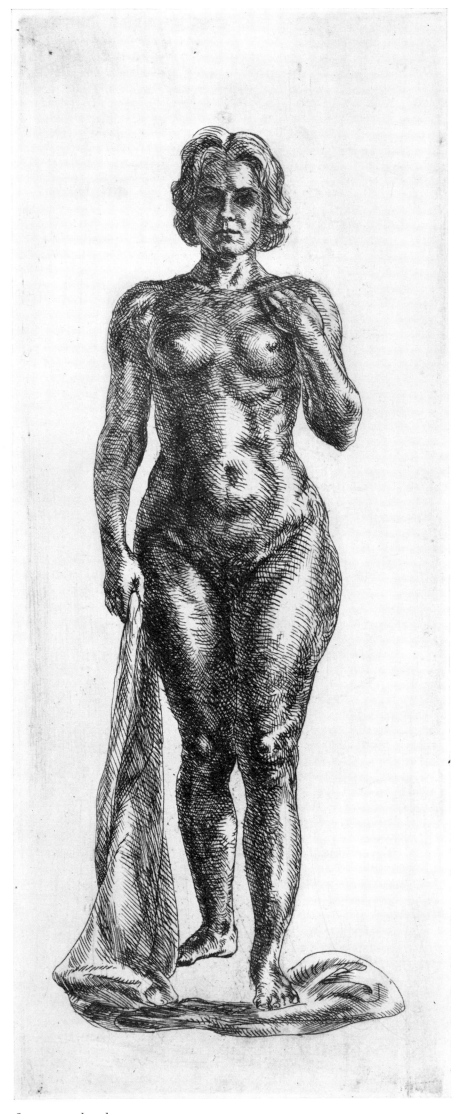

first state, reduced

262. STANDING NUDE

1933. Dated May 1933 in JS records.
Etching and engraving. 332 x 139 mm. (13 x 5½ inches) plate.
States:

1. Standing woman only, no background. Platemark measures 353 x 135 mm. (14 x 5½ inches). Ph, JST.
2. Background added with graver. Gaps appear between the ends of the horizontal lines, giving a pronounced moiré effect. Blank space to right of left arm. Diagonal shading in a row across the top. Ph ("one proof").
3. Plate trimmed at the top. Platemark now measures 329 x 135 mm. (13 x 5½ inches). Additional horizontal shading in background, including the filling of the blank area next to the left arm. Still with gaps and moiré pattern. Ph ("one proof").
4. Gaps in background filled with more horizontal lines. Published state.

Edition: 100. Printing: 40. Platt 20, Roth 20.
Plate exists: JST. Copper.
No tissue.

"The figure etched, the background engraved with burin" (Dart 100). "There is an early state with no background, which was done with the graver. Not the work of a trained engraver, but it would be very inconsistent if it were" (JS 1945).

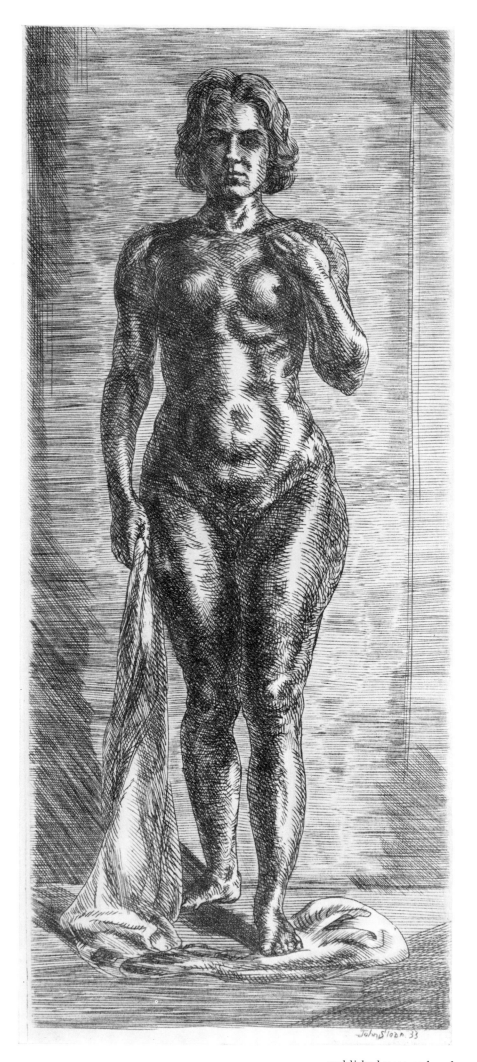

published state, reduced

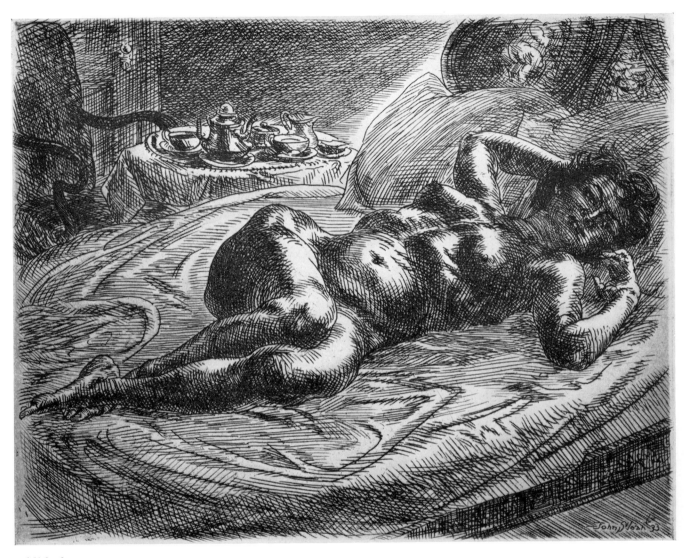

published state

263. NUDE AND BREAKFAST TRAY

1933. Dated June 1933 in JS records.

Etching and engraving. 140 x 177 mm. (5½ x 7 inches) plate.

States:

1. Nearly complete. Ph, JST–2.
2. Added vertical shading on door and chair back at upper left. Additional shading in lower left corner, on baseboard and headboard of bed, and on under side of woman's chin. Ph.
3. Shading on chin and right cheek burnished lighter. Published state.

Edition: 100. Printing: 75. Platt 20, White 30, Roth 25.

Plate exists: JST. Copper, steel-faced.

No tissue.

"This plate is very satisfactory to its producer, and it might be hoped that general appreciation may come eventually. If the figure to you looks like brass, I thoroughly agree; that is one reason why I like it. Too many nudes absolutely fail as art because they look like flesh *looks*" (Dart 99). "Another of the accomplished ones. Craftsmanly" (JS 1945). The same model appears in *Brunette Head and Shoulders* (275) and several paintings of the period.

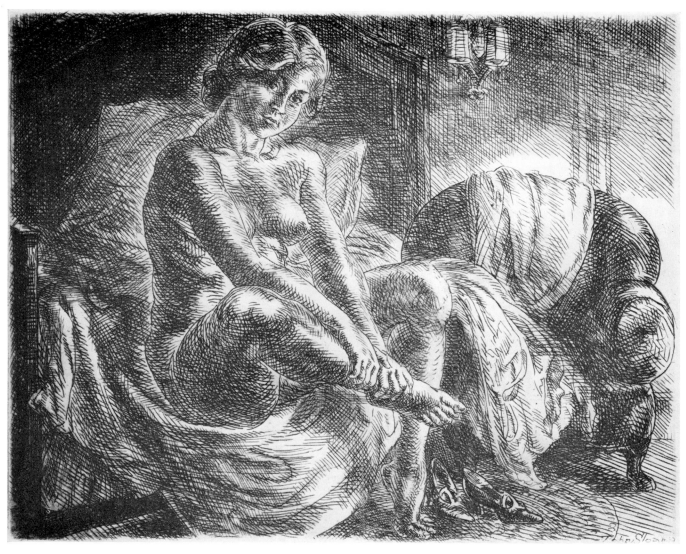

published state

264. NUDE AT BEDSIDE

1933. Dated July 1933 in JS records.

Etching. 140 x 178 mm. (5½ x 7 inches) plate.

States:

1. Nearly complete. Cloth over back of armchair has large blank area. Ph, JST–2.
2. Added shading on cloth over armchair and on pillow behind woman. Highlight burnished under right eye. More shading on wall to left and below lamp, on arm of chair, and on bedclothes below right leg. Ph, JST.
3. Slight additional horizontal shading at top of highlight on right shoulder and on outside of left upper arm. More shading on upper part of right calf near the knee. Published state.

Edition: 100. Printing 51. Platt 20, White 31.

Plate exists: JST. Copper, steel-faced.

No tissue.

"Many of these nude study plates have invented accessories, which in this case assist the figure considerably. The model was just sitting somewhere in the studio" (JS 1945).

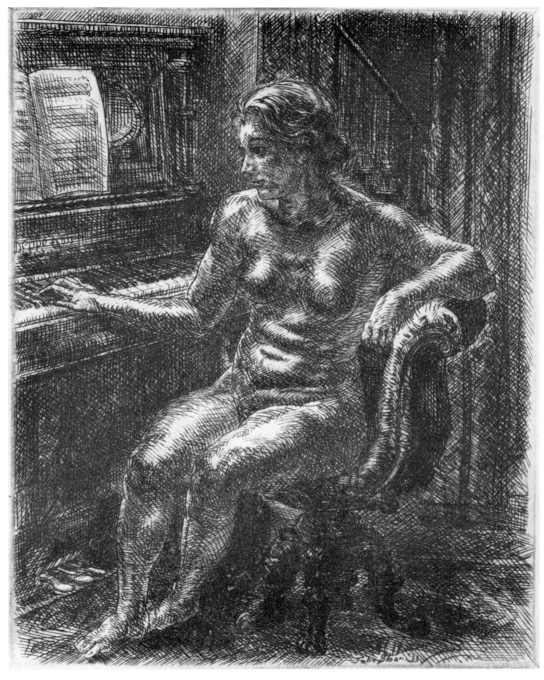

fourth state

265. NUDE AT PIANO
1933. Dated July 1933 in JS records.
Etching. 177 x 140 mm. (7 x 5½ inches) plate.
States:

1. Nearly complete. Face dark. Strong dark lines in hair and outlining tendon on the left side of the neck. Ph.
2. Hair, face, and neck burnished to a more even texture. The dark line of the collarbone remains. Additional shading on floor and curtains at right. Ph.
3. Further burnishing on face and collarbone, removing the dark line of the latter. Maker's name on piano, "Deppe & Son," is clear and unshaded. Twenty impressions were made (by Platt) of the plate in this state. Some are inscribed "20 proofs this state." Some, of which I have noted at least fourteen, are inscribed "100 proofs," with no other distinguishing notations.

4. Horizontal shading added across piano maker's name. Additional diagonal cross-hatching on floor directly beneath the back of the chair. Sixty-five proofs have been printed in this state (by White and Roth). All known 4th state impressions are inscribed "100 proofs." Published state.

Edition: 100. Printing: 85. Platt 20 (3rd state), White 20 (4th state, marked "later state" in JS records), Roth 45 (4th state).
Plate exists: JST. Copper.
No tissue.

"A strong relationship between this etching and the painting of Renoir is to me quite noticeable. My own best results in painting of the nude are made with the same graphic intent" (Dart 98). "A sensitive thing, like a very good painting, the head particularly" (JS 1945).

296

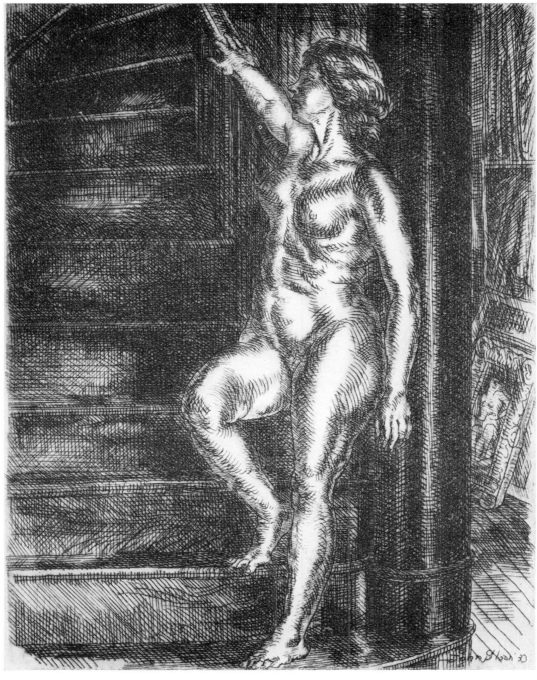

published state

266. NUDE STANDING ON STAIRWAY

1933. In plate. Between July and October 1933, JS records.
Etching. 177 x 139 mm. (7 x 5½ inches) plate.
States:

1. Nearly complete. Ph.
2. Added shading across blank highlights on all stair risers. Right upper arm, forearm, and wrist burnished lighter. Mouth changed to a downward curve at corner. Added shading on left hip and side of left calf. Ph, JST.
3. Horizontal shading added across highlight on two risers beside right knee. Strong diagonal and horizontal shading on the riser next above these, horizontals on the next riser above this, and diagonals on the next above. Published state.

Edition: 100. Printing: 70. White 20, Roth 50.
Plate exists: JST. Copper.
No tissue.

"Many of these figure etchings are, I trust, quite lacking in emotional appeal. But many have no lack of sculptural integrity" (JS 1945).

297

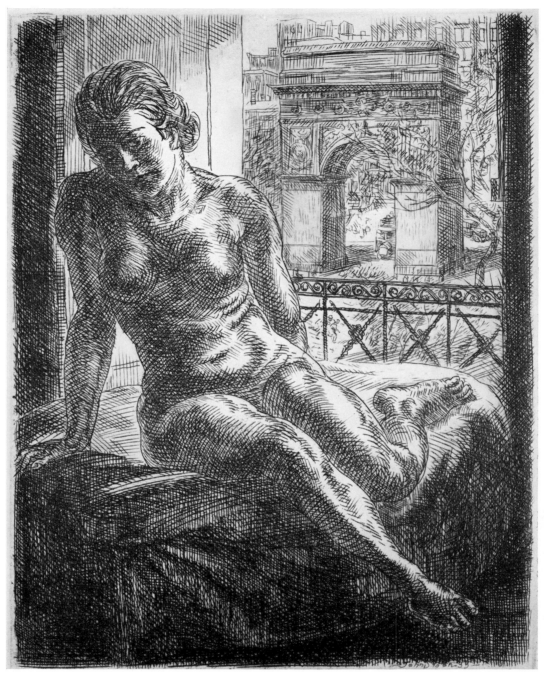

published state

267. NUDE AND ARCH

1933. In plate. Between July and October 1933. JS records. Most likely July or August, judging by the open window.

Etching and engraving. 177 x 140 mm. (7 x 5½ inches) plate.

States:

1. Nearly complete. Heavy shading on wall above head. Ph, JST–2.
2. Area on wall above head is burnished white. Additional shading in hair. Lower front sides of arch burnished lighter. Ph, JST.
3. Light vertical and diagonal shading in area above woman's head. Added vertical shading on wall between head and right shoulder and between right forearm and body. Much additional heavy shading on right and left sides of the picture, and on the bed. Published state. A proof in Ph, inscribed "working proof 4th state" appears identical to the published impressions of this state.

Edition: 100. Printing: 75. White 20, Roth 55.

Plate exists: JST. Copper.

No tissue.

"For about ten years [1927–35] my studio overlooked Washington Square, in a house remodelled by George Inness, Jr., son of the great landscape painter" (JS 1945).

298

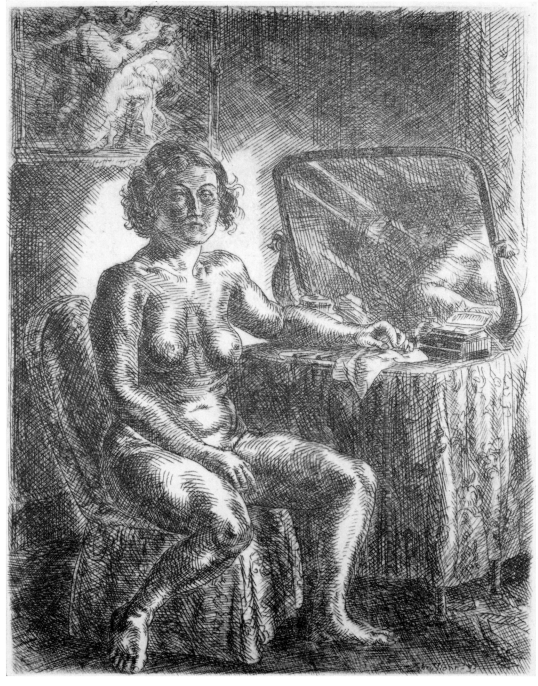

published state

268. NUDE AT DRESSING TABLE

1933. In plate. Between July and October 1933. JS records.
Etching. 177 x 139 mm. (7 x 5½ inches) plate.
States:

1. Nearly complete. The wall area between head and mirror is blank. Ph, JST–2.
2. Shading added on wall along edge of mirror and below and to right of painting. Slight added shading on left cheekbone and left calf. Additional shading on floor beneath left foot, on left side of chest below left shoulder, and on shoulder in mirror reflection. Ph.
3. Additional diagonal shading on wall below painting, horizontal on mirror, vertical on floor at lower right corner, on painting, on chair, and elsewhere. Chin burnished lighter.

Ph, JST.

4. Thin line of mouth between the lips is much strengthened. Short curved line added at left corner of mouth. Published state.

Edition: 100. Printing: 51. Early 20 (Platt or White), White 31.
Plate exists: JST. Copper, steel-faced.
No tissue.

"I hope and I almost believe that some day more people will join the artist in liking the nude plates of 1931–1933" (JS 1945). A painting after this etching was made in Santa Fe in 1943 (Sloan estate). The painting seen at the upper left of this etching is Rubens' *Rape of Europa,* of which Sloan had a reproduction in his studio.

299

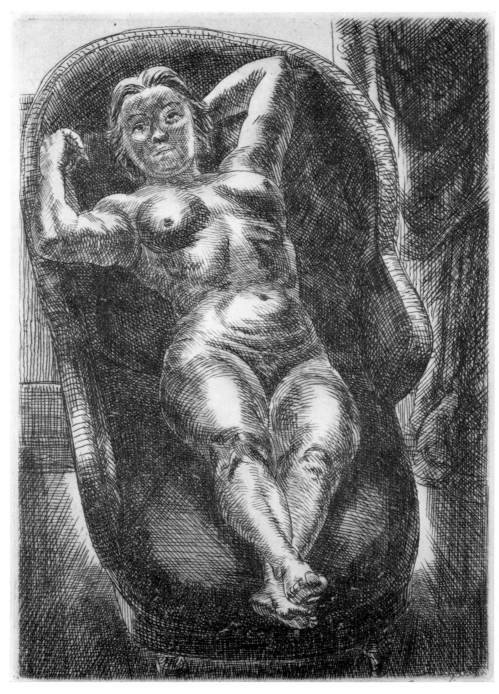

published state

269. NUDE FORESHORTENED

1933. In plate. Between October and December 1933. JS records.
Etching and engraving. 177 x 126 mm. (7 x 5 inches) plate.
States:

1. Nearly complete. Face very dark. Ph.
2. Face considerably lightened with burnishing, especially under the eyes. Additional shading on both thighs, stomach, and chaise longue to right and left of legs. Published state.

Edition: 100. Printing: 35. Platt 10, Roth 25.
Plate exists: JST. Copper.
No tissue.

"The presence of some engraved lines in this plate makes many of the etched lines seem to have the same quality. Just that and only that. Released without being finished" (JS 1945). Despite Sloan's comment, no further work appears to have been done on the plate.

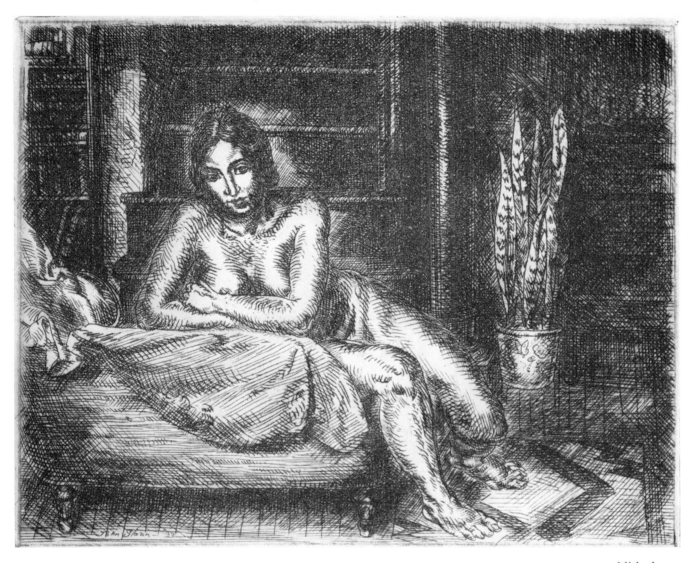

published state

270. NUDE LEANING OVER CHAISE

1933. In plate. Between October and December 1933. JS records.
Etching. 140 x 177 mm. (5½ x 7 inches) plate.
States:
1. Nearly finished. Ph.
2. Added shading in highlight on stair risers, in square on rug
 at lower right, on cloth and side of chaise longue at front,
 and elsewhere. Published state.
Edition: 100. Printing: 75. Platt 10, White 40, Roth 25.
Plate exists: JST. Copper, lightly and poorly steel-faced.
No tissue.

"This is more sensitive than some others of this period, but
has also sufficient strength and perhaps beauty. I should have
painted this subject" (JS 1945).

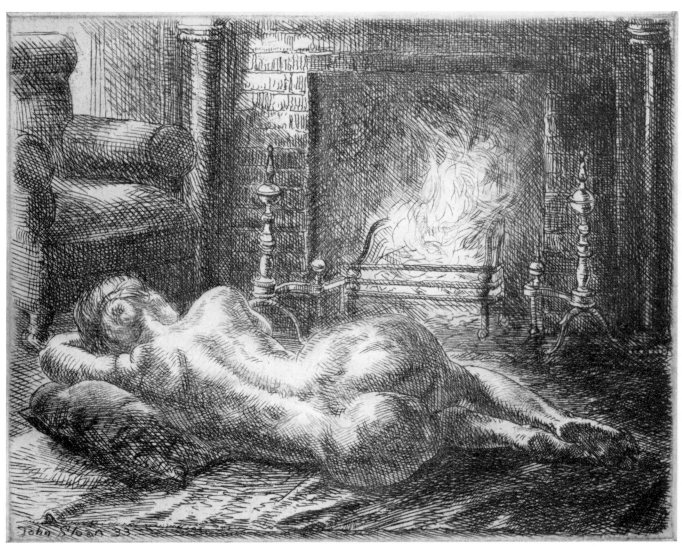

published state

271. NUDE ON HEARTH
1933. Proof of 1st state dated October 7, 1933. Ph.
Etching. 139 x 177 mm. (5½ x 7 inches) plate.
States:
 1. Nearly complete. Entire body burnished. Ph ("one proof").
 2. Highlight burnished in center of right shoulder blade. Additional shading on buttocks. Published state.
Edition: 100. Printing: 75. Platt 10, White 40, Roth 25.
Plate exists: JST. Copper, steel-faced.
No tissue.
 "This etching is to me related to the painting of Renoir, which is not surprising since I believe the approach is similar to the painter's approach to realization" (Dart 96).

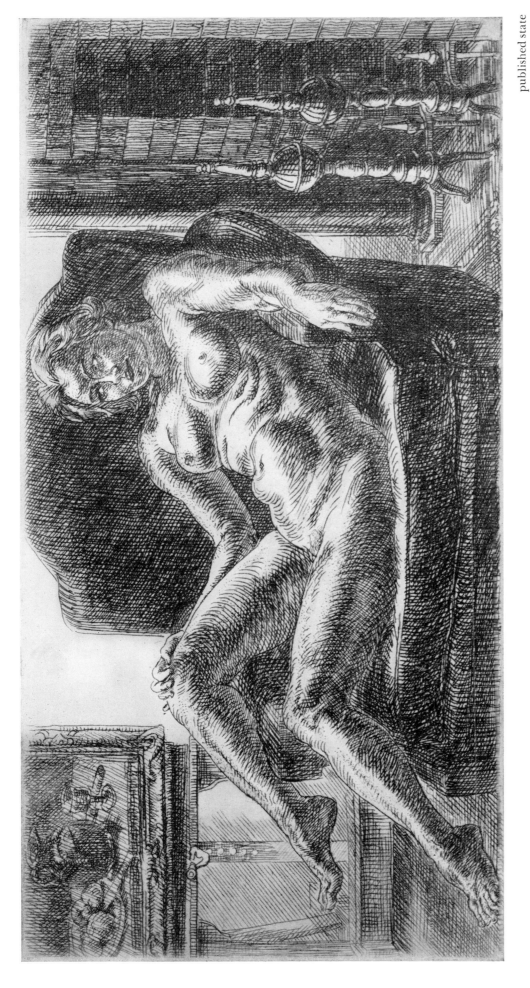

272. NUDE IN ARMCHAIR BY FIREPLACE

1933. In plate. Between October and December 1933. JS records. Etching. 128 x 252 mm. (5 x 10 inches) plate.

States:

1. Nearly finished. Face dark. Ph, JST.
2. Face burnished lighter, especially along the jawline. Additional shading on left upper arm. Ph.
3. Added diagonal shading on rear wall below painting on

easel, and between floor and left arm of chair. Published state.

Edition: 100. Printing: 35. Platt 10, Roth 25.

Plate exists: JST. Copper.

No tissue.

"Many of these plates will be better appreciated when print collectors break through their conventional attitude toward technique and subject matter" (JS 1945).

published state

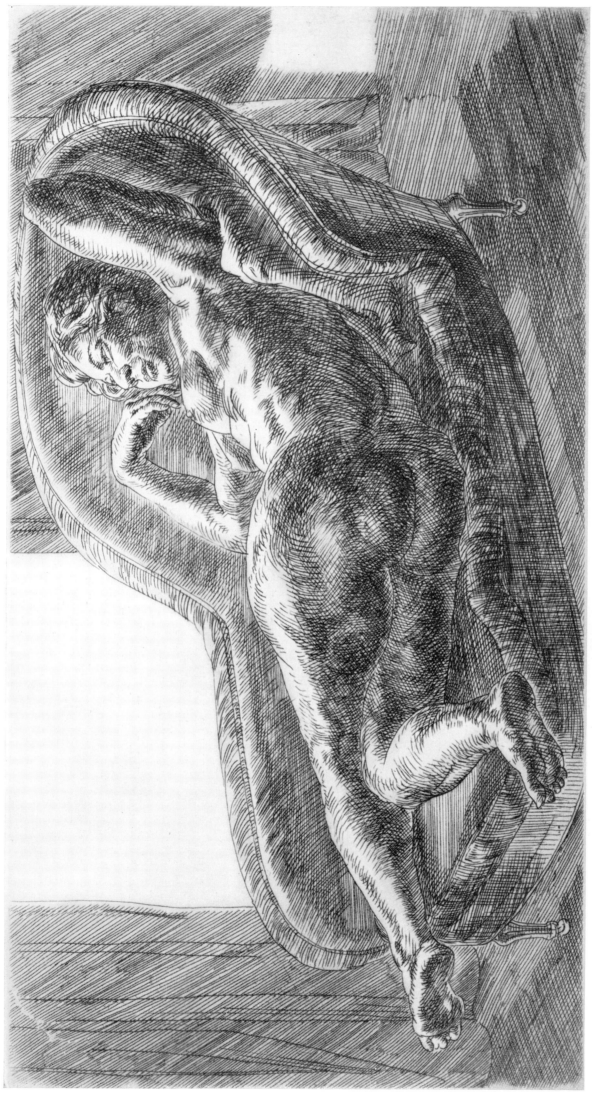

273. NUDE ON CHAISE LONGUE BY WINDOW
1933. In plate. Between October and December 1933. JS records.
Etching and engraving. 153 x 290 mm. (6 x 11½ inches) plate.
States:

1. Nearly complete. White pupil in left eye. Ph.
2. Dark pupil in left eye. Additional shading on both arms, both legs, face, chaise longue above figure, lower right cor-

ner, and elsewhere. Published state.
Edition: 100. Printing: 30. Platt 10, Roth 20.
Plate exists: JST. Copper.
No tissue.

"I had intended to go on with this plate; however, experience tells me that further work does not always mean improvement" (JS 1945).

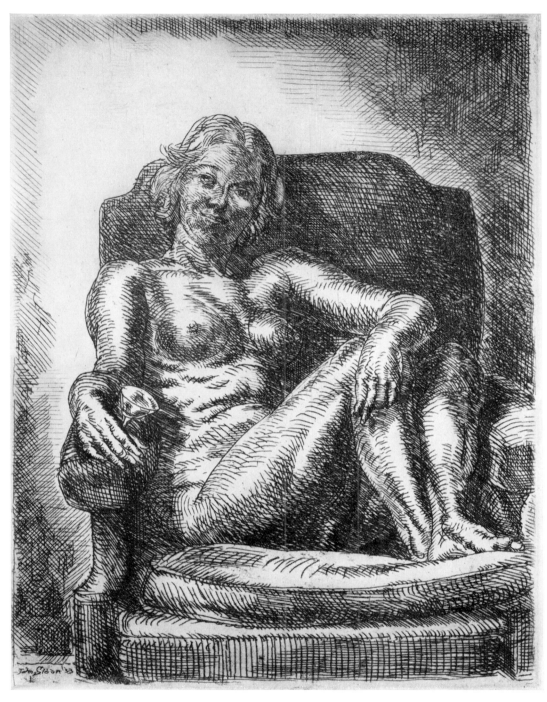

published state

274. NUDE WITH WINEGLASS

1933. In plate. Between October and December 1933. JS records.
Etching. 177 x 139 mm. (7 x 5½ inches) plate.
States:
 1. Nearly complete. Face dark. Ph.
 2. Highlights burnished on face under left eye, beside right
 eye, and on the right side of the forehead. Hair extended
 further out from the left side of the head. Additional shad-
 ing at the upper left side of the picture. Published state.
Edition: 100. Printing: 35. Platt 10, Roth 25.

Plate exists: JS⊐. Copper.
No tissue.

"This will become a rare state as soon as I get around to clear-
ing up the face, which is at present inconsistent. This might well
have been painted" (JS 1945). Sloan's comment was made after
the printing of 10 impressions by Platt (in the 2nd state) and be-
fore the printing of 25 by Roth, which was done in 1950. There
is no visible state difference between the two nor on the plate.
Evidently, he did no further work on it.

305

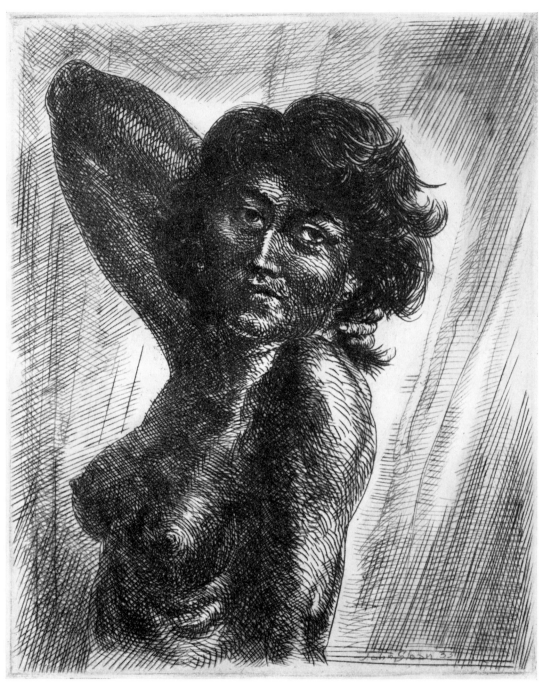

published state

275. BRUNETTE HEAD AND SHOULDERS

1933. In plate. Probably December 1933. JS records.
Alternative title: *Nude with Arm Raised.*
Etching and engraving. 178 x 140 mm. (7 x 5½ inches) plate.
States:

1. Nearly finished. Highlight on center and top of left breast. Ph, JST, Bowdoin (with pencil).
2. Highlight shaded on left breast. Hatching and burnishing on left arm, producing a highlight at shoulder, dark in the center of upper arm, another highlight lower. Ph ("working proof").

3. Highlight burnished to the lower right of right eye. Both pupils darkened. Long engraved diagonal shading added in background at lower right, upper right, and lower left. Published state.

Edition: 100. Printing: 75. White 50, Roth 25.
Plate exists: JST. Copper.
No tissue.

"A color-sculptural result is achieved here which is all too infrequently found in etchings" (Dart 97). This is the same model portrayed in *Nude and Breakfast Tray* (263).

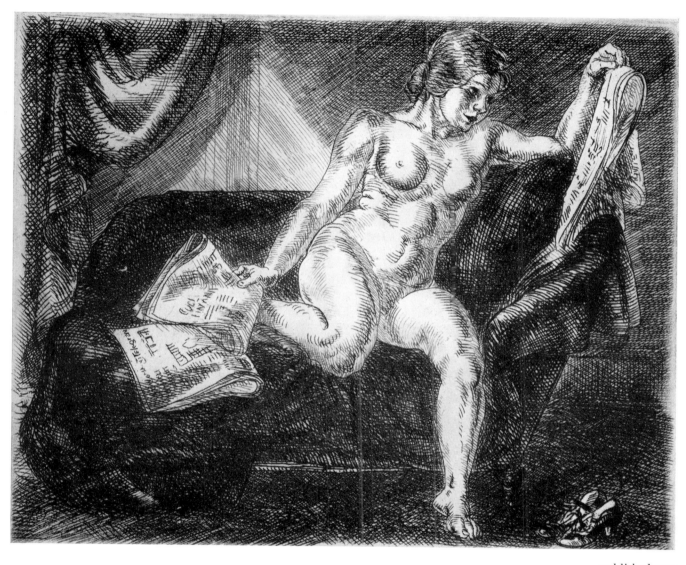

published state

276. NUDE AND NEWSPAPERS

1933. In plate. Probably December 1933. JS records.
Etching. 140 x 178 mm. (5½ x 7 inches) plate.
States:

1. Lightly drawn. Newspaper at lower left almost unshaded. Ph ("only proof").
2. Horizontal shading added across upper U-shaped folds of curtain at top left. Additional shading on couch to left and below model and on arm of couch below newspaper at right. Still with a generally light appearance. Ph–2, JST–3.
3. Curved shading added on curtain fold at upper left. Additional shading on newspapers in and below woman's right hand. Much darker shading on couch, giving a strong chiaroscuro. Published state.

Edition: 100. Printing: 45. White 20, Roth 25.

Plate exists: JST. Copper.
No tissue.

"Strong in drawing and striking black and white relation-ships. Real and not realistic; has carrying power that may some-times be desirable in a print. Going further in color-texture had perhaps been my intention, but it is just as well that I left the plate when I did. Perhaps before long the public will begin to realize that nudes are not necessarily cheaply realistic, sentimen-tal, or even sensuous, as Thomas Craven seems to demand" (JS 1945). Sloan's reference is to Craven's *Modern Art* (New York, 1934, pp. 327–28). "Titles are always a problem. If I think of a good title, maybe it's a reason to paint" (JS 1945). "Nude subjects have so often been treated sensually, sentimentally—or cheaply realistic—that the American public hesitates to show any inter-est in a more sincere approach" (JS 1945).

only state, reduced

277. COSTUME BALL POSTER

1933. The occasion advertised was planned for December 15, 1933.

Linoleum cut. 483 x 305 mm. (19 x 12 inches) entire design.
Only state. Ph, JST–5, WSFA, SI. Printed in reddish brown ink on cream heavy wove paper, showing every sign of hand-printing from a hand-carved block.
No edition. Printing unknown.
Block unknown.
Probably no tissue.

"The Artists and Writers Dinner Club [is] an organization on the model of the Actors Dinner Club, which will provide meals for artists and writers who have difficulty in providing for themselves. . . . The club was the idea of John Sloan, president of the Society of Independent Artists" (*New York Times,* April 2, 1933, p. 22).

"The Artists and Writers Dinner Club . . . has given approximately seven thousand meals since last April. . . . Announcement was made by John Sloan, painter and etcher, president of the Society of Independent Artists and treasurer of the Artists and Writers Dinner Club, that a costume ball would be given at Webster Hall on December 15 to raise funds" (*New York Times,* Oct. 21, 1933, p. 17). Heywood Broun, incidentally, was in Washington, D.C., on December 15 (*New York Times,* Dec. 16, 1933, p. 15).

A photomechanical relief linecut reproduction of this poster is known, measuring 278 x 175 mm. (11 x 7 inches), printed in black ink on white paper (JST). The reproduction has a printed "J.S." below the wolf's left forearm. The original has none, but is usually signed in pencil by the artist in the same place.

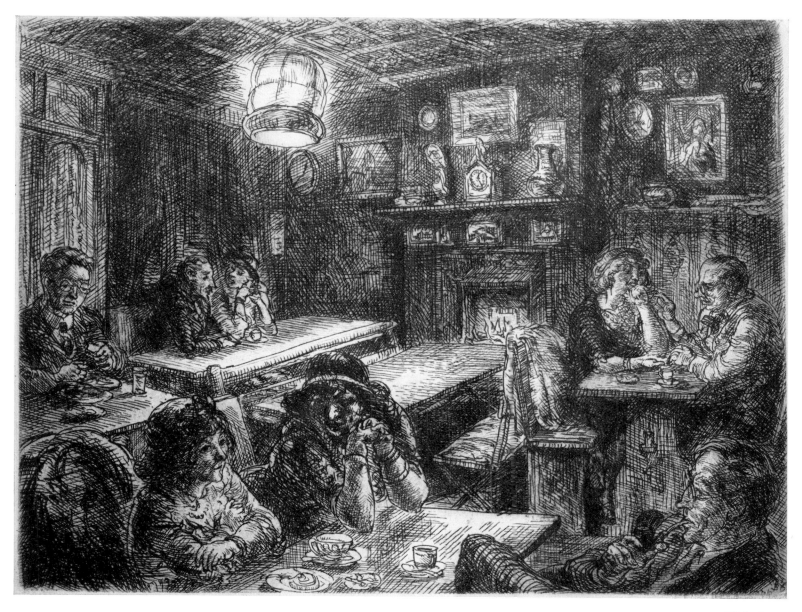

278. ROMANY MARYE IN CHRISTOPHER STREET, 1922

1936. Proof of 4th state dated January 1936. Ph. Sent to exhibition at Art Students League on January 7, 1936. JS records.
Etching. 152 x 205 mm. (6 x 8 inches) plate.
States:

1. Design generally finished. Dolly Sloan, at lower left, is in full profile. Ph, JST–3 (inscribed as 1st state), Bowdoin (inscribed "100 proofs").
2. Dolly now in three-quarter front view, with nose extending beyond face line, eyes looking across at Sloan in the lower right corner. There is a single vertical line in the center of her upper lip. Left eye and mouth of Romany Marye, at lower center, are strengthened. Sloan's face burnished lighter. More shading on the couple in the right rear. Ph, JST–4.
3. Dolly's nose redrawn, inside face line. Ph (inscribed as 2nd state).
4. Both of Dolly's eyes are darkened, now looking more toward the front, to the near side of Sloan. Two vertical lines on her upper lip. Ph, JST–2 (inscribed as 5th state).
5. Strong vertical shading added under left eye of Romany Marye. Ph, JST (inscribed as 3rd state).
6. Added diagonal shading on Romany Marye's right cheek, and short vertical strokes to the left of her left eye. Ph, JST (inscribed as 4th state).

7. Face line of man at extreme left is redrawn inside glasses frame, instead of outside. Published state.

Edition: 100. Printing: 52. White 52.
Plate exists: JST. Copper, steel-faced.
Tissue: Ph. The tissue was drawn in 1922, but only used for an etching in 1936.

"All Greenwich Villagers know Romany Marye, who has acted the part of hostess, philosopher, and friend in her series of quiet little restaurants for the past thirty-five years. The etching shows her chatting in her deep comfortable voice to Dolly and myself" (Dart 101). "Romany Marie's was one of the famous places [in the 1920s]. She was a Rumanian, I think a Rumanian Jew, very dark, and she used to read tea leaves" (Holger Cahill notes, Columbia University, New York, N.Y., April 1957, p. 59).

"Romany Marye was important as one of the first real 'tea room' hostesses. It would be wrong to call her places tea rooms, but she only sold liquor in the last few years and then under pressure from a partner. She could attract a lot of artists and writers with her hospitality, kindness, and humor. Dolly Sloan spent a lot of time there, but I never went in for tea table conversations" (JS 1950, p. 254).

The hostess' name was evidently written "Marie." Sloan's spelling seems to be a personal idiosyncracy, though he used it consistently.

279. DOLLY 1936

1936. Proof of 4th state dated January 20, 1936. Ph.
Etching and engraving. 152 x 204 mm. (6 x 8 inches) plate.
States:

1. Frowning expression. Dark shading immediately under both eyes and in both eye sockets next to nose. Deep dark arcs of shading on both cheeks. Ph–2 (one with pencil, one inscribed "1st state").

2. Inner part of both eyebrows, next to nose, removed with burnishing, especially lightening the left eye socket. Ph fragment (inscribed "1a").

3. Light horizontal shading added on top dress strap between the button and the crossing of the straps. Highlight burnished on left cheek next to the nose, extending down to the mouth. Ph (complete proof), JST–2 (fragments).

4. Additional diagonal shading on forehead above nose, inside both eye sockets, and on left side of chin. Much additional shading on chair and pillow. Ph (inscribed "2nd state / Jan. 20, 1936 / Hotel Chelsea, N.Y.").

5. Additional shading between nose and left corner of mouth. Circular highlight burnished on left cheek. Right cheek lightened between right hand and eye. Ph, JST. Both proofs are inscribed "4th state." The Ph proof is in addition inscribed "Last / Jan. 26 / 36." HFS believes an edition of 10 to 20 was pulled in this state. If so, these may be proofs printed by Sloan himself, or they may conceivably be the first printing noted in the JS records: 25 proofs printed by White in February 1937. It seems more likely, however, that the White proofs are represented by the 10th state below.

6. Drypoint sketch of right thumb in a new position more widely spread from the fingers. Old thumb still visible. Burnishing on right side of right eye and in a large area on left cheek. The eyes are now pale instead of black. Slight additional diagonal shading on right forearm across lengthwise highlight. Ph, JST–6 (all fragments with pen and pencil additions).

7. Old thumb removed. Additional shading on left cheek between nose and mouth. Ph (fragment).

8. Right arm redrawn except for the outline. Now with a large arc at the point of the elbow, instead of the previous small arc. The thumb is completely etched in the new position, spread wide on the shoulder. Added shading in the middle of the forehead and on the left arm. Cross-hatching added across both strap buttons. Horizontal shading added across "NEW" of newspaper heading. Longer highlight burnished on chair back to the right of the head, now extending from the left shoulder to the top of the picture. Left arm burnished much lighter. Ph.

9. Additional shading on right arm and completely encircling left arm. Ph, JST (both inscribed "working proof 3rd state").

10. Areas beneath left eye and on left side of chin are burnished lighter. Added light shading on left side of chin. Ph–2, JST, LC, Bowdoin. A number of these proofs are inscribed "25 proofs this state." There are also proofs in this state inscribed "100 proofs," of which I have counted at least thirteen. This state very probably represents the White printing of February 1937.

11. Speckling of small dots added on right elbow, arm, and hand, also on neck, forehead, cheeks, and left hand and arm. Left forearm and upper arm burnished much lighter. Published state. This work was probably done after the 1937 printing. It represents the subsequent printings by Roth in 1945, 1948, and 1951, and the present state of the plate.

Edition: 100. Printing: 70. White 25 (probably 10th state), Roth 45 (11th state).
Plate exists: JST. Copper.
Tissue: Ph.

"On account of the graphic experiment going on in this etching, it is best viewed from a distance of about three feet, as perspective is deliberately reversed" (Dart 102). "Perhaps a little too experimental" (JS 1945).

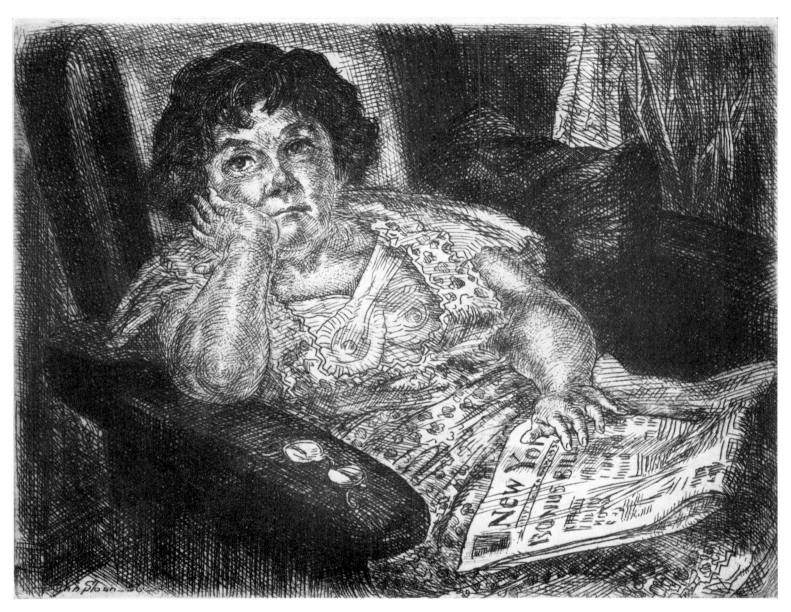

eleventh state

During July, August, and September of 1937, Sloan made sixteen etchings (and one rejected variant) illustrating W. Somerset Maugham's novel *Of Human Bondage*. The commission was given to Sloan in April 1937 by George Macy, director of the Limited Editions Club of New York. This club is devoted to producing fine illustrated editions of well-known books.

"August and much of September I devoted to working on the plates for the second volume of *Human Bondage,* and two or three of those plates gave me a lot of trouble. I don't know now whether I am through with them, but I'm going to let them 'ride' until I get home. . . . I really have enjoyed my struggles with the etchings" (JS letter to Don Freeman, dated Oct. 28, 1937, by internal evidence; SI). Sloan's appointment calendar for 1937 clearly indicates that he did not leave for Santa Fe that year until August. Since one known proof is dated July 29, 1937, he must have begun the etchings in New York.

Of Human Bondage was issued in a two-volume set, in an edition of 1,500 copies. Each of the two volumes contains eight original etchings by Sloan. The printing of all the etchings was done by Charles Furth of New York, who did not work for Sloan on any other occasion. As the plates were all steel-faced, no wear is noticeable. The prints are in black ink on a putty-white rag paper made by the Worthy Paper Co. especially for this edition. A caption from the text of the book is printed from type on each sheet along with the etching. A special artist's edition of 25 was also printed by White for Sloan's own use, apparently subsequent to the printing for the books, using a heavy cream wove paper with a mesh pattern and a five-point star watermark, and without captions. The prints of the artist's edition were each signed by Sloan. The book prints were not signed, but the colophon at the end of the second volume of each set was. Generally speaking, the impressions in the books are better than those of the artist's edition.

The catalogue information is given under each print separately. They are all 6 x 4 inches in size, printed from steel-faced copper plates, which are now in JST, except the rejected subject. Four of the tissues and two sketches are in Ph. The rest of the tissues have not been located.

The books were designed by Carl Purington Rollins of Yale University and were printed at the Yale University Press, New Haven, Conn. George Macy discusses the edition at some length in *The Monthly Letter of the Limited Editions Club* (no. 105, Feb. 1938). The books were published early in 1938.

Macy gave Sloan this commission because he knew and admired the De Kock etchings from 35 years before. Sloan had already read *Of Human Bondage* more than once and was delighted to undertake the job. His payment was $1,500. In addition, the Club paid $1,680 to Furth for the printing of the etchings—in other words, seven cents apiece for 24,000 impressions.

Sloan did not make separate comments on these prints (with one exception). His general remarks on the series are as follows:

Of Human Bondage is a great and strong novel, and I welcomed the opportunity of making sixteen etchings for the Limited Editions Club. I dare not hope that the illustrations I made reach the perfection of Somerset Maugham's masterpiece. Of course people form their own ideas of characters in books. I had never been to London, so I went to the picture department of the New York Public Library, where the staff worked for me just like employees of mine. I also went to see Bette Davis in the movie. She did a good job of acting, but it was no good to me for background. Leslie Howard disappointed me; he didn't even have the limping right. I read the book three times, first noting every place I felt was pictorial. I could have made sixty etchings. Then I had to sift them through, so they would be spaced pretty well. I suppose the plates lack sweetness, delicacy, and charm, but they have to some degree those qualities of strength that the novel has. (JS 1945).

George Macy commented (*Monthly Letter,* p. 2): "Some of these we consider to be among the finest illustrations we have ever had in our books. . . . Some of the etchings we do not like so much; but we gathered from Mr. Sloan's reaction, when we said as much, that *these* are the etchings which *he* likes *best.*" (They are not named.)

Also of considerable interest in judging the success of these etchings as illustration is the author's view. Sloan sent a set of proofs to Maugham, who replied:

> Ritz-Carlton Hotel
> New York
> Jan. 19 [1938]
>
> Dear Mr. Sloan
>
> Thank you very much. I arrived here today and found your etchings and I cannot tell you how delighted I am to have them; the more because I have just moved into a tiny house in Carolina and they will be a grand decoration to my empty walls.
>
> I am not qualified to speak of them as etchings for that is an art of which I am lamentably ignorant, but as the author of the book which occasioned them I think I may venture to say that they are very good illustrations, very imaginative and of an ingenious invention. To my mind you have caught wonderfully the tang of the period. They do what surely good illustration should do, excite the reader's interest and make him eager to know more about the people whose image the artist has shown him.
>
> Yours very gratefully
> W. Somerset Maugham*

*Quoted in full with the kind permission of Spencer Curtis Brown. The original letter is in JST.

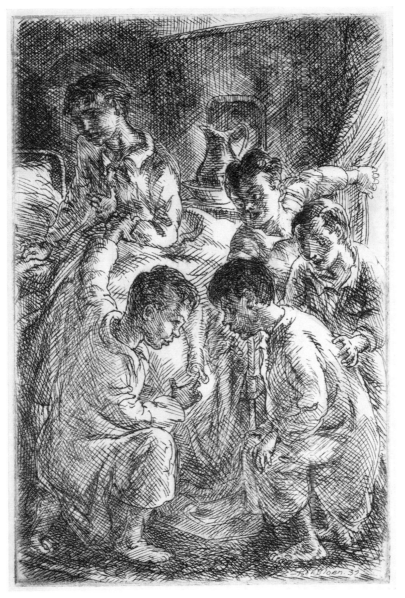

published state

280. OF HUMAN BONDAGE, CHAPTER 11
1937. In plate.
Vol. 1, facing p. 50.
Caption: "Philip put out his foot."
Alternative title: *Philip and Schoolmates.*
Etching. 152 x 101 mm. (6 x 4 inches) plate.
Only state. Published state.
Edition: 1,500. Printing: 1,525. Furth 1,500, White 25.
Plate exists: JST. Copper, steel-faced.
Tissue unknown.

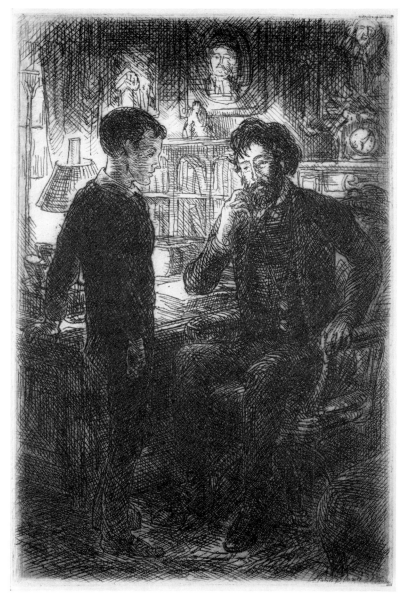

published state

281. OF HUMAN BONDAGE, CHAPTER 21
1937. In plate.
Vol. 1, facing p. 110.
Caption: ". . . he went to Mr. Perkins to bid him good-bye."
Alternative title: *Philip and Mr. Perkins.*
Etching. 152 x 101 mm. (6 x 4 inches) plate.
Only state. Published state.
Edition: 1,500. Printing: 1,525. Furth 1,500, White 25.
Plate exists: JST. Copper, steel-faced.
Tissue unknown. Sketch in Ph.

Published state

282. OF HUMAN BONDAGE, CHAPTER 29
1937. In plate.
Vol. 1, facing p. 152.
Caption: "Philip in . . . the little street near the old bridge."
Alternative title: *Philip and Streetwalkers.*
Etching. 152 x 101 mm. (6 x 4 inches) plate.
States:

1. Right eye and mouth of woman at front right are lightly drawn. Ph, JST (inscribed "2—last"). No earlier state is presently known, and this is clearly not the last state of the plate. Sloan's inscriptions on all the trial proofs of this set are rather cryptic.
2. Woman's right eye and mouth both darkened. Published state.

Edition: 1,500. Printing: 1,525. Furth 1,500, White 25.
Plate exists: JST. Copper, steel-faced.
Tissue unknown.

published state

283. OF HUMAN BONDAGE, CHAPTER 34
1937. In plate.
Vol. 1, facing p. 188.
Caption: ". . . she had never seemed so unattractive; but it was too late now."
Alternative title: *Philip and Miss Wilkinson.*
Etching. 152 x 101 mm. (6 x 4 inches) plate.
Only state. Published state.
Edition: 1,500. Printing: 1,525. Furth 1,500, White 25.
Plate exists: JST. Copper, steel-faced.
Tissue unknown.

284. OF HUMAN BONDAGE, CHAPTER 43

1937. In plate.

Vol. 1, facing p. 252.

Caption: "Foinet criticises."

Alternative title: *The Art Teacher*.

Etching. 152 x 101 mm. (6 x 4 inches) plate.

Only state. Published state.

Edition: 1,500. Printing: 1,525. Furth 1,500, White 25.

Plate exists: JST. Copper, steel-faced.

Tissue and one sketch: Ph.

"Sloan said he used memories of John Butler Yeats' descriptions of the Slade School—where he had studied along with Samuel Butler—when visualizing this studio" (HFS 1966)

published state

285. OF HUMAN BONDAGE, CHAPTER 47
1937. In plate.
Vol. 1, facing p. 286.
Caption: "She took the leg of mutton and held it high above
her . . ."
Alternative title: *The Artists' Party*.
Etching. 152 x 101 mm. (6 x 4 inches) plate.
Only state. Published state.
Edition: 1,500. Printing: 1,525. Furth 1,500, White 25.
Plate exists: JST. Copper, steel-faced.
Tissue: Ph.

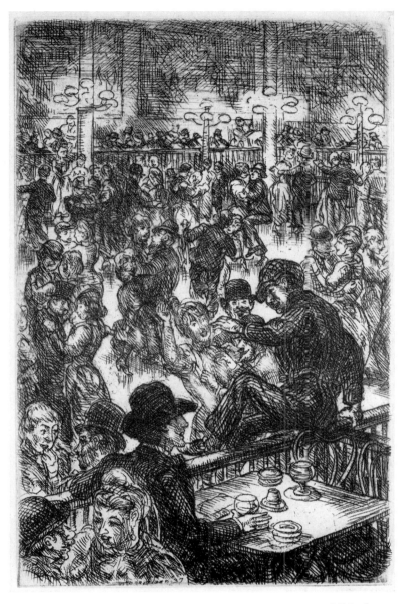

published state

286. OF HUMAN BONDAGE, CHAPTER 49
1937. Trial proof dated July 29, 1937. JST.
Vol. 1, frontispiece, facing title page.
Caption: "Flanagan . . . with a wild shout leaped over the barrier . . ."
Alternative title: *Philip and Flanagan.*
Etching. 152 x 101 mm. (6 x 4 inches) plate.
Only state. Published state. A proof in JST is inscribed "July 29/37—last." Early states may therefore exist.
Edition: 1,500. Printing: 1,525. Furth 1,500, White 25.
Plate exists: JST. Copper, steel-faced.
Tissue unknown.

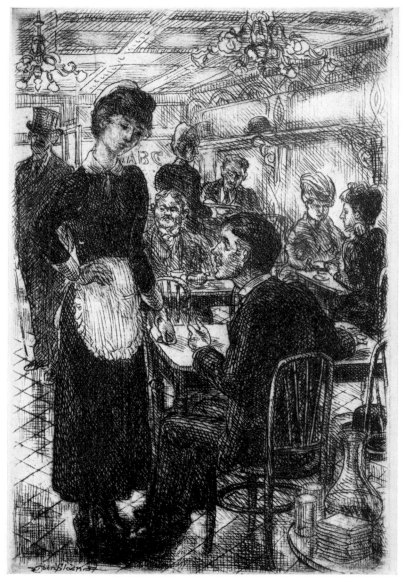

only state

287. OF HUMAN BONDAGE, CHAPTER 56
 (rejected variant)

1937. In plate.

Etching. 151 x 98 mm. (6 x 4 inches) platemark.

Only state. Ph.

No edition. Printing unknown. The only known proof is inscribed by HFS, "one of two proofs known."

Plate unknown, presumably destroyed by Sloan.

Tissue unknown, probably the same as used for the published version.

 This print is, in reverse, so close in detail to the published print that they must surely both come from the same tissue. It is interesting to note, however, that Sloan has correctly drawn Philip's clubfoot on the left side in both cases.

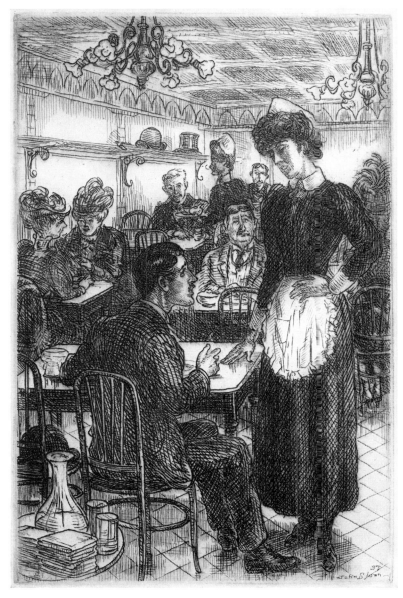

published state

288. OF HUMAN BONDAGE, CHAPTER 56

1937. In plate.

Vol. 1, facing p. 354.

Caption: " 'I didn't know you could draw,' she said."

Alternative title: *Philip and Mildred in the Restaurant.*

Etching. 152 x 101 mm. (6 x 4 inches) plate.

States:

 1. Nearly complete. Heavy shading on right side of man's face
 in foreground. Ph, JST. (Inscribed "2—not last.")

 2. Shading on face is burnished much lighter. Published state.

Edition: 1,500. Printing: 1,525. Furth 1,500, White 25.

Plate exists: JST. Copper, steel-faced.

Tissue unknown, also probably used for the preceding print.

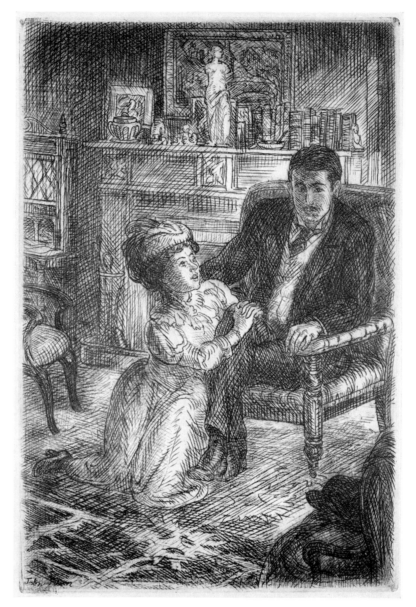

published state

289. OF HUMAN BONDAGE, CHAPTER 71
1937. In plate.
Vol. 2, facing p. 452.
Caption: "She let herself down on the floor by his side and clasped his knees."
Alternative title: *Philip and Norah*.
Etching. 152 x 101 mm. (6 x 4 inches) plate.
States:
 1. Nearly complete. Front of man's coat and vest shaded completely dark. Ph (inscribed "2—not last").
 2. Vest burnished white with slight additional shading. White lines of pattern burnished on rug in foreground. Published state.
Edition: 1,500. Printing: 1,525. Furth 1,500, White 25.
Plate exists: JST. Copper, steel-faced.
Tissue unknown.

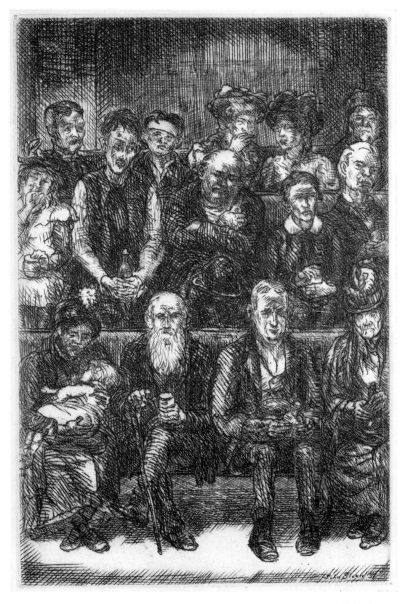

published state

290. OF HUMAN BONDAGE, CHAPTER 81
1937. In plate.
Vol. 2, frontispiece.
Caption: ". . . a large, dark waiting-room . . . Here the patients
waited . . ."
Alternative titles: *Out-patients Waiting; The Clinic.*
Etching. 152 x 101 mm. (6 x 4 inches) plate.
Only state. Published state.
Edition: 1,500. Printing: 1,525. Furth 1,500. White 25.
Plate exists: JST. Copper, steel-faced.
Tissue: Ph.
 "This is one of the most interesting to me" (JS 1945).

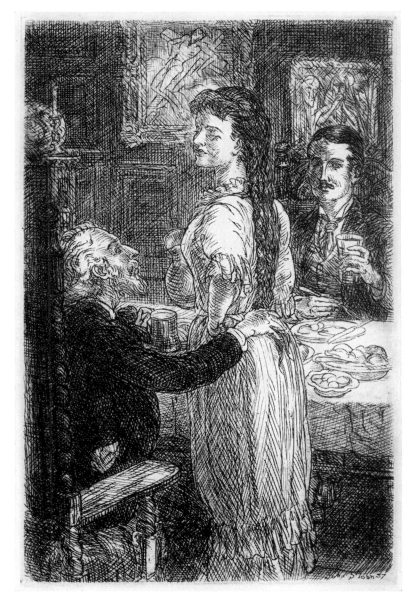

published state

291. OF HUMAN BONDAGE, CHAPTER 87

1937. In plate.

Vol. 2, facing p. 564.

Caption: ". . . Sally came in with the beer, and . . . her father . . . put his hand round her waist."

Alternative title: *Athelny and Sally*.

Etching. 152 x 101 mm. (6 x 4 inches) plate.

States:

1. Nearly complete. Heavy shading on girl's chin and lower lip. Ph.

2. Heavy shading removed from girl's chin and lower lip, with slight additional shading on chin. Ph, JST–2.

3. Painting of crucifixion at top center burnished much lighter. Three light vertical lines of shading across white area of handkerchief in the father's pocket. Published state.

Edition: 1,500. Printing: 1,525. Furth 1,500, White 25.

Plate exists: JST. Copper, steel-faced.

Tissue unknown.

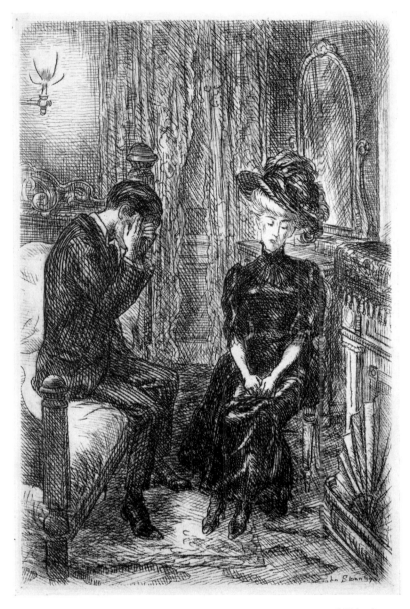

published state

292. OF HUMAN BONDAGE, CHAPTER 90
1937. In plate.
Vol. 2, facing p. 584.
Caption: " 'My God, it is awful,' he groaned."
Alternative title: *Philip and Mildred in Bedroom.*
Etching. 152 x 101 mm. (6 x 4 inches) plate.
States:
 1. Nearly complete. Wall behind lamp at upper left is relatively dark. Ph (inscribed "2—not last").
 2. Strong highlight burnished around lamp at upper left. A few additional vertical lines on right side of mirror. Published state.
Edition: 1,500. Printing: 1,525. Furth 1,500, White 25.
Plate exists: JST. Copper, steel-faced.
Tissue unknown.

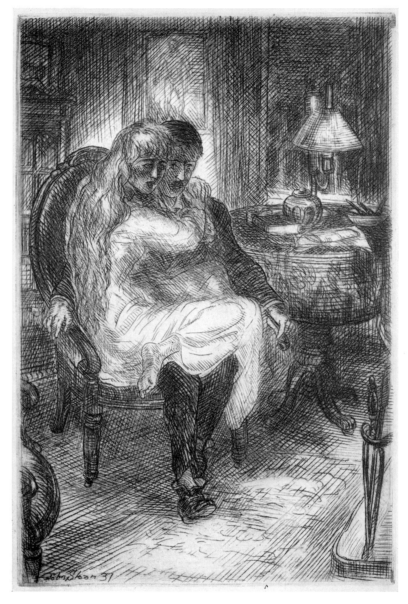

published state

293. OF HUMAN BONDAGE, CHAPTER 96
1937. In plate.
Vol. 2, facing p. 630.
Caption: " 'Why are you so horrid to me, Phil?' "
Alternative title: *Philip and Mildred in Chair*.
Etching. 152 x 101 mm. (6 x 4 inches) plate.
Only state. Published state.
Edition: 1,500. Printing: 1,525. Furth 1,500, White, 25.
Plate exists: JST. Copper, steel-faced.
Tissue unknown.

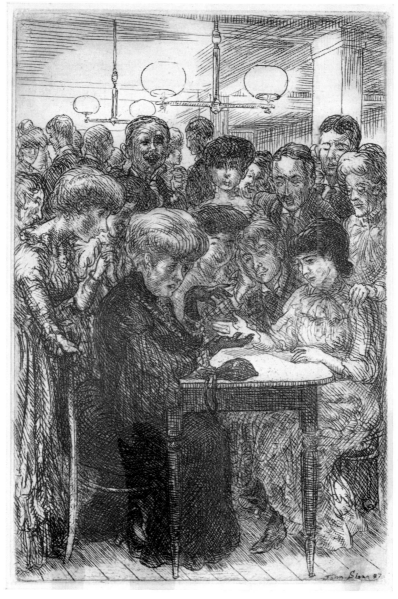

published state

294. OF HUMAN BONDAGE, CHAPTER 104
1937. In plate. Proof of 4th state dated September 30. Ph.
Vol. 2, facing p. 678.
Caption: "... she talked mysteriously of fair and dark men ..."
Alternative title: *The Fortune-Teller.*
Etching. 152 x 101 mm. (6 x 4 inches) plate.
States:

1. Woman at front center is shown in profile. Ph.
2. Center woman now facing three-quarters front. Faces of woman standing at left front, of man seated at right center, and woman seated at right, all burnished lighter. Ph, JST.
3. Hair of man seated at right center is darkened with shading at front and side. Hair and face of woman standing at left are very much darkened. Ph.
4. Top of hair and face of woman standing at left are con-siderably lightened with burnishing. Added shading on face and hair of man standing at left center. Face and neck of woman standing at right center, burnished lighter. Additional light shading on all faces in far rear. Face of woman standing at extreme right, lightened. Face of woman seated at right, lightened with burnishing, removing the jawline. Her dress below the waist burnished much lighter. Shading completely removed from floor at bottom. Ph.
5. Face of woman seated at right, burnished lighter. Light jawline added. Ph (inscribed "not last").
6. Diagonal shading added on floor under figures, not in the foreground. Published state.

Edition: 1,500. Printing: 1,525. Furth 1,500, White 25.
Plate exists: JST. Copper, steel-faced.
Tissue unknown.

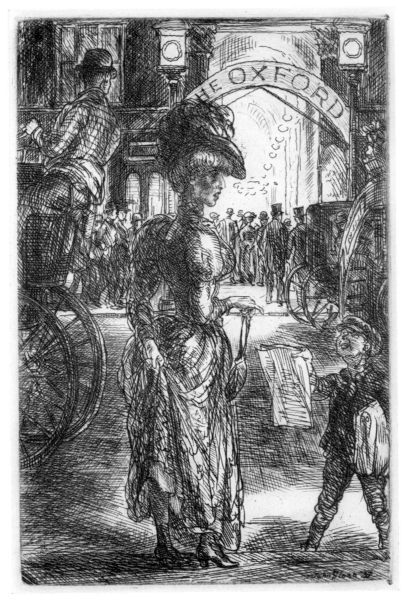

published state

295. OF HUMAN BONDAGE, CHAPTER 109
1937. In plate.
Vol. 2, facing p. 718.
Caption: ". . . at the corner of Oxford Street she . . . crossed over
to a music-hall."
Alternative title: *Mildred in Oxford Street*.
Etching. 152 x 101 mm. (6 x 4 inches) plate.
States:
1. Nearly complete. Woman has small tight mouth, no shad-
ing under it. Ph.
2. Mouth enlarged. Shading added under mouth, on cheek,
and on right hand. Published state.
Edition: 1,500. Printing: 1,525. Furth 1,500, White 25.
Plate exists: JST. Copper, steel-faced.
Tissue: Ph.

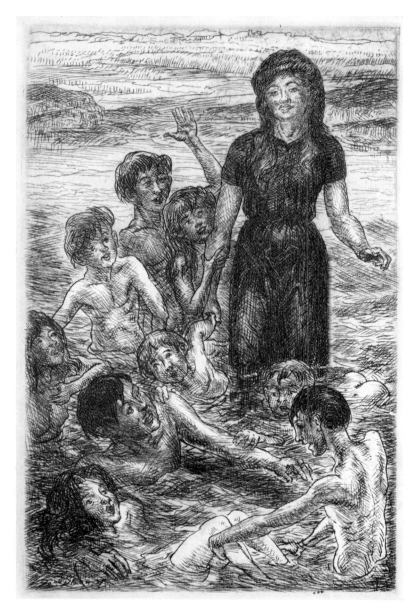

296. OF HUMAN BONDAGE, CHAPTER 118

1937. In plate. Proof of 1st state dated September 30. Ph.

Vol. 2, facing p. 778.

Caption: "The bathe was uproarious . . ."

Alternative title: *Sally, Kids, and Philip Bathing.*

Etching. 152 x 101 mm. (6 x 4 inches) plate.

States:

1. Woman's face is dark and unsmiling. Ph (inscribed "Sep 30" and "3" in a circle).
2. Wave at upper center is shaded on both sides of boy's upraised hand. Ph, JST (inscribed '3' in a circle).
3. Woman's face burnished much lighter. Mouth changed to a smile. Light shading added on left side of face and neck. Published state.

Edition: 1,500. Printing: 1,525. Furth 1,500, White 25.

Plate exists: JST. Copper, steel-faced.

Tissue unknown.

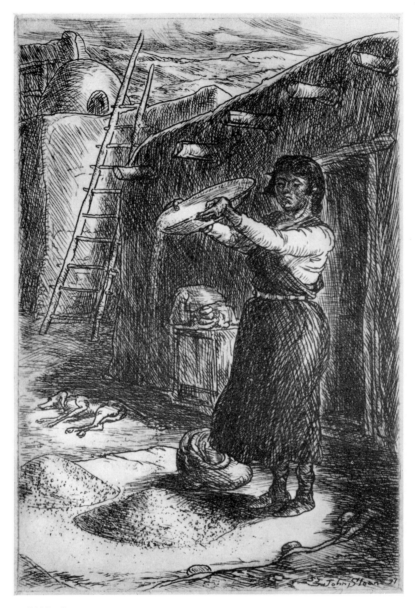

published state

297. WINNOWING WHEAT
1937. Proof of 1st state dated October 13, 1937. JST.
Etching. 152 x 101 mm. (6 x 4 inches) plate.
States:
1. Lightly drawn. Sky blank. Ph, JST–2.
2. Mountains and clouds added in the blank sky area. Much additional shading on the ground and on both buildings. Ph, JST–3.
3. Added diagonal shading on the building in the upper left corner. Published state.

Edition: 100. Printing: 74. White 49, Roth 25.
Plate exists: JST. Copper, steel-faced.
Tissue: Ph.

"A primitive process still to be seen in the Indian villages of the New World" (Dart 104).

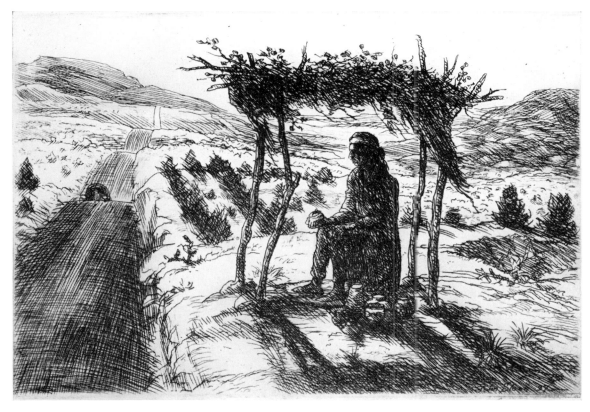

published state

298. BETTER MOUSE TRAPS?

1937. Proof of 1st state dated October 21, 1937. JST.
Etching. 101 x 152 mm. (4 x 6 inches) plate.
States:

1. Nearly complete. Road in left foreground is relatively light. Ph, JST–4.
2. Added horizontal shading on road at left, across the highlight in the foreground. Published state.

Edition: 100. Printing: 75. White 50, Roth 25.
Plate exists: JST. Copper, steel-faced.
Tissue: Ph.

"Someone had written: 'If a man excel in anything, even if it only be in making better mouse traps, the world will make a path to his door' " (Dart 103).

"The world has certainly made a path close by the Indian artist's door, but since the world passes at a rate from 60 to 80 miles an hour, patronage is scarce" (JS 1945).

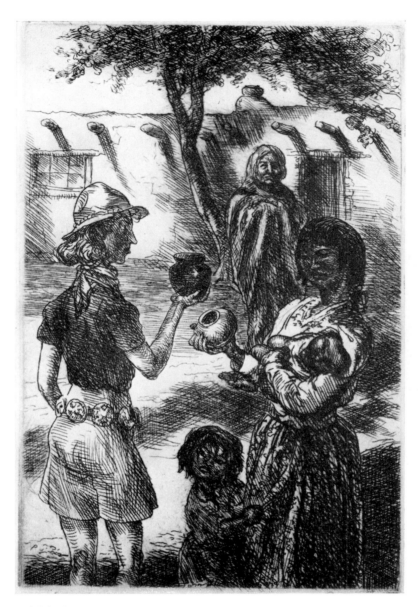

published state

299. BLACK POT

1937. Proofs of 2nd state dated October 21, 1937. Ph, JST.
Etching. 152 x 102 mm. (6 x 4 inches) plate.
States:

1. Nearly finished. Face of Indian man in background is dark.
 Ph, JST.
2. Indian man's face redrawn, much ligher. Highlights bur-
 nished on his blanket. Added shading on ground on both
 sides of tourist woman's neck, on left leg of her shorts, and
 on baby's face. Published state. The dated trial proofs in
 this state, in Ph and JST, show no visible state difference
 from the published prints.

Edition: 100. Printing: 75. White 50, Roth 25.
Plate exists: JST. Copper, steel-faced.
Tissue: Ph.

"The potter's art bridges the gulf between two civilizations"
(JS 1945).

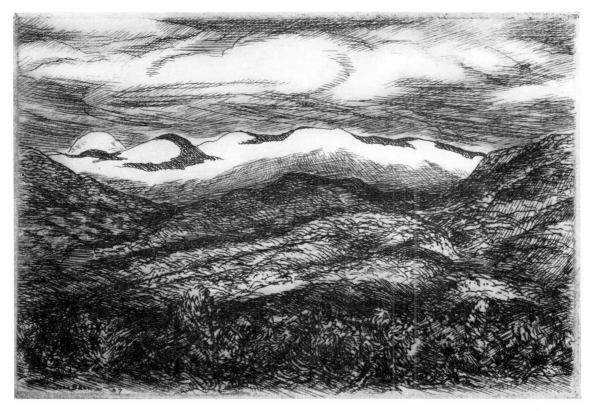

published state

300. SNOW ON THE RANGE

1937. Proof of 1st state dated October 24, 1937. JST.

Etching. 101 x 152 mm. (4 x 6 inches) plate.

States:

1. Nearly complete. Horizontal lines of shading only, in and above the clouds. Ph, JST–3.
2. Diagonal hatching added in the sky. Ph, JST.
3. Highlight burnished at the top, near the right corner. Light diagonal shading added across the same area. Published state.

Edition: 100. Printing: 53. White 53.

Plate exists: JST. Copper, steel-faced.

Tissue: Ph.

 "Early in October the Sangre de Cristo Range [near Santa Fe] wears its first blanket of snow" (JS 1945).

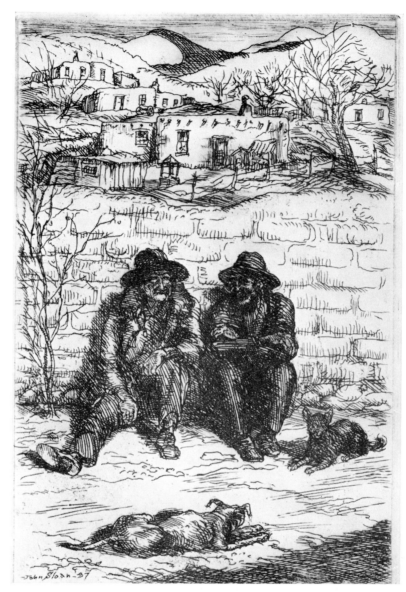

only state

301. HOMBRES IN THE SUN
1937. Proofs dated October 24, 1937. Ph, JST.
Etching. 152 x 102 mm. (6 x 4 inches) plate.
Only state. Published state. There are two proofs, Ph and JST,
inscribed "first state" by Sloan. There is no visible difference be-
tween these and the published prints. Either Sloan decided to do
no further work on the plate, after pulling and inscribing these
proofs, or else the changes are so slight as to be indistinguishable
from variations in inking and printing.
Edition: 100. Printing: 75. White 50, Roth 25.
Plate exists: JST. Copper, steel-faced.
Tissue: Ph.
 "Santa Fe Winter: warm in the sun, cold in the shade" (Dart
105).

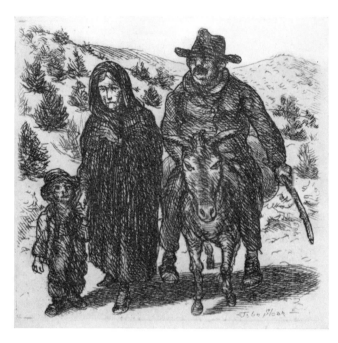

only state

302. SANTA FE FAMILY

1937. JS records. First sent to the printer in November 1937, at the same time as these other five Santa Fe plates (297–301).

Etching. 81 x 82 mm. (3¼ x 3¼ inches) plate.

Only state. Published state.

Edition: 100. Printing: 75. White 25, Roth 50.

Plate exists: JST. Copper, steel-faced.

Tissue: Ph. The tissue has spots of wax at each corner beyond what would be the edge of the plate.

 "A burro carries the male; the señora and child proceed on foot. Christmas card for Cyrus McCormick" (JS 1945). JS's financial records, January 1938, show a payment of $100 from McCormick for an unknown number of proofs.

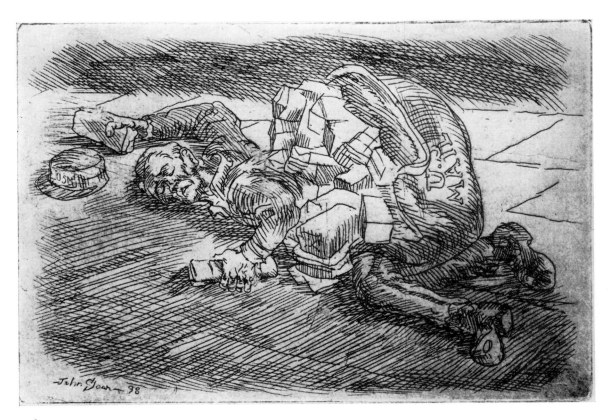

only state

303. THEIR APPOINTED ROUNDS
 (rejected variant)
1938. In plate.
Etching. 101 x 156 mm. (4 x 6 inches) plate.
Only state. Ph, WSFA, SI.
No edition. Printing 3. Harris 3. No early impressions are
known.
Plate exists: JST. Copper.
Tissue unknown. The same tissue was very probably also used
for the following print, the published version.

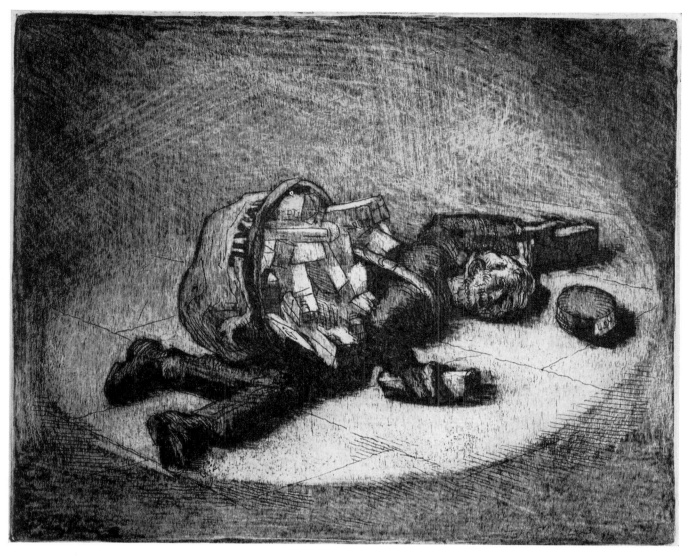

304. THEIR APPOINTED ROUNDS

1938. In plate. Probably November or December (see below).
Alternative title: *Postman*.

Etching and mezzotint. 140 x 178 mm. (5½ x 7 inches) plate.
States:
1. Nearly complete. Without signature and date at lower left. Ph.
2. Signature and date added at lower left. Front of cap burnished lighter. The partly erased signature at lower right remains throughout. Published state.

Edition: 100. Sloan originally intended to limit this print to an edition of 50, and the 50 proofs printed by White in 1938 are all inscribed "50 proofs." In 1951 Sloan either forgot about his earlier edition limit or decided to raise it to 100. In any case, he had 25 additional proofs printed by Roth, all of which are inscribed "100 proofs." Despite the earlier inscription, therefore, the edition must now be taken as 100. Printing: 75. White 50 (December 1938), Roth 25.
Plate exists: JST. Copper, steel-faced.

Tissue unknown. The same tissue was presumably also used for the preceding print, the rejected version. The two correspond very closely, in reverse.

"A mezzotint practically. It was a discarded plate that I ground down on a carborundum wheel. Then I etched the drawing, took the wax off, and burnished down the surface to make the lights. The highest whites were the most highly polished. I never would know the plate was mine" (JS 1945). The subject, an overladen postman, probably pertains to Christmas time. Used as a Christmas greeting.

The discarded plate was possibly originally a nude subject of 1931–33. The plate is the same size as many of these. The partially erased signature at the lower right appears in all known proofs and was undoubtedly part of the eradicated image.

Sloan is referring to the following well-known quotation from Herodotus, freely translated, which is inscribed on the 8th Avenue facade of the General Post Office in New York City: "Neither snow nor rain nor heat nor gloom of night stays these couriers from the swift completion of their appointed rounds."

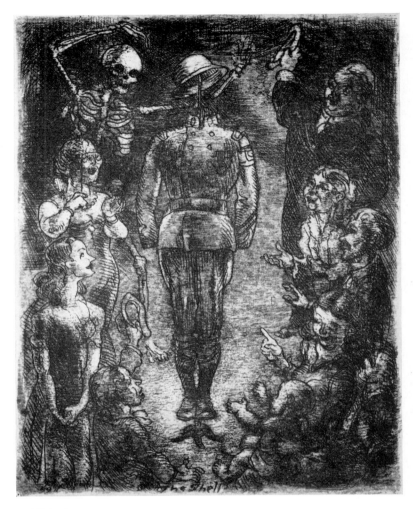

published state

305. THE SHELL OF HELL!

1939. Proofs of the 1st state dated January 1939. Ph, JST.
Etching and mezzotint. 127 x 101 mm. (5 x 4 inches) plate.
States:
1. Nearly complete. Ph, JST–3.
2. Vertical hatching added across the background at top. Published state.
Edition: 100. Printing: 45. Roth 45. The first commercial printing was not until July 1945.
Plate exists: JST. Copper.
Tissue: Ph.

"Etching and mezzotint. This plate, made in January 1939, is an expression of the idea that uniforms are one of the basic devices of militarism. The world began to go to war a few months later" (JS 1945).

HFS points out that the basic idea represented here came to Sloan first from one of Angna Enters' compositions. "My *A Modern Totalitarian Hero* is a gas-masked, strutting and preening figure in a fantastically overdecorated uniform" (Angna Enters, *Artist's Life,* New York, 1958, p. 156). Sloan wrote her on December 20, 1937, "The bitterness of the Dictator picture was splendid" (quoted by Miss Enters, ibid., p. 158).

Although the print was reproduced in *Gist of Art* (p. 333) in September 1939, Sloan was reluctant to publish it until after the war, in 1945. This is also probably done on a discarded and ground-off plate.

338

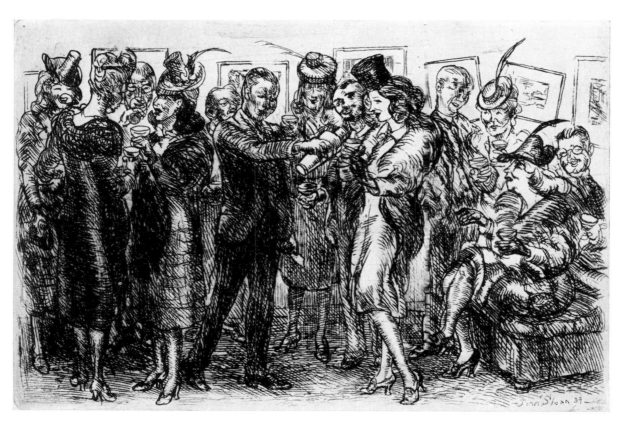

third state

306. A THIRST FOR ART

1939. In plate. Sent to printer in March 1939. JS records.
Etching. 100 x 153 mm. (4 x 6 inches) plate.
States:

1. Nearly complete. Coat, hair, and fur piece are dark on woman with fox wrap, fourth person from left. Ph (with pen, pencil, and erasures).

2. Vertical highlight burnished on coat of woman second from the left, extending from center of back to hem. Feather added on hat of woman seated second from right. Ph, JST–2.

3. Strong horizontal shading added in center of back of woman second from left. Additional shading on beard of man above cocktail shaker, making a solid black goatee. First published state (inscribed "100 proofs").

4. Hair of woman fourth from left burnished from brunette to blonde. Her fur piece and dress burnished lighter. Additional vertical shading on the bottom front of her skirt. Second published state (without edition inscription). An edition of 100 in this state was donated for the benefit of the Society of Independent Artists, of which Sloan was President.

Edition: 200. 100 in 3rd state, 100 in 4th state. Printing: 110 in 3rd state by White; 100 in 4th state by White.
Plate exists: JST. Thin zinc plate.
Tissue and one sketch: Ph.

"One of those exhibition opening cocktail parties. Enthusiasm resulting from the lifting of Prohibition prevails over interest in art" (Dart 106). "They don't see the pictures at all, knocking them crooked on the wall with their shoulders" (JS 1945).

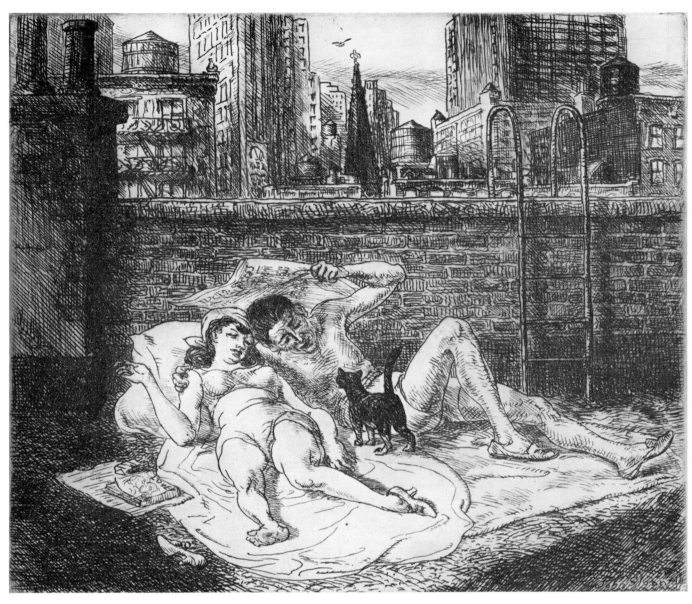

only state

307. SUNBATHERS ON THE ROOF

1941. Dated September 6–15, 1941, in JS appointment calendar. JST (see below).
Etching. 149 x 176 mm. (6 x 7 inches) platemark.
Only state. Published state.
Edition: 175, of which 125 were provided on commission to the American College Society of Print Collectors, and 50 reserved for Sloan. There is no inscription of edition limit on any known impression. Printing: 175. White 175.
Plate unknown. The plate is probably in existence, canceled, but its present location is unknown. It was commissioned in 1941 by the late Dr. Marques E. Reitzel of San Jose (California) State College for distribution by the American College Society of Print Collectors. Dr. Reitzel apparently single-handedly managed the affairs of the Society, which ceased operation in 1942. The canceled plate appears to have been sent to Dr. Reitzel as part of the contract. It is not in JST. There is a possibility that Sloan, as a lark, had the copper plate gold-plated before sending it. There is a $4.40 payment to Charles White for gold-plating, dated November 14, 1941, for which there is no other likely explanation. Mrs. Marques Reitzel has been most helpful in trying to find the plate, but the records and effects of the Society seem to have disappeared. Judging from its size, the plate may be an old wedding invitation, like others made by Sloan in Santa Fe. Tissue: Ph.

"Twenty years during which my summers were spent in Santa Fe lessened my opportunities of studying New York life at its best in the summer. This etching, done many years after most of my New York plates, is, I think, of equal merit" (Dart 107). "From an incident seen in New York" (JS 1945).

"In the spring as the rays grow warmer, the tenement roofs in New York begin to come to life. More washes are hung out—gay colored underthings flap in the breezes, and on Saturdays and Sundays girls and men in bathing togs stretch themselves on newspapers, blankets or sheets in the sun, turning over at intervals like hotcakes. I think that many of them are acquiring a coat of tan in preparation for coming trips to Coney Island. The roof life of the Metropolis is so interesting to me that I am almost reluctant to leave in June for my summer in Santa Fe" (written by Sloan in 1941 and published in the pamphlet which accompanied the etching as it was sent out to members of the College Society of Print Collectors; copy in SI).

"Reitzel agreed J.S. to make plate for College Print Soc." (JS appointment calendar, Sept. 6, 1941; JST). "Sent plate Sunbathers to C. S. White air mail" (ibid., Sept. 15, 1941). Sloan was paid $900 for the commission.

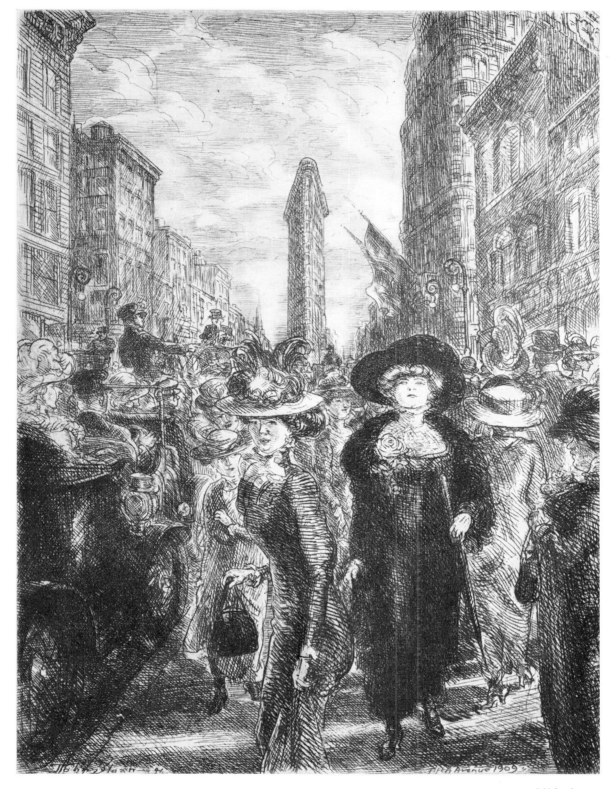

published state

308. FIFTH AVENUE 1909

1941. In plate. Done after no. 307 (see below). First sent to printer in November 1941. JS records.

Etching. 203 x 154 mm. (8 x 6 inches) plate.

States:

1. Nearly complete. Woman at front center has blond hair. Ph.
2. Front woman's hair darkened. Horizontal shading added on right arm of woman next to the car at left. Shading added on sidewalk at lower right and lower left. Ph.
3. Entire sky burnished lighter. Left side of face of woman at right center, burnished lighter. Ph.
4. Chin line of right center woman made much stronger. Ph.
5. Dresses burnished much lighter on front center woman and woman at left next to car. Ph (with pencil).
6. Dresses of both women darkened with new shading. Highlight burnished on hat of front center woman. Additional shading on back of woman second from right edge, on two buildings at right, and on near side of building at left. Streak of light on pavement in foreground burnished to extend completely across the picture. Published state.

Edition: 100. Printing: 45. White 45.

Plate exists: JST. Copper, steel-faced.

Tissue and red chalked transfer paper: Ph. Copied from the photograph in *Gist* (p. 221) of the painting *Fifth Avenue,* of

1909, now in the collection of Mrs. John F. Kraushaar, New York.

"The worst print I ever made. It was done the same summer as the 'Sunbathers.' I copied it from a photograph in *Gist of Art* of the 1909 painting, *Fifth Avenue*. The print is too imitative of tones. I sent it to the Artists for Victory show, where it won the $500 first prize [of which he gave $100 to his dealer as commission]. The first Sloan to win first prize, because it is one of the worst I ever did" (JS 1945). Sloan's comment which appeared with the print in the Renaissance Society show was more restrained. "My most recent etching and my most honored, a prize winner in fact. I hardly think the plate deserves this distinction, but prizes have always been the least of my worries" (JS 1945).

Sloan's comment on the painting: "An impression of the Avenue walking south from Thirty-fifth Street. Perhaps nobody but I will recognize the old Waldorf on the right but the Flatiron Building at Twenty-third Street will be clear to anybody. I have been told that the lady in black with the rose was undoubtedly Katharine Clemens Gould" (*Gist*, p. 221).

"I was out in Santa Fe and had made an etching, a good one, the *Sunbathers*. I thought I would do another. Since I used a reproduction of one of my old paintings to work from, instead of a few notes on the back of an envelope, it became more and more an imitation of the tones and tints of the painting. My dealer sent it to an exhibition, Artists for Victory. I got a five hundred dollar award for the best etching in the exhibition. I was embarrassed. It was nothing but an award for living to be the dean of American artists. They can give me prizes now because it keeps the young folks from quarrelling" (Feb. 15, 1945, Moody Lecture, University of Chicago, Chicago, Ill., p. 6; JST).

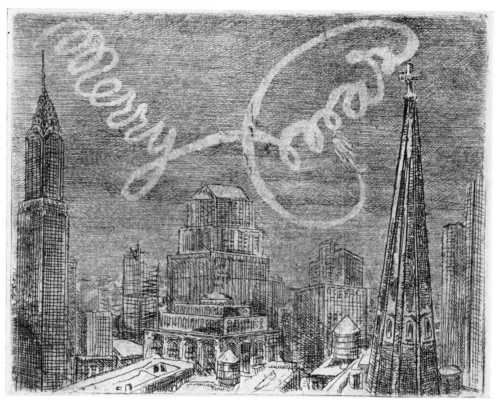

only state

309. MERRY CHRISTMAS

1941. Estimate (see below).
Etching. 100 x 126 mm. (4 x 5 inches) plate.
Only state. Ph, WSFA, SI.
No edition. Printing: Harris 3. No early proofs known.
Plate exists: JST. Copper.
Tissue unknown.

The Chrysler Building dates the plate after 1929 when that building was completed. HFS comments about this print (1966): "Probably made in Santa Fe in 1941. The church steeple is the same as that in the center background of *Sunbathers on the Roof*. As Sloan had just recovered from a serious gall bladder operation and pneumonia, he might have felt like making a Christmas message etching this year. 'But,' he remarked while looking at the plate, 'it was so delicately bitten that I did not bother to go on with it.' I don't remember that Sloan told me the date of its making, but this suggestion of 1941 seems reasonable. The linework is thin, as in the *Fifth Avenue 1909* plate." The print was not sent out as a Christmas card.

only state

310. HOLD UP ON FOURTEENTH STREET
(rejected variant)

1949. Dated June 27, 1949, in JS diary.

Etching. 181 x 133 mm. (7 x 5¼ inches) plate.

Only state. Ph–2, JST, WSFA, SI.

No edition. Printing unknown, but very small. The 5 known proofs are by Sloan and Shuster 2, Harris 3.

Plate exists: JST. Copper.

Two tissues: Ph. Both used for tracing, one with ocher on the verso.

"Cleveland Ohio Museum asked me to make an etching for their 250 print collectors. As they want a large plate and the sketches of the plate (I am to have ten proofs), I do not think that $500 could be enough for the job" (JS diary, unpublished, Santa Fe, June 12, 1949; all following comments are from the same source, same year). "Tried a few sketches in preparation for an etching, but didn't please myself. When it comes to a subject, I am more than a little rusty" (June 19). "I am trying to make a preliminary sketch for an etching" (June 25). "I am working on the preliminary sketch for an etching" (June 27). "I worked on the tracing of my sketch and now have it in red on the plate grounded" (June 28).

"Worked a while on the etching and find myself quite out of the swing of it. My fingers and the needle do not seem to harmonize. I have only made two plates in about fifteen years!" (June 29). "Worked on the plate during the rest of the day and made every mistake a beginner at etching might run into. But the time passes very pleasantly on the whole" (June 30). "Worked on the plate today" (July 1). "I worked on the plate a couple of hours" (July 2). "Worked on the etching. Perhaps it may turn out passably" (July 3).

"This morning a visit from W. Shuster. He says he will be glad to make proofs of my plate on his new motor driven plate press, a device of his own for speedier printing. I worked on the re-grounded (second time) plate for some hours" (July 4). "I took my etched plate to W. Shuster's and saw his wonderful plate printing press, his own contrivance with a motor drive. It is really wonderful and quite efficient. The plate proved to be quite as bad as I had thought it would be" (July 5). The plate was abandoned at this point. Sloan started a new one (312) on July 18, 1949.

Lloyd Goodrich has pointed out to me that this subject derives from a drawing Sloan did for *Harper's Weekly* (59, Aug. 29, 1914, inside front cover), entitled *The Spirit of the West— Coney Island.*

311. ADAM AND EVE

1949. Dated July 16, 1949, in JS diary.

Alternative title: *Etching Test Plate*.

Etching. 183 x 151 mm. (7¼ x 6 inches) plate.

Only state. Ph–2, JST, WSFA, SI.

No edition. Printing unknown, but very small. The 5 known proofs were printed by Sloan and Shuster 2, Harris 3

Plate exists: JST. Copper.

No tissue.

"I worked on an old copper plate, once a wedding invitation, attempting to recall some of my small technical ability of fifteen years ago. I was able to lay a more perfect ground, and did control biting a bit better. But my hand seemed stiff at the needlework" (JS diary, Santa Fe, July 16, 1949).

312. HOLD UP ON FOURTEENTH STREET
1949. Dated July 18, 1949, in JS diary.
Etching. 177 x 152 mm. (7 x 6 inches) plate.
States:

1. Nearly complete. Ph, JST–2 (all inscribed "4th state").

2. Highlight burnished between photographer's left hand and head. Light shading added behind right hand and arm of woman at left. Lower lip of left woman strengthened. Ph, JST (inscribed "2nd state").

3. Light vertical lines added in burnished area to left of photographer's head. Mouth of center man now smiling, showing teeth. Slight additional shading on right shoe of center man. Published state. (Proofs in Ph and JST inscribed "3rd state" show no visible difference from the published prints.)

Edition: 100. Printing: 42. Shuster 17, Roth 25. Shuster's proofs have a blind-stamped "WS" monogram in the lower margin.
Plate exists: JST. Copper, steel-faced, verso of old wedding invitation plate.
Tissue and three sketches: Ph. Some of these sketches may have been done before the first version of this subject(310).

"Later in the day I started a new attempt at etching a new plate. Same subject as the last failure" (JS diary, Santa Fe, July 18, 1949; all following comments are from the same source). "I worked on the new etching, and find the little store room a bit stuffy in spite of a fan going" (July 19). "I worked on the copper plate again today and toward evening removed the first ground and was disappointed again. I may go on with it tomorrow" (July 20). "I kept myself aloof, working on the etching in my small store room" (July 21). "I bought a pound of nitric acid. Working on my plate" (July 22). "I went on working on my etching" (July 23). "Worked on the plate in the early part of the day" (July 24).

"I go to Shuster's and prove my etching plate. Mrs. Shuster phoned [later] that Shus couldn't print plate right" (July 27). "I drove out to Will Shuster's, and he made proofs of my etched plate. I am not too pleased with it; maybe I can improve it" (July 30).

"I hid in my little etching room and did some work on the plate. Scraping, burnishing, hammering up to level" (Aug. 11). "To W. Shuster's studio, where he made two proofs of my etched plate, which looks rather better now" (Aug. 12). "Worked on the plate this morning and think I now need another proof" (Aug. 14). "We drove to town and W. Shuster's studio, where he proved *The Hold Up on the Limited*" (Aug. 29).

"I mailed a proof of the etching made here, *The Hold Up on Fourteenth Street*. (Scene in a little photo *gallery* with a false rear of California Limited and group of four, two girls, two fellows. One with a wooden horse holding a pistol 'Hands Up.') Helen wrote to Cleveland Art Museum offering it in response to her request that I make a plate for their Print Club" (Sept. 9). The Secretary of the Print Club (not officially connected with the Museum) wrote back on September 20, 1949: "The members

of the Publications Committee met yesterday and I regret to say rejected this print. They felt the subject was mainly of local interest and would not be intelligible outside of New York" (JST).

Sloan had trouble with Shuster's printing of this plate and *Wake on the Ferry* (313). Shuster made a total of 28 prints from the plate, of which Sloan found only 17 to be satisfactory. The rejected 11 were returned to Shuster, who was asked to destroy them.

published state

313. THE WAKE ON THE FERRY

1949. Dated August 21, 1949, in JS diary.
Etching. 126 x 178 mm. (5 x 7 inches) plate.
States:
1. Nearly complete. Ph.
2. Horizontal lines of rain added at center, continuing up to
 roof line. Ph, JST–2.
3. Dark diagonals of rain above bridge tower, burnished
 lighter. Ph, JST–2.
4. Cheek outline of man kneeling at lower right is redrawn,
 making face thinner, now without shading on right cheek.
 Published state.
Edition: 350, of which 200 were for the Art Students League,
New York, and 150 for Sloan's own use. Quite a number of the
prints are inscribed "200 proofs," others "250 proofs." Printing:
350. Shuster 100, Roth 250. Shuster's proofs have a blind-stamped
"WS" monogram in the lower margin, and are on Fabriano
paper. Roth's are on Rives paper.
Plate exists: JST. Copper, steel-faced.
Tissue: Ph.

"Charles W. K., Jr., [Kraushaar] advises us *against* using one
of my present plates in a special printing of 200 etchings for sale
to the League members at $5.00 each. I to get $200.00 for use of
plate. Helen and I think that he is right and that I should make
a new plate for the purpose. I think it will interest me to see how

rusty I am after five years inactivity in the medium. Klonis [Di-
rector of the Art Students League] proposed this last night" (JS
diary, New York, March 9, 1949; the following comments are
from the same source, same year, unless otherwise noted). "In
the evening I looked over some old sketches hoping to find a sub-
ject for the etching I am to make for the A.S. League. Some of
these sketch notes as far back as 1908–1913 make me regret that
I have not done this sort of thing for years" (March 11). "Klonis
phoned, and I told him I would make an etching for the A.S.
League. I have time, as they won't publish the plate until fall"
(March 16).

"Letter from Cleveland in re my making an etching for their
print club. Answering, they suggest that I make a lithograph of
one of my old paintings, *The Wake of the Ferry*. [There are two
paintings of this title, one in Detroit and one in the Philips
Gallery, Washington, D.C.; illustrated in *Gist*, pp. 209, 211.] I
won't do it. But that gives me an idea for a humorous plate, The
Wake *on* the Ferry (Drunken Irish 'Wake')" (Santa Fe, July 15).
The letter from the Secretary of the Print Club to HFS, dated
July 13, 1949, had praised several of Sloan's early New York
etchings and went on: "Would he care to repeat any of these
subjects or do something similar in the lithographic medium?
Would he be interested in making a print similar to some of his
paintings, such as the glorious *Wake of the Ferry?*" (JST). Sloan

was furious, but clearly not to the point of losing his sense of humor.

"I worked on a new plate, having made the drawing on tissue. The idea is, I think, amusing. A hearse and merry-making mourners on the front of a ferry boat. The title: *A Wake on the Ferry*. (I have made two paintings with title *Wake of the Ferry*)" (Aug. 21). "I worked on the new plate. Just needlework so far" (Aug. 22). "After lunch I worked on the plate" (Aug. 23). "Worked on the etching in the morning. Back to the etching in the afternoon. The plate looks pretty well" (Aug. 24). "This morning worked on the *Wake* plate" (Aug. 26). "I had worked a couple of hours during the afternoon on my plate, which is ready to prove" (Aug. 27).

"We drove to town and W. Shuster's studio, where he proved both of my plates, *The Hold Up on the Limited* first, and *The Wake on the Ferry*, the new one, which will need more work" (Aug. 29). "Worked a while on *The Wake on the Ferry* etching and called Shuster arranging for a proof. He proved my *Ferry* plate for me. It looks better but needs attention" (Sept. 19). "I went to Shuster's, and he made me two proofs of the *Wake* plate" (Sept. 21). "I took my two plates to W. Shuster's studio and told him to make me 25 proofs of each. He says he will be happy to print them. Later after receiving a letter from V. Porter, assistant to Klonis, Manager of the Art Students League, ordering 200 proofs of *The Wake on the Ferry* plate, I phoned Shuster and increased the order on that plate to 225 proofs" (Sept. 26).

Shuster had some difficulties with the printing. "During the afternoon W. Shuster brought the *Ferry* plate and proofs. He is still having trouble getting clarity in lights. He laid a very good ground for rebiting and we gave it some necessary nips" (Oct. 5). Sloan returned to New York shortly after this entry. The problems with Shuster's printing are enumerated at some length in Sloan's diary. His letters and telegrams to his friend Shuster are quite bitter on the subject. In the end, of the 225 proofs made by Shuster, Sloan approved and kept 100, returning the rest to Shuster to be destroyed.

In November he gave the plate to Roth, who printed 100 satisfactory proofs. (The other 150 Roth proofs were printed in 1950.) "Helen delivered 200 prints of *Wake on the Ferry* to Vernon Porter at the Art Students League, where they were pleased. The League agrees that the *Wake* plate belongs to me, and that I can print any that I want from it" (Nov. 18). "Ernest Roth delivered some prints from my plates today. By some misunderstanding he has printed another 100 proofs of *Wake on the Ferry*. Helen phoned him and said we would accept them, making 350 proofs!" (Jan. 3, 1950).

Posters

Sloan probably did more than 150 poster designs in his lifetime, few of which appear to have survived. Almost all those listed here are from Sloan's own very incomplete files.

All but three were produced by strictly commercial processes. The three exceptions were carved by Sloan on linoleum blocks, entirely his own work. They are therefore listed in the section of this catalogue devoted to original prints (194, 201, 277). The remainder are presented here for the benefit of collectors and because of the light they shed on certain aspects of Sloan's art not emphasized in his prints, particularly his "poster style" of the 1890s.

His series of posters for the Bradley Coal Co. appears to have been his earliest work in this medium. Each poster included Sloan's own verse in praise of Bradley's coal. Many of these and subsequent posters of the period were in a modified *art nouveau* idiom, inspired in part by the Japanese newspaper artist Beisen Kubota (see p. 383). "The Japanese style has made a hit," Sloan wrote Henri on July 30, 1894 (JST). A later notice said, "Will H. Bradley and John Sloan were the first artists in this country to use the Japanese or 'Poster' style in black and white work in 1894" (Newspaper Artists' Association *Catalogue,* New York, April 1903, p. 39). Many of Sloan's newspaper feature-illustrations as early as 1892 (linecuts, some in color) are also in this style.*

In addition to the Bradley Coal posters, Sloan very probably did considerable poster work for the Philadelphia *Press* and perhaps other newspapers. Also known are posters advertising magazines, stage performances, commercial products, Socialist meetings, and art exhibitions. Others in these categories may be discovered, and all known clues to such work are given here. Also included are a reproduction of a drawing (Q) which Sloan sometimes signed like a print, and a linoleum-cut poster of 1921 (T), done in cooperation with another artist. It is hoped that the publication of these twenty poster designs may stimulate the search for others.

*Only one of the illustrations of Sloan's work in Percival Pollard's *Posters in Miniature* (New York, 1896) is an actual poster.

only state, reduced

A. STERN WINTER: Bradley Coal Poster
1894. Estimate.
Relief linecut, photomechanical, black ink on white card. 215 x
142 mm. (8½ x 5½ inches) picture.
Only state. SI. (JS catalogue no. 2260.)
Accompanying verse:

> Onward she comes chilling our homes
> Stern winter with frost and snow
> But she has no control
> Over those who buy coal
> From the Walter T. Bradley Co.

This is the only known surviving actual poster of the long
series Sloan did for the Bradley Coal Co. It is a torn half of a
poster card (of good quality) which must have originally meas-
ured about 11 x 18 inches, designed for streetcar display. Sloan's
poetry is handwritten on the card. The remaining fragments of
the text show that some of the lettering was printed in red, some
in black. The picture is signed in the plate. This poster came
from Sloan's own file.

only state, reduced

B. MINER POET: Bradley Coal Poster
1894. Estimate.
Relief linecut, photomechanical, black ink. 95 x 21 mm. (3¾ x ¾ inches) picture.
Only state. SI (proof impression in black on white paper).
Accompanying verse:

> Bradley's Coal, the people know it.
> It has merits all its own.
> I'm its humble miner poet—
> Yours sincerely, Johnny Sloan.

The single known proof, from Sloan's files, seems a bit small for a poster. Sloan sent it to Mr. Bradley for Christmas, along with one of his better verses. It is signed in the plate.

drawing

C. BURNING BADLY: Bradley Coal Poster
1895. Estimate.
Relief linecut, photomechanical. 216 x 123 mm. (8½ x 5 inches) picture.
Only state. JST (proof impression in black on white paper).
The original drawing, unsigned, measures 307 x 174 mm. (12 x 7 inches). SI (JS catalogue no. 521). Sloan told HFS that this drawing was for Bradley Coal and supplied its accompanying verse:

How has your coal bin been?
Have fires been burning badly?
Oh, few will better fuel have
If you will buy of Bradley.

The difference in size clearly indicates the use of photo-mechanical means of reproduction.

from a reproduction

D. THREE WITCHES: Bradley Coal Poster

1895. Estimate. Design published July 25, 1895.

Relief linecut, photomechanical. Size unknown. Illustration made from a reproduction measuring 123 x 85 mm. (5 x 3½ inches). The original was probably larger.

Only state. Reproduced in *Moods* (2, July 25, 1895, n.p.).

The poetry for this design may have been that given under the *Burning Badly* Bradley poster (C). No separate verse is known. Sloan identified this illustration to HFS as being a Bradley Coal design.

354

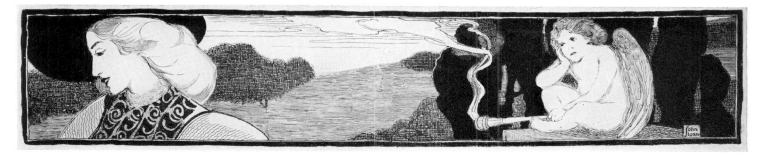

E. CUPID TAKE HEED: Bradley Coal Poster
1895. Estimate.
Relief linecut, photomechanical. 450 x 82 mm. (7½ x 3¼
inches) picture.
Only state. JST (proof impression in black ink on white paper).
Sketch drawing with verse (JST):

> Cupid take heed, you shall succeed
> And fire with love her soul;
> If torch of flame has lost the game,
> Why not try Bradley's Coal.

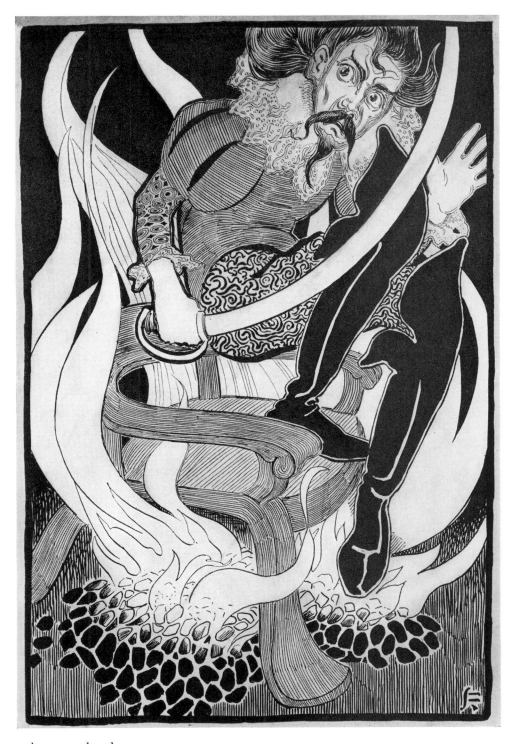

only state, reduced

F. PIRATE ON COALS: Bradley Coal Poster
1895. Estimate.
Relief linecut, photomechanical. 226 x 150 mm. (9 x 6 inches)
picture.
Only state. JST (proof impression in black on white paper).
No verse is known. Identified by JS as Bradley Coal design.

OTHER BRADLEY COAL POSTERS

In a letter to Robert Henri on February 14, 1900, Sloan wrote, "And my Bradley Coal verses—think of a poet who can stick without wavering to one small theme like 'coal' for ten consecutive years" (JST). This would place the first Bradley Coal poster in 1890. Since he did one a month (for $5 each plus free coal; JS records) for more than ten years, there must have been well over 120 different subjects. Of all these, just 6 have been found. Sloan was still doing them after his move to New York in 1904 (at $7.50 each; JS records, Dec. 1903) and considered taking them up again as late as 1909 (*NYS*, pp. 279, 281).

The Bradley Coal Co. had a long life. A listing for "Walter T. Bradley, coal, 987 North 9th Street" first appears in the 1888 Philadelphia business directory. The company continued well beyond the death of its founder, being in operation until 1944. None of its records can be found, nor does the Philadelphia Transportation Co. have any record of the posters used in its streetcars.

Sloan, in later years, recalled a few other Bradley verses. One, of which no actual proof is known, consisted of a totally black rectangle, with the following poetry:

> The view on the right
> Which is quite out of sight
> Represents a poor miner
> Whose lamp's lost its light.
> His mishap we condole
> He is like the poor soul
> Who is struggling for comfort
> Without Bradley's Coal.

Another poster, with a self-evident subject, had the following:

> Said Santa Claus, "Jiminy shoot me,
> These chimneys that soot me don't suit me.
> If you'd buy Bradley's Coal like a sensible soul,
> I'd be suited for they never soot me."

And in the same seasonal context, Santa Claus said:

> I'll fill them full
> From top to sole;
> These folks are using
> Bradley's Coal.

There is a small sketch in JST, showing a heavily wrapped man pouring coal into a stove, with this accompanying verse:

> If in heating you're meeting
> With little success and no fun,
> Go gladly to Bradley;
> He sells happiness by the ton.

Yet another Bradley design, from 1901, has a linecut portrait of Theodore Roosevelt and verse on a piece of blotting paper (SI). It is clearly a promotional gift, not a poster.

A linecut proof impression in black on white paper (JST) is illustrated here (Fig. 25). The design measures 229 x 128 mm. (9 x 5 inches). Sloan has written on it, "Bradleys Coal (?) J.S." No verse is known.

One further named reference, in Sloan's financial records (p. 112, Sloan file, Mod), is to a subject entitled "King Coal." See also Sloan's "Autobiographical Notes," p. 382. Perhaps this catalogue will encourage a search for more posters and more information.

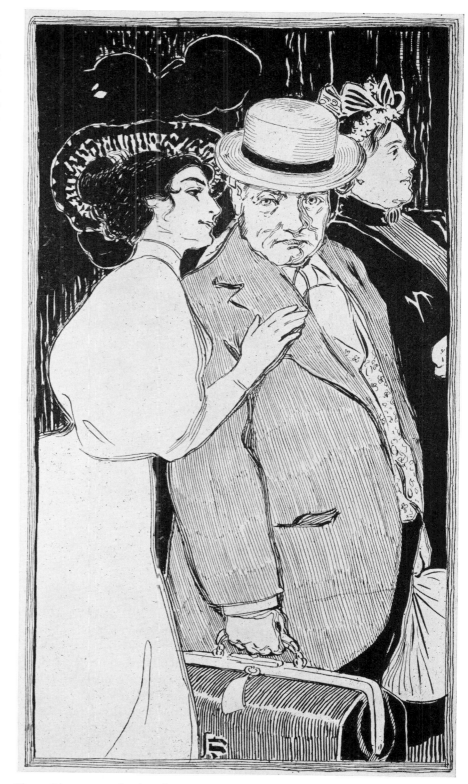

Fig. 25. Linecut reproduction of a drawing, c. 1895, inscribed by Sloan: "Bradleys Coal (?)."

only state, reduced

G. THE LADY AND HER TREE, Poster
1895. Sloan's copy of the book is dated March 1895 in his hand.
WSFA.
Relief linecut, photomechanical, black only. 182 x 124 mm. (7¼
x 5 inches) picture, on 11 x 14 inch white sheet.
Only state. JST.

 This poster is listed for sale at 15 cents at the rear of the
pamphlet *The Reign of the Poster* by Charles Knowles Bolton
(Boston 1895). The same linecut is used on the cover of the book
it advertises, *The Lady and Her Tree: A Story of Society,* by
Charles Stokes Wayne (Philadelphia, Vortex Co., 1895). In ad-
dition, it appears on a yellow paper sheet with text at the bot-
tom: "221 pages SELLS ON SIGHT heavy paper" (NYPL Art
Dept., clipping file). The actual poster was discovered (by HFS)
only in 1969, a fact which gives hope that other Sloan posters
may yet be found.

358

second state, reduced

H. MOODS, Poster

1895. Before July 1895, date of the issue of *Moods* that this poster
advertised.

Chalk-plate, in green ink. 583 x 281 mm. (23 x 11 inches).

States:

 1. With remarque. No proof known.

 2. Remarque removed. Ph, JST, WSFA, SI, LC, Met, Boston
 Public Library, New-York Historical Society, Samuel
 Nowak (Philadelphia).

Edition: 20 (1st state). No edition for 2nd state.

 The publication *Moods: A Journal Intime* appeared in only
three issues, published in Philadelphia in 1895 and 1896. Sloan

was listed as the art editor. His poster advertised volume 2, dated July 25, 1895. On an unnumbered page near the back of this issue appears the following notice: "The Poster announcing the second volume of MOODS, designed by John Sloan, and drawn by the artist in reverse on zinc, is issued in two editions. The Artist's Remarque Proof Edition, of Twenty Copies, printed on toned India proof paper, in green ink, and signed by the artist may be had of the Publishers at the rate of one dollar and a half per copy. The Publisher's Edition, printed on heavy green-tinted antique cover paper, in green ink, may be had of the Publishers at the rate of fifty cents per copy."

This poster is done by the chalk-plate method. In this process, no longer in commercial use, a flat metal plate was covered with soft chalk to a depth of about a sixteenth of an inch. The artist then carved his design in the chalk, penetrating down to the plate. "Like scratching your name in snow," Sloan commented (JS 1950, p. 7). A cast of type metal was then made of the prepared plate and used for printing. Sloan may have used the same medium for other posters; it was in common use at the time (see Charles W. Hackleman, *Commercial Engraving*, Indianapolis, 1921, pp. 382–83). Today it would be quite possible to consider chalk-plate as an original print process, for the plate was prepared entirely by the artist's own hand, without the use of photomechanical means. Its whole purpose, however, was for commercial reproduction.

I. ECHO, Poster
1895. First advertised in *Echo, 2,* no. 1, November 1, 1895, 22. Relief linecut, photomechanical, two impressions, black over red. 251 x 153 mm. (10 x 6 inches) picture.
States:
1. Design complete. Text reads, "For Sale Here." Both states are in Boston Public Library; the first state in LC and NYPL; state not noted on other copies in Ph, WSFA, Mod, New-York Historical Society, Gallery of Modern Art (New York).
2. Text changed to, "Fortnightly / Chicago / February 15, 1896."

The editor of the *Echo,* Percival Pollard, wrote Sloan on August 19, 1895, "If you care to, I should be glad to have you design a cover for the *Echo,* in black and red, the colors we've had the most success with. I think your work would show splendidly in those media" (JST).

"A new *Echo* Poster by John Sloan, in black and red, on heavy buff paper, odd size, narrow and long, in a tube 25¢" (*Echo, 2,* 22). Exactly the same design was used for the cover of the *Echo* (2, no. 8, Feb. 15, 1896). This magazine had a short life, existing only from May 1895 to December 1896. A complete file is in LC.

In the collection of the Gallery of Modern Art, New York, Sloan's illustration *La Belle Trilby* is also listed as a poster, but is only a clipped illustration. This subject appeared in the *Echo, 1,* no. 3, June 1, 1895, 41, but there is no evidence whatever that it was ever used as a poster. Reproductions of Sloan's work or comments on it appear at various places in the *Echo* (*1,* 41, 98, 99, 100, 149, 171, 172, 189, 196; 2, 22, 48, 73, 74, 268, 287; *3,* 180, 208).

first state, reduced

J. GIL BLAS, Poster
1895. Advertises *Gil Blas, 1,* no. 2, November 11, 1895.
Alternative title: *Love's Kalendar.*
Relief linecut, photomechanical, in black and pink, with very little of the latter. 258 x 125 mm. (10 x 5 inches) picture.
Only state. JST.
Drawing: JST (no. S-902).

No actual example of the poster is known. Sloan told HFS that this picture, which appeared on page 1 of *Gil Blas, 1,* no. 2, November 9, 1895, was also used for a poster, advertising the cited issue of the short-lived Philadelphia literary magazine. Illustrations by Everett Shinn also appeared in this magazine. From Sloan's files came an unsigned *Gil Blas* poster (now in SI) which he said was by Shinn (HFS 1966).

Philadelphia Press Posters

A photograph of Sloan and Joe Laub in their Philadelphia studio (JST) shows a poster on the rear wall, portraying a man and woman in medieval costume, in "poster style," and presumably by Sloan. The text reads: "Women's Edition / The Press / Thanksgiving Eve / November 27th—1895." It is too faint to authenticate conclusively or to illustrate here, but indicates that Sloan very probably did a number of posters for the *Press* during this period.

magazine illustration

only state

K. AUCTION POSTER
1896. Dated February 15, 1896, in the plate.
Relief linecut, photomechanical, black on brown paper. 116 x
157 mm. (4½ x 6 inches).
Only state. SI.

Like the other Sloan posters in SI, this came originally from
Sloan's own files. It is signed in the plate. Sloan was a student
three years earlier at the Pennsylvania Academy of Fine Arts,
under Thomas Anshutz. He was painting a mural for the Acad-
emy at about the time of this small poster.

L. CINDER-PATH TALES, Poster
1896. In plate. First illustrated in the *Echo, 3, no. 8*, September
12, 1896, 180.
Lithograph, photomechanical, black and white ink on brown
paper. 531 x 284 mm. (20½ x 11¼ inches) including text; 439 x
284 mm. (17¼ x 11¼ inches) picture.
Only state. Ph, WSFA, SI, LC, NYPL, Boston Public Library,
Lock Haven.
Printed by George H. Walker & Co., Lithographers, Boston.

This poster advertised the book *Cinder-Path Tales* by William
Lindsey, published by Copeland & Day (Boston, 1896). The copy-
right deposit was received by LC on August 27, 1896. The same
design, reduced in size (173 x 97 mm., 6¾ x 3¾ inches) and in
black only, was used on the front cover of the book. "John Sloan
. . . has now designed a cover for a book of clever stories just is-
sued by Copeland & Day, of Boston, entitled *Cinder-Path Tales.*
It has also been enlarged to form a poster" (*Echo, 3*, no. 10, Oct.
10, 1896, 208).

CINDER-PATH TALES
WILLIAM LINDSEY

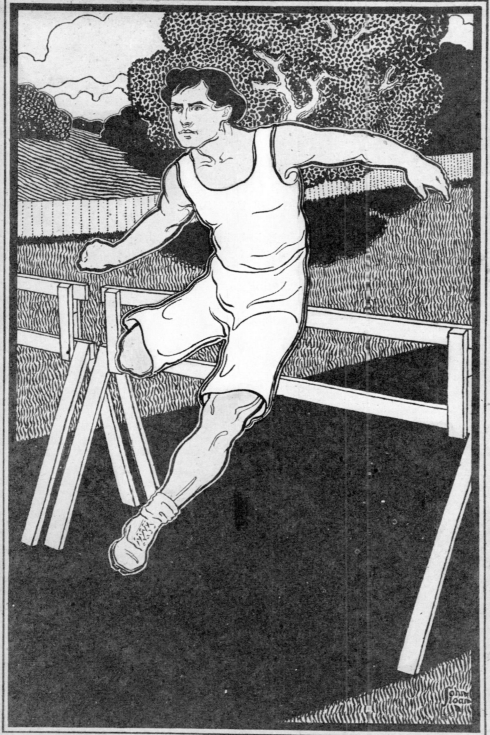

BOSTON: COPELAND AND
DAY ❧ ❧ ❧ PRICE $1.00

M. APOLLO BICYCLES POSTER
1898. Estimate.
Relief linecut, photomechanical, in black, red, yellow, and
blue. 534 x 339 mm. (21 x 13¼ inches).
Only state. NYPL.
Printed by the Franklin Printing Co. of Philadelphia.

This poster was not in Sloan's files, nor did he mention it. It is
signed in the plate. The smudges seen in the illustration are on
the poster itself.

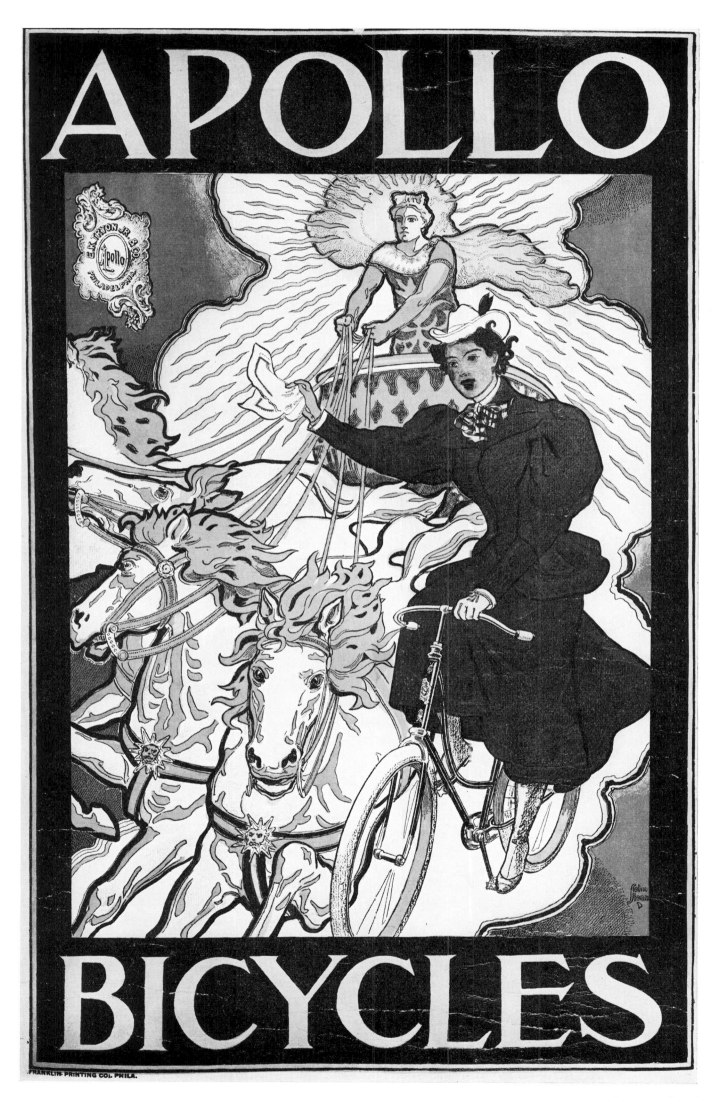

only state, reduced

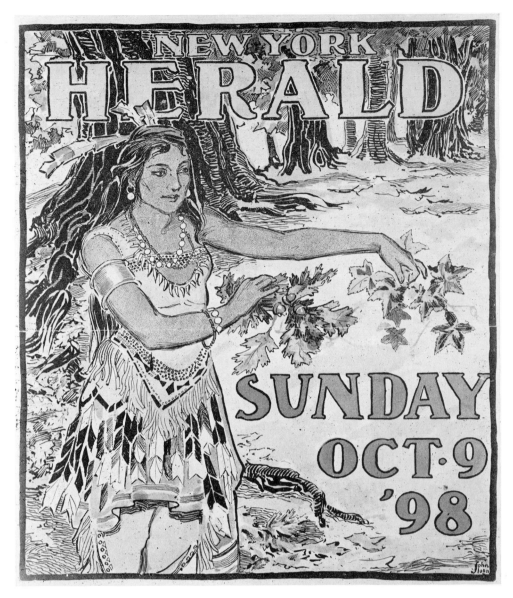

only state, reduced

N. INDIAN GIRL POSTER
1898. Dated October 9, 1898, in the poster.
Relief linecut, photomechanical, three plates, brown, red, and yellow, printed on heavy white paper. 304 x 255 mm. (12 x 10 inches) design.
Only state. SI.

This poster came from Sloan's personal files and is signed in the plate at the lower right. It seems quite possible that Sloan did more than this one poster for the New York *Herald* during his three-months with the newspaper in 1898.

O. GREAT BATTLE POSTER
1900. Dated January 21, 1900, in the poster.
Relief linecut, picture entirely in black, some text in red. 555 x 280 mm. (22 x 11 inches) picture, on 1062 x 702 mm. (42 x 27½ inches) sheet.
Only state. SI.

The only copy known of this poster came from Sloan's files. It is on cheap newsprint, which had become very brittle with age. It has now been mounted on mulberry paper for preservation. There were undoubtedly many other such posters done by Sloan for the Philadelphia *Press*. It is doubtful whether many can have survived without special treatment.

Two other Philadelphia *Press* posters are in Ph. One shows a young woman driving an automobile, dated October 19, 1902, relief printed in brown and black. The other portrays a bearded Moses with a Menorah candlestick, dated November 2, 1902, relief printed in purple and orange. Both measure 18 x 12 inches. Neither is signed. Though both came to Ph from Sloan's files in the 1956 acquisition, it is difficult to believe they are by Sloan. Carl Zigrosser agrees with this opinion. HFS remembers no comments by Sloan on either of them.

The Press.

Sunday, January 21, 1900
The Weather To-day...Fair and Cooler

SEE TO-DAY'S PRESS

FOR ALL THE NEWS

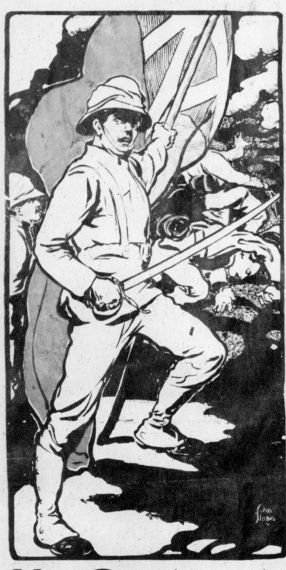

A Great Battle
A Terrible All Day Conflict in South Africa Wilds

British Gain
Warren's Corps Drives Boers Back Over Three Miles With Very Heavy Loss

Medical Frauds
Dr. S. Weir Mitchell Discusses "The Press" Exposure

Women's Clubs
Prominent Pennsylvania, New Jersey and Delaware Women Express Their Opinions

Mr. Dooley Again to the Fore
The Famous Humorist Writes About the Latest Fads in Senatorial Oratory

It Pays To Use PRESS Want Ads.

P. SONS OF THE VELDT POSTER

1900. Estimate, based on the subject matter from the Boer War.
Relief linecut, photomechanical, in reddish-brown ink, with hand-painted additions. 381 x 664 mm. (15 x 26 inches) design.
Only state. SI.

Printing: 3 (JS annotation).
Plate destroyed (JS annotation).

The only known copy, in SI, a gift of HFS, is inscribed by Sloan, "SONS OF THE VELDT / one of 3 proofs—plate destroyed." It appears to have been planned as a poster, probably advertising a newspaper story. No book of this title has been found. Sloan kept it for many years in a frame with wooden backing, which has left the print in bad condition. It is printed in reddish-brown ink and hand-colored in green, red, and white watercolor.

Scribner's Poster

Sloan's financial records for February 1905 (JST) show his receipt of $25 for a poster advertising *Scribner's Magazine*. The files of Charles Scribner's Sons, New York, contain a card with the following data: "Artist: Sloan, John / No. 101 / Style: Water Color / Price: $25.00 / Title: Poster / Published: April 1905." I am grateful to George McKay Schiefflin for this information. The two references are probably to a single poster subject, of which no actual example is now known.

only state, reduced

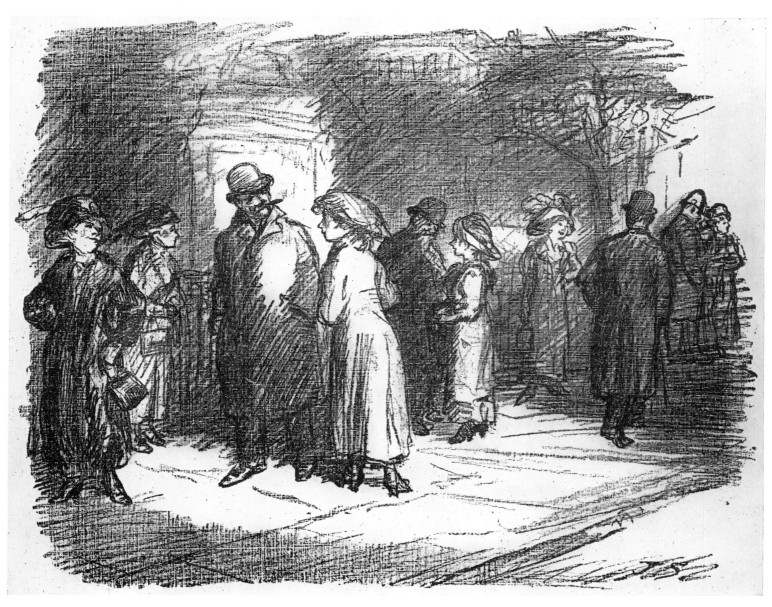

only state, reduced

Q. PICKETING THE POLICE PERMIT

1910. Dated January 11, 1910, in JS diary (see below).
Alternative titles *Pickets; The Sort of Picketing the Police Permit.*
Relief linecut, photomechanical. The original drawing was made on paper placed on canvas to give it the texture. It was printed on tan laid paper, having 30.7 mm. between chain lines and watermarked "ENFIELD & CO. 1887." 207 x 274 mm. (8¼ x 11 inches) design.
Only state. Ph, JST-7, WSFA, SI.
No edition. Printing unknown.
Plate unknown, formerly in Sloan's possession (see below).
Drawing: Location unknown.

This illustration was sometimes signed in pencil by Sloan and may pass as a lithograph without careful examination to note the relief printing.

"Some thousands of shirtwaist makers, girls—are on strike for improved conditions. They have been arrested for 'picketing' the shops" (Dec. 30, 1909, *NYS,* p. 366). "Went down to the *Call* and gave them a drawing of *Pickets the Police Protect* (street walkers) made today, in reference to the shirt waist strike now going on in which much police brutality has been cited" (Jan. 11, 1910, *NYS,* p. 374). "My *Pickets of Capitalism* came out in the *Call* today. It looks good" (Jan. 23, 1910, *NYS,* p. 377). "Kopelin gave me the cut of the *Pickets* drawing and the original drawing" (Jan. 27, 1910, *NYS,* p. 379). "*Picketing the Police Permit*—a good biting title" (JS diary, May 15, 1950).

This linecut was indeed published in the New York *Sunday Call,* January 23, 1910, section 1, at the top of page 7, with the title, *Pickets on the Outposts of Capitalism.* Sloan is not identified as the artist, though his initials are in the plate.

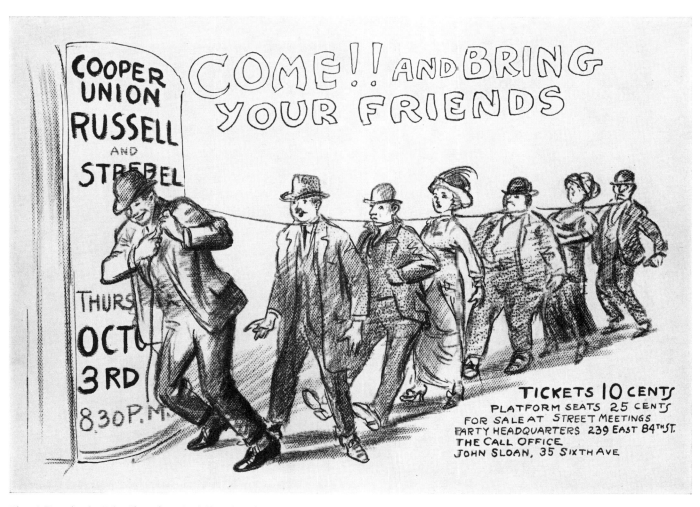

Fig. 26. Drawing by John Sloan for a Socialist advertisement, 1912; JST.

Socialist Posters

There are a number of drawings in JST, from Sloan's files, which, like the illustrated example (Fig. 26), are advertisements for Socialist meetings, all of 1912, in pencil and pen, drawn on paper laid over textured board. The annotation "4 col" on the example shown indicates that it was intended for newspaper use. It and the others may, however, have also been printed as small posters. This drawing measures 181 x 273 mm. (7 x 11 inches) and has the JS catalogue no. 2387. Other similar drawings are numbered 2388, 2389, 2390, 2391, 2392, and 2393. They may provide a guide to discovering other Socialist posters by Sloan.

At least one other poster is definitely known from Sloan's diaries to have been done, but no copy of it has yet been found. "I made a drawing for the Debs Meeting poster today. A gift, of course, to Local New York Socialist Party" (Sept. 18, 1911, *NYS*, p. 554). "Gerber, Organizer Local N.Y.C., called with my Debs Meeting drawing for my suggestion as to engraving. I told him I'd have it engraved and he left it with me. I took the drawing to Walker Eng. Co. and they are to make cut for it for less than $10.00" (Sept. 2., 1911, *NYS*, p. 564). The actual meeting advertised took place on October 21, 1911 (*NYS*, p. 570).

R. SOCIALIST RATIFICATION MEETING
POSTER
1912. September 29 fell on Saturday in that year.
Relief linecut, photomechanical, black and red on white paper.
824 x 559 mm. (32½ x 22 inches) entire design.
Only state. SI.
 The known impression came from Sloan's files.

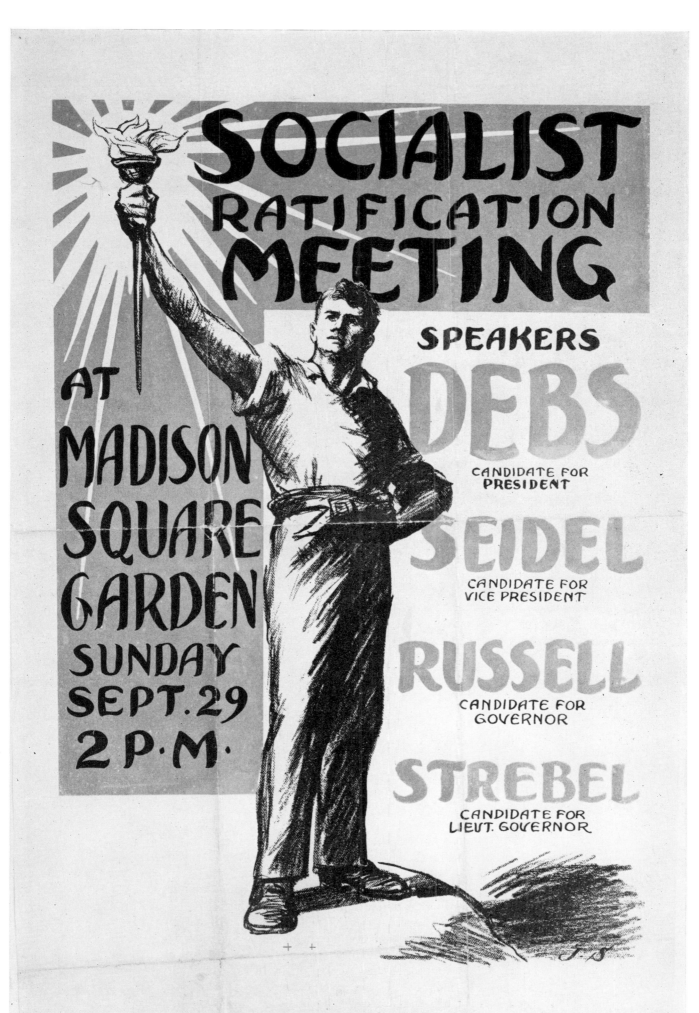

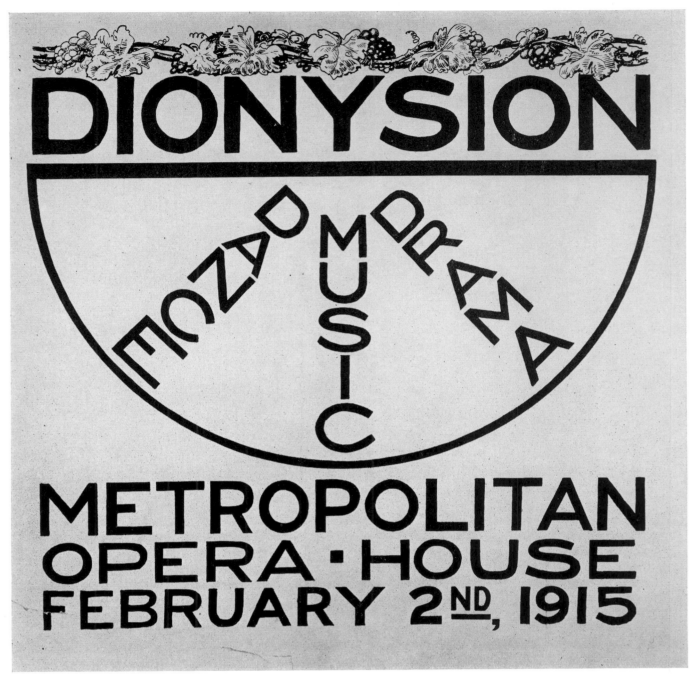

first state, reduced

S. DIONYSIAN POSTER

1915. Prior to February date in poster.

Relief linecut, photomechanical, black ink on white cardboard.

445 x 440 mm. (17½ x 17¼ inches) design, on 20½ x 20¼ inch board.

States:

 1. Complete. Bottom line reads "February 2nd, 1915." SI.

 2. Bottom line changed to "February 25–2:30 P.M.—Mar. 2–8:30 P.M." SI.

Though there is no signature in the poster, both examples came from Sloan's files and were acknowledged by him.

The occasion advertised was a performance by Isadora Duncan. "Isadora Duncan's performance, with her pupils yesterday afternoon at the Metropolitan, was a repetition of the bill already twice given, which she describes by the title of dionysian" (*New York Times*, Feb. 3, 1915, p. 11; see also *New York Times*, Feb. 26, 1915, p. 9, and March 3, 1915, p. 11).

376

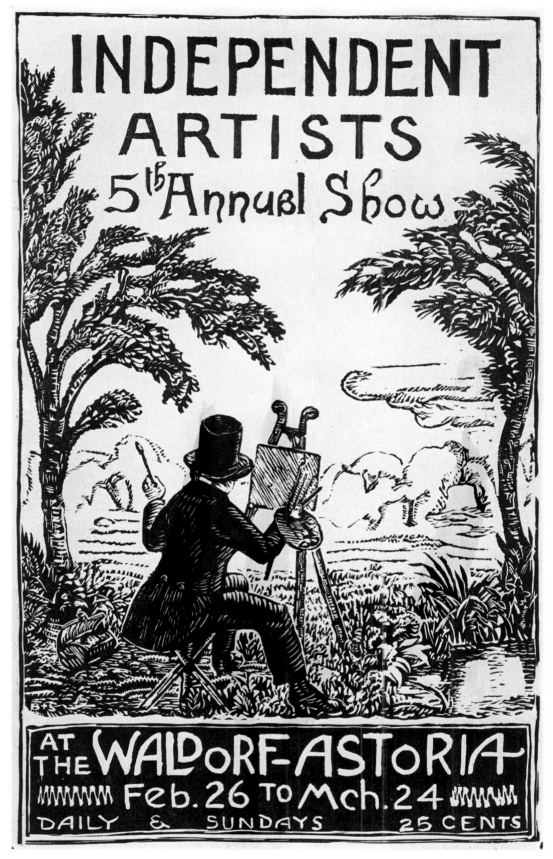

only state, reduced

T. ARTIST IN TOP HAT POSTER

1921. The Fifth Annual Exhibition of the Society of Independent Artists was held from February 26 to March 24, 1921.
Linoleum cut. Black ink on yellow or blue cardboard. 540 x 336 mm. (21¼ x 13¼ inches).
Only state. Ph, NYPL.
No edition. Printing unknown.
Block unknown.

Tissue unknown, probably nonexistent.

The signature in the block reads: "B & S." It is explained by Frank Weitenkampf's note on the NYPL poster: "Drawn by James Butler (Claude Monet's grandson), cut on linoleum by J. Sloan." The poster now in Ph was formerly in Sloan's own files. James Butler was the son of the artist Theodore E. Butler, who married Monet's stepdaughter.

Documentary Appendix

The three statements by John Sloan presented here are of special pertinence to his work as a printmaker. They give, respectively, some notes on his aesthetic motivation as an etcher, his personal history as a printmaker, and his technical procedure in etching. Two have never been published, and one is now difficult to find.

The "Foreword," published here for the first time, was written by Sloan in 1944 for a book about his etchings planned by the American Artists Group, which published his *Gist of Art*. The idea was originally suggested by HFS. It was to have been a companion to the small book, *John Sloan*, American Artists Group Monograph Number 1, New York, which was actually published in 1945. The etching book had to be dropped, after Sloan had written this foreword, because of wartime problems with printing and paper restrictions in effect at the time. (See HFS letter to Carl Zigrosser, Aug. 31, 1945; Ph.) Sloan's individual comments on his etchings, begun for the Renaissance Society exhibition in Chicago in February 1945, were also intended for this monograph.

The unpublished "Autobiographical Notes on Etching" derive from a 1947 interview, which was arranged as a coherent narrative by HFS, and annotated and approved by Sloan. Footnotes have been provided by the present compiler.

"The Process of Etching" was published in 1920, in the art magazine, *The Touchstone*, now long out of print. While intended as an article of general instruction in etching, it describes Sloan's own personal etching technique in considerable detail. I have added footnotes where they seem to be of interest.

Foreword

by John Sloan

I hardly feel that I am an "etcher" at all in the generally accepted meaning of the term. Robert Henri, my great friend and counsellor, always was strong in his conviction that my prints were of importance, not for their technical skill, but because they were made with sympathy for and understanding of life. He many times declared that he hated most modern etchings.

The selections shown in this monograph should make it clear enough to any lover of prints that if my work has any special merits, they are not those of a virtuoso. Frankly, I have always been rather proud of the fact that I have done so much with so little technical skill. Apart from steady application necessary, I could communicate all I know of the craft in a half hour or less. I believe that with sufficient creative urge derived from life's surroundings and graphic ability, one can produce one's own etched results. The secret of etching as of painting lies in command of graphic expression. Etching is drawing; painting is drawing; sculpture is drawing. Drawing is the ability to carry out the creative intention of the artist's mind.

Line drawing, which of course includes etching, is, among all techniques practised by the artists in human history, the most purely creative and abstract. Its importance in painting and sculpture is too little understood.

While the subject matter motivating these prints shows a great variety—from the New York life etchings which were considered vulgar back in 1906 to the nude figures of the later years—still I feel that my point of view has been consistent: I have been interested in life, in the reality of things. Nowadays, oddly enough, the earlier prints have grown popular; the subject matter evokes "nostalgia" on the part of contemporary critics.

Subject matter is of small importance in the real value of a work of art. Love or hatred of something about life may start the artist's creative impulse, but the product will not be art if subject and technique are all that result.

The two hundred and twenty-three plates made to date constitute a somewhat meagre output, but considering the fact that I have also been painting, illustrating and teaching, I cannot feel that I have been too much lacking in production.

As my etchings have never had a popular sale, the public and students may have the opportunity of becoming acquainted with more of them through the medium of this little book.[1]

1. Sloan's suggested title was: "A Selection of 54 etchings from the works of John Sloan, with introductory notes and comments by the artist, and a complete list of the etchings." The 54 etchings chosen by Sloan for illustration in the volume are of interest in showing the prints he considered either good or representative: 70, 79, 93, 101, 126, 127, 128, 129, 132, 134, 135, 136, 137, 139, 152, 155, 169, 172, 182, 183, 186, 193, 197, 208, 216, 218, 221, 222, 223, 225, 231, 233, 235, 238, 239, 241, 245, 246, 247, 248, 249, 257, 259, 261, 263, 265, 270, 275, 276, 278, 284, 290, 307, 308. He also planned to include enlarged details of 251.

Of his 155 "published" etchings, he had done 153 by 1944. These, plus the 53 De Kock etchings, plus the 16 for *Of Human Bondage*, make a total of 222. He probably included the early portrait of Robert Henri (115), but not that of George W. Childs (45), both of which appeared in the Kraushaar lists of his published work.

Autobiographical Notes on Etching[1]

by John Sloan

My first job on leaving high school at the age of sixteen was at Porter and Coates (the Scribners of Philadelphia in those days), where I was assistant cashier in the retail department. Captain Barr was in charge of the print department there, and through him I came in contact with etching for the first time. I used to make pen and ink copies of some Rembrandt etchings, particularly the self-portrait leaning on the window sill, which Barr could sell for five or ten dollars. It was a lot of money for me at the time. He sold them to collectors, men like E. R. Cope,[2] who was one of their regular patrons.

I picked up a copy of Chattock's book on print making,[3] and from that learned something about the technique of etching. I went to Weber and Co., got myself a plate and needle and roller (which has lasted me all my life) and began to try the technique. Perhaps the plate I call *Dedham Castle* was the first attempt. It was made from a good color lithograph of Turner's watercolor which we had at home, we called it "our Turner." The plate is so feebly bitten that it is hardly more than a drypoint. I was so scared when the acid started to bubble in the lines that I didn't go on with the biting.

Next, I believe, I made an attempt to copy a Rembrandt head. This awful thing was also barely bitten at all.[4]

About this time, I left Porter and Coates to work for A. Edward Newton (later the famous book collector) who had been a salesman for Porter and Coates and who was setting up a fancy goods business. There, in a room full of girls decorating candy boxes and novelties, I was the only man. I went to work there because I liked the idea of making a living in doing something connected with drawing. I was designing valentines, box covers, and so forth for him, for nine dollars a week.

Then, and without much other experience in etching, I told him that I would like to make some etchings for calendars and that sort of thing. I did a set of plates of Homes of American Poets for a calendar, made from photographs. Also a series on

Westminster Abbey taken from photogravures of drawings made by some English artist.[5]

These etchings were printed by Peters in Philadelphia, and it was there that I got my first practical help in etching.

I had been going to the Spring Garden Institute at night to take some classes in drawing, but at that time there were no formal classes in the graphic arts, so I was largely self-taught by the trial and error method. Later I learned some things from James Fincken, a commercial engraver who lived near my studio on Walnut Street.[6]

Finally I got tired of working all day for Newton, left him and got a studio for myself at 705 Walnut Street for five dollars a month.[7] I swore then that I would never again work for anyone full time. I tried doing free-lance work, and managed to pick up some advertising jobs. For the Bradley Coal Company I made a drawing and verse every month to be used as a street car ad.[8] It paid the rent and supplied me with fuel. I also made some drawings of sundials, and I remember one difficult job, a letter-head showing an entire orchestra, to be made from a photograph.[9]

One day I wandered into the *Inquirer's* art department with some of my drawings. They had no use for free-lance work but offered me a regular job in the department. Since the work began at two in the afternoon it left my mornings free, so I accepted.

I was nineteen when I left Newton to branch out for myself, and I think it was 1891 when I started at the *Inquirer*, at the age

1. This previously unpublished manuscript derived from notes taken by Helen Farr Sloan during a conversation between Sloan and Carl Zigrosser on April 12, 1947. She wrote it up as a coherent narrative, which Sloan then read and emended. Footnotes are by the compiler. Sloan's brief digression on painting has been left to show its relation in his own mind to his prints.

2. Cope, whom Sloan mentions nowhere else, was possibly Edward Drinker Cope (1840–97), a celebrated paleontologist, who was a professor at the University of Pennsylvania at the time Sloan was with Porter & Coates.

3. R. S. Chattock, *Practical Notes on Etching* (2d ed., New York, 1883). Sloan's own copy of this book, inscribed "John F. Sloan / 1921 Camac Street / Philadelphia / Sept. 21, 1889," is now in the Philadelphia Museum of Art. Sloan also used P. G. Hamerton's *The Etcher's Handbook* (3d ed., London, 1881) in his early studies. His signed undated copy is also in Ph. Later he studied Maxine Lalanne's *Treatise on Etching* (trans. S. R. Koehler, Boston, 1880), which he read but could not afford to buy in 1911 (*NYS*, p. 553). In 1928, he bought E. S. Lumsden's *Art of Etching* (Philadelphia 1926), which he subsequently recommended to his students (*Gist*, p. 179); his copy also in Ph.

4. If this is the same print as no. 1 in this catalogue, it is not bitten at all, being completely drypoint. Sloan's inscription on the only known proof identifies it as his first print. *Dedham Castle* (2) is the first etching.

5. *The Homes of the Poets* are nos. 5–10 in this catalogue, the *Westminster Abbey* series nos. 11–23. The notation of "several calendars" appeared in A. E. Gallatin's listing of Sloan's early etched work (*International Studio*, 58, March 1916, xxviii) and has cropped up several times since. I have located only one calendar (29–41) etched by Sloan. The explanation may be that Sloan, as here, thought that the *Homes of the Poets* and *Westminster Abbey* etchings were also done for calendars. He may never have seen the finished publications.

6. Little is known about James H. Fincken. Mantle Fielding's *Dictionary of American Painters* . . . (Philadelphia [1926], p. 119) notes that he was born in England in 1860, and had his address at 1012 Walnut Street in Philadelphia, very close to Sloan. He first appeared in the Philadelphia business directory in 1893. A letter from his son to Sloan in October 1933 (JST) shows that he was still alive at that time. I have seen a few samples of his work, which show him to be a sensitive and competent commercial etcher. Sloan noted in his diary March 6, 1906 (*NYS*, p. 20), that on a visit to Philadelphia, "we went down and called on James Fincken, my friend, the engraver. He is a fine man certainly and has always been so much help to me technically from his great knowledge of the mechanics of etching." His help was clearly important to Sloan, for the latter referred to him on a number of occasions. In addition to the assistance he mentions from the Peters brothers and Fincken, Sloan surely also learned from his father, who, as a salesman for Marcus Ward, the publisher, would have been familiar with various printing techniques.

7. The first studio was actually at 703 Walnut Street, where the rent was $6.00 per month (receipts in JST). Sloan subsequently moved to 705 Walnut and then to 806 Walnut.

8. See posters A–F in this catalogue.

9. The orchestra picture was a photomechanical reproduction, not an etching.

of twenty. Soon after this I first met Robert Henri, who had such a great influence on me and the other newspaper artists, like Glackens and Shinn, and it was his inspiration and encouragement which led us to take up painting seriously in our spare time.

Some of us had been drawing at the Pennsylvania Academy. I was working from the antique under Anshutz and had had a bit of a tiff with him when he rebuked me for drawing the members of the class instead of sticking to the cast which I was tired of studying over and over again. I was one of the ringleaders of the group who seceded from the Academy to form the Charcoal Club [1893]. We borrowed a photographer's studio and equipped it with Welsbach lights, and had a good-sized group who came to draw once or twice a week. Henri (Fig. 27) had just come back from Europe, and he would come in to give us criticism on our work. The club finally failed because the members dropped out in the summer (it only ran about five or six months, from spring to fall), and the director of the Academy very shrewdly bought our equipment, lights and all.

My first drawings for the *Inquirer* were pen and ink. Later I saw some of the brush drawings made by Beisen Kubota (Fig. 28), who had come from Japan to attend the Columbian Exposition in Chicago in 1893. He used stick ink, but Henri and I got the idea of carrying a bottle of Higgins ink around in our pockets, and made a lot of sketches on the spot.[10]

From these brush and ink drawings I developed a less sketchy style by using pen lines in addition, and from this I developed my "poster style." This was before I had seen any work by Beardsley or Steinlen. My work was always more realistic, less imaginative than Beardsley's.

Bob McCabe, the Sunday Editor of the *Inquirer* liked my poster style drawings, so I did most of my work for the Sunday Supplement. They found I was not much good at work on quick assignments anyhow. The *Inland Printer* gave me my first publicity for these poster style drawings.[11]

From the time I left Newton I did very few etchings until 1902, when I started making etchings to illustrate the de luxe edition of De Kock's novels for the Frederick J. Quinby Co. of Boston.

When Captain J. E. Barr had left Porter and Coates, he and his brother started a print place on Walnut Street. I think Edward Campion, also an old Porter and Coates man, joined them. Young Barr came to me in my little five dollar a month studio, with a photograph of George W. Childs from which I made an etching for him. I got two or three proofs from Peters, and then Barr somehow wangled the plate away from me and that is the last I ever saw of it. Perhaps it was used to illustrate some book. The Childs plate was the only one which was ordered or made for sale after I left Newton until I made the De Kock plates. There is only one proof I know about, which is in the Whitney or Rockefeller set.[12]

While I was working on the newspaper I was too busy with my job, and I was giving my spare time to painting, so there are very few etchings; one of C. K. Keller, a sketch portrait, with too much perspective in the hand, another of Will Bradner the violinist who was, I think, a friend of Keller's.[13]

In my pen and ink drawings for the newspaper I was trying whenever possible, with the influence of Leech and Keene, to do as well as I could. Of course a great deal of the work I did was not in the poster style.

It has been said that I was influenced by Cruikshank, but this is an entirely erroneous conclusion. His work comes more from the imagination and has more of caricature in it than any of mine.

I still regard Leech in his linework, as practically the peer of Rembrandt. I refer to his things in *Punch* which were drawn directly on the block, not the etchings on steel which are stiffer and more stylized.

Keene was more of a visual realist, and from him DuMaurier carried on the tradition with more elegance. Leech was an imaginative creative artist, though I don't think you could get a better sidelight on life in the England of that time than from his drawings in *Punch*.

One of the very few etchings I ever made which catered to the "white space" point of view is the *Schuylkill River,* a plate made from nature when I was giving Glackens his first lesson in etching. He took his plate to a friend in the engraving department who offered to do a wonderful job of printing for him, and printed it in reverse with white lines on the black surface.[14]

It was through Glackens that I was offered the job to make etchings to illustrate some of the De Kock novels being published by Quinby and Co. in Boston. From 1902 to 1905 I made fifty-three plates for them, fifty-two of which were used.[15] This concentrated work in the medium gave me a great deal of worthwhile experience.

At first they did not give one artist the job of illustrating a whole book, which led to a strange assortment of work. Later we were given a whole book to do. With the etchings there were also line drawings and wash drawings which were reproduced, but the etchings were all printed from the plates. The better editions such as the "St. Gervais" have well-printed proofs, but the "Artists'" Edition has clean-wiped prints which cannot do the plates justice.

There was one very expensive edition printed on vellum, with illuminated letters and other special features, which was to sell for a thousand dollars a volume. Of course, etchings printed on vellum are poor prints anyhow, and the absurd price of the books led to the downfall of this type of publishing venture. There were several court rulings which declared the contracts for these expensive sets null and void. We had some trouble collecting from the publisher at this time.

In 1904 I came to New York. The introduction of halftone process reproduction of photographs made the work of artists less necessary in newspaper work. When I moved from Philadelphia I was still making "Puzzle" drawings for the *Sunday Press* every week, and I had one job to illustrate an article in *The*

10. Kubota was a newspaper artist for the Tokyo daily, *Kokumin Shimbun*. (See, for instance, Arthur Diósy, *The New Far East,* London, 1898, pp. xvi–xvii and illustrations.) Their meeting appears to be dated by a drawing by Kubota, portraying Robert Henri, and inscribed in Sloan's hand, October 5, 1893. It is now in JST and is illustrated here. Two unidentified newspaper articles of 1895 or 1896, in the Sloan file at Mod, confirm the predominantly Japanese influence in Sloan's "poster style."

11. F. Penn, "Newspaper Artists—John Sloan," *Inland Printer (14,* Oct. 1894, 50–52). See also *The Poster Period of John Sloan* (ed. Helen Farr Sloan, Hammermill Paper Co., Lock Haven, Pa., 1967).

12. Catalogue no. 45. Actually, two proofs are known, one in the Met (gift of Mrs. Whitney), one in the Mod (gift of Mrs. Rockefeller).

13. No. 81 is *C. K. Keller;* no. 82 is *Will Bradner.* Both etchings done in 1903.

14. Sloan's print is no. 60 here. This curious proof of William Glackens' etching is now in SI, the gift of Mrs. Sloan.

15. All 53 plates were used, one of them, *Madame Mondigo* (76), only in the more elaborate editions, which Sloan possibly never saw.

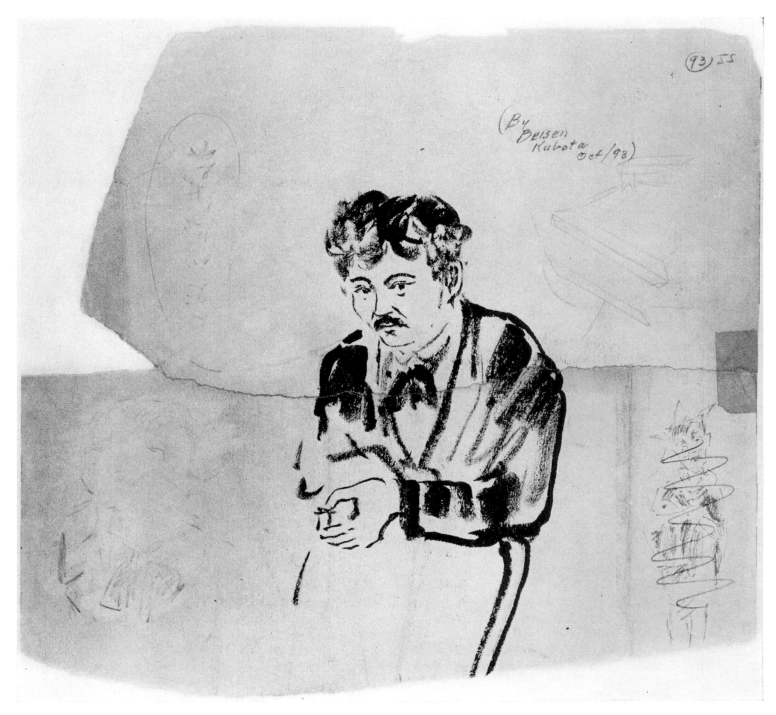

Fig. 27. Robert Henri. Drawing by Beisen Kubota 1893; JST.

Century. The Puzzle drawings were the only steady income I had and just about covered the higher rent I was paying in New York.

From that time on, the periods when I felt free to etch or paint for myself have depended on whether I had illustration or teaching work on hand to bring in the money needed for rent and food. I have never been able to work for myself when worried about the next month's rent. As soon as I had finished an illustration job and had another one in the house to do, I would feel free to paint.

The first New York etchings were made around 1905, when I worked quite steadily at them. I liked to work at night when there would be no interruptions, and would often work until four and five in the morning. I like to etch under a single light, in a small room. My first little studio in Philadelphia was so small that I could reach both walls with my hands when I was

sitting at the table. It was ideal for concentration. There was nothing else to look at but the brick wall out the window.

Henri was one of the few, the very few, who believed in the work I was doing in my first New York plates. There was no sale for them. In 1912, I got out a brochure offering twelve of them for $35, sending brochures to a list of 1,600 selected from *Who's Who*. Two sets were sold, one to the Newark Museum and the other to C. J. Taylor.[16]

16. The correspondence in the Newark Public Library (not Newark Museum) indicates that Sloan's mailing actually took place in February 1915. The halftone illustrations of his thirteen "New York City Life" etchings first appeared on the inside back cover of the October 1913 issues of *The Masses*, in a promotional advertisement which produced not a single response. Sloan evidently used them later in his brochure (copy in JST), which offered signed prints at $10.00 each or three for $20.00. His accompanying letter, dated February 1915, read:

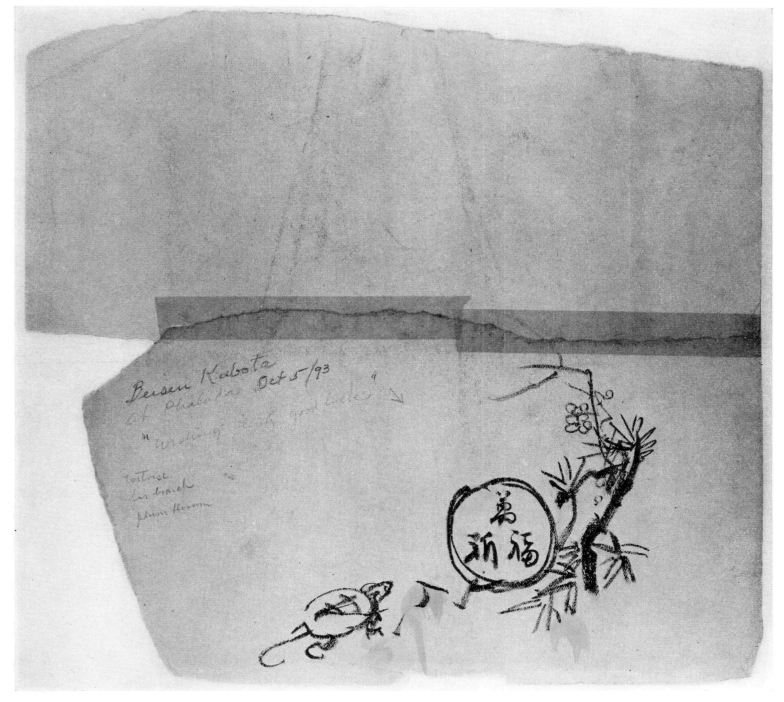

Fig. 28. Drawing by Beisen Kubota 1893, verso of Figure 27. The plum, pine, and bamboo are Japanese symbols of longevity, as is the tortoise. The text reads, literally: ten thousand / good luck / pray for / —or as Sloan has written: "wishing plenty good luck."

Mielatz invited a group of the city plates to the National Academy, and they refused to show most of them as being "vulgar, unfit to show publicly, and indecent." *Turning out the Light* was one of the ones which fell in that category. This plate,

I am sending herewith a folder in which some of my Etchings are reproduced in miniature.

The New York Public Library Print Department shows about fifty of my etchings, and proofs are in many private collections here and abroad.

The prices are unusually reasonable, as I am my own publisher and all distributors' profits are eliminated.

I hope that you will be interested and inclined to send me an order.

Yours, John Sloan

The second purchaser was Charles Jay Taylor (1855–1929), a well-known painter and illustrator, who was at the time head of the department of painting of the Carnegie Institute, Pittsburgh. Sloan probably knew him.

on the other hand, was the only one which impressed Russell Sturgis, the well known critic, as having the necessary "charm" to be art.[17]

I don't think I had any socially conscious justification for my choice of subject matter at this time. It was just under my nose, and the sight of city life interested me, especially in the summer. I was reading Zola and Dreiser and the other so-called social realists at the time, but just by chance. It was later that I became actively interested in Socialism.

When I wanted to say something with obvious social consciousness I made a drawing or cartoon for *The Call* or some other Socialist publication. I particularly did not put social

17. *Turning Out the Light* is no. 134 in this catalogue. The American Water Color Society rejected four of the ten "New York City Life" etchings (see p. 134).

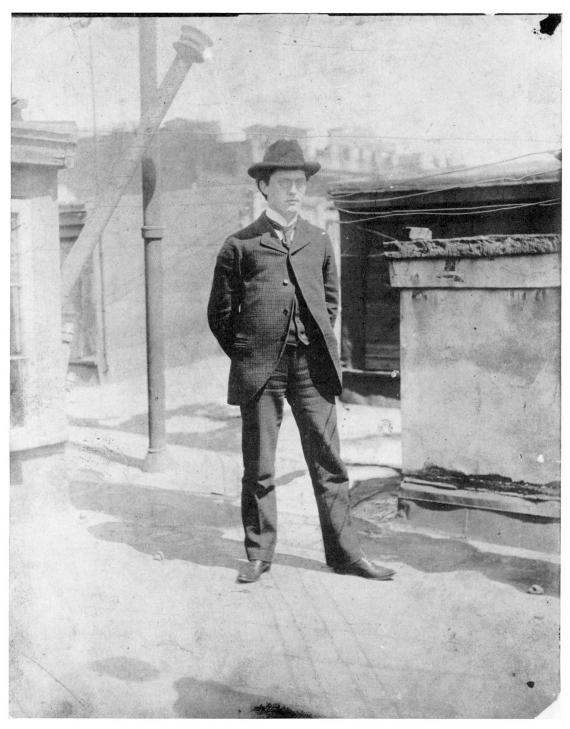

Fig. 29. John Sloan 1893, on the roof of the Philadelphia *Inquirer;* JST.

content of a literary nature in my etchings and paintings. There has been a class of art criticism which attributes "Social Consciousness" to some of my early work, the intent of which I deny. Nor was I conscious of drawing the "American Scene." It might almost be concluded that the greater was my participation in Socialist activities and the later venture of the social satire publication, *The Masses,* to which I gave a great deal of time from 1912 to 1914, the less did I care to etch and paint what might be called social subject matter.

Another thing which led me away from city life subject matter was the fact that I started teaching at the Art Students League in 1916 and from 1914 on had taken a summer holiday in Gloucester, Massachusetts, where I spent all my time painting landscapes.

When I found time to paint in the winter, between teaching

and illustration jobs, I found myself more and more painting from the figure. I had to keep ahead of my students.

The Armory Show undoubtedly had a strong and perhaps subtle effect on my work also. The clarion call of freedom which the ultra-moderns gave us led to a greater interest in color, plasticity, geometric consciousness about form. While I made only one excursion into the abstract field, the aquatint *Mosaic,* the impact of the ultra-modern work has greatly influenced my thinking.[18] And particularly through the work of Renoir I was led to a greater understanding of the tradition of the masters of form and color: back to Rubens and Rembrandt and Titian, via Renoir.

Through my more conscious interest in structure and textural

18. *Mosaic* is no. 185 here and dates from 1917.

realization, I came to the conclusion that form and color are separate in the mind. I believe that the mind can concentrate on only one at a time, that the eye sees only color and light and shade effects, which are sorted out by the mind and coordinated with memory-experiences of the sense of touch. The sense of touch is the key to form consciousness. Color and form are not the same thing. Color, properly used, is just one of the devices used in building form through its inherent quality of recession and projection. Without line and sculpturing changes in the black and white scale and textural realization you cannot make form.

The line is the most powerful graphic symbol the artist has; it is the only purely invented device, you cannot see a line in nature, only the edges of tones. The use of line as a sign-making technique is what interests me in etching. I have nothing but contempt for the type of linework used to imitate brushstrokes in painting.

I don't have any special interest in the beauty of etching technique per se. As a craftsman I am patient but not finicky. I don't believe there is one etching "connoisseur" in this country who has one of my plates. Probably they feel as many collectors do about modern painting, that they "could do it themselves just as well." But I do have a profound concern for honesty of mental technique. I like linework that is talking about *things*. You can see that kind of straightforward line technique in the old engravings, the work of Dürer. Then there is a more descriptive "talking" line and use of hatchwork that gives a feeling of light and shade enveloping and focussing on the forms. The greatest master of realization, Rembrandt, is for this reason the greatest etcher. He is great because of his mental technique, not for psychological insight or technical virtuosity.

It may be a form of conceit on my part, but I have never had a great urge to travel to see the work of the past. I have been too much absorbed in the problems of my own work. From another point of view, it is depressing to look at the work of the masters: what is the use of trying to do what has been done? If I could do it ten times as well as I am able to do, the results would be only one-hundredth as good as the original. Sometimes I read about artists whose lives are filled with a consuming emotional or intellectual urge. Great sacrifices have to be made by them because of art. I have never felt that way about my work. I have never thought of any drawing or painting as art while I was making it. If there is any urge that keeps me at my work it is the fact that I cannot do what I want to do. As soon as I have mastered any problem it ceases to interest me and there is always the insoluble mystery: how to get things more real, how to get greater realization into the work. This kind of isolation, or drifting quality may be partly responsible for the real growth in my work. I stumbled across some of the principles in the old work while I was trying to solve problems for myself.

About 1920–24, I began making some charcoal drawings from the figure. On the rough white paper with the granular charcoal medium I found I could put audacious darks in the light, accenting the form and not destroying it, making figures that looked like bronze sculpture. I thought of the harsh textures on the "light" areas as color surface, they gave the form plasticity, realization. As I studied these drawings I found that in the best there were two things going on: first a general statement of the structure, a light and shade definition of the form made with "rubbed in" charcoal grays; then there were the top textures, the granular markings made by dragging the coal across the rough surface of the paper. The specks of black caught on the tiny

bumps in the paper were separate, not blended. The white paper kept on going underneath the dotted screen of charcoal granules.

How could this same positive separation in technical thinking be carried over into painting? The problem has devilled me for the last twenty years. In Rembrandt's paintings the rough surface of the impasto underpainting was used to catch glazes, and thereby get a kind of surfacing in the light areas. I started underpainting in pale monochrome with heavy loading of Dutch Boy white lead, and then glazing color over the rough surface. But when I made any attempt to translate the harsh charcoal texturings on the light surface into color tones laid on with paint, the pigment choked up the light. I wanted to be able to use positive color-darks as though working with dry chalks on a rough surface. This led me to the use of a super-glaze of linework. Only in this way could I get the same harsh textural statement in the light which I had dared to make in the charcoal drawings. Sometimes the linework is broken by dots, sometimes it carries some color quality, but essentially I think of this linework as a sign for surface. From the moment the first lines are put on the light area of a form which had been quite adequately sculptured, the whole drawing or painting seems nebulous, an under-thing until all the surfaces have been taken hold of by the superimposed network of texturing lines.

In point of time, it was first of all in etching that I used linework super-texture to translate the surfacing darks of the charcoal drawings. There are a few glazed paintings in 1929 where I started to slip into linework, using the parallel lines which are a sign for space and shade. It seems only natural that this should have happened, considering my long career as a pen draughtsman and etcher. The use of colored lines is just as legitimate in this way as it is in black and white technique. And as a matter of fact this type of linework was used by many of the old fresco painters like Signorelli and by the great artists who painted the murals in Pompeii. The *Girl in Revery* painted in 1929 has some tentative linework used for surface indication in painting the dress, but no attempt was made to surface the flesh in the same significant manner.[19]

The etching *Nude on Stairs* of 1930 is the first important use of super-glazing with linework. There are sets of lines which define the form in light and shade, more which give it sculptural texture, and then there are top-texturing lines which attack the lights and give them greater realization than the eye can see.[20]

During the next two years and mostly in 1933 I made some thirty plates from the figure, drawing directly on the copper with no preliminary study. Fourteen years later I can look back on the work of that period with amazement—as though it were the product of another man. There is some rudimentary thing that is in me as an artist, just now and then, accidentally and occasionally, I have had a spurt of it, and that is a real command of an authoritative line. The mastery of an authoritative line is the thing that is back of Picasso and what distinguishes him from all the people who are pattering around after him. With Picasso there is no such thing as failure.

Except in the case of the figure plates which I made in the early thirties, which were needled directly on the copper, all my

19. Hamerton (n. 3 above, p. 21) had written, "Painting depends upon tones and it would be a barbarism to introduce lines in that art." Sloan has underlined this in his copy (Ph) and added the wry marginal comment: "Thanks! / John Sloan 1930." The painting, *Girl in Revery*, is illustrated in *Gist*, p. 302, collection of Miss Barbara Woodward, LeRoy, N.Y.

20. *Nude on Stairs* is no. 241 in this catalogue.

plates were made from drawings carefully worked out on tissue paper.[21] The advantage of this was that I could trace the selected plan of the drawing from one piece to another if the study got too messed up or the paper wore out from changes. Then I could take the tissue paper and treat it with paraffin to make it transparent. By placing a sheet of paper rubbed with fine red chalk face down on the grounded plate, and laying my waxed tissue drawing on this, reverse side up, I could then trace the outlines of the composition onto the plate in reverse. Thus, when the plate was printed, the etching itself would be like the original drawing. When you set about a composition you have some feeling about the direction of the masses and flow of the design which can easily be disturbed if the composition is reversed.

Contrary to the usual procedure of etchers today, I prefer to needle from dark to light. By this I mean that I draw first the

lines which are to be bitten strongest. I start to bite these, then take the plate out of the acid bath, wash and dry it, and needle in the lines which are to be next strongest. I continue this process until the most delicate lines are drawn in and bitten. I don't use much stopping-out except as an emergency process when some area has started to bite too fast or the ground has broken down.

After the first trial proof there are usually many, many states. I don't recall any plate which came off successfully in the first biting. The *Isadora Duncan* plate has at least forty states, all different, particularly when I was working on the head. I hardly know the difference in many of them myself, just a change of a line here or there, scraping down, pounding up from the back.[22] I am not a skillful craftsman but I have patience, and I always struggle through with a thing. Some artists make four or five starts and then carry the final thing through in a streak of concentrated effort. My way is more plodding.

21. This is a slight exaggeration. He apparently sketched a few other etchings directly on the plate. Examples which he specifically mentions in his comments are nos. 126, 164, 176, and 187.

22. No. 172 here. I have discovered 29 different states, represented by 46 proofs.

The Process of Etching

Notes by John Sloan[1]

GROUNDING THE PLATE

Thoroughly clean the plate with engravers' willow charcoal, use the end of the grain. Keep charcoal under water when not in use.

Fix corner of plate in *hand vise* with a bit of blotter to avoid damage.

Heat the plate evenly, not too hot, a burnt ground will not hold.

With the etching *ground* in a taffeta cover spread a little on the plate.

With the *roller* get it evenly distributed, easing the pressure as it becomes satisfactory.

While the plate is still hot, *smoke it,* by sweeping it with the flame of a resin candle (or a bit of rag on a wire, dipped into kerosene).

A surface like polished ebony should result.

Cool the plate.

FIRST DRAWING

Work behind white tissue screen about two feet square to diffuse light.

Preliminary drawing may be made on tissue (Dennison's best white silver tissue). After making a sketch, it may be reversed by laying the back of the tissue drawing on a film of hot paraffin (spread on a copper plate).

Fix drawing to plate with four little pellets of wax.

Slip a piece of tissue rubbed with red pastel or dry vermilion powder between the sketch and the plate (colored side down), then, with a blunt tracing point, go over the sketch. This gives you your sketch, *reversed* or *direct,* as you may choose, in red chalk, on the dark ground of the plate.

NEEDLING[2] (Fig. 30)

Sharpen needles with a rolling motion across the oil-stone or carborundum; remove extreme sharpness by rubbing end on crocus cloth.

Test. A good point *should not scratch* the thumb-nail—even tho' very sharp. (*Some like* a digging sharpness, however.)

Use even pressure. Variety is to be produced by biting, rather than by elbow power.

As a *general principle, the darker the bitten passage, the fewer the lines.*

Use a firm pressure for all lines, no matter how delicate they are to be.

DIRECT STOPPING OUT PROCESS: NEEDLING IN ADVANCE[3]

Stopping out varnish may be bought, or, as well, made, by dissolving engravers' *red sealing wax* in wood alcohol.

1. This article was first published in *The Touchstone* (*8,* Dec. 1920, 227–40). This was an art magazine edited by Mary Fanton Roberts, who was well known as an art critic and patron. Sloan's first draft manuscript, dated February 1920, is in JST, in both handwritten and typed form (the latter a carbon copy). The published article, with one exception noted below, contains all the text of the manuscripts, plus additional material. Both the text and Sloan's drawings (see Fig. 31 on p. 390) are taken from the published version. The heavy italicizing and the punctuation are Sloan's own.

2. Sloan's entire etching tool kit is now in JST, as it was left at the time of his death. A detailed inventory of it has been prepared by the compiler and is, in manuscript, in the files of Ph, JST, and SI. All the working tools mentioned in this article are found in the kit, with the exception of a burnisher. The only such tool found is one in the shape of a file, good only for burnishing beveled plate edges. Sloan must clearly have had some sort of burnisher for working on the surface of a plate, and it can only be presumed lost.

3. Sloan's own etching procedure was the "darks to lights" one he describes here, not the "direct stopping out process." For acid biting, he used the

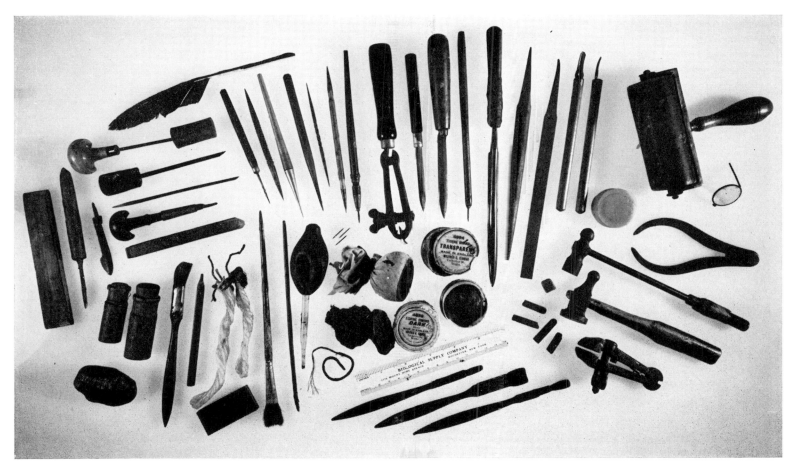

Fig. 30. The contents of Sloan's etching tool kit; JST.

Apply to the *back and edges* of plate and let dry ten or fifteen minutes.

Saturate a string with paraffin and lay it, double, across your *tray,* so that the plate will be resting on it and can be lifted from the bath by means of the string.

A good "set of bubbles" in the lines, indicates action and is the etcher's guide to biting, unless the exact strength and temperature, etc., are noted by experiments.

BATH[4]

Nitric acid, C. P. ½, water ½. Put a little copper scraping in to take off the "raw edge," or a little used acid to give the bath a blue tinge. *Test*—Put a drop or two of acid on the back of the plate. If bubbles form too soon, add more water to the mixture. A bath is good as long as it gives action in reasonable time.

Keep acid in *glass stoppered* bottles.

BITING

Bite until a good set of bubbles forms.

Remove from bath, wash, dry with blotters and stop palest passages out.

method without the tray, less elegantly known as "spit-biting." His etching technique has been discussed in detail by the present author in an article which concentrates on the print, *Copyist at the Metropolitan* (148) (Peter Morse, "John Sloan's Etching Technique: An Example," *Smithsonian Journal of History* 2, 1967, no. 3, 17–34).

4. The 50% nitric acid recommended by Sloan is an exceptionally strong mordant. His original manuscript for this article suggested an even stronger concentration, in a ratio of 3/5 acid to 2/5 water, or 60%. He himself enjoyed the "exciting moments" of strong biting action.

Bite again for the next darkest parts, then remove, wash, dry and stop *them* out—so on, until the darkest work is deep enough.

Wash, dry and look the plate over. More work can be added in the bath, or during stopping out periods. Stopping out varnish of sealing wax can be worked in before it becomes brittle dry.

A bottle of *ammonia* is handy for emergencies of spilt acid.

BITING WITHOUT A TRAY

No tray for acid is necessary if your nerves are good and you don't mind a prospect of exciting moments.

With a camel's hair brush and saliva, moisten the whole plate, avoiding the edge, or moisten such portions as you wish to bite. The acid will confine itself to such portions, when applied by means of an eye dropper.

The tip of a feather brushes away bubbles. This method saves the necessity for varnishing the back of the plate.

A PROCESS FOR NEEDLING FROM DARKS TO LIGHTS

Needle your *darks first.* Don't use too many lines. Remember, they widen as they deepen.

Bite the plate giving these lines a start—wash and dry.

Needle your next darkest Bite again. Wash and dry.

Needle your next lightest. Bite again. Wash and dry.

Needle your palest portions. Bite again. Wash and dry.

At any stage, stop out anything that has, in your opinion, gone far enough.

JUDGING DEPTH

One way to look at your lines during the course of the work is to dry plate thoroughly (blotter, then a drying period of time)

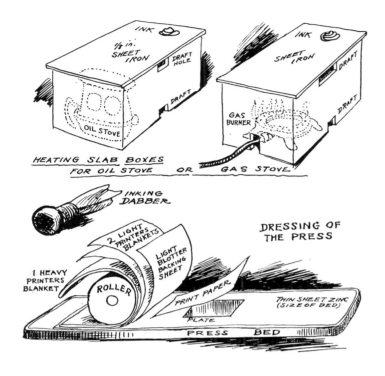

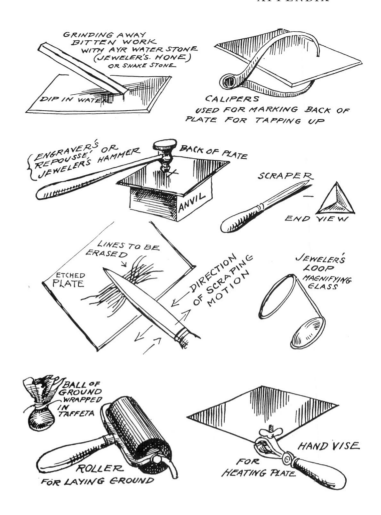

Fig. 31. Illustrations by John Sloan for "The Process of Etching."

and lightly rub talcum powder into the lines, wipe the face of plate with side of palm of hand. An estimate may thus be formed of how the biting is going.

Lines may be "felt" with a needle.

An idea of depth may be gained by looking toward the light, holding plate horizontally.

After you have gone as far as you can with the first ground, and are ready to remove it, do so with turpentine (for the ground) and wood alcohol for the stop varnish.

Clean the plate well with the above on a rag, then with a good *sharp file,* bevel the sides of the plate, so that it won't cut your paper in printing. After filing, *smooth* bevel with a *burnisher.*

PRINTING[5]

Paper—Japan or Plate Paper—many are satisfactory. Dampen the paper some hours before printing. Sponge well or wet by immersing a dozen or more sheets at a time (cut to size desired).

Pile neatly between glass plates or a couple of Ferrotype irons (used by photographers) with a weight (like a few books) on top. It usually works well to put your pile of paper after dampening, between wet newspaper—cover and weight.

Heating box to keep plate warm while wiping.

Plate to be quite warm, but not too hot to touch.

5. Sloan's etching press was a small iron press with a bed probably no bigger than 40 x 20 inches. It can be seen in prints 248 and 254 and in a number of photographs. Its design is basic and simple, with an ungeared five-spoke star handle. He apparently bought it about the time he was starting on the De Kock etchings in 1902. He kept it until 1941 when, after having an operation plus pneumonia and not wanting the strain of printing, he either sold it or gave it away. Its present location is not known.

Keep ink on cooler end of the heating plate. Use warmer end for wiping and inking your etched plate.

Apply ink to the plate by means of a dabber, made of horsehair, tightly covered with unbleached muslin, tied with strong twine.

Clean the dabber after printing by scraping loose ink off with palette knife.

After pushing the ink into all lines of plate with a twisting, punching motion, take the *wiping rags* (tarlatan pad covered with a layer of mosquito netting), and wipe away briskly the superfluous surface ink. Then, if desired, *retroussé* the plate with a piece of soft *cheese cloth,* pulling up a little feather of ink over the edge of the line.

Tone on the plate is left by clever handling of wiping rags (of a softer sort than above sometimes).

Wipe the edges of the plate and put it in position in center of press-bed, cover with a piece of printing paper of proper dampness, drop your blotting sheet over this, then your blankets and turn it through under the roller. Your pressure should have been previously adjusted by running the plate through uninked with a piece of paper laid in place and the tension screws on the roller regulated until pressure is strong and even all over plate.

After your trial proof, you may do further work on the plate.[6] If passages are to be cut out, use the scraper or snake-stone (wa-

6. Sloan did a great deal of reworking on most of his plates, using the method described here. The working states of his prints, as given in this catalogue, show his process. The backs of many of his plates are masses of hammer marks. Sloan's own engraver's anvil, HFS says, was misplaced during her move from the Chelsea Hotel in 1954.

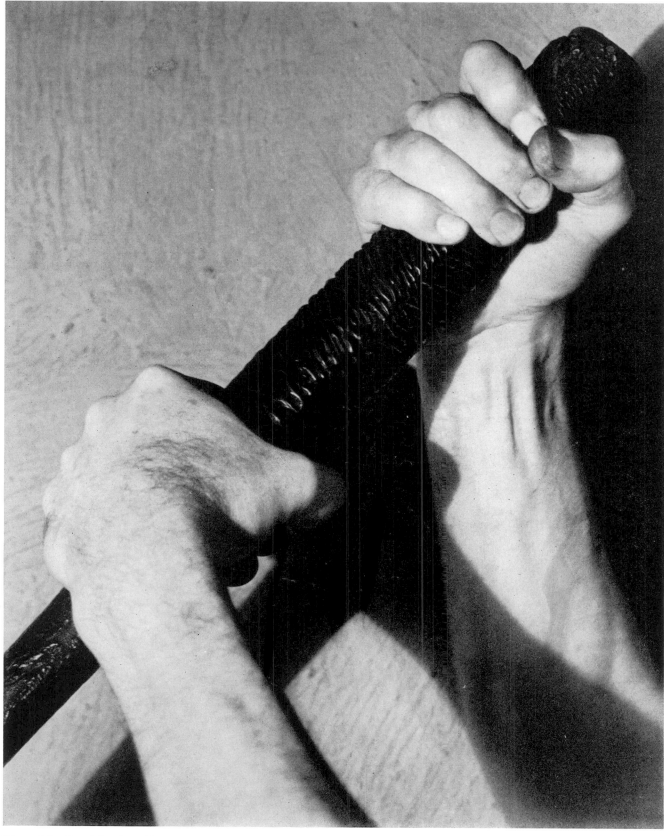

Fig. 32. John Sloan's hands on his press.

ter of Ayr stone pencil). Burnish away scratches and tap up from the back, ascertaining the spot for tapping by means of *calipers,* and tapping lightly with *repoussé* hammer on an *engraver's anvil,* which is a block of steel with polished surface.

Use the scraper *across* sets of lines, otherwise it will make rounded furrows.

When alterations are prepared for by erasure, etc., *lay a new ground,* being particular to *drive the wax well into all the lines* —smoke lightly or not at all.

7. One of Sloan's models has described to me his working method for the nude etchings of 1931 and 1933. This differed in some details from his procedure on other occasions. A special session would be reserved for etching. Sloan would determine a pose, either on the spot or sometimes in advance (if he had drawn previously from the model). He made certain that she would remain comfortable through the three-hour stint. Then he would stand and draw directly on a grounded (but not blackened) plate, placed flat on a tall table. He used two or three needles for different effects, but kept all his materials very orderly. He would draw confidently, but with great care and precision.

Make your additions and corrections following the process of the first bitings.[7]

After printing, spread open all ink-charged rags, to avoid spontaneous combustion.

After printing, clean all ink out of the lines of the plate.

After printing, clean your dabber, scraping ink off with palette knife.

After printing, put out the light in your plate heater.

Frequently, he would walk away from the plate to view the model from different directions, getting the three-dimensional quality of the form, returning to the table for additional work on the plate. There was neither preliminary drawing on paper nor any biting or technical work on the plate while the model was present. It therefore seems possible to presume that the first state of each of these prints represents the work actually done from the model, the remainder being done later. It is notable that in most of these cases the entire concept is present in the first state, requiring only slight additions.

Bibliography

This bibliography is intended to be only a very selective listing of significant writings about Sloan, with special emphasis on his prints. Extensive bibliographies are contained in "John Sloan," *Index of Twentieth Century Artists* (1934); Goodrich, *John Sloan* (compiled by Rosalind Irvine); and in Rueppel, "Graphic Art." A comprehensive file of published material, compiled during the present research, is now deposited in the Division of Graphic Arts, Smithsonian Institution, Washington, D.C. Most of the extant manuscript sources and much published data are in the John Sloan Trust. Many other sources are cited in the body of the catalogue and, for the most part, are not repeated here. Two of Sloan's early ledgers and his large personal file of clippings were donated to the Museum of Modern Art by HFS and are now in the library of that institution in eight boxes, under the catalogue number *S58/S56.

Addison Gallery of American Art, "John Sloan: Retrospective Exhibition," exhibition catalogue (Andover, Mass. 1938), notes by John Sloan.

"Artists Ready for Work Again," *The Index (Pittsburgh's Illustrated Weekly) 17* (Aug. 31, 1907), 6.

Barker, Virgil, "Rough-Riding Artist," *Saturday Review 38* (March 12, 1955), 19.

Barrell, Charles Wisner, "The Real Drama of the Slums, As Told in John Sloan's Etchings," *Craftsman 15* (1909), 559–64.

Beam, Philip C., *The Language of Art,* New York 1958, pp. 129–32.

Beer, Richard, "The Independent," *Art News 32* (Jan. 27, 1934), 11.

Brace, Ernest, "John Sloan," *Magazine of Art 31* (1938), 132–35, 183–84.

Brooks, Van Wyck, *John Sloan: A Painter's Life,* New York, 1955.

Brown, Bolton, "Lithographic Drawing," *Print Connoisseur 2* (1921), 139–50.

Brown, Milton W., "The Two John Sloans," *Art News 50* (Jan. 1952), 24–27, 56–57.

Caffin, Charles H., *The Story of American Painting,* New York, 1907, pp. 373–81.

Cahill, Holger, "John Sloan: Man and Artist," *Shadowland 4* (Aug. 1921), 11, 71–73.

Craven, Thomas, *Treasury of American Prints,* New York, 1939, pls. 81–85.

Dartmouth College, "John Sloan Paintings and Prints," exhibition catalogue, Hanover, N.H., June 1, 1946, notes by John Sloan.

du Bois, Guy Pène, *John Sloan,* New York, 1931.

Eastman, Max, *Enjoyment of Living,* New York, 1948, pp. 394, 397–422, 441, 549–56.

"The Etchings of John Sloan," *Carnegie Magazine 11* (April 1937), 9–11.

"Exhibition of American Humor," *New York Times Magazine* (April 18, 1915), pp. 22–23.

Flexner, James Thomas, "Slums Were As One Saw Them," *New York Times Book Review* (Nov. 21, 1965), p. 7.

Gallatin, A. E., "The Etchings, Lithographs and Drawings of John Sloan," *International Studio 58* (March 1916), xxv–xxviii, contains a checklist of prints, which also appears in Gallatin, *Certain Contemporaries,* New York, 1916, pp. 28–30.

——, *John Sloan,* New York, 1925.

"The Galleries," *The Scrip 1* (1906), 328, ed. Elizabeth Luther Cary.

"The Galleries," *The Scrip 2* (1907), 197.

Goodrich, Lloyd, *John Sloan,* New York, 1952.

Hayes, Bartlett H., Jr., "An Artist's Angle of Vision," *Saturday Review 48* (Nov. 27, 1965), 48.

Hopper, Edward, "John Sloan and the Philadelphians," *Arts 11* (1927), 169–78.

Hudson Guild, "Exhibition of Paintings, Etchings, and Drawings by John Sloan," exhibition catalogue, New York, Feb. 10, 1916, notes by John Sloan.

Ivins, William M., Jr., "A Gift of Etchings by John Sloan," *Bulletin of the Metropolitan Museum of Art 21* (1926), 218–19.

Jewell, Edward Alden, "John Sloan Show of Etchings Opens," *New York Times* (March 25, 1936), p. 19.

Katz, Leslie, "The World of the Eight," *Arts Yearbook 1* (1957), 55–76.

Kraushaar Art Galleries, "Catalogue: Complete Collection of Etchings by John Sloan," New York, Feb. 1937.

LaFollette, Suzanne, *Art in America,* New York, 1929, pp. 304–06, 316, 324–25.

M'Cormick, William B., "The Realism of John Sloan," *Arts and Decoration 5* (1915), 390–91.

Missouri, University of, "A Selection of Etchings by John Sloan," exhibition catalogue, Columbia, Mo., March 3–24, 1967, introduction by Peter Morse.

Morse, John D., "John Sloan 1871–1951," *American Artist 16* (Jan. 1952), 24–28, 57–60.

Morse, Peter, "John Sloan's Etching Technique: An Example," *Smithsonian Journal of History 2* (1967, no. 3), 17–34.

Pach, Walter, "The Etchings of John Sloan," *Studio 92* (Aug. 1925), 102–05.

——, "John Sloan," *Atlantic Monthly 194* (Aug. 1954), 68–72.

——, "John Sloan To-Day," *Virginia Quarterly Review 1* (1925), 196–204.

——, "Quelques notes sur les peintres americains," *Gazette des Beaux-Arts 51* (Paris 1909), 324–35.

Pearson, Ralph M., *Experiencing American Pictures,* New York, 1943, pp. 164–68.

Penn, F., "Newspaper Artists—John Sloan," *Inland Printer 14* (Oct. 1894), 50–52.

Perlman, Bennard B., *The Immortal Eight: American Painting from Eakins to the Armory Show,* New York, 1962.

Renaissance Society, "Retrospective Exhibition of Etchings by John Sloan," exhibition catalogue, Chicago, Feb. 16, 1945.

Roberts, Mary Fanton, "John Sloan: His Art and Its Inspiration," *Touchstone 4* (1919), 362–70.

Rueppel, Merrill Clement, "The Graphic Art of Arthur Bowen Davies and John Sloan," doctoral dissertation, University of Wisconsin, 1955 (University Microfilms publication no. 14,733).

Salpeter, Harry, "Saturday Night's Painter," *Esquire 5* (June 1936), 105–07, 132, 134.

Sloan, John, *Gist of Art,* ed. Helen Farr, New York, 1939.

———, Introduction: Thackeray, William M., *Vanity Fair,* Heritage Press ed., New York, 1940.

———, *New York Scene: From the Diaries, Notes and Correspondence 1906–1913,* ed. Bruce St. John, New York, 1965.

———, *The Poster Period of John Sloan,* ed. Helen Farr Sloan, Hammermill Paper Co., Lock Haven, Pa., 1967.

John Sloan, American Artists Group, New York, 1945.

"John Sloan and American Art," *Times Literary Supplement 55* (London 1956), 1–2.

"John Sloan, Artist," *New York Times* (Sept. 9, 1951), pp. 1, 90.

"John Sloan—Painter and Graver," *Index of Twentieth Century Artists 1* (Aug. 1934), 167–74, supplement i–ii; (Sept. 1934), iii.

"John Sloan's Work on View," *New York Times* (Jan. 28, 1916), p. 8.

"Sloan Etchings at Kraushaar," New York *Herald-Tribune* (April 11, 1926), sec. 6, p. 10.

Smithsonian Institution, "John Sloan," exhibition catalogue, Washington, D.C., 1961, essays by Helen Farr Sloan and Bruce St. John.

Sweeney, James Johnson, "Ashcans Instead of Powder Puffs," *New York Times Book Review* (Feb. 20, 1955), pp. 1, 21.

Walker Art Museum, "The Art of John Sloan," exhibition catalogue, Bowdoin College, Brunswick, Me., Jan. 20, 1962, essay by Philip C. Beam.

Watson, Forbes, "John Sloan," *Magazine of Art 45* (1952), 62–70.

Weitenkampf, Frank, "John Sloan in the Print Room," *American Magazine of Art 20* (1929), 555–59.

West, Herbert F., *John Sloan's Last Summer,* Iowa City, 1952.

Wilmington Society of the Fine Arts, "The Life and Times of John Sloan," exhibition catalogue, Wilmington, Del., 1961, essays by Helen Farr Sloan and Bruce St. John.

Yeats, John Butler, "John Sloan's Exhibition," *Seven Arts Chronicle 2* (1917), 257–59.

———, *Letters to His Son . . . 1869–1922,* New York, 1946, pp. 38, 43, 44, 132, 137, 138, 139, 252, 259, 289.

———, "A Painter of Pictures," *Freeman 4* (1922), 401–02.

———, "The Work of John Sloan," *Harper's Weekly 58* (Nov. 22, 1913), 20–21.

Zigrosser, Carl, "John Sloan Memorial: His Complete Graphic Work," *Philadelphia Museum Bulletin 51* (Winter 1956), 19–31.

Title Index

Concordance

The following concordance table gives this catalogue's numbers in the left column, followed by the catalogue numbers of the Zigrosser, Kraushaar, and Gallatin listings. A blank indicates that the print was not included in the named catalogue. All prints in the three previous lists have been included in the present catalogue. The asterisks in the Gallatin column indicate a mention without a catalogue number.

	Zigrosser	Kraushaar	Gallatin
1	233		*
2	234	1	*
3	235		
4	239	2	*
5	249		*
6	250		*
7	251		*
8	252		*
9	253		*
10	254		*
11	242		*
12	243a		
13	243		*
14	244a		
15	244		*
16	245a		
17	245		*
18	246a		
19	246		*
20	247a		
21	247		*
22	248a		
23	248		*
24	241	3	
25	240		
26	238		
27	237		
28			
29	255		
30	256		
31	257		
32	258		
33	259		
34	260		
35	261		
36	262		
37	263		
38	264		
39	265		
40	266		
41	267		
42	270		
43			
44			
45	271	4	*
46	268		
47	236		
48			
49			
50			
51			
52			
53			

	Zigrosser	Kraushaar	Gallatin
54			
55	272		
56	273		
57	269		
58			
59			
60	1	5	*
61	275		
62	278		
63	5		1
64	6		2
65	7		3
66	17		12
67	18		13
68	19		14
69	20		15
70	58	9	
71	8		4
72	9		5
73	10		6
74	11		7
75	12		8
76	13		
77	276		
78	277		
79	2	6	53
80			
81	3	7	54
82	60	11	56
83	21		51
84	22		52
85	14		9
86	15		10
87	16		11
88	33		26
89	34		27
90	35		28
91	36		29
92	37		30
93	38		31
94	39		32
95	40		33
96	41		34
97	42		35
98	43		36
99	44		37
100	45		38
101	46		39
102	47		40
103	48		41
104	4	8	55
105	23		16
106	24		17

	Zigrosser	Kraushaar	Gallatin		Zigrosser	Kraushaar	Gallatin
107	25		18	172	95	46	91
108	26		19	173	96	47	92
109	27		20	174	100	51	96
110	28		21	175	99	50	95
111	29		22	176	101	52	97
112	30		23	177			
113	31		24	178	102	53	
114	32		25	179	105	56	98
115	59	10		180	106	57	
116	49		42	181	103	54	
117	50		43	182	104	55	
118	51		44	183	110	61	
119	52		45	184	107	58	
120	53		46	185	108	59	
121	54		47	186	109	60	
122	55		48	187	112	63	
123	56		49	188	111	62	
124	57		50	189			
125	61	12	57	190	113	64	
126	62	13	58	191	282		
127	63	21	66	192	229		
128	64	14	59	193	119	70	
129	65	19	64	194			
130	67	17	62	195	114	65	
131	66	20	65	196	117	68	
132	68	15	60	197	116	67	
133	223		L-2	198	115	66	
134	70	16	61	199	118	69	
135	69	18	63	200	121	72	
136	74	25	73	201			
137	72	23	68	202	122	73	
138	71	22	67	203	230		
139	73	24	72	204	120	71	
140	75	26	74	205	123	74	
141	76	27	75	206	128	79	
142	224		L-3	207	127	78	
143	225		L-6	208	124	75	
144	227		L-5	209	231		
145	228		L-4	210	232		
146				211	126	77	
147	226		L-1	212	129	80	
148	77	28	76	213	125	76	
149	78	29	77	214	130	81	
150	81	32	70	215	132	83	
151	79	30	78	216	131	82	
152	80	31	69	217	135	86	
153	82	33	71	218	133	84	
154	280			219	134	85	
155	83	34	79	220	136	87	
156	85	36	82	221	138	89	
157	281			222	141	92	
158				223	139	90	
159	84	35	80	224	140	91	
160	86	37	82	225	137	88	
161	88	39	84	226	144	100	
162	89	40	85	227	142	93	
163	90	41	86	228	143	94	
164	91	42	87	229	145	95	
165	279			230	148	98	
166	87	38	83	231	146	96	
167	94	45	90	232	147	99	
168	92	43	88	233	149	97	
169	93	44	89	234	150	101	
170	97	48	93	235	151	102	
171	98	49	94	236	152	103	

	Zigrosser	Kraushaar	Gallatin
237			
238	154	105	
239	155	106	
240	153	104	
241	156	107	
242	159	110	
243	157	108	
244	158	109	
245	160	114	
246	163	113	
247	161	111	
248	162	112	
249	164	115	
250	165	116	
251	167	118	
252	171	122	
253	168	119	
254	169	120	
255	166	117	
256	170	121	
257	172	123	
258	174	125	
259	173	124	
260	175	126	
261	176	135	
262	190	141	
263	188	139	
264	189	140	
265	187	138	
266	185	136	
267	184	134	
268	186	137	
269	179	129	
270	178	128	
271	180	130	
272	182	132	
273	177	127	
274	181	131	
275	183	133	

	Zigrosser	Kraushaar	Gallatin
276	191	142	
277			
278	192	143	
279	193	144	
280	200	151	
281	201	152	
282	202	153	
283	203	154	
284	204	155	
285	205	156	
286	206	157	
287			
288	207	158	
289	208	159	
290	209	160	
291	210	161	
292	211	162	
293	212	163	
294	213	164	
295	214	165	
296	215	166	
297	196	147	
298	194	145	
299	198	149	
300	195	146	
301	199	150	
302	197	148	
303	283		
304	217	168	
305	218	171	
306	216	167	
307	219	170	
308	220	169	
309	274		
310	285		
311	284		
312	221	172	
313	222	173	

Photograph Credits

Frontispiece. Photo by Louise Dahl Wolf.
Figs. 1, 2. Courtesy of Linda I. Young.
Fig. 3. Courtesy of Peggy Bacon.
Fig. 31. Library of Congress.
Fig. 32. Photo by Louise Dahl Wolf.

Catalogue Entries

1, 3. Philadelphia Museum of Art.
5. Free Library of Philadelphia.
6–8. Philadelphia Museum of Art.
9. Free Library of Philadelphia.
10. (etching) Philadelphia Museum of Art.
 (photograph) New York Public Library (Rare Book Division).
11–23. Philadelphia Museum of Art.
26. Courtesy of Brown University.
27. Philadelphia Museum of Art.
28. Alfred J. Wyatt photo. Courtesy of Kirke Bryan.
29–42. Philadelphia Museum of Art.
45. Metropolitan Museum of Art.
46. Philadelphia Museum of Art.
50. Library of Congress.
51. (etching) Library of Congress.
52. Alfred J. Wyatt photo. Courtesy of Kirke Bryan.
53. George H. Tweney photo.
54. Free Library of Philadelphia.
55. Library of Congress.
57. Philadelphia Museum of Art.

58. Alfred J. Wyatt photo. Courtesy of Kirke Bryan.
59. New York Public Library (Rare Book Division).
75, 78. Philadelphia Museum of Art.
115. Museum of Modern Art.
132. Museum of Modern Art. Photo by Soichi Sunami.
133. Philadelphia Museum of Art.
134. (tissue) Philadelphia Museum of Art.
136. (first state) Philadelphia Museum of Art.
137. Museum of Modern Art. Photo by Soichi Sunami.
142. (redrawn proof) Lessing J. Rosenwald Collection.
143. Philadelphia Museum of Art.
148. (tissue) Philadelphia Museum of Art.
157. Philadelphia Museum of Art.
172. (published state) Museum of Modern Art.
 Photo by Soichi Sunami.
192. Philadelphia Museum of Art.
195. (seventh state) New York Public Library (Prints Division; Astor, Lenox and Tilden Foundations).
212. (fourth state) Philadelphia Museum of Art.
224. (first state) Philadelphia Museum of Art.
246. (fifth state) Cleveland Museum of Art.
246. (seventh state) Museum of Modern Art.
 Photo by Soichi Sunami.
246. (drawing) University of Nebraska (F. M. Hall Collection).
Poster I. Library of Congress.
Posters M, T. New York Public Library (Art and Architecture Division).

Index

Individuals and subjects portrayed in Sloan's prints are listed here only if there is additional information on them in the written text. Otherwise, they will be found in the Title Index, p. 395.